D1596977

BEAUTIFUL

UGLINESS

MARK
WILLIAM
ROCHE

BEAU TIFUL

UGLI NESS

CHRISTIANITY,
MODERNITY,
AND THE ARTS

University of Notre Dame Press

Notre Dame, Indiana

Library of Congress Control Number: 2023942032

ISBN: 978-0-268-20701-4 (Hardback)
ISBN: 978-0-268-20703-8 (WebPDF)
ISBN: 978-0-268-20700-7 (EPpub)

In memory of

CATHY ROCHE

and for all who loved her

CONTENTS

List of Illustrations ix
Acknowledgments xiii
Abbreviations and Translations xvii

Introduction 1

PART I. Conceptual Framework
24

ONE Unveiling Ugliness 25

TWO Aesthetic Categories 61

THREE Intellectual Resources 88

PART II. The History of Beautiful Ugliness
109

FOUR Imperial Rome 113

FIVE Late Medieval Christianity 131

SIX The Theological Rationale for Christianity's
Immersion in Ugliness 162

Historical Interlude 191

SEVEN Modernity 201

EIGHT Modernity's Ontological and Aesthetic Shift 236

PART III. Forms of Beautiful Ugliness
259

Styles of Beautiful Ugliness 263

NINE Repugnant Beauty 265

TEN Fractured Beauty 291

ELEVEN Aischric Beauty 306

Structures of Beautiful Ugliness 337

TWELVE Beauty Dwelling in Ugliness 339

THIRTEEN Dialectical Beauty 360

FOURTEEN Speculative Beauty 384

Conclusion 411

Notes 429
Works Cited 445
Index 479

ILLUSTRATIONS

1. Otto Dix, *The Match Seller*, 1920 2

2. Hans Holbein the Younger, *The Ambassadors*, 1533 4

3. Peter Paul Rubens, *Head of the Medusa*, 1618 34

4. Auguste Rodin, *Despair*, 1890 37

5. Edvard Munch, *The Scream*, 1893 39

6. Felix Gonzalez-Torres, *"Untitled" (Portrait of Ross in L.A.)*, 1991 73

7. Domenico Ghirlandaio, *An Old Man and His Grandson*,
 ca. 1490 80

8. Max Beckmann, *Descent from the Cross*, 1917 83

9. Side view of the *Crucifixus dolorosus*, St. Maria im Kapitol,
 ca. 1304 136

10. Detail of the *Crucifixus dolorosus*, St. Maria im Kapitol,
 ca. 1304 137

11. *Röttgen Pietà*, ca. 1300–1325 138

12. Matthias Grünewald, *The Crucifixion, Isenheim Altarpiece*,
 ca. 1512–15 140

13. Detail of Matthias Grünewald, *The Crucifixion,
 Isenheim Altarpiece*, ca. 1512–15 142

14. Detail of Matthias Grünewald, *The Crucifixion,
 Isenheim Altarpiece*, ca. 1512–15 143

15. Jacob Matham, *Avarice*, ca. 1587 146

16. Giotto, *Envy (Invidia)*, ca. 1306 150

17. Hieronymus Bosch, right panel of *The Garden of Earthly Delights*, 1490–1510 152

18. Anonymous master from Swabia or the Upper Rhine, *The Dead Lovers*, ca. 1470 155

19. Pieter Bruegel the Elder, *The Triumph of Death*, ca. 1562 156–57

20. Maxim Kantor, *The Temptation of St. Anthony*, 2015 159

21. Bosch or a follower of Bosch, *Christ Carrying the Cross*, 1500–1535 160

22. Michelangelo Caravaggio, *Madonna of the Pilgrims*, ca. 1603–6 172

23. Matthias Grünewald, *The Resurrection of Christ, Isenheim Altarpiece*, ca. 1512–16 181

24. Pieter Bruegel the Elder, *Christ Carrying the Cross*, 1564 184–85

25. Maxim Kantor, *Golgotha*, 2015 187

26. Hans Holbein the Younger, *The Body of the Dead Christ in the Tomb*, 1520–22 188–89

27. Cindy Sherman, *Untitled #175*, 1987 208

28. Jenny Saville, *Torso II*, 2004–5 209

29. Frida Kahlo, *The Broken Column*, 1944 212

30. George Grosz, *Shut Up and Soldier On*, 1928 214

31. John Heartfield, *As in the Middle Ages . . . So in the Third Reich*, 1934 215

32. Francisco Goya, *Still Life of Sheep's Ribs and Head*, 1810–12 218

33. Jeff Wall, *The Flooded Grave*, 1998–2000 220

34. Andres Serrano, *Self Portrait Shit*, 2007 233

35. Otto Dix, *Skull*, 1924 240

36. Jacques-Louis David, *The Death of Marat*, 1793 270

37. Francisco Goya, *The Third of May, 1808, in Madrid*, 1814 272

38. Hans Baldung Grien, *Three Ages of Woman and Death*, 1510 277

39. Charles Csuri, *Gossip*, 1990 283

40. Käthe Kollwitz, *The Survivors*, 1923 285

41. Frank Gehry, *Lou Ruvo Center for Brain Health*, Las Vegas, 2010 298

42. Henri Laurens, *Head of a Young Girl*, 1920 300

43. Umberto Mastroianni, *The Farewell*, 1955 301

44. Max Beckmann, *The Night*, 1918–19 307

45. Giuseppe Arcimboldo, *Winter*, 1563 310

46. Giuseppe Arcimboldo, *The Lawyer*, 1566 311

47. Georges Rouault, *Head of Christ*, 1905 312

48. Paul Klee, *Outbreak of Fear III (Angstausbruch III)*, 1939 314

49. Otto Dix, *Wounded Man (Bapaume, Autumn, 1916)*, 1924 315

50. Otto Dix, *Skat Players/Card Playing War Invalids*, 1920 317

51. George Grosz, *The Funeral (Dedicated to Oskar Panizza)*, 1917–18 318

52. Pablo Picasso, *Guernica*, 1937 320–21

53. Pablo Picasso, *Weeping Woman*, 1937 322

54. Patricia Piccinini, *The Young Family*, 2002 343

55. Ivan Albright, *Into the World There Came a Soul Called Ida*, 1929–30 356

56. Francisco Goya, *Disasters of War*, 1810–20 363

57. George Grosz, *The Pillars of Society*, 1926 364

58. Romuald Hazoumè, *Liberté*, 2009 373

59. A. Paul Weber, *The Rumor*, 1943 374

60. Jacopo Robusti Tintoretto, *The Adoration of the Shepherds*, 1578–81 400

61. Diego Velázquez, *The Surrender of Breda*, 1634–35 402

62. Styles of Beautiful Ugliness 414

63. Structures of Beautiful Ugliness 414

64. Francis Bacon, *Self-Portrait*, 1969 417

65. Barbara Roche, *Just Warped*, 2018 419

A C K N O W L E D G M E N T S

My interest in the ugly dates back to 1989 when I was at Ohio State University and taught Karl Rosenkranz's nineteenth-century German classic *Aesthetics of Ugliness* in a graduate seminar titled Objective Idealism and the Study of Literature. The initial catalyst for my exploring ugliness in a still deeper and more systematic way was a 2010 lecture I gave at the University of Notre Dame: "Within modern art, the concept opposite to the beautiful, the ugly, has gained a strange prestige: What is its function in enhancing the expressivity of art?" In developing the lecture, I realized, first, that the topic could hardly be exhausted in a brief analysis and, second, that the puzzles and insights I had uncovered were very much worth pursuing in greater depth.

Since embarking on this book project a bit more than ten years ago, I have interrupted the process to write and complete three other books on unrelated subjects, but the topic stayed with me and has engaged me consistently. I have experimented with the material by offering various lectures on the topic, including at Oberlin College, Duke University, the University of Waterloo, the University of Amsterdam, North Park University in Chicago, and the annual meetings of the German Studies Association and the Midwest Symposium in German Studies. On these occasions I received engaging questions and comments from a range of persons, some known to me, some unknown. In a few cases I gave lectures to large audiences of mainly nonacademics, including a lecture at the Hegelwoche in Bamberg and a series of three lectures at the Hochshulwochen in Salzburg. The kinds of questions I received from educated laypersons have led me to add new elements and tailor various sections for a broader audience.

During 2012–13, a senior fellowship at the Notre Dame Institute for Advanced Study (NDIAS) offered me the time and support to begin serious work. During that year I received excellent feedback in response to four presentations. I was able to give an overview of the project to the initial group of NDIAS fellows in fall 2010, and I had the good fortune to give the inaugural presentation to the incoming NDIAS fellows in the fall of 2015.

Primarily in the context of these various talks, but also to some extent in subsequent correspondence and in informal conversations, I have received leads, heard provocative questions, or garnered new insights. In particular, I would like to thank John Betz, Martin Bloomer, Tobias Boes, Costica Bradatan, Wolfgang Braungart, Thomas Brooks, Tom Burish, Don Crafton, Vanessa Davies, Bill Donahue, Carsten Dutt, Sabrina Ferri, Brad Gregory, Kevin Grove, Andreas Grüner, Jan Hagens, Elizabeth Hamilton, David Hart, Vittorio Hösle, Peter Holland, Steve Huff, Christian Illies, Robin Jensen, Claire Jones, Vincent Lloyd, Jacob Mackey, Jim McAdams, Tara Mendola, Vittorio Montemaggi, Gundi Müller, Richard Oosterhoff, Cyril O'Regan, Federico Perelda, Thomas Pfau, Barbara Roche, Ellen Rutten, John H. Smith, Robert Sullivan, Maria Tomasula, Daisuke Uesaki, and Jens Zimmermann. Of these, I want to single out Vittorio Hösle, who directed NDIAS while I was there. My conversations with him benefited greatly from his combination of intellectual range, analytical acumen, and generosity of spirit. My gratitude also extends to the two anonymous reviewers at the University of Notre Dame Press. Finally, I want to thank copyeditor Scott Barker and associate acquisitions editor Rachel Kindler for their very helpful suggestions during the editorial process.

Thanks to the cooperation of many individuals and institutions from around the world, I was able to obtain all the images needed for this book. I owe particular gratitude to the contemporary artists to whom I reached out, none of whom declined my requests: Romuald Hazoumè, Maxim Kantor, Patricia Piccinini, Barbara Roche, Jenny Saville, Andres Serrano, Cindy Sherman, and Jeff Wall.

Mary Elsa Henrichs provided research assistance, locating English translations for many of the foreign-language quotations. Kelvin Wu, also a research assistant, was kind enough to give me helpful feedback on my examples and analyses from music.

The book incorporates and revises my earlier thinking on the topic, published as "The Function of the Ugly in Enhancing the Expressivity of Art," in *The Many Facets of Beauty*, ed. Vittorio Hösle (Notre Dame, IN: University of Notre Dame Press, 2013), 327–55. Those insights are integrated here with the permission of UNDP.

ABBREVIATIONS AND TRANSLATIONS

To aid both scholars and general readers, I have tried to give references to works in their original language and in English, using recognizable abbreviations, such as "Ger." for "German" and "Eng." for "English." For works that have universally identifiable sections, as with the Stephanus pagination of Plato's works or acts and scenes in dramas, I cite those. My one unusual abbreviation is A, which refers to Knox's English translation of Hegel's *Aesthetics*.

I have used published translations whenever possible and practical. In some cases, all of which are marked "translation modified," I made slight modifications to published translations. In a few instances my translation differs so much from the published source that I write "my translation." My goal has been to be as accurate and fluid as possible. With some works, no translations were available for consultation, so I offered my own translations. In these cases, references are given solely to the original source. Emphasis in quotations is always taken from the original.

INTRODUCTION

Ugliness is a signature element of modern art. Ugly works attract those of us who are fascinated by what lies beyond traditional beauty. Yet viewers may also be repelled. Otto Dix, who experienced the trauma of World War I, not only portrayed ugliness, but he also thematized our intuitive resistance to ugliness. Dix's *Match Seller* (1920), an oil and collage on canvas, depicts an invalid from whom others scurry away (illustration 1). The veteran is without limbs. His lack of legs (and the dog's short legs) are contrasted with the seemingly overly long legs of the well-dressed pedestrians who flee by him. The flight from ugliness reveals an unwillingness to confront reality. Dix's etching on the same topic, also from 1920, is even more dramatic in conveying our fear and flight. We glance past what is ugly and repellent unless we are forced to look. With its hard edges, the painting seems almost to shout at us. The veteran is blind now, but he has seen the horror of war and the plight of poverty. The dog, with its prominent eyes, urinates on the veteran's leg stump, underscoring his place in the hierarchy and his mistreatment as an object. Obscured above his head is the image of a cross, which stresses his victimhood and the lack of Christian values around him. Indeed, we see three crosses askew: the prominent one above the match seller's head, the pattern on the sidewalk, and the partial, but incomplete crosses in the street. Although the painting draws on the imagery of the cross, linking the suffering

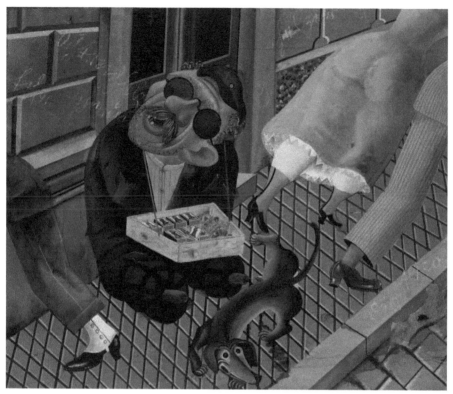

ILLUSTRATION 1
Otto Dix, *The Match Seller*, 1920, Collage, Staatsgalerie, Stuttgart © 2022 Artists Rights Society (ARS), New York/VG Bild-Kunst, Bonn, bpk Bildagentur/© Art Resource, NY.

veteran with the crucified Christ, the veteran is even worse off than Christ: without limbs he could not even be nailed to the cross.

Although the ugly and the beautiful may appear to be opposites, many beautiful artworks are in some sense also ugly. They may have repugnant content, as with Gottfried Benn's poems about corpses. Distorted forms may predominate, as with British painter Francis Bacon's torturous self-portraits. Dissonance may be unresolved, as with Polish composer Krzysztof Penderecki's musical lament for the victims of Hiroshima. Yet such works are beautiful. I use the term "beautiful ugliness" for works that satisfy two conditions. First, they involve either ugliness in the object depicted, such as physical, emotional, intellectual, or moral ugliness, or ugliness in the work's properties, such as distorted forms, unintegrated parts, or unresolved dissonance. Second, the works are aesthetically excellent and therefore beautiful.

In the aesthetic realm, the word "beauty" is ambiguous. On the one hand, "beauty" designates positive aesthetic value; "beautiful" is what is "aesthetically excellent" (Bosanquet, *Three Lectures* 85). On the other hand, "beauty" is a particular kind of positive aesthetic value, one that is associated with what is pleasing or harmonic and that can be contrasted, for example, with the sublime. A pleasurable meadow landscape is beautiful, whereas a mountain landscape that evokes awe is sublime. Similarly, we can contrast the beautiful in its more specific meaning with the ugly. A photograph of a junkyard might be ugly and not at all pleasing, but it may have positive aesthetic value: the photograph may be beautiful in the sense of aesthetically excellent. Nelson Goodman notes: "If the beautiful excludes the ugly, beauty is no measure of aesthetic merit" (255). If we retain—with Goodman and others—the overarching association of beauty with aesthetic merit, then ugly works may be beautiful not in the specific sense of pleasing or harmonic but in the overarching sense of aesthetically excellent. Although ugliness often has negative aesthetic value, it can have positive aesthetic value. In such cases we can speak of beautiful ugliness.

Let's briefly consider two more examples. In the Renaissance, the discovery of perspective enhanced beauty. Artists could now portray reality, including beautiful objects, more accurately. But once perspective is known, it can also be distorted. Formal experimentation and distortion become a catalyst for ugliness. Consider the distorted skull in *The Ambassadors* (1533), an oil on panel by the great portrait painter Hans Holbein the Younger (illustration 2). When we view this masterful painting straight on, we see at the bottom an odd distorted smear, an oblong shape that is formally ugly, but if we look at the work from an oblique angle, to the right of the canvas and close to the plane of the work, an exquisite rendition of a skull reveals itself. Holbein uses anamorphosis, a term coined in the Baroque to designate distortion of perspective (Mersch 29). Presumably one reason for Holbein's use of anamorphosis is the desire to display his mastery of technique, to play with it for purposes of trickery; yet another is to underscore the extent to which death can surprise us and is often otherwise veiled. Holbein suggests that we do not face or see our mortality, but, consumed with the vanity of life, we twist its meaning, as with the image of the skull. Death is both present and hidden for the two figures, who appear to be confident and very much of this world, with fine garments and a wealth of treasured objects. Jean de Dinteville, the figure

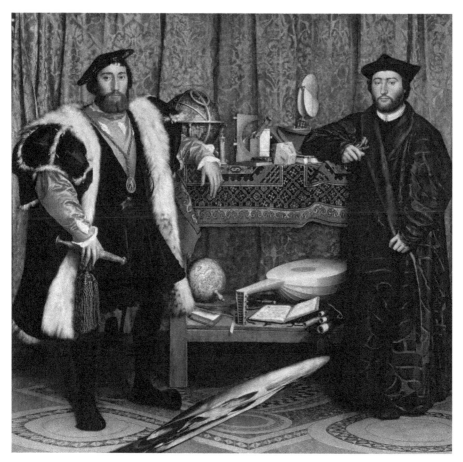

ILLUSTRATION 2
Hans Holbein the Younger, *The Ambassadors*, 1533, Oil on panel, National Gallery, London/Bridgeman Images.

on the left, who commissioned the painting, is flamboyantly clothed in fur, velvet, and satin. The top shelf contains objects devoted to astronomy and the heavens, such as a celestial globe and a sundial; on the bottom shelf, we see more earthly objects, for example, a terrestrial globe and a lute. The figure on the left holds a dagger; the elbow of the figure on the right, a bishop, rests on a book. The active and contemplative life are here contrasted, but they along with the cultured study of the heavens and the earth are all placed in opposition to the distorted skull. The skull is not visible as a skull when the observer views the figures and objects in the painting head on, but the skull becomes clear when the figures and other objects recede from

Beautiful Ugliness

our view, and we look at the work from high on the right side or low on the left side.

Penderecki's *Threnody for the Victims of Hiroshima* (1960), to take an example from music, is not simply dissonant, but eerie, discordant, disabling. Its mood evokes both solemnity and disaster and is in this way fitting as a composition of mourning. Penderecki, who had experienced the Nazi occupation of Poland firsthand, scored *Threnody* (threnody = "a song of lamentation") for fifty-two strings: twenty-four violins, ten violas, ten cellos, and eight double-basses. The work expresses mourning along with rage and does so with unconventional sounds. By using a finger or the frog of the bow to tap on the instrument's wooden frame, the string players produce percussive effects. For such sounds Penderecki had to invent new notation symbols. The work opens with a cluster chord of all the instruments playing in their uppermost register. Intermittently the chord returns, including at the end. We hear glissandi, continuous slides upward or downward between two notes; meanderings across registers; dissonant micro-tonality; and abrasive sounds triggered by extreme bowing techniques. The cacophony between the various groups of strings seems to evoke many human voices wailing.

As such cases reveal, the beautiful has the capacity to integrate within itself and transform ugliness. John Dewey articulates this principle well: "Something which was ugly under other conditions, the usual ones, is extracted from the conditions in which it was repulsive and is transfigured in quality as it becomes a part of an expressive whole. In its new setting, the very contrast with a former ugliness adds piquancy, animation, and, in serious matters, increases depth of meaning in an almost incredible way" (100). Much of beauty is dialectical—a sterile opposition of the beautiful and the ugly fails to capture the energy and complexity of art, the intersection of ugliness and beauty. The parts of an artwork often gain in individuality when they are ugly (212), and the quality of a work depends on both parts and whole. In describing Christian art, John Cook comments: "There are visual works of art that are beautiful that nevertheless include the ugly, and without that ugly factor the artwork would not be complete, and therefore not be beautiful" (126). The idea that the beautiful and the ugly are not to be understood simply as opposites transcends the West. The Japanese concept of *wabi-sabi* draws on Buddhist ideas of impermanence, incompleteness, and imperfection. It elevates artworks with

elegant imperfections and asymmetries: "Wabi-sabi is ambivalent about separating beauty from non-beauty or ugliness" (Koren 51). Indeed, wabi-sabi suggests not only that beauty is coaxed out of ugliness, but that any dualism of the two is untenable (Juniper 110).

Despite the deep interwovenness of beauty and ugliness, ugliness has received only modest attention in the Anglo-American world. In 1977, American literary scholar and theologian John Timmerman observed: "Almost neglected in aesthetic theory has been a concern for what constitutes ugliness" (138). In 1994, Israeli philosopher Ruth Lorand lamented that what stands as the opposite of beauty, its negation, "has hardly ever been discussed in the literature" (Lorand 399). At the turn of the century, British philosopher Frank Sibley, underscoring that ugliness is "of considerable fascination and complexity," noted that it is "seldom discussed" (190). In 2018, Katy Kelleher observed in *The Paris Review*: "Ugliness has never been the subject of much scrutiny."

But anyone who has surveyed the German aesthetic tradition of the past two centuries would not find the topic unaddressed, neglected, or seldom discussed.

Several studies on ugliness have begun to appear in English.[1] Interest has likewise increased in neighboring fields, such as horror studies and disability studies. The time is ripe for a more comprehensive assessment that takes into account valuable insights in other languages and recent contributions in English. The ugly represents promising terrain: it engages elements from which we might otherwise be tempted to avert our gaze, helps us understand the world as it is, and expands art's critical potential. It opens up avenues of artistic creativity, challenging artists to find ways to blend the ugly and the beautiful. And it expands our receptivity to new and innovative forms.

Overview

Beautiful Ugliness offers readers a conceptual framework for understanding ugliness. Although art can make understandable and available what might be incomprehensible and inaccessible in the form of reasoning, art is also often complex, recalcitrant, and in need of interpretation. This complexity follows from its indirection. In great art, meaning is not self-evident, but must be ascertained through interpretation; this endeavor is often difficult. The interpreter's task is to be

schooled in the categories of interpretation, the history of art, including its diverse forms, and the specific diachronic and synchronic dimensions affecting the work under analysis, all of which are prerequisites for a meaningful interpretation. With regard to ugly works, the stakes are raised, for *to date we have no vocabulary for the diverse ways in which ugliness is interwoven into beautiful artworks.* This book offers readers that vocabulary.

Herein I analyze the eras when works of beautiful ugliness were especially prominent. Christianity and modernity play central roles, even if not the only roles, in this narrative. I also consider the ways in which ugliness expresses itself in distinctive forms, including the ways in which the forms emerge over time and across the full range of arts, from architecture to film. Many artworks are beautiful portrayals of ugly subjects, a combination of beautiful form and ugly content that already Aristotle considered legitimate and that we recognize, for example, in Jacques-Louis David's *Death of Marat* (1793). We also see the reverse: innocuous content that is presented in a deformed and fractured way, as with Picasso's odd and distorted renderings of human subjects. Fascinating are cases where ugly content is reinforced by formal distortion. In Robert Wiene's early Weimar film *The Cabinet of Dr. Caligari* (1920), the distorted sets mirror the chaos of the narrative—and the era. Beyond the diverse relations of form and content, we also see a range of ways in which part and whole relate to one another, from works in which ugliness envelops the whole to works that include prominent moments of ugliness, which are nonetheless subordinate within the whole.

Part I, "Conceptual Framework," integrates insights from analytic philosophy, such as the distinction between the object depicted and the properties of the work, but draws primarily on categories from Christianity and from German idealism, which have animated much of my earlier work in aesthetics. Dialectical structures, with their attentiveness to paradox, effectively illuminate beautiful ugliness, including the creative ways in which the organic unity of form and content, part and whole, can be achieved.

In chapter 1, "Unveiling Ugliness," I weigh three definitions: the ugly as what is opposite the beautiful, the ugly as what we find repellent, and the ugly as an appearance that contradicts what belongs to the normative concept of an object. Defining ugliness as the deviation from a valid norm leads to an elaboration of the spheres in which we

encounter ugliness. I differentiate types of ugliness—physical, emotional, intellectual, and moral—and discuss their combinations. In each case we see an appearance that veers from what should be. For example, ignorance combined with arrogance and a lack of curiosity betrays the human capacity for reason. The ways in which types of ugliness overlap or oppose one another is fascinating. Thersites, for example, "the ugliest man" in Homer, is also intellectually inferior and "without decency" (*Iliad* 2.214–16), whereas Socrates represents a mixed type, the physically ugly person who has extraordinary intellectual and moral capacities. The relation of physical and moral realms can be especially intriguing, as when a physically beautiful person, such as Oscar Wilde's Dorian Gray, is morally ugly. Above all, it is important to recognize the range of spheres beyond the physical in which ugliness can be encountered. I also examine various motivations for including ugliness in art, ranging from empathy and moral outrage to formal innovation and playfulness. Ugliness should not be reduced, as it often is, to physical ugliness, and ugliness can elevate artworks, making them richer and more complex.

Chapter 2, "Aesthetic Categories," addresses the concepts that can help us make sense of ugliness. For example, an artwork about an ugly topic can be beautifully executed. In my account of categories, as in my earlier definitions of ugliness, I emphasize not the production or reception context, as important as these are, but, as Hegel does, the work itself: its content, its form, the relation between the two, and the relation of part and whole. Artwork aesthetics is the driving force in my forays into the aesthetics of ugliness. I distinguish between ugliness and seeming ugliness. In the concept of the seemingly ugly, we recognize philosophical connections to the neighboring field of disability studies and historical connections to what the Nazis called "degenerate art." Seeming ugliness involves beauty that is difficult to discern and that recipients might be inclined to criticize. However, a seemingly disordered structure may have a hidden logic that requires greater discernment.

A revised Hegelian aesthetics is already present in chapter 2. In chapter 3, "Intellectual Resources," I explore medieval and early modern Christian thinkers, Hegel, and the Hegelians insofar as their work touches on ugliness. The aesthetic contributions of medieval Christians have not been integrated into recent studies, but they offer an enduring, counterintuitive insight. Hegel receives close analysis, for his dialectical approach provides us with rich categories for examin-

ing the complex relation of the beautiful and the ugly, even if his own comments on ugliness are not as extensive as those of his followers, the early Hegelians, who vigorously engage ugliness. These thinkers offer intriguing and understudied insights: they analyze the ugly in relation to the sublime and the comic, recognize ugliness as a valuable moment within art, and emphasize the diverse ways in which ugliness is both integrated and negated. These insights, known only to specialists in the history of ideas, can be developed to shed new light also on modern examples of ugliness.

Part II, "The History of Beautiful Ugliness," analyzes the historical, intellectual, and aesthetic factors that led to the prominence of ugliness in diverse eras and offers close readings of selected works. Although one can recognize ugliness along a spectrum, such that it is almost always present to some degree, in a few eras ugliness breaks new ground or is especially prominent. My analyses focus on imperial Rome, late medieval Christianity, and modernity.

After recognizing moments of ugliness in ancient Greek literature and in Hellenistic sculpture, I turn in chapter 4, "Imperial Rome," to the first period of radical and sustained immersion in ugliness, imperial Roman literature, from the death of Augustus in AD 14 until about 200. Here we find an array of factors leading to a deep immersion in ugliness, culminating in the moral revolt of Lucan and the emergence of an entirely new genre, satire, which has, especially in Juvenal, a pervasive interest in decadence and depravity coupled with its bitter indictment. My account of imperial Roman literature culminates in a close analysis of Juvenal's ninth satire.

Chapter 5, "Late Medieval Christianity," analyzes how deeply interwoven medieval Christian art is with ugliness: Christ's horrendously brutal crucifixion and the ugliness manifest in human sinfulness. In late medieval Christianity we see Gothic images of Christ tormented on the cross, culminating in the early sixteenth-century *Crucifixion* by Matthias Grünewald. Moreover, Christianity portrays moral turpitude and the torments of hell, for example, in Dante's *Inferno* and Bosch's paintings. As with imperial Rome, the categories become paradigmatic and enduring: empathy with the suffering individual and portrayals of willful evil persist into modernity, offering two distinct paths to the portrayal of ugliness.

Chapter 6, "The Theological Rationale for Christianity's Immersion in Ugliness," explores the factors that drive Christianity's immersion in

ugliness. First, the gruesomeness of Christ's crucifixion gives us ample images of ugliness and upends one hierarchy after another, rendering the highest being one with the lowliest of the low. Second, Christianity introduces a new anthropology, with deep recognition of human sinfulness. Christian depictions of moral evil far exceed what we see in classical Greece. Finally, the ugly and repugnant are recognized as transitory and part of a larger tale of promise. To descend into the depths of negativity and ugliness is more palatable if you have the expectation of redemption. Christianity sees suffering as part of a divine plan and so takes us beyond the dying God.

In "Historical Interlude," I briefly survey the mixed reception of ugliness from the end of the Middle Ages to the advent of modernity. In some periods, such as the Renaissance and the Enlightenment, we encounter little engagement with ugliness, but we see far more interest in other eras, including the Baroque and the early modern.

Modernity represents the third dominant age of ugliness and is the focus of chapter 7, "Modernity." No early twentieth-century writer better illustrates the integration of ugliness into high art than Gottfried Benn, who published beautiful poems about cancerous bodies and corpses. Many contemporaries found these poems abhorrent. Today we see therein a signature element of modernity. Beyond illustrating the prominence of ugliness in modernity, I explore two consistent threads. First, I analyze reversals of idealized female beauty, which effectively mock instrumentalization, reductionism, and dehumanization. Second, I assess the extent to which, even as modernity turns away from Christianity, traces of Christianity continue to surface in works of beautiful ugliness. I also analyze what I call the "paradoxical greatness and crisis of modern art." To some extent this greatness arises from innovative forms of beauty that integrate ugliness. The crisis appears in the overabundance of two forms of deficient art, both of which have connections to ugliness: *kitsch*, which assiduously avoids the ugly and to which less educated recipients are drawn partly because of their unease with challenging artworks that integrate ugliness; and *quatsch*, a term I introduce, as a counterpart to *kitsch*, to refer to art that prominently integrates ugliness but which lacks aesthetic merit.

Chapter 8, "Modernity's Ontological and Aesthetic Shift," explores two broad reasons for modernity's fascination with ugliness. First, modernity rejects the idea that there is an ideal world we seek to understand and imitate in moral activity and in art—and we are left

with a concept of reality as simply what is. Moreover, the view emerges, and becomes dominant, that our existing world is repugnant, fragmentary, and without overarching meaning. "Ugliness was the one reality," suggests Oscar Wilde's Dorian Gray (3:325). Also contributing to this shift are skepticism concerning religious answers to the problem of evil and a greater eye for ugliness in the world, not least of all industrialization and its effects. Second, transformations in aesthetic values contribute to increasing ugliness. In an aesthetic interpretation of ugly reality, asymmetries and perversions of what is traditionally called "beautiful" may be appropriate. Further, the severing of the link between the aesthetic and the ethical leads to works that celebrate moral ugliness. An analysis of Wilde's novel, focusing on its seeming ugliness, its submerged religious motifs, and its ambiguities, adds a hermeneutic dimension to my account of modern ugliness.

Part III, "Forms of Beautiful Ugliness," analyzes diverse types of beautiful ugliness. The extensive and diverse relations between the beautiful and the ugly call out for a taxonomy of its types as a basis for critical analysis. The taxonomy works out its distinctions in Hegelian dialectic: horrendous content and ugly form can be interwoven with one another to constitute a higher organic unity, and moments of ugliness can find their truth in a larger arc that both lingers in ugliness and moves beyond it. In part III, I lay out and analyze the different modes in which ugliness can become beautiful. I stress, first, the relation of form and content and, second, the interconnection of part and whole. These two lenses (form and content, on the one hand, and part and whole, on the other) lead in turn to three distinct *styles of beautiful ugliness* and three diverse structures.

In chapters 9 and 10, I analyze two styles that mirror one another, *repugnant beauty* and *fractured beauty*. Chapter 9, "Repugnant Beauty," analyzes the first style: the interweaving of ugly content with beautiful form, as in Thomas Eakins's *The Gross Clinic* (1875), a masterful depiction of a surgeon at work, with blood prominent on the canvas. We see in repugnant beauty the skillful representation of an unappealing subject. Repugnant beauty is the most widespread form of beautiful ugliness and can be found in almost every age and culture. In terms of subject matter, such works cover a full range, from physical ugliness to emotional, intellectual, and moral ugliness, in each case portraying what differs from the ideal. The focus on ugly subject matter is often an end in itself, but not always: Käthe Kollwitz's portrayals of hunger

and misery, of the poor and disenfranchised have a certain beauty that is designed to widen our sense of empathy, drawing attention to the abject circumstances of our fellow human beings. Such art can be understood as a kind of subversive beauty, for it challenges our everyday sensibilities.

In chapter 10, "Fractured Beauty," we see the reverse: innocuous content that is conveyed via disjointed or fragmented forms, as in Picasso's various renditions of *Head of a Woman*. The occurrence of this playful form in premodern periods is uncommon, but in modernity fractured beauty becomes widespread. Such works underscore the partial and fragmented sense of the world that defines modern consciousness. Moreover, as modern art moves toward a kind of antirealism and a focus on form as form, fractured beauty gains ascendancy. Further, fractured beauty contributes to innovation, a category that, along with fragmentation, is very much embraced in modernity.

Works that are not only ugly in subject matter but also fractured in form is the subject of chapter 11, "Aischric Beauty." The third style combines the ugly content we see in repugnant beauty with fractured beauty's formal ugliness. Drawing on the Greek *aischros*, a word that encompasses both the aesthetic ugliness of form (*deformis* in Latin) and the moral ugliness of content (*turpis* in Latin), I introduce the neologism *aischric beauty* to capture this third style of ugliness, which encompasses works that are both repugnant in content and dissonant in form. Some works exhibit, paradoxically, a higher unity of form and content. The episodic structure of Arthur Schnitzler's comedy *Anatol* (1893) formally reinforces the protagonist's lack of progress and is in this way paradoxically organic, an example of aischric beauty. In a fractured style, Picasso's *Guernica* (1937) depicts the effects of bombing on soldiers, civilians, and animals; the formal distortion effectively matches the horrendous subject matter. In presenting what is ugly, works often integrate dissonant forms, which then serve the work's meaning and are thus, at a higher level, not dissonant but organic, that is, form and content ultimately cohere. The hidden organic element, turned upside down, offers a new lens to approach difficult works, and it challenges prevailing models of avant-garde art as necessarily nonorganic.

Whereas my initial approach to modes of ugliness draws on content, form, and their interrelation, a second and complementary lens asks, To what extent does the work identify with, or distance itself from, ugliness? This question, which focuses on the interaction of

parts and whole, leads to what I call diverse *structures of ugliness*. In chapters 12 and 13, I analyze two modes that appear as opposites. Chapter 12, "Beauty Dwelling in Ugliness," analyzes what I call *beauty dwelling in ugliness*, a lingering in ugliness without criticizing it in any way and without moving beyond it. Works are characterized by either an indifference to, or an embrace of, ugliness, even though the work itself may be beautiful, as in the early poetry of Benn. Even though beauty dwelling in ugliness increases in modernity, it does surface in earlier ages, including in the book of Psalms. In this chapter, we begin to recognize patterns of frequent overlap, for example, in Benn between repugnant beauty and beauty dwelling in ugliness.

In chapter 13, "Dialectical Beauty," I analyze the second structure. Although ugliness dominates such works, *dialectical beauty* points to the ugliness of the ugly and so offers an implicit critique. The concept of a negation of a negation as a way of integrating ugliness into art was prominent among the early Hegelians. The mode fits the satiric tradition and meshes nicely with all of what we see in imperial Rome. George Grosz, who presents the corruption of modern Germany in ugly ways, offers a modern example: his artistic portrayals are invariably designed to uncover the ugliness of the ugly. Francisco Goya and Otto Dix use similar strategies: their works negate negativity. Dialectical beauty is in principle possible in all arts, but it is rare in two art forms: architecture and instrumental music. Although dialectical beauty can be integrated with diverse styles, its most frequent partner is aischric beauty.

In chapter 14, "Speculative Beauty," I conclude the typology. Here the ugly, repulsive, or hateful is present, even prominent, but ultimately subordinate within a larger, more complex and organic unity. The term "speculative" derives from Hegel's elevation of what transcends opposition and negativity, as central as both are within the unfolding of the dialectic. An example is Aeschylus's *Oresteia* (458 BC), which moves beyond tragedy. Speculative beauty is most common in literature and other temporal arts, but we find rare, creative instances even in the static arts. In our age, speculative beauty is uncommon.

The conclusion articulates the book's implications and raises puzzles about the ways in which works transcend individual forms of beautiful ugliness. Dix's postwar works and Francis Bacon's portraits show how ambiguous works both embody and move beyond the earlier taxonomy.

Idealism, Aesthetics, Christianity

In my various work in aesthetics, I have tried to combine a more traditional idealist orientation with analyses of modernity. This has involved, for example, developing a new theory of tragedy and comedy by drawing on, but also revising, Hegel's approach to these genres (Roche, *Tragedy and Comedy*). I have made the case that an idealist orientation can help us uncover the strengths and weaknesses of dominant paradigms of literary criticism and enable us to grasp the distinct relevance of literature in an age of ecological crisis (Roche, *Why Literature Matters*). More broadly, I have argued that idealism, specifically the objective idealism we associate with Hegel, can be a rich resource for a range of issues in modern aesthetics (Roche, "Idealistische Ästhetik" and Roche, "Being at Home").

Objective idealism consists of two interconnected ideas. First, objective theoretical knowledge is available to us through reason; not all knowledge comes from experience. Second, this knowledge has ontological valence: the laws of this knowledge are also the laws of reality; that is, the ideal structures we can identify via reason are manifest in the world. Hegel's entire project was an attempt to ascertain the complex and interrelated set of categories that constitutes the ideal sphere and to analyze the various realms of reality—nature, history, politics, psychology, art, religion, and philosophy—by way of these categories. The logic and *Realphilosophie*, that is, the philosophy of these various realms of reality, seek to grasp the idea of the absolute and its unfolding presence in reality.

Objective idealism has an analogue in the sacramental vision of Catholicism, the idea that the divine manifests itself in this world, that the transcendent reveals itself in finite reality. According to this sacramental vision, humans suffer and sin in their humanity, but they are nonetheless able to recognize God's continuing presence. Hegel advances a philosophy that has loose similarities with this sacramental vision, just as he shares with Catholicism a dominant interest in the unity of truth. It is not by chance that in Thomas Mann's novel *The Magic Mountain* (1924) Leo Naphta calls the Protestant Hegel "a 'Catholic' thinker" (*Der Zauberberg* 535).

The two most prominent objective idealists in the history of philosophy are Plato, who attached the greatest importance to the ideas themselves, and Hegel, who, transformed by the revolution of Christi-

anity, sought further to understand the presence of ideas in reality. One can be an objective idealist and not endorse the views of other objective idealists; for example, Plato's disparagement of art as an imitation twice removed from reality or Hegel's controversial thesis that the age of art is now past and has been replaced by philosophy. Today's most prominent objective idealist is the German philosopher Vittorio Hösle, who recognizes an array of ways, both systematic and empirical, in which we can improve on Hegel (*Hegels System*). In his major work, *Morals and Politics*, Hösle seeks to combine aspects of Hegel's political philosophy (and beyond that elements of ancient political philosophy, including its elevation of the intertwining nature of morals and politics) with advances in the social sciences and historical developments since the time of Hegel.[2] I have tried to achieve analogous results in the realm of aesthetics.

One can judge the merit of a contribution in aesthetics not only by its internal coherence and fit within a larger system but also by its heuristic value. My hope is that readers from a range of perspectives, including ones indifferent to, or even hostile to, objective idealism, will find appealing and unexpected insights in these pages. In fact, one of my main arguments is that precisely an idealist perspective opens up new categories with which we can analyze the distinguishing features of modern and contemporary art and literature. With the humanities and literary criticism in particular suffering from a crisis of legitimacy, we must be flexible in weighing viable paradigms, including alternatives to dominant models.

Rarely in history has aesthetics been a dominant branch of philosophy, but German idealism was an exception. Schelling and Hegel developed systems of aesthetics, and their engagement with the philosophy of art followed Kant's turn to aesthetics in his third critique. Hegel's aesthetics addresses not only the systematic position of art and the relation of the arts to one another but also art's historical development. Ernst Gombrich, one of the most eminent art historians of the twentieth century, called Hegel "the father of the history of art" (*Tributes* 51). Friedrich Schiller and Friedrich Hölderlin, who made enduring contributions not only to narrative, poetry, and drama but also to the philosophy of art, also belong to the idealist period. The fascination with aesthetics continued among the Hegelians. Never before or since the era of German idealism and its aftermath has the philosophical world been so deeply invested in the analysis of art.

This fascination with art is not unique to *German* idealism. Although Plato is normally chastised for his criticism of art, he is the greatest artist among all philosophers. Plotinus, the last great aesthetician of antiquity, was an objective idealist who saw beauty as a path to the divine. Plotinus suggests, in contrast to Plato, that the object of imitation is not our created world but the ideal itself. The Italian philosopher Giambattista Vico, whose works seek to discover objective laws in the world, exhibits, especially in his *New Science*, a deeper interest in art than any great philosopher outside of the German idealists. He links art and history in ways that no other critic approaches before Hegel. Vico notes, for example, that historical processes of rationalization dilute the emotional richness and poetic mentality that great art presupposes. He also articulates the conditions necessary for the oral tradition of Homer, and in an age that felt repelled by the Middle Ages, he recognized the greatness of medieval literature, in particular Dante.

Why would an objective idealist be interested in art? Basic to objective idealism is the idea that transcendental categories illuminate the world; such categories are deeply productive for interpreting artworks. Dialectical structures are relevant throughout aesthetics but perhaps nowhere more visibly than with works of beautiful ugliness. Moreover, art has a profound metaphysical dimension: in art, deeper meaning comes to consciousness via sensuous material. Further, art unveils problems and often anticipates, however unconsciously, however elliptically, answers to these problems: psychology was first introduced through literature, not philosophy, technology was first thematized in art and literature, not philosophy, and great artworks uncover puzzles that remain unsolved. In his poem "The Artists," Schiller writes: "What here as beauty we're perceiving, / Will one day as truth before us stand" (*Werke*, 1:209). Finally, as Schiller emphasized in his essays, art has a mediating and motivational dimension that most philosophy lacks.

Beautiful Ugliness interweaves Christianity, Hegel, and modernity. Although much of today's popular Christian art emphasizes joy and light, at times bordering on kitsch, the best Christian art is anchored in a more complex tradition. Hegel recognized in Christianity a revolution in aesthetics and saw therein a radical turn to negativity.

Whether one reads Hegel, as I do, as a Christian philosopher who sought to interpret Christianity in the light of reason, or as the atheistic forerunner to the Left Hegelians Ludwig Feuerbach and Karl Marx, no one would contest that Hegel's education in dialectic emerged not only from idealists such as Socrates, Plato, and Kant, but also from Christianity. Hegel's dialectical readings of the two central ideas of Christianity, the Incarnation and the Trinity, give ample evidence of this connection.

A truncated Christianity surfaces in the contemporary landscape of religious kitsch. Catholic theologian Richard Egenter criticized religious kitsch not simply for aesthetic reasons but also on moral and religious grounds: it desecrates and cheapens the Christian worldview, in which suffering and repentance are central. Simply compare Caravaggio's *Conversion of Saint Paul* (1600–1601) or his *Calling of Saint Matthew* (1599–1600) with kitschy images of religious inspiration, as we see in prettified holy cards and artworks defined more by their positive religiosity than by their complexity, as with Warner Sallman's religious paintings, for example, *Head of Christ* (1940), *The Lord Is My Shepherd* (1943), *Christ at Heart's Door* (1942), or *The Boy Christ* (1944), all of which are significant more for their cultivation of visual piety than for their artistic merit.[3] Roger Scruton justly disparaged "the kitschification of religion" (158), which we find not only in the visual arts, but also, for example, in sweet, insipid hymns.

The divide between religious subjects and aesthetic judgment is evident in James Elkins's extraordinary assertion that "there is almost no modern religious art in museums or in books of art history" (*On the Strange* ix). The claim is hyperbolic, but not without a moment of truth. Much of modern and contemporary art has rejected religion. Elkins, who teaches at one of the largest schools of art and design in the United States, the School of the Art Institute of Chicago, observes that religion is rarely mentioned in art schools, except in the context of scandals, as when the Madonna is painted with elephant dung or a crucifix is submerged in urine (*On the Strange* 15). And much of contemporary religious art is, alas, without formal merit, even if notable exceptions exist. Instead, it tends toward kitsch—ugly and spurious because not appropriate, not true to the concept behind the object.

I want to reclaim a concept of Christian art that integrates ugliness. In this book I return again and again to examples that are Christian or

that integrate and modify Christian moments. The final structure I explore, *speculative beauty*, brings together Christianity and Hegel, for it involves as its primary example the Christian narrative, which moves from the ugliness of the Crucifixion to the beauty of the Resurrection. Moreover, the structure embodies what Hegel elevates as the highest moment in the dialectic, the speculative. Works of speculative beauty both integrate and move beyond ugliness.

A dialectical sequence is evident in the *styles of beautiful ugliness*, where *aischric beauty*, being ugly in both content and form, is the synthesis of *repugnant beauty* and *fractured beauty*, the former ugly solely in content, the latter ugly solely in form. The dialectical frame in the structures of beautiful ugliness is more complex. Among Theodor Adorno's achievements in aesthetics is his recognition of ugliness and dissonance as the central categories of modern art, but one of his limits was his unwillingness to recognize as great any art that does not elevate ugliness or dissonance. A theory that excludes nonugly artworks lacks a nuanced sensibility for the variety of legitimate art. In response to Adorno, I would introduce the concept of "radiant beauty," which I define as "beautiful art that does not include ugliness or in which the ugly plays a modest role." Consider as examples Raphael's harmonious and graceful *Sistine Madonna* (1512), Vermeer's luminous and intimate *Girl with a Pearl Earring* (ca. 1665), or the beautiful creations from nature by German artist Wolfgang Laib or British artist Andy Goldsworthy.

If we think of radiant beauty as involving the relative absence of ugliness, then we can recognize a tetradic structure from *radiant* to *speculative beauty*. Radiant beauty affirms beauty independently of ugliness. Beauty dwelling in ugliness and dialectical beauty involve deep immersion in ugliness and so could be viewed as two manifestations of an antithetical structure. Speculative beauty is an integrative form insofar as it portrays the negative or the ugly within the work but renders it a meaningful moment within a larger whole. That the antithesis would be split into two is not unusual from a Hegelian framework, given the way in which negativity tends to divide within itself. The dominant category of any antithetical structure is after all difference and multiplicity. It belongs, therefore, to the nature of the dialectic that the middle position itself be split into more than one. For this reason the early Hegel was drawn to tetradic, as opposed to simply tri-

adic, structures.[4] Whenever an antithesis is broken down into more than one position, whenever the antithesis has itself two or more moments, form mirrors content.

What I am seeking in my account of forms of beautiful ugliness is not simply a classification, but a system, a set of relations between the forms. Peter Szondi, one of the best German interpreters of Hegel's aesthetics, notes that what distinguishes the aesthetics of the German idealists from their predecessors is the search for systematic relations: "The speculative genre poetics of German idealism differs from the pragmatic-normative of the previous centuries not least in the fact that it does not isolate the individual genres and forms, but rather endeavors to determine their reciprocal relationship: only this speculative poetics establishes in the strict sense a system of poetic forms, while one should speak in the case of earlier theories of genre rather of classifications" (292). Alas, theories of genre and of form since Hegel have tended to fall back into mere classification.

The attempt to differentiate *forms of beautiful ugliness* and understand them in relation to one another is the most unusual aspect of my book and borders on the iconoclastic. I am not aware of another author, other than the Hegelian Karl Rosenkranz, whose study was published more than 150 years ago, who seeks in any extensive way to define and analyze types of beautiful ugliness. Such neglect is partly understandable. Critics have moved away from artwork aesthetics and toward production and reception aesthetics, where form plays less of a role; the analysis and development of broad systematic structures has given way to historical analyses and micro-specialization; and work in related fields such as genre studies tends to be disparaged as moving beyond the purely descriptive realm.

But if we value grasping not only what makes an artwork distinctive but also how it fits into a wider landscape of forms, if we think that taxonomies, like genre studies, can lead to new perspectives, categories, and interpretive questions, and if we recognize the value of artwork aesthetics, which privileges the relations of form and content and of part and whole, we will naturally wish to learn from such studies. We still turn to systematic thinkers, such as Hegel, to understand a complex genre such as tragedy. Elkins has called on his colleagues in art history to pay greater attention to "systematic concepts" (*What Happened* 59). A taxonomy has a certain value in and of itself:

each style and structure I elaborate merits analysis on its own. Yet the forms also exhibit intriguing relations, and the categories generate questions that can help readers analyze artworks. The identification of new types and categories can be a gain for criticism. I seek not only to invent a taxonomy but to go beyond it by creating a summative understanding of beautiful ugliness.

Hegel is a master at recognizing the complex ways in which categories relate to one another, being in some ways opposed to one another and in other ways connected. In that sense he overcomes the binary oppositions common to tradition, including medieval Christian aesthetics, yet he also moves beyond the mere dissolution of opposition, without any overarching unity, which has dominated poststructuralist thinking. Hegel's categories are crucial in helping us grasp the dialectical relation of the beautiful and the ugly. In fact, of the six forms of beautiful ugliness I explore, two, *dialectical beauty* and *speculative beauty*, draw directly on Hegelian categories. In the final form of beautiful ugliness, *speculative beauty*, ugliness is prominent and pronounced but ultimately absorbed into a larger process in which it plays a part. This form covers much of great Christian art, and Hegel gives us the categorical apparatus to articulate its structure. The aesthetics I am defending, built on an idealist concept of the organic, is not only compatible with ugliness, but it may in fact offer the most creative and compelling way of understanding, evaluating, and appreciating ugliness.[5]

I seek to explore examples from throughout Western history, but I recognize modernity's distinctive engagement with ugliness. This, too, is a complex phenomenon, for modernity emphasizes ugliness partly in tandem with a widespread turn away from God. One year after the end of World War I, Max Beckmann, whose works are full of visual ugliness, declared provocatively: "I am done with humility before God. My religion is hubris against God, defiance against God. Defiance, that he created us such that we cannot love one another. In my pictures I reproach God for all that he has done wrong" (Piper 331). Guenther Nenning has gone so far as to suggest that "the history of ugliness can be written as the history of atheism." And yet many modern artists, including Beckmann, allude to Christianity and to the Christ figure in particular as they portray the victims of moral ugliness.

Even as *Beautiful Ugliness* engages modernity, it draws on, and seeks to advance, an aesthetic tradition that is far from modernity's

reigning model. I challenge many common assumptions by arguing for the value of systematic and normative perspectives. I maintain both that rational categories exist for the analysis and evaluation of art and that ugliness can be an enriching dimension of great art. At the same time, I extend Christian and Hegelian thought so as to shed new light on modernity, including its immersion in beautiful ugliness. In order to guard against the potential error of treating only one form of artistic expression, which might present ugliness idiosyncratically, my book moves freely across artistic disciplines.

CONCEPTUAL FRAMEWORK

U N V E I L I N G
U G L I N E S S

Three Definitions of Ugliness

What exactly is the ugly? On a descriptive level, it might make sense to define ugliness as "the opposite of beauty," a common practice (Athanassoglou-Kallmyer 281). To speak of the ugly without presupposing a concept of the beautiful is difficult. Few would contest such a definition, even if much is left thereby unsaid. Yet the definition is also misleading, for defining the ugly as the opposite of the beautiful overlooks the extent to which the ugly and the beautiful can work together, such that their status as opposites is dissolved.

To see the ugly and the beautiful as only opposites is difficult even on the level of ordinary language. We often associate ugliness with asymmetries, unconventionalities, irregularities, blemishes, deformities. But prettiness can be boring, insipid, without differentiation. In F. Scott Fitzgerald's "The Popular Girl" (1922), the hero, Scott Kimberly, asserts: "After a certain degree of prettiness, one pretty girl is as pretty as another" (*Before Gatsby* 463). Asymmetries and anomalies that might otherwise be associated with ugliness can express character. One often looks for more than prettiness, more than superficial attractiveness or beauty. The French have a term for this combination,

jolie laide ("pretty-ugly"). Many persons who do not match conventional concepts of beauty are nonetheless rightly considered beautiful. And a voice that is not conventionally beautiful, such as Bruce Springsteen's, can be extraordinarily expressive. Over time, Maria Callas developed vocal flaws that limited her operatic range, but she remained peerless in using her distinctive voice to give meaning and life to music. In Japan, the home of "adorable" characters such as Hello Kitty and dialectical concepts such as *wabi-sabi*, an analogous term arose during the 1990s: *kimokawaii* ("ugly-cute"), a word that is now widely used. Examples include city mascots that are both adorable and weird, such as Nishiko-kun, which has a huge head and no arms, or Okasaemon, with an odd-looking face. Not only in popular culture but in examples from throughout this book we see that it is not easy to separate the beautiful and the ugly such that they are only opposites.

A second definition, also common, suggests that the ugly is whatever we find repellent or, in a less extreme version, "whatever yields an unpleasant aesthetic experience" (Garvin 404). This, too, is not unreasonable. A commonsense tradition espouses this connection, which we see, for example, in David Hume, who associates the "beautiful" with the "agreeable" and with "pleasure," the "ugly" in contrast with the "disagreeable" and "uneasiness" (*Treatise* 2.2.5; cf. 2.1.8). For Hume "beauty and deformity . . . are not qualities in objects, but belong entirely to the sentiment," even if Hume acknowledges "there are certain qualities in objects, which are fitted by nature to produce those particular feelings" ("Of the Standard" 141). Cognitive science reinforces the link between the ugly and the disagreeable: we tend to associate beauty with what is pleasurable and pleasing and ugliness with what is painful and displeasing (Kandel 385, 390–91).

Yet four difficulties arise with this definition. First, as Sibley notes, the ugly is not always repellent. It need not engender disgust: "In most cases we can make quite cool judgements as to this or that being ugly. We do not have to show or feel disgust, distaste, or revulsion; we do not utter 'ughs' or 'ohs,' turn away or avert our eyes" (204). The reason is simple: our reception of art is more than simply emotional; it is also cognitive. For the greater gain of knowledge we can endure emotional unease, and we can identify ugliness without reacting emotionally.

Second and related, much as cognition can temper an initially emotional response, so can a repellent part play a modest but meaningful role in the whole of an artwork and so be sublated in this way.

I use *sublate* as a translation for Hegel's *aufheben* with its threefold meaning of "negate," "preserve," and "elevate." This verb captures precisely the role of subordinate parts in a larger whole. The ultimate meaning of disagreeable parts is modified and transformed within the whole.

Third, even if we admit that much of what is ugly engenders initial unease or disagreeableness, aversion or unpleasantness, reception is dynamic over time. After a certain period, the ugliest properties to which we become accustomed, and which become part of our cultural baggage, become less offensive. We begin to tolerate them and may even find them beautiful, at the very least no longer repellent. In short, what we empirically find beautiful and ugly shifts across time. Santayana notes that "the centaur and the satyr are no longer grotesque; the type is accepted" (157). Stravinsky's orchestral ballet *The Rite of Spring* was once considered difficult and dissonant but is no longer viewed that way. A tonal work, it is nonetheless full of radical and innovative dissonances. Because of its novelty, audiences at first couldn't stand the piece. At the premier were catcalls, shouts, and eventually a riot. Today we appreciate it as beautiful. To look at Picasso's various female portraits and see them as ugly, as did so many of his contemporaries, is no longer easy. People now have reprints of these works on their walls and as screensavers and do not find them in the least disturbing. Picasso's *Guernica* was commissioned for the Spanish Republican pavilion at the 1937 Paris World's Fair (L'Exposition Internationale des Arts et Techniques dans la Vie Moderne), but visitors were repelled, and authorities tried to replace it with Horacio Ferrer's realistic and propagandistic *Madrid 1937* (*Black Aeroplanes*), which has appropriately been called kitschy (Richardson 6). Not only are what we call beautiful and ugly not stable across time, even more dramatically differences in reception arise simultaneously. Photographs of public lynchings were received eagerly and enthusiastically in the U.S. South as sublime rituals and spectacles that reaffirmed white virtue and Black degeneracy (Wood 71–111), but in the North those same images engendered revulsion and outrage; they were viewed as dehumanizing, ugly, an abomination, and so spurred antilynching activism (Wood 179–222). If we define the ugly according to its reception context, according to our sense of repulsion or disgust, then the ugly shifts over time and according to context.

However, the statement that the ugly changes over time is false. What changes is what we subsume under that concept, what we find repellent

or disagreeable. Different times and places differ in what they subsume under a concept, which allows for empirical diversity. This is not unrelated to conventions that shift over time, for example, what belongs in a tragedy, what defines a beautiful body, what counts as dissonant music. Conventions, like affects, are not stable. But the ugly is not an affect or a convention. It is a concept. Concepts do not change. Concepts are atemporal. They carve out certain spaces in possible worlds. Even from a Hegelian perspective that speaks of the self-motion of the concept, concepts are atemporal; it is our understanding of what was already implicit in the concept that changes, a matter of perception or understanding (*Werke* 5:44; *Science of Logic* 67).

The combination of a universal definition along with differences in what we subsume under that definition invites us to ask, Are there objects that in all cultures are viewed as ugly and objects that in all cultures are considered beautiful, even as some objects will be viewed variously? Traditionally, anthropologists looked for universal constants. In *Purity and Danger*, British anthropologist Mary Douglas argued that some objects, for example, human excrement, are perceived in virtually all cultures as repugnant and kept at a distance. Unadorned dead bodies are another example. We view such bodies through the rituals by which we process them. Some cultures deal with death via a kind of performance art that seeks to make sense of it; the ritual takes away the repugnance, removes its power over us. When artworks today nonetheless integrate excrement, the works tend to be designed to elicit outrage and so presuppose universal or widespread repugnance. Still, even such seeming constants could shift further over time.

My fourth and final objection to the equation of the ugly and the repugnant is that we do not want to reduce the beautiful and the ugly to their reception context. Defining the ugly from a reception context (what we find repellent) has the disadvantage that it works not from the object but from reception, not from any normative level, as to what we *should* find repellent, but only from a descriptive level. For example, if the murder of members of a particular minority were not repellent in a given society, it would not, according to this definition, be ugly. That itself is an ugly thought. Some moral actions and judgments should be recognized as morally ugly. I am thus attracted to a normative definition of ugliness. What is comical is defined not simply by what produces laughter, but also by what should elicit laughter.

A mean joke about race or disability is not comical, but ugly. So, in the realm of the beautiful and the ugly we recognize the validity of a normative realm. Not everything people find pleasurable captures the essence of beauty, as kitsch teaches us, and not everything we find displeasing is ultimately ugly. We must speak not of what we find ugly, but of what should be ugly; here, too, what changes is not the ugly but what we subsume under it. Note that if we capture a normative view of ugliness, what strikes us as repugnant can in fact be integrated into a beautiful work.

The elevation of reception aesthetics over artwork aesthetics is not unrelated to the mistaken idea that the beautiful and the ugly shift. According to Karl Marx, the effect of ugliness, which is repulsion, can be negated by wealth: "I am ugly, but I can buy myself the most beautiful women. Consequently, I am not ugly, for the effect of ugliness, its power of repulsion, is negated by money" (118). Marx's distinction is between the object and its reception: the person really is ugly, but money influences the person's reception, such that the person is taken to be not ugly. If we don't make normative distinctions between the ugly and the beautiful, if ugliness is simply a matter of reception or taste, then we see from this perspective that what might have been the province of aesthetics or hermeneutics gives way to history and the social sciences. No criteria exist to question the relativity of personal preference, the reigning consensus, or the whims of the market. Even if we wanted to link the displeasing and the ugly, it would still be more rational to say that something displeases us because it is ugly as opposed to saying that something is ugly because it displeases us, an insight that dates back to the Euthyphro dilemma of Plato and one that Augustine applies directly to the puzzle of beauty (*True Religion* 32.59).

The ugly as the opposite of the beautiful and the ugly as what is repellent are workable descriptive definitions of ugliness; they capture much of what we mean when we use the term "ugly" and are often suitable for what I analyze in this book, even if both definitions have their limits. Although I recognize their intuitive appeal and communicative functionality, I would like to propose a third definition, which I find more attractive and more cogent than the mostly workable first two definitions. *The ugly is an appearance that contradicts what belongs to the normative concept of an object.* Most philosophers today do not have "a normative concept of the concept," and so I recognize that this

is an unusual definition for our age, even as it is close to what idealist philosophers such as Plato and Hegel have said. Plato argues in the *Sophist* that ugliness is an appearance that is contrary to what is appropriate to the nature of something (228a–d). Hegel notes in his *Encyclopaedia Logic* that even everyday language draws on normative concepts: when someone acts according to normative expectations of friendship, for example, we assert that the person is a true friend (Hegel *Werke* 8:86). For Hegel, "truth exists when the object corresponds to itself, that is, to its concept" (*Werke* 8:323; *Encyclopaedia Logic*, 250, translation modified). When we remark that a given arthropod with eight legs is a spider, reality and concept are in harmony. Similarly, when an artwork satisfies certain conditions of greatness, we can say that it is true to the criteria for aesthetic excellence. Such a work is beautiful.

From this frame, the "ugly" is what deviates from what should be. For example, an industrial blot in the midst of a nature park is ugly. An immoral act for which I despise myself is ugly. Here we see the hidden logic of the word's etymology. The German word for "ugly," *hässlich*, comes from the Middle High German *hazlich*, "hateful" (Götze). We hate the world when it is not as it should be; the ugly is that which is hated (*verhasst*) or hateful (*gehässig*). Understood here is that historically we have held different views about what satisfies a norm, which is not to say that the norm changes. Instead, our understanding of the norm changes. With ugliness, one of our important distinctions is that what we expect to see in an object and find missing and therefore can label as ugly need not apply in the same way to a human being. Why? Because the human being is limited, in theological language "fallen." We know that a human being will not always reach its concept or telos, but this striving and inadequacy belong on a metalevel to the concept of humanity. We are paradoxical beings, and this paradox makes us particularly fascinating cases concerning the potential for beautiful ugliness. To the extent that we can recognize our failures and faults as interwoven with our trajectory, we live more organic lives, and thus lives where ugliness becomes an accepted part of our overall trajectory.

Ugliness, then, is an appearance that contradicts what belongs to the normative concept of an object. Essential to any definition are two elements, which are not easily combined: comprehensiveness (we want to capture ugliness in as wide a sense as possible, including more

than just physical ugliness) and epistemic effectiveness (we want our definition to be competent in singling out ugly entities from other objects, including beautiful ones). For example, color cannot be a general definition of beauty. Indeed, it cannot even be a general definition of aesthetic beauty, because a symphony doesn't have colors, and there are beautiful symphonies. When Aquinas elevates color, optic beauty is elevated. Optics has often been privileged in aesthetics, but already in *Greater Hippias*, a dialogue on *kalos* ("the beautiful"), probably by Plato but perhaps by one of his students, we see an attempt to find a concept of the beautiful that encompasses both sight and sound.[1] An important question is, How does one generalize the concept of beauty beyond individual senses and beyond particular art forms? At the other extreme are definitions that are so broad as to lose the differentia specifica of the beautiful and the ugly. The Hegelian Max Schasler, for example, defines ugliness as negativity in general, but not all negativity is ugly or even seemingly ugly. The definition I propose captures, for example, a shoddy artwork that contradicts the idea of a beautiful artwork; willful ignorance, which runs counter to the privileged human capacity for intellect; and moral ugliness or evil, which violates the normative concept of ethics. We see the proximity to the two everyday definitions: a normative definition suggests that the ugly can only be understood in relation to a violation of a (beautiful) norm and that, if our intuitions are well schooled and just, we will find the ugly repellent.

From within a normative frame, beauty arises when objectivity conforms to its concept, when the descriptive matches the normative realm. The ugly sets in when a contradiction surfaces between the descriptive and normative realms, when something is not as it should be. We speak in this way when we say that someone has done a beautiful deed or someone has committed an ugly act or when we suggest that Homer's *Iliad* is a beautiful work or that a Michael Haneke film has ugly moments.

The structure can work within the descriptive realm also, even if this is rare. For example, when a particular crime, say, a forgery, perfectly embodies the ugly concept (of a forgery), we can say, paradoxically, that it was a beautiful forgery. Or to use analogous adjectives, we are all familiar with the phrase "a perfect storm." Victor Hugo speaks of "perfect ugliness" or "the perfection of his ugliness" (la perfection de sa laideur) when he introduces the radically misshapen Quasimodo

in the fifth chapter of his 1831 novel *Notre-Dame de Paris* (71). The concept of the beautiful functions analogously: a page later, Maître-Coppenole says in astonishment, "I've never seen anything so beautifully ugly [la plus belle laideur] in all my life!" (72). That is, I've never seen anything that corresponds so perfectly to our concept of what is ugly. The use of such adjectives to capture ideal negativity is paradoxical insofar as beauty and perfection capture the symmetry of concept and reality, but "forgery" and "storm" and "ugliness" have negative value and are thus by definition also ugly. That is, we see a paradoxical interweaving of the normative and the descriptive: a perfect storm or a beautiful forgery or perfect ugliness are perfect or beautiful because of the normatively privileged correspondence between concept and (ugly) reality. Still, since the paradoxical nature can be disorienting, its use in this way is uncommon, but not invalid.

Beauty in this idealist sense is a self-accord of reality with its concept or ideal. According to this view, something is beautiful when it is as it should be, and something is ugly when it lacks what belongs to its concept, when it is not as it should be. Although I work from within an idealist tradition, a proximity arises here between my view and what Sibley, an analytic philosopher, suggests when he speaks of the ugly as "some kind of departure from some standard or norm" (200). For Sibley, ugly is a relational value. A relational value can be understood descriptively, as in the departure from what is the dominant or familiar norm, or evaluatively, as in the departure from an idealized norm, such as an organic artwork. At times, the ugly represents a departure from a descriptive and evaluative norm. Willful ignorance is ugly because it is a deviation from a more common desire to know and because it contradicts the (normative) concept that belongs to human intelligence. People may find a disfigured human body ugly because it contradicts what they expect of a human body, but a disfigured body represents a less central part of the human being than the mind or the soul, and so a disfigured body that houses a beautiful soul recedes in importance; it is not central to the normative concept of a human being. One thinks of the misshapen but endearing Alonzo Gieshübler in Theodor Fontane's nineteenth-century novel *Effi Briest* (1895). In essence Gieshübler is a beautiful character. In this case the overwhelmingly descriptive and the legitimately normative diverge, thus giving greater nuance to the concept of ugliness and to our assessment of seeming ugliness.

If we have not only a sensuous but also a cognitive interest in the beautiful, the pleasing and the repellent are reductive concepts. Beauty, for example, is not reducible to the perceptual or sensuous mode, to a pleasing appearance. Instead of focusing on what is pleasing, we might consider Plato's idea that the beautiful generates a love of the ideal, a longing for something greater than what is (*Symposium* 211c–212a). A cognitive dimension is part of Plato's concept of beauty. This idea has vanished for the most part from the contemporary landscape, but a vestige of it was still present, to some extent, in Edmund Burke: "By beauty I mean, that quality or those qualities in bodies by which they cause love, or some passion similar to it" (83). Burke calls love "that satisfaction which arises in the mind upon contemplating anything beautiful, of whatsoever nature it may be" (83). The idealist tradition continued to elevate this link. Despite radical differences between the two former roommates the poet Friedrich Hölderlin and the philosopher Hegel, both recognized the link between beauty and love. Today, one finds similar ideas in Alexander Nehamas: "The attraction of beauty always includes an erotic aspect" (141). When we experience a beautiful object, we sense that we have yet to exhaust all that is of value in it. We want more: we want it to be part of our lives and we want to explore it further, to appreciate and understand it. We sense that this encounter will enrich us. Beauty attracts us and creates a longing for understanding that is complex and not yet immediately or fully present to us; it takes us beyond ourselves, toward the object and toward the ideal.

Physical, Emotional, Intellectual, and Moral Ugliness

Whichever of these three definitions the reader prefers—"an appearance that stands opposite the beautiful" (a useful but overly binary definition), "an appearance that we find repellent" (a commonsensical but philosophically unpersuasive position), or "an appearance that deviates from what belongs to the normative concept of something" (arguably the most coherent and compelling definition)—we can differentiate the realms in which ugliness surfaces. Let's now look at diverse kinds of ugliness—physical, emotional, intellectual, and moral ugliness—and their fascinating combinations.

In Peter Paul Rubens's *Head of the Medusa*, the head is severed, the face pale, the lips green, the eyes horrific (illustration 3). Rubens

portrays Medusa's decapitated head in a desolate landscape. Although Medusa is dead, with her pallid face transfixed in horror, the serpentine locks still writhe about hideously, biting one another, giving birth, emerging out of the blood below her neck. What we see on the surface here is *physical ugliness*, even if we also recognize elements of moral ugliness, in particular misogyny. In the myths of older cultures, such as archaic Greece, physical ugliness is prominent.

Monsters, excrement, death are all physically ugly; they awaken unease or revulsion. In evolutionary and psychological terms, unease and disgust are natural reactions to what is offensive and alien, contaminants that awaken fears of our animality and mortality (Nussbaum, *Upheavals* 200–206). But a beautiful representation of a physically ugly object may allow us to see and imagine ugliness more clearly. We react not with disgust, but with pleasure, when we see accurate portrayals of repugnant beasts or dead bodies; to see such items vividly is to expand our realm of knowledge (Aristotle, *Poetics* 1448b). Positive aesthetic value, beautiful ugliness, can result. Presumably we find corpses ugly partly because we sense that we might get diseases from them, partly because a dead body represents the loss of a specific life, and partly because a corpse reminds us of our own mortality.

One could argue that a corpse does not contradict the concept of life, since life presupposes aging and death, and a decomposing corpse is hardly at variance with the concept of death. Still, the corpse contradicts the normative concept of life as having higher value than death. A live body is normatively privileged over a dead body, and the corpse contradicts the higher identity with which it was once identified. Still, the two points are not incompatible: a view of death as not only loss but also the celebration of a life, especially a longer and meaningful life, is certainly part of adopting a more holistic frame and thus perfectly compatible with the idea that the seemingly ugly has its place within a larger order and more comprehensive whole.

Physical ugliness has some universal features. Across gender and culture, studies show that the human mind prefers symmetry over asymmetry, including facial symmetry (Jones et al.). Hermann Weyl opens his classic work on symmetry by linking beauty and symmetry (3). In African sculpture, symmetry is an important criterion for beauty, even if tasteful asymmetry is also encouraged (Van Damme 30). In Olmec sculpture, ugliness is conveyed via a lack of symmetry (Baudez 24). Modest asymmetry often adds character, but extreme asymmetry tends to be seen as ugly. On the descriptive level, physical ugliness is often associated with what is different from the norm or average, such as a face marred by disease or a stinking body with pus and abscesses.

However, disability studies has helped us recognize that we often need to expand our concept of beauty and limit our concept of ugliness, since these tend to be laden with cultural biases that are contrary to human dignity. We need to consider the social meaning, the reception and broader significance, of physical difference, a point to which I return in chapter 2. Indeed, much of what we understand by physical ugliness is culturally specific. Obesity in today's developed world increases the risk of illness and mortality, so people often react against it. In the Hebrew Bible, however, obesity was not a prominent physical danger; the greater threat for an ancient culture was thinness, weakness, and emaciation (Olyan 19). Old age, a kind of physical ugliness, surfaces as ugly in art and literature, as in Juvenal. The association of the ugly with what weakens humanity, with decline, degeneration, and impoverishment of life, is very much part of Nietzsche's vocabulary of ugliness (*Twilight of the Idols*, in *Werke* 2:1002; Unpublished Fragments, in *Werke* 3:753).

Physical ugliness includes also formal ugliness, since aesthetic form is art's physical or material side. Formlessness can be physically ugly, as can a distorted, disjointed, or ill-proportioned form. Equally ugly is a form that does not fit its content. Ruth Lorand gives a helpful description of physical ugliness on a formal level: "A clash of orders in an object occurs when each of its parts has an order of its own, but these orders do not fit together, and thus the whole is fractured" (402). But not only can disharmony be physically ugly, so, too, can boring regularity, a lack of differentiation. Kant suggests in his *Critique of Judgment* that stiff regularity is not pleasing but tiring (§22; B 72). Think of the monotony and ugliness of tenement housing. Intriguing are examples in the physical realm that are both beautiful and ugly: in terms of physical effects on human health, cancer is obviously ugly, as it elicits illness and death, but under the microscope its structures can be extraordinarily beautiful.

Emotional ugliness encompasses states that, though they have close physical and intellectual correlates, are defined by emotions, such as fear, rage, despair, and humiliation. Also, extreme mood disorders, including a sense of worthlessness and hopelessness, are emotionally ugly. Our recognition of emotional ugliness involves deciphering the physical expressions of an inner world; the concept is thus more complex than physical ugliness. In Albrecht Dürer's engraving *Melencolia I* (1514) a stationary but winged figure is bent over with her hand on her cheek: she appears to suffer from depression or melancholy. The engraving is not only fitting (during the Renaissance, artistic imagination was often associated with melancholy) but ironically fitting: we experience a magisterial artistic portrayal of an artist who is unable to create. Its reception sometimes tells a different story. In chapter 12 of Thomas Mann's novel *Doctor Faustus* (1947), we learn from the narrator, Serenus Zeitblom, that the hero, Adrian Leverkühn, has the magic square from Dürer's beautiful woodcut hanging in his room. Leverkühn suffers the ugly depression of those who desperately seek to create beauty but struggle with insufficiency: the ugly emotion of depression is here linked to an obsessive and unproductive focus on the beautiful.

The eighteenth-century Austrian-German sculptor Franz Xaver Messerschmidt, whose character heads express an array of distorted faces, was an early master of emotional ugliness. Emotional ugliness is also evident in Auguste Rodin's various versions of *Despair*, including

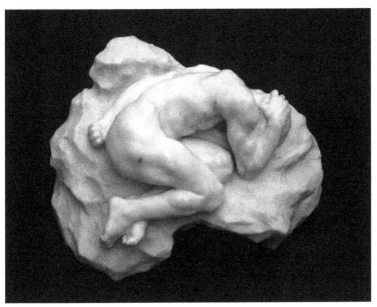

ILLUSTRATION 4
Auguste Rodin, *Despair*, 1890, Marble, © Saint Louis Art Museum/Museum
Purchase/Bridgeman Images.

his 1890 marble statue at the St. Louis Art Museum, where the human
figure lies on a bare rock, in the fetal position, the face hidden, almost
buried in the rock, the right hand over his head, grasping his hair, the
left fist clenched, the toes pulled inward (illustration 4). The rough-
ness of the rock adds to the sense of unease, and the similarity of ma-
terial between figure and earth underscores his distance from any-
thing lofty. Interesting is the tension between physical strength and
beauty, on the one hand, and emotional ugliness, on the other. One is
reminded of the famous scene of a godlike hero crying in despair:
Odysseus weeping on the rocks when we first encounter him in book 5
of the *Odyssey*, a hero who has been absent from his own narrative,
sealed away from the world, living in total anguish. In the twentieth
century, artistic portrayals of emotional ugliness are abundantly pres-
ent in the Viennese modernists, such as Oskar Kokoschka. His painted
clay sculpture *Self-Portrait as Warrior* (1909) awakens anguish, with its
open mouth, thumb prints, and unexpected colors, designed not for
physical naturalness but for the expression of emotions. Similarly ef-
fective in conveying unease is his *Self-Portrait with Hand near Mouth*
(1918–19), in this case through the turn of the head, the placement of

the hand, the rough brush, the dark colors, and the shadows. Also impressive in its capacity to express emotional ugliness is *Desperate Man* (1988), a black serpentine sculpture by one of the best-known Zimbabwean artists, Nicholas Mukomberanwa. The simultaneous intensity and distortion of the human figure adds to the sense of despair, which is reinforced by the dominant gesture of the hand over the eye.

Much as we sense physical ugliness already at an early age, so do we experience emotional ugliness as children: when our needs and longings are not met, we cry. Moments of emotional ugliness surface throughout life and, again like physical ugliness, accompany us to the grave. Sianne Ngai employs the expression "ugly feelings" to describe negative moods that evoke disenchantment, among them envy, anxiety, paranoia, irritation, and an amalgamation of shock and boredom for which she coined the neologism "stuplimity" (*Ugly Feelings* 3). What distinguishes these moods from more radical emotions, such as rage, is that they can be sustained over a longer period. Ngai then seeks to show how literary forms enact these ugly feelings or create a tone in which they predominate; for example, "exhausting repetitions and permutations" may express the simultaneity of shock and tedium, of excitation and fatigue (*Ugly Feelings* 9). As examples, she mentions the recursive works of Andy Warhol, Jasper Johns, and John Cage (*Ugly Feelings* 262).

Works by the painters Vincent van Gogh and Edvard Munch and writers Franz Kafka and Jorge Luis Borges seek to uncover a deeper reality, often an emotional ugliness, beyond the superficiality of realistic representation. Various formal elements, from color to shape, allow for the beautiful expression of ugly emotions. In Munch's *The Scream* (1893), the scream and its ramifications take over the entire work: the face is distorted, and the gnarled waves of lines reinforce the scream (illustration 5). The combination of straight and curved lines, both of which lead to the figure, adds to the tension. The bold colors seem to express the figure's emotions, and the uneven lines accentuate the curves of the head and hands. Munch's painting has elements that remind us of caricature, but the telos is despair, not humor. The background, which seems as uncertain as the face, paints a landscape of the soul. Munch wrote: "I felt as though the whole of nature was screaming—it seemed as though I could hear a scream. I painted that picture, painted the clouds like real blood" (Stang 90). In the lithograph version of 1895, the black-and-white face almost evokes a skull—

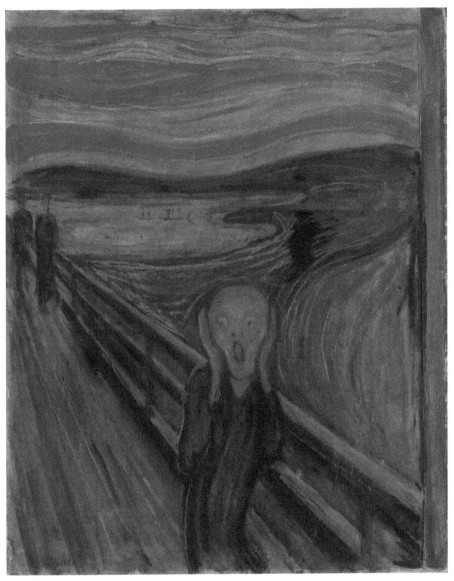

ILLUSTRATION 5
Edvard Munch, *The Scream*, 1893, Oil, tempera, pastel, and crayon on cardboard, National Gallery of Norway/Bridgeman Images/© 2022 Artists Rights Society (ARS), New York.

and with it the idea of sickness unto death. In both versions, form and content work together beautifully to express ugly emotions. Fascinating is also the contrast: the two figures walking on seem oblivious to the emotions expressed by the harried and neurotic figure crying out.

The viewer, however, cannot turn away. In Kafka's *The Metamorphosis* (1915), Gregor Samsa's transformation into a monstrous vermin is a physical correlate of his troubled and oppressive emotional state. Here the metaphor becomes literal. The works of these artists are not superficially mimetic, but they are mimetic in a complex way. Via exaggeration and absurdity they capture essential structures of reality, including aspects of emotional ugliness, many of which are otherwise hidden to us. Also, self-portraits via objective analogues can combine physical and emotional ugliness. John Isaacs's *Self Portrait as an Uninhabited City* (2001), a landscape of severed body parts, dirt, and bugs, evokes loneliness, hopelessness, anticipation of death.

Despondency and disorientation are common literary themes. In Boethius's *Consolatio philosophiae* (ca. 524), the author initially despairs about being unjustly imprisoned, and in the opening monologue in Goethe's *Faust*, the hero articulates his frustration at being unable to know the deepest principles of the universe (*Goethe's Faust*, lines 382–83). In modernity, despair reaches a new low. In Dostoevsky's *Notes from Underground* (1864), the nameless hero and narrator, a misanthrope who lives alone in Saint Petersburg, is alienated from society. His only interactions lead to humiliation. His bitter, cynical, and contradictory reflections unveil a seriously distorted mind. His early moments of idealism give way to self-loathing and self-destruction, but as long as he is the cause of ruin, even his own, he feels some level of self-satisfaction. Dostoevsky's narrative takes us into the character's consciousness even as it mockingly distances us from him. Emotional ugliness is likewise manifest in Benn's "Lost I" (1943). We see in each of these works the extent to which intellectual crisis contributes to emotional ugliness. The middle lines of Benn's poem read "down the maw of the beast" (hinab den Bestienschlund), which concludes a stanza on war, in which the ideal order of the stars is reduced to the guts of freshly slaughtered animals, and "the world thought to pieces" (Die Welt zerdacht) ("Lost I," in *Sämtliche Werke* 1:205). Two great errors of the modern world are here conveyed: loss of dignity via bestial behavior and merely functional thought. Both undermine higher meaning; both lead to despair.

A third form of ugliness, *intellectual ugliness*, encompasses ignorance as well as incongruities, absurdities, and untruths. Here ugliness contradicts what belongs to a normative concept of reason. A child

who knows little is not expected to know much, and so is not intellectually ugly. Intellectual ugliness arises only when appropriate expectations are unmet—for example, when curiosity or intellectual discipline is needed and expected but lacking, when it should be present but is not. Ignorance and stupidity combined with arrogance is the worst combination. The image of the ugly American comes to mind. Contrasting concepts to intellectual ugliness surface when we speak of a beautiful proof or a beautiful mind. Intellectual ugliness can be consciously cultivated, as in the Dadaist embrace of the "abolition of logic . . . the interweaving of contraries and of all contradictions" (Tzara 13). A lack of curiosity about what is important is also ugly. Incorrectness, another form of intellectual ugliness, tends to surface in comedy, as in the varieties of linguistic incorrectness in Shakespeare, for example, the malapropisms of Dull and Costard in *Love's Labor's Lost* and of Dogberry in *Much Ado about Nothing*.

Comedy offers us abundant examples of intellectual ugliness, including stupidity and arrogance, at times bordering on, or moving over to, moral ugliness. Arrogance, especially when it is combined with error, is a kind of intellectual ugliness ripe for comic unraveling. The intellectual, Leopold, in Woody Allen's *A Midsummer Night's Sex Comedy* (1982) is a skeptic who confidently announces that "there is nothing magical about existence," yet ironically, Leopold must not only revise his ideas and learn to believe in spirits, but he himself becomes a spirit. Death is comic when the dead person becomes a friendly spirit, and death is especially comic when the person who becomes a spirit announces before his death that he does not believe in spirits. Inconsistencies are a driving force of comedy and of ugliness.

Already Aristophanes's comedies introduce us to stupid and ridiculous figures. Strepsiades, the father in *The Clouds* (427 BC), is shown to be a "feeble-minded, imbecilic, slow-witted country bumpkin" (lines 628–29), who wants to avoid paying his son's debts. One strategy he contemplates is hanging himself, for, if he were dead, he wouldn't need to pay his debts! The multiple allusions to sexual organs, sometimes limp, sometimes erect, and to flea bites contribute to the audience's sense of physical ugliness. Strepsiades's son, Pheidippides, is brighter, but Pheidippides uses his partial cleverness to justify abusing his father. In Aristophanic comedy we are far removed from the world of the *Odyssey*, with the kind of prized father–son relationship Odysseus

and Telemachus enjoy—and that is precisely Aristophanes's lament: a loss of tradition and norms at the expense of Socratic reason. This ugliness is the ultimate target of Aristophanes's mockery.

Yet Plato has his own fun with intellectual ugliness, showing not Socrates as the comic figure, but his interlocutors. Euthyphro, for example, is a paradigmatically ugly character—on the surface ridiculous but in his intentions (of trying his father for impiety without himself being able to give a cogent definition of piety) horrific: Euthyphro contradicts himself many times over, returns to already refuted definitions, fails to recognize Socrates's irony, is oblivious to hints at more tenable definitions, and remains overconfident even as he fails to define piety and refuses to continue the discussion.[2] We know what can result when persons are armed with confidence and a false concept of piety; in this early work Plato already achieves the combination of ridiculousness and horror, of comedy and tragedy that Socrates contemplates at the end of the *Symposium* (223d).

Intellectual ugliness may be the least intuitive form of ugliness, that is, the form we may be slowest to identify as ugly. In the *Sophist*, Plato introduces the category, but the idea is not simply anachronistic: the concept of intellectual ugliness also surfaces in twentieth-century theory, for example, with Peter Carmichael, who in an essay on ugliness suggests the link between "ugliness" and "inept ignorance" or, more specifically, a "capable mind, uneducated, perverse, deficient in the fulfillment of its capacities" (Carmichael 498). Such a gap "contradicts" what belongs to the concept of humanity.

In contrast to physical or moral ugliness, intellectual ugliness seems less immediately repellent. Ordinary language follows this trend. Whereas we often see positive attributions with regard to truth, a beautiful proof, for example, we rarely hear someone say that an intellectual mistake or falsehood is ugly. But when we move from truth to goodness, we find the reverse. So, an "ugly vice" or an "ugly crime" would not be an uncommon attribution (that is, moral ugliness is immediately recognizable as ugly). German and English use the phrase "ugly as sin." Augustine calls out the ugliness of pride (*Confessions* 13.21.30), and Martin Luther King Jr. uses the concept of moral ugliness to condemn Birmingham's "ugly record of brutality" (290). When intellectual ugliness triggers moral ugliness, as with the lies that led to the January 6, 2021, insurrection at the U.S. Capitol, the appellation

"ugly lies" readily applies. To speak of a beautiful virtue or a beautiful act is less common, but it does happen. Consider the father's beautiful action in the story of the Prodigal Son (Charlton 304). Hume uses the phrase "moral beauty" (*Treatise* 2.1.8), and in Leo Tolstoy's *War and Peace* (1869), Nikolai Rostov recognizes Marya Bokonsky's "moral beauty" (955).

Moral ugliness is not reducible to the physical, emotional, or intellectual realms. In German we see a development in language from *hassenswert* ("worthy of hatred") to *hässlich* ("ugly") to *übel* ("evil") (Götze 211). For vivid examples of moral ugliness, think of Regan, Goneril, and Edmund in Shakespeare's *King Lear*. Moral ugliness is the form of ugliness most evident in an intersubjective context. It ranges from modest foibles to cruelty, violence, and betrayal. Marinus van Reymerswaele's painting *The Misers* (1548–51) captures two greedy and wealthy men gleefully counting their money. The painting seems crowded, constraining, even claustrophobic, which underscores the narrowness of their vision. The limited horizon is given a temporal dimension by the flame, which will soon burn out, symbolic of the extinction of time, after which their money will be worthless. Molière's comedies likewise engage moral ugliness, such as miserliness in Harpagon, the hypocrisy against which Alceste rails, and the pious stupidity of Orgon, which has as its inverse mirror the malicious cleverness of Tartuffe. James Ensor's *The Intrigue* (1911), with its ugly, distorted, masked faces, itself unmasks the ugliness and cruelty of prejudice.

Just as human foibles and common sins surface in ugly artworks, so too the abominable, as in Jean-Baptiste Carpeaux's marble *Ugolino and His Sons* (1861) or Rodin's plaster *Ugolino and His Children* (1881), both of which draw on canto 33 of Dante's *Inferno*, which describes the imprisonment and subsequent death by starvation of the Pisan Count Ugolino della Gherardesca and his offspring. The sculptures capture the uncanny moment when Ugolino, condemned to die of starvation and driven crazy by hunger, yields to the temptation to devour his children. In Carpeaux's work, the children desperately cry out to him. In Rodin's version, Ugolino's pose reveals his complete loss of human dignity. As time runs out for Ugolino, he seeks to relieve his physical ugliness, his hunger, but does not acknowledge his moral ugliness: he is unwilling to repent and ask for forgiveness. The worst form of ugliness is moral. When Wilde's narrator describes the "dreadful"

painting of Dorian Gray's immoral soul as "worse than the corruption of death itself" (3:269), he is suggesting that moral ugliness exceeds physical ugliness. In the brutal scene between the doctor and the midwife in Austrian director Michael Haneke's *The White Ribbon* (2009), we see moral and physical ugliness together and recognize the far deeper ugliness of the former.

Rubens's *The Head of Medusa*, which we analyzed above in the context of physical ugliness, also represents moral ugliness. Though the dominant reading stresses Perseus's slaying of the horrific and monstrous Medusa, the morally ugly woman who literally petrifies anyone who locks eyes with her, a deeper reading brings out the work's misogyny. The fascination of Medusa as a monster and a threat overshadows her once having been beautiful. Her alleged crime was being so alluring that Poseidon raped her, thereby desecrating Athena's temple. Athena takes revenge not on Poseidon, the violator, but on Medusa, the victim, transforming her into a terrifying snake-haired monster and helping to ensure her mutilation. Athena gives Perseus her shield, which he uses as a mirror to deflect the curse, so that he can decapitate her and so display her head as a prize. Rubens portrays Medusa's beheading as a victory over a hideous monster, female blood as danger, the woman as threat. The serpent imagery, with its link to the garden of Eden, associates not only Medusa but women in general with evil. Today we see in Medusa not so much the monstrous threat that must be thwarted, but instead the kind of horrific suffering and death that befall victims of moral ugliness, in this case, rape, revenge, instrumentalization.

The portrayal of women as ugly is a recurring, misogynistic theme, a vivid example of moral ugliness. In selected works of medieval poetry, women are deemed ugly when they deviate from what was viewed as their normative ideal: young, beautiful, noble, pure, and silent—thus the parodies of women who are old and ugly, peasants or prostitutes, or whose speech challenged male authority (Bettella). In early modern English literature, women are often represented as depraved and unattractive (Baker). The misogynistic theme underscores an ideology of women as less than fully human and demonizes them as a threat to male power; Medusa fulfilled both moments. The reverse idealization of women, which is also part of tradition, the female nude as the embodiment of pure beauty, is also a dehumanizing

abstraction, which has been increasingly resisted by female artists, as we shall see in chapter 7.

The ways in which these various forms of ugliness relate to one another are fascinating. Obviously we can imagine a harmony of physical and intellectual ugliness, as with Homer's Thersites. Odysseus, who belittles Thersites, represents the inverse symmetry, a handsome body and extraordinary intelligence. Though physically ugly, Socrates has peerless intellectual capacities. The reverse of Socrates is the physically attractive person who is deficient in intelligence, for which Americans have traditionally had derogatory expressions, "pretty boy" and "dumb blonde" among them.

The relation of physical and moral ugliness can be especially fascinating. Very simple is the physically beautiful person whose ideas are moral and the ugly figure who espouses repellent ideas. The confluence of physical and moral ugliness dominates until modernity. Another dimension of misogyny is that this symmetry lasts longer for women than for men (Baker 69–96). In medieval literature, physical ugliness almost always indicates moral turpitude (Specht). Concerning such literature, Jan Ziolkowski notes: "Those men regarded favorably had to be good and handsome, while those criticized had to be bad and unattractive" (7). The fifth-century poet Sidonius Apollinaris, who was influential on later, medieval writers, brings physical and moral ugliness together, as in his attack on the parasite Gnatho. After describing Gnatho's moral depravity, Sidonius continues with an account of his "hideous mass of misshapen features" (*Letters* 3.13). Gnatho is

> just like the filth of a sewer, which stinks the more, the more you stir it . . . he has ears elephantine in their vastness; the two apertures are encircled by ulcerated skin, and stony knots and warts oozing with pus project along the exterior curves. . . . He displays a mouth with leaden lips and the ravening jaws of a wild beast, with festering gums and yellow teeth; it is frequently befouled by a mephitic stench exhaled from the hollow seat of decaying grinders; and this stench is reinforced by meaty belching from yesterday's feast and the sewage of suppers that keep coming back upon him. . . . I say nothing of his belly curving in pendulous folds, its wrinkles, ugly in themselves,

making a still uglier cover for genitals rendered doubly shameful by their impotence. (*Letters* 3.13)

We see here not only the confluence of physical and moral ugliness but hatred, perhaps even in the abundance of gory detail a perverse fascination.

In the late medieval art of northern Europe, physical deformities signaled one or the other dimension of wickedness. These included missing teeth or large, animal-like teeth; bulging, squinty, or bleary eyes; bulbous noses; and skin blemishes or sores (Mellinkoff, *Outcasts*). Shakespeare's Richard III is the most prominent early modern example. His villainy is accentuated by his misshapen body (1.1.14–30). In Schiller's *The Robbers* (1782), Franz Moor, whose physical "ugliness" is notable (1.1), is also morally ugly, full of calculating deceptions and obsessed with power. In the eighteenth century, pseudo-scientific attempts were made to discern moral inclinations based on body and facial types, with certain physical features revealing evil dispositions. The Swiss physiognomist Johann Caspar Lavater advanced this view: "The beauty and ugliness of the countenance has a true and precise relation to the person's moral beauty and ugliness. / The more moral, the more beautiful. / The morally worse, the uglier" (*Essays on Physiognomy* Ger. 1.63; Eng. 1.183, translation modified). Lavater tried to counter objections by conceding that virtue is not the sole cause of human beauty. He wanted instead to make the more limited claim that "virtue beautifies, vice deforms [macht häßlich]" (Ger. 1.64; Eng. 1.184), but the overarching connection is clear. In the nineteenth century, Karl Rosenkranz still holds to this idea, writing in *Aesthetics of Ugliness* "that truth and goodness of the will result in a dignity of personal bearing which pushes outward all the way to sensible appearance, insofar justifying [Georg Christoph] Lichtenberg's saying that all virtue makes beautiful, all vice makes ugly" (Ger. 27; Eng. 42). Interest in this itself ugly structure helped inform twentieth-century racial ideology along with the Nazi evaluation of "degenerate art." Its vestiges today lie in popular culture, where evil characters may be symbolically marked by their darker clothing or a deformity.

The diversion between physical and moral ugliness is more complex. On the one hand, a superficially ugly person can be morally beautiful; the beautiful can lie hidden behind the ugly, as when Athena turns Odysseus into a beggar. Consider, too, the physical ugliness of

such moral figures as the threatening Magwitch in Dickens's *Great Expectations* (1861) or the misshapen John Merrick in David Lynch's *The Elephant Man* (1980). On the other hand, a superficially beautiful person can be morally ugly. If a bad person is superficially ugly, as with Thersites, there is less danger that we will succumb, that the person will deceive us. To recognize that a person who is beautiful can be morally ugly is to grasp ugliness in a more complex way. That Dorian Gray is beautiful despite all his vices is more disturbing, more upsetting than if he were physically ugly. Tolstoy often played with the tension between physical and moral ugliness. In *War and Peace*, persons with beautiful bodies and facial features tend to be vapid, dishonest, or otherwise unappealing (among others, Fedja Dolokhov, Anatole Kuragin, and Hélène Kuragin), whereas those who are ugly or fat, plain, awkward, or unattractive tend to be likeable and good (among others, Pierre Bezukhov, Marya Bolkonsky, and Natasha Rostov).

Greek and Hebrew do not distinguish linguistically between beauty and goodness or formal and moral beauty. This is also the case with Arabic and with various sub-Saharan African languages. In Arabic, *ḥasan* and *qabīḥ* have aesthetic dimensions (beautiful/ugly) and ethical components (good/bad) (Van Gelder 337). Every Bete village in West Africa selects a *bagnon* ("community representative") to the outside world: the man chosen must be "both physically and morally beautiful" (Van Damme 17). The tension between physical and moral realms becomes a trademark only in the modern Western world, with Plato's depiction of Socrates an exception. Ziolkowski observes: "Dorian Gray, the man whose body remains pristine as his soul turns cankered from debauchery, would have been incomprehensible in the Middle Ages" (7). As much as Dante innovates in his *Commedia*, Satan predictably moves from beautiful (*bel*) to hideous (*brutto*) when he turns away from God (*Inferno* 34.34).

Vitality and ugliness offer us interesting combinations. From a purely descriptive perspective, physical ugliness often derives from, and contributes to, a lack of vitality (Kirchmann 2:38). Various manifestations of emotional ugliness, such as indifference, despondency, and self-loathing, also undermine vitality (Schopenhauer *The World as Will and Representation*, in *Zürcher Ausgabe* 2:470–71). And yet, not all ugliness is antivital. Mathematical ugliness, a form of intellectual ugliness, functions independently of any relation to vitality. Moreover, moral ugliness is not at all reducible to vitality: indeed, persons

who cling to life may be uglier than those who are willing to sacrifice their lives for higher values.[3]

Often interwoven are physical and emotional ugliness. Our first reaction to works of great beauty, as with classical Greek statues of the fifth century, portrayals of Athena, Apollo, and Aphrodite, for example, or the paintings and sculptures of the Italian Renaissance, works by Leonardo, Michelangelo, Raphael, and others, is to focus on their extraordinary physical beauty. But these works are invariably animated by emotional harmony: expressions of serenity, grace, composure, and confidence add greatly to our experience of them. Emotional ugliness is the reverse in both respects: emotional distress tends to be coupled with physical ugliness or lead to it. Think of music, where discordant sounds express emotional ugliness, or literature, as when the emotionally distraught Oedipus rips out his eyeballs, blood pouring forth from his face. Facial expressions, gazes, and hand gestures, especially when they are exaggerated, can express despair, anxiety, terror, and aggression. In painting, distorted composition and bold and unexpected colors project strong emotions. The figure in Egon Schiele's *Self-Portrait with Striped Armlets* (1915) seems distraught, even hysterical, which is evident in the body posture, facial expressions, and hand gestures, and in the bright orange hair and clown-like clothing. In Béla Tarr's film *Damnation* (1987), the physically desolate setting becomes for the lonely and despondent hero a landscape of the soul.

Ugly emotions may be connected to intellectual or moral ugliness, or both, for ugly emotions often arise from contradictions and inappropriateness. The bad-tempered or irritable, for example, "get angry quickly and with the wrong persons and at the wrong things and more than is right" (Aristotle, *Nicomachean Ethics* 1126a). Ugly emotions surface, however, not only because of weaknesses in the subject but also because of justified unease with objective gaps between the world as it is and as it should be. The catalyst for such ugly feelings lies outside us, even if our unease presupposes a level of cognition.

At the intersection of physical and intellectual ugliness we find nomological ugliness, that is, ugliness that transgresses the laws of reality. In many surrealist works the combinations of images do not violate the rules of formal logic, but instead break nomological laws, as with Max Ernst's fantastic collage *Murdering Airplane* (1920), part airplane and part human. Salvador Dali's *The Persistence of Memory* (1931), with its melting clocks, belongs here also; so too his *Soft Construction with*

Boiled Beans (Premonition of Civil War) (1936), which depicts a bizarre figure at war with itself. Arguably, the technically most creative surrealist was M. C. Escher, who drew lithographs, such as *Up and Down* (1943) and *Relativity* (1953), that depict complicated images that may seem correct but that in terms of gravity are impossible. In the best surrealist works, creative imagination trumps the laws of reality to convey deeper meaning beyond the ordinary and expected. Thus, though we can speak of nomological ugliness, "beautiful ugliness" is also an apt descriptor. We recognize by way of nomological absurdity the historical connection between surrealism and Dada, each of which sought to counter ordinary consciousness, albeit in different ways.

Moral ugliness is often intertwined with the emotional and intellectual realms. For example, vanity can be driven by emotional insecurity and a lack of self-perception, while cynicism may have intellectual roots but moral consequences. In Marquis de Sade's *Justine, or The Misfortunes of Virtue* (1791), the perpetrators' cynicism ensures that any internal barriers to sexual abuse are lifted. Self-indulgence, contempt, haughtiness, and hatred are examples of emotional ugliness that give rise to moral ugliness when they are not turned inward toward the self but instead are directed outward and express themselves in actions that affect others. That such emotional concepts often have moral consequences suggests that the distinctions are heuristically valuable, but hardly absolute. The consequences of morally ugly acts are also relevant for our differentiation of terms. Art grapples not only with morally ugly perpetrators but also with their victims, as with Käthe Kollwitz's lithographs and etchings and Otto Dix's oil paintings.

A complex relation arises when ugly situations, such as deaths or wars, trigger certain virtues. War is prominent in literature: an artistic urge exists to try to remember the deceased, especially those who fought and died for our side. As a society, we owe something to those who have fallen in battle and so try to remember them. War poetry belongs to virtually all cultures and is almost as universal as war itself. Paradoxically, we can experience certain aspects of moral beauty only as a result of ugly situations; this contributes to the complexity of the puzzle and to the possibility of art's regaining meaning in difficult times. Courage is not possible without danger or adversity, endurance does not exist without suffering, and generosity cannot surface without want.

This dialectic represents one possible answer to the theodicy, but it can also be abused to celebrate unjust conditions. In Thomas Mann's

comic novel *The Confessions of Felix Krull, Confidence Man* (1954), the first-person narrator, Felix, and the parents of Marquis de Venosta embrace beggars for their role in a stable social hierarchy. Krull, who pretends to be the Marquis de Venosta, recounts his conversation with the king of Portugal, in which Krull defends "the necessity of a clearly defined social hierarchy" (Ger. 339; Eng. 335). Krull embraces "the distinctions between rich and poor, nobleman and commoner, distinctions in whose defense nature and beauty perpetually join hands. By his very existence, the beggar, huddled in rags, makes as great a contribution to the colorful picture of the world as the proud gentleman who drops alms in his humbly outstretched hand, carefully avoiding, of course, any contact with it" (Ger. 339; Eng. 335). The parents of the marquis respond: "We both completely share your conviction in the God-appointed necessity of distinctions between rich and poor, noble and commoner, on earth, and of the necessity of the beggar cast. Where would the opportunity be for Christian charity and good works if poverty and misery did not exist?" (Ger. 351; Eng. 346). Of course, in terms of values (and not only values), Felix is an unreliable narrator, so Mann is mocking this perverted theodicy. Moreover, Krull's ability to deceive and so move through the layers of society ironically undermines his own theory of an objective social hierarchy. Moral and intellectual ugliness coincide.

Neighboring Terms

Several concepts that border ugliness—above all the *grotesque*, the *abject*, and *disgust*—have gained currency of late. I take *ugliness* to be a more comprehensive concept that can absorb these adjacent terms. The grotesque has less width than ugliness and could be said to function as a subcategory of ugliness that involves exaggeration and caricature, with an emphasis on the material world and the body, including deformity.[4] Think of the grotesque heads by Leonardo in the late fifteenth century and by Jusepe de Ribera in the early seventeenth. In a fascinating book on the grotesque, Wolfgang Kayser argues that the grotesque surfaces in the sixteenth century, as the security of the medieval era fragments; in the period between Storm and Stress and Romanticism (in Bonaventura, for example), as the rationalism of the world is called into question; and in modernity. According to Kayser,

the grotesque seeks via aesthetic formation to evoke and ward off the demonic (203). The grotesque is always ugly, odd, and bizarre, but it can border on the comical. One element of the grotesque is its hybridity, at once horrific and comically outlandish. One can see why Friedrich Dürrenmatt, the Swiss writer of tragicomedies, such as *The Visit* (1956) and *The Physicists* (1961), was attracted to the grotesque.

Another well-known category is the *abject*, whose prominence comes from theory and practice. The Bulgarian-French critic Julia Kristeva reflects at length on abjection. For Kristeva, the abject is that from which we turn away because it disturbs order and violates our sense of cleanliness and propriety: excrement, vomit, disease, corpses, outcasts. For contemporary artists, partly influenced by Kristeva, abject art confronts taboo topics and does so by integrating abject materials: hair, menstrual blood, urine, tears, spit, sperm, and excrement. The abject is a form of ugliness that has gained ascendency in our age, partly because contemporaries focus more on the body, partly because they like to break taboos.

As an example of abject art, consider American Kiki Smith's *Tale* (1992), which displays a naked woman made of wax, pigment, and papier-mâché who crawls hesitantly and painfully on the floor. Her butt is smeared with excrement and a trail of feces extends outward from the rectum, giving the figure a kind of tail. The degrading image reverses the patriarchal view of the idealized female body. The feces still connected to the woman are not only literal but also metaphorical. The exterior seems to have implications for the figure's interior, hinting at a burdensome, if not horrific, past from which she is hardly free. We thus see the title's homophonic meaning: tale and tail, emotional and physical ugliness. The tail tells a tale about the figure's baggage (or shit), forever attached and here exposed to the world, but its content is uncertain beyond its being repulsive and unnerving (Engberg 36). The vulnerable figure is in some sense so bizarre and exaggerated that we ask whether in its absurdity it is simply ridiculous. However, the pain and horror of the abject sculpture, with its crawling, drooping, burdened figure, seem too dark for such a reading, even if Smith repeatedly hints that the comic dimensions of her works are underappreciated (Engberg 39; Frankel and Posner 40).

Note that the related concept of *disgust* refers to an affect and is a reception-aesthetic category. As such, it differs from ugliness, which is a category of artwork aesthetics. Ugliness and disgust are compatible

with one another but not interchangeable. Disgust is an intense, even extreme reaction to ugliness. To the extent that artists and curators believe that the meaning of a work is less important than the emotional reactions it elicits, ugliness gives way to disgust (cf. Cotton and Hutchinson 3). Already Lessing noted that the emotion associated with ugliness is disgust (*Laocoön*, ch. 25; Ger. 173). Kant argues that we can't have an aesthetic portrayal of something so horribly ugly that it triggers disgust: "Where fine art manifests its superiority is in the beautiful descriptions it gives of things that in nature would be ugly or displeasing. The Furies, diseases, devastations of war, and the like, can (as evils) be very beautifully described, and even represented in pictures. One kind of ugliness alone is incapable of being represented conformably to nature without destroying all aesthetic delight, and consequently artistic beauty, namely, that which excites disgust" (*Critique of Judgment*, §48; B 189). Kant suggests that we can portray the ugly in beautiful art only as long as it does not evoke disgust, which is contrary to the experience of beauty, a position that will be echoed by Schopenhauer (*The World as Will and Representation*, in *Zürcher Ausgabe* 1:267) and indeed surfaces intermittently into the twentieth century, but it has been strongly challenged in recent decades.

The historically most thorough study is Winfried Menninghaus's *Disgust*, which traces 250 years of discussion. For Menninghaus, the disgusting is an unassimilable otherness; he speaks of "an acute crisis of self-preservation in the face of an unassimilable otherness" and of "the experience of a nearness that is not wanted" (Ger. 7; Eng. 1). Disgust requires the introduction of not only an object but also a recipient. In 1929, Aurel Kolnai published an essay on disgust, after which the field was dormant for several decades. But in recent years, besides the contribution by Menninghaus, a flurry of books has appeared: a work on disgust from the late 1990s by William Miller; a 2002 book by Robert Wilson; a 2010 work by Martha Nussbaum; and in 2011 alone books by Daniel Kelly, Carolyn Korsmeyer, and Colin McGinn. Among these, one of the more intriguing claims is that we experience revulsion at those aspects of the physical world that remind us that our mind, which seeks the transcendent, is in fact limited by, and will end as a result of, physical limitations. Korsmeyer says, "The exalted human will become one with the worm" (123). This idea is at the heart of McGinn's intriguing contribution. An analogy surfaces with por-

nography: even if pornography and disgust may land on opposite ends of the sensuous spectrum, in both we see the integration of taboos and a severing of any link to the transcendent. Not by chance both gain importance in modernity.

The contemporary fascination with the ugly as a kind of transgression, a bold integration of what is taboo, which we find in theoreticians and practitioners, should not lead us to forget that disgust is not a weak or false response, but, along with other distancing devices, such as mockery, a normatively appropriate response, to moral ugliness. Nussbaum notes that disgust can be directed to the wrong object, but when in harmony with moral values, it remains a valid emotion. As with laughter, the validity of disgust depends on the rational criteria by which we evaluate the object, not on its phenomenological presence.

Jerome Stolnitz, who likewise focuses on reception, draws a distinction between invincible and noninvincible ugliness. In the former, we are so disgusted by the overwhelming and intense unpleasantness of the object that we are compelled to turn away, whereas in the latter we are capable of having a holistic aesthetic experience. We see here a limit of reception aesthetics. Is the work invincibly ugly because it is received in a certain way, or would it not be more appropriate, given that reception shifts over time, to ask, Is the ugly organically integrated into the whole, such that the ugly is not gratuitous but necessary, not simply there, but organically connected? If gratuitous, we would be justly repelled. If necessary, it is internally justified and not invincible, however hard it might be to take.

In this range of diverse categories, as earlier with our elaboration of the different realms in which ugliness operates, we see how complex and multifaceted ugliness is. Before we complete this brief comparative account, let's consider two other neighboring terms, both historical in nature. In the medieval era, the terms for "ugly" (*deformis* and *turpis*) were less prominent than "privation" (*privatio*), as in lack of proper proportion or lack of beauty (*privatio pulchritudinis*). The focus on privation, which emerged as central in medieval and Renaissance theory, derived from the idea that just as evil represents a lack of goodness (*privatio boni*), so is ugliness a lack of beauty. Even if the term "lack" retains occasional heuristic value, it has waned dramatically. Its contemporary usage tends to be restricted to "lack of talent."

Yet for a long stretch of Western culture, people would have said not that a work was "ugly" but that it "lacked beauty."

A second historical concept is *mirabilia* ("marvels"), objects of amazement that are "rare, mysterious, and real" (Daston and Park 17). Marvels, such as conjoined twins or a hand with three fingers, were unexpected and without explanation. These physical abnormalities were viewed as both marvelous and monstrous because they seemed to violate the laws of nature. Marvels fascinated persons from the twelfth century onward (Daston and Park), but evidence suggests that interest in *mirabilia* dates back as far as ancient Rome (Garland). Augustine weighs in on the topic in book 21 of his *City of God* and, less fully, in book 16 (16.8). He seeks thereby to make a case for the eternal punishments of hell (including the idea that God can make bodies burn in hell forever). His case begins with analogous marvels in the world of nature, such as Mt. Etna, which burns continually without being consumed (21.4). Augustine speaks further of the amazing properties of fire, lime, charcoal, diamonds, magnets, and other such marvels (21.4). He says that we should bracket seeking to reconcile wonders of divine origin, including *mirabilia*, to reason, since such works transcend human comprehension (21.5).

Reception was central to the concept of marvels. A person with two heads challenged our sense of normality and vitality, evoking curiosity and disgust. Such forms deviated from previous experience and were perceived as physically ugly. Fascinating and off-putting, *mirabilia* triggered ambivalent reactions, not unlike ugliness today: a horrendously ugly oil painting, say, a Francis Bacon self-portrait, may make us uneasy, perhaps even make us squirm, which need not take anything away from its deeper meaning or form. Such unease is perfectly compatible with our being drawn to such a work. Some *mirabilia* were perceived positively, as noteworthy and evocative of pleasure or awe, but others were disparaged as negative omens, a reception that increased over time. In the fifteenth century and beyond, monsters and monstrous births, with various deformed, even animal-like traits, were regarded as ominous for the wider community (Daston and Park 177–90). Martin Luther and Philip Melanchthon viewed monsters as *contra naturam*. In their pamphlet *Interpretation of Two Gruesome Figures* (1523), for which Lucas Cranach provided woodcut illustrations, the two reformers interpreted two contemporary monsters as revelations of God's wrath at monastic and papal corruption.

In the sixteenth and seventeenth centuries, *mirabilia* increasingly came to be seen as ugly deviations from nature's regularity (Daston and Park 201–14). These creatures, with their many imperfections, did not reach their telos. In seventeenth-century London, Samuel Pepys notes in his diary the existence of marvels, for example, a bearded woman, "about forty years old; her voice like a little girl's; with a beard as much as any man I ever saw, black almost and grizly: it began to grow at about seven years old, and was shaved not above seven months ago, and is now so big as any man's almost that ever I saw; I say, bushy and thick" (December 21, 1668). For Pepys such marvels were contrary to nature.

Mirabilia fade as a field of study in the seventeenth and eighteenth centuries. First, in the wake of the developing scientific empiricism of the seventeenth century, writers turned to describing particulars, including strange facts, detached from any explanatory, theoretical, or evaluative context (Daston and Park 231–46). As reflection on general rules receded, the tension between the particular and the general or regular became less visible, less important. Second, to the extent that the Enlightenment elevated what was common and regular, *mirabilia* ceased to be considered possible; they were not so much debunked as ignored (Daston and Park 361). Third, the theory developed that everything in nature follows general laws, whereas for Aristotle and Aquinas, in contrast, *mirabilia* have no causal explanation. Such rarities occur outside or beyond the course of nature. When a society has a teleological theory of nature, *mirabilia* are a challenge and a disturbance; one is necessarily ignorant of the causes for such phenomena. Once a general account emerges that causal laws exist for everything, when "natural" means following, or according to, the laws of nature, then *mirabilia* become as natural as everything else. Eventually, Charles Darwin understood that some of the most beautiful organisms are the result of random mutations that may have led at the beginning to strange creatures that, however, had a strong evolutionary advantage and then could become very complex. The Darwinian understanding that progress in nature is based on deviations from what is normal challenged the whole concept of *mirabilia* as negative phenomena. "Mirabilia" disappear as a category when irregularity is seen as potentially positive. Our understanding of ugliness in relation to beauty becomes thereby increasingly complex.

Motivations for the Inclusion of Ugliness

What motivates artists' integration of ugliness and our attraction to ugly works? I suggest various, at times overlapping, rationales. First, *empathy* is a catalyst for depicting ugliness or, more commonly, the consequences of ugly circumstances or actions. The reception of such ugliness evokes solidarity and encourages compassion with the vulnerable, the outcast, the abject. This is recognizable already in selected ancient works: consider the blind bard Demodocus's beautiful Homeric simile in the *Odyssey* wherein the now lamented, one-time conqueror Odysseus cries much as the vanquished Trojan widows weep for husbands killed in battle and who are now being dragged off in bondage (8.521–30); Antigone's final advice to her father in *Oedipus at Colonus* to relinquish vengeance and not return evil with evil (1182–1204); or the dignity of *The Dying Galatian*, a technically superb Roman marble copy of a lost Hellenistic sculpture depicting the dying enemy. The empathy motif is radically reinforced in Christianity and later by nonreligious influences on social sensibility. Empathy is deeply evident in the works of Kollwitz, who not by chance works at the same time as empathy becomes a meaningful category for theorists and philosophers, such as Theodor Lipps, Max Scheler, and Edith Stein.[5]

Second is *moral revolt*, which is visible in negative portrayals of moral ugliness, most commonly associated with satire. Sometimes ugliness is insisted upon, as in Lucan's *Civil War*, to destroy an ideology of beauty, splendor, and pompousness that is regarded as unbearable, particularly with regard to the phenomenon of war. Ugliness is exposed via disgust with what *is* in its deviation from what *should* be. Erasmus's *Praise of Folly* (1511) and Francisco Goya's *Los caprichos* (1797–98) use different media to attack idiocies and superstitions. The ugliness of George Grosz's works serves a moral purpose, as does the unraveling of the heroic myth of war in Erich Maria Remarque's *All Quiet on the Western Front* (1929).

A third model is not evaluative, but simply epistemic: it wants to know the way in which the world works, how things are and appear to be. Here the impetus is interest in what is and might be, a *desire for knowledge*, including the logic of evil. In his dramas, Schiller seeks to portray vice "along with its entire internal apparatus" (mit samt seinem ganzen innern Räderwerk) (preface to *The Robbers*, in *Werke* 2:16). Working within the realm of possibilities, artists experiment

with positions that are as yet unclear. John Gardner alludes to this possibility: "True moral fiction is a laboratory experiment too difficult and dangerous to try in the world but safe and important in the mirror image of reality in the writer's mind" (115–16). Whereas some works advance a clear doctrine, others pursue unfinished thoughts. In *The Experimental Novel*, Émile Zola writes that a novelist wants to show "by experiment in what way a passion acts in a certain social condition" (25). Dürrenmatt, whose works are rich with moral ugliness, viewed theater as a "thought experiment" in which the author creates an alternative world that nonetheless sheds light on reality (27:91). For Dürrenmatt, such experiments are most meaningful when the results are unpredictable (7:91). No less than scientific experiments, artistic experiments help us understand the world in its complexity. The artist's desire to experiment can push the envelope, leading to forms that appear to be, at least superficially, unorganic.

Not unrelated to the aspiration for knowledge is the desire to play with forms in such a way as to push the envelope of what is possible. Here is an engagement with ugliness, often, but not only, in form, whose primary catalyst is not empathy, moral revolt, or knowledge, but *playful fascination*. This may involve gruesomeness that exceeds what seems necessary or appropriate, as in the battle of the Lapiths and Centaurs in Ovid's *Metamorphoses* (12.210–535). It may involve fascination with what is technically possible, as in Holbein's play with perspective in *The Ambassadors*, the visual puns of the Hapsburg court painter Giuseppe Arcimboldo, or Escher's surrealistic creations. In medieval literature, the rhetorical tradition dictated what constituted beauty, which over time became modestly stale. What was ugly was less prescribed. The ugly thus liberated writers to innovate and experiment, to express their creativity and individuality, and to engage in the outlandish (Ziolkowski).

Today innovation may be driven by the desire to shock audiences, to test their capacities for reception, even endurance. This may explain the increase of nonevaluative aesthetic fascination with moral ugliness, as we see with Quentin Tarantino.[6] German painter Georg Baselitz stated that his paintings from the early 1960s that focused on male penises, including his oil on canvas *The Big Night Down the Drain* (1963), which portrays a disfigured boy with hair like Hitler's and an erect penis, were explicitly designed "as an aggressive act or a shock" to awaken what Baselitz thought was a complacent postwar

German public (Baselitz 27). In this example we see that the motivations I am listing need not be mutually exclusive: out of a sense of moral revolt Baselitz wanted to shock his audience.

Although we tend today to think of shock as gratuitous provocation or an attack on tradition, it can be viewed as a form of negativity that leads to something positive. Pope Benedict XVI, whose name is not otherwise often uttered together with that of Baselitz, likewise elevates and praises the role of shock: for Benedict art is meant to disturb, it pulls us away from false contentment, reawakens us through suffering, and opens our eyes to new horizons. It would be a mistake to deride shock as by itself an unappealing aspect of art. On the contrary, it can give art dignity.

Note that empathy and moral revolt, though seemingly at odds with one another, are motivated by a strong moral compass and a set of ideals even when those ideals have been violated. The result can awaken empathy with the downtrodden or incite hatred toward the unjust. Both impulses arise from attentiveness to the deficiencies of reality. Some works give rise to both moments, moral revolt and empathy with victims.

The third and fourth moments also seem to be at odds with one another, one looking for knowledge and the other seeking effect, but both have in common a curiosity about how things work and play out, in the world or in imagination; both test our cognitive understanding of human possibilities. We are fascinated with the ugly partly out of a desire for knowledge, a longing to experience it. This principle functions in the realm of reception too. According to Stephen Bayley, one of the most popular works at London's National Gallery is the Flemish master Quentin Matsys's *The Ugly Dutchess* (ca. 1513), a portrait of a woman with horrible facial deformities ("The Ugly Truth" 22).[7] We are pulled toward such works, just as artists are drawn to create them.

A fifth motivation I call the *challenge of the abnormal*. Often the monstrous must be overcome in order for the hero to shine. Here ugliness may also be intrinsically fascinating, but instead of experiencing empathy with what is ugly, the reader or viewer is more likely to identify with the hero who overcomes unappealing obstacles. Odysseus must combat or evade monsters, such as Polyphemus, Scylla, and Charybdis. When it comes to the suitors whom Odysseus must vanquish, the challenge overlaps with an imperative for justice, as the suitors break with conventional standards of moral excellence. Abnor-

mality can be at the opposite of empathy, as with Hellenistic sculptures that mock physical deformities. Today we find these unappealing, but similar gestures of ridicule endured long after the advent of Christianity, as in early modern poems that mock ugly women. In some cases, the abnormal is justly presented as negative, so, for example, the intellectual ugliness of a character who is both arrogant and ignorant. The abnormal can also awaken our curiosity and longing for knowledge. Australian artist Patricia Piccinini's hyperrealistic creations involve vulnerable-looking creatures with human traits (for example, eyes, sagging flesh, and expressions that reveal intelligence) combined with snouts, floppy ears, and tails. These ambivalent figures awaken fundamental questions about dignity beyond the human realm.

The final catalyst for integrating ugliness is *metaphysical*, the idea that ugliness has a role to play in a larger whole. A necessary presupposition of human existence is differentiation, including suffering, longing, and death. Because moments of negativity and ugliness are a condition for becoming, they are as a whole to be embraced. Christianity plays a role here in our understanding, so, too, do modern secular reinterpretations of Christianity as a threefold process, from an imaginary but ultimately empty state of bliss, to struggle and becoming, and then further toward a higher state of differentiated unity (Abrams). The notion that ugliness plays a necessary role in a larger whole and is thus ultimately beautiful will be challenged in modernity, but the concept animated earlier artists, such as Dante, who explored the depths of hell as part of his *Commedia*. Within such a metaphysical frame diversity exists. The contrast between Dante and Goethe, for example, is remarkable. One could never imagine Dante's immobile and lifeless Satan chatting amiably with God in heaven (Hösle, *Dantes "Commedia"* 53). But Goethe, living in an age that stressed not dualism but dialectic, with its concept of a differentiated unity, prefaces *Faust* with just such a conversation. For Goethe, evil has an even greater role in the whole of creation; the devil is a subordinate but productive partner in moving humanity forward. A metaphysical horizon for ugliness can also arise from a post-Christian perspective, as in the bleakness and desolation that Hungarian director Béla Tarr portrays with his slow camera movement and long takes in his black-and-white film *Damnation*.

Because these forms of motivation are not mutually exclusive, we often find in individual works multiple catalysts. Indeed, *Dorian Gray*,

which I analyze in chapter 8, seems to play with all of these elements, even as it treats some of them with ambivalence or even irony.

I conclude this chapter with the simple observation that in some instances ugliness is not intended at all but is the indirect result of another impulse. For example, the tendency toward realism brings with it an inadvertent focus on ugliness. This is true in the case of Lucretius, with his graphic accounts of pestilence that ravaged Athens during the Peloponnesian War, and much later with the busts or character heads of Messerschmidt, who wanted simply to capture the breadth of reality. In the context of inadvertent ugliness, consider also American realist Thomas Eakins's large *Portrait of Dr. Samuel Gross (The Gross Clinic)*, which is masterful in its technical virtuosity and uncompromisingly realistic in depicting an eminent surgeon at work. The mainly dark colors allow the blood to stand out—on the scalpel, on the surgeon's hand, and on the patient's thigh, on which he is operating. In a self-reflexive gesture, one observer is repelled by the surgery. In this case life imitated art, as the organizers of the exhibition where it was submitted "felt repulsed by its bloody display and shunted it off to a local hospital for hanging" (Kammen xiv). The goal is realism, but ugliness is a result, and the painter is aware of this ugliness as a challenge for his audience.

AESTHETIC
CATEGORIES

In 2001, Damien Hirst, one of the world's most famous artists, set up an installation at London's Eyestorm Gallery. But the installation was "dismantled and discarded the same night by a cleaning man who said he thought it was garbage" (Hoge). The artwork, which had been completed and placed in the gallery, consisted of a collection of half-full coffee cups, ashtrays with cigarette butts, empty beer bottles, a paint-smeared palette, an easel, a ladder, paint brushes, candy wrappers, and newspaper pages strewn about the floor. The cleaning man said, "It didn't look much like art to me. So I cleared it all in bin bags, and I dumped it" (Hoge). Immersed in what Jed Perl calls "laissez-faire aesthetics" (11–23), which eschews arguing about quality in art, many intellectuals are hesitant to criticize anything that is marketed as art. Cleaning crews are not so deferential. Equally amusing, in May 2016 two teenagers were visiting the San Francisco Museum of Modern Art. They decided to play a prank and placed a pair of eyeglasses on the floor. Very quickly museum visitors rapturously mistook the gag for a work of art (Mele). They took pictures, gathered around it, and discussed it at length. Is one of these examples art and the other not? Is one art because it was done by an artist? Was the one by the pranksters better art because it was appreciated as art?

Production, Artwork, and Reception Aesthetics

Jean-Marie Schaeffer gives voice to a dominant view: art and beauty have no distinctive or objective qualities and are "never anything but what people make of" them (7). From within this frame, positive aesthetic value is what is beautiful in the eyes of the beholder or deemed beautiful by convention. Both views privilege reception as the determiner of aesthetic value and suggest that instead of looking for objective criteria with which to distinguish good from bad art, we turn instead to personal taste or consensus. We can subsume this focus under what is called *reception aesthetics*. Reception aesthetics explores the history of a work's reception, shifting conventions of interpretive communities, questions concerning the universality and particularity of taste, the emotions evoked by artworks, preconceptions and their influence on interpretation, and the effects of aesthetic experiences on our subsequent worldview. Ugly art may be analyzed in this context as what engenders disgust or what a community accepts as beautiful or ugly.

Alternatively, we might respond to the question of aesthetic value by focusing instead on who created the work. If the creator says that the work is art, then it is art. If it was done by Picasso, then it must be good. Who am I, a nonartist, to say otherwise? The focus on who created the work, what the artist's intentions were, and what they might have said about the work belongs to *production aesthetics*, a second realm within aesthetics. Production aesthetics asks about the author's sources and influences, preliminary versions, related works, issues of identity, and the broader political, socio-historical, and intellectual context out of which the artist and the work emerged. Instead of asking if a work is ugly, we ask under what conditions and for what purposes was it created.

Paradoxically, these seemingly modest perspectives—that evaluation is tied to reception or production—make a bold claim: that there is nothing objectively distinctive about art or about the value of art. Claims of aesthetic value are subordinate to the work's genesis or reception. Beauty and ugliness are sociological, not aesthetic categories.

The third realm of aesthetics, *artwork aesthetics*, analyzes and evaluates the content of the artwork, including the story, theme, argument, and broader ideas; the form, that is, the art and genre to which the work belongs, its style, structure, and capacity to express meaning indirectly; and the interrelation of form and content and of parts and

whole. Unlike production and reception aesthetics, artwork aesthetics focuses on what is distinctive about art. What differentiates an artwork after all is not that it has a production or reception context (realms common to all intellectual products), but that it has distinctive qualities that constitute it as an artwork. If we want to be attentive to what distinguishes art as art and what makes an artwork beautiful or ugly, we must prioritize not production or reception but artwork aesthetics, focusing thereby on the content and form, their interrelation, and the connections between the parts and the whole. When it comes to questions of aesthetic value and approaches to understanding aesthetic ugliness, I favor, therefore, artwork aesthetics.[1]

The excellence of a work does not depend on its having been created by someone who had this or that background, traits common to many individuals whose intellectual products do not interest us in the least, nor does it derive from a given culture's reception of the work, because not all cultures have approached works with cogent and compelling categories. To elevate reception over the work would be to find oneself arguing that a work is good because people say that it is good instead of making the more rational claim that people find a work good because it is good. To elevate production over the work would be to find oneself arguing that a work is good because it was created by a particular person or emerged out of a given context.

When we focus exclusively or primarily on production or reception, the distinguishing qualities of the aesthetic object disappear. We can say that a work's value is determined by what people are willing to pay. Against the market no arguments exist unless one distinguishes value from price, but that distinction requires a normative perspective, value as independent of the market. Without a normative dimension, the study of art consists of what social-scientific disciplines tell us. The philosophy of art can merge with empirical surveys that capture our views on art.[2] We are left with what the market can bear, what is widely consumed and what is advanced by connoisseurs, who might elevate criteria such as being shocking or outrageous, which, however, when taken to be sufficient, lead to our elevating a lot of bad art.

We can have a more intelligent understanding of aesthetic excellence, including an account of art that is only seemingly ugly, but only if we have a normative concept, with criteria, as a counter to the descriptive sphere. Note that we can criticize propaganda, including ugly images of the other, as objectively deficient only if we have a standard

that does not reduce the meaning of such images to the dynamics of power, the market, collective beliefs, or personal preference; otherwise, the ugly is whatever is deemed ugly by one or the other group. In contrast, focusing on artwork aesthetics allows us to develop criteria for an interaction with art as art. We can then speak philosophically and not simply sociologically about beauty and ugliness. Such aesthetic categories are of course compatible with a certain amount of elasticity that allows for variation and personal preference, especially as multiple forms of beauty exist (Roche, *Why Literature Matters* 24–25).

Although production and reception aesthetics are secondary to artwork aesthetics, they are nonetheless essential to a full understanding of artworks. Literature, for example, requires the interpretation of linguistic signs. It is not so that a poem exists simply in a set of typographical symbols; the work exists also in the fact that these words have a certain meaning, which can exist only in the mind. The mind may be that of a creator or a recipient, but we cannot get away from referring to states of mind. Iconic artworks trigger cultural memories; for example, we recognize in Picasso's *Guernica* the crucified Christ. This is something that is the property not only of the painting but also of the culture that is familiar with other paintings and the tradition that makes this meaning apparent. Artwork aesthetics cannot and should not seek to overcome referring to the broader culture. In his *Principles of Art History*, Heinrich Wölfflin demonstrates the extent to which we need to bring to an artwork an understanding of formal structures and their meaning. In *Studies in Iconology*, Erwin Panofsky shows that we can understand works only if we have knowledge of certain images or conventions as carriers of specific meanings. In other words, even artwork aesthetics requires contextual knowledge above and beyond the words and images on the page. We must know, for example, that in the Western tradition fish, sheep, and crosses as well as stigmata carry associations of Christ.[3]

Reception aesthetics has taught us much: that we must be conscious of the presuppositions of our interpretive practices, creative with the questions and categories with which we approach a work, and receptive to new meanings and diverse interpretations. Meaning depends on the quality not only of the artwork but also of the imagination with which we approach it. The more schooled the imagination is in interpreting, the more we can take from a work; the more intelligent the interpreter, the more the work has to say. Some works are not

immediately recognizable as beautiful and require a variety of cognitive and imaginative capacities for us to be able to understand the ways in which dissonance, tension, and seemingly heterogeneous parts, along with often repugnant subject matter, fit together to constitute an artwork. Reception aesthetics, therefore, is invaluable for works of beautiful ugliness. A concept of reception is already embedded in artworks as a starting point of communication: art exists to be seen, read, experienced, interpreted. The reception context is in some ways implicit in the work itself: works contain signals for a certain kind of reception.

However, neither production nor reception can address the work's ideal meaning. A work may mean something more or even different than the creator consciously intended, and the ultimate criterion is not the artist's conscious intention but the work itself. What do the words and images say? How does the form shape the meaning? What interpretation does full justice to their complexity? So, too, with reception. We can learn a great deal from the reception history of a work, but a given reception may be based on prejudice or false claims, which need to be measured against the work itself. Thus one can speak of an ideal meaning, which prioritizes the artwork itself. This ideal meaning is the standard by which our efforts at interpretation are to be measured. Do our results attend to the relation of form and content? Do they take account of part and whole? Are they aware of complexities and ironies and ambiguities and other subtle forms of indirection? An ideal meaning does not exclude the possibility that the work might be ambiguous and that two equally opposed interpretations might be valid, such that they must both be thought together. Or that interpretations with different foci might complement and enrich one another. However, without such a standard, which we can only approximate and which always requires that we return to the work itself as the measure of our interpretations, we are at a loss to evaluate competing assertions about a work, including claims about its value, for we cannot truly evaluate a work until we have offered a compelling interpretation. Hermeneutic interpretation and aesthetic evaluation are intertwined, which is why we must be open to diverse interpretive possibilities before assessing a work's aesthetic value (Roche, *Why Literature Matters* 53–71). These two interrelated tasks—interpretation and evaluation—are central to the puzzle of aesthetic ugliness.

Understanding and Evaluating Artworks

Philosophers distinguish between positive aesthetic value (or good art) and negative aesthetic value (or bad art). Our common, everyday understanding of ugliness includes negative aesthetic value. Ugly art is art that has no merit. We want, however, to understand the ugly, like the beautiful, with greater nuance. We want to grasp the ways in which the ugly, more precisely, the seemingly ugly, can contribute to positive aesthetic value, to beauty.

If one accepts the primacy of artwork aesthetics, then interpretation will focus on an artwork's idea, its form, the interrelation of content and form, and the integration of parts and whole. For Hegel in his *Aesthetics* the content of art is truth (*Werke* 13:21, 13:151). Great art opens a window onto truth. Art has a cognitive dimension, which is perfectly compatible with the idea that aesthetic meaning is indirect, often elusive, and not easily exhausted. In addition to focusing on an artwork's moments of truth, we want to explore a work's form, its level of innovation or nuance, the extent to which the form is an appropriate fit for the content being expressed, if even in subtle and counterintuitive ways. Not all works with positive aesthetic value are formally innovative. Some adopt inherited forms and make them intriguing and meaningful for a specific content. Ideally, the form is so interwoven with the content that to separate the larger meaning and the particular shape would be to violate the integrity of the whole. In works that embody positive aesthetic value, parts and whole are united such that the parts, though of independent interest, nonetheless gain their full meaning only within the whole.

In his third logical investigation, Edmund Husserl has a concept of parts according to which we can grasp to what extent my third focus (on the interrelation of form and content) and final focus (on the connection of part and whole) are both similar and different (227–300). Form and matter could be conceived as two interwoven parts of the whole. One could, therefore, combine criteria three and four and simply say that the parts and the whole should relate, or one could suggest, as I do, that these represent in a conceptual sense the same (the common relation of parts and whole) but two discrete ways of looking at parts. The third criterion focuses on form, which is part of the whole, in its relation to content; the fourth refers to the inclusion of elements, such as those that could in principle be dropped or al-

tered, but if deleted or altered would change the work as a whole. Common to the third and fourth criteria is the concept of a relation of parts and whole that is organic; the difference between them is the question of the potential independence of parts.

The decisive distinction lies between what Husserl calls a *Moment* (part as a moment or aspect) and a *Stück* (part as an element, a piece or slice of a whole). *Moments* are parts that can only exist together with other parts, such as form and content. Hegel rightly notes: "The right form is so far from being indifferent with respect to content, however, that, on the contrary, it is the content itself. A work of art that lacks the right form cannot rightly be called a work of art, just for that reason. It is not a true work of art. It is a bad excuse for an artist as such to say that the content of his works is certainly good (or even excellent) but that they lack the right form. The only genuine works of art are precisely the ones whose content and form show themselves to be completely identical" (*Werke* 8:265–66; *Encyclopaedia Logic* 203). *Elements*, in contrast, are parts that are potentially independent (Husserl 272–74), such as a scene in a drama or an embedded story within a larger frame narrative. What I mean when I speak about form is a moment, and what I mean when I speak of parts and whole are elements that can in principle be imagined by themselves, even if their ultimate meaning derives from the whole. Form is always interwoven with the content. There is no way to look at the content fully independently of the form. The two can be noted separately but not imagined separately. And even though the various sections of a work ideally blend together, one could envisage a work without certain elements, including minor characters, passages, and the like, and one could envision parts published autonomously.

Because hermeneutics and aesthetics are interwoven, if we focus in our interpretations on a work's idea, its form, the interrelation of content and form, and the integration of parts and whole, then our evaluation will likewise focus on each element. Thus our criteria for positive aesthetic value include the work's idea, its form, the relation of content and form, and the relation of parts and whole.

A decisive question when we evaluate a work is the following: Are we weighing the depicted object or the depiction itself? The former captures the content; the latter involves the work's form and properties. When we think of aesthetic ugliness, we need to distinguish what the work represents or describes, which can involve physical, emotional,

intellectual, or moral ugliness, and what kinds of properties it has as an artwork. This conceptual distinction was first advanced by Aristotle; it has been given contemporary relevance by Goodman (*Languages* 31).[4] Differentiating between the act of depicting and the object depicted is essential. We need to distinguish the properties of the act of representation (we can say this is a beautiful representation of a corpse in the sense that it is absolutely faithful to the essence of the corpse) and the object of the act of representation (we can say that the corpse itself is not at all beautiful). This distinction is relevant for our evaluation of an artwork—we can have beautiful depictions of ugly objects, such as *Suspension* (2002–3), Jenny Saville's remarkable oil painting of a slaughtered pig. The distinction between the depicted object and the depiction is also pertinent to diverse types of beautiful ugliness, which involve the relation of depiction and depicted object, form and content. Benn, for example, gives us beautiful depictions of ugly objects, whereas Penderecki gives us an ugly depiction of an ugly object, such that the work is beautiful or fitting only on a metalevel.

Goodman makes another distinction between depiction or representation, on the one hand, and exemplification, on the other. Representation involves what is represented, the object depicted. In some cases, as in abstract painting or instrumental music, no object may be portrayed. Exemplification arises from the way in which the representation is made. For example, a painting may depict flowers, but it may metaphorically express or exemplify sadness. In a sonata, the interacting first thematic material and the second thematic material may depict different musical ideas, but the composer may exemplify a tension between the two. A building may not depict an object, but it may metaphorically exemplify strength or warmth: "To exemplify or express is to display rather than depict or describe" (Goodman, *Languages* 93). In poetry, meaning may come from patterns of words and sounds. Exemplification, argues Goodman, is one of the least noticed and least understood aspects of art (*Ways* 32). It is also one of the most important.

Exemplification is part of art's indirection. It refers not to the object depicted but to the mode of depiction, which itself conveys indirect meaning: "An experience is exemplificational insofar as concerned with properties exemplified or expressed—i.e., properties possessed and shown forth—by a symbol, not merely things the symbol denotes" (Goodman, *Languages* 253). Goodman here recognizes "the primacy

of the work over what it refers to" (*Ways* 69). Van Gogh gives us abundant examples of works in which indirect meaning arises more from the way in which an object is portrayed than from the object itself. The haunting dimensions of Van Gogh's works do not derive from the rooms, buildings, flowers, or landscapes he paints. Instead, they flow from his unprecedented use of brush strokes and stylized patterns, as in *The Starry Night* (1889); exaggerated perspectives, as in *The Bedroom at Arles* (1889); and twisted shapes, as in *The Church at Auvers* (1890). The resulting distortion, with its conscious avoidance of accurate mimesis and superficial beauty, suggests intensity and disorder bordering in some paintings on an unease we might identify as emotional ugliness. Exaggeration and distortion in an artwork elicit intense emotional responses.

What object is depicted in an artwork? is a legitimate question, but hardly the most important question for interpretation and evaluation. Certainly some subjects are more likely to evoke deeper insights than others, but even seemingly mundane subjects, when addressed in fascinating ways, can evoke deeper meaning, and portrayals of ugly objects and actions can be integrated into works with positive aesthetic value. We need to dig deeper and ask what sort of representation or description it is. In other words, what are the properties of the artwork? To summarize, then, to grasp the role of the ugly in artwork aesthetics, we need to distinguish between what the work represents or describes, the object depicted, and the sort of representation or description it is, what kinds of properties it has as an artwork. The aesthetic quality of a work, which includes not only the content but also the form, the relation of the two, and the relation of part and whole, is not in the least harmed by the inclusion of ugly content. This needs to be emphasized against all convention, which in the past has often hesitated to allow certain elements of ugliness into the content of artworks, and against the tendency of recipients not to want to be confronted by ugly content. The question becomes, How is the content shaped in the work as a whole?

Note that ugliness can itself be part of the object depicted or part of the work's overarching properties. Imagine again a painting of a corpse. In such a work physical ugliness may be the object. The depiction could be formally beautiful, or it could be formally deficient; the latter would mean physical ugliness in the work's properties. We can imagine a comedy about a character who constantly lies. And we can

imagine a work that is illogical and internally contradictory, not in the object depicted, but in its properties. That would be intellectual ugliness, not as an object, but as a property of the work. Finally, a novel could portray the mindset of a murderer. Here the object is moral ugliness. If such a work were not simply to portray but to embrace the murderer in terms of its evaluative function, then the work, in terms of its properties, would be morally ugly.

Difficult Beauty

The seemingly ugly arises whenever a work has dimensions that are so unusual, innovative, or complex, such as parts that seem not to integrate into the whole, that they appear to have negative aesthetic value. The seemingly ugly is an element in an artwork, be it formal, thematic, or both, that initially causes displeasure and resists being integrated into a concept of the beautiful. It may be an element of a larger whole that we initially find repulsive or dissonant but that in the end turns out to be meaningful and coherent. The form does in the end match the content, and the parts do cohere. These demanding works may be misjudged as ugly, but they are only seemingly ugly. When the hidden beauty of a work, say, an El Greco painting, is finally recognized after decades or even centuries, the work did not suddenly become beautiful; it was always beautiful, and we were simply not equal to the challenge. Positive aesthetic value is a feature not of reception but of the work itself.

Analogously and beyond art, when the Nazis attacked the Roma peoples and homosexuals as physically or morally ugly, they were not ugly at the time and then beautiful once the Nazis were defeated; the Nazis simply imposed illicit categories and acted according to them. Human dignity was violated, and persons were mistreated, but they did not lack dignity. If one accepts the idea that there are aspects of the good, the beautiful, and the true that are normative (not in the social-scientific sense of average, but in the philosophical sense of ideal), no evidence of conflict or variation in empirical reality suffices to eliminate the normative ideal. One could say to those who point out many instances where racism is taken to be good, where kitsch is considered beautiful, where the truly ugly is embraced as beautiful, where logic is simply denied, so much the worse for reality. One cannot allow

reality to be the measure of the ideal if one wants to hold to an alternative that allows us to criticize reality, and no number of cultural disagreements about beauty or other higher values, no number of dramatic changes in perception across time and generations renders an ideal wrong.

What I am calling the "seemingly ugly" is related to a concept introduced by the British neo-Hegelian Bernard Bosanquet, who spoke of "difficult beauty" (*Three Lectures* 85). Bosanquet was the first Anglo-American writer to address the ugly at any length. In *A History of Aesthetic* (1892), he calls ugliness a "question of supreme aesthetic importance" (393). Bosanquet argued that many observers will call certain works ugly, but others will—on the basis of education, experience, and imagination along with a willingness and patience to attend to details—come to recognize beauty. When Goethe visited the Strasbourg cathedral, he expected to see a disordered, ugly, barbaric building. A lover of classicism, Goethe was famously taken aback, as he says in his short essay "On German Architecture," by his unexpected admiration for the Gothic cathedral, with its splendor and glory, its unity amidst so many complex details. Goethe's conversion gives us an instructive example of someone extending his horizon of taste and expanding his tolerance and capacity for discrimination ("Von deutscher Baukunst"). Under difficult beauty, we can include works that initially had mixed receptions. The Eiffel Tower, to take another cultural example, received tremendous resistance, for it fit no previous style. Instead, it sought to draw its form from its material, iron (Frederick Brown 124–54).

Bosanquet analyzes three types of difficult beauty. He begins with "intricacy," where recipients fail to grasp a complex whole (*Three Lectures* 87–89). A viewer may be repulsed by a part and not see its complex position within the greater whole. The second challenge is "tension" (89–92). Some viewers cannot endure brutal or extreme scenes, which are nonetheless necessary for the organic whole. Bosanquet's final variation on difficult beauty is range or "width" (92–94). For example, many recipients will not let themselves enjoy a comic work that seems beyond the bounds of normality and upends what might otherwise be viewed as acceptable. Each form of resistance can be analyzed via the relation of part and whole: Is the part so interwoven with the whole that, despite our initial resistance, be it emotional or intellectual, we can, after some difficulty, understand its organic relation to the whole?

Although the term "difficulty beauty" comes from Bosanquet, a version of the concept was already introduced by Schasler, who, as Bosanquet notes, was the first to view difficult and displeasing elements in art as not only permissible but essential (Bosanquet, *History* 424). Bosanquet offers the important insight that the seemingly ugly is understood to be beautiful only when the eyes are seasoned and the categories appropriate. However, the concept of difficult beauty, as Bosanquet develops it, has a weakness. The focus on reception at the expense of the work means that Bosanquet has no categories with which to distinguish difficult beauty from bad art (*Three Lectures* 97–108). He implies, perhaps unintentionally, that there is in art no such thing as ugliness. If beauty is expressive form, and all art involves expressive form of some kind, then there is no ugliness: "If it [an object] has no expressive form, it is nothing for aesthetic. If it has one, it is beautiful" (*Three Lectures* 98). There is only the inability of the spectator to tolerate unpleasant content or recognize deeper connections and patterns. Often the problem lies with the viewer, who may fail to recognize a deeper beauty. But to deny the existence of ugly art is to suggest that all art is beautiful, which is not a defensible claim.

Difficult beauty, as Bosanquet defines the term, is not a tenable concept. In contrast to Bosanquet, we can recognize that not all works that seem ugly are beautiful; some works are simply ugly. But the concept of difficult beauty can be reappropriated as a combination of work and reception: in my view difficult beauty designates what is objectively beautiful but might not be immediately processed that way. Moreover, we can recognize that works may miss the mark (or seem to miss the mark) in more than one way. Bosanquet considers only works that are in one sense or another sensuously unattractive, but I would include a second category: works that may have sensuous appeal but that seem to lack substance or an idea. Difficult beauty would thus encompass both seeming ugliness and seeming vapidness, the latter category designating works that seem to be without deeper meaning and thus without positive aesthetic value but that upon closer analysis surprise us. Some works that appear superficial, shallow, and gimmicky turn out to have hidden depth. One must have the patience to puzzle through them. Consider a 1991 work by the minimalist Cuban artist Felix Gonzalez-Torres. His installation *"Untitled" (Portrait of Ross in L.A.)*, which is housed at the Art Institute in Chicago, consists of a 175-pound pile of brightly colored candies individually wrapped in

ILLUSTRATION 6
Felix Gonzalez-Torres, *"Untitled" (Portrait of Ross in L.A.)*, 1991/Candies in variously colored wrappers, endless supply/Overall dimensions vary with installation/Ideal weight: 175 lb./ Installed in *Contemporary Collecting: Selections from the Donna and Howard Stone Collection*, Art Institute of Chicago, Chicago, June 24–September 19, 2010, Curator James Rondeau. Catalogue. © Felix Gonzalez-Torres, Courtesy of The Felix Gonzalez-Torres Foundation.

cellophane (illustration 6). Visitors who see the artwork sometimes eat or remove pieces of the candy. One wonders whether to take the work seriously. Surely, many would laugh and call it yet another gimmick in the art world, but the installation is a meaningful meditation on love and loss, which arose in relation to a taboo topic. The work invites what Hegel calls "thinking contemplation of objects," a principle central to philosophy, including aesthetics (*Werke* 8:41; *Encyclopaedia Logic* 24; translation modified).

The work is an allegorical representation of the artist's partner, Ross Laycock, who died in 1991 of an AIDS-related illness. When first situated, the installation is set to 175 pounds, which has been understood to correspond to Laycock's healthy body weight.[5] As the 175 pounds begin to diminish and eventually disappear, the installation mirrors how Laycock wasted away from the complications of AIDS. The diminishing exhibit can be read as corresponding to Laycock's loss of weight and suffering prior to his death. Through this creative

portrait and installation, the viewer gains a sensibility for loss. And one sees how others can meet the loss of one's loved one with emotions ranging from indifference to glee; indeed, societal reactions can even contribute to the sense of loss, much as the larger society was insensitive to the dissolution of the gay community, as the AIDS epidemic spread. Gonzalez-Torres himself died of AIDS-related causes in 1996 while still in his thirties.

As we take the candy away, we change the work's form and content, but in the spirit of the work. We symbolically enact a cannibalism, which gestures to the societal neglect that contributes to loss, but we also participate in Laycock's being, engaging in a kind of communion. Within us we carry forward his memory. The work thus alludes to the Eucharist. The association of Christ's body with contemporary suffering is not blasphemous, but richly evocative of Christ's ugliness, as it has been portrayed in the tradition, for example, in Gothic crucifixes. Christ is thus connected to a particular kind of suffering dominant in the early 1990s and taboo at the time, ugly and beyond our sight. The physical existence and diminishing of the installation is a constant reminder of loss and also a way of keeping the memory of the beloved alive; each time the work is on display, the exhibitor can decide how often and to what extent they may replenish the work—if at all. When candy is added or the work newly installed, Laycock receives symbolically a new kind of life. Even as the suffering is symbolically reenacted, so, too, is the sense of communion with others, and the dominant visible impression is not of darkness and death but of color and life. The work is an affirmation of life in the face of AIDS and so a way of thematizing and confronting ugliness. The installation seems simple and slick, but it is a work of beauty and depth. One must have the patience and hermeneutic capacities to puzzle through such works. To be flexible when being confronted with works that seem either horrid or gimmicky or both is important.

The Dada poet Hugo Ball, to take another example, created poems that he recited in costume: they consist of sounds that, beyond the title, fit no known language. His "Threnody" (Totenklage) begins: "ombula / take / biti / solunkola / table tokta tokta takabla / taka tak tabubu m'balam / tak tru - ü" (*Gedichte* 71). The poem seems to be total nonsense. The language is as far from German as it is from English. We may think this Dada poet has created a charade, but the work is an example of the way in which an artist, much like Penderecki later, creates

a new form to express inconceivable horror. Normal language fails, and Ball must invent expressions, often truncated ones, to convey the ravages of war. In interpreting Ball's poem, Carsten Dutt analyzes a wide array of hidden meanings. For example, "taka tak" has echoes of the French *attaque*, the German *Attacke*, and the *Tak Tak Tak*, by which those who experienced World War I sought to describe the sound of machine-gun fire. Much of the poem has a priestly cadence. The work ends with a Christian allusion to alpha and omega, "a-o-auma," which may, in its lowercase reduction of A-O, represent a loss of Christian values or register a modest gesture of hope. The work is ambiguous.

Monroe Beardsley has argued that "critical evaluation is at its best a group enterprise, for it may take a variety of talents and sensitivities to see what is good and what is bad" in a given work (485). Gathering a range of views elevates not necessarily consensus, but certainly the value of listening to diverse perspectives and arguments. In seeking to make defensible judgments, we must draw on rational criteria, working within artwork aesthetics and distinguishing between the object depicted and the work's properties. Beyond addressing the content, we attend to the form. In commenting on the satiric tradition of artists from Hieronymus Bosch and Pieter Bruegel to Grosz and Beckmann, Paul Tillich notes: "The artistic form separates critical realism from simple fascination with the ugly" (324).

Innovation often leads to initial incomprehension and a tepid or negative response. Some ages have a dearth of categories to deal with aesthetic objects and so cannot recognize difficult but great art. Even Mozart struggled with a partly negative reception. He had trouble, for example, with the reception of his string quartets dedicated to Haydn, which were considered overly difficult and dense, especially his sixth and final one (String Quartet no. 19 in C major, K. 465), which opens with "an unprecedented network of disorientations, dissonances, rhythmic obscurities, and atmospheric dislocations" (Solomon 200). Just as Mozart belongs to the canon of classical music, so are the French Impressionist painters universally accepted and widely admired, but they, too, were initially criticized; indeed, they were occasionally described as mad. They had deviated from traditional norms, seemingly abandoning line and color, balanced compositions, and correct drawing. Persons were reduced to simple dots, which was interpreted as an attack on human dignity, and spectators who observed the works up close could not make heads or tails of them. Because the Impressionists,

among them Paul Cézanne, Camille Pissarro, and Eduard Manet, had defied the rules of the conservative Académie des Beaux-Arts, which had informed art training since 1648, they were not permitted to participate in the prestigious "Salon de Paris" of 1863.

That year, the "Salon des Refuses" was formed. Initiated by Emperor Napoleon III, it displayed the work of those who were prohibited from participating in the official salon. Two years later at the 1865 Paris Salon, Manet exhibited his *Olympia* (1863), which was criticized for its content (the woman, recognizable as a prostitute, gazes at, and in a sense confronts, the viewer with her independence) and its form (its crude realism, harsh lighting, and lack of depth did not fit expectations). In the wake of the uproar, critics gave Manet the title they had once conferred on Eugène Delacroix, "Apostle of Ugliness" (Ross King 153). Louis Leroy, one of the early critics of Impressionism, who inadvertently coined the term, wrote a satiric dialogue in 1874, mocking the Impressionists for their sloppy and haphazard form and their content, criticizing their caricatured cabbages and reduction of human beings to "black tongue-lickings" and "strips of color" (25–26). Commenting on Claude Monet's *Impression, Sunrise* (1874), the fictitious interlocutor laments: "Wallpaper in its embryonic state is more finished than that seascape" (26). The narrator, in turn, mocks the "ugliness" of Cezanne's *A Modern Olympia* of 1874 (26).

The turn-of-the-century Klimt affair further illustrates resistance to difficult beauty, to the seemingly unorganic. At the University of Vienna, the Austrian symbolist Gustav Klimt was commissioned to prepare three ceiling paintings depicting philosophy, medicine, and jurisprudence. The works were ambiguous and mysterious. Above all they blurred distinctions. Not only conservatives, who were alarmed by what they took to be pornography, protested, so too did faculty members and political liberals, who wanted Klimt to endorse the clarity of reason and the progressive nature of science (Schorske 225–52). Torn between their progressive values and their criticism of such innovative paintings, they mounted an assault by criticizing Klimt's paintings as "ugly art" (*Gegen Klimt* 23). At the time, ugliness was defined as what was blurred and indistinct, a description that fit not only Klimt's works but also those of the French Impressionists. Such a mechanical definition evidenced no capacity to see the larger organic purpose behind such formal innovations. Any innovation will in some sense be a deviation and can thus be perceived as varying or even vi-

olating a norm, as ugly, but there can be a hidden rationale to such deviations and a higher, more complex conception of beauty (Arnheim).

The Klimt affair reminds us that distorted forms might have a deeper aesthetic rationale. We see this in the other arts too. For example, the loss of overarching connections in modern Germany is expressed stylistically in the parataxis and serial style (*Reihungsstil*) of early Expressionist poetry, with its abundance of unconnected and random images, as in Jakob van Hoddis's "The End of the World" (1911) and Alfred Lichtenstein's "Twilight" (1911). Images seem disjointed and out of place, but the stylistic strategy underscores the disarray on the level of content. The diction with which Gottfried Benn's later "Lost I" (1943) opens is not superficially organic:

> Lost I, blasted apart by stratospheres,
> victim of ion—: gamma-ray-lamb—
> particle and field—: chimeras of infinity
> on your grey stone of Notre-Dame. (1:205)

This heterogeneity—the first stanza interweaves classical mythology, Christian religion, modern science, and categories of modernity, such as dissonance and quantity—serves, on a metalevel, the poem's theme of unconnectedness and alienation and is thus at a higher level organic.

When an artist moves decidedly away from traditional conventions, recipients can be challenged. Works that break our horizon of expectations may be labeled ugly. In a commentary on Jackson Pollack's being unafraid to create works that seem ugly, Clement Greenberg went so far as to suggest that "all profoundly original art looks ugly at first" ("Review" 2:17). The claim is false (it can hardly be said to apply to all original art), but it does capture a common tendency. Claude Debussy's symphonic poem for orchestra, *Prelude to the Afternoon of a Faun* (1894), was arguably a turning point in the history of music. In his superb lectures at Harvard, Leonard Bernstein contends that Debussy's work pushes tonality to its limits, using an augmented fourth, a tritone, as the basic structural principle, thereby setting up the atonal works of the twentieth century (238–59). A contemporary critic viewed Debussy's originality as ugly: "Debussy's *L'Après-midi d'un faune* was a strong example of modern ugliness. The faun must have had a terrible afternoon, for the poor beast brayed on muted horns and whinnied on flutes, and avoided all trace of soothing

melody, until the audience began to share his sorrows. The work gives as much dissonance as any of the most modern artworks in music. All these erratic and erotic spasms but indicate that our music is going through a transition state. When will the melodist of the future arrive?" (Slonimsky 92).

Who, we might be tempted to ask, resists the ugly? Traditionalists for whom art is associated more with the conventional and superficially appealing than the innovative and alienating, those who want art to depict only idealized versions of reality, those who do not recognize the hidden logic of ugliness, and authoritarian governments that want to cover up any hint of dissonance. The resistance is varied, ranging from critics who simply have different presuppositions to those who will not give complex art an opportunity. Much of this resistance has little to do with art itself but takes us instead into broader cultural issues.

Disability Studies and Degenerate Art

The concept of the seemingly ugly can be considered beyond aesthetics and invites fuller reflection, especially because one of the most vibrant developments in recent cultural studies has been disability studies, which is not unrelated to questions of the seemingly ugly. Disability is a particular restriction in ability; deformity, which may or may not overlap with disability, is what appears misshapen. When we encounter a disability or deformity, everyday consciousness might take it to be ugly. After all, it seems to violate principles of health and vitality, as with a deformity, such as a deeply scarred face, or a disability, such as two missing legs. However, when we think in a more profound way about what distinguishes a human being, such superficial issues recede in importance. The person may be healthy in the deeper sense that belongs to humanity. We want to make appropriate distinctions: a physical trait that is abnormal in the sense of different from the norm as a statistical average does not at all affect what belongs to a normative concept of the human being. Between the statistical and philosophical concepts of a norm is the social concept of norms as conventions, what society tends to accept or reject. Here is where discrimination against the abnormal occurs. In that context, Nicola Cotton makes a helpful distinction, suggesting that we differentiate be-

tween a violation of a social norm (as a kind of infringement or attack on convention) and an innocuous variation in relation to a statistical norm (123). Analogously, or, we might say, in reverse, we recognize that excellent satire and caricature seek to unveil not variations in human behavior, that is, violations of social norms or variations to statistical norms, but unjust violations of moral norms.

Physical ugliness has no effect on humanity and dignity. In his intimate *An Old Man and His Grandson* (ca. 1490), Domenico Ghirlandaio plays with this distinction and with the complex relation between physical ugliness, the old man's rhinophyma, and a deeper truth that renders the ugliness irrelevant (illustration 7). The child's look of love transfigures the apparent ugliness of the nose. The child ignores it. The ugliness is present but overcome by wonder, love, and naivete. The speculative moment works in both directions: the grandfather is not at all inhibited by his ugliness, he is beyond it. Their deep connection is accentuated through their eyes meeting and the red that links both figures. Lynch's *The Elephant Man* captures in its range of characters the ability and the inability to see beyond the seemingly ugly. We cannot focus so much on the higher standard of inner dignity that we ignore actual physical disabilities, including the ways in which they impair persons and lead to social discrimination. Voyeuristic portrayals of disability, be they positive or negative, also tend to reduce persons to their disabilities, rendering them "more or less than human" (Fiedler 3). Rendering disability as a person's defining feature is contrary to a normative concept of the human being. However, the disability should not be ignored, for that would be socially unjust and contrary to a holistic sense of self.

Hegel's philosophical question, "Who thinks abstractly?" can be helpful in the context of understanding disability. Normally, we would say it is the philosopher who thinks abstractly, the philosopher who looks beyond particular traits, but Hegel turns this idea on its head, suggesting that the person who is obsessed with one facet of another person's profile, that he is a murderer, for example, abstracts from his essence as a human being: "This is abstract thinking: to see nothing in the murderer except the abstract fact that he is a murderer, and to annul all other human essence in him with this simple quality" (*Werke* 2:578; *Hegel Texts* 116–17). The uneducated person, says Hegel, holds on to the one predicate, whereas the educated person knows that everyone has a richer life beyond the singular context in which we

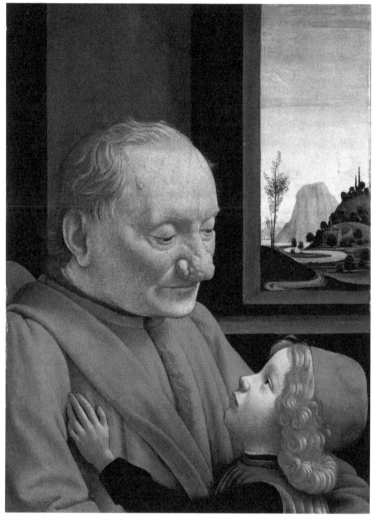

ILLUSTRATION 7
Domenico Ghirlandaio, *An Old Man and His Grandson*, ca. 1490, Oil on wood,
Musée du Louvre, Paris/© RMN-Grand Palais/Art Resource, NY.

encounter that person, including, for example, as a co-worker or a
family member.

Analogously, to think of someone only as disabled is to think
abstractly and inadequately. Disability studies theorists lament "the
prejudicial reduction of a body to its disability" (Siebers 81). Theorists
encourage us to think of the whole person and to reflect on our own
categories, in Hegel's vocabulary, our abstractions. One should look

beyond particular dimensions to recognize diverse aspects of the human being. Disabled persons should be defined not by their disability but instead by their dignity. Hegel's argument foreshadows a further defining thrust of disability studies—that disability is less a personal predicament than a "social problem" (Goodley 3). Disability studies argues against viewing impairment as only a personal challenge. Instead, it advocates for social changes that would allow for greater human flourishing. Oliver and Barnes write of "calls for effective political and social change with which to bring about a more equitable and just society that acknowledges, supports and indeed celebrates the reality of human diversity, difference and frailty" (153).

The idea here is to recognize disability as one piece of a larger puzzle, not the defining characteristic of a human being, and to embrace the idea of a social world in which disability is a part of the human being, not a defining characteristic. Literature often accomplishes this. Though Melville's Captain Ahab is disabled, he is more fully formed by "revenge, megalomania, and the quest for transcendence" (Robinson 21). In "On Abstraction," German poet Ludwig Steinherr alludes to the death camps. In the spirit of Hegel, his poem speaks of neat and tidy general concepts and then the sorting of men and women along with piles of clothes, shoes, glasses, and gold teeth, abstracting all the while from any holistic concept of the human being (Steinherr 88).

The absurdity of misjudging the seemingly ugly as ugly is manifest in Paul Schultze-Naumburg's *Art and Race* of 1928. Schultze-Naumburg was an architect, painter, and theorist— and early proponent of Nazi racial ideology. By the time his book appeared, he had met the racist ideologue Alfred Rosenberg and through him Adolf Hitler. Schultze-Naumburg, who later became a Nazi representative in the Reichstag, discusses what he calls (and what later were designated) "degenerate" artworks, that is, seemingly ugly works in content and form. Schultze-Naumburg thought that one could read the souls of artists from the objects they represented, and he lamented that we see "everywhere a preference for and emphasis on the appearances of degeneracy [Entartung], as they are known to us from the army of the downtrodden, the sick, and the bodily misshapen" (87). Schultze-Naumburg sees in the "horror chambers of museums" "a true hell of subhumans [Untermenschen]," and places on facing pages works of modern art and images of persons with deformities or diseases to

underscore the unhealthy and horrific nature of both (89, 87, 99). The artists who create such works, he concludes, must be the deviants in our society who carry with them "sundry features of degeneracy" (95). Not only does Schultze-Naumburg see the artworks and human beings in their partiality, he concludes that the artists must themselves be degenerate. Individual moments of ugliness, with appropriate rationale, are permitted, as in Dante, Schultze-Naumburg argues, but not widespread ugliness, which signals decay (96).

The concept of degenerate artworks animated the 1937 Nazi exhibit on "Degenerate Art," which was essentially a state-sponsored attack on modern art. In this Munich exhibit, the Nazis prominently placed Emil Nolde's multipanel painting *The Life of Christ* (1911–12) and Ludwig Gies's large wooden sculpture *Crucified Christ* (1921) in the entrance hall and the first gallery of the upper floor.[6] Both works portray Christ in deep agony. Gies, in particular, shows a Christ whose body is deeply contorted. For the Nazis, these works illustrated modern art's attack on Christianity. Beside Nolde's work was the commentary: "Under Centrist rule insolent mockery of the Divine" (Unter der Herrschaft des Zentrums freche Verhöhnung des Götterlebens).[7] The Nazi judgment underscored their deep ignorance of the Christian idea, which we explore in chapter 6, that immersion in the lowliest of the low, manifest in the ugliness of Christ's crucifixion, is a form of transcendence. The deformed and the lowly were linked with Christ, but these categories were in turn ennobled. The abject could carry the seeds of the divine. The Nazis' ignorant and ham-fisted reaction to difficult beauty included, then, not only contemporary but also historical topics.

Also included, though a bit less prominent, was Max Beckmann's oil painting *Descent from the Cross* (1917), which draws equally on the tradition of the deeply suffering Christ (illustration 8). Here Christ is pale and emaciated, bruised and replete with sores; the beginning signs of rigor mortis reinforce the shape of the cross. The diagonal Christ dominates the canvas. The figures on the upper left are seen from below, the kneeling figures on the bottom right from above, such that our eyes always return to Christ (Selz, *Max Beckmann* 30). All three works draw on the tradition of the distorted, disfigured, and ugly Christ, which accentuates his extreme suffering for the sake of humanity.

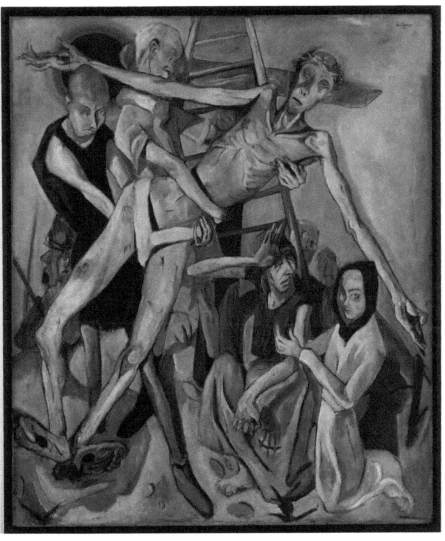

Works that are criticized as blasphemous or morally ugly are best
addressed with the categories of the *ugly*, the *seemingly ugly*, and *dif-
ficult beauty*. If we abandon these or similar categories, no art would
be objectively ugly. The only ugly art would be art that is rejected by
the majority. That would be a horrid situation, for if a consensus were

to form against minority rights, racist art would become valid, potentially even great, and there would be no legitimate recourse to a higher standard of justification. The reference to what is widely thought or what constitutes a consensus is simply not convincing. We may be wrong. Reality is not always right. Rational criteria beyond the power of consensus are needed.

Ugliness as Organic

The rise of the ugly in modern art would seem to resist every traditional concept of art, including the organic, which animated criticism from Plato to the early twentieth century. For Plato, an argument should be organic, like a living being, with a beginning, middle, and end, the diverse parts conjoined and forming a coherent and unified whole (*Gorgias* 505c-d). Great art follows this organic model: art integrates content and form in such a way that to separate the meaning and the shape would be to violate the integrity of the whole. Just as the two major moments of form and content belong together, so do the various parts stand in an organic relation to one another. Hegel, who follows Plato in elevating the organic, both in general and in art, articulates three aspects (*Werke* 9:368, *Encylopaedia* §342). First, all the parts have a certain autonomy, which renders them interesting in and of themselves. Second, each part is connected to the others; they fit or belong together such that no part is not expressive of the whole. Third, despite the relative interest they garner as parts, their full meaning evolves only from their position within the totality of the artwork and slowly becomes recognizable in this way (*Werke* 13:156–57; A 115).

This connection between art and the organic begins to fade or is directly countered in modernity; its few adherents, such as Leo Spitzer, stand out as exceptions. Instead, modernity tends to favor the nonorganic, arbitrary, and contingent. Contingency is an important theme in modernity, but much depends on what you do with it. A contemporary master of contingency is the Turkish-German film director Fatih Akin, who integrates the contingent not only in a comedy such as *In July* (2000), a genre in which coincidence and chance are common, but also in darker works, such as *The Edge of Heaven* (2007). Missed chances and missed opportunities abound. The characters see

only their own contingent dimensions, whereas the viewer grasps the fuller picture. Akin explains that he had to cut his favorite scene from the latter film because it did not help to carry the meaning of the whole. Although the scene had great independent or intrinsic value, it did not fit organically ("The Making"). Akin thematizes chance without making his work nonorganic. Jazz, too, is able to combine chance and the organic, folding idiosyncratic and innovative parts into a larger whole. These practices contrast with those of composer John Cage, whose work with chance pushes art into the realm of the arbitrary, or Karlheinz Stockhausen, whose aleatoric compositions allow much of the work to be finalized by the contingent decisions of the performers. Hegel had foreseen this movement to contingency in modern art, which culminates in the idea of art as a game, and contrasted it with devotion to substantive topics and organic form (*Werke* 14:223–29).

A creative approach to ugliness will help us recognize that many seemingly contingent, dissonant, and negative works are in fact organic, but organic in a complex way and on a metalevel, insofar as dissonance serves a higher meaning or insofar as an artwork may be the negation of a negation. Many conservative critics simply fail to grasp the complex beauty or nuanced unity of much of modern art. The mixture of genres, for example, is not an argument against harmony, especially as unity presupposes difference. The blurring of categories can be admirable, as in tragicomedy, an appropriately complex way to address an intricate subject. Christian Weiße, one of the first modern theorists of ugliness, is wrong when he argues that when instrumental music, say, a flute, imitates human song, the sound is ugly, for it inappropriately mixes the abstract realm of instrumental music with the human world (*System der Ästhetik* 2:66). The pushing of boundaries can in fact be the forerunner to the creation of a new and beautiful form. In addition, an element of formal dissonance may serve a higher unity, as when the dissonance of Holbein's skull conveys some sense of our inability to face our own death.

The more original the work, the more difficult it is to recognize the constituent moments and their meaningful interconnections. What is new is often strange. Indeed, Charles Baudelaire thought that "the beautiful is always strange" (Le beau est toujours bizarre) ("The Universal Exhibition of 1855: The Fine Arts," in *Œuvres complètes* 2:578). In this sense, the beautiful is often difficult to discern and process.

A reverse way of saying this is that the superficially pleasant will rarely have the complexity of beauty. Wittgenstein writes: "What is pretty cannot be beautiful" (*Vermischte Bemerkungen* 85). The difficulty of recognizing complex beauty may be especially intense in postclassical eras, where the artistic desire to be innovative may oblige artists to experiment with forms that appear to be, at least superficially, nonorganic. In our capacity to see the hidden logic of seemingly nonorganic forms, to grasp new and surprising interconnections, we must be broad. Here hermeneutics and aesthetics function dialectically. The questions we ask of a work may better illuminate its hidden features or organic connections, thus altering our evaluation of it. The organic suggests that the constituent elements of a great artwork—from language and manner to theme and structure—are variable, but what remains common is the transformation of the elements into a meaningful whole.

Let's recall here our two definitions of beauty: *beauty as what pleases* and *beauty as what marks aesthetic excellence*. The first definition suggests that the beautiful artwork is superficially harmonic and pleasing to the senses. This limited concept captures certain forms of art, but it is hardly exhaustive. It excludes, for example, the tragic and the sublime. A merely pleasing work can easily become empty of substance and devoid of complexity. Some content simply cannot be subsumed under a more superficial definition of beauty, which indicates its limits. If art deals with the full range of being, ugliness cannot be excluded. We do not need to fall victim to a false dichotomy of ugly or beautiful, organic or avant-garde if we think dialectically. This is hardly an abstract exercise. Why is the skull distorted in Holbein's *The Ambassadors*? Because it captures an ugly subject, death; we see not simply ugliness or distortion, but a distortion that matches the object, and thus a unity of form and content. The disabling discord of Penderecki's *Threnody* is another example where the discordant form is in harmony with the horrific content, such that on a metalevel we see a harmony of form and content. The works are clearly ugly, but when understood in relation to their content, they are fitting, aesthetically excellent, beautiful. In Wiene's *The Cabinet of Dr. Caligari*, the stylized Expressionist sets emphasize uncertainty and dread, with jagged, zigzag lines, including rhomboid windows and houses that seem to lean over, entrapping and oppressing the townspeople. These ominous and

ugly surroundings, with exaggerated painted shadows, convey disorientation and precariousness and so mirror the utter confusion and chaos of the period immediately following World War I. Architectural forms, which are normally objects of the real world, are distorted and handled symbolically and abstractly to underline the emotional landscape of a world out of joint. The ugly form and ugly content work together to render the work surprisingly organic.

INTELLECTUAL

RESOURCES

Theories of ugliness surface throughout Western history, beginning already with the first philosopher to reflect on the organic, Plato. An objective idealist, Plato offers four original insights, all of which have an enduring legacy: (1) ugliness and beauty are not binary opposites (one must look more deeply); (2) humans are irresistibly drawn to ugliness; (3) the ugly is what is contrary to what is appropriate to the nature of something; and (4) powerful ugliness is abhorrent, but ineffective ugliness is ridiculous. Aristotle draws on the last point to develop what is the most famous and enduring philosophical comment on ugliness, the link between the ugly and the comic. In the fifth chapter of the *Poetics*, Aristotle writes that the comic mask is "ugly and distorted," but he also emphasizes—and this is an essential insight that seems to hold even today—that it is tolerable because it does not trigger "pain" (1449a).

This is not the place to analyze ancient ideas of ugliness, but I want to highlight two of Plato's insights. In the *Sophist*, Plato characterizes the mindless soul as "ugly" or "deformed," implying a definition of the ugly as what is not fitting, an appearance that is contrary to what is appropriate to the nature of something (228a–d). Ignorance is an aberration or perversion of the mind, a withdrawal from, or nega-

tion of, what belongs to the mind as the human organ for knowledge. As a negation of what is intrinsic to the human ideal, ignorance is ugly. Among the various forms of ignorance, Plato seems most interested not in the ignorance that requires technical instruction, but instead in the vain stupidity of claiming to know when one does not. The latter is to be cured by cross-questioning. The *elenchus*, the questioning that Socrates adopts to uncover contradictions and refute positions, addresses the soul's ugliness, much as gymnastics and medicine address physical ugliness and disease. In the *Philebus*, Socrates describes "ignorance in the strong" as "hateful and ugly," and ignorance in the weak, because it is not harmful to others, as simply "ridiculous" (49c). Later in the same dialogue, Socrates notes that no one would rightly have "a vision of intelligence and reason as ugly" (65e), and when we see someone absorbed in bodily pleasures (without measure or appropriateness and destitute of reason), we detect in them "an element of the ridiculous or of extreme ugliness" (65e–66a). The ridiculous and the ugly contradict the maxim that one should know oneself; they are "the opposite of the inscription at Delphi" (48c; cf. *Sophist* 229c–230e). That is, the ugly and ridiculous are forms of badness that cannot be as they should be because those who are ugly and ridiculous do not even understand what should be. Such persons do not grasp the distinction between what is and what ought to be. Like the true and the good, our cognition of the ugly as ugly is based on a normative/descriptive discrimination. Plato's distinction, which will be further developed by Aristotle, is still useful today: the ugly that is powerful we abhor and the ugly that is harmless we find ridiculous. We hate and fear a murderous dictator, whereas Homer's Thersites is simply ridiculous.

Though insights surface throughout the Western tradition, intense, systematic discussion of ugliness emerges only after Hegel. Lessing, who was known to all of the Hegelians, devoted some pages to ugliness when in his *Laocoön* (1766) he analyzes differences between the spatial and temporal arts, arguing that ugliness is more easily absorbed in the temporal arts. A generation later, in *Über das Studium der griechischen Poesie* (*On the Study of Greek Poetry*) (1795), Friedrich Schlegel noted the relevance of the ugly in aesthetics and even went so far as to call for a "theory of ugliness" (Ger. 311, 315; Eng. 68, 70). That theory arrives only with the Hegelians, a series of thinkers for whom ugliness was a central aesthetic category. But before we turn to them, let's consider the

leading insights of medieval theorists, who capture a moment of truth that will be lifted up and transformed by the Hegelians.

Medieval and Early Modern Christian Thinkers

The dominant category in medieval aesthetics was not ugliness, but beauty. We have already previewed the most prominent and distinctive medieval claim about ugliness: just as evil is a privation of the good, a *privatio boni* (Aquinas, *De divinis nominibus* 4.14.479, 4.22.587), so is ugliness a privation or failure of beauty, a *defectus pulchritudinis* (4.5.345). This analogy builds on the idea that "the good and the beautiful is the same" (Pseudo-Dionysius, *Divine Names* 4.7). Despite differences in time, sources, and perspective, Pseudo-Dionysius the Areopagite, Augustine, and Aquinas all share this overarching claim. In a generous reading, they seem to be saying not that any absence of beauty is ugly, for some things, such as numbers, are neutral, neither beautiful nor ugly. Instead, ugliness involves a privation, lack, or void where one would have expected to experience beauty.

In a monotheistic world, evil cannot be a divine counterforce to God, and because God could not have created evil, what humans take to be evil must be reinterpreted as a moment within a larger whole that is necessary and in the long run good, part of God's subtle and complex plan: as such it is not truly evil. In the finite realm, we seem to recognize evil, but such seeming evil is for these medieval thinkers necessary and even good, part of the cosmic fabric of divine order. In the *Summa theologiae*, Aquinas notes that evil serves a limited purpose even in bringing forth various goods, among them human virtues and divine grace: "God allows evils to happen in order to bring a greater good" (*ST* III.1.3). Thus, evil "belongs to the perfection of the universe . . . by reason of some good joined to it" (*ST* I-I.48.1).

In this world, all things are arranged in a hierarchy, with less or more goodness and beauty, depending on their proximity to the divine: one can "observe that all things are arranged according to their degrees of beauty and excellence, and that the nearer they are to God, the more beautiful and better they are" (Aquinas, *Three Greatest Prayers* 45). Augustine argues that insofar as human beings are more beautiful than apes, the ape is comparatively ugly: "In all these things those that are small are, in comparison with greater ones, called by contrary

names. In that way, because there is greater beauty in the form of a human being, the beauty of an ape is said to be deformed in comparison with it" (*Nature of the Good* 14, translation modified; cf. *Confessions* 13.20.28). Augustine embraces the opposition of contraries as essential to the beauty of the universe (*City of God* 11.18 and 16.8). Even sinners, whose deformity in itself is a blemish, contribute to the beauty of the whole when they are appropriately punished (*City of God* 11.23; cf. 14.11). God, Augustine argues, "knows how to weave together the beauty of the whole in the similarity and diversity of its parts. But anyone who is unable to see the whole is offended at what appears to be the deformity of a part, for the person does not know how it fits in or how it is connected with the whole" (*City of God* 16.8; cf. 12.4).

We recognize here a twofold conception: first, the ugly is simply a privation of beauty; second, in the long run nothing is ultimately ugly insofar as it participates in the greater beauty of the universe. In *True Religion*, Augustine argues that in order to recognize "the beauty of the whole universe," we must look beyond individual parts: "That which we abhor in any part of it gives us the greatest satisfaction when we consider the universe as a whole" (40.76, translation modified). The same principle applies to an artwork: when we "pay exclusive attention to the part, our judgment is itself base. The color black in a picture may very well be beautiful if you take the picture as a whole" (40.76, translation modified). According to Augustine, even the seemingly ugliest of animals—mice, frogs, flies, and worms—remain, as part of God's creation, ultimately beautiful (*On Genesis* 1.16.26). The order of creatures ensures variety and the perfection of the whole (*On Free Choice of the Will* 3.9). Contrary to a Platonic vision, this idea affirms all creation, all matter. One sees that when later Leibniz connects the best of all possible worlds to principles of plenitude and efficiency, he can draw on earlier Christian sources. In the *City of God*, Augustine connects the idea to scripture ("God saw everything that He had made, and indeed, it was very good") (Genesis 1:31; cf. Genesis 1:25). Augustine endorses the organic idea that parts play a role within the whole: "For, just like a painting, when it has dark colors in their proper places, so the entire universe—if anyone could see it whole—is beautiful even when it has sinners, despite the fact that, when sinners are considered in themselves, their ugliness is repulsive" (*City of God* 11.23; cf. 14.11). For Augustine the part gains its meaning in the whole, and being and goodness are ultimately one.

In his early dialogue *On Order*, the first book after his conversion, Augustine debates the role that moral and intellectual ugliness play in the universe. The character Trygetius suggests that everything that seems disorderly, ugly, or unappealing when viewed by itself nonetheless makes sense within the larger whole (2.4.11–13). The beauty of the universe is enriched by the clash of contraries (1.18; cf. 2.2). Augustine repeatedly suggests that an essential task in seeking truth is to develop the knowledge that allows the seeker to grasp the role of seeming disorder within the larger whole in which it plays an appropriate part (2.5.17, 2.7.24, and esp. 2.17.46 and 2.19.51). Although Augustine refers to evil as "nothing" or "a nonentity" (2.7.23), the reader gains the impression that moral evil is not nothing but an active force, a seeming disorder, that has a certain role to play, a role that we must work very hard to discern and that ultimately we are capable of reinterpreting as a part of the larger order and whole and thus as not quite evil, a view that is not foreign to the Stoic universe either, for example, in Seneca's *On Providence*.

When Peter Abelard makes his case for this same idea, he cites Augustine as his authority. All things flow from God, who is good. God's plan is ordered, and thus all that exists is fitting and appropriate, because God wanted plenitude and diversity. Evil is not possible unless it is good that there be evil, that is, unless evil has a part to play in a greater good. In making his case, Abelard, too, turns to art: "For as a picture is often more beautiful and worthy of commendation if some colors in themselves ugly are included in it, than it would be if it were uniform and of a single color, so from an admixture of evils the universe is rendered more beautiful and worthy of commendation" (Abelard 56; Arthur Lovejoy, translation at 72).

Despite the medieval Christian language of privation, these thinkers come close to recognizing a dialectical relation of the ugly and the beautiful: by playing an appropriately subordinate role, the ugly can contribute to the beauty of the larger whole. A part can be viewed qua part as deficient, but when this deficiency is viewed from the perspective of the whole, our evaluation is transformed, and the part becomes beautiful. To take an example from medieval architecture, monstrous gargoyles contribute to the larger beauty of a cathedral. These ugly constructs are not only apotropaic, that is, designed to avert the power of evil; they affirm that moral and physical ugliness are part of God's creation, part of God's harmonious whole. Moreover, they fit

within the larger narrative by haunting us and thereby drawing us into the security and sanctity of the church. Victor Hugo still works within this paradigm: he gives the hideous hunchback Quasimodo, who is at home among such monsters and demons (*Notre-Dame de Paris* 166), the role of ringing the bells in Notre-Dame de Paris: the ugly Quasimodo contributes to the larger harmony.

In his sermons, especially his ninth homily on the First Epistle of John, given in 407, and his twenty-seventh sermon, delivered a decade later, which explores diverse texts, including Isaiah 53:2–3, Augustine links this conceptual argument with the narrative of Christ. Christ became ugly, abject, deformed in order to demonstrate his love for humanity, to show solidarity with the lowliest of the low, and to offer them a path from their own lowliness to beauty. Christ "hung on the cross, deformed; but his deformity was our beauty" (Sermon 27.6). In such passages, Augustine thinks dialectically: Christ became ugly and shed his blood for those who are ugly only to make them beautiful (Sermon 62.8). Christ is for Augustine both deformed and beautiful, even if to his persecutors he was only ugly. The Christian grasps ugliness in its full unfolding, as part of a larger whole. This is the most valuable insight into ugliness that we can take from medieval aesthetics. It builds on Plato's idea that there is a dialectic of beauty and ugliness, but the medieval thinkers give Plato's idea a distinctly temporal dimension, which is layered with Christ's death and resurrection. The idea finds its fulfillment in portrayals of the crucified Christ as truly ugly and supports the idea that only a sequence of images or a temporal art can do justice to the Christian narrative, in which ugliness is one moment in a larger whole.

The Christian claim that the truth of the part is in the whole continues into the early modern era. In *On the Ultimate Origination of Things* (1697), Leibniz, a champion of the great chain of being and the idea of the best possible universe, draws a compelling comparison between the universe and a painting. If we cover most of a beautiful painting and look only at one isolated part, it may seem arbitrary and unappealing, perhaps even ugly. But when we can see the entire painting again, we realize that the part has a much different meaning in the work as a whole. So it is with the universe: what appears in life to be only unfortunate, only dissonant, may in fact be a necessary part of a much larger and ultimately harmonious whole, of which we can see only fragments (*Philosophical Essays* 153–54). Here uniformity does

not bring pleasure, Leibniz argues, and we must recognize that a part "can be disordered without detracting from the harmony of the whole" (154). The idea of a harmonious whole will be vociferously challenged in modernity. Still, it is possible to separate out two distinct points. We can understand evil to be more than simply a privation, yet still argue that evil and its parallel, the ugly, are necessary. The idea that evil as such is a necessary part of the universe is perfectly compatible with the idea that we have a moral obligation to combat any and all particular evil. From the perspective of Leibniz, evil and ugliness are a function of finitude, which is necessary for the plenitude of creation.

Hegel

Leibniz and Hegel differ in many ways. Whereas Leibniz sees only positive attributes in God, Hegel integrates negativity into the absolute itself, and as much as Leibniz could compete with any philosopher in breadth, Hegel was far more attentive to aesthetics than was his German predecessor, but Leibniz and Hegel share a common desire to understand the negativity and complexity of this world as ultimately rational. In the so-called Hotho edition of the *Aesthetics* (the lectures were never published during Hegel's life but were instead compiled from various sources afterward by his student Heinrich Gustav Hotho), Hegel rarely speaks of ugliness and for the most part dismisses it. He understands the need for negativity in art, but he views "ugliness" as below the aesthetic realm unless it is "elevated and carried by an intrinsically worthy greatness of character and aim" (*Werke* 13:288; A 222). Hegel also recognizes the inevitable presence of ugliness in caricature (*Werke* 13:35). He sides with Lessing in suggesting that the ugly is best presented in the temporal arts, whereas in the visual arts, especially sculpture, ugliness "is fixed and permanent without being superseded" (*Werke* 13:268; A 205). He continues: "Here it would be a blunder to cling to the ugly when the ugly cannot be resolved" (*Werke* 13:268; A 205). Hegel views moral ugliness as beyond aesthetic treatment: "Evil as such, envy, cowardice, and baseness are and remain purely repugnant. Thus the devil in himself is a bad figure, aesthetically impracticable; for he is nothing but the father of lies and therefore an extremely prosaic person" (*Werke* 13:288–89; A 222). Hegel comments in another passage that "the withdrawal of

subjective inwardness into itself, the inner turmoil, the instability, the whole series, in short, of disunions that produce in their midst the ugly, the hateful, the repulsive" are all foreign to Greek culture but implicitly of course part of Hegel's age (*Werke* 14:24–25; A 436, translation modified).

Two recent research projects on Hegel's aesthetics have involved, on the one hand, publishing various student transcripts from the lectures and, on the other hand, making the case, partly via the transcripts, that Hegel's view of ugliness shifted over time and was more accommodating than the views of his eventual editor, Hotho (Gethmann-Siefert, *Einführung* and "Hegel über das Häßliche"; Iannelli, "Hegel und die Hegelianer" and *Das Siegel*). The overarching thesis is that Hegel was more modern than the early Hegelians, for, although the early Hegelians focus much more on ugliness, they see it as valid only insofar as it is negated, whereas Hegel seems comfortable with ugliness as such. The evidence from the student transcripts makes clear that the ugly does appear in Hegel's later lectures more so than Hotho captures it in his edition, and it figures more positively. For example, we read in one of the lecture transcripts that art must sometimes portray "what is not beautiful [Unschönes], for sin and crime and evil must be portrayed" (*Vorlesungen über die Philosophie* 189; *Lectures on Philosophy* 340, translation modified). In another transcript, Hegel turns from classical art, which he calls "perfected art," to romantic art, in which subjectivity plays a greater role. He notes there the presence of ugliness: "In this diremption, evil, the opposite of the natural, enters; it is bound up with the nonbeautiful and advances to ugliness" (*Vorlesungen zur Ästhetik* 101).

Still, the overarching case for Hegel's view of ugliness as an end in itself is less convincing. Annemarie Gethmann-Siefert elevates Schiller as Hegel's ideal. Though the ugly is present in Schiller's dramas, it is not easy to see it as one of Schiller's dominant categories, neither in the dramas themselves nor in his theoretical essays on drama. In these essays, Schiller elevates suffering that passes over into greatness and nobility, not suffering that festers by itself: "The portrayal of suffering—as mere suffering—is never the end of art, but as a means to this end it is of the utmost importance to art. The ultimate purpose of art is to portray what transcends the realm of the senses" (*Werke* 8:423; *Essays* 45, translation modified). Schiller describes tragedy as involving two moments and underscores that we cannot overlook either one: "Depicting

the suffering nature is the first law of the art of tragedy. Portraying moral resistance to suffering is the second law" (8.426; Eng. 48, translation modified). Tragedy is the expression of a moral will despite already annihilating circumstances. Queen Elisabeth in Schiller's tragedy *Don Carlos* captures this resistance to suffering, which Schiller calls the sublime: "How great is our virtue, / If our hearts break in the practice of it!" (1.5.632–33).

Schiller certainly gives us ruthless characters—from the scheming Franz Moor in his first drama, *The Robbers*, to the brutal Vogts Gessler in his final completed play, *Wilhelm Tell*, but he tends to offer mirroring figures of at least relative goodness and to gesture toward moments of reconciliation. At the end of *The Robbers*, for example, Karl Moor gives himself over to the courts, and in *Wilhelm Tell* the hero defeats the tyrannical Gessler. Though *Don Carlos* ends brutally, we see elements of noble self-sacrifice from Elisabeth, Posa, and Don Carlos. Even the brutal Phillip II longs for friendship. In Schiller, moral ugliness is present, even vibrant, but also exhibited within a wider horizon. Arguably, Schiller's darkest tragedy is *Wallenstein*, to which Hegel vehemently objected, for it lacked any hint of reconciliation. In his unpublished essay "On Wallenstein," Hegel writes: "When the play ends, it's all over, the kingdom of nothingness, of death is victorious; it does not end as a theodicy. . . . Life against life; but only death rises up against life, and incredible! horrific! death triumphs over life! That is not tragic but appalling!" (*Werke* 1:618–20). As a final note in the context of Hegel's evaluation of German *Klassik*, it is not unimportant that even in the transcripts, as Gethmann-Siefert concedes, Hegel praises Goethe's *Iphigenia*, a work that is richly conciliatory (*Einführung* 321).

Nor is it easy to read Hegel as completely avoiding an aesthetic evaluation of modern art and being solely interested in cultural history, as Gethmann-Siefert contends (e.g., *Einführung* 299). Hegel's praise of *Iphigenia* and many other works makes this clear. Francesca Iannelli, a student of Gethemann-Siefert, argues via the example of the crucified Christ that Hegel recognizes the value of ugliness ("Hegel und die Hegelianer"). Yet even in the Hotho edition, Hegel acknowledges that beauty is not the proper category for the crucified Christ: "Christ scourged, with the crown of thorns, carrying his cross to the place of execution, nailed to the cross, passing away in the agony of a torturing and slow death—this cannot be portrayed in the forms of Greek

Conceptual Framework

beauty" (*Werke* 14:153; A 538). Hegel, then, integrates, even in the Hotho edition, the value of artistic negativity. And in one of the lecture transcripts, which supposedly elevate ugliness, for they give us a more authentic Hegel, we read, for example, that, though Christ on the cross cannot represent a classical ideal, "ugliness may not be admixed with this figure" (*Vorlesungen über die Philosophie* 186; *Lectures on Philosophy* 337, my translation). In another transcript, this one from the last set of lectures, where Iannelli argues that Hegel has moved on to a clearer embrace of ugliness as such, we read: "Christ on the cross does not embody the concept of ideal classical beauty, but the profound inwardness of the transfiguration of spirit is expressed therein" (*Vorlesungen zur Ästhetik* 116). Hegel adds later in this final set of lectures that even in paintings of Christ, when he is mocked and isolated, or in depictions of his supporters, who are on the brink of despair, fearing that salvation may be a subjective illusion, there is "anguish, in which at the same time the objective, reconciliation, is certain" (*Vorlesungen zur Ästhetik* 169). In the passage (from one of the unpublished manuscripts) that Iannelli cites to underscore Hegel's emphasis on the ugliness of Christ, the expression Hegel uses is not simply "ugly" but "häßlich-verklärt" (ugly-glorified), that is, a coincidence of opposites that hints at transfiguration (Iannelli, *Das Siegel* 151). Never in the Christian narrative is there mere ugliness, but there is always also ambiguity, and thus beauty. In a transcript of the 1826 lecture, Hegel notes that with Christ "the unbeautiful" enters art, but Hegel then moves on, elevating the pietà for its "reconciliation" (*Philosophie der Kunst* 160). And, of course, not only in his lectures on aesthetics but also in his lectures on the philosophy of religion, Hegel underscores that the negativity of the cross is part of a fuller Christian narrative, which does not end with ugliness; Iannelli does not mention this larger horizon. When Hegel notes the need for art's portrayal of sin and crime and evil, the larger context for Hegel is that the human being conquers "sin and wrongdoing" (*Vorlesungen über die Philosophie* 189; *Lectures on Philosophy* 339). That is, the ugly is present, but only as a moment in a larger dialectical process. Hegel elevates the portrayal of Maria Magdalena, for she combines negativity and reconciliation (*Vorlesungen über die Philosophie* 189; *Lectures on Philosophy* 340). In short, Hegel seems to have stressed ugliness more than did his conservative student Hotho, but even in the student transcripts, Hegel does not make the case that the ugly is valuable simply as an end in itself. On the contrary,

Also independently of religion, Hegel shies away from pure ugliness. Quoting Schiller, Hegel speaks of art as involving "Heiterkeit," (serenity, or, more literally, brightness), which Hegel paraphrases as "sovereign composure" even in difficult circumstances: "Serenity is smiling in tears, a reconciliation with oneself in anguish in spite of the unreconciled nature of existence" (*Vorlesungen zur Ästhetik* 42). Following Schiller, Hegel notes that when tragic heroes are forced into impossible situations, they retain their freedom and composure. In modernity, negativity and suffering increase, but, according to Hegel, heroes, even when internally torn, even when sacrificing their lives, do not lose themselves: "In this pain, however, one should hold oneself together and remain free in total dependence. A person who lacks self-possession is repellent and ridiculous" (*Vorlesungen zur Ästhetik* 42).

The paradox of Hegel and ugliness is that there is no question that Hegel is not the person to whom we should turn for a detailed discussion of ugliness, but there is equally no question that we can find in Hegel, as did his followers, extraordinarily productive categories for understanding ugliness. Ultimately, for Hegel the greatest art integrates the beautiful and the ugly and is not simply one or the other. For Hegel every position calls forth a counterposition that calls into question the initial position. Out of their interaction develops ideally a more stable and coherent synthetic category. The ugly is essential as a reaction to the beautiful. For Hegel, only art that unites the two, as with the conflict in *Antigone*, is truly great. How that evolves in particular is more fully represented by the Hegelians than by Hegel himself.

The Early Hegelians

The greatest sequence of thinkers in the history of aesthetics to reflect on ugliness were the Hegelians and those associated with the Hegelians: Christian Weiße, Arnold Ruge, Johann Georg Martin (G. M.) Dursch, August Wilhelm Bohtz, Friedrich Theodor Vischer, Kuno Fischer, Karl Rosenkranz, Max Schasler, and Moriz Philipp Carrière. With the exception of Rosenkranz, whose work was recently translated into English, these figures have for the most part been forgotten; only a half dozen or so studies have been devoted to the most important figures, and almost nothing exists in English. Yet these thinkers are worthy of our attention.[1] The early Hegelians emphasized what

seemed left out of the idealist synthesis: thus the post-Hegelian turn to ugliness and complete embrace of ugliness as a dimension of art. According to Rosenkranz, the ugly is necessary if art is not to be restricted or one-sided (*Aesthetics of Ugliness* Ger. 39; Eng. 48). As was the case with Hegel, the Hegelians Vischer, Rosenkranz, and Schasler find collision and contradiction important not only as logical and ontological categories but also as specifically aesthetic categories; working through contradictions is a privileged avenue in art. The Hegelians simply take the point further. Despite the Hegelian turn to finitude, what invariably remained was an implicit normative moment. The Hegelian analyses of art were not simply descriptive but sought to comprehend what made an artwork truthful or formally successful. Their interest was as much in the normative as in the descriptive. They were also of course riveted by the dialectic. Indeed, the most prominent move across thinkers involves viewing ugliness as what should not be (or, more precisely, should not be except as a moment) and must therefore be negated. Thus their elevation of the comic, which mocks what is untenable, thereby moving beyond it, and their emphasis on the structure of a negation of a negation.

The first Hegelian to address ugliness was Christian Hermann Weiße, whose *System der Ästhetik als Wissenschaft des Schönen* (*System of Aesthetics as the Science of the Beautiful*) appeared in 1830, a year before Hegel's death, and well before the posthumous publication of Hegel's aesthetics. In his preface, Weiße, who in 1823 had heard Hegel lecture in Berlin, makes clear that he belongs to the Hegel school (x–xviii). Weiße elevates above all the Hegelian method, but he adds that he does not agree with all that has been published in the name of the school. In his diverse writings, Weiße took issue not only with other members of the school but also with much of Hegel.[2] At the time of publication, Weiße was an *außerordentlicher Professor* in Leipzig, having done his first *Habilitation* there in 1823 (he later did a second *Habilitation* in theology) and having taught aesthetics, Hegel, or related subjects more than a dozen times before the work appeared.[3]

Weiße is important for three reasons. To begin with, Weiße was the first person in the history of aesthetics to address the ugly in a sustained and systematic way. He devotes a substantial section of his *System der Ästhetik* to ugliness (1:173–207) and then returns to the topic throughout his study. As had Schlegel, he consciously demands that art and aesthetics deal with ugliness. Weiße insists on "watchful immersion

in the contradiction itself" and praises works that integrate and overcome ugliness (1:176). He writes: "If an art form is able to represent ugliness objectively without being contaminated by a poison and succeeds in glorifying beauty by thus triumphing over the archenemy of all beauty, this should be considered a merit and not at all a deficiency or degradation" (2:217–18). Above all, Weiße goes beyond Lessing in seeking fully to elaborate the essential attributes of ugliness and its role in aesthetics.

Second, Weiße introduces much of the basic vocabulary that the early Hegelians will develop and refine: above all conceptualizing ugliness in the context of the sublime and the comic and introducing the important structure of ugliness as a moment within a larger dialectical process of beauty, which became in some ways the signature post-Hegelian move, even if Lessing had loosely anticipated the process. The moment of ugliness is "fleeting and vanishing" (*System der Ästhetik* 1:198). In its finitude, the beautiful deals with contrast and contradiction. In this context Weiße recognizes three relevant categories, the sublime, the ugly, and the comic (1:137). Whereas the sublime lifts us beyond the beautiful to the concepts of the good and the divine, resulting in the mediation of the infinite and the finite, the ugly involves a recalcitrant fixation on the finite alone (1:163–64). For Weiße the ugly is beauty in reverse, "inverted beauty or beauty placed on its head" (1:179; cf. 1:144 and 1:157). Articulating a perspective that amounts to a dialectical negation of negativity, Weiße argues that the concept of the ugly belongs to art, but "only in the dialectical unfolding of the idea of beauty" (1:203). Art portrays the ugly in such a way as to show that the ugly is at a higher level invalid; this process is accomplished above all in comedy (1:207–14). Although the proximity of the comic and the ugly finds its first formulation in Aristotle, the structure of the comic as the negation of a negation, a rendering of the ugly as ugly, which indirectly affirms the positive, is a Hegelian innovation. Weiße speaks of comedy as "*superseded ugliness* [*die aufgehobene Häßlichkeit*], or . . . the *reconstitution of beauty out of its absolute negativity, which is the ugly*" (1:210). These two insights—that the ugly is a negation that is itself negated and that this negation occurs primarily via the comic—continue through the early Hegelians.

Third, although Weiße is conscious of traditional reflection on ugliness as privation, he is also familiar with Schelling's theory of evil as more than a privation, which Schelling developed in his 1809 essay

on freedom and which we shall explore in chapter 8. In his *System der Ästhetik* Weiße follows Schelling and draws the parallel that the ugly, too, is more than a privation. Weiße attacks "the widespread misconception that everything that is negative is merely a flaw in something that is positive" (1:174). Later Weiße makes clear that the concept of the ugly he is developing "corresponds to the definition of *evil* that has been repeatedly put forward in contemporary philosophy. According to this definition, evil is not simply the non-good, but rather seceded goodness, goodness that has been perverted and turned on its head" (1:179; cf. 2:415). The reference to Schelling is unambiguous. Developing his points further, Weiße argues that ugliness can be understood as the destruction of truth and a "double lie": first, that no higher truths exist, and, second, that the particular replaces the true and enduring (1:182). Weiße's description of the ugly is remarkably prescient in terms of later views that will embrace the ugly instead of the beautiful and in this process go so far as to erase the concept of truth and elevate the particular as the only carrier of meaning.

Arnold Ruge, the next Hegelian to analyze the ugly, does so in his book on comedy, *Neue Vorschule der Ästhetik*, which appeared in 1837. Besides his philosophical work, Ruge was active as a political writer, often under a pseudonym, and a literary writer, trying his hand at prose, poetry, and drama, and he did work as a translator. A political liberal, Ruge served prison time for his views and was well acquainted with both Feuerbach and Marx, with whom he collaborated. In 1849, he immigrated to England. A prominent Left Hegelian, Ruge refers explicitly to Weiße, praising him for recognizing the importance of ugliness, "this rich and aesthetically infinitely important concept" (88). Less of an innovation and more of a development is that Ruge articulates more clearly and fully than Weiße the dialectical structure of the ugly or the idea of the negation of a negation. Ruge calls the ugly "the *first negation*" and "the finite contradiction" (92). Like Weiße, he reflects on the desire of the finite to assert its own particular validity. It negates the true without negating itself, thus holding on to contradiction and stagnating in negativity (93 and 96): "The finite spirit itself suffers this defeat by not ascending, but instead by wanting in its finiteness to be sufficient unto itself" (91). It is in the nature of the ugly to lack consciousness of its own insufficiency (98). Intriguing is Ruge's insistence that the ugly is more prominently visible and dramatic in the spiritual than the material realm, where one encounters

not simply the ugly but the ugly in its unshakeable fixation on finitude. The ugly stubbornly seeks to replace the beautiful and insert itself in its stead. Stressing the refusal of ugliness to be moved by truth, Ruge defines the ugly further as "the appearance of the false spirit that opposes spirit's truth" (110). The ugly requires a further negation in order to participate in truth; this results in what Ruge calls "the negation of the negation or the absolute contradiction" (92). To recognize the ugly as ugly is to transform it. Ruge agrees with, and reformulates, Weiße to the effect that "ugliness is the first negation, the comic the second negation" (60). For Ruge comedy is not just the negation of tragedy but the negation of the negation of tragedy; it is not just a portrayal of finitude but the negation of a position that seeks to render finitude what it is not, absolute. We see the ugly as less than ideal and laugh at it. The negation (of the beautiful) is itself negated. Thus, even caricature has the seeds of the ideal within it, but it does not explicitly reveal the ideal.

Unlike Ruge, Friedrich Theodor Vischer, who taught in Tübingen and Zürich and later became well known also as a novelist and satirist, analyzes ugliness not only in its relation to comedy. Vischer sees the ugly also in the context of the sublime and indeed investigates the role of ugliness within aesthetics as a whole. In the first volume of his aesthetics, *Ästhetik oder Wissenschaft des Schönen*, which he published in 1846, with the sixth and final volume appearing in 1857, Vischer explicates the beautiful in the spirit of Hegel. Vischer, who carefully read Hegel after he had concluded his studies, is the first and only early Hegelian to develop a truly comprehensive analysis of aesthetics, looking at all of its features. Still, Vischer, who studied with Hotho, does not elevate ugliness to any significant degree, a position he regrets at the end of his life after having read Schasler on ugliness (*Kritische Gänge* 6:115–16; cf. 6:106 and 6:112). However, Vischer does contribute an original analysis of the ugly and the sublime. We recognize ugliness, for example, when power extends beyond appropriate measure and evokes in the sublime "dread and horror" (*Ästhetik* 1:262). A singular passion that becomes excessive is likewise ugly: "As soon as it becomes total and habitual, it passes over into ugliness" (*Ästhetik* 1:274). Vischer cites bitter and obsessive hatred that exceeds the bounds of defending the good and leads instead to self-destruction (*Ästhetik* 1:274–75). Pure evil, not privation, but willful inversion of the good, is ugly. Such moral evil can appear in a disfigured person,

such as Richard III (*Ästhetik* 1:277), or, more deceptively, in the most beautiful of persons.

Contemporaries called Vischer "V-Vischer" to distinguish him from the Heidelberg philosopher Kuno Fischer, who likewise had a lengthy career in aesthetics. Fischer studied with J. E. Erdmann, a Hegelian, in Halle and published a book on Hegel's life and works late in his life and also wrote a highly influential study of Kant earlier. In Heidelberg, Fischer garnered a reputation as one of the best teachers of his age. Fischer explores ugliness in his first work, *Diotima: Die Idee des Schönen* (*Diotima: The Idea of the Beautiful*) (1849), which is infused with the idealism of Hegel along with a romantic spirit that elevates both religion and art. As with almost all of his early Hegelian predecessors, for Fischer comedy resolves contradictions, overcomes ugliness, and so reintroduces beauty; the comic brings forward "a dissolution of the ugly" (262–63).

The ugly is not simply a mistaken truth or a mistaken good; ugliness surfaces only with the persistently negative: "Error becomes ugly only when it dominates cognition, deliberately holds firm, and so as *prejudice* or *superstition* emphatically denies truth" (Fisher 252). Fischer stresses this element of obstinacy, which involves a failure to recognize the gap between what is and what should be along with an unwillingness to resolve it. Ugliness thus erases from the self moral striving: "Thus *flaccid*, *weary* selfishness would be the form in which immoral spirit in its final phase also accomplishes its final aesthetic role—that of ugliness" (256–57). This sense of resistance and false fixation on finitude as a final moment is a recurring theme in German reflection on ugliness, which Fischer expresses as well as any other thinker.

In 1850, Karl Rosenkranz corresponded with Fischer about *Diotima*; in return Rosenkranz sent Fischer an outline of his developing concept of aesthetics, with its three main sections: the beautiful in itself, the ugly, and the comic (Glockner 108–10). Three years later, Rosenkranz published an entire book on the ugly, *Die Ästhetik des Häßlichen* (*Aesthetics of Ugliness*). When Rosenkranz studied in Berlin, he was taken by Schleiermacher and not the least impressed when he dropped in on Hegel's lectures (*Von Magdeburg* 187). In Heidelberg, Rosenkranz had already encountered Hegel's *Encyclopaedia*, which he found difficult. But eventually Rosenkranz became an enthusiastic reader of Hegel, partly under the influence of Hermann Friedrich Wilhelm Hinrichs, Hegel's former student and a professor in Halle,

where Rosenkranz continued his studies after his sojourns in Heidelberg and Berlin. The idea of studying at several universities was common at the time and was connected to the German concept of *Lernfreiheit*, a kind of academic freedom for students, which encouraged independent learning and residencies at multiple universities. When Rosenkranz finally immersed himself in Hegel, primarily through his earliest book, *The Phenomenology of Spirit*, Rosenkranz described the experience as "a revolution" in his education and a kind of "intellectual ecstasy" (*Von Magdeburg* 290). Rosenkranz went on to write the only contemporary biography of Hegel.

Scholars unfamiliar with the details of the post-Hegelian period tend to identify Rosenkranz as the thinker who initiated systematic reflection on the ugly (e.g., Gigante 584; Schaeffer 328; Bachmetjevas 30; Hammermeister 108). We have seen that this is false. Nonetheless, it is true that Rosenkranz is the author of the one and only attempt in the history of aesthetics to give a truly comprehensive and detailed account of ugliness. A sign of contemporary interest in the ugly and the standing of Rosenkranz is that his study has been reprinted in German at least eight times with four publishers since the late 1960s,[4] and translations have appeared in Romanian (1984), Spanish (1992), French (2004), and Italian (2004).

Rosenkranz offers a comprehensive set of terms to describe various forms of ugliness. Rosenkranz's three main concepts are *formlessness*, *incorrectness*, and *deformity* (*Verbildung*). The stress on the comic is so pronounced that the final and third category under deformity is "caricature," that is, a release from deformity through exaggeration and disproportion. Caricature is for Rosenkranz "the peak in the conception of ugliness" and offers the transition to the comic (*Aesthetics of Ugliness* Ger. 387; Eng. 233) and the ridiculous (Ger. 427; Eng. 256). According to Rosenkranz, caricature is essentially identical in its structure with satire (Ger. 394; Eng. 236), though he favors caricature that does not overly dwell on ugliness but cheerfully and serenely moves beyond it (Ger. 412; Eng. 247). In this, he follows Hegel, who writes that only after reading Aristophanes can we truly know "how a person can be as happy as a pig in muck" (wie dem Menschen sauwohl sein kann) (*Werke* 15:553; A 1221, my translation). Rosenkranz prizes that form of caricature, "the fantastic" (Ger. 424; Eng. 255), that is deeply imaginative and creative and with its unbridled exaggeration leaves the realm of reality behind.

As much as Rosenkranz insists on the importance of ugliness, he also emphasizes that the ugly must be temporary and subordinate, "a vanishing moment" (*Aesthetics of Ugliness* Ger. 40; Eng. 49). To render it full and independent would be contrary to its concept (Ger. 41; Eng. 49). Thus, it is important that the ugly be presented not in its simple being, but in a state of becoming or transformation (Ger. 168; Eng. 117). It belongs to the nature of the ugly to negate itself, and so its subordination is the result not of some external machination on the artist's part. Instead, the artist lets its internal contradictions emerge, lets the ugly reveal itself as ugly (Ger. 43; Eng. 50). An isolated depiction of ugliness would give it too much independence; ugliness cannot be an end in itself (Ger. 49; Eng. 53). But its negation returns us to the beautiful, to what Rosenkranz calls "beautiful ugliness" (das schöne Häßliche) (Ger. 301; Eng. 185).

Prominent for Rosenkranz, as for his predecessors, is the figure of double negation, which he associates above all with the comic: "The comic is the *dissolution* of the ugly insofar as it *destroys itself*" (*System*, para. 831). Comedy is built on the structure of portraying what is inadequate, untenable, deviant, and then showing its inner contradiction and self-cancellation, the self-destruction of what is untenable. Any contradiction becomes tolerable when it is viewed through a comic lens or comic turn of events (*Aesthetics of Ugliness* Ger. 136; Eng. 99). The comic is not the negation of substance but the negation of the negation of substance or the negation of ugliness as the reduction of truth. In comedy, we laugh at contradictory positions; we don't take them as the final truth. Thus, for Rosenkranz the ugly is invited into art but only insofar as it is transformed or overcome. Satire has always portrayed the ugliness of reality, but it does so in such a way as to reveal it for what it is, something negative, a reality to be overcome. The comic presents obscenities and other inadequate positions in their absurdity and as such negates them. The aesthetic rendering of obscenities indirectly serves a moral purpose: "This whole sphere of sexual vulgarity" is "aesthetically freed through the comic" (Ger. 246; Eng. 155, my translation). This is the case, one could say in support of Rosenkranz, with Aristophanes and Ben Jonson, who are masters of the reductio ad absurdum.

A prominent student of Rosenkranz was Max Schasler, who had a Hegelian as a teacher already at his Gymnasium in Bromberg, Heinrich Theodor Rötscher, the author of a superb book on Aristophanes

that Rötscher dedicated to Hegel. On Rötscher's recommendation, Schasler then continued his studies with Rosenkranz in Königsberg. Schasler participated in the revolts of 1848 and was subsequently exiled from Prussia. Eventually as longtime editor of the *Dioskuren*, he became one of Germany's most influential art critics. Schasler addresses the ugly in his two-volume *Kritische Geschichte der Ästhetik* (*Critical History of Aesthetics*) of 1872, which he dedicated to Rosenkranz and which had considerable influence, and his less well-received two-volume *Ästhetik* of 1886. Surprisingly, he is left out of even some detailed histories of the German aesthetics of ugliness, for example, the monograph by Werner Jung.

Schasler's distinction, which he develops already in his history of aesthetics, involves expanding the concept of ugliness so as to call it "the negative moment" in art (*Kritische Geschichte* 2:1036). Schasler notes that beauty is not absolute if it is only positive and one-sided; it requires ugliness, that is, negativity, which is itself negated as the beautiful emerges (*Kritische Geschichte* 2:791–92, 2:961, 2:1024, 2:1036–37). The ugly is thus broader in his eyes than in those of his predecessors. According to Schasler, negativity gives shape and richness to what would otherwise be mere abstraction. Negativity ensures that the Platonic ideal in its abstraction comes into appearance and is realized. Already in the first chapter of his *Ästhetik*, ugliness is front and center as a necessary element of beauty. Beauty must be grasped dialectically. Just as we understand truth by thinking through and refuting erroneous positions, so does beauty emerge through its engagement with ugliness (*Ästhetik* 1:19). Ugliness is reality in its distance from the idea, yet the idea cannot become real without this element of distance or differentiation (1:21). One sees here, although Schasler does not mention it, another way in which the post-Hegelian discussion of ugliness is compatible with Hegel's aesthetics. What Schasler analyzes as a comprehensive element of art is analogous to Hegel's articulation of the origin of tragedy. In order to manifest itself in the world, the absolute or divine must take on definite shape and particularity, which engenders a necessary rift in the absolute. In this world, the absolute is no longer one; collision and tragedy are inevitable (Hegel, *Werke* 15:522; A 1195).

Hegel's theory of drama includes not only his heralded analysis of tragedy, but also an underappreciated account of comedy and an original analysis of a third genre, the drama of reconciliation, a form of

drama in which a substantial conflict ends harmoniously. Most Hegelians dwell on the sublime and especially the comic as modes of wrestling with, and overcoming, ugliness. Moriz Philipp Carrière, a Christian philosopher, is unusual in returning to the drama of reconciliation. His *Aesthetik*, which was first published in the early 1850s and appeared in its third edition in 1885, includes a section on the ugly, tellingly entitled "The Ugly and Its Overcoming" ("Das Häßliche und seine Ueberwindung") (1:147–68). Carrière argues that ugliness very much belongs in works that seek to portray the world's richness, but the ugly must be tempered. He defines ugliness quite broadly as "the conscious break with the ideal" (1:153). Carrière insists that some level of poetic justice be preserved and that the ugly not be elevated as the ugly but instead be overcome. If art is the sensuous portrayal of the idea, it must at some level embody not only truth but also goodness. If moral ugliness is affirmed, the work has negative aesthetic value. Like the still earlier Hegelians, Carrière argues that "the ugly . . . cancels itself" (das Häßliche . . . hebt sich selber auf) (1:159). Much like Plato, Carrière speaks of the ugly as "something that should not be [ein Nichtseinsollendes] but which nonetheless pushes its way into existence" (1:159). Were it to become stable and not be dissolved, it would cast beauty from its just throne. Dante and Shakespeare are among his primary examples of authors who meaningfully integrate ugliness. In their works, beauty is seen not as given but as becoming: "Thus we obtain the appearance of nascent beauty as something which is not completed in immediate harmony, but instead comes into being only through the resolution of dissonances" (1:168). In the drama of reconciliation, Carrière recognizes a genre in which ugliness and dissonance are prominent, but eventually overcome or resolved, as in Aeschylus's *Oresteia* or Sophocles's *Oedipus at Colonus* (*Das Wesen* 291–304, and *Aesthetik* 2:611–16).

In elevating the significance of ugliness, the Hegelians, indeed the broader German tradition, underscore the interwoven nature of beauty and ugliness. The static Aristotelian insight that had been dominant— that one can create a beautiful depiction of an ugly object—gives way to a focus on two more complex processes. First, we see a dialectical structure, which was already evident in Hegel's analysis of satire and is developed at length by the Hegelians, who draw on comedy and caricature to emphasize that the ugly content of a work cannot be frozen as such but must be negated. Second, we recognize a more expansive

framework, whereby ugliness is presented as part of an unfolding narrative that includes but also moves beyond ugliness. We see this structure in Lessing's elevation of the temporal arts and also in Hegel's introduction of the drama of reconciliation. This particular framework is less common in modern theory and practice, but a strong advocate surfaces in the neo-Kantian Hermann Cohen, whose concept of humor as loving critique is not far removed from this speculative realm (1:289; 1:304).

The Hegelians, perhaps partly influenced by German art, also argue that some topics, such as Christ's crucifixion and human misdeeds, demand aesthetic ugliness. The Hegelians see ugliness not as privation but as a central and constitutive element, be it of art in general or of beauty in particular. After them, there is no serious return to the idea of ugliness as mere privation. And all of them, in various ways and to varying degrees, present ugliness as part of a larger structure: the ugly should not have the final word but must itself be negated. We also see more complex associations between the ugly and other central aesthetic categories. Not only Aristotle's insight into the links between comedy and the ugly is further developed, but also several Hegelians view the ugly in relation to the sublime. Ugliness involves a recalcitrant fixation on the finite alone without any higher connection and so provides us with a contrasting category to the sublime. Ugliness as fixation on the real to the exclusion of the ideal or the transcendent reinforces the role of ugliness in a modern world that has moved beyond the Platonic/Christian ontology.

THE HISTORY
OF BEAUTIFUL
UGLINESS

Just as theoretical interest in ugliness varies over time, so does artistic engagement with ugliness. Most histories of aesthetic ugliness begin with, and focus on, modernity.[1] Modernity is indeed central to the history of ugliness, but a wider compass reveals an intense focus on ugliness also in imperial Rome and in late medieval Christianity, and it makes clear that in multiple eras, such as ancient Greece and the early modern era, ugliness is very much present even if it is not the dominant mode of aesthetic expression.

Prelude

In ancient Greece we encounter ugly, hybrid monsters, as with the Hydra, with its poisonous breath and many heads (if you cut off one head, two new heads grow in its place) and the Gorgons, with their hair of living, venomous snakes (their dreadful visage turns anyone who sees them into stone). Hades, the Greek underworld, was filled

with these and other horrendous creatures, among them Cerberus, a monstrous multiheaded dog (in Hesiod he has fifty heads), who ensured that the dead could not escape. Hesiod also introduces Typhon, from whose shoulders grew a hundred snake heads and in each head voices that uttered every kind of unspeakable sound: "Cacophony, indescribable, and all in unison!" (*Theogony* 830). We read further of his lover, the cave-dwelling and slithering monster Echidna, half-woman and half-snake, who gave birth to Cerberus, Hydra, and others, including Chimaera, a monstrous combination of several animals—lion, goat, and serpent. Hesiod also tells of Kottos, Briareos, and Gyges, huge, misshapen monsters, each with a hundred arms and fifty heads. Homer gives us Polyphemus, the savage one-eyed giant who devours human beings, and Scylla, the sea monster with six doglike heads and twelve legs, who lies in wait opposite the whirlpool Charybdis. Other mixed beings, such as the centaurs and satyrs, also belong on this list of ugly mythological figures from ancient Greece.

Moving from monsters to humans, we can consider Thersites, the ugliest man in Homer; Thersites is disfigured, vulgar, and abusive, hated by both Achilles and Odysseus (*Iliad* 2.212–19). Achilles's rage-filled defilement of Hector's body exemplifies a combination of emotional and moral ugliness. The tale of the Cyclops vomiting up human flesh evokes physical and moral ugliness. The suitors who occupy Odysseus's home and abuse the revered Greek concept of hospitality are morally repugnant. In tragedy, ugliness is evident in the Furies' torment of Orestes, the dismemberment of Pentheus, the blood from Oedipus's eyes, the insanity of Ajax, and the stench from Philoctetes's flesh-eating and oozing wound. The Dionysian and the tragic are at the opposite end of the serene beauty that has often been associated with ancient Greece. The Greeks also elevated ugliness in the grotesque satyr plays that followed tragic trilogies. Arguably the most energetic forces of ugliness in Greek antiquity arise in the earthy comedy of Aristophanes: his ribald jokes shock many a young student expecting to find only high art among the classics of ancient Greece.

In addition to literary representations of ugliness are the historical figures who broke down the boundaries between life and art. Besides the ugly Socrates (more on him later), we have the example of his follower Diogenes of Sinope, "The Dog," the founder of Cynicism, who received his name because he lived like a dog, happy and content, always outdoors, barefooted, drinking only water without even a cup,

begging, with no needs beyond the most basic. Scorning propriety and personal hygiene, Diogenes prided himself on his shamelessness as well as his frank speech and breaking of social taboos. Self-sufficiency was central to his philosophy, so he reduced material needs and scorned illusory goods. He was known to defecate and masturbate in public (Diogenes Laertius 6.46; 6.69). In a legendary story, Alexander the Great stood over him when Diogenes was lying in the sun in Craneion, near Corinth, and asked him what favor he might grant him in the light of his great power. Diogenes responded, "Stand a little out of my sun" (Plutarch, *Life of Alexander*, in *Plutarch's Lives* 14.3).

The ugly plays a prominent role in archaic Greece, in Hesiod and Homer. It is likewise present in the tragedies and Old Comedy of the classical period. In the Hellenistic era, with its turn to realism, ugliness again becomes conspicuous. The turn to realism invariably brings forth a greater integration of ugliness. In Hellenistic sculpture we find abundant portrayals of dwarfs and hunchbacks, exaggerated penises, and other deformities that were presented as material for ridicule, derision, and merriment (Garland).[2] Deformities and exaggerated phalloi were apotropaic, designed to avert the evil eye, including through their embodiment of ugliness or the dispelling effects of laughter (Fowler 66). Laughter arises from incongruities, such as a dwarf with an oversized penis that reaches to the ground, as in the late Hellenistic or early imperial *Dwarf Boxing* located at Boston's Museum of Fine Arts. Such images also create ambivalence, as in the combination of rejection and mockery, on the one hand, and curiosity and strength, on the other. This is likewise the case with the bronze-seated hunchback holding his large phallus, which we find in the Museum für Kunst und Gewerbe in Hamburg.

The tradition of mocking the deformed is evident already in portrayals of the Greek gods. Among them, the lame Hephaestus is the butt of jokes (*Iliad* 1.599–600). The negative associations of deformity continue into the Roman age and are intensified there: the Latin *monstrum* is linked etymologically to *monere* ("to warn"). In ancient Rome, births of deformed babies were interpreted as negative omens, and deformed slaves were used for entertainment.[3] Not surprisingly, the ancient Greek scapegoat (*pharmakos*), expelled from the community in order to bring about purification, was always ugly, even the "ugliest of everyone" (Scholia on Aristophanes, *Plutus* 454; David Dawson, translation at 137).

Overlooking such instances of ugliness, Johann Winckelmann sought with the expression "noble simplicity and serene grandeur" to capture and elevate the defining characteristic of Greek art (20). That phrase was too one-sided, as Hölderlin and Nietzsche, in their ruminations on ancient Greece, make clear.[4] The short set of examples above reinforces the more complex understanding of Greek antiquity that these contrarian thinkers advance. Although the Greeks knew the ugly well and wrestled with it, as have, at least to some extent, all ages, to make the argument that the ugly dominated their culture would be difficult. The Greeks portrayed ugliness, but they also understood and created radiant beauty, becoming renowned for their refined and handsome creations. Indeed, the concept of classical beauty is deeply interwoven with ancient Greek artworks. One thinks of distinctively beautiful divine and human figures in metal and stone, especially bronze and marble, cylindrical columns, symmetrical composition, ornamentation, and the use of beautiful proportions, such as the golden ratio (*sectio aurea*) of the Parthenon. Ugliness is present but subordinate in the works of Plato, who articulated the concept of the organic and whose dialogues compete with Homer's epics and Sophocles's tragedies as being among antiquity's greatest literary works. The ugliness we see in Greek culture tends to involve moments within a wider and arguably more positive whole. And so even as ancient Greece reminds us that most cultures do integrate ugliness, Greece can hardly be seen as a dominant age in an overarching history of ugliness. The ugly was present in ancient Greece but readily balanced by beauty and harmony.

The History of Beautiful Ugliness

IMPERIAL ROME

In the Roman era, ugliness comes still further to the fore. Indeed, ugliness is a defining feature of the imperial age, especially the first two centuries AD, culminating in the new genre of satire. Not all of Latin literature fits this model. When gruesome elements surface in Virgil, they tend to be restrained. They serve the work's overarching purpose. The battle scenes of the *Aeneid* are scarcely visible to us and certainly not in gory detail. Virgil after all is a writer whose vision of history is idealistic and positive, who worked in imitation of the ancient Greeks, and whose concept of art is deeply organic. Imperial Roman literature partly reacts against the Virgilian model, and this turn against the beautiful becomes a signature element of the era.

The emergence and prominence of the ugly during the imperial age is evident in five partly overlapping respects. First, shifts in literary strategies led to changes in the way in which the ugly surfaced, a point made by Manfred Fuhrmann in his essay "Die Funktion grausiger und ekelhafter Motive in der lateinischen Dichtung."[1] The shifts in literary aspirations emerged partly from a tendency to detach individual passages from their meaningful integration within the work as a whole. The presentation of isolated moments in gruesome detail and in ways that do not render them simply a necessary moment of a greater whole is evident already in Ovid. Consider, for example, the two great battles in Ovid, first, of Perseus with Phineas and his followers in *Metamorphoses*, book 5 (5.1–235) and, even more so, the battle of the Lapiths

and Centaurs in book 12 (12.210–535). One cannot easily make the case that lingering on such details—spears stuck in skulls, gore splattered onto tables, smashed faces, shattered heads, bits of brains being vomited or coming out the nose and the ears, eyes gouged out by antlers, swords being run through testicles, people falling on their own blood—is a necessary part of the whole; instead, we see fascination with the material in and of itself. One could argue against Fuhrmann that insofar as the Perseus story parodies Odysseus's wiping out Penelope's suitors, we need an overabundance of gory detail, but in Homer all of the details are subordinate to a larger frame that seems absent in Ovid. We see instead a reveling in gruesome detail for its own sake, playful fascination with the material mixed in with horror.

What Ovid modestly inaugurates—in terms of portraying gruesome details—is intensified in Seneca and layered with a second catalyst for integrating ugliness. Fuhrmann makes the case that Seneca's overwrought portrayals of gruesome vices have philosophical origins, that is, they derive from Seneca's elevation of Stoicism and his presentation of images and events that are opposed to the Stoic ideal. When in his dramas Seneca makes the case for Stoicism, he presents, via contrast, tragic figures in intense states of confusion and affect, rage and agony, that far surpass what we see in the Greek originals on which he draws. In *Thyestes*, hate is presented in extremis, and the consequences of this hate are evident in gory detail, including the hacking of bodies from limb to limb. From such a world, the gods have fled ("fugientes deos"; *Thyestes* 893; cf. 1021; and *Medea* 1027). Even Euripides, the most dramatic and emotional of the Greek tragedians, is relatively mild in his treatment of the Phaedra theme compared with Seneca, who emphasizes the heroine's moral ugliness, bestial recklessness, madness, and deceit and who vividly describes Hippolytus's vicious death. Throughout his dramas, Seneca puts greater weight on the presentation of misery and affect, on the destruction of human ideals and the human body, on unspeakable abominations ("nefandi monstri"; *Thyestes* 632) than he does on organic plot structures or tragic conflicts of competing goods, which is why his works are almost exclusively dramas of suffering and not tragedies of the highest order (Roche, *Tragedy and Comedy* 91–108). The turn to reality seems partly related to Seneca's desire to contrast Stoic virtue with its absence. In comparison with Sophocles's play, Seneca's *Oedipus* is stunningly graphic. Seneca lingers over the brutal details and through bodily images ex-

hibits the hero's rage: Oedipus wrenches his eyeballs out of their sockets, his fingers grope in the hollow orbits, and blood pours from the vessels (935–79).

The Stoic context also colors Lucan, Seneca's nephew. In the ninth book of his *Civil War*, Lucan confronts readers with horrifying suffering triggered by snake bites. He shows the courage of the Stoic leader Cato, who does not shy away from the intensity of the threat. Cato inspires his soldiers, who despite their intense and even bizarre suffering die without affect. One soldier expires of thirst, and in trying to quench it, drinks his own blood (734–60). Another loses his skin, flesh, and organs (761–88). The body of a third swells massively (789–804). A fascination with gore in and of itself, as in Ovid, seems to be an additional motivating force.

Inadvertent Ugliness and Disgust

A third and still more consequential factor exists. Ugliness emerged as prominent in the wake of a turn to realism, a desire to increase the range of reality depicted. Imperial literature brings in more of reality. In some ways the less idealistic Hellenistic age had already anticipated this development. This broader turn to reality leads to a partly inadvertent focus on ugliness. The impetus to describe more of reality means that less savory aspects come into focus that earlier art tended to slide over. In this way, the realistic impetus leads to a fuller integration of ugliness, even when portraying ugliness is not the artist's primary goal.

As part of the turn to realism, battle scenes are presented in gruesome detail. What we see in Lucan far exceeds what Virgil or others depicted. We see hints of realism already in the Republican period, for example, in the first century BC. In the sixth and final book of *On the Nature of Things*, Lucretius recounts in truly graphic, gruesome, and appalling detail the symptoms and effects of the horrendous pestilence that ravaged Athens during the Peloponnesian War. A few excerpts in inadequate prose translation convey the ugliness that surfaces as a result of Lucretius's fidelity to realism:

> The first symptoms were a burning heat in the head and a reddening of both eyes with a suffused glare. The interior of the throat turned livid and exuded a bloody sweat; the vocal passage became clogged

and choked with ulcers; and the tongue, the mind's interpreter, en-feebled by the disease, heavy to move and rough to touch, oozed out blood. . . . The breath issued from the mouth with a foul stench simi-lar to that given off by carcasses that have been thrown out and left to rot. Then the mind lost all its vigor, and the whole body grew lan-guid, being already on the very threshold of death. . . . Moreover, a convulsive retching, often continuing all day and all night, persist-ently wracked the sinews and limbs, wasting the victims away and making the wary wearier still . . . the internal parts of the body were burning to the bones, and flames were raging within the stomach as within a furnace. . . . Their bodies were parched through and through with an insatiable thirst that made vast drafts of water seem no more than a few drops . . . as life's final hour approached, the nos-trils became constricted, the tip of the nose sharper, the eyes deep-sunk, the temples hollow, the skin cold and hard, the mouth unvary-ingly agape, the forehead constantly tense. (6.1145–95)

Pestilence is grotesque, and Lucretius does not shy away from de-scribing its dreadful effects, offering details of physical ugliness that if visible to the eye would lead us to turn away in horror. In Greek litera-ture there is no counterpart to such brutal and bold descriptions.

The realistic thrust continues in much of Latin literature, even when in the late fourth century it becomes Christian and allegorical. Prudentius's *Psychomachia* is an allegory of the battle between vice and virtue that one might translate as *Battle of the Soul*. Here the dreadful ugliness of the fight is viewed positively. What the virtues do to the vices is described in lurid detail. Faith, for example, chops off the head of its enemy, Worship-of-the-Old-Gods (*Veterum Cultura Deorum*), which tumbles bloodily in the dust. Faith then "tramples the eyes under foot, squeezing them out in death" (32–33). Pruden-tius shows that we must be ugly and act in an ugly manner in order to overcome vices, and thus we cannot simply say that the ugly is bad and will destroy itself. Instead, the virtues completely mutilate the vices. This is modestly surprising, given the Platonic-Christian idea that goodness by itself, as with the Socratic ideal or Christian martyrdom, triumphs over vice, independently of worldly contests and worldly success. But Prudentius operates within a different *Zeitgeist*. In his work, the virtues and vices act contrary to their definitions. Neither Modesty nor Avarice, for example, would otherwise be associated

with killing, and virtues such as Sobriety or Chastity (*Pudicitia*) act not simply beyond their purview but contrary to their definitions (Ernst Schmidt). Sobriety's actions against Lust, for example, are brutal and gruesome, not modest or restrained, and her victory speech is not sober, but bold and triumphant. Still, the battle underscores the active nature of moral ugliness and the pressing need to combat it even if such a battle calls for ugly tactics. As a result, in Prudentius, Wrath and Fury along with Deceit and Greed can hardly be understood, as later theology would have it, as simple privations of the good.

In Latin literature, the inadvertent integration of ugliness as part of a wider effort at realism is combined, fourth, with a more intentional focus on ugliness arising from conscious disgust with the world. As Latin writers began to engage the grotesque nature of reality, in war and beyond, we see a deliberate emphasis on ugliness, which reaches new heights with Lucan's *Civil War*. Among the more striking examples of the gore and dread of the epic are the bloody sea battle of Massilia (3.509–762) and the strewn corpses and uncounted dead at the battle of Pharsalus (7.466–646). In depicting the civil war of 49–48 BC between Julius Caesar and Pompey the Great, leading, with the victory of Caesar, to the demise of the Roman Republic, Lucan offers us some of the most horrific images in all of Latin literature. In his realistic turn, Lucan eschews significant references to the Olympian gods and any attempt at a theodicy. The gods are virtually silent: "In fact, there are no powers over us; blind chance ravages the centuries; we say 'Jove reigns,' we're lying" (sunt nobis nulla profecto / numina: cum caeco rapiantur saecula casu, / mentimur regnare Iouem) (7.445–47).

Lucan is anti-Virgil: he vies with Virgil and tries to invert the Virgilian epic and mindset. Why? Because he hates the outcome of the Roman Empire. He detests the political system under which he is to live and will then be obliged to commit suicide. And therefore he is tired of the magnifying and heroizing account of the civil war. He wants to show its horrors. One way to justify the atrocities of war is by the result, but here the result is Nero, a horrendous outcome after all the suffering. The bold refusal to continue to applaud the beauty of the world signifies moral revolt. Many persons are maimed by the brutality of history, and Lucan makes this his focus.

We see, then, with this turn to reality not only an aesthetic interest in ugliness, not simply an inadvertent emphasis on ugliness as part of the turn to realism, but also a conscious disgust with the world,

which adds an even stronger impetus for the portrayal of ugliness and results in even more brutish images. Senselessness and absurdity define the tone of Lucan's engagement with the war. The anti-Caesar thrust is evident in his portraying the victory of criminality over justice, which is visible already in the epic's first lines: "Of civil wars and worse waged on Emathian fields, of crime made law we sing [iusque datum sceleri canimus]" (1.1–2). The citizens destroyed themselves, and the measure of right was might (mensuraque iuris uis erat) (1.175–76). Lucan experiences conscious disgust with the world that has been brought about by the reckless exploits of Caesar, which reach even into violations of sacred norms (3.399–508), and by the abundance of crime and guilt (nefas) that usurps virtue: "Wicked crimes / will be called virtue" (scelerique nefando / nomen erit virtus) (1.667–68). Lucan revolts against the reversal of Republican virtues and the cause, conduct, and consequences of the cursed "civil crime" (civile nefas) (4.172). Lucan describes the enormous price of a civil war, the horrific consequences and distortion of normality, from fraternal atrocities to famine, thirst, massacre, and unburied dead.

Seeing war as unjust in its origin or outcome, or both, inevitably casts reality in a negative light. This is evident not only in Lucan but also with his contemporary Statius, who in his *Thebaid* portrays the battle of Oedipus's two sons, the fraternal battle of Thebes, in its brutality, grotesqueness, and bleak despair. Statius describes, for example, the ways in which horses and wagons plow down wounded men, mangle corpses, and sever limbs (7.760–68; 10.476–81). The dying Tydeus beheads his enemy and in his "rage" bites and tears flesh—"sluiced with the foul gush of a brain smashed into gobbets, / his jaws evilly stained with living blood"—such that Minerva turns away and flees (8.752; 8.761–62; cf. 8.751–9.7). The brutality in Lucan and Statius is not unrelated to the critique of unjust war. As Antigone states in Statius: "nothing was gained by the war" (nil actum bello) (12.442). The question of who is killed hardly matters; what matters is the striking portrayal of suffering, the arbitrary consequences of a meaningless battle. Disgust with reality is evident in both Lucan and Statius, even if it is arguably more prominent in Lucan. Throughout the period we see suffering that is not tragic, that is, not the inevitable and organic result of a certain kind of greatness; instead, senselessness drives undeserved suffering.

The History of Beautiful Ugliness

Roman Satire

Epic, even if it is enacted differently by the Romans, existed in Greek antiquity, but an entirely new literary genre emerged in imperial Rome: satire. The turn to realism is not by chance connected to satire, whose focus is ordinary reality. Satire not only integrated reality, thus bringing ugliness in its wake; it incorporated indignation with reality, disgust with human foibles. It even included decadence and moral depravity. Although Roman literature is for the most part derivative of its Greek forbears, satire, which has no counterpart in Greece, is an exception.[2] Quintilian himself notes: "Satire at least is entirely our own" (Satura quidem tota nostra est) (*Institutio oratoria* 10.1.93). In Roman satire we recognize a pervasive interest in moral ugliness coupled with its bitter indictment. Ugliness, for the first time, acts as the central focus of a literary genre. Moral ugliness thus reaches a new level of concentration and encompasses a wider range, with truly wayward characters.

Hegel also underscores that satire is a new form introduced by the Romans: "What is particularly Rome's own is only that mode of art which is prosaic in principle . . . above all satire" (*Werke* 14:124; A 515, translation modified). Hegel does not simply recognize the newness of satire. With satire he begins his historical account of the break from classical art. This shift is inaugurated when the artist no longer feels at home in this world, but retreats from it, is repelled by it, and draws inward (14:117–20). In a sense the seeds of this subjectivity begin already with Socrates, who advanced the concept of autonomy, with its critical distance to the world (14:118), but for Hegel, partly influenced by Winckelmann, satire is not at home in ancient Greece as "the land of beauty" (Socrates, after all, was the exception who was condemned to death), but instead fits the Roman world perfectly, whose spirit is dominated by abstraction, with its distance from the world (14:123). Hegel explicates abstraction as the dissolution of tradition, including customs and family, the sacrifice of the individual to the more abstract idea of the state, and the dominance of law—all of which characterize Rome (14:123).

Hegel uses the term "Entzweiung" (diremption) for this process of recognizing that one's inner concept of what should be does not match what is. One can see in Hegel's analysis of the Romans a certain

proximity to Schiller's account of the sentimental mode, which lives in opposition to the world, more specifically, the satiric, which presupposes a gap between what is and what should be (Hegel, *Werke* 14:119; Schiller 8:741).[3] For Hegel, too, satire resides in this realm of opposition and does not move forward to reconciliation (14:120). Thus Hegel sees in the turn toward negativity and disharmony a dissolution of beauty and harmony. In one of the lecture transcriptions, we read: "Satire is now a matter of shattering the unity of the beautiful, and so we have, on the one hand, abstract thinking, abstract willing, virtue, and on the other hand a humdrum actuality devoid of thought" (*Vorlesungen über die Philosophie* 178; *Lectures on the Philosophy* 331). Satirists, conscious of being dedicated to the true and the good, stand in hostile opposition to what they view as a corrupt and godless world (14:122). Whereas earlier literary forms, including epic and tragedy, emerged within a sacred horizon, satire lacks a divine frame. The artist sees that truth and goodness are not realized in this world and, armed with an abstract idea of virtue, turns in moral revolt and bitter indignation against this reality. Moral degeneracy and a capacity for abstraction, a cold and bitter recognition of the disharmony between the world as it is and as it ought to be, are presuppositions for such satire. The result is a new recognition of ugliness and a desire to portray it artistically.

By contrasting abstract wisdom with reality, satire lacks reconciliation. For Hegel this means a loss of the poetic and in its stead the cultivated expression of "ill-humor, vexation, wrath, and hatred" (*Werke* 14:125; A 515). The satirists, Hegel notes, are one-sided: "They have nothing to set against the vacillation, the vicissitudes, the distress and danger of an ignominious present except Stoic equanimity and the inner imperturbability of a virtuous disposition of heart" (14:125; A 515). Still, Hegel admires the satiric engagement with negativity that is able to exhibit its self-destruction, for this corresponds to the dialectical: "Reality is shown in the madness of its ruin, such that it destroys itself from within" (14:120; A 511, my translation). In one of the lecture transcriptions, Hegel notes that such satire is legitimate within the realm of aesthetic excellence. He even laments the absence of satire in his age (*Vorlesungen über die Philosophie* 179; *Lectures on the Philosophy* 331).

The first prominent Roman satirist was Gaius Lucilius. In the last three decades of the second century BC, he wrote targeted and sear-

ing satires. He could be so blunt partly because he was wealthy, powerful, and connected. Alas, of his writings only fragments remain. Still all three of the great satirists whose works are still read today—Horace, Persius, and Juvenal—cite him and view him as a model (Persius, *Satires* 1.115; Horace, *Satires* 2.1; Juvenal, *Satires* 1.19–21). Of these, Horace is the most refined, artful, and traditionally poetic; his tone is almost conversational. He is also the most programmatic and self-reflective (1.4, 1.10, 2.1). Persius is compressed, even obscure; his Latin is difficult. His major innovations in relation to Horace are twofold: first, his turn away from city and society and toward the soul; and, second, his focus on ethical issues as opposed to simply social norms (Kißel 11–13, esp. 12). In Persius, one finds "positive moral exhortation" (Harvey 1). Juvenal is the most brutal, indignant, negative, and direct, even if Persius has his own obscene passages (4.34–38). The greatest challenge in reading all of them is their attention to realistic detail. Because satire focuses on the specific and ordinary and not on the universal, many allusions require explanatory notes, unlike, for example, Marcus Aurelius's broad-ranging observations.

Still, we recognize among the satirists recurring conceptual themes: above all envy, greed, and self-indulgence. Moreover, they lament the restless longing for wealth that can never be satisfied. They criticize the Romans as avaricious, superficial, decadent, hypocritical, and oblivious. All three writers play on the etymological associations of satire with *satur* ("full" or "enough," as in our English "saturated" or the German "satt") and *satura* ("a mixed platter" or "medley of topics").

The eminent classicist Gilbert Highet described the last Roman satirist, Juvenal, as "the greatest satiric poet who ever lived" (2). Of the Roman satirists, Juvenal's immersion in ugliness is the most dramatic. We know very little about Juvenal, for unlike Lucilius and Horace, Juvenal avoids speaking about himself in any realistic way. Juvenal lived from approximately 55 to 138 AD, being slightly younger than Statius, to whom Juvenal refers in his seventh satire. He appears to have been active from 100 to about 130. His contemporaries included Tacitus and the younger Pliny.[4] Sixteen satires survive, written in hexameters, with abundant use of alliteration and assonance along with double entendres. Juvenal stands out for his distinctive reception. In the English-speaking world, his works have had greater influence on the concept of satire than those of the other Roman satirists. Imitations of Juvenal range far and wide, beginning in the sixteenth century

(Martin Winkler). In his nuanced comparison of the Roman satirists, John Dryden, arguably England's greatest verse satirist, exalts Juvenal. For Dryden, Juvenal is the most delightful and the greatest: Juvenal "gives me as much Pleasure as I can bear" (63).

Juvenal's stylistic range is greater than what we see in Horace or Persius. Nonetheless, a dominant motif, especially in the first two books, is anger, moral outrage, and indignation (*indignatio*) as well as an insurmountable urge to criticize: "for who could endure / this monstrous city, however callous at heart, and swallow / his wrath?" (1.30–32). Or in an analogous expression, in such an age "it is hard not to write satire" (difficile est saturam non scribere) (my translation, 1.30). Within Juvenal's satires, however, we recognize a shift from *indignatio* or moral outrage toward more subtle criticism along with a more cerebral attitude vis-à-vis the world's follies (William Anderson; Braund).

Juvenal does not criticize all of society. Instead, he presupposes the validity of prescribed class and gender roles, and he chastises those who violate them. Politically conservative, he feared change and contrasted the present with a superior past. In addition, he was, like many authors of ancient Greece and Rome, misogynistic, at least his literary persona and performances were. In terms of both intention and reception, much of what he says needs to be taken with a grain of salt. Above all, Juvenal directs his ire toward the corrupting power of wealth, which surfaces throughout his satires, indeed in almost every one, including the programmatic first satire: "of all gods it's Wealth that compels our deepest / reverence—though as yet, pernicious Cash, you lack / your own temple" (1.112–14). The theme is continued in satire 10: "The most popular, urgent prayer, well-known in every temple, / is for wealth. *Increase my holdings, please make my strong-box / the largest in town!*" (10.23–25); and in satire 14, among others: "no vice of the human heart / is so often inclined to mix up a dose of poison, / or slip a knife in the ribs, as our unbridled craving / for limitless wealth" (14.173–76). Like Horace, Juvenal abhors avarice or "the insatiable lust for profit" (14.125), especially when it is driven by the idea that "nothing will be enough" (14.328; cf. Horace, *Satires* 1.1.62). Related is the corrupting power of luxury and the burdens of wealth, which Juvenal contrasts with the "restraint" necessary for happiness (11.208). Because "there's a price-tag / on everything in Rome" (3.182–83), human relationships are no longer based on integrity, loyalty, generosity, or commitment to a code of honor but are instead reduced to instrumen-

tal ends. Juvenal laments, for example, legacy hunters who sacrifice friendship for wealth: "May their possessions rival all Nero's loot, may they pile up / gold mountain-high, love no man, and be loved by none" (12.128–30).

Juvenal attacks aristocrats who betray the code of their class and to whom nothing is sacred, parents who model for their children vice and depravity, and persons obsessed by the foolish desire to live a long life, which means becoming "an ugly and shapeless caricature" of one-self (10.191–92). Among Juvenal's other themes are immoral behavior, including lust and licentiousness, the elevation of power and glory over virtue, hunger and humiliation, duplicity of all kinds, and the derivative, cliché-ridden dimensions of much of contemporary literature. Juvenal's modus operandi consists of introducing negative examples, as in satire 10. In each case Juvenal's descriptions are detailed and vivid. In his tirade against women in the sixth satire, he describes a wife visiting the steam bath:

> When her arms drop, exhausted by the weighty dumb-bells,
> the masseur takes over, fingers caressing her little crest
> from the top of her thigh, and making her yelp as she comes.[5]
> Her unfortunate guests, meanwhile, are nearly dead with hunger.
> At last she appears, all flushed with a three-gallon thirst,
> enough to empty the brimming jar at her feet
> without assistance. She knocks back two straight pints
> on an empty stomach, to sharpen her appetite: then
> throws it all up again, souses the floor with vomit
> that streams across the terrazzo. Her gilded jordan
> stinks of sour wine. Like some big snake that's tumbled
> into a wine-vat, she drinks and spews by turns.
>
> (6.421–32)

In this sixth satire, the longest we have of any Roman writer, Juvenal makes the case that marriage is impossible because women are spoiled by luxury, engaged in unappealing follies, and invariably deceptive and unchaste. In this passage just quoted we see all three moments. The Latin "loto terram ferit intestino," here translated as "souses the floor with vomit," is about as ugly a Latin phrase as one could imagine. This ugliness is underscored by the break in rhythm: we encounter a spondee in the fifth foot, *intes*tino. The ugliness is also indirectly

comic, for the Latin *spondeus* comes from Greek *spondê*, "libation." What the woman offers with her liquid is not exactly a libation worthy of the gods. Juvenal states that virtue remains the one true nobility (8.19–20) and is alone the path to "a tranquil life" (10.364), but his gaze is invariably not focused on virtue; instead it dwells hyperbolically on its contrary: "Today every vice has reached its ruinous zenith" (1.149).

Juvenal's Ninth Satire

The anger that Juvenal displays in his initial programmatic satire and his first two books (satires 1 to 6), where *indignatio* is the dominant motif, shifts in his last three books (satires 7 to 16), including the third book, which contains the ninth satire. John Ferguson calls the ninth "one of the most powerful of the satires" (248), and Edward Courtney writes, "In respect of literary artistry it is Juvenal's masterpiece" (424). Let us look more closely at this vivid satire, the only one in dialogue format.[6] Here, whatever anger Juvenal experiences is conveyed subtly and indirectly through irony, which in Juvenal is otherwise rare.

The speaker meets Naevolus, a client who looks disheveled, like a shabby outcast. The speaker compares Naevolus with Marsyas, a satyr who in an act of unwarranted pride had challenged Apollo to a musical contest, lost, and had his skin flayed while hanging upside down. The comparison with a satyr has implications for Naevolus's sexuality: satyrs were known to lust for sexual gratification. The connection is reinforced in the next lines, as the speaker compares Naevolus to Rovola, who surfaced with a wet beard after just having rubbed a crotch. The Marsyas comparison places Naevolus into a rustic, as opposed to urbane, category; suggests something of his arrogance; introduces a contrast between his previous beauty (or dandyism) and his fall; and sets the stage for the portrayal of his wretchedness. The physical disarray finds its analogue within.

The speaker continues his introductory comments by describing Naevolus with the language of ethics—*propositum* ("plan"), *modico contentus* ("content with moderation"), *animi tormenta* ("tormented soul")—but then just before Naevolus takes the stage, the speaker ends, as Courtney notes (425), with a gross colloquialism, describing Naevolus's laying husbands and also wives (*inclinare*). We recognize that a word such as *propositum*, normally a favorable term, is here used

ironically (Ferguson 249). The gloomy Naevolus bemoans being exhausted, overworked from his drudgery, which he reinforces with complaints about his poor earnings and his patron's greed. His opening lament contains aspects of what we have recognized as Juvenal's *indignatio*: Naevolus speaks at great length (for more than 60 lines); uses blanket words, such as *semper* ("always"), *numquam* ("never"), *omnes* ("every"), *nullus* ("none"); makes abundant use of comparatives and superlatives, such as *maior* ("better"), *ulterius* ("farther"), and *brevissima* ("briefest");[7] with his apostrophes, asks more than a dozen angry questions; invokes repetition, including anaphora; employs multiple diminutives, for example, *spumanti Virro labello* ("Virro's drooling little lip"), *tabellae* ("little letters"), and *filiolus* ("a little son"), which seem to convey contempt ("Naevolus" is itself a diminutive, meaning "little mole or wart"); and frequently ends lines with elisions, with monosyllables that indirectly project abruptness and agitation.

Naevolus believes that he is being insufficiently compensated for his invaluable work, "but its never brought *me* fair return for my labors" (at mihi nullum / inde operae pretium) (27–28). Naevolus's duties include having sex with his patron's wife, fathering his patron's children, and then satisfying his patron's desire to be penetrated in anal intercourse. Naevolus laments that his patron is both sexually indulgent and miserly: Virro is a "close-fisted pervert" (9.38). Naevolus contrasts his miserable payment with his great services: "You think it's easy, or pleasant, to thrust a proper-sized / cock into your guts till it encounters last night's supper? / The slave who plows his master's field has less trouble / than the one who plows *him*" (an facile et pronum est agere intra viscera penem / legitimum atque illic hesternae occurrere cenae? / servus erit minus ille miser qui foderit agrum, / quam dominum) (9.43–46). The adjective that describes the penis— "proper-sized," or, more literally, "lawful" or "legitimate" (*legitimus*)— is emphasized by enjambment, and the juxtaposition of two body parts, guts or intestines (*viscera*) and penis (*penis*), seems to add to the obscenity. Naevolus is resentful, arrogant, and oblivious to his subservience and obscenity. Naevolus complains further as he recounts a dialogue with Virro:

> . . . don't you
> think it worth something, Virro, that if I hadn't displayed
> true dedication to duty, your wife would be virgin still?

You know well how, and how often, you begged for my assistance,
and what you promised. The girl was actually bolting
when I got her to bed; she'd torn up her marriage-vows
and was leaving for good. It took me all night to change her mind,
with you boo-hooing outside—as witness the bed, and yourself
who heard its creaks, and your lady's sudden climax.

(9.70–78)

Noting that adultery has saved many shaky and unraveling marriages,
Naevolus continues:

Does it mean nothing to you, you treacherous ingrate, *nothing*
that you've managed a son and daughter, all by my doing?
Your rearing them as your own, you loved advertising these proofs
of your manhood in the Gazette. *Hang a wreath from your lintel:
you're a father*, I've given you something to kill the gossip.

(9.82–86)

Naevolus trumpets his dutiful actions toward Virro, reminding him
that he broke his wife's virginity and fathered children on Virro's be-
half.[8] Naevolus argues that this was a great achievement on behalf of
Virro, but in the telling, he insults Virro, underscoring his impotence,
whining, and duplicity, and he engages in far more detailed sexual
rhetoric than would have been necessary to make his case.

When Juvenal finishes his tale, the speaker comments that he has
a perfectly justifiable case for feeling resentful: "Indeed, just cause for
complaint here, Naevolus" (Iusta doloris, / Naevole, causa tui) (90–91).
The irony at this point peeks through and becomes even more mani-
fest as the conversation continues. The speaker asks Naevolus how
the patron would respond to his complaints. The question suddenly
forces Naevolus to confront his own accusations. Not surprisingly, he
asks the speaker not to reveal what he has himself just openly de-
clared. Clearly, Juvenal is critical of both Virro and Naevolus. Virro is
pathetic and weak (he lacks *virtus* in a literal and metaphorical sense),
and he is devious and stingy. He represents the widespread corrup-
tion at the top of society, but Naevolus is also the object of critique.
The speaker indirectly undercuts him. Even more interesting, Naevolus
undermines himself, as with his unease at hearing back what he just
said. Moreover, he uses vulgar language seemingly unawares: "The fan-

tastic size of your cock will get you nowhere" (nil faciet longi mensura incognita nervi) (34). He uses crude words and phrases, such as "butt twitching" or wiggling his ass (cevet, line 40), "penis" (penem, line 43), "plough" or "thrust" (foderit, line 45), and "exhausted loins" (exhausti lumbos, line 59). The reader notes Naevolus's duplicitous behavior, for which he feels no shame or embarrassment, but which he instead describes as meritorious (meritum). Naevolus lambasts avarice but indirectly divulges his own greed; criticizes callousness but then reveals his lack of gratitude; compares himself unfavorably to an agricultural slave and uses ambiguous language to describe himself, such as lowly "follower" (humili adseculae), which has connotations not only of rank but also of morals; revels in his own self-pity and pessimism, as when he speaks of his feeble prayer (votum miserabile); describes adultery as a common way to save a marriage; trashes his patron and divulges his secrets without respect for decorum and then wishes he had not been so indiscreet; pretends to have the moral high ground but then refers more than once to his own interests (indeed, utile is his very first word); and contradicts himself by saying that he wants a simple retirement even as he piles on his lofty desires.

Naevolus also undermines himself by his allusions. He interprets his situation within a cosmic frame. The fates, he laments, govern all, even "those private / parts that our clothes conceal. If your stars go against you / the fantastic size of your cock will get you precisely nowhere, / though Virro may have drooled at the site of your naked charms" (9.32–35). The juxtaposition of philosophical and sexual language, with the explicit sexual language coming in the following line, is incongruously comic. Satire works best if it is not simply angry, but has enough elasticity—a combination of distance, nuance, and indirection—that anger is supplemented by laughter. Various allusions, partly from Naevolus, partly from the speaker, mock Naevolus. Naevolus alludes to Homer (37, 64–65, 149–50), but he is far removed from heroic virtue. The language used by Naevolus in lamenting his sorry state has loose analogies with the language Dido uses in book 4 of the Aeneid, but the allusion is also a parody that reflects poorly on Naevolus (Bellandi 494–97). The speaker links Naevolus with Virgil's second eclogue, but the idealistic homosexual longing in Virgil is the opposite of Naevolus's baseness. The speaker also evokes in the reader an association between Naevolus and slaves; the speaker comments that slaves betray their masters' secrets.

The urbane speaker holds back his commentary in this dialogue, letting the character's vanity, self-pity, and complete lack of moral dignity reveal themselves on their own. The irony and mockery carry an implicit moral understanding. This indirect conveyance of meaning undermines Naevolus's telling and his position. Naevolus unwittingly undermines himself with his indiscretion, which results in his begging the speaker not to reveal his tale to others. The use of artistic indirection reminds us that satire can be subtle and clever. The genre is not exhausted by unwavering indignation.

Critique of society, though abundant in satire, was hardly restricted to this genre. Via clever exaggeration, Petronius, who lived from about 27 to 66 AD, used a different literary form to bring ugliness to the fore and express moral indignation. In his fragmented Roman fable or novel, *Satyricon*, which shares something with the later picaresque, Petronius exposes the decadence of the age and also the vulgarity and pretentiousness of the nouveau riche. Sexual licentiousness, cruelty, decadence, and the substitution of money for virtue play prominent roles. The longest and most memorable episode, Trimalchio's feast, has analogies to what we later see in Roman satire: it uses the base motif of eating to criticize ostentatiousness and overindulgence, pretentiousness, and vulgarity (e.g., Horace, *Satires* 2.8 and Juvenal 1.5). Although *Satyricon* is etymologically linked to satyr (*satyrus*), as in satyr-like tales, and not satire (*satura*), the similarity in sound creates a loose association, which is reinforced by the critique of ordinary reality. Trimalchio is a freed slave who has acquired great wealth, which he displays in vulgar and excessive ways; he seeks unsuccessfully to come across as learned. Toward the end of the many courses, he unveils his lavish tomb and stages his own mock funeral, so that he can hear himself be praised and celebrated. In seeking at the end of the 1960s to satirize contemporary decadence, Federico Fellini returned not surprisingly to Petronius; the Italian director filmed a loose adaptation, entitled *Fellini Satyricon*, which offers a fascinating and surreal window onto human depravity.

Unlike Juvenal, Petronius seems partly fascinated with the very vulgarity he criticizes. We encounter this kind of ambiguity elsewhere: the artist is critical of ugliness but simultaneously fascinated by it, such

that the portrayal becomes an end in itself, which can stand in tension with the critical spirit. With his elaborate and creative portrayals of human depravity and punishment, Hieronymus Bosch is arguably the greatest Christian figure to embody this tendency. The ambiguity becomes even more common in modernity. The conflict between content that seems to contain a clear moral message and form that lingers in aberration as an end in itself renders moral messages more complex and less certain, elevating instead a work's ambiguity. We return to this complexity in chapters 12 and 13, as we reflect on two neighboring forms of beautiful ugliness, one that lingers in ugliness and another than mocks it. Some works hover in the middle. In fact, Bosch adds a third dimension beyond harsh critique and artistic fascination. In both undermining temptations and enticing us to lose ourselves in their visual enjoyment and fascination, Bosch implicates not only himself but also his viewers.

Satire, which continues as a genre into modernity, persists as one of the great sources of ugly art. Schiller's *On Naive and Sentimental Poetry* contains the most convincing philosophical theory of satire. Schiller suggests that the two main forms of sentimental poetry are the elegiac and satiric. Both are characterized by a (sentimental) gulf between the ideal and the real. Whereas the elegiac focuses on the ideal, evoking an idyllic past or a utopian future, the satiric stresses the ways in which reality deviates from the ideal. Schiller, who cites Juvenal as an example, notes in his essay *On Naive and Sentimental Poetry*: "In satire, the actual world as something lacking is contrasted with the ideal as the supreme reality" (*Werke* 8:741; *Essays* 206, translation modified). Two dimensions are of interest here: first, satire presupposes a gulf (the world is not as it should be, and satire focuses on these deficiencies); and, second, satire postulates an ideal (the real can be seen as inadequate, Schiller implies, only against an ideal that it fails to realize, even when that ideal is not explicitly mentioned). Ugliness necessarily becomes part, if not the center, of this vision. Schiller's view is echoed by Kurt Tucholsky, a modern German satirist: "The satirist is an aggrieved idealist: he wants the world to be good, it is bad, and now he rails against the badness" ("Was darf die Satire?," in *Gesammelte Werke* 2:43). Whether the satirist believes the world can ultimately be changed and human faults remedied or whether we are irretrievably lost is an open question. Both

stances are possible. For Juvenal, the latter, more pessimistic position seems to hold.

he turn to ugliness in imperial Rome has, then, four partly over-lapping dimensions that we see in other ages: (1) aesthetically lin-gering on grisly details abstracted from a larger whole, be it because of an intrinsic fascination or a desire for certain effects; (2) expanding the impulse toward realism, including what earlier ages had neglected, which results in fuller and deeper portrayals of ugliness; (3) dwelling on negative aspects of reality, such as civil war, to express disgust and reveal the horrors of moral ugliness; and (4) exposing grotesque and perverse realities via satire. Only the attempt to contrast extreme emo-tional and moral ugliness with the balance and restraint of Stoicism is left behind as a simply historical phenomenon. The others become continuing dimensions of aesthetic ugliness in the Western tradition.

LATE MEDIEVAL CHRISTIANITY

After imperial Rome, the next major development arises with Christianity. Two moments dominate the Christian turn to ugliness: Christ's suffering on the cross and extraordinary attentiveness to human wickedness. These twin preoccupations work themselves out in a variety of artistic motifs. Though most of my focus is late medieval Christianity, the era when we first see Christianity's marked turn to ugliness, I occasionally interweave the continuing reach of these ideas, in some cases into modernity.

The Ugliest Death of the Cross

The connection between Christ and ugliness emerges only over time. The earliest depictions of Christ focus on his earthly life and work, Christ as teacher and healer. In the fourth century, portrayals of Christ's divinity and salvific work arise. Christ is enthroned, triumphant over death, dressed in white, with haloes and aureoles, an object of veneration (Jensen, *Understanding* 107–12). Images of the Crucifixion did

not appear until centuries after Christ's death, a fact that surprises many nonscholars accustomed to its centrality, but the reason is not counterintuitive: the early Church needed converts. In that context, miracles, healings, and hopeful topics such as the Resurrection were more encouraging and inviting than the Passion and the Crucifixion (Clark, *Civilisation* 4).

The first crucifixion images surface in the fourth and fifth centuries, but these remain rare until the sixth century (Jensen, *The Cross* 83). In the British Museum's *Maskell Ivories* from the early fifth century, Christ is alive on the cross, his arms outstretched, his eyes wide open. No suffering is evident. It is as if Christ were impassible, invulnerable to pain, not fully human. Insensibility to pain also surfaces in contemporary tales of early Christian martyrs. From the second to the fifth centuries, many martyrs were described in narrative accounts as physically harmed but full of divine presence, impervious to pain and suffering, a development that was contrary to ancient tradition and expectations (Cobb). In some portrayals, Christ is represented simply by a lamb above the cross. Only later did the crucifix as such become more standard; in fact, the emerging practice of presenting Christ instead of the symbolic lamb was not formally endorsed until 692 (in canon 82 of the Synod of Trullo). In the earliest crucifixes we still see no gruesome images: instead, Christ is invincible and unconquered, *crux invicta*, with no vestige of suffering, shame, and horror (Taubes 183–85). One of these earlier images is from the eighth-century *St. Gall Gospel Book*, located in the Abbey Library of St. Gall in Switzerland (Codex Sangallensis 51). Christ is alive, with eyes open, elaborately clothed and covered by a halo. The diminutive soldiers are almost ridiculously unthreatening.

Through the Carolingian and Romanesque periods, with Christianity deeply linked to governmental structures, and indeed in some cases into the twelfth and thirteenth centuries, Christ is presented as ruler and judge, victor over the cross, and crowned. Made of ivory in northern France circa 870, the Carolingian *Plaque with the Crucifixion and the Holy Women at the Tomb*, which is now housed in the Cloisters Collection at the Metropolitan Museum of Art, shows Christ with a prominent halo surrounded by angels. Through the ninth century, we see little of Christ's body, which is instead often robed in a long, flowing tunic. *The Crucifixion*, a carved ivory plate from Musée

de Cluny/Musée national du Moyen Âge, in Paris, dated to the end of the tenth or the early eleventh century, and most likely originating in Cologne, shows a haloed Christ, with his eyes open, draped in a long tunic while appearing almost to be floating or dancing. One of the most outstanding images of Christ in his glory is the *Batlló Majesty*, a twelfth-century Romanesque wooden crucifix, now in the National Art Museum of Catalonia. Christ, with his eyes open and body fully erect, is depicted in his kingly and priestly role. He wears an elaborately decorated colobium, which signals his status and strength. In the thirteenth-century *Figure of Christ from a Crucifix* from Limoges, France, and now in the Walters Art Museum in Baltimore, Christ is alive and without suffering. He is not dressed in rags; instead, his long loincloth is lavishly decorated. In such images, Christ does not hang from the cross. His head is fully erect, and he is simply attached to the cross, eyes open, in dignified, glorious repose. When Mary is present, she is not weeping or troubled. In no images does Christ carry his cross. The emphasis is not on the humiliated and abject Christ, but on the risen Christ in all his glory. This image of divinity is in harmony with what we see in antiquity.

Portrayals of the crucified Christ start to change in the late tenth and early eleventh century. We begin to see Christ's suffering. With the advent of Gothic art, the turn becomes widespread, even if vestiges of the earlier model continue. Christ's humanity is recognized, not only in his crucifixion but across his life: the infancy narratives of Matthew and Luke gain prominence, the crèche is introduced, the mother–child relationship is emphasized, and a radically different view of the Crucifixion is introduced. As the medieval viewer identifies more with Christ, the crucifixion scenes are humanized. R. W. Southern has noted the extent to which the period from about 1050 to about 1320 led to a radical elevation of humanism, which included, on the one hand, a sense of the dignity of the human being and, on the other, an emerging sensibility for God's humanity (*Medieval Humanism* 29–60, and *Scholastic Humanism* 1:17–45). Even in his fallen state, the human being has dignity, as does the natural and social world whose order humans can recognize through reason. This medieval turn toward humanism unleashes a search for God within the human soul and an emphasis on friendship and community. God became reconfigured: no longer a distant power evoking awe, God was a person

in whose image we have been formed and with whom we can connect. God is seen not as the otherworldly creator and judge. God is in fellowship with humanity. Through this conceptual reframing, humans can identify with Christ, and in having taken on humanity's sins, Christ is portrayed as a suffering being.[1]

From the high to late Middle Ages, Christ is often shown in excruciating pain. The turn to the humiliated and suffering Christ is evident in a number of anonymous thirteenth-century sculptures. In Italy, Anne Derbes dates this turn to the 1230s and stresses thereby the role played by the emerging Franciscan Order, whose founder was devoted to the Passion. We encounter the suffering Christ in the thirteenth-century works of Cimabue and in the late thirteenth and early fourteenth centuries in Giotto. In northern Europe we see a turn not simply to the suffering Christ, but to the broken and bloody Christ. For a population suffering from wars and plague, such depictions offered a point of contact. Veneration became secondary to identification. In the typical image of this era, Christ's head is drooped to the side, his arms pulled away from the now twisted body, the legs crossed, with one nail replacing the previous tradition of two (and even earlier no nails). In this version, Christ's face expresses agony, blood flows from his wounds, the crown of thorns is introduced. Stigmata begin to appear. The resulting image is more moving, more accessible, more human, and at the same time more conducive to devotion. The praying person can find a bridge to Christ and recognize more fully Christ's sacrifice on behalf of humanity.[2]

Consider in this context the early fourteenth-century tradition of the forked cross (*Gabelkreuz*): the wood of the crucifix is shaped like a fork or the letter Y, with the horizontal pieces as vertical as they are horizontal. These works, which were found above all in the German Rhineland, increased after the plague years of 1348 and 1349 (Mühlberg 77). The official name for a fork cross of this era is *crucifixus dolorosus*; in earlier times it was more commonly called a *Pestkreuz*, "plague cross." The most striking example, both intense and horrific, is in St. Maria im Kapitol in Cologne, an eleventh-century Romanesque church, the largest of twelve such churches in Cologne, with a crucifix from about 1304.[3] Christ's head, which hangs low on his chest, and his body are strewn with blood (illustration 9). The excruciating blood-dripped facial expression, with closed eyes, open mouth, teeth

visible, conveys utter agony (illustration 10). The ribs are visible, the stomach is compressed, and the arms are contorted and stretched upward beyond capacity. The Y shape resembles a tree, symbolically, the tree of knowledge, which is tied to the origin of sin, to which Christ responded with his suffering on the cross. Such *crucifixi dolorosi* ("sorrowful/painful crucifixes") served as devotional images (*Andachtsbilder*) and arose in tandem with the theological call to identify with the suffering and crucified Christ.[4] The eleventh-century *Prayer to Christ* by Anselm of Canterbury and the twelfth-century *Steps of Humility and Pride* by Bernard of Clairvaux (3.7–9) were written when more realistic images of Christ's suffering begin to emerge, and believers were encouraged to experience, via devotion to the cross, Christ's self-sacrificial atonement for our sins. Passion mysticism, which encourages identification with the suffering Christ as the path toward mystical union, animates also the fourteenth-century German mystic Henry Suso (Heinrich Seuse), who in his *Little Book of Eternal Wisdom* repeatedly turns to Christ's suffering, describing it in detail and encouraging God's servants to imitate it, and to "love bodily discomfort" (Eng. 56; chap. 3). Readers are inspired to recognize not simply Christ's suffering, which has moments of physical and emotional ugliness, but also his extreme disfigurement. Christ was not only "bowed down by pain and torment" but also "most wretchedly disfigured" (vil jemerlich verkert) (Eng. 55; chap. 3). Suso, a Dominican friar, lingers over Christ's tortuous pain, describing it limb by limb. He concludes in Christ's voice: "My hot blood burst out copiously through many a wound. . . . My young, fair healthy body began to grow grey, to dry up and wither. The gentle weary back leant painfully on the rough cross, My heavy body sank down, My whole frame was bruised, wounded and cut through and through—and yet My loving heart bore all this lovingly" (Eng. 58; chap. 4). Christ's suffering becomes for humanity an ideal: "Suffering is an abomination to the world, and yet to Me it is an incomparable dignity. Suffering extinguishes My anger, and obtains My favor. Suffering makes men lovable to Me, for the suffering man is like unto Me [Liden machet mir den menschen minneklich, wan der lidende mensch ist mir anlich]. . . . Suffering casts out sin, drives away temptation, diminishes purgatory, destroys faults, renews the spirit. . . . It mortifies the body, which after all must rot, but feeds the noble soul, which is to exist for ever" (Eng.

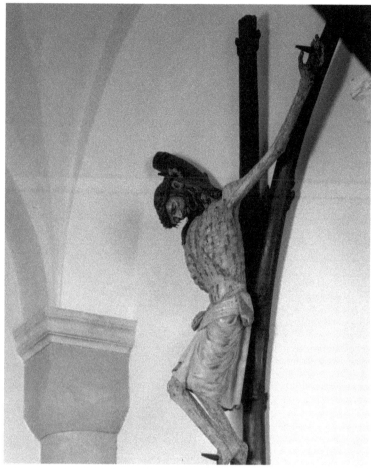

ILLUSTRATION 9
Side view of the *Crucifixus Dolorosus*, the so-called Plague Crucifix, St. Maria im Kapitol in Cologne, ca. 1304, Photo: © Rheinisches Bildarchiv Cologne, rba c018772, Helmut Buchen.

97–98; chap. 13). Suso encourages sorrowful and loving meditation on Christ's self-sacrifice for our enormous sins and celebrates receiving in his mouth drops from the open wounds of Christ's heart (Eng. 103; chap. 14, and Eng. 141; chap. 23). In this way suffering becomes a path to the divine. It also becomes a source of great art. As German sociologist Georg Simmel noted many centuries later, early Christianity "discovers the aesthetic value of suffering" (129).

Germany also provided the context for the fourteenth-century *Röttgen Pietà* (1300–1325), a painted wood sculpture located in Bonn,

The History of Beautiful Ugliness

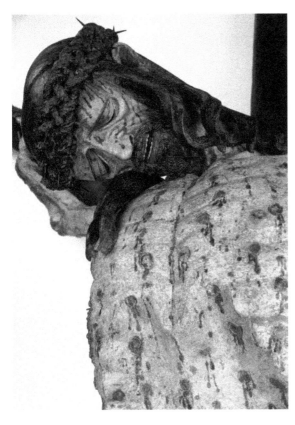

ILLUSTRATION 10
Detail of the *Crucifixus
Dolorosus*, St. Maria im Kapitol
in Cologne, ca. 1304, LVR-Amt
für Denkmalpflege im Rheinland,
Michael Thuns.

which shows, with a kind of Gothic realism, an emaciated, deformed Christ draped over Mary (illustration 11). Jeffrey Hamburger calls this sculpture, with its "exact delineation of Christ's excoriated flesh," "ugly" and "abject" (10–11). Gaping, gruesome wounds cover Christ's hands and feet and penetrate his side. His right arm hangs lifeless. The ribs are exposed, and the body is stiff. Blood comes over his head from the long, sharp needles of the crown of thorns. Not only is Christ's humanity stressed, so, too, is Mary's: she is absolutely despondent, not in the least serene, not the Queen of Heaven, but absorbed instead in the human moment of utter disconsolation. It would be difficult to imagine a greater contrast to Michelangelo's beautiful and idealized Italian Renaissance pietà, with Mary's youthful and serene face, which followed two centuries later. Another horrific set of images, in this case from late Gothic, arises in the *Karlsruhe Passion* (ca. 1450), an altarpiece by the Master of the Karlsruhe Passion, which depicts Christ in intense suffering, severely beaten and downtrodden.

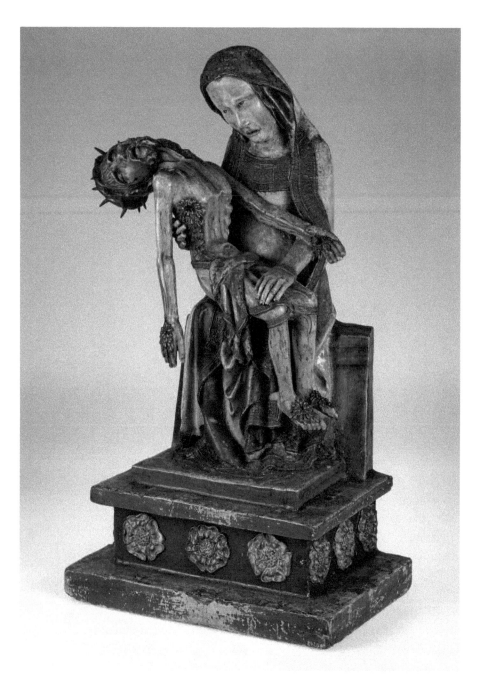

ILLUSTRATION 11
Röttgen Pietà, ca. 1300–1325, Painted wood, Courtesy LVR-LandesMuseum Bonn.

Grünewald's *Isenheim Altarpiece*

Images of the suffering Christ continue into the sixteenth century, for example, with Quentin Matsy's *Christ Carrying the Cross* (ca. 1510–15) and Lucas Cranach the Elder's *Christ as a Man of Sorrows* (1515). The Regensburg master Albrecht Altdorfer's realistic *Christ on the Cross between Mary and St. John* (ca. 1510–16) shows a bloodied and ravaged face, with drooping and distorted eyes and blood dripping down the entire body. The streaks of blood lead the viewer to see the painting as at some level abased and ugly, yet they also form a vertical, which reminds the viewer of Christ's eventual ascension. The ratios of the figures are radically distorted: the two kneeling figures are almost minuscule in relation to the main figures. The intentional distortion signals a world out of joint. The perspective is such that the background seems to drop down, which has the indirect effect of hinting, in contrast, at Christ's eventual ascension. Mary is turned slightly forward and John looks into the horizon, but we are drawn to the center, to Christ, with his deep wounds. Altdorfer's work has similarities with Matthias Grünewald's *Crucifixion* in his *Isenheim Altarpiece*, which was painted at the same time. Both works are vivid and even brutal in depicting Christ's suffering and blood. Scholars see no evidence of any influence of Grünewald on Altdorfer, or vice versa, which speaks to the spirit of the age and the place, northern Europe during the waning Middle Ages.[5]

In 1515, Grünewald painted the *Crucifixion* of his *Isenheim Altarpiece*, which was developed for the abbey's hospital church at Isenheim in Alsace; it is now located in the Museum Unterlinden in Colmar, France. The Antonite community for which the work had been commissioned cared for the sick, especially those suffering from St. Anthony's fire (Hayum 20–21). The order encouraged the sick to enter the church and pray there regularly (Hayum 28). The painting, which gives Christ some of the symptoms of plague-like illness, invites patients to identify with Christ, both in their suffering and in the possibilities of healing and salvation (illustration 12). The idea prevalent at the time was that all illness was related to sin; therefore, to reflect on Christ was to undergo a possible healing process (Gottfried Richter 12).

In his classic history of art, Gombrich notes: "Of beauty, as the Italian artists saw it, there is none in the stark and cruel picture of the crucified Savior. . . . Grünewald left nothing undone to bring home to

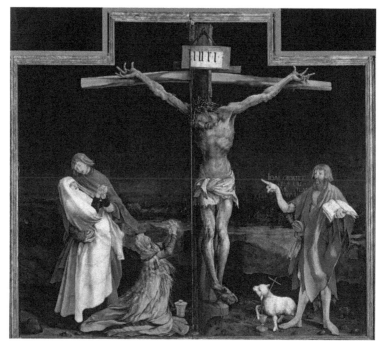

us the horrors of this scene of suffering: Christ's dying body is dis-
torted by the torture of the Cross; the thorns of the scourges stick in
the festering wounds which cover the whole figure. The dark red
blood forms a glaring contrast to the sickly green of the flesh" (*Story of
Art* 351–53). Our perception of distortion only increases if we com-
pare the scale of the figures: the hands of Mary Magdalene under the
cross are diminutive in contrast with those of Christ. The unrealistic
scale of the figures adds to the sense of fracture and exacerbates the
intensity of Christ's suffering, as does the contrast between the closed
hands of Mary, which evoke prayer, and the isolated, extended fingers
of Christ. Normally, extended fingers are visible only in the thieves
who were crucified with Christ; the fingers signal excruciating pain
and a desperate cry for help.[6] Pious viewers of Grünewald's *Cruci-
fixion* would be reminded of the Gospel of Mark and Gospel of Mat-
thew, with their "My God, my God, why have you forsaken me" (Mark
15:34; Matt. 27:46). The scene is far removed from Luke's conciliatory

tone of model martyrdom: "Father, into your hands I commend my spirit" (Luke 23:46). Joachim Ringleben notes that the Grünewald image captures Rudolf Otto's twofold understanding of the religious, being both fascinating and awful (Ringleben 28). The sufferers who see the work identify with Christ as he endures pain, but they empathize further with the witnesses below, who lament Christ's crucifixion. Though the witnesses are important, they are far less visible than in, say, Lucas Cranach the Elder's *The Lamentation of Christ* (*The Schleißheim Crucifixion*) of 1503, where John and Mary, who wring their hands in lament, are central, while Christ, with his hands closed, is on the side (Reuter 84).

Grünewald portrays Christ more prominently and in such torment and abjection that "ugly" is a valid epithet. As the comparativist Eric Auerbach notes, Christ's passion involved "the ugly, the undignified, the physically base" (*Mimesis* 72). Consider the hands, the body, and the ripped and worn rags. The *Isenheim Altarpiece* evokes associations with the leper in Leviticus 13:45–46: "The person who has the leprous disease shall wear torn clothes and let the hair of his head be disheveled; and he shall cover his upper lip and cry out, 'Unclean, unclean.' He shall remain unclean as long as he has the disease; he is unclean. He shall live alone; his dwelling shall be outside the camp." Christ's torn and tattered loincloth has no counterpart in the history of art (Reuter 82).

At almost nine feet high, the powerful crucifix was at the time the largest ever painted in Europe (Ziermann 82; Schubert 48). Still, Christ is not elevated, as in many versions, but brought down to earth. Blood continues to flow from the side and the head, which hangs as low into the breast as one can imagine. Some of the thorns have broken off and are projected into the flesh, the wounds are still visible, the flesh is marked with pustules, sores, and lesions, the ribs protrude, and the skin and lip colors evoke death (illustration 13). The nails do not simply affix Christ to the cross, they themselves become instruments of torture (illustration 14). The lamb with the cross and the blood flowing into the chalice reinforce the theme of sacrifice.

The vertical of the cross is dark, indicating the misery of Christ's human fate and a severing of, or a shadow on, the link to the divine. The very darkness of Christ's body is accentuated by the bright clothes of the neighboring figures. John the Baptist appears to be pointing not to his prophecy, but to the horrendous sight. The dark background,

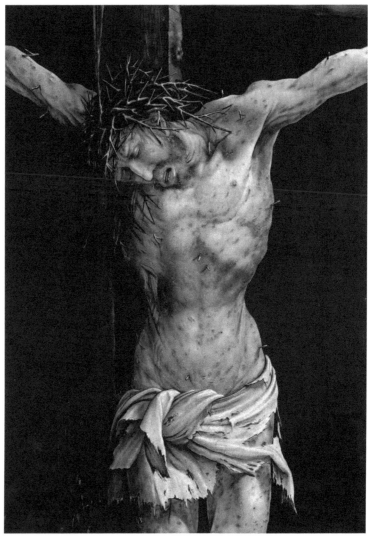

ILLUSTRATION 13
Detail of Matthias Grünewald, *The Crucifixion, Isenheim Altarpiece*, ca.1512–15, Oil on panel, Musée d'Unterlinden, Colmar, France/Bridgeman Images.

which has theological roots ("darkness came over the whole land," Luke 23:45), gives the work a bleak backdrop but also serves, by contrast, to highlight Christ. Christ's mother is pale and swooning, wringing her hands and supported by John the apostle, whose suffering seems to become one with hers. This unity is accentuated via a Gothic distortion: John's right arm is too long for his body (Viladesau, *Triumph*

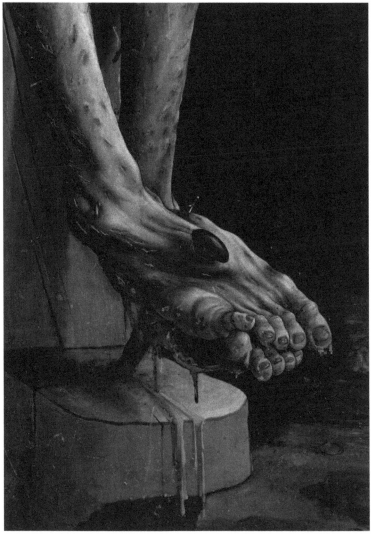

of the Cross 75). Mary Magdalene gazes into Christ's face, weeping. The
gruesome torment in Grünewald's *Crucifixion*, the deformity or ugli-
ness of Christ, *deformitas Christi*, as Augustine called it, makes mani-
fest Christ's humanity and the cost of his suffering (Sermon 27.6).

The late medieval Grünewald's overwhelmingly brutal image of the
grotesque and ugly contrasts with later, idealizing depictions of Christ

on the cross, such as Annibale Carracci's *The Virgin Mourning Christ* (1599–1600), Rubens's *Christ on the Cross* (1615–16), Guido Reni's *Crucifixion* (1619), or Francisco de Zurbarán's *Christ Crucified* (ca. 1665), all of which present beautiful images of a strong and heroic Christ and all of which emerged in the wake of the Counter-Reformation. In 1563, the twenty-fifth session of the Council of Trent endorsed the creation of clear and ordered artistic works that glorified God and so could provide an edifying example (*salutaria exempla*). The council approved of images that exhibited Christ's suffering as long as they encouraged adoration; thus, painters portrayed Christ's body as muscular and powerful. The Crucifixion was a triumph. Even when a post-Tridentine painter such as Rubens painted the crucifixion scene more brutally, as in *Descent from the Cross* (1612–14), Christ nonetheless remains strong and full of light. In contrast to Grünewald's portrayal of Christ's agony, no one would use words such as "ugly" or "abject" to describe even Rubens's more grievous renderings of the Crucifixion.

Just as Hegel noted the radical historical juncture of satire, so here he helps us grasp the extraordinary turning point of Christ's suffering and death, in particular for aesthetics. For Hegel, suffering on the cross and the pain of death are the central moments of Christ's life: "This sphere of portrayal is separated *toto caelo* from the classical plastic ideal because here the subject-matter itself implies that the external bodily appearance, immediate existence as an individual, is revealed in the grief of his negativity as the negative, and that therefore it is by sacrificing subjective individuality and the sensuous sphere that the Spirit attains its truth and its Heaven" (*Werke* 14:152–53; A 538). Hegel continues that the human being's earthly body and frail nature are elevated by the fact that God himself appears as a human. Yet precisely this human body is cast down and comes to grief. Christ's torment contrasts with the classical ideal of undisturbed harmony: "Christ scourged, with the crown of thorns, carrying his cross to the place of execution, nailed to the cross, passing away in the agony of a torturing and slow death—this cannot be portrayed in the forms of Greek beauty" (*Werke* 14.153; A 538). That is, the Greek sense of harmony, of beauty, is unable to do justice to Christ's great suffering. Christ on the cross offers us a qualitatively different aesthetic experience and requires an adjustment in aesthetic categories. The nega-

tivity gestures toward transcendence. That, for Hegel, becomes what he calls Romantic art, which has in common with Schiller's sentimental mode that it recognizes the gap between what is and what should be. Christianity takes satire's rejection of this world one step further.

Sin and Hell

A second revolutionary moment that animates Christian immersion in ugliness arises from the very puzzle that was said to require Christ's sacrifice, humanity's unrelenting sinfulness. Already in Grünewald's *Isenheim Altarpiece* we see abundant references to evil. On the left flanking panel is St. Sebastian and on the right a gigantic image of St. Anthony, both of whom battled evil. In another panel, St. Anthony is plagued by hideous demons. *Concert of Angels—Nativity*, also part of the same altarpiece, gives us a direct but hidden image of the devil, which links Christ's birth with the eventual defeat of Satan (Mellinkoff, *Devil at Isenheim*). Dante's creative depictions of hell, Bosch's portrayals of divine torments, colorful accounts of the devil and his temptations, literary and artistic explorations of sin, death, and the inevitability of Judgment Day all belong here. In recognizing the pervasiveness of human depravity, Christianity elevates moral ugliness in everyday life and in art. Even as the Reformation broke with the medieval Church, it reinforced the Christian focus on sin and moral depravity, such that the emphasis on wickedness lasts well into the early modern era.

Arguably the deadliest Christian sin was pride, for pride brought down Lucifer and was a catalyst for other sins. Jacob Bidermann's medieval miracle play *Cenodoxus* (1602) focuses on this at times hidden vice. Avarice competed for status as most heinous insofar as the Bible insists that "the love of money is the root of all evils" (1 Tim. 6:10). Exhibiting the great burden of wealth, Dutch artist Jacob Matham's ink on paper *Avarice* (ca. 1587), from his series *The Vices*, effectively captures the concept (illustration 15). In Matham's engraving, the figure hoards her money, which, partly strapped in bags around her body, weighs heavily on her. It is not at all clear that the money is for any meaningful purpose, yet she fears losing it and looks about, anxiously clutching her larger bags. The woman is obsessed. A bloated, poisonous toad reinforces the image. The woman's avarice, a form of moral

Perdita Auaritics, corrasis obruta, vuo
Magnas inter opes (heu mihi) fonper inops .

ILLUSTRATION 15
Jacob Matham, *Avarice*, ca. 1587, Engraving on laid paper, Courtesy National
Gallery of Art, Washington, DC.

ugliness, overtakes her whole being; in the language of the day, she is
possessed by the devil.

The portrayal of evil and its punishments has for humans a spe-
cial fascination. Dante's *Inferno*, with its riveting portrayal of moral
ugliness, its tortures and torments, has always been the most popular

part of the *Commedia*. Dante places even popes in hell. Evil can be uncovered in the most exalted places. Dante's fascinating depiction of hell's torments creates a new imaginative universe, with the lowest circles of hell reserved for maliciousness and conscious deception, including fraud against those to whom one owes a special bond or trust. The author inserts a literary version of himself into the narrative. Unlike Dante the poet, Dante the pilgrim, who sympathizes with the sinners, must learn to accept divine judgment.

The sinners' torments echo their sins, reverse them, or both, what Dante calls *contrapasso* (*Inferno* 28.142). In the second circle, the lustful, those who make reason slave to appetite, get blown around in hell; they are out of control in death, as in life. The prodigal and the miserly senselessly roll a heavy boulder back and forth. The avaricious, undiscerning in life, are now unrecognizable in their filth. Those who committed suicide lose self-determination and are denied bodily form. The flatterers are plunged in excrement.[7] The hypocrites wear dazzling, glittery cloaks lined with heavy lead. We see not only echoes, but also reversals. The gluttonous exchange their warm comfort for cold, dirty rain and hail. They are forced to eat filth and mud. The proud are humbled under burdensome stones. The soothsayers, who wished to look too far ahead, are silent and can see only behind (their back is their chest). The thieves are without anything; they cannot call their forms or their personalities their own. Those who sowed scandal and schism in life are themselves torn asunder. In some cases we see continuation and reversal. The first shades are nowhere because of their refusal to make a choice in life, receiving neither blame nor praise. "Let us not speak of them—look and pass by," says Dante's guide, Virgil (*Inferno* 3.51). These souls remain nameless, unremembered, thus fulfilling the logic of their crimes. But their punishment includes running after a banner as part of a crowd, which reverses their indecisive life on earth, and yet, since the banner flows arbitrarily, without purpose, they continue the indeterminate pattern of their earthly life. Lucifer, who first sang God's praises and then protested, is silent. In eating traitors with each of his three heads, he reverses the Trinity but remains unnourished. Satan is precisely where his actions have driven him, removed from God, frozen immobile, and distant from the light.

Dante's universe includes some of the ugliest figures of world literature, such as the monster Geryon, who in canto 17 takes Dante and Virgil down into the abyss, transporting them to the Malebolge, hell's

lower region. Dante lingers in describing the monstrous features of his creation: the foul-smelling Geryon has a deceptively benevolent and righteous human face, but the body of a serpent, a scorpion-like tail, and a hairy upper body and forepaws. Dante seems to revel in his own imaginative description (Kleiner 117–37). The ambiguity of the ugly monster, as fearful and fascinating, is present, all the way down to the intricate weaving and embroidery on his back, a monster and a literary creation.

As with Plato, Dante arrives at truth via the refutation of error. Like Aristotle, Dante elevates measure, but what is absolutely fascinating and revolutionary versus the Greeks is how clever Dante renders sinners and the devil's helpers. The sinners do not blame themselves; instead, they slyly rationalize their actions. Unrepentant sinners who are able to spin wily tales to justify their actions and who blame external forces and other persons abound. Their cleverness and lack of remorse are interwoven, ensuring their condemnation to hell. In some cases, as with Francesca, the adulteress in canto 5, characters avoid telling all of their crimes. Francesca does not reveal to Dante the pilgrim that she was married, that she slept with her brother-in-law, and that her husband caught them in the act. In a threefold anaphora, Francesca blames love, which becomes an active force that seized them and eventually brought them to death (5.100–108). Refusing to take responsibility, Francesca cites the book that she and Paulo read together, the story of Lancelot and Guinevere: "More than once that reading made our eyes meet. . . . That day we read in it no further" (5.130, 5.138). Francesca inverts Augustine, whose conversion was triggered by his hearing a divine command. The childlike voice says "pick it up and read," and Augustine turns to Romans 13:13–14, after which he recalls, "I had no wish to read further, nor was there need" (*Confessions* 8.12.29, *Works* I/1:207). His conversion has taken place. Dante aligns himself with Augustine in wanting his work to turn readers' eyes to God. The punishment of Francesca and her lover is to be blown around in a hellish squall that never rests: "here, there, down, up" (5.43, translation modified). In life, as in death, Francesca is distant from God and out of control. She is clever and offers a compelling tale, such that Dante the pilgrim, still early in his journey, pities her, implicitly challenging the wisdom of God's punishment.

Such figures are evil and deceptive, clever and cunning, and so intellect and evil become one. The dark angels in Dante's universe are

"versed in logic" (27.123); they can ferret out contradictions. In canto 27, Guido, a master at "cunning stratagems and covert schemes" (27.76), echoes Ulysses, whom Dante had portrayed in the previous canto. A warrior, Guido joins the Franciscans, who traditionally stand for peace and repentance. But Guido betrays his order and offers advice for conquering Palestrina. Pope Boniface VIII, whom Guido blames for his fall (27.70–71), promises Guido in advance a pardon for his misdeeds (27.100–102; 27.108–9). But the devil's representative is cleverer still and counters: "One may not be absolved without repentance, / nor repent and wish to sin concurrently— / a simple contradiction not allowed" (27.118–20). In Christianity, reason (or, more precisely, reason in the form of cleverness and cunning) can contribute to moral ugliness.

The devil was often portrayed as deformed, lame from his fall from heaven, his knees backward, his wings cropped. His image drew on the promiscuous satyr figure: the devil, who was adorned with a pair of horns and the stub of a tail, had cloven hoofs and body hair. Like the devilish pagan gods, he was naked. For Dante, the devil is as ugly now as he was once beautiful (*Inferno* 24.34). But the devil's image was discontinuous (Link). He could also disguise himself, appearing in human form, even as a young maiden. Shakespeare's Hamlet notes this variability when he sees what appears to be his dead father's ghost: "The spirit that I have seen / May be the devil, and the devil hath power / T'assume a pleasing shape" (*Hamlet* 2.2.599–601). Disguised as a scholar in Goethe's *Faust*, the devil is witty and clever.

The preoccupation with vices and their consequences animated medieval artists. Consider Giotto's frescoes in the Scrovegni Chapel, including his fourteen panels of *Vices and Virtues* (ca. 1305) and his large portrayal of *The Last Judgment* (ca. 1305). The figure of *Invidia* ("envy," with connotations of jealousy, hatred, and selfishness) is engulfed in flames and clutches a bag in one hand (illustration 16). With the other, she reaches for more. Her overly large ears reveal that she is hyperaware of all that is around her, what others do and have. Out of her mouth emerges a snake that coils back and is ready to attack the very eyes with which she sees what others have. Envy can only be cured by its corresponding virtue, a different form of outer-directedness, namely, charity or love, the panel with which *Invidia* is paired in the chapel's iconography. In Giotto's *The Last Judgment*, which was contemporaneous with Dante, the disarray and chaos of the damned

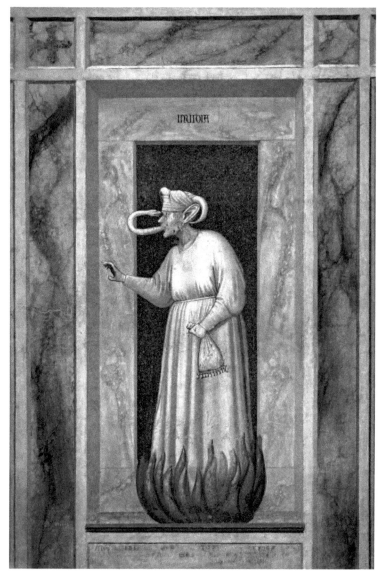

ILLUSTRATION 16
Giotto, *Envy* [*Invidia*], ca. 1306, Grisaille fresco, Scrovegni Chapel, Padua,
Alfredo Dagli Orti/Art Resource, NY.

is set off against the orderliness of the mirroring panel: the elect who
pray and look toward Christ, as they start their ascent accompanied
by angels. The damned, in contrast, are thrown into a topsy-turvy,
helter-skelter world of suffering and punishment, dominated by cha-
otic energy, with figures falling, and horrendous beasts seizing, tortur-

The History of Beautiful Ugliness

ing, or devouring sinners. As with Dante, a large Satan dominates the scene, and we see fitting punishments: the usurers, for example, are hanged with their bags of money.

Arguably our most familiar visual image of hell is later and comes from *The Garden of Earthly Delights*, a triptych oil on panel by Hieronymus Bosch (1490–1510). Bosch's work, like Dante's *Inferno*, exhibits the physical ugliness of punishment. The Spanish priest Jose de Sigüenza commented in 1605 on Bosch's capacity to portray the soul's deformity: whereas other artists paint persons as they outwardly appear, Bosch "has the courage to paint them as they are inwardly" (Cinotti 10). Over time, the Western tradition moved from Sophocles's portrayal of humans as they *should be* to Euripides's portrayal of humans as they *are* and eventually to Bosch's portrayal of humans as they *should not be* (Aristotle, *Poetics* 1460b). In the wake of Christianity, portraying humans via their moral ugliness became an ascending norm.

Of particular interest is Bosch's right panel, which visualizes hell and damnation (illustration 17). We see Christian vices, such as lust, gluttony, and sloth; contemporary abuses, such as gambling and indulgences; and nonreligious music making, which distracts from the divine. How can one not imagine hell as ugly and abject? At the top of this dark panel (night has descended on this world), we see explosions and a river of blood. Then as we move down the panel we are met with images of torture and cruelty, monstrous predators of various kinds, an army led by a horned demon, bizarre distortions, vomiting, and excrement. The world of nature is for the most part absent. Hell is not the idea of being permanently cut off from the vision of god, but a reality rendered concrete by torment. Our normal frame of reference has been turned upside down: "Pleasure becomes torment and music torture" (Belting 35). Whereas heaven and the divine are often characterized by clarity and harmony, a signature element of hell, in Bosch as earlier with Giotto, is chaos.[8] Instead of light we see darkness, instead of the tree of knowledge we find the dark wood. Gombrich offers the helpful observation that Bosch combines the medieval idea of a tortuous hell, which begins to recede in modernity, with a new capacity for precision and perspective. Concerning the right panel of Bosch's triptych *Paradise and Hell* (ca. 1510), which likewise presents horror, fires, torments, and bizarre demons, Gombrich writes: "It was an achievement which was perhaps only possible at this very moment, when the old ideas were still vigorous and yet the modern spirit had

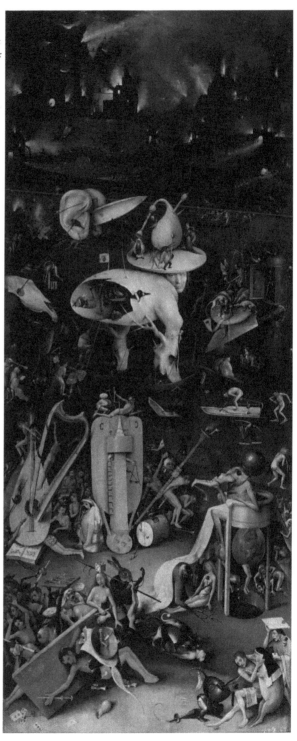

provided the artist with methods of representing what he saw" (*The Story of Art* 359).

What further distinguishes Bosch is that each of the panels in *The Garden of Earthly Delights*, which share the same horizon and have similar bodies of water, seems to evoke hellish moments. In the left panel, God is hardly a towering figure, and from the central panel he is absent. Paradise seems to be filled with mischief: we see a lion ravaging a gazelle, a cat dancing off with a mouse, a monstrous bird devouring a frog, and bizarre animals (such as a platypus-mermaid dressed in a monk's habit who is reading a book while resting in a dark pond), a three-headed crane, and a two-legged dog with long ears—all figures that could just as easily have appeared in the more sinister setting of hell. Because the idyll has such bizarre features, taking it seriously is difficult (Pokorny 25). The Eve we see in paradise is mirrored by the woman sitting in hell who personifies *Superbia* ("pride"). Toward the bottom right a demon accosts the woman. And though she looks like Eve, her seated posture mimics Adam's (Koerner, *Bosch and Bruegel* 215). The woman embodies, then, not only Eve's but also Adam's pride. Thinking that he could be satisfied with Eve, Adam turned from loving God to lusting after God's creation. The attacking demon (presumably a tortured version of Adam) explores Eve's body. Her image, which is reflected in the convex mirror, signals her vanity, to which she seems oblivious. The projection of Eve's reflection onto the head of the demon or ersatz Adam further melds Adam and Eve into one complex scenario. The middle panel is filled with sexuality and unbridled lust. We see here ominous cracks, mockery of chivalrous behavior, fantastic figures and fruits, and melancholic persons with their heads in their hands, seemingly bored with life. In the right panel, differentiating sinners and demons is not always easy.

The melting of defined borders in Bosch's triptych suggests a more chaotic and troublesome vision than we find in the conventional Christian narrative. Lynn Jacobs notes that similarities between exterior and interior as well as across panels break down traditional "hierarchical ordering" (1012). Guido Boulboullé underscores Bosch's unconventionality and the odd connections between heaven and hell. He emphasizes the work's multivalence: it cannot be captured with any single lens but seems to play with a variety of possible meanings: a moral lesson, warning sinners of their destined fate in hell; an apotropaic gesture, keeping demons at bay; a passing carnivalesque revelry

in bodily enjoyments; a hidden and perhaps even heretical message; and a modern depiction of a kind of earthly paradise. Joseph Koerner opens his analysis of Bosch's triptych by calling it "the most elusive artwork ever made" (*Bosch and Bruegel* 179). What might bring the various aspects together is the idea that the meaning of the universe transcends our understanding, which frees the artist to experiment with different worlds or different dimensions of this one world: the comically bizarre, the sensuously attractive, and the fearful and threatening. We see why the surrealists were enthralled not only by Arcimboldo but also by Bosch.

Bosch's work seems to be as much about the artist's fascination with his own creation, his remarkable capacity to blend the realistic and the absurd, the eccentric and the mundane, as it is with any univocal message. Bosch's absorption in the bizarre may have contributed to our uncertainty about the work's meaning. Koerner weighs whether Bosch's fascination is also our own, such that our mesmerized viewing of these bizarre images and acts, particularly Adam and Eve on the left panel and the idolaters and lustful in the middle, makes us as viewers analogous to those very figures. Koerner argues that "the scenes and structures that fascinate seem like projected symptoms of our own mesmerized beholding" (*Bosch and Bruegel* 219). We are drawn to an array of sensuous pleasures, to a combination of physical beauty and moral ugliness.

Bosch and his contemporaries were fascinated by death, from its physical ugliness to the afterlife torments inflicted on the sinful. In *The Waning of the Middle Ages*, Johan Huizinga writes: "No other epoch has laid so much stress as the expiring Middle Ages on the thought of death. An everlasting call of *memento mori* resounds through life" (124). The imminence of death was a reminder of human ephemerality and the inevitable accountability of Judgment Day. In *The Dead Lovers* (ca. 1470), two emaciated humans, their skin wilting and rotting, are infested by flies, snakes, and toads (illustration 18). Another brutal image is the *Triumph of Death* (ca. 1562), an oil on panel by the great Flemish painter Pieter Bruegel the Elder (illustration 19). A hellish scene on earth represents the transition to death. The landscape is dark, desolate, and bereft of life. Throughout are images of killing and dying as well as skeletons, as with the horse and rider drawing a wagon full of skulls. Rich and poor alike fall victim to indiscriminate death.

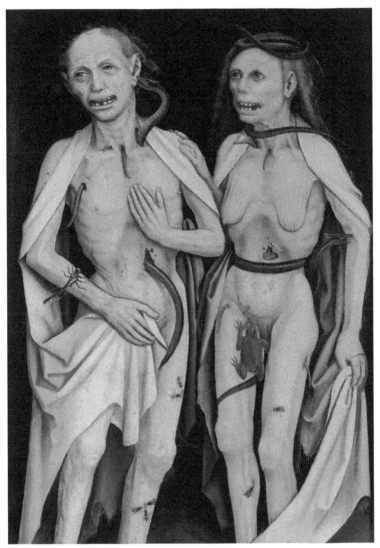

ILLUSTRATION 18
Anonymous master from Swabia or the Upper Rhine, *The Dead Lovers*, ca. 1470,
Oil on panel, Musée de l'Œuvre Notre-Dame, Strasbourg/Bridgeman Images.

One could almost say that death comes alive in the way it cele-
brates itself, as in Michael Wolgemut's *Dance of Death* (1493). Death
haunts the figures in Hans Baldung Grien's painting *Death and the
Woman* (ca. 1518–19) and Holbein's *The Cardinal, the Abbott, or the
Monk* from his *Dance of Death* woodcut series (1538). Baldung's maca-
bre and grotesque *Death with an Inverted Banner* (ca. 1506) illustrates

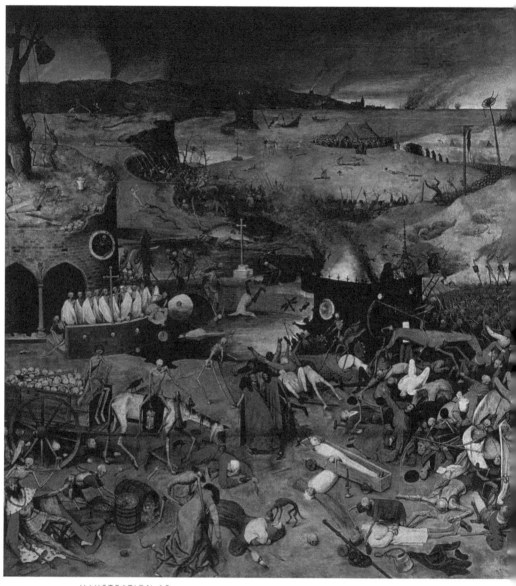

ILLUSTRATION 19
Pieter Bruegel the Elder, *The Triumph of Death*, ca. 1562, Oil on panel, Prado, Madrid/Bridgeman Images.

the late medieval northern Renaissance engagement with death, a major theme also in Koerner's comprehensive account of the German Renaissance. Baldung, who was Dürer's best student, models the figure of death on Dürer's *Adam and Eve* (1504), disfiguring the image of Adam in the process. Koerner writes: "The decaying corpse is linked

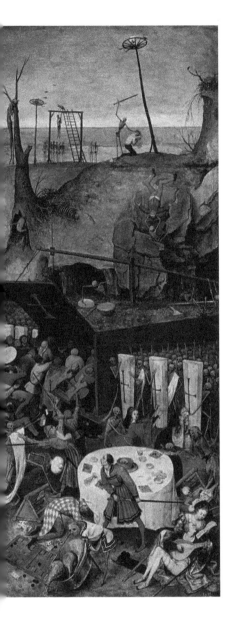

to Adam because it was through Adam's sin that death came into the world. Thus all that is living in Dürer is given over to death in Baldung's sketch" (*Moment of Self-portraiture* 256). The perfect body is a rotting, if animated, corpse. The tree of life is replaced with the banner of death, the naturalized landscape with blankness. Niklaus Manuel Deutsch's *Death and the Girl* (1517) accentuates the link between death and sin. One can die symbolically and morally (via sin) and also literally and physically: death embraces the girl, kisses her, and grabs her crotch, guided by the girl's own hand. Moral ugliness is layered over her physical beauty and death's ugliness.

Northern European art of the late sixteenth century is influenced by Luther, who was fascinated by the devil; one need only read his *Tischreden* (*Table Talk*), in which the devil appears hundreds of times, at times quite colorfully. Luther emphasized human baseness and continued to advance the connection between cleverness and evil, noting that the devil is a crafty interlocutor (no. 612) and disguises himself well (no. 1144). John Calvin expanded Luther's stress on human corruption. In *Institution of the Christian Religion*, he argues that in Adam's "corruption all humankind was worthily corrupted" (2.1.6, translation modified). The Swiss Reformer underscores the ugliness of Adam's sin: "When *Adam* fell from his estate, he was by that departure estranged from God. Wherefore although we grant that the Image of God was not altogether defaced and blotted out in him, yet was it so corrupted

that all that remained was ugly deformity [ut quicquid superest, hor-
renda sit deformitas]" (1.15.4, translation modified).

The devil's supernatural powers to harass and afflict are evident in
the temptation of St. Anthony, which has been rendered by a wide
array of Christian artists. These range from figures of the northern
Renaissance, such as Martin Schongauer, Lucas Cranach the Elder,
and Niklaus Manuel Deutsch, and Dutch and Flemish artists, such as
Hieronymus Bosch, Quentin Matsys, and Pieter Brueghel the Elder,
to late sixteenth-century artists, such as Tintoretto and Jacques Callot.
Partly because of his versions of St. Anthony, Bosch was considered
peerless in his capacity to portray the devil and his temptations. These
came not only from the outside, but also from within: the more one
sought ascetic renunciation, the more lucid became the soul's vision
of the suppressed temptations (Koerner, *Bosch and Bruegel* 169–70).

The St. Anthony theme reaches even into modernity. The nine-
teenth and twentieth centuries saw versions not only in painting, as
with Paul Cézanne and James Ensor, Max Beckmann and Max Ernst,
Otto Dix and Salvador Dalí, but also in music, as with Paul Hindemith.
Hindemith tried in his *Mathis der Maler* (*Matthias the Painter*), espe-
cially the symphony (Hindemith composed both an opera and a sym-
phony by the same name), to capture Grünewald's striking version of
the devil's torments. In the third and final movement of the symphony,
the music is chromatic and at times haunting, hectic, seductive, and
twisted until we move to the glorious brass alleluias of the conclusion.

In 2015, the accomplished Russian émigré Maxim Kantor painted
a striking contemporary version of *The Temptation of St. Anthony* (il-
lustration 20). The oil on canvas has several fascinating elements. First,
the greatest danger comes in the form of a dragon, which has unmis-
takable traces of Vladimir Putin, in the eyes and in the shape of the
head, which resembles a skull. The allusion to Revelation 12:3–9 sug-
gests that Putin is the devil. Second, the group of pigs around Putin,
one of whom wears glasses, echo his supporters—intellectuals, minis-
ters, and oligarchs. Third, the Christian motif of the fish, symbolizing
Christ, has been transformed. The fish are eating other fish: the Chris-
tian message has been used as a shield to destroy one another, partly a
general allusion to the modern world's loss of Christian values, partly
a more specific reference to the corruption of the Russian Orthodox
Church, which has worked in tandem with the Russian state to sup-
port illiberalism and authoritarianism, not least of all because of their

Maxim Kantor, *The Temptation of St. Anthony*, 2015, Oil on canvas, Collection Maxim Kantor, Germany.

shared hatred of multiculturalism and homosexuality. The heavens are water, in which many are drowning, a seemingly unprecedented image. The sickish green and pink, colors of war, evoke poison gas, camouflage, putrefaction, and the glow of bombs. Not only the dragon itself, but the other human figures are combined with nonhuman creatures, partly bats, partly pigs, partly fish. The only red, the red of martyrdom and true socialism, belongs to Anthony. Unlike in the tradition, Anthony is completely beyond temptation, riding the fish of Christianity and immersed in a book, which, as in Augustine and unlike in Dante's second circle of hell, provides orientation for faith and intellect. The image alludes to Bosch and Daumier, even as it remains distinctive.

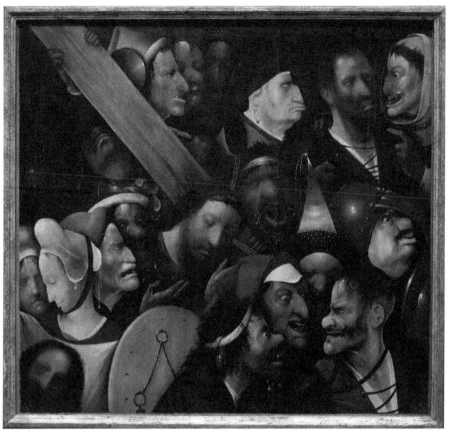

A powerful work that combines the two dominant themes of Christian ugliness—the Crucifixion and human sinfulness—is *Christ Carrying the Cross* (1510–35), an oil on panel by Bosch or a follower of Bosch (illustration 21). On the one hand, the very center of the work exhibits Christ's burden in carrying the cross. On the other hand, the crowd is depicted in its perverse ugliness, with various kinds of hateful and scornful expressions. The work is laced with abundant physical ugliness, indeed grotesqueness. One can almost hear the cacophony. In the language of the time, the faces reveal such vices as rage, cruelty, deceit, aggression, and gluttony. Beyond including anti-Semitic clichés, the artist extends his portrayals of ugliness to humanity as a whole. The extreme close-ups, beyond which one cannot see,

along with the resulting lack of depth, add to our sense of oppression, even claustrophobia. In the combination of faces one could almost speak of social ugliness as an intensification and interweaving of other forms of ugliness. This kind of social ugliness reappears centuries later in Belgian painter James Ensor's *Christ's Entry into Brussels in 1889* (1888), which likewise presents viewers with a mob of ugly faces, skulls, and masks. The themes in *Christ Carrying the Cross*—crucifixion and moral ugliness, the two distinctive elements of Christianity's immersion in ugliness—are ultimately connected, for the Crucifixion had as its purpose the forgiveness of human sins.

THE THEOLOGICAL RATIONALE FOR CHRISTIANITY'S IMMERSION IN UGLINESS

The Lowliest of the Low

Why was the Christian world able to tolerate such ugliness long before it became a more widely accepted aesthetic category? The Incarnation and Crucifixion are central. Christ did not simply enter this world. He became the lowliest of the low, expressing solidarity with the downtrodden. The New Testament consistently associates Christ with the rejected. Galileans were among those whom the educated, prosperous, and well-connected mocked and despised (Elizondo 49–66). Christ, who took the form of a servant, praises the poor and elevates the simple (Matt. 11:25–30; Luke 6:20–26, 10:21–23; Phil. 2). The crucial theological concept for Christ's humility and abasement is

kenosis, "self-emptying." Its locus classicus is Paul's Letter to the Philippians 2:7, where Jesus "emptied himself." By lowering himself, identifying with the outcast, and welcoming sinners (Luke 15:2), Christ reversed all hierarchy. Moreover, Christ's lowliness implicitly elevated the forsaken. For Christ, the most wretched person, however deficient in word or deed, has dignity and is loved.[1] Those who appear exalted are no longer exalted, the lowly no longer low: "But God chose what is foolish in the world to shame the wise; God chose what is weak in the world to shame the strong; God chose what is low and despised in the world, things that are not, to reduce to nothing things that are, so that no one might boast in the presence of God" (1 Cor. 1:27–30). Just as Christ's life culminates in abjection, the abject and forsaken carry the seeds of the divine. Christ is mocked, spat upon, struck, slapped, and eventually stabbed (Matt. 26:67, 27:30; Mark 14:65; John 19:1–3, 33–34), dying in weakness (2. Cor. 13:4; cf. 2 Cor. 12:9; Phil. 2:7–8). When after his death he appears to the apostles, he still has wounds in his hands and side (John 20:20). The horizontally outstretched arms of Christ on the cross became reinterpreted over time as the form of death in which Christ signaled universal embrace.[2]

In depicting Christ so gruesomely, Grünewald, along with his forerunners and contemporaries, drew on biblical resources and the patristic tradition. Christ laid aside his pure divinity and majesty. He "had to become made like his brothers and sisters in every respect" so that he could identify with them in their suffering and temptation. He could thus "sympathize with our weaknesses" (Heb. 2:17–18 and 4:15). At the time, crucifixion was reserved for the lowliest of the low: slaves, robbers, rebellious foreigners, and violent criminals (Hengel). It was "one of the most terrible deaths known to antiquity" (Raymond Brown 855). Indeed, the root of the word "excruciating" (*cruciatus*) is "cross" (*crux*). When in section 124 of his *Commentary on Matthew*, Origen analyzes Matthew 27:25, he speaks of "the ugliest death of the cross" (ad mortem turpissimam crucis) (Origen, *Matthäuserklärung II* 259). The Latin *turpissimus* is the superlative of *turpis* ("ugly"); it means here "ugliest possible" or "most vile."[3]

Christ as the lowliest of human beings is underscored by biblical references to the Messiah as a worm. In Job 25:6, "the son of man," the phrase adopted by Christ, is likened to "a worm." In Psalm 22:6, the Messiah psalm that begins "My God, my God, why have you forsaken me?" we read: "But I am a worm, and not human; scorned by others,

and despised by the people." Pseudo-Dionysius invokes this theme, the divine in the form of a worm (*Celestial Harmony* 2.5). Speaking in Christ's voice, Suso says that Christ hung on the cross and was mocked and scorned: "They destroyed Me in their hearts completely, even as if I were an unsightly worm" (als ob ich ein ungenemer wurm were) (*Little Book of Eternal Wisdom* Eng. 105; chap. 15). Psalm 69 was likewise interpreted as prefiguring Christ's shame. On the cross, Christ was despised and humiliated, treated with the contempt one might show for a worm. Isaiah 53, with the ugly, despised, and rejected servant, is likewise associated with Christ. The passage refers to one who had "no form or majesty that we should look at him, nothing in his appearance that we should desire him . . . he was wounded for our transgressions, crushed for our iniquities; upon him was the punishment that made us whole, and by his bruises we are healed . . . the Lord has laid on him the iniquity of us all . . . like a lamb that is led to slaughter."[4] The Gospels make reference to Isaiah: "He took our infirmities and bore our diseases" (Matt. 8:17).

For the early Christians, Christ's crucifixion was a scandal: How could Christ undergo such a cruel, indignant, humiliating, indeed shameful death? The puzzle is so overwhelming and the message so revolutionary that even the disciples were unable to understand.[5] A primary subtext of the Gospel of Mark is the disciples' failure to comprehend Christ.[6] This inability comes to the fore when Peter rebukes Christ for the prophecy that he will be rejected, suffer, and die. In response, Christ scolds and threatens Peter, calling him "Satan" and telling him to follow, not lead (Mark 8:33). The disciples' lack of understanding is particularly prominent when, after Christ prophesies being condemned, mocked, spit upon, flogged, and killed (Mark 10:33–34), two of the disciples respond by completely ignoring Christ's comments and requesting privileged roles for themselves. Christ admonishes them: the last will be first, and those who would save their lives must lose them (Mark 10:43–45; cf. 8:34–38 and 10:31).

To Paul we owe explicit reference to the "foolishness" and "weakness" of the cross and the difficulty of comprehending Christ's death, its "offense" to those who do not understand (1 Cor. 1:18–2.5; Gal. 5:11). For the ancients, death by crucifixion contradicted the concept of divinity. The Gospels of Mark and Matthew do not portray a beautiful, harmonious death. Christ was "distressed and agitated" (Mark 14:33), mocked and "taunted" (Matt. 27:41–44). He was "deeply grieved, even

to death" (Mark 14:34). On the cross, Christ lamented that he had been forsaken, and at the moment of his death he "gave a loud cry" (Mark 15:37). Not only the idea of a God who is broken in this way is revolutionary, so too the disruption of the symmetry of physical and moral ugliness, which had been prominent in the Old Testament. In Leviticus 21:16–24, those who are "blind or lame," those with a "mutilated face or a limb too long," those with a "broken foot or a broken hand," those with an "itching disease or scabs or crushed testicles" may not approach the altar, for they have "a blemish." Christ stands this link on its head—not only in his suffering but also with his words (John 9).

In the early third century, Tertullian cites Isaiah: "It shall be my Christ, be He inglorious, be He ignoble, be He dishonored" (Si inglorius, si ignobilis, si inhonorabilis, meus est Christus) (*Against Marcion* III.17). Not celestial in his body, Christ was like us. Tertullian comments: "His body did not reach even to human beauty, to say nothing of heavenly glory. Had the prophets given us no information whatever concerning His ignoble appearance, His very sufferings and the very contumely He endured bespeak it all. The sufferings attested His human flesh, the contumely proved its abject condition. Would any man have dared to touch even with his little finger, the body *of Christ*, if it had been of an unusual nature; or to smear His face with spitting, if it had not invited it (by its abjectness)?" (*On the Flesh of Christ* ch. 9). In making the case that Christ is not only divine, Tertullian stresses Christ's humanity, suffering, and abjectness. Tertullian is not alone among the early Church fathers. Already Irenaeus makes clear that Christ was "a man without comeliness [indecorus], and liable to suffering . . . despised among the people" (*Against Heresies* 3.19.2). Christ was "weak [infirmus] and inglorious" (44.33.12). Origen also cites the vision of Isaiah, noting that Christ had "no form nor glory . . . no form nor beauty; but His form was without honour, and inferior to that of the sons of men" (*Against Celsus* 6.75).

We find an even stronger intellectual rationale for such a depiction in Augustine. In his ninth homily on the First Epistle of John, given in 407, Augustine introduces the idea of Christ's ugliness by suggesting that God is both beautiful and ugly. God is beauty and splendor. In contrast, our wickedness renders us loathsome and "ugly" (9.9). Yet because Christ assumed human form, he partook of our loathsomeness: "But, because he took on flesh, he took on as it were your loathsomeness—that is, your mortality—in order to accommodate

himself to you and to be suited to you and to arouse you to love beauty inwardly. How, then, do we find that Jesus is loathsome and ugly, as we have found that he is beautiful and *splendid in form beyond the sons of men*? How do we find that he is also ugly? Ask Isaiah. *And we saw him, and he had neither splendor nor comeliness* (Is. 53:2)" (9.9). Augustine invites us to use our understanding to solve this riddle. He cites Philippians 2:6 and argues that God sacrificed himself to make us beautiful. Christ "*had neither splendor nor comeliness* so that he might give you splendor and comeliness" (9.9). Our soul is loathsome through wickedness, but "by loving God it is made beautiful" (9.9). Likewise in his *Homilies on the Gospel of John*, Augustine underscores this theme: Christ "loved the foul and ugly in order to make them beautiful" (10.13).

About a decade later, Augustine returns to God's ugliness. The concept is central to his twenty-seventh sermon, which explores Psalm 96, Paul's Letter to the Romans, and several other texts, including Isaiah 53:2–3. After Augustine opens with comments on human sinfulness, the sermon expresses caution about doubting divine justice or seeking to decipher it from our limited perspectives. Instead we are called to have faith in divine justice, which is inscrutable and wondrous. In outlining the possibility of faith in divine justice, Augustine emphasizes Christ's deformity: "For the sake of your faith Christ became deformed" (Sermon 27.6). "*And we saw him, and he did not have any sightliness or comeliness, but his features were abject . . . contemptible and deformed his bearing, a man beset with injuries and familiar with enduring infirmities* (Is 53:2–3). Christ's deformity is what gives form to you [deformitas Christi te forma]. If he had been unwilling to be deformed, you would never have got back the form you lost. So he hung on the cross, deformed; but his deformity was our beauty [pendebat ergo in cruce deformis, sed deformitas illius pulchritudo nostra erat]" (Sermon 27.6). For Augustine the "deformity of Christ" is his crucifixion: "Let us not be ashamed of this deformity of Christ" (Sermon 27.6). Augustine argues that Christ shed his beauty so that love could exist between him and our deformed souls. He shed his pure existence in the realm of the ideas and forms (*forma*) and became ugly (*deformis*) for us. But in truth, Christ who seems ugly is alone beautiful (Sermon 138.6; *Exposition of the Psalms* 127.8).

Augustine's idea is received and advanced by later Christian thinkers, including Bonaventure. The horrendous crucifixion is central to

his *Tree of Life* (1259–60), a meditation on Christ's life. Bonaventure devotes much of the treatise to Christ's having been betrayed by Judas, surrounded by a mob, bound with chains, denied by his followers, scorned by all, nailed to the cross, pierced with a lance, and dripping with blood. Christ "appeared ugly [deformis] for the sons of men" in order to avert God's anger toward our wantonness (§29).

We see a dialectic whereby Christ is indeed ugly but also and ultimately beautiful. In her revelations, Julian of Norwich, a contemporary of Chaucer, the first known female author in English literature, and the greatest of the medieval English mystics, exhibits this dialectic. In a vision of Christ's face on the cross, Julian sees "a figur and a liknes of our foule, black, dede hame [skin] which our faire, bright, blessed lord bare for our sinne . . . wilfully going to his death, and often changing of coloure" (*A Revelation of Love* 159). This foul and dark image comes partly because Christ, though himself unblemished, has taken into himself our ugly sins. In her revelation of Christ's death, Julian does not shy away from its ugliness: "This was a swemfulle [terrible] change, to se this depe [deep] dying. And also the nose clongen togeder and dried, to my sight, and the swete body waxid browne and blacke, alle changed and turned oute of the fair, fresh, and lively coloure of himselfe into drye dying. . . . This long paining [suffering] semede to me as if he had be sennight deade [had been dead seven nights = the number of nights Julian had lain sick], dying, at the point of outpassing, alwey suffering the gret paine" (*A Revelation of Love* 179). Yet before she describes her revelations, she says not Christ on the cross, but everything other than the cross is ugly: "All that was beseid the crosse was oglye and ferful to me, as if it had ben mekille occupied with feindes [greatly infested with fiends]" (*A Revelation of Love* 133). Julian draws on these visions to move toward an understanding of the divine as loving, not wrathful (267). She reevaluates sin as a path toward self-knowledge and adopts a capacious understanding of the world as all-pervasively good (*A Revelation of Love* 209–11).

For Christians, God's dialectical beauty is evoked in lowliness. Grünewald is able to integrate uncompromising realism with a sense of transcendence. Common to the philosophical, theological, and artistic traditions is the effort to capture divine complexity by way of the *coincidentia oppositorum*, "coincidence of opposites." Associated above all with Pseudo-Dionysius, Meister Eckhart, and Nicholas of Cusa, the idea has endured and is shared across the Catholic and Protestant

traditions. After speaking at length of God's glory and beauty, the Swiss Reformed theologian Karl Barth turns to the Incarnation, emphasizing God's oneness with human corruption, his suffering, and his humiliation. And yet it is here—and not in the idea of "a glorious Christ who is not the crucified" (*The Doctrine of God* Ger. 2/1:750; Eng. 2/1:665)—that we find Christ's ultimate beauty: "God's beauty embraces death as well as life, fear as well as joy, what we might call the ugly as well as what we might call the beautiful" (Ger. 2/1:750; Eng. 2/1:665). Grünewald's *Crucifixion* is mentioned more than fifty times in Barth's writings (Marquard 9), and in a letter a few months before his death, Barth wrote that "as a visual aid Grünewald's picture of the passion has hung before me for the last fifty years" (*Briefe* 503; *Letters* 315).

This dialectical concept of the divine extends into the present. German Reformed theologian Jürgen Moltmann says that "God is revealed as 'God' only in his opposite, in godlessness and abandonment by God" (Ger. 32; Eng. 27, translation modified). Moltmann notes that "the crucified Christ became the brother of the despised, abandoned, and oppressed. . . . Christian identification with the crucified Christ means solidarity with the sufferings of the poor and the misery both of the oppressed and the oppressors" (Ger. 29; Eng. 24–25). Reflecting on Grünewald, Moltmann states, "Through his own abandonment by God, the crucified Christ brings God to those who are abandoned by God" (Ger. 49; Eng. 46). Moltmann adds, "The church of the crucified was at first, and basically remains, the church of the oppressed and insulted, the poor and wretched, the church of the people" (Ger. 54; Eng. 52). God "humbles himself and takes upon himself the eternal death of the godless and the godforsaken, so that all the godless and the godforsaken can experience communion with him" (Ger. 265; Eng. 276).

It is not surprising, then, as we take a closer look at the wider implications of the lowly and ugly Christ and Christ's insistence on solidarity with, and action on behalf of, the poor, to find a link between the poverty and ugliness of Christ and liberation theology (Matt. 5:3, 25:21–46; Luke 6:20). *A Theology of Liberation*, by the Peruvian theologian and priest Gustavo Gutiérrez, is animated by the idea that Christ calls us to express solidarity with the oppressed. Gutiérrez's desire to denounce injustice and consider the poor "preferentially" is very much informed by the meaning of Christ's mission, including his sacrifice on the cross: "Vatican II asserts that the Church ought to carry out its

mission as Christ did 'in poverty and under oppression' (*Lumen gentium*, no. 8)" (131). Salvadoran painter Roberto Huezo's *Stations of the Cross*, located in the Jesuit Chapel at the University of Central America in San Salvador, evokes parallels between the agony of Christ and that of the Salvadorans, who suffered years of violence and torture, including the murder of tens of thousands. The focus on deep affliction is unrelenting, even as the torment still points toward the hope of redemption. Horrific images of the crucified Christ are not uncommon in developing countries, whereas crucifixes of a serene and handsome Christ figure are encountered more frequently in developed countries. Christian African Americans who suffered under white supremacy during the era of lynching turned to the cross more than to any other aspect of Christ's ministry or narrative. In fact, they drew comparisons between the cross and the lynching tree: both were instruments to humiliate, torture, and execute the lowliest of the low (Cone, *The Cross*).

In his magisterial *Mimesis*, Eric Auerbach, a German Jew who fled Nazism, shows how the Christian worldview altered the aesthetic sensibilities of believers and, eventually, the Western tradition. Much as the noble Christ could be portrayed as ugly, in the humility of his crucifixion, so could the lowly servant Peter, with his betrayal of Christ, be lifted out of comedy and into tragedy (*Mimesis* 40–49, 72–73, 151–60, 247–48). A fisherman who has no political role, a servant who thinks he knows more than his master and doesn't—such a person belongs in comedy. The style with which Peter's lies are narrated is a lower style, not elevated, the style of comedy. Even the repeated iteration of his mistake belongs in comedy. And yet the account in the Gospel of Mark ennobles Peter, a simple person, to tragic stature. When he denies Christ three times and weeps, we weep with him. The ideas that God is all-loving and that all persons have dignity and deserve our sympathy break apart genre expectations, for the lowly human then becomes capable of revealing and embodying transcendence.

Auerbach does not focus on ugliness, but the thrust of his thesis allows us to see a radical shift in views of ugliness. Whereas in the Hellenistic age images of deformity and ugliness had as their telos laughter and derision, Christianity reverses this evaluation. Sympathy becomes the overriding reaction: we become aware of the hidden dignity in even the most grotesque bodily shapes. Of course, the idea does not immediately translate into reality, as we know from the medieval Christian emphasis on the symmetry of physical and moral ugliness,

but Christianity does over time shift our perception of ugliness. Some progress is visible early, such as the Christian response to the abandonment of newly born children. Among those exposed (*expositio* = "placing out") were deformed babies.[7] Christians rescued abandoned children, and Christian writers, including Justin Martyr, Tertullian, and Lactantius, spoke out against the abandonment, thereby contributing to changes in attitudes and eventually in Roman law (Grubbs). The Christian attitude toward physical ugliness led more broadly and over time toward not only tolerance and acceptance but also eventually an embrace of all insofar as everyone carries a divine spark.

In his essay "*Sermo humilis*," Auerbach continued his focus on aesthetic reevaluation, noting that *humilis* means above all "low," "negligible," "disdainful," "worthless," if also "modest." To contemporaries versed in ancient rhetoric, the style of the New Testament seemed vulgar, but Christians embraced this lower style as proper to its elevated theme (1 Cor. 1:18–31). The paradoxical idea of the most noble ideas and most sublime mysteries being accessible to the least educated, the humble in spirit, matched the Bible's language. The modest style was appropriate to the dialectic whereby the most exalted humbled himself to lowliest stature: "The absurdity of Christian revelation, the birth of God in a stable, had its exact parallel in the intolerably barbaric style of Biblical portrayal" (Haug, Ger. 18; Eng. 18, translation modified). Idea and style were in harmony, each a coincidence of opposites. Ugliness in form mirrored ugliness in content.

The most important adjective associated with the Incarnation was *humilis* (Auerbach, "*Sermo humilis*" 317). Having been born as a lowly servant was central to Christ's identity (Phil. 2:7–8). Augustine, who as a teacher of rhetoric disparaged the low style, eventually learned to understand and embrace it (*Confessions* 3.5.9 and 7.21.27). He compares Christ, who was "humble" and "came in lowliness," with the Platonist philosophers, who in their pride looked down on the body: "Christ came in humility, and you are proud" (Christus humilis, vos superbi) (*City of God* 10.29). The word "humility" comes from the Latin "humus," meaning "ground," "earth," or "soil." One of the first painters to capture this idea of humility was Jacopo Bassano, whose influence on Caravaggio was not insignificant. Consider the soiled feet of the pious worshiper in Bassano's *Adoration of the Shepherds with Saints Vittore and Corona*, also known as *Il Presepe di San Giuseppe* (1568), which is in the Bassano Museo Civico or in the various nativity

paintings of unnamed artists in Bassano's circle, such as *Nativity*, by an unrecorded Italian artist after Bassano (ca. 1600), which is in the Raclin Murphy Museum of Art at the University of Notre Dame.

Caravaggio beautifully captures this concept of Christian humility, the intertwining of the undignified and the transcendent. Consider the unwashed feet and soiled cap of the peasants in Caravaggio's *Madonna of Loreto* or *Madonna of the Pilgrims* (1603–4), a painting ahead of its time in elevating "pious poverty" and simplicity over "decorum" and the "church-approved trappings of divinity" (Spike 149–50) (illustration 22). The ideal and the real are here interwoven, with the filthy feet in the foreground, imposing themselves on us, as we and the pilgrims look up to Mary and child. His *Madonna of the Rosary* (1606) also highlights the dirty feet of worshipers. Further, Caravaggio portrays Christ with his wound and the apostles with their torn clothing and rustic-like appearance. *The Incredulity of St. Thomas* (ca. 1601–2) underscores this integration of lowliness, even if the light from above casts a nobility on their earthly appearance, again linking the divine with the lowly.

The identification of Christ with those of lower status was also extended to women. A small number of biblical passages link Christ with female imagery, such as Christ as a hen gathering her chicks under her wings (Matt. 23:27). In the twelfth century, the association becomes more prevalent. One factor is the increasing recognition, underscored above, of Christ as a figure humans can not only venerate but with whom they can identify. The connection is further deepened by "the rise of affective spirituality and the feminization of religious language" (Bynum, *Jesus as Mother* 129).[8] The body of Christ is often described with explicitly maternal imagery, underscoring Christ's accessibility and nurturing love; he is portrayed in ways that suggest identification with the female. The grammar that associates the body of Christ with *ecclesia*, the (feminine) Church, and the patristic analogy that spirit is to flesh as male is to female also reinforce the parallel. More vividly, Christ's flesh is shown as female, maternal and lactating. The wound in Christ's side serves as a kind of breast that bled and made salvation possible.

In the medieval mindset, breast milk was a kind of blood (Bynum, *Jesus as Mother* 132). In the Middle Ages, a bared breast need not be seen first and foremost as erotic, but could instead be viewed as maternal, offering food and sustenance. Bernard of Clairvaux, the father

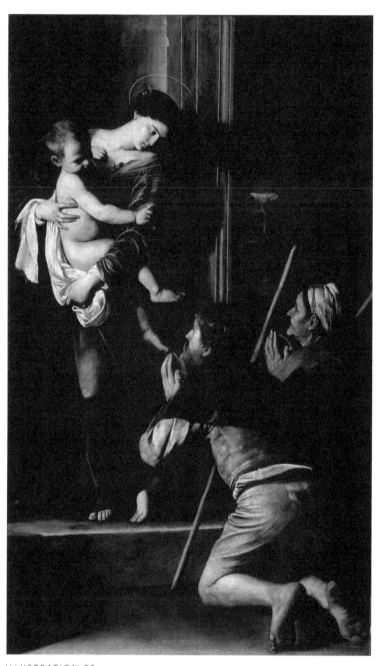

ILLUSTRATION 22
Michelangelo Caravaggio, *Madonna of the Pilgrims*, ca. 1603–6, Oil on canvas,
Chiesa di Sant'Agostino, Rome/Luisa Ricciarini/Bridgeman Images.

of the Cistercian Order, commands his readers: "Suck not so much the wounds as the breasts of the Crucified" (suge non tam vulnera quam ubera Crucifixi) (quoted in Bynum, *Jesus as Mother* 117). The inversion of the high and the low is analogous to the reversal of male and female; the seemingly inferior female gender could be made superior by God. Quirizio di Giovanni da Murano's *The Savior* (1460–78) portrays Christ offering his wound as a mother would offer her breast; in his *Triptych of Antonius Tsgrooten* (1507), Goswyn van der Weyden draws the parallel between Christ's wound and Mary's breast; and Jacob Cornelisz's *The Man of Sorrows* (ca. 1510) shows Christ's wound lactating like a breast, his blood representing suffering and salvation. In the fifteenth century, the core of Christ's humanity was seen in his suffering, and the sustenance of Christ was not available without suffering. In eating and drinking Christ's crucified body and his blood, the believer became Christ's crucified body, and so the Eucharist naturally led to stigmata, most especially for women, who were associated with the physical world (also in the pain of giving birth) and thus with Christ's humanity (Bynum, *Jesus as Mother* 146). Women did not need to reverse who they were to identify with Christ; they could simply sink more deeply into themselves, into vulnerability and suffering, into motherhood and bleeding (Bynum 172). To find themselves as Christ, men needed to become as women (Bynum 178). The reverse of this is that Christ, by being identified as female, elevated the status of women.

Moral Depravity

After the association of the mocked and ugly Christ with those who have been cast down, which allows Christians to understand the lowliest as having a spark of divinity, a second factor, which we have already introduced in chapter 5 (Sin and Hell) via examples, contributes to the ascendancy of ugliness: a greater recognition of the human capacity for evil and a conception of the human being as necessarily sinful. Sin conflicts with what should be and as such is a mode of ugliness. Sin, including original sin, and the all-pervasive temptations of the devil, followed by divine punishment, ensure that the Christian universe is deeply entrenched in moral ugliness.

All of this breaks with the ancient tradition. Socrates and the young Plato argued that if we know the good, we necessarily do the good. Knowledge is virtue. They contended further that if you are evil, you are necessarily unhappy, and so evil can be combated simply with reason. For Socrates and the young Plato, knowledge transforms your whole being, such that if you know, you will act. If you really have a vision of the moral world order, it transforms you, and you cannot help but act according to it. Knowledge involves "turning the whole soul" (*Republic* 518c). If you are not transformed by the insights, your understanding is only partial.

Christianity offers a radically different worldview. The human being is necessarily wicked, and reason does not prevent sin, it gives evil figures strategies to realize their aims. Machiavelli cannot be understood separately from his philosophical anthropology. He not only broke with the ancient idea that morals and politics are necessarily interwoven, he also advanced a Catholic interpretation of the human being as inconstant and deceptive, self-interested and wicked. It is not by chance that Machiavelli carried Dante around with him (*Prince*, "Letter to Francesco Vettori," 2). Christianity's deeper capacity for moral ugliness followed, according to Hegel, from its elevation of subjectivity. Greek art does not fully probe evil and ugliness,[9] for unlike Christianity it lacks a fuller exploration of "sin and evil," of "the ugly, the hateful, the repulsive" (*Werke* 14:24–25; A 436).

Christianity presents us with two moments foreign to the Greeks: first, Satan as an embodiment of evil and tempter of humanity; second, moral depravity as intrinsic to humanity. The two narrative arcs of Milton's *Paradise Lost* articulate the mythic origin of evil: on the one hand, the rhetorical cleverness and temptations of Satan; on the other hand, Adam and Eve's original sin, with its legacy of inevitable human failing and resulting need for redemption. In the New Testament, the devil is Christ's tempter and counterpart. Eusebius, the early fourth-century historian of Christianity, repeatedly calls Satan *misokalos*, a hater not only of good but also of beauty (*Ecclesiastical History* 2.14.1, 4.7.1, 5.14.1, and 5.21.2). In the Christian worldview, unlike the Greek model, knowledge need not lead to goodness, and for two reasons. Not only can the person with insight into virtue, such as Augustine, be morally weak and conflicted, failing to live up to ideals, but the devil can be knowledgeable, indeed may have abundant insight and formal intelligence. Humanity has to reckon, then, not only with its own sin-

fulness. The devil, too, is a threat. As we saw in Dante, the devil's helpers are shrewd, and those who follow Satan adopt his strategies. Shakespeare's dramas have no shortage of evil persons, such as Iago and Richard III, who enjoy their intellectual superiority. In Goethe's *Faust*, Mephisto has a captivating and rhetorically fascinating role. It is not by chance that mid-twentieth-century Germany's greatest actor, Gustav Gründgens, chose to play Mephisto, not Faust.

Whereas the ancient world had systematized the virtues, recognizing the four cardinal virtues and their interrelation, it had not done the same for vice. The Christian world, however, evolved the concept of the seven deadly sins. A writer such as Dante and an artist such as Bosch would have been unimaginable in ancient Greece. They are, however, at home in a Christian universe focused on moral depravity and our being led astray, with and without intellect. Not only do Satan and his many temptations render evil more prominent, the human will is itself interpreted as deficient. The concept of inevitable sin breaks radically with ancient tradition. Although references to flesh invoke the Incarnation (the "Word became flesh," John 1:14), they also suggest that the human being cannot help but sin: "The mind that is set on the flesh is hostile to God; it does not submit to God's law— indeed, it cannot, and those who are in the flesh cannot please God" (Rom. 8:7–8). Humans are, so the New Testament says, "slaves of sin" (Rom. 6:20). Taken literally, original sin means that sin came into the world through Adam, and subsequent human beings inherit Adam's sin; taken allegorically, it means that everyone is born with a sinful disposition, inclined to do evil and disobey God.

No one was more prominent in establishing original sin's literal and allegorical meanings than Augustine, who winds the concept through his *Confessions*, interweaving it with his own story of sin and salvation.[10] Already in book 1 the literal meaning surfaces. Addressing God, Augustine refers to "the sin of my infancy (for sin there was: no one is free from sin in your sight, not even an infant whose span of earthly life is but a single day)" (1.7.11). The deeper meaning of original sin is evident as Augustine explicates his weakness of resolve. His multifaceted concept of will breaks with the Socratic/Platonic idea that knowledge necessarily leads to goodness.[11] For Augustine the divided and broken will brings forth sin. Augustine recognizes the "bizarre situation" or monstrousness (*monstrum*) of a will that resists reason: "The mind commands the body and is instantly obeyed; the mind

commands itself and meets with resistance" (8.9.21). Augustine calls this inconsistency and lack of wholeness "a sickness of the mind [*aegritudo animi*], which cannot rise with its whole self on the wings of truth because it is heavily burdened by habit. There are two wills, then, and neither is the whole: what one has the other lacks" (8.9.21). Later, Augustine speaks of four or even more competing wills (8.10.24). He concludes by recalling "the sin that dwelt within me as penalty for that other sin committed with greater freedom; for I was a son of Adam" (8.10.22). Adam had the ability not to sin, but the heirs of Adam are born to sin (13.20).

For Augustine, original sin is historically the first sin, the sin with which humanity as a whole began, Adam's sin handed down through time; autobiographically too it is the first sin, the sin with which Augustine and all individual human beings are born; and it is the first sin in the sense of the most fundamental sin, at the heart of all moral weakness (Rigby 85). The devil's inviting temptations complement the human being's almost helpless disposition to sin. The Christian emphasis on the universality of original sin has an equalizing effect, which complements the Christian idea of humility, lowliness, vulnerability: all are equal before God, both in dignity and in the potential for sin.

Two passages in the *Confessions* are particularly memorable in illustrating human sinfulness, in particular the will's incapacity to realize the good. In book 2, Augustine steals pears not out of need or desire but simply for the sin itself: "We derived pleasure from the deed simply because it was forbidden" (2.4.9). The young Augustine loved evil for its own sake: "The malice was loathsome, and I loved it" (2.4.9). In retrospect he describes his soul as "depraved" (*turpis anima*) or, one could say more literally, "ugly" (2.4.9). Despite the profound influence of Plato, Augustine adopts here an anti-Platonic stance: Augustine knows the good but does not follow it. With Augustine full of pride and God absent from his heart, sin necessarily follows. In book 8, Augustine wants to reform but hesitates. He confesses that in praying to God, he even pleaded, "Grant me chastity and self-control, but please not yet" (8.7.17).

Sin as a central element of the human condition is related to the Fall and the need for a savior. In other words, from within this strict frame Christ would not be necessary if humans were not so bad, the world not so corrupt. Adam's sin is paired with Christ's sacrifice: "Therefore just as one trespass led to condemnation for all, so one

man's act of righteousness leads to justification and life for all. For just as by the one man's disobedience the many were made sinners, so by the one man's obedience the many will be made righteous" (Rom. 5:18–19).[12] The moral ugliness of human beings is ultimately overcome by the ugliness of Christ's torturous death. The idea that Adam's sin can only be reconciled by Christ's sacrifice is a general insight that has been emphasized more or less at various times, just as Christian thinkers have come forward with different views on the possible salvation of all. The two are related, for when the deep capacity for sin is coupled with the fear of eternal damnation, ugliness confronts Christians both in this world and beyond.

Sin and damnation are prominent themes in a genre of Christian writing called *de contemptu mundi* ("on contempt for the world") that began in the twelfth century and lasted through the seventeenth (Bultot). The first book of Thomas à Kempis's well-known fifteenth-century *Imitation of Christ* fits the model. Central to this tradition are the corruption of the human body; the brevity, mutability, and vanity of earthly things; the moral ugliness of society; and reward or punishment in the afterlife. The genre is in some ways a Christian version of Juvenalian indignation. Bernard of Cluny's *On Contempt for the World* alludes to Juvenal and consciously continues the satiric tradition (2.805). Written around 1140 and composed in dactylic hexameters, the work argues that love of God presupposes contempt for worldly things, which are fleeting and unworthy of our attention: "The world bestows nothing lovable. . . . Why do our fickle hearts cherish things that are nothing, things which our guilty hearts briefly rejoice about, but do not briefly grieve about a short time later? Why is the flesh, our nearest fire and inmost enemy, loved? . . . Oh beautiful flesh, after a short time stinking and full of filth, now a flower but soon dung, the lowest dung, why are you puffed up?" (1.726–38). Death is the purpose of life: "Why is a man born or a child brought forth? That he might die. He goes out into the air, he bears his troubles, he departs, he is buried as perishing sand, as a fleeting breeze has man been born" (1.726–38). As later Christian poets such as Andreas Gryphius do, Bernard plays with dichotomies: "Earthly glory is like lilies now, but tomorrow like the wind. Fair youth now flies away because of time, but later because of death. . . . If anyone might have the eyes of the lynx and keenness of mind, he would see, I believe, that sweet things are full of gall and handsome things are ugly" (1.819–26). We hear

echoes of Juvenal in the monk's recurring lament: "O wicked age!"[13] But Bernard's lamentation integrates the specifically Christian dimension of sin: "The face of the whole world is so ruined by sin that not even a child now goes forth untouched by corruption, by disease.... The whole world in every part rushes freely toward all evil" (2.379–99). In his descriptions of hell—fire, ice, darkness, stench, demons, serpents, whips, and torture—Bernard seems almost to anticipate Dante (1.475–718).

A few years before being elected to the papacy in 1198, Lotario dei Conti di Segni (Lotario dei Segni), later Pope Innocent III, wrote his widely read *On the Misery of the Human Condition* (*De miseria humanae conditionis*), which follows in many ways Bernard's model and is the most famous work of the *contemptus mundi* tradition. In assessing the vileness of the human condition, the future pope describes the human being as little more than "the food of inextinguishable, consuming worms" (1.1, my translation). Already in the first section he writes: "Man has been formed of dust, clay, ashes and, I think far more vile, of the filthiest seed. He was conceived from the itch of the flesh, in the heat of passion and the stench of lust, and worse yet, with the stain of sin. He was born to toil, dread, and trouble; and more wretched still, was born only to die" (1.1). In wailing at birth, humans "express the misery of our nature" (1.6). Almost like Juvenal, whom he quotes on the brevity of joy (1.21) and on unquenchable avarice (2.6), Lotario rails against the misery and idiocy of old age: "If anyone does reach old age, his heart weakens, his head shakes, his vigor wanes, his breath reeks, his face is wrinkled and his back bent, his eyes grow dim and his joints weak, his nose runs, his hair falls out, his hand trembles and he makes silly gestures, his teeth decay, and his ears get stopped with wax. An old man is easily provoked and hard to calm down. He will believe anything and question nothing" (1.10). He even includes a section on what is essentially emotional ugliness: "How much anxiety tortures mortals! They suffer all kinds of cares, are burdened with worry, tremble and shrink with fears and terrors, are weighted down with sorrow. Their restlessness makes them depressed, and their depression makes them restless" (1.14, translation modified). But the majority of the work interweaves physical and moral ugliness. Sexual pleasure is "utmost ugliness" (*extrema turpitudo*), and its result is the horrible condition of humanity from birth to death (2.21, my translation).

Transitory Ugliness

In Christian art and literature, the ugly and repugnant are brutal and horrific, yet, even in works such as *On the Misery of the Human Condition*, they are ultimately recognized as transitory, part of a larger tale of promise and redemption. This is the third reason why Christianity was able not only to tolerate, but to immerse itself in, ugliness. Christ sacrifices himself for humanity's sinfulness, but the Crucifixion does not conclude the Christian narrative. For Christians, ugliness is a moment in a larger story that ends with resurrection. Faith in this larger arc gives Christians the strength to linger in the abyss. Disgust with this world is combined with love of God and praise of heaven. Paradoxically, the religious frame allows for a deeper encounter with ugliness. Focusing on ugliness, on negativity, is less difficult if you have the expectation of eventual transfiguration and harmony. With that horizon before one, the human mind can more confidently descend into the depths. And when one has experienced the abyss, redemption is that much greater, as in the parable of the prodigal son. Augustine notes in his *Confessions*: "In every case, greater joy is heralded by greater pain" (8.3.8, translation modified).

If we focus only on the dying God, then we are quite close to atheism. A narrative that ends with Christ's death would give us a world of unredeemed suffering, a world without transcendence. Christian Boltanski expresses his admiration for Christianity by emphasizing Christ's poverty and weakness. Especially in a nation such as Mexico, Christianity portrays the dying Christ as "a poor, sickly body, all wounded and ugly" (Boltanski and Grenier 128): "When Christ dies, there's no God" (Boltanski and Grenier 127). But ultimately Christianity takes us beyond the dying God. At the core of its theology, Christianity holds out the possibility of atonement. In Christianity, radical grace, the unmerited love of God, is constantly possible. There is always the potential for redemption.

Grünewald's *Isenheim Altarpiece* II

In Christianity, suffering is but one part of a larger narrative arc. Grünewald painted the Crucifixion with the Resurrection in mind:

Grünewald's *Resurrection* after all belongs to the same Grünewald altarpiece as his *Crucifixion*. Patients at Isenheim saw both works. The predella panel, the *Lamentation*, exhibits Christ with his countless wounds and putrefying skin. It is visible below the main panel whether the wings are closed (and the crucifixion panel is visible above it, as during most of the year, including, of course, Passion Week) or whether the wings are open, as on festive occasions, such that the panels depicting the Annunciation, Christmas, and Resurrection are on display. Christ's death unites all: incarnation, crucifixion, and resurrection. The wounds and putrid skin of the *Lamentation* provide continuity with the *Crucifixion*, while the reddish sandstone coffin of the *Lamentation*, with its earth and flesh colors, appears again in the *Resurrection* (illustration 23).

Here the serene Christ is contrasted with the writhing Roman guards. One wears a helmet that shields him from the light, whose meaning he does not grasp, yet the helmet appears in the shape of a rose, his weapon includes the image of a rose, and he is one of five persons in the image. The five petals of the rose were traditionally associated with the five wounds of Christ: two hands, two feet, and side. Together, these images suggest that even the enemy of Christ is capable of developing toward selfless love (Schubert 108–9). Note the unprecedented array of colors. The light of Christ blinds or overwhelms the Roman guards. Such an astonishing stream of colors cannot be found before Grünewald (Schubert 103). They evoke the hallucinations and visions associated with St. Anthony's fire, which was being treated at the abbey (Hayum 50–51). The colors are also symbolic: red suggests sacrifice and royalty, and the blue fabric, which seems almost like a river, hints at the heavens and the saving power of baptism. The vivid colors are especially impressive, for on the eve of the Reformation, northern artists had become cautious about painting the divine. The center of the arts had moved toward printmaking and carved wooden sculptures (Hayum 57 and 69). Between the extreme distortion of the Crucifixion and the distinctly bold colors of the Resurrection, one can see why German Expressionists, such as Emil Nolde and Max Beckmann, were drawn to Grünewald.

John the Baptist appears in Grünewald's *Crucifixion* partly so that we can see him as once again whole (Fraenger 13). The vestiges of where he was beheaded are visible. This wholeness fulfills the idea of

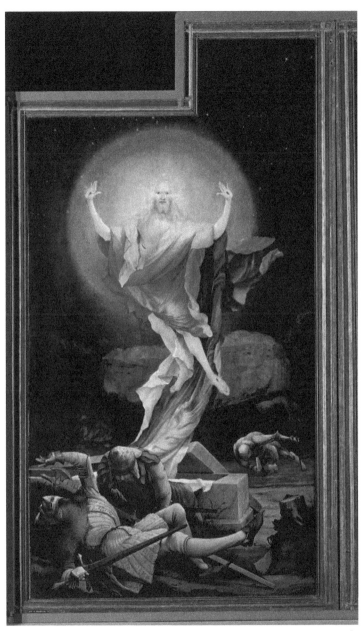

ILLUSTRATION 23
Matthias Grünewald, *The Resurrection of Christ, Isenheim Altarpiece* (right wing), ca.1512–16, Oil on panel, Musée d'Unterlinden, Colmar, France/Bridgeman Images.

baptism, which the healing water in the painting underscores. Wholeness becomes possible through Christ's sacrifice, in which John indirectly participates: his foot seems almost to be the lamb's fourth foot (Hayum 73–74). His raised finger calls attention to the full story. Just as John the Baptist pointed to the future of Christ, here he gestures to future redemption. The wood of the cross (death) and the waters of life (transcendence) are connected. Grünewald mediates baptism and the Eucharist as central and linked sacraments. Although the vertical of the cross, signifying transcendence and incarnation, represents in its darkness the severity of Christ's death, the light of the horizontal beam, indicative of community, alludes to the effects of this saving sacrifice. The blood flowing from the lamb into the chalice offers a modest gesture of hope, for the chalice signals the Eucharist, Christ's continuing presence among the faithful. The lamb's head, like Christ's, is tilted, but unlike that of Christ, it is raised, perhaps not simply to see Christ's sacrifice but also as a gesture toward transcendence. The realism of the *Crucifixion* is not contradicted by the seeming nonrealism of the lamb and the transhistorical appearance of John the Baptist; they are instead gestures to a different concept of reality (Gottfried Richter 13).

Grünewald shows how suffering and death can be exposed in their fullness insofar as they are part of a larger narrative. This dialectical structure animates not only Christianity but also art and literature informed by the Christian tradition. Consider as an example the German poet and journalist Matthias Claudius, who observes that at funerals most persons who look into a fresh grave cry or turn away, pale in their face, their eyes glazed over, trembling before the gravity of death. Claudius, however, is happy. Why? The deceased now has peace: "To look a corpse in the face is a moving, sacred, beautiful sight, but it must be one unadorned with costume and finery. The still, pale character of death is its jewelry, and the traces of decay its necklace and the first cockcrow of resurrection" (195–96).

Not all Christian art immerses itself in struggle and suffering. The very idea that ugliness is transitory has encouraged some believers to move far too quickly beyond Christ's suffering. Bruegel's *Christ Carrying the Cross* (1564) thematizes this temptation and its

aberrant consequences (illustration 24). The viewer must study the painting, which is overwhelming not only in its size (approximately 4 x 6.5 ft.) but also in its variety and busyness, including the range of human reactions, before discovering the small image of Christ, even though Christ is in the very center. Christians, so the work suggests, all too easily overlook Christ's collapsing under the cross, even though it is central. The artist has placed and sized Christ so as to lead the viewer to realize how easy it is to forget Christ and overlook the divine in human form. We are like those around him, who also have their heads turned away from Christ. The gathering clouds foretell not only Golgotha but also the darkness of our own inattentiveness.

The greatness of Grünewald lies in his exceptional focus on ugliness, which contrasts with crucifix images not only by Rubens but also by many others, from Raphael's *Crucifixion* (1502) to David's *Christ on the Cross* (1782) and beyond. The angelic tone of much of idealizing Christian art breaks radically with Grünewald. Consider the many images of St. Sebastian, such as the appealingly sensuous, even sensual images of Guido Reni, his *Saint Sebastian* (ca. 1615), *Saint Sebastian* (1617–19), and *Saint Sebastian* (ca. 1625). One sees how St. Sebastian became all the way to Oscar Wilde and beyond a symbol for homoeroticism. The idealizing strand within Christianity has continued to Warner Sallman's *Head of Christ* (1940), which has been reproduced more than 500 million times (Morgan, "Warner Sallman" 26), and into the world of contemporary Christian kitsch.

The Swiss theologian and Catholic priest Hans Urs von Balthasar, who undertook the most ambitious effort to reestablish the centrality of beauty for twentieth-century Christianity, has underscored, in contrast to modern Christian kitsch, the ways in which a Christian concept of beauty, which finds its pinnacle in Christ's death and resurrection, must not overlook ugliness. The title of Balthasar's multivolume study of theological aesthetics, *Herrlichkeit* (*The Glory of the Lord*), underscores the magnificence of the Crucifixion, which despite its superficial ugliness is in truth the crowning moment of Christian beauty, for it embodies Christ's suffering and self-sacrificial love, which evokes wonder and awe. Christ on the cross is a coincidence of opposites: God glorifies himself through a humbling act, by rendering himself lowly (Eng. 1:670; Ger. 1:645). Balthasar argues that through his crucifixion Christ gains knowledge of God, and by extension followers

ILLUSTRATION 24
Pieter Bruegel the Elder, *Christ Carrying the Cross*, 1564, Oil on wood, Kunsthistorisches Museum, Vienna/Bridgeman Images.

of Christ learn to know God through suffering (Eng. 1:263; Ger. 1:253). Balthasar rejects an idea of beauty as sweet, sentimental, and secure. Just as divine aesthetics integrates ugliness, so, too, worldly aesthetics "cannot exclude the element of the ugly, of the tragically

The History of Beautiful Ugliness

fragmented, of the demonic, but must come to terms with these" (Eng. 1:460; Ger. 1:442–43).

When beauty integrates ugliness, beauty itself can be difficult to discern. For Balthasar, God is hidden in the suffering Christ (Eng. 1:523; Ger. 1:503). We recognize concealment in worldly aesthetics also: "Where something unremarkable—the face of an old man, for example, or the still, restrained sorrow of a mother—suddenly betrays a secret beauty; most intimately, when what is crude, what is explicitly ugly, what is painful to the point of meaninglessness, the experience of being handed over to what is vulgar and humiliating, can appear as assimilated into a totality which can and must be accepted positively—without sweetening, just as it is" (Eng. 4:29; Ger. 3:1.30, translation modified). Consider in this context contemporary German writer Ludwig Steinherr's poem "Beauty." A physically ugly woman, short, with felt hair, and the face of a mummy slinks through the subway entrance, a plastic bag in her hands, and again and again stops in her tracks, smiling invisibly. The poem does not stall in this image of a homeless person lingering in the subway but concludes that she represents "That dreadful form of / beauty // in which archangels / undyingly / fall in love" (152). Just as truth is the whole, so is beauty the whole, and within beauty ugliness is present and in Christ central. For Balthasar, God's greatness, his "transcendental form" (Übergestalt), is most manifest in his bearing of sin and his "deformity"

(Ungestalt) (Eng. 1:460; Ger. 1:442). Balthasar, like Barth, had an image of Grünewald's *Crucifixion* hanging over his desk (Long 9). The work was in fact a gift from Barth, whose passage on the ugliness and beauty of Christ Balthasar quotes in his own account of God's simultaneous humiliation and exaltation (Eng. 1:55–56; Ger. 1:52).

Against the merely glorifying tradition that forgets the ugliness of Christ stand Christian works by modern and contemporary artists, such as George Rouault, Max Beckmann, David Jones, Graham Sutherland, and Maxim Kantor, all of whom employ elements of visual distortion. In Jones's *Crucifixion* (ca. 1922), a pencil and watercolor on paper, with Christ fully isolated, his blood runs across his body and down his feet beyond the paper. Sutherland's *Crucifixion* (1946) has obvious echoes of Grünewald. We see the suffering, not the risen, Christ. Kantor's *Golgotha* (2015) dramatizes Christ's immense suffering on the cross, his continuing awareness of the difficult human condition even as the robbers have passed away (illustration 25). The deep blue, which marks the gloom in the background, is also layered onto the harshly painted human figures, yet the same blue is associated with the heavens and thus redemption, such that there is a unity of Christ and the robbers, which reflects both suffering and possible salvation. As a final example, consider John Bisbee's harsh but poetic sculpted crucifix at the University of Notre Dame, *Spes unica*: although the composition as a whole is beautiful, the work is fabricated from nails and so is laden with the motif of suffering.

A Christian art that is realistic and not otherworldly or triumphalist is able to do justice to the gruesome aspects of reality without losing itself in them. Painting the wretched in their connection to the divine would seem to be more in harmony with the Christian message than religious kitsch. Both realistic and exaggerated, *The Body of the Dead Christ in the Tomb* (1520–22), by Hans Holbein the Younger, immerses the viewer in suffering (illustration 26). Holbein, who had seen Grünewald's *Crucifixion*, offers us a harrowing oil on panel that emphasizes not Christ's divinity but his humanity and death. The horizontal structure symbolically works against transcendence. The face is green, the body almost emaciated, wounds visible on the hand, side, and feet. The eyes and mouth are open, as if unable to comprehend the putrefaction of death. Rigor mortis seems to have disfigured the one visible hand. The colors are dark and earthy (such as brown) or cold (such as gray and green). The thin, emaciated body has a yellowish

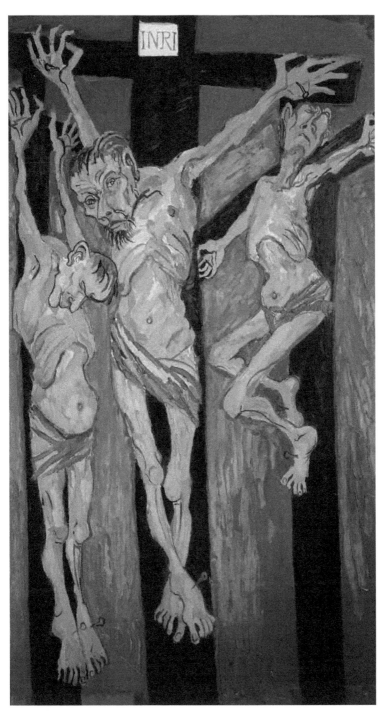

ILLUSTRATION 25
Maxim Kantor, *Golgotha*, 2015, Oil on canvas, Collection University of Notre Dame, Courtesy of Maxim Kantor.

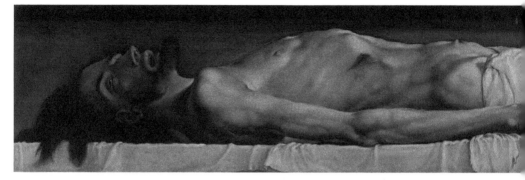

ILLUSTRATION 26
Hans Holbein the Younger, *The Body of the Dead Christ in the Tomb*, 1520–22,
Tempera on panel, Kunstmuseum, Basel/Bridgeman Images.

and in parts olive ugly hue. Showing Christ's flesh in the early stages of decay, the work is very much in the tradition of Grünewald. The macabre work is without any hint of radiance or transcendence.

Holbein's somber, realistic portrayal is repeatedly discussed in Dostoevsky's novel *The Idiot* (1868). Prince Myshkin comments that "some people may lose their faith by looking at that picture" (210; chap. 2.4). For the atheist Ippolit, the work elicits "a strange feeling of uneasiness" (391; chap. 3.6). The dark, sobering image would especially torment Orthodox Christians accustomed to icons, which offer an inspiring venue for humans to contemplate becoming more like the divine. The somber sensibility embodied in Holbein's work underscores the novel's darker moments, including the disastrous fate of the novel's Christ figure, Prince Myshkin, a wise simpleton and holy fool, who is unable to operate in society and goes mad. The gap between the ideal and the real becomes unsustainable. The horror of his epileptic fits shields his ecstatic visions from the world. As a Christ figure, Myshkin is "torn apart by the conflict between the contradictory imperatives of his apocalyptic aspirations and his earthly limitations" (Frank 317).

Although we see in modernity many deifying portraits of Christ, the Russian tradition has kept the ugliness of Christ alive. In Mikhail Bulgakov's unfinished novel *The Master and Margarita*, the Crucifixion, a scene of torture, is rendered with grotesque realism. To the great lament of his disciple, Matthew Levi, Yeshua's death comes slowly. (Bulgakov uses Aramaic, at the time the lingua franca of the Middle East: Yeshua, an Aramaic name, corresponds to the Greek *Iesous*, from which, through the Latin *Iesus*, we arrive at Jesus.) Swarming flies and

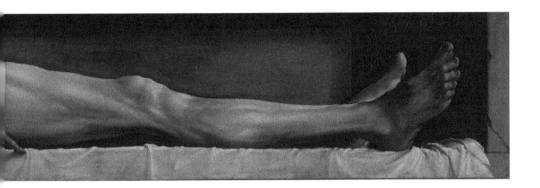

horseflies cover Yeshua's face, groin, belly, and armpits. Yeshua's body is yellow, and blood runs down the protruding ribs, the face swollen with bites and unrecognizable (180; chap. 16). The crucifixes of Russian oil painter Kantor tend to place greater emphasis on the suffering and humanity of Christ than on his triumph and divinity. Germany, too, is deeply conversant, even today, with the ugliness of Christianity. Not by chance Kantor has had his greatest reception there, and German poet Ludwig Steinherr has written a poem on Holbein's painting of the dead Christ, "Note in Damascus," which is no less harrowing than the image that inspired it.

As with Roman literature, so with Christianity, the motifs of these works become markers for subsequent appearances of ugliness. Even if later ages add new catalysts and contexts, a continuing impulse toward the dignity of all and enduring fascination with evil and darkness are central to modern art. However, the additional Christian idea that the ugly is to be embedded within a larger and more positive narrative recedes dramatically—indeed, it is almost entirely eclipsed.

O ur account so far has taken us from a time period (ancient Greece) to the culture of a time period (Hellenism) and then to a time period within an empire (imperial Rome) and finally to a time period and a religion (late medieval Christianity). This overarching development was known in the Middle Ages as *translatio studii et imperii*, "the transfer of culture and legitimacy" from ancient civilization to Christianity. After inserting into this well-known narrative a focus on ugliness, I have underscored revolutionary moments in imperial Rome and in late medieval Christianity. Although only Christianity survives, much of what we see in the earlier periods, for

example, ugly monsters, comic ugliness, and the link between realism and ugliness, endures.

Until now we have seen diverse impulses for ugliness. In the culture of ancient Greece, the ugly is above all a threat that challenged heroes and allowed them to shine. In Hellenism, the ugly in the guise of physical deformity becomes an object of ridicule. In the culture of imperial Rome, the dominant factor is political and social critique, a negation of the world's ugliness. In late medieval Christianity, we recognize two different themes. On the one hand, in images of the crucified Christ and in the dignity of the human being we see an empathetic impulse, designed to extend our range of acceptance; the ugly does not repel but brings us closer. On the other hand, the focus on moral ugliness embodies a critical thrust, but it is oriented far less toward political and social conditions and far more toward metaphysics and psychology, including human sinfulness. In addition to these content-oriented impulses, we have seen from a purely formal perspective fascination with ugliness. This impulse increases in modernity, along with the desire for originality. Still, modernity brings forward an equally strong critical impulse and moments of empathy. In many cases a layering of motivations is visible.

HISTORICAL
INTERLUDE

As we survey the long stretch from the late Middle Ages to the begin-
nings of modernity, the extent of ugliness at any given time and place
varies. Some epochs, such as the Italian Renaissance, step away from
ugliness. Other movements and periods, such as Mannerism and the
Baroque, engage ugliness. National differences play a role in this de-
velopment, but even they change over time. Although during the
Middle Ages and the Reformation the German tradition was deeply
immersed in ugliness, German *Klassik*, which viewed ancient Greece
as its ideal, tends, at least to a degree, to shy away from ugliness.

As humanism ascends, ugliness recedes. The Italian Renaissance
consciously shifted away from the cult of physical ugliness that domi-
nated the late Middle Ages, developing instead a more positive world-
view and elevating order, elegance, and harmony in sculpture and in
architecture.[1] Not surprisingly, in comparison with preceding cen-
turies, the Italian Renaissance, despite its interest in Christian themes,
gives us few examples of the Crucifixion (Rimington 44). In the ones
we have, suffering is modest. The Crucifixion tends to be integrated
peripherally and subtly. With its pyramidal structure, Raphael's *Ma-
donna of the Meadow* (1506) is stunning in its harmony. The meadow
runs beautifully across the back. Mary supports Christ and looks fondly

at the young John the Baptist. The references to the cross are subdued: the red of Mary's clothing, the poppy, and the small cross itself. Uniformity, symmetry, and an elevation of the organic whole over autonomous parts are among the categories by which the Renaissance distinguishes itself from medieval Gothic.

In *The Lives of the Painters, Sculptors, and Architects* (1550), a work that until the eighteenth century had no rival in art history, the Renaissance architect, painter, and historian Giorgio Vasari not only introduced the word "Gothic," he lamented "erections devoid of order or measure, and totally deficient in grace, proportion or principle" (*Lives* 1.xxvii). These "abominations of buildings," "the invention of the Goths," are "monstrous and barbarous and lack everything that can be called order" (*Vasari on Technique* 83–84, translation modified). The contrast with the Italian Renaissance could not be starker. Gothic architecture is characterized by sharp lines; seemingly unwieldy and exaggerated forms; an emphasis on the intricacy of individualized parts; fantastic ornamentation, including grotesque gargoyles; and pointed instead of rounded arches. From the perspective of Renaissance theorists and artists, who elevated smooth, harmonic lines, Gothic art was barbaric, disordered, ugly.

In contrast to the dismal medieval view of Lotario dei Segni, the future Pope Innocent III, with his *On the Misery of the Human Condition*, consider Giannozzo Manetti's Renaissance counterpolemic *On Human Worth and Excellence* (*De dignitate et excellentia hominis*) (1452). Manetti often cites classical thinkers, including Aristotle and Cicero. He stresses not simply that human beings receive divine gifts, but that they realize the potential of such gifts (Trinkaus 1:230). Though not without sin, the human being nonetheless reflects the divine. Toward the end of the third book, Manetti adopts the unusual view that even if human beings did not sin, Christ would have come into the world not to redeem the human being, but to ennoble and glorify humanity (3.58).

In his fourth and final book, the longest of the four, Manetti directly addresses Lotario dei Segni along with other thinkers, including ancient authors, who advanced a pessimistic anthropology. According to Manetti, the future pope overstates his case that from birth to death human beings suffer misery, affliction, and illness. Further, Lotario dei Segni does not recognize the extent to which inevitable afflictions are complemented by happiness (*On Human Worth* 4:22, 57). We enjoy seeing beautiful bodies, hearing musical sounds, smelling

flowers, tasting delicious foods, and engaging in sexual pleasure, with its recognition that individuals find fulfillment beyond their private selves (3:32, 4:23). We experience also internal capacities: memory, understanding, judgment, and wisdom along with recognition of complexities and subtleties (4:23). Without our fragile bodies, such experiences would not be possible (4:50). According to Manetti, there is no better vessel for the soul than the human body. Indeed, he speaks of "human nature's perfect design" (1:2). Unlike the bodies of ugly beasts, the human body, in all its frailty, is suited for dignity and for speech and understanding (4:50). Manetti contrasts Lotario dei Segni's focus on the infirmities of old age not only with the joys of youth but also with the overlooked pleasures of old age (4:56–59).

No less optimistic is humanist Bartolomeo Facio's slightly earlier *De excellentia ac praestantia hominis* (*Of the Excellence and Outstanding Character of Man*) (ca. 1447), which Manetti knew, and Pico della Mirandola's later and still more famous *Oration on the Dignity of Man* (1486). These thinkers reinterpret the Christian tradition, aided by references to antiquity, with a vision of humanity not as plagued by affliction and deserving of contempt but as capable of greatness and worthy of dignity. Such works represent humanistic thinking that is mirrored in the works of Renaissance artists, such as Fra Angelico, Piero della Francesca, Botticelli, Leonardo da Vinci, Michelangelo, Raphael, Titian, and others, and that—with few exceptions—are far removed from ugliness.

Mannerism, which emerged in the later years of the Renaissance, and the Baroque, which followed, are closer to ugliness. Where the Renaissance emphasizes balance and beauty, sixteenth-century Mannerism tends toward exaggeration—distortion, asymmetries, and occasionally bizarre features. It replaces an idealized naturalism with artificiality. After the high achievements of the Italian Renaissance, the Mannerists attempted to create something different (Gombrich, *Norm and Form* 9). They sought to free themselves from the burdens of scientific technique and appropriate proportions. As a result, their works are creatively deformed. In Parmigianino's oil on canvas *Madonna with the Long Neck* (1534–40), the virgin has not only an elongated neck but also unusually long fingers and legs, and the infant's body is in parts lengthened. With this exaggeration and distortion, Parmigiano introduces an unexpected but internally consistent strategy to challenge classical dominance.

In Mannerism, technique and innovation override harmony. Arguably the greatest Mannerist painter, but one whose singularity also places him beyond that movement, is El Greco, who used elongated forms and unusual pigmentation. His *Holy Trinity* (1577–79), in which the elongated body is colored in ash-like grey and placed at an awkward angle, stylistically grasps the darkness and deformity of Christ's human fate. Even some of the angels seem anguished. Not surprisingly, El Greco had a tremendous influence on, and positive reception with, early twentieth-century artists who moved yet further away from harmony (Wismer and Scholz-Hänsel). Arcimboldo, whom we explore in chapters 10 and 11 and whose eccentric works likewise turn away from classical beauty, has also been associated with the Mannerists (Maiorino).

Ugly moments likewise arise in early modern England, in Shakespeare and in less prominent authors: Thomas Nashe, for example, whose first-person picaresque novel *The Unfortunate Traveller* (1594) takes the hero through tales of disaster filled with ugliness. His battle scenes recall the gruesomeness of Lucan, even if they are told with a certain blitheness. The hero arrives in Italy in time to witness the battle of Marignano, which took place in 1515: "All the ground was strewed as thicke with Battle-axes as the Carpenters yard with chips; the Plaine appeared like a quagmyre, ouerspread as it was with trampled dead bodies. In one place might you behold a heape of dead murthered men ouerwhelmed with a falling Steede in stead of a toombe stone, in another place a bundell of bodies fettered together in their owne bowells. . . . Anie man might giue Armes that was an actor in that Battell, for there were more armes and legs scattered in the Field that day than will be gathered vp till Doomes-day: the French King himselfe in this Conflict was much distressed, the braines of his owne men sprinkled in his face" (2:231). Nashe's horrific portrayals remind us that ugliness appears to some degree in almost all ages.

As we leave the medieval world behind, we begin to transcend the automatic equation of physical and moral ugliness. That symmetry continues at times, for example, in Shakespeare's *Richard III*, but we also see a contrasting model, where physical and moral ugliness clash. In *The Terrors of the Night Or, A Discourse of Apparitions* (1594), Nashe directly challenges the traditional equation (1:370–71). As Naomi Baker shows, the disparity between physical and moral ugliness is more frequent in men, for which already Socrates and Christ

were models, whereas a congruence of inner and outer ugliness remains common with women. Early modern writers often focused on ugly bodies that were "female, old, black, obese or from the lower social orders" (2; cf. 69–96).

An aspect of early modern literature that borders on the ugly is the connection to, and anticipation of, eighteenth-century Gothic (Bronfen and Neumeier). The early Hegelians, including Weiße, Ruge, Bohtz, and Rosenkranz, include under ugliness the spectral dimensions associated with ghosts and the supernatural. Think of the apparitions in *Macbeth* and *Hamlet* and also the horrific dreams and nightmares in *Richard III*, the living statue in *The Winter's Tale*, Taliban in the *Tempest*, and the grotesque elements in Ben Jonson's *The Masque of Queenes*. Still, even if early modern England integrated more of the ugly than did the Italian Renaissance, these remain rather moments within an overarching whole than a primary orientation.

A peculiar development in early modern England tells us much about the difference between early modern and modern. Some early modern works praise deformity, not because deformity as such is to be elevated. Instead, they wish to show how rhetoric can transform an ugly object into beautiful poetry. A gender dynamic is at play in Philip Sidney's *The Countess of Pembroke's Arcadia* (1590). Its mock praise of ugliness "celebrates masculine creativity at the expense of the (ugly) female body" (Baker 131–32). Rhetorical transformation draws on the ancient idea that an ugly object can be rendered beautiful, but it casts the concept anew, focusing on the female body as being shaped and reshaped by the male artist. Art can turn ugly female bodies into beautiful female bodies.

Cruelty and disparagement motivate portrayals of ugliness. In Samuel Johnson's *Dictionary of the English Language*, the second meaning under "deformity," after "ugliness," which occupies the first slot, is "Ridiculousness: the quality of something worthy to be laughed at" (n.p.). Roger Lund has traced the ways in which a range of eighteenth-century British writers deride deformities. This callousness is evident in William Wycherley's "To a Little, Crooked Woman, with a Good Face and Eyes, tho' with a Bunch before, and behind" (1706). Misogyny is again manifest. The woman's beautiful face could be dangerous to her chastity, but her hunchback protects her: "Because your Crooked Back does lie so high, / . . . / You, because Saddled, never will be Ridden" (220). Lund speculates that such cruelty, manifest

also in joke books, has three origins: projection of one's fears about physical degeneration, a kind of Hobbesian laughter of superiority, and a view of imperfection as violating the argument from design. Deformities were flaws in an otherwise beautiful universe. Ridicule was a form of cultural purification directed toward the deformed. A technique that arises also in other cultures had here also time-specific origins. Any deviation from beauty was viewed as perverse, even wicked.

Outside of Shakespeare's *King Lear* and a small number of other works, the early modern era returns to the previous Hellenistic and Roman paradigms of mocking deformity and does not draw on the link between Christ's ugliness and empathy. Nor do we see much anticipation of a normative view of justice as separate from arbitrary physical traits. A programmatic shift arrives only with the Enlightenment. In his essay on deformity (1754), William Hay, who was a self-described hunchback, rejects any obligatory connection between physical and moral ugliness (24). Physical deformity can be advantageous, a spur toward developing outstanding moral and intellectual virtues, partly as a way of surmounting scorn and prejudice (esp. 26, 29–32, 40–43). Hay writes: "The more a Man is unactive in his Person, the more his Mind will be at work: and the time that others spend in Action, he will pass in Study and Contemplation: by these he may acquire Wisdom" (43). Hay draws implicitly on the Stoic idea that virtue is best exercised in the face of adversity and applies the concept to being disabled and being viewed as deformed.

The Baroque, which discarded beautiful proportion and artistic completion and evoked the unlimited and incomplete, is likewise intrigued by the aesthetics of ugliness. The term "baroque" originates from the French translation of the Portuguese *borrocco*, a word used in jewelry to designate a misshapen or deformed pearl. Like "Gothic," "Baroque" begins then as a derogatory term. The Baroque, which has the waning of the Renaissance on one side and the emergence of Enlightenment and classicism on the other, flirts with ugliness, so, for example, in Rubens's *Head of Medusa* or in grotesque poetry devoted to women who lack teeth or exhibit deformities. We see examples not only in early modern England, where the term "Baroque" tends to restrict itself to architecture, but also in Italy (Bettella). A taste for what is strange and odd develops. The seventeenth-century fascination with the bizarre is in some ways a continuation of, or return to, two

traditions in which the ugly has always been prominent: realist art and comic art. These traditions foreground misogynistic portrayals of women as ugly, with a particular focus on aged women. In a sense, the spirit of Roman satire does not disappear in the medieval era, it is continued in lower forms of literature, primarily comic-realistic poetry, and then revived in the Baroque. Not surprisingly, the Baroque elevates terms such as *capriccioso* ("capricious"), *bizzarro* ("eccentric"), and *stravagante* ("odd") that, as Wölfflin notes, expand our concept of the beautiful (*Renaissance und Barock* 21). The classical and medieval *memento mori* also continues to play a prominent role. The contrast with the eternal and transcendent accentuates the fleeting nature of reality. But a skull in a *vanitas* painting, even if we don't want to be reminded of our own mortality, is still in the geometry of its shape more beautiful than a decomposing body, which we find on the other side of *Frau Welt* (ca. 1298) in the medieval cathedral of Worms. In the front is a beautiful woman; in the back are snakes and worms as well as a decaying and decomposing body. Similar is the *Prince of the World* (ca. 1325) at St. Sebald in Nürnberg. In the front the figure is young and comely. From the rear we see through his clothes and skin and are repulsed by images of bones, bodily decay, worms, and frogs. Though the early modern and Baroque eras had more ugliness than the Renaissance, they were not as deeply immersed in ugliness as the Middle Ages or modernity.

In the German Baroque we see a continuation of the Christian emphasis on moral ugliness, which the medieval world had introduced and the Reformation underscored. Christian poetry works with the gap between the ideal and the real and focuses on our vanity, which will be swept away by death. Consider the sonnets of the Lutheran Andreas Gryphius. Using Alexandrine verse, with caesurae that emphasize stark contrasts and a dualistic worldview, Gryphius portrays the emptiness and vanity of this world and chastises us for neglecting the otherworldly, which alone offers meaning and solace. His sonnet "All Is Vanity" (1637) begins:

> You will see wherever you look only vanity on this earth.
> What one man builds today, another tears down tomorrow;
>
> .
>
> What now blooms in magnificence, will soon be tread asunder;
> What today pounds with defiance, tomorrow is ash and bone.

These and other lines contrast the splendor of this world with its later vanishing, be it through the vagaries of fortune or death itself. For that reason we should turn our attention to God. Gryphius opens "Human Misery" (1637) with metaphors that make manifest the horror of humanity and echo the *contemptus mundi* tradition:

> What indeed are men! A dwelling house for grim pains,
> A ball of false fortune, a will-o'-the-wisp of their times,
> A stage of bitter fear, set with sharp pain,
> A quickly melting snow and burnt out candles.

The second stanza of "Tears of the Fatherland/Anno 1636" (written 1636; published 1643) reminds us that Gryphius cast his pessimistic shadow during the devastation of the Thirty Years' War: "The towers stand in flames, the church is violated, / The strong are massacred." He describes the all-pervasive "fire, pestilence, and death." The "fatherland" in the poem's title can mean not only the (earthly) state but also heaven. In the latter case it alludes to what we have done to God's creation. "Likeness of Our Life" (published 1643) employs the world-as-a-stage motif to emphasize the Baroque dichotomy of an unseemly present and the true world to which we fail to devote our attention. We are not acting as though we are in the image or likeness of God. Formally beautiful, Gryphius's poems capture multiple kinds of ugliness.

Part of seventeenth-century ugliness is tied, then, to religious conflict. Although Gryphius offers beautiful depictions of the repugnant repercussions of war, the conflict of faiths brought forward also unconventional forms of aesthetic ugliness, including two-headed medallions, which became popular in the fifteenth and sixteenth centuries (Christine Winkler). The medallions, and in some cases also woodcuts, were designed such that the viewer could recognize a majestic image of a pope or a cardinal, but when one looked at the portrait upside down, flipping it 180 degrees, the same figure was transformed into a horrific devil or ridiculous fool. Since in Christian theology ugliness and evil are two sides of the same coin, such portrayals link Catholic leaders with Satan. The depictions target the worldly aspirations and attraction to splendor that animated many Renaissance popes and cardinals, to which the Reformation responded with its elevation of Christ alone, its attack on the hierarchy,

its elevation of asceticism, and its stress on human depravity. Motivated by moral outrage, artists also turned to experimentation and took joy in bizarre creations. One way to express ugliness during this era was to meld the human and the animal, to create a mixed being or monster. Melchior Lorch's copper plate engraving *The Pope as Wild Man* (1545) portrays the pope as having physical characteristics that are animal-like, indeed monster-like. The fur, long tail, and donkey ears render the pope monstrous. Even the papal insignia are deformed: the tiara ends in a spiral of excrement, and the key to heaven is broken. As with other ugly images, contradiction and stark juxtaposition play central roles.

As we move forward to Enlightenment tolerance and to the cosmopolitanism of German *Klassik*, we are again to some degree removed from ugliness, and so it is no surprise that the Germans take the classical period of ancient Greece as their model. The Renaissance and German *Klassik* recognize the value of organic forms, and both have within their view the potential greatness of humanity. In almost all of his tragedies, Schiller gives us characters who adopt extreme positions and so integrate aspects of ugliness, but they also incorporate elements of greatness, even an ugly figure such as King Phillip in *Don Carlos*, so it is difficult to read Schiller's works as simply elevating ugliness.

Goethe, too, is averse to any one-sided elevation of ugliness. He describes his "physical-aesthetic pain" when encountering the Middle High German narrative of Hartmann von Aue's *Poor Heinrich*, with its depiction of leprosy and the prospect of female self-sacrifice (Goethe, *Tag- und Jahreshefte* 72–73). Goethe felt contaminated simply touching such a work. Also, Victor Hugo was beyond the pale for Goethe. In his June 18, 1831, letter to Carl Friedrich Zelter, Goethe describes his unhappy encounter with the contemporary French novel: "In a word: *it is a literature of despair!* In order to produce an instantaneous impression (and that is what they want, because one edition should follow upon the other), they press upon the reader the opposite of all that should be proclaimed to persons for their well-being, such that in the end the reader no longer knows how to save himself. It is their Satanic business to exaggerate the ugly, hideous, horrible, worthless, with the entire riffraff of castaways, until the impossible is reached" (*Briefwechsel* 3.431; Eng. 453, translation modified).[2] Ten days later, also in a letter to Zelter, Goethe uses analogous categories to describe his unease with *Notre-Dame de Paris*.[3]

Still, a wide-ranging writer such as Goethe was not immune from including ugliness or recognizing its value. In *Faust II*, Goethe makes explicit the ugliness of Mephistopheles by transforming him into the wretched Phorkyas. Goethe's integration of ugliness surfaces as part of a larger whole or as a contrasting image (the ugliness of Phorkyas highlights Helen's beauty). The entire Mephistophelian narrative, including Mephisto's moral ugliness, takes place within a cosmic frame. In God's creation the devil plays a subordinate and unwitting role. Faust after all is saved. Moreover—and this is central to the role of Mephisto—for Goethe the ugly is best integrated via mockery. In *The Dancer's Grave*, Goethe writes: "Divine art, which knows to ennoble and elevate everything, does not like to reject even the despicable, the hideous. Precisely in this domain it powerfully enacts its grand right; but it has only *one* path to achieve this: it does not master the ugly unless it treats it comically; witness Zeuxis, who was said to have laughed himself to death when he beheld his painting of Hecuba, whom he had portrayed in the ugliest possible manner" ("Der Tänzerin Grab" 27:305). In a contribution on the philosopher J. G. Sulzer, Goethe made the case that art must, like nature, take ugliness into account, yet in such a way as to tame it. Art has the task of creating goodness, virtue, and beauty out of the world's massive power, energy, and diversity.

Goethe's overarching aversion to ugliness is not unrelated to what Eric Heller has called Goethe's "avoidance of tragedy" (37–63), but what one might better frame as an organic interest in ugliness as part of a greater whole.[4] Goethe does not so much avoid tragedy as overcome it via the drama of reconciliation, a prominent dramatic genre in German *Klassik* in particular and the age of idealism in general. Here suffering and ugliness are included but ultimately overcome, as in Goethe's *Iphigenia in Tauris* (1779). After Goethe and Hegel, who brought the drama of reconciliation to the level of the concept, overcoming ugliness becomes a rare phenomenon. Modernity, to which we now turn, prefers instead to linger in ugliness.

M O D E R N I T Y

A drunken corpse on a table, an aster wedged between its teeth. A nest of young rats in the stomach cavity of a drowned girl. An undertaker pulling a gold tooth from the mouth of a prostitute and running off to a dance. A woman lying on a pillow of dark blood, her throat slit open with a knife. These seemingly random images, common only in their ugliness, dominate the opening four poems of Gottfried Benn's cycle of five poems, *Morgue*. "Requiem" concludes the series with repeated inversions of Christian motifs. Throughout, the German poet's attention and rhetoric are devoted not to human beings, but to their body parts and the surrounding images, the flower, the rats. *Morgue* was published together with four additional poems in March 1912. The first edition of 500 copies sold out in eight days.

The most famous poem, "Man and Woman Walk through the Cancer Ward," includes the following lines:

> Here in this row are decaying wombs,
> and in this row are decaying breasts.
> Bed beside stinking bed.
>
>
>
> They take little nourishment. Their backs
> have wounds. You see the flies. Sometimes
> the nurses wash them. As one washes benches.
>
> (Ger. 1:16; Eng. 187, translation modified)

The poem names women by their body parts (wombs, breast, backs). By depersonalizing them further to beds and benches, the speaker treats the patients as objects, as if they were already dead. This poem and others in the collection are revolutionary in their affront to human dignity, even as many of them continue traditional misogynistic tropes, integrating violence against women and portraying sick and older women as abject. The formerly flourishing existence of the cancer-ridden women is reduced to hopelessness, "lumps of fat" and "putrid juices." The "cancer ward" in the title, "Krebsbaracke," is more a barracks or shed than a ward, temporary but large (with rows). In these unseemly surroundings, traditional poetic strategies—synecdoche, anaphor, metaphor, simile—convey the decay of self. The speaker describes a "scar on the breast," from which a tumor has been removed. Below the skin are "rosary beads of soft lumps." The striking image reverses tradition: religion does not triumph over illness; instead, it signals the cancer. The poem denies not only religious solace but any transcendence. The final words, "Earth calls," are ambiguous, for even as they summon the phrase's religious resonance in Genesis 3:19, with its suggestion that in death humans "return to the ground" or the earth, the words seem to mock traditional religious meaning.

Benn's provocative images shocked the bourgeois audience of his day and were rejected by all but the most avant-garde as scandalous and disgusting. One newspaper critic lamented: "Ugh! What an unbridled imagination, devoid of any intellectual decency, is there exposed; what disgusting delight in the abysmally ugly, what malicious pleasure in bringing to light things that cannot be changed" (Hohendahl 26). Another warns: "Anyone who intends to read these - - - poems should prepare a stiff drink. A very stiff drink!!!" (Hohendahl 91). Here was the decay of the body without any nobility or transcendence. More brutal and grotesque than Baroque portrayals of decay, the poems lack any contrasting images of transcendence. For contemporaries, they were a cold and irreverent challenge to human dignity. For Benn, no longer the summit of creation, the human being is seen in its bodily function, including its decay and dissolution, its stench and obliteration. The death of a girl makes possible the "beautiful youth" of the rats that live off her body ("Beautiful Youth" 1:11). The second section of Benn's "The Doctor" (1917) opens with the unsettling line, "The pinnacle of creation, the swine, man" (1:14). The reader sees a reduction of humanity to biology, the dissolution of the body,

The History of Beautiful Ugliness

decay, and death, yet this portrayal of ugliness is accomplished through exquisite poetry.

Modernity's Fascination with Ugliness

Benn is a model of the modern writer who is fascinated by ugliness. The long age of modernity commences in the early nineteenth century, in a few cases already in the eighteenth century, and reaches its peak in the twentieth. With perverse responses to the Enlightenment, as with the Marquis de Sade, the darker moments of Romanticism, and then reactions against idealism by writers such as Georg Büchner and Heinrich Heine, the turn to ugliness in all its facets becomes visible.[1] The German artist Hugo Ball underscores modern art's dehumanizing impulses: "The image of the human form is gradually disappearing from the painting of these times, and all objects appear only in decomposition. This is one more proof of how ugly and worn the human countenance has become and of how all the objects of our environment have become loathsome to us" (*Die Flucht aus der Zeit* 76–77; *Flight Out of Time* 55, translation modified). In 1889, painter Paul Gauguin wrote: "Ugliness: a burning issue; it is the touchstone of modern art and its criticism" (39). A generation later, early in World War I, German philosopher Paul Feldkeller wrote: "The ugly is a topic that demands artistic treatment fully just as much and with the same right as beauty" (916). Modern artists readily integrate taboo subjects, which tended, with the exception of comedy and satire, to be beyond the realm of art. Over time, ugliness surfaces in every possible way, with repugnant content, distorted forms, unintegrated parts, and unresolved dissonance.

In music, ugliness arises in a sustained way only in modernity. Music thus accentuates the break with the past. Theodor Adorno, who addresses the revolutionary nature of modern art, including music, comments: "In modern art the weight of this element [the ugly] increased to such a degree that a new quality emerged" (*Aesthetic Theory* Ger. 74; Eng. 46). What was new in music is simply accentuated in the other arts. Katy Kelleher notes that in "our postmodern or post-postmodern art world, it can be hard to remember why ugliness matters because ugly paintings are now everywhere. Ugly paintings hang in every major museum, and ugly work has been accepted as part of the canon." Fledgling artists aspire to ugliness, which is viewed as "virtuous and

provocative," whereas an "emphasis on the beautiful suggests an absence of critical content" (Fine xiv and 71). Not only does ugliness become pervasive, it evolves into a mark of the artist's modernity.

We can see the rise of ugliness in selected themes of Romantic and post-Romantic literature. A loss of vitality deriving from a sense of overriding boredom, which can be a breeding ground for the contemplation of morally ugly acts, is one such theme. Boredom is "a specifically modern phenomenon" (Nikulin 85). Georg Büchner's comedy *Leonce and Lena* (1836) interweaves the nobility's boredom with its oppression of the lower classes. Peter-André Alt notes that *ennui* is the inner mood most conducive to moral ugliness, "because it distinguishes solely between attraction and monotony without knowing moral measures of value" (225). Evil enchants the tired soul (225). This can lead to fascination with the macabre. Other factors that drove the ascendance of ugliness include modern technological warfare and its brutal consequences; greater awareness of social ills, such as unemployment, poverty, and hunger; and a disparaging, even cynical, anti-Enlightenment view of human nature as depraved. We also detect in modernity a pervasive social and psychological sense of unease and an imagination unrestricted by religious or moral boundaries. A dialectic of revulsion and empathy is at play in much of modernity's engagement with ugliness. It is no surprise that in modernity we experience two archetypal figures who are physically repulsive but inwardly attractive, the monstrous creation of Shelley's Victor Frankenstein and the hunchbacked bell ringer Quasimodo in Hugo's novel.

In modernity, new genres, such as the Gothic novel and the criminal narrative, emerge. Cruelty abounds in the Gothic novel, as in Lewis's *The Monk* (1796) and Maturin's *Melmoth the Wanderer* (1820). *The Picture of Dorian Gray* integrates aspects of the Gothic tale. Whereas the detective story focuses on the detective's superior mind in ferreting out the elusive suspect, criminal narratives, as, for example, Dostoevsky's *Crime and Punishment*, wallow in the abject and express a fascination with strange personalities. The modern attraction to criminals reveals some of the most abhorrent aspects of ugliness. In *Crime and Punishment*, Raskolnikov rationalizes his murder: if the intended victim is intellectually ugly, then Raskolnikov's moral ugliness is only seemingly ugly. The person he will kill is "a stupid, meaningless, worthless, wicked, sick old crone, no good to anyone" (65). There is thus no crime: "Crime? What crime?...I killed a vile, pernicious louse, a little old money-lend-

ing crone who was of no use to anyone" (518). Dostoevsky's antihero divides all people into the ordinary and the extraordinary, and the status of being extraordinary triggers Raskolnikov's perception that he has the right to transgress law's normal boundaries (258–61).

Genres that already existed gain new prominence and supplant classical forms. In an earlier book on tragedy and comedy, I introduced the term "drama of suffering" to designate a work that in the extent of the suffering resembles tragedy but in which suffering emerges without the organic connection to greatness we see in classical tragedies, for example, in Sophocles's *Antigone* or Shakespeare's *Macbeth*, where at least an element of formal greatness is evident (Roche, *Tragedy and Comedy* 91–102). In the United States, dramas of suffering are among the most prominent works of the long twentieth century: O'Neill's *Long Day's Journey into Night* (written 1941–42); Williams's *A Streetcar Named Desire* (1947); Miller's *Death of a Salesman* (1949); Shepard's *The Curse of the Starving Class* (1978); and Albee's *The Goat* (2002). Although the genre has long existed, as in Euripides's *Trojan Women*, it gains new prominence in modernity and becomes, alongside absurdist theater and the theater of cruelty, a signature element of modern drama.

A paradigmatic example of a drama of suffering, which reminds us that the form, though different from tragedy, can still achieve greatness, is Büchner's *Woyzeck*, still a fragment when Büchner died in 1837. In the lead role is a victim, a hapless soldier who is abused by his superiors. Woyzeck tries unsuccessfully to make a life for himself, his common-law wife, Marie, and his child. The Captain lectures Woyzeck on his lack of morality—for having an illegitimate child—but the Captain cannot articulate what morality is. The Doctor experiments on Woyzeck by feeding him nothing but peas. The work is modern in its fragmented form and its empathetic portrayal of a lower-class protagonist. Its inclusion of an inverted fairy tale captures the ugliness of Woyzeck's world: "Once upon a time there was a poor child with no father and no mother, everything was dead, and no one was left in the whole world. . . . Since nobody was left on the earth, it wanted to go up to the heavens, and the moon was looking at it so friendly, and when it finally got to the moon, the moon was a piece of rotten wood and then it went to the sun and when it got there, the sun was a wilted sunflower and when it got to the stars, they were little golden flies stuck up there like the shrike sticks 'em on the blackthorn and when it wanted to go back down to the earth, the earth was an overturned pot and was all alone and it sat down and

cried and there it sits to this day, all alone" (Ger. 1:168–69; Eng. 218). Not only does Büchner invert tragedy into a drama of suffering, the fairy tale genre becomes in his hands devastatingly bleak.

A focus on the downtrodden is very much evident in naturalism. In this movement, which eschewed poetic coloring of reality, the drama of suffering plays a prominent role, especially in Germany. Almost all of Gerhart Hauptmann's plays belong to the genre, such as *Before Dawn, The Weavers, Drayman Henschel, Rose Bernd*, and *Before Sunset*, all of which premiered between 1889 and 1932. Naturalism not only focused on everyday life and social misery, it also brought forward formal innovations, such as the *Sekundenstil*, "second-by-second style," whereby narrated and narrating time are identical, a formal device that accentuated reality. Naturalism coincided with Germany's industrial revolution. Because Germany did not become unified until 1871, industrialization and urbanization arrived late, but both advanced quickly: unification accelerated industrialization, as the federal government supported heavy industry, and the increase in manufacturing led, in turn, to rapid urbanization. The age was defined not only by substantial social upheaval, but also by positivism, which elevated close observation of reality and looked askance at transcendence. This world, especially its lower strata, became naturalism's sole focus. Gerhart Hauptmann, the movement's greatest writer, centered his works around poverty, unemployment, and alcoholism.

Other genres associated with ugliness, such as satire, lose none of their force. Themes we know from Juvenal, such as wealth and waste, continue even into the present. Lauren Greenfield's documentary film *The Queen of Versailles* (2012) exhibits the vulgar materialism of a rich American family, which, having drawn many bad-credit customers into their timeshare resort firm, suffered through the crash of 2008. We see the partial completion of a 90,000 square foot house as a kitschy imitation of Versailles along with comically wretched excess and poor taste. The film is a funny satire and a serious allegory of overreaching America. The characters are oblivious to contradictions. The family sees itself as normal but has no grasp of normality. When the family is expected to cut expenses, they purchase cart upon cart of consoling presents from Walmart.

Caricature, which developed in the fifteenth and sixteenth centuries, is a distortion, often a comic exaggeration, of the face or body that takes away a certain concept of measure and proper proportion,

such that quantity disrupts quality. The goal is to capture not a detailed likeness but a resemblance of the whole by emphasizing and exaggerating the most distinctive and often least appealing physical features. The form receives renewed investment in modernity.[2] Honoré-Victorin Daumier's caricatures of the French offer arguably the greatest examples. Precisely the disproportion and distortion, which could superficially be said to be inaccurate, capture something deeper and can be in a surprising sense more revelatory in terms of grasping a character's essence (cf. Comaroff and Ker-Shing 206). Gombrich notes: "This is the secret of good caricature—it offers a visual interpretation of a physiognomy which we can never forget and which the victim will always seem to carry around with him like a man bewitched" (*Art and Illusion* 281). Reality gives rise to an image, but the image becomes the new reality. Thus, it is not surprising that Daumier was hailed as a precursor of a later aesthetic movement immersed in ugliness: Expressionism (Gombrich, *Art and Illusion* 355).

Inversions of Idealized Beauty

Expressionism takes disfigurement to an entirely new level when it thematizes sexual murder. *Lustmord* ("sexual murder") is the German word for a combination of misogynistic sexuality and disfiguring violence, including female sexual mutilation. *Lustmord* was prominent in the art, literature, and cinema of the turbulent Weimar Republic, which still bore traces of war trauma (Tatar). The unsparing gruesomeness of a work such as Dix's *Sex Murder* (1922) upends the concept of beautiful art, which had so often idealized the female body. A new aesthetics of ugliness emerges, which rejects classical aesthetics.

In the tradition, women were often idealized as the embodiment of beauty. In rejecting this objectification of the female body, modern artists turn to strategies that challenge viewers and integrate ugliness. The nonidealized prostitute in Manet's *Olympia* returns the male gaze and confronts the viewer with her own subjectivity. In her installation *Tale*, Kiki Smith confronts the viewer with an abject image of the female body. The critique of female instrumentalization is dominated by female artists. We see this across the twentieth century and via diverse visual arts. These female artists emphasize the superficial ugliness of the female body, no longer, however, as a means for a male artist to

ILLUSTRATION 27
Cindy Sherman, *Untitled #175*, 1987, Chromogenic color print, 120.7 x 181.6 cm/47 x 71 in., Whitney Museum of American Art, New York © Cindy Sherman/Courtesy the artist and Hauser & Wirth.

exhibit strategies for turning such ugliness into mocking satire or beautiful poetry, but as critique of beauty as a commodity, a reaction against instrumentalization and dehumanization.

Cindy Sherman's photograph *Untitled #175* (1987) is both grotesque and alluring, horrific and fascinating: we see gorgeous color photography and a fascinating composition, cupcakes and other sweets, some half eaten, what looks like suntan lotion, a beach towel, sand, and vomit (illustration 27). The work may allude to gluttony, but more likely to bulimia. A pair of sunglasses reflects the face and neck of a female figure who appears ill. No longer fulfilling stereotypical expectations of female beauty, the figure is only indirectly the object of the viewer's gaze. If female figures are the embodiment of sensual beauty, the woman who falls short of this ideal immediately becomes ugly, whether because she has an unappealing appearance, such as being overweight or elderly or marked with scars (which in men would likely be seen as positive marks of courage), or because she is not a docile and willing object, but contrarian and independent. The reduction of women to the body, and thus to sexual function, a reduction that was aided by fear of women as the cause of male sin as well as, presumably,

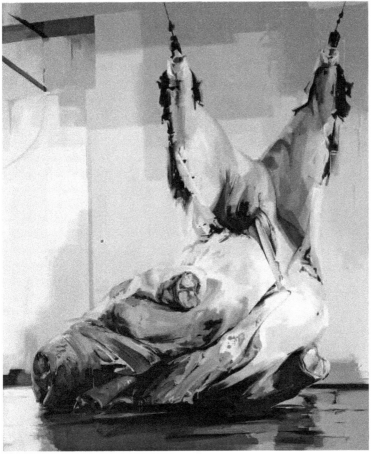

ILLUSTRATION 28
Jenny Saville, *Torso II*, 2004–5, Oil on canvas, 141 3/4 x 115 3/4 inches / 360 x 294 cm, © 2022 Jenny Saville and Artists Rights Society (ARS), New York, Courtesy Gagosian.

envy of women for their long orgasms—cuts both ways; in each case it represents reductive praise or scorn. Sherman's photograph can be understood as a critique of stereotypical ideals of feminine physicality that contribute to such disturbing behavior and an empathetic and symbolic portrayal of the distraught woman reflected in the glasses.

The critical potential of art, art as the medium through which we see reality anew, including uncovering our own prejudices, is evident in much of modern ugliness, including modernity's revision of female beauty. In Jenny Saville's *Torso II* (2004–5), we are seduced by the aesthetic quality and repulsed by the specific image, the female body objectified and transformed into a piece of meat (illustration 28).

Although ugly images of the female exist very early, these are almost always comic and derogatory. Saville's images are not comic, but confrontational and contemplative. Saville also paints women's bodies in such a way as to challenge preconceived and oppressive notions of physical beauty. In *Trace* (1993–94), the body's large flesh consumes the entire canvas, not what we would anticipate if we were expecting, as in the tradition, an idealized or flawless female body. The body is seen from the back, with marks visible on the skin. The very harsh light seems to expose the nakedness even more. The work questions the tendency to reduce the female human being to physicality, be it beauty or ugliness. The suffocating image suggests that for most viewers this is all there is to the female. In such revisions of the female body we see one of the most important movements away from traditional beauty and toward seeming ugliness. This integration of what society neglects to see or face or recognize reinforces the value of art as a critical force, so it is no surprise that modernity's focus on ugliness opens up new perspectives in areas such as gender and disability studies.

Earlier still is Frida Kahlo. In *A Few Small Nips* (1935), an oil on metal, Kahlo paints a gruesome portrait of a female body. The woman, her upper and lower body turned in opposite directions, is lying on a bed, her body drenched with blood from multiple stab wounds; her blood-stained killer, seemingly self-satisfied, stands beside her. The blood oozes across the canvas, extending even onto the frame. With one foot of the bed cut off, the image almost jumps off the canvas. In a stroke of dark humor, Kahlo gives us, along with the blood, light pastel colors and two doves holding the grotesque title. Where traditionally male blood in a painting is associated with sacrifice and understood as an allusion to Christ, in female figures, blood has tended to be connected to menstruation and viewed as taboo, a kind of disorder. Liza Bakewell writes that Frida's nudes "challenge and expose long-standing sexual paradoxes—men's blood is holy as in the blood of Christ or courageous as in the blood of the war victim ('the red badge of courage'); women's blood is profane and evidence of a violation" (174). Kahlo challenges this cliché. Allusions to Christ normally reserved for males are prominent: the woman's drooping arm, the cuts in her side and hand, the turned head.

In Kahlo's *Remembrance of an Open Wound* (1938), wounds are visible on her foot and thigh, but the title and the concept allude to the vagina, to a negative space that renders women a vulnerable object of

penetration. The foot is wrapped, but the thigh wound is open and in the shape of a vagina. The term "open wound" is multivalent. First, it is linked with the vagina and male objectification and violation. The wound is open because the threat of violation is always present. Second, associated with patriarchy, it is layered with Kahlo's own wounds in having to endure her husband's affair with her sister Cristina (Herrera 181–91). Third, the open wound is more broadly linked to unsound societies that have yet to treat women with equality and so have their own unresolved offenses. The mutilated body is an affront to the idea of the female as the object of male desire, to be possessed and subordinated. The work resists objectification by another person insofar as the figure's right hand, which is not visible, is in a position that could give her self-satisfaction through masturbation, an interpretation that Kahlo herself supported (Herrera 190–91). The hidden hand is symbolic of independence and subjecthood, activity, not passivity, even if it cannot be revealed without consequences. The female body is after all socially in the service of men.[3] Here in a hidden way the vagina is transformed from its patriarchal symbolism to its biological reality.

Likewise placing the painter in a position removed from, or in tension with, traditional beauty is Kahlo's self-portrait *The Broken Column* (1944) (illustration 29). The work challenges the reduction of the female body to a physical object of male desire. The breasts are painted beautifully, but another traditional image of beauty, the column, crumbles down her spine like ruins, extending and reinforcing the critique of idealized beauty. The ruins allude to aging, which in the widespread cliché renders the female body less attractive. The cloth below and the nails driven into the naked body allude to the suffering Christ. The work is also a personal reflection on suffering caused by childhood polio and an early traffic accident, both of which left Kahlo with a damaged body. The landscape has fissures, just as the column does, indicating that suffering colors her view of the world or that the world itself is damaged. The painting, created in the wake of her having undergone surgery and having to wear a steel corset, exhibits tears but lacks any other expressions associated with crying: she carries her suffering with dignity and bearing.

I have stressed the female body because its inversion represents a frontal attack on traditionally idealized concepts of beauty, but a general tendency in modernity is disfigurement. Tobin Siebers, who focuses on links between disability and modern art, argues that modern

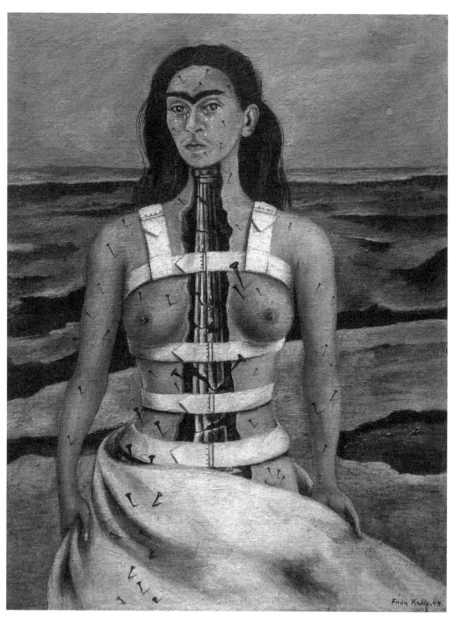

ILLUSTRATION 29
Frida Kahlo, *The Broken Column*, 1944, Oil on masonite, Museo Dolores Olmedo Patino, Mexico City © 2022 Artists Rights Society (ARS), New York, Photo © Leonard de Selva/Bridgeman Images.

art "finds its greatest aesthetic resource in bodies previously con-sidered to be broken, diseased, wounded, or disabled" (35). Just as the idealized female body is inverted, so is the broken body elevated. New aesthetic movements, such as decadence, and new aesthetic goals, such as shock, also reveal dramatic shifts. It is not by chance that the poet in Rimbaud's *A Season in Hell* "cursed" or railed against "Beauty" (265); that Marinetti asserts: "Bravely, we bring the 'ugly' into literature" (113); that Umberto Boccioni titles one of his paintings "Antigrazioso" [Anti-pretty]; that Marcel Duchamp selects a urinal to inaugurate the idea of found art; that Tristan Tzara declares in 1918 "beauty" "is dead" (4); or that one of the major movements in twentieth-century drama is called the "theater of cruelty." Arthur Danto is not entirely wrong when he writes that "beauty had almost entirely disappeared from artistic reality in the twentieth century" (*Abuse of Beauty* 7). Danto even goes so far as to introduce the concept "kalliphobia," which he defines as "an inversion to if not a loathing for beauty," a position that in our age has been respected if not also elevated (*What Art Is* 11).

Echoes of Christianity

As we saw with our very first image in this book, Dix's *The Match Seller*, and just now in Kahlo's *A Few Small Nips* and *The Broken Column*, vestiges of Christianity remain long after Christianity's hold on modern culture has disintegrated. Even as modernity tends to reject most elements of Christianity, it nonetheless has a deeply ambivalent relationship to Christianity: modernity integrates Christian images, including the Crucifixion, even as it transforms them. Despite waning religious sensibilities, the Crucifixion has remained into modernity an enduring subject for painters and sculptors.

Consider George Grosz's *Shut Up and Soldier On* from the collec-tion *Background*, which was prepared for Erwin Piscator's 1928 stage-adaptation of Jaroslav Hasek's Czech novel *The Fateful Adventures of the Good Soldier Švejk during the World War* (illustration 30). The peace-loving Christ has been transformed into a sacrificial soldier adorned with a gas mask. The work offended many, but it does not criticize Christ. Christ is not speaking the titular words, for the gas mask effectively silences him. Instead the work mocks the abuse of Christian principles. It seeks to create a solidarity between Christ as

victim and the soldier as victim in World War I. At the time the connection between Christ and soldier was remarkably widespread, indeed cross-cultural. Consider American Stanley Spencer's contemporaneous *The Resurrection of the Soldiers* (1928–29). There are so many crosses held by dead soldiers covering Spencer's canvas that to recognize the Christ figure to whom the soldiers are making their journey is difficult.

Despite the widespread connection between soldier and Christ in World War I and Grosz's attacking not Christ, but the abuse of Christian principles, Grosz, who had himself served in the infantry, underwent a series of trials for blasphemy, at first losing his case, then eventually and partially winning it on appeal with an otherwise conservative judge, Julius Siegert, who in 1933 was, alas, one of the first to fall victim to the regime change.[4] The several trials received unprecedented publicity, with the ironic effect that the image was more widely reproduced than would have been the case without the protest against it. Grosz's work was later included in the 1937 Nazi exhibit of "Degenerate Art" (Barron 247).

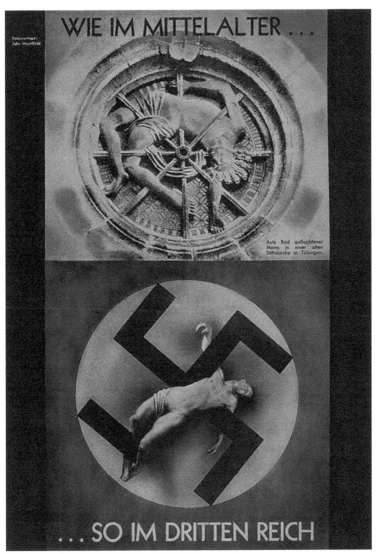

WIE IM MITTELALTER . . .

Auts Rad geflochtener
Mann in einer alten
Stiftskirche in Tübingen.

. . . SO IM DRITTEN REICH

ILLUSTRATION 31
John Heartfield, *As in the Middle Ages . . . So in the Third Reich*, 1934
© The Heartfield Community of Heirs/Artists Rights Society (ARS), New York, 2022.

John Heartfield's photomontage *As in the Middle Ages . . . So in the Third Reich* (1934) appeared, as many of his images did, on the cover of *AIZ*, the *Arbeiter-Illustrierte-Zeitung* (*The Workers Pictorial Newspaper*) (illustration 31). Heartfield was arguably Hitler's fiercest visual critic. During the early months of World War I when Heartfield was still a teenager, he changed his name (from Helmut Herzfeld) in

order to protest German nationalism, with its common greeting, "God punish England" (Selz, "John Heartfield's 'Photomontages'" 309). (For analogously antinationalist reasons, Georg Groß changed his name to George Grosz.) In 1933, while preparing to go into exile, Heartfield escaped the SS by leaping over a balcony and cowering in a garbage can for hours while the Nazis demolished his studio (King and Volland 15). In 1916, Heartfield and Grosz experimented by cutting images and then pasting them together. Heartfield eventually mastered the new art form; in his creative hands, photomontage became a complex and fascinating synthesis of Dada and surrealism (Herzfelde 311).

In *As in the Middle Ages . . . So in the Third Reich* (1934), prepared in exile, Heartfield alludes to the Nazi abuse of Christian principles (illustration 31). The top is taken from a late medieval image of torture, the breaking wheel. In the bottom half we see a variation of this image, but here the victim is crucified by the swastika. Heartfield juxtaposes and integrates images to create a new mode of perception, cutting to a deeper, symbolic reality, and he does so with a specific target in mind. Andrés Zervigón calls Heartfield "a prosecutor with scissors" (1). The breaking wheel serves to intensify the suffering and gives a perverse spin to the concept of *Die Bewegung* ("movement"). In the iconography of sixteenth-century northern European art, with its tendency toward realism and the grotesque, the Crucifixion and the wheel were occasionally linked as instruments of torture (Merback). With the swastika, Heartfield reinforces that connection. The image of arms hung over the cross bars derives from the two thieves who were crucified with Christ. Whereas Christ is invariably portrayed as nailed on the cross, the thieves were shown in wretchedly contorted positions, with their arms hooked over the horizontal beams, their hands tied to the cross via rope, as, for example, in Balthasar Berger's oil on panel *Calvary* (1532), which is housed at the Staatsgalerie in Stuttgart. The model on which Heartfield draws is taken from the Stiftskirche in nearby Tübingen. In drawing on this connection, Heartfield portrays the Nazis as violating Christian morality and returning the population to medieval barbarism. The year before, in 1933, the Nazis had used the emergency decree to pass the Law for the Imposition and Implementation of the Death Penalty. As with his other images, Heartfield paints a picture of even worse atrocities to come. The works by Grosz and Heartfield might be overly transparent, but they are hardly blasphemous.

The question of blasphemy is less clear in Serrano's *Piss Christ*, a large (60 x 40 in.) 1987 photograph. The work depicts a plastic crucifix submerged in the artist's urine and illuminated by dramatic lighting. *Piss Christ* is, on one level, disgusting. The lofty and sacred is enveloped in a bodily excretion. The work gained notoriety for its debasement of Christianity and its shock value, which the provocative title underscores. Yet on another, more ambiguous level, the image could be interpreted as superficially beautiful, and its earthy dimensions could be said to represent something of the humanness of Christ's incarnation, or, alternatively, could be said to criticize how we have dealt with Christ in modernity, cheapening and even abusing the Christian message. Serrano himself notes the ambiguity and underscores that one possible reading involves "a criticism of the billion dollar Christ-for-profit industry and the commercialization of spiritual values that pervades our society" (Stiles and Selz 280). Moreover, the initial sense of outrage and shock along with the contradiction between the apparent beauty and the material element may mirror the seemingly incomprehensible way in which Christ as both divine and human violates traditional sensibilities, breaches clear categories, and resists determinate concepts. The work includes a dialectic: the earthly suffering of Christ is reinforced, but the lighting points beyond. Such an interpretation might rescue such a work from the charge of blasphemy.

Goya's *Still Life of Sheep's Ribs and Head* (1810–12) interrogates injustice and contemporary brutality (Napoleon conducted his brutal siege on Madrid in 1808), but unlike the previous few works we've just discussed, it raises questions without being overly direct and without requiring hermeneutic gymnastics to rescue the work (illustration 32). Its meaning, true to art, is more indirect than the others just discussed. Goya's image belongs of course to an earlier time. We recognize in the sheep an allusion to Christ, which is reinforced by the open eye, which captures our attention; the blood smeared on its face; the still open mouth, with teeth visible; the prominent ribs; the two parts of the body, which form a cross; and the animal's seemingly hovering between life and death. This is not an innocent still life in the *memento mori* tradition, but a still life with blood that captures the symbolism of (human) butchery and brutality, a deeply anti-Christian world. It is worth recalling that Goya's series *Disasters of War*, which included images of severed limbs and decapitation, was created contemporaneously, even if it was not exhibited until 1863, thirty-five years after Goya's death.

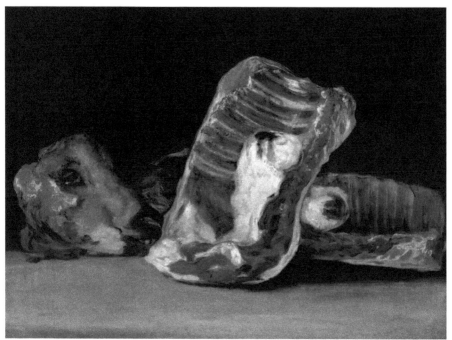

Francisco Goya, *Still Life of Sheep's Ribs and Head*, 1810–12, Oil on canvas, Louvre, Paris/Bridgeman Images.

Today artists are much more engaged in open debasement and shock, but once artists have used up the possibility of ugliness with respect to traditional images, including religious ones, a quandary arises. Works that transform the Crucifixion are parasitic. Where do artists next turn? An obvious possibility is to become crasser and crasser to the point of vulgarity. Alas, not every transgression is a moral or aesthetic advance. In 2012, in association with Documenta, the prominent exhibit of modern and contemporary art that takes place every five years in Kassel, Germany, Mario Lars presented a poster comic strip image of Christ suffering on the cross, which was located in the Caricatura, a cartoon gallery within the train station. A voice from above says to Christ: "Hey . . . you . . . I fucked your Mom!" This is the level on which we have arrived when provocation and parody have been exhausted and artists wrestle to find new angles. Tired attempts at taboo-breaking and shocking audiences contrast vividly with the inexhaustibility of a work of aesthetic excellence that invites our continuing attention, as is the case with Goya.

And yet artists who see traditional images as fully exhausted may be mistaken. In 2015, iconographer Mark Dukes painted an icon, *Ferguson Mother of God: Our Lady against All Gun Violence*, which was commissioned by Trinity Church Wall Street in New York. The icon draws on images of Mary and Jesus and gives them new meaning in the context of the Black Lives Matter movement. A Black Mary raises her arms in prayer, adopting the *orans* position, which indicates pleading and supplication. Where Mary's womb would be is a small silhouette of a Black Jesus, also in the *orans* position, but in this case Jesus's arms are higher. The arms loosely echo the Crucifixion but more prominently the position of suspects when police order them to raise their hands. "Hands up, don't shoot" is the gesture and slogan that, since the 2014 shooting of Michael Brown in Ferguson, Missouri, has been used to protest police violence. Superimposed on the silhouette is the crosshair of a gun, which echoes the (religious) cross. The silhouette and truncated figure suggest a partial absence of Christ. The image's strength lies more in its message and juxtaposition than in its subtlety and indirection. Still, we see that the crucifix is not so easily exhausted, not so easily dismissed as being without further (positive) meaning. The link between Christ and Black victim has a meaningful history, which is evident in the artistic overlap between lynching and the Crucifixion, as in Franklin Watkins's *The Crucifixion* of 1930. It is further manifest in Jamaican-born Renee Cox's photographic montage *It Shall Be Named* (1994), part of a 1995 exhibit "Black Male" at the Whitney Museum of American Art. *It Shall Be Named* is a collage in the shape of a crucifix, which is constructed from manipulated photographic negatives. The Black figure, with no penis, alludes to Christ and a lynched man. (After a lynching, the mob would often cut off the victim's penis.)

A contemporary work that returns us to indirection and subtlety in the ways it draws on Christianity is Canadian Jeff Wall's staged and digitally manipulated photograph *The Flooded Grave* (1998–2000), a large work (90 x 111 in.) displayed as a transparency on a lightbox (illustration 33). At first blush it looks like a simple, open grave with a tarp and mound of dirt beside it. We might be inclined to ask, What could possibly be great about such a work? Is it really art? And if it is art, is it not simply ugly? In truth, however, Wall's photograph is a complex meditation on death and religion. If one looks more closely, one sees that the hole is filled not simply with water. It has a variety of

ILLUSTRATION 33
Jeff Wall, *The Flooded Grave*, 1998–2000. Transparency in light box, 228.6 x 282.0 cm,
The Art Institute of Chicago, courtesy of the artist.

organic elements, including fall leaves and colorful sea life, starfish, red anemone, purple urchins, moss. The rich colors—orange, purple, green—evoke associations with stained-glass windows (Dutt, "Das leere Grab" 28). We see a seeming continuation of religious art, but in a new medium and with uncommon strategies. The graveyard setting stresses death and so is easily connected with the stations of the cross. But it could also be read to mean that such windows, though still bright, are now fractured. All we have are traces, semblances. Wall is himself not religious, yet his works are not without religious symbolism, including the use of the triptych, a religious form, and works such as *The Arrest* (1989) that loosely evoke the narrative of Christ's life, but Wall's tendency is generally to exhibit only gestures and echoes. He recognizes that art is characterized, like nature, by "beauty and complexity," but modern art, and thus his own, is no less defined by "disfiguration" and the "grotesque" (*Jeff Wall* 248–49).

The water is the water of life, which suggests the intricate connection of life and death, that one is the presupposition of the other. The dominance of complementary colors, red and green, symbolically underscores the unity of opposites. Further, the life in the grave reminds us of the extent to which a decomposing body gives nourishment to other life forms. But water is also the medium of baptism, so a connection to one of the sacraments is present, including a gesture of hope beyond life and death. As one studies the images in the water, one sees among them, close to the center, a starfish, an image that is a double allusion to Christ, as a fish and as a star marking Christ's impending arrival. It suggests that the dead may meet Christ. But the gesture is only partial, for the image gives us little direct confidence that it is anything more than a playful evocation of past tradition. Thus the grave could signify the end of Christianity. The pile of dirt adjacent to the grave will soon cover all that resides within. Even if the stone that has been removed from the cover of the empty grave renders the image an allusion to Christ's grave, Christ is of course absent.

The blue tarp is also ambiguous. Perhaps it is what one might expect to find in a cemetery along with grass, dirt, gravestones, and shovels, but it is also presented in analogy to the elaborate blue fabrics that traditionally cloak the Virgin Mary. Wall, an art historian, often plays with, and modifies, tradition. The birds that are soaring could represent seagulls that gather near waste of various kinds or the doves that symbolize the Holy Spirit. That there are eight birds in the sky or heavens suggests, in the more religious reading, a link back to baptism and indeed to resurrection: in Christian vocabulary, eight is the number of resurrection, for on the eighth day after his entry into Jerusalem, Christ was said to have risen from the grave (which is why Christian baptismal fonts are octagonal in shape). The octagon itself is the intervening shape between the circle, a symbol of the eternal, and the square, a symbol of the temporal, and so represents the mediation of the eternal in time, or spiritual regeneration. Yet the grave here is a very earthly rectangle, neither a square nor a circle, and flooding has of course negative biblical connotations.

Farther up the cemetery, one sees a hose. Again, the mundane may have deeper meaning, as hoses are used to save persons from fire, an element associated with the devil, but since fire also has religious connotations, the fire of the Holy Spirit, the hose may suggest an extinguishing of the Christian flame. And of course it is also an everyday

element, without significance, what one might expect to find in a cemetery. The staged photography is richly evocative and deeply ambiguous. Wall himself emphasizes that artworks integrate "opposite, contradictory qualities" (*Jeff Wall* 327). In an interview on the work, Wall commented: "The everyday, or the commonplace, is the most basic and the richest artistic category. Although it seems familiar, it is always surprising and new" (Tumlir and Wall 114). A work that is seemingly insignificant and even ugly can be read as a rich meditation on presence and absence.

Audience Puzzlement

A work such as Wall's *The Flooded Grave* can be revealed in its full richness, but many recipients will simply walk by in puzzlement. Although the expansion of ugliness and complexity in modern art has led to many great works, it has also engendered audience uncertainty and unease—and not only in the visual arts. Atonal music, which lacks keys and avoids standard tonal chords, repels most audiences. Even if cognition is the principal distinguishing feature of atonal music, dissonance is certainly secondary as an aesthetic feature and, contrary to Adorno, probably primary in effect (Adorno, *Philosophy of Modern Music* 124). This prominent twentieth-century technique, beginning with Arnold Schoenberg and then continuing with others, including his students Alban Berg and Anton Webern, breaks with classical music. The logic of the material, not tonality, determines the sequences, such that sharp dissonances, for example, a minor second, are not avoided (*Philosophy of Modern Music* 85). Schoenberg himself speaks of "the emancipation of the dissonance" (258). Any chord becomes possible, and the conventional transition from dissonance to consonance no longer plays a role.

Modern music's movement to dissonance has many causes, among them the idea that dissonances are more cerebral, more intellectual, because "more difficult to comprehend than consonances" (Schoenberg 282). Another is the association of dissonance with innovation. The variety of dissonance increases possibilities for uniqueness. Schoenberg writes: "The number of consonant chords is limited; in fact, it is rather small. The number of dissonances is so great that it would be difficult to systematize the relation of even the simplest ones

to all the consonances and to each other, and to retain them in the memory" (282). Schoenberg provides in a sense an answer to the despair that haunted the young John Stuart Mill, who became despondent as he contemplated that the pleasure of music fades with familiarity and that options for musical combinations were finite. In the fifth chapter of his autobiography, Mill writes that he "was seriously tormented by the thought of the exhaustibility of musical combinations. The octave consists only of five tones and two semi-tones, which can be put together in only a limited number of ways, of which but a small proportion are beautiful: most of these, it seemed to me, must have been already discovered, and there could not be room for a long succession of Mozarts and Webers, to strike out, as these had done, entirely new and surpassingly rich veins of musical beauty" (119). Dissonant combinations, in contrast, are inexhaustible. In the wake of the burdens of tradition, modern music finds new avenues via dissonance, suggesting that the catalysts for music's immersion in dissonance are as formal as they are socio-historical.

Discordant, irritating, and incomprehensible music leads to a loss of audience. Early reviewers of Schoenberg expressed unease at his "aesthetics of ugliness" (Slonimsky 148, my translation). One critic described the music as resembling "the wailings of a tortured soul" (150). Another calls Schoenberg's cacophony a "sort of cat music, whining, wailing, desperate" (157). Still another draws this set of analogies: the music "combines the best sound effects of a hen yard at feeding time, a brisk morning in Chinatown and practice hour at a busy music conservatory" (163). Audiences interrupted performances, shouting, "Stop! Enough! We will not be treated like fools!" (149). With the provocative title "Who Cares If You Listen?," American composer Milton Babbitt defended indifference toward audiences, calling in 1958 for "total, resolute, and voluntary withdrawal from this public world to one of private performance and electronic media, with its very real possibility of complete elimination of the public and social aspects of musical composition" (Babbitt 126).

The unpopularity of modern art has invited philosophical reflection. Already in 1925 Spanish philosopher José Ortega y Gasset analyzed contemporary art's inaccessibility: modern art "divides the public into the two classes of those who understand it and those who do not" (6). Not only do we see an increase of ugliness and dissonance, many artists, as with Babbitt, do not wish to address a wider, more

skeptical public. It's not that modern and contemporary artists can't achieve beauty. Often they don't seek it. Consider the Viennese performance artists Günter Brus, Hermann Nitsch, and Otto Mühl, whose Aktionen in the 1960s included the slaughtering of animals, defecation, masturbation, self-mutilation, urination into a partner's mouth, and the eating of excrement (*Brus Muehl Nitsch Schwarzkogler*; Warr 92–96) or the 1980s performance art of GG Allin, who defecated and urinated on stage—eating his excrement, rubbing it over his body, and throwing it into the crowd—drank the urine of others, masturbated on stage, injured himself, and brawled with his audience. Ugliness along these lines has not always won over recipients and critics. In 1970, writer Anaïs Nin wondered about the cult of ugliness that obliterates hope: "The cult of ugliness is distinct from the acceptance that there is ugliness, just as taking pleasure in cruelty is distinct from the acceptance that there is cruelty in the world. But an obsession with ugliness lies ultimately in the writer's vision of the world, and when the writer loses his perspective and balance, he adds to the ugliness" (165).

Artists want to shock us with revolting images because they are critical of society. Western life can be boring. We become content, even apathetic. We create lifestyles where we don't have to confront ugliness. Shock forces us to do so. But if all art is designed to alienate, then it becomes difficult to estrange audiences further. Today efforts to break boundaries and agitate audiences are sometimes undertaken with a kind of tired self-irony, as if shock itself has become so routine, at least for observers of the art world, that it hardly provides the desired antidote to boredom or cultural satiation or whatever else the artwork is trying to break through in its efforts to transgress taboos (Menninghaus 398). That is the dialectic of shock: designed to address boredom, it can itself become tiresome, predictable, empty.

What John Stuart Mill feared in music seems to have unsettled also the visual arts, and the resulting movement into stranger territory has not always attracted a grateful audience. In 2007, Urs Fischer, a Swiss-born artist who lives in New York City, created an installation called *You* at Gavin Brown's Enterprise Gallery in Manhattan. A crater in the gallery, approximately 38 x 30 feet and dug eight feet deep into the foundation, extends almost to the gallery walls and is surrounded by a fourteen-inch ledge of concrete floor. Is *You* an indirect parody of museum artifacts looking too much alike? Is it a joke on the audience, antiart as art? Is it a great work or simply a gimmick, a cunning strategy

to surprise and shock audiences? What in turn should we make of Piero Manzoni's cans of artist's shit that seek to parody the art market and consumer waste while at the same time benefiting from the art market? Or consider Damien Hirst's dead-animal sculptures, one of which, *Two Fucking and Two Watching*, featured "two pairs of dead, rotting cows simulating copulation by means of a hydraulic device"; it was banned by New York public health officials for fear that the smell would induce nausea and "vomiting among spectators" (Lyall). What interweaves these attempts at unnerving the public is, on the one hand, a disfiguration of what has traditionally been called the humanistic element, a trend that Ortega y Gasset called "dehumanization and disgust for living forms" (42), and, on the other hand, a focus on form that breaks with tradition and turns on itself. With its inability to link to tradition, which has become both burdening and boring, and its need to mock tradition, the modern stance, becomes "jesting" (Ortega y Gasset 47). The desire to outrage audiences, once unleashed, has few limits. Jake and Dinos Chapman demonstrate this, from their fiberglass sculpture of two naked girls, one clinching a penis in her mouth (*Piggyback*, 1997) to multiple Ronald McDonalds on crucifixes (*In Our Dreams We Have Seen Another World*, 2013). To elicit shock, one must try ever-new strategies, including dangerous ones. The American Chris Burden enacted performance art that involved deliberate injury to himself, including his 1971 performance *Shoot*, in which an assistant shot him in the arm with a .22 rifle.

Independently of repugnant subject matter and shock as an end in itself, we see a dissolution of form, for example, installation pieces that consist of unconstructed, unfinished, and incoherent assortments of objects, as with Jason Rhoades's installation *Garage Renovation New York* (1993). We encounter conceptual art without demonstrable skill, such as Sarah Lucas's play with melons, oranges, a cucumber, and a bucket to imitate sexual organs atop a mattress, which she calls *Au Naturel* (1994). The dissolution of traditional theatrical performance is combined with self-reflection and audience mockery, as in Austrian dramatist Peter Handke's *Offending the Audience* (1966), which takes Brecht's alienation effect to the nth degree. Handke seeks to have the audience become aware of theater as theater. The play has no plot. The actors contradict themselves repeatedly, and they berate and insult the audience, calling them at times "accomplished actors" (for since there is no play, the audience members are the play), but also addressing

them as fascists, nihilists, prehistoric monstrosities, scumbags, and nobodies (*Die Theaterstücke* 40).

As ugliness increases, many artworks no longer fulfill the expectations of positive aesthetic value, such as opening a window onto truth or integrating part and whole. Critics have become uncertain what vocabulary they should use in the face of such extreme developments, both the increase in ugly works and the lack of aesthetic criteria. When today we are confronted with art objects that are ugly or gimmicky or without formal merit, we often hesitate to call them "ugly" or to refer to them as "bad art." Those terms sound too derogatory. Such designations could be taken to be unenlightened and uninformed. Yet we often do not know what to make of an art object that confronts us in this way: it is unexpected, odd, at some level ugly, and yet has been elevated into a museum or a gallery.

Perhaps the most common word to which we instinctively turn in such cases is "interesting," an in-between concept to which we are sometimes drawn when we need time to process the work, perhaps even with new categories, or when we hope that someone else can explain it as art or offer a more precise analysis, thus rescuing us from our inability to decipher or evaluate the work. In the social sciences, "interesting theories" tend to disrupt expectations and contest reigning assumptions even when they are untrue (Davis). The art world is not radically different, but here the recipient's appellation of "interesting" tends to imply also befuddlement and "indefiniteness" (Ngai, *Our Aesthetic Categories* 117). The category of the interesting as a response to modern art's incomprehensibility revives a term first introduced by Schlegel, more than 200 years ago, who emphasized that modern poetry is indifferent to form and coherence and wants simply to cultivate "*interesting individuality,*" which is characterized by new and strong effects (Ger. 222; Eng. 20). The elevation of the interesting, as opposed to the beautiful, becomes for Schlegel a new measure: "The *interesting* remains the actual modern standard of aesthetic value" (Ger. 346; Eng. 83, translation modified).

"Interesting" is an ambiguous term. On the one hand, it can signal attraction and perplexity and be a prelude to deeper engagement and reflection, a sign that one doesn't yet know, but wants to know. Important here is the diffuse and imprecise nature of the term, which at its best indicates continuing attentiveness to the work and openness

to substantive intellectual discussion. On the other hand, "interesting" can convey a final state of nonjudgment, a nonsubstantial engagement because recipients and critics have simply thrown up their hands and despair, in some cases even joyfully, of the inability to make judgments about contemporary works and the lack of categories to evaluate them with any confidence. At times, then, use of the word "interesting" arises as a subterfuge to avoid deeper engagement. The term allows one to dodge being characterized as a philistine, for if one were instead to say that the work is meaningless or absurd or crap, the speaker would surely be dismissed and disparaged as intolerant. Thus, "interesting" can be a sign that those employing it lack the categories to address and evaluate a work. The widespread use of the term points to the limits of much contemporary art theory and criticism, which has been increasingly shorn of normative perspectives.[5] "Interesting" all too often becomes not a prelude to patient exegesis but an implicit strategy to avoid the hard work of interpretation and evaluation. This development is understandable, given perplexing, often ugly artworks and the loss of normative categories, but it also blunts a fuller engagement that takes art seriously, be it via deeper, empathetic examination or critical judgment that links concrete details with coherent aesthetic categories.

Visitors to museums and galleries might easily be intimidated or confused, perhaps even bored. Already in 1960, Arnold Gehlen noted that the movement to abstraction brought forth modern art's need for commentary. The artwork and its commentary are for Gehlen so intertwined that he calls commentary an "essential *component of modern art*" (54). But since images are often so hermetic that grasping and interpreting them is difficult, commentary itself becomes elusive. The categories that gave us a common language to decipher older works are no longer in play. Moreover, ideologies and jargons have developed to fill the void, such that whatever one says about one work may in fact be transferable to another—and thus fail to capture a work in its specificity (Gehlen 168). The kind of language Gehlen describes can hardly satisfy those who are not themselves already part of a given school or ideology. Cynicism is one possible result—toward art and toward critics. Surely, many persons turn away or no longer take art seriously. Others may feign engagement and call contemporary works "interesting."

Kitsch and *Quatsch*

One consequence of modernity's turn away from the pleasing and accessible and toward the disgusting and bizarre is the partial loss of an audience, which as a result looks elsewhere, including to kitsch: sentimental, tacky, or formulaic works that eschew ugliness and lack tension. Kitsch is stereotypical, derivative, formulaic. Garden gnomes, sentimental images, and other imitative attempts at art call forth stock emotions. Whereas great artworks convey their meanings indirectly, kitsch is transparent, its ideas easily recognizable and its targeted mood directly evoked. Works of aesthetic excellence have some level of depth or negativity; kitsch is superficial and facile. It is not critical, which is one reason authoritarian rulers favor kitsch over art. It requires no serious effort on the audience's part and reinforces what the recipient already knows and wants. Hegel, who emphasized the role of negativity in beauty and in truth, speaks of the form of beauty that shuns negativity as "powerless" (*Werke* 3:36; *Phenomenology* 19, my translation). Kitsch idealizes; it does not include negativity or subtlety. It does not point beyond itself to something deeper and more complex.

Kitsch is immediately satisfying, which explains its popularity and consumerist appeal. The form is not original but conventional, which does not mean that it cannot be technically good (Giesz 29). People find kitsch sensuously appealing, and so the form fulfills a human need. It cannot be easily dismissed. To make kitsch effectively is to have access to an important market. People long for art and beauty but may not be in a position to discriminate between shallow kitsch and great art. Moreover, kitsch gives recipients an outlet to flee ugliness and elevate the beautiful in an age when it seems inappropriate. Still, kitsch lacks what we understand by beauty and is another mode of not being beautiful. In terms of negative aesthetic value, kitsch is in fact ugly. Adorno comments that in its lack of tension and avoidance of contradiction, kitsch is, paradoxically, "the beautiful as the ugly" (*Aesthetics*, Ger. 77, Eng. 47; cf. Noten 601; Notes 2:249).

The Austrian Hermann Broch has given us the best analysis of kitsch.[6] In "Das Böse im Wertsystem der Kunst" ("Evil in the Value-System of Art"), Broch argues that within the realm of appearances, evil resembles goodness. Drawing on a religious metaphor, Broch argues that the Antichrist looks like Christ, speaks like Christ, promises salvation, like Christ, and yet is Christ's opposite (145). We are

drawn to him, even though he is the father of falsehood. Writing in 1933, Broch was preoccupied with fascism and Hitler, not simply as an ethical but also as an aesthetic phenomenon. Broch draws an analogy between ethics and aesthetics. Kitsch has the appearance of beauty but is ultimately its opposite. It draws us in, much like beauty, but is not a window onto truth. Kitsch pretends to be art, but is instead nothing other than mere sentimentality and enjoyment (Klüger, *Von hoher* 25). Even a writer as sophisticated as Max Brod, Kafka's literary executor, notes with only partial irony the almost irresistible pull of kitsch. Brod suggests how understandable, if ambivalent, its seduction can be (17–23). Though kitsch replaces beauty, we deceive ourselves into thinking we are still in the realm of beauty.

The interest in kitsch and, related, the turn to melodrama rises at the same level that discontent surfaces about developments in modern and contemporary art. Whereas Clement Greenberg proposed in the 1930s the (production-aesthetic) argument that the avant-garde was a response to consumerism in art and so to kitsch, I want to suggest a reverse (reception-aesthetic) argument: modern esoteric art, including its integration of ugliness, drives many potential recipients of art instead to kitsch. Much of art today challenges us and our categories; in many cases it is unintelligible and inaccessible. For people who don't know what to make of it, their aesthetic impulses remain unsatisfied, and so they turn to kitsch. Already in the 1930s, John Dewey recognized this structure: "When, because of their remoteness, the objects acknowledged by the cultivated to be works of fine art seem anemic to the mass of people, esthetic hunger is likely to seek the cheap and the vulgar" (4). The inaccessibility of difficult beauty surfaces in multiple arts—esoteric painting, atonal music, ambitious literature, and perplexing installations. An additional challenge lies in modernity's focus on irony and unresolved metaphysical discontent (Giesz 92). Negativity is difficult, and when recipients turn away, their intuitive desire for meaningful sensuous beauty remains unfulfilled. It is this unmet need that Jeff Koons has sought to address as he has worked to erase the differences between kitsch and art. A final factor that has enhanced the modern rise of kitsch is the increasingly inexpensive and accessible mechanical reproduction of art, which allows those with even modest funds to obtain reproduced images (Benjamin).

Thomas Kinkade, who profited greatly from the propensity for kitsch, was at the time of his death in 2012 the most-collected living

artist in the United States. It has been estimated that a Kinkade image can be found in almost one of every twenty dwellings in the country (Boylan 1). Kinkade's works center around well-lit homes, appealing images of nature, often loose gestures to religion, a sense of emotional security, sentimental evocations of wealth and abundance, and nostalgic evocations of an earlier, less hectic era. Take as examples *The Good Shepherd's Cottage* (2001), *Home for the Holidays* (1991), *Lakeside Manor* (2006), and *Gardens beyond Spring Gate* (1998), each of which combines every one of these motifs. Kinkade viewed himself as a Christian artist, but his works exclude suffering or sin, brokenness or ugliness. His works do not engage a fallen or complex world. They lie at the opposite end of Kollwitz's, whose creations are infused with the dark challenges of modernity and the suffering of modern life. Whereas Kinkade's paintings are utterly serious, and Koons's creations—at the opposite end of kitsch—play with ironic self-awareness, in both cases we can stand with Adorno and say that the kitschy products of each artist are ultimately ugly, even if ugly in different ways. In contrast to the religious art of Grünewald and Caravaggio, sentimental, religious kitsch offers us cozy images and inoffensive saints unchallenged by the abysses of sin and grief.

The contrast between esoteric art and kitsch is hardly restricted to painting. Whereas avant-garde composers have difficulties finding an audience, elevator music, a kind of easy or unobtrusive listening with simple melodies, consistent keys, and reduced range, has widespread appeal. Even before the advent of elevator music, Hubert Parry suggested that "the complacency of a work which sedulously avoids everything that might be described as ugly is soporific and soothing, but it does not enlarge men's lives much. It only ministers to the feeling of being comfortable" (508). The desire to be comfortable in an age of disarray and to avoid difficult, including at times insurmountable, aesthetic challenges, renders kitsch attractive and alluring.

Another form of negative aesthetic value arises in conjunction with difficult beauty: what I call *quatsch*. A German word, like kitsch, *quatsch* means "bunk," "nonsense," or "bullshit" with reference to speech. I am borrowing the term and extending its meaning, as a counterpart to kitsch. In my reformulation and extension, *quatsch* refers to a would-be artwork, usually ugly in nature, in which there is no opening onto deeper meaning and whose formal accomplishment tends to exhaust itself in innovation. In short, *quatsch*, which always

lacks aesthetic merit, tends to elevate ugliness. Think of the naked Günter Brus or of others, whose works reveal, in their cases metaphorically, that the artist is wearing no clothes. It is not clear to me that there is an art theorist clever enough to explain how art that reaches its high-point in performances of self-mutilation and public defecation can be understood to have great aesthetic value and is deeply worthy of wide audience viewing. Performing acts of self-mutilation, putting together random assortments of objects, and then challenging the audience to make something of them may well be the ideal avenue for opening up metaphysical meaning. But maybe not. Perhaps only by distinguishing between bad art and great art that integrates ugliness can we hope to engage in the difficult task of evaluating controversial art. Ugly art that lacks either deeper meaning or formal accomplishment demands an expansion and refinement of our categories.

Many complex cases can and should be debated. We can make mistakes in sifting what is great art and what is *quatsch*. Some revolutions in art will only appear to be *quatsch*. And some works that at first blush seem superficial, shallow, and gimmicky, such as Ball's "Threnody," Gonzalez-Torres's *"Untitled" (Portrait of Ross in L.A.)*, or Wall's *The Flooded Grave* may turn out to have hidden depth. One might employ the category *prima facie quatsch* to describe such works. If we believe that criteria exist for the evaluation of art, the category of *quatsch* allows us to debate both criteria and judgment, to defend some works and criticize others. Where, for example, does one place Tracey Emin's *My Bed* (1998), an installation piece consisting of an un-made bed and its immediate surroundings, with stained sheets, worn panties, KY Jelly, used condoms and tissues, empty liquor bottles, cigarette butts, and other items strewn about the floor. What evaluation is one to give of its aesthetic quality, its form and its idea, its relation of part and whole? Is it simply ugly art or a contemporary transformation and remake of Delacroix's *An Unmade Bed*? Where does one place Jake and Dinos Chapman's *Zygotic Acceleration, Biogenetic De-Sublimated Libidinal Model* (enlarged 1000 times) of 1995, which is a life-size installation of sixteen fiberglass female figures, all naked, save for black sneakers, and fused together? Four of the girl puppets have erect penises in place of noses and anuses instead of mouths. At various points where the girls' heads are fused together we see instead of ears vulvae. The work hints at genetic engineering gone awry but seems above all to be a transgressive combination of play dolls, juvenile girls,

and perverse adult sexuality. Is it great art, pornography, or *quatsch*? How about the graffiti-like, chaotic paintings of German artist Jonathan Meese with their nonsensical titles, for example, his 2016 multimedia work *Fort d'EVOLUTIONSKNOXOZ de ZARDOZEDADADDY 2 (ERZ JOHNNY WAYNE IS DADDY COOLISMEESE)*?

And what are we to make of the works of Paul McCarthy, whose performance art includes such recurring elements as smearing condiments on the body, pouring liquids into pants, placing private parts in contact with various kinds of food, masturbating, urinating, injuring one's body, being or feeling trapped, stuffing food into the mouth to the point of excess, and retching. Can one make the case that these works are not *quatsch*? In the 1970s, McCarthy integrated the work of the Viennese actionists, even if in a typical American shift he replaced blood with ketchup. Initially painting by manipulating his head, face, and penis as a brush and using as material also his own feces, McCarthy moved on to still more radical and involved actions. In *Hot Dog* (1974), McCarthy strips and shaves his body. He puts his penis into a hot dog bun, taping it in place, and smears his butt with mustard. Approaching the audience, he then drinks ketchup and stuffs his mouth with hot dogs to the point of excess. Retching and gagging follow, even as he binds his mouth shut with bandages across his head, ensuring that the foodstuffs remain in his mouth. Artist Barbara Smith offers an account: "Binding his head with gauze and adding more hot dogs, he finally tapes his bulging mouth closed so that the protruding mouth looks like a snout. . . . He stands alone struggling with himself, trying to prevent his own retching. It is apparent that he is about to vomit. . . . Should he vomit he might choke to death, since the vomit would have no place to go. And should any one of us vomit, we might trigger him to do likewise" (Rugoff et al. 43). The performance may be said to mock social decorum, criticize gluttony, reflect on the relation of inner and outer self, or make manifest the tension between freedom for consumption and imprisonment in desire, but one also wonders whether the purpose might simply be to shock the audience. Another example is McCarthy's *Class Fool* (1976). After a slow windup in a dark classroom, a naked and ketchup-layered McCarthy jumps around a ketchup-spattered classroom and repeatedly falls. He then vomits several times. The work ends when the audience can no longer stand to watch the performance (Klein 15). *Class Fool* is a reductio ad absurdum of the topic, but perhaps more as embodiment than critique.

ILLUSTRATION 34
Andres Serrano,
Self Portrait Shit, 2007,
Photograph, Courtesy
of the artist and Galerie
Nathalie Obadia,
Paris/Brussels.

Andres Serrano's 2008 exhibit *Shit*, which consists of sixty-six pho-
tographs of excrement, from various animals, and in diverse shapes
seems like *quatsch* but may exceed it (illustration 34). One could argue
that Serrano is trying to show us that we have organs that function in a
certain way so as to cleanse the self, and that even though we turn away
from this waste, we should not suppress it, we must recognize it as part
of life, and so in this way we are encouraged to see the shit as beautiful.
That would be a modestly clever interpretation by a critic who says,
"Give me any artwork, and I will make it interesting." Perhaps Serrano
wanted simply to shock his audience and thereby attract attention and
resources. The crucial question is whether the work includes deeper
meaning or is reducible to a clever gimmick.

Much depends on the role of ugliness within the work. In Park
Chan-wook's Korean film *Oldboy* (2003), we are confronted with mul-
tiple gruesome acts. Park takes his viewers beyond where they might
have wanted to go, but the logic of this excess is tied to the cinematic
unveiling of horrific knowledge and ugly vengeance. Park also adds
complexities, making the arch-revenger, Lee Woo-jin, not only evil,

but also intelligent and imaginative, with moments of humanity. Park uses the recurring theme and structure of mirrors and mirroring characters to enhance complexity and convey that even as we are repelled, we are not in the least above the action. Despite his innovations, Park acknowledges tradition, making rich allusions to Sophocles and to the Bible. The film pushes the envelope in its grotesqueness, perhaps even because of a fascination with it, but the parts garner meaning within the whole, and the work raises moral questions without advancing morally repugnant positions.

Alas, what seems most distinctive today is not difficult beauty of this kind but an increased interest in kitsch on the part of recipients who do not understand the difficult beauty of much that is seemingly ugly and an increased production of *quatsch* on the part of would-be artists who have abandoned meaningful aesthetic criteria and hang their hats on gimmicks—ugly content, unrefined form, marketing cleverness, and shock. The difficult beauty of *Oldboy*, which has classical resonance, even in its gruesomeness, differs radically from the kind of art that does not embody technical achievement and often enough exhausts itself in narrow self-reflection. It differs also from what consumers of Kinkade desire. For Broch, kitsch is, to an alarming degree, the sensuous expression of our age, a positivistic, anti-Platonic world, which reduces the infinite to the finite (145, 168–69). But *quatsch* is its sister: whereas kitsch seeks to please, independently of any higher aspirations for art (123), *quatsch* seeks to shock or confound, independently of any higher aspirations for art.

Although much of *quatsch* lacks an audience, *quatsch*, precisely because it cultivates a notion of exclusion, an impression of the avant-garde, can create excitement and invite investment. Like kitsch, it has the potential to become marketable. Sometimes *quatsch* is even "interesting." To continue to shock the public is not easy, and so *quatsch* can also become repetitive and banal even if it seeks not to please through sugary form but instead to confront the viewer with its contrariness, its jests, its middle finger. *Quatsch* is now widely accepted. Gerhard Richter, the most versatile painter of our era, stated some years ago that about "70 percent" of what is shown in art catalogues and often sold for huge sums is "garbage" (*Müll*) ("Gerhard Richter"). *Quatsch* has become part of the status quo, even as, ironically, much of *quatsch* seeks to challenge the status quo. In some ways the substitution of kitsch for beauty is the inverse mirror of the replacement of

beautiful ugliness by *quatsch*: the final goal is a feeling or experience. In *quatsch*, this involves not pleasure, but disgust, not ease, but irritation. In kitsch and *quatsch* we recognize the absence of a higher purpose that includes, but transcends, elements of pleasure or disgust. Both lack transcendence; the one manufactures a sentimental, alternative reality, while the other mimics the reality of repugnance or moves art into the realm of a confidence game.

MODERNITY'S ONTOLOGICAL AND AESTHETIC SHIFT

What triggers the modern ascendance of ugliness, which has continued into our age? What led to such a radical turn away from centuries of art that placed a premium on beauty? What factors have turned so many modern artists toward ugliness, such that some recipients wonder why a particular work is even called art?

A New Concept of Reality

In modernity, a different concept of reality emerges. In ancient Greece, mimesis was not simply imitation of the existing world, but an attempt to uncover metaphysical meaning, to discern the higher forms, to portray characters who are greater than real life. The abandonment of the classical ideal and the widespread dissolution of Christianity as the dominant paradigm of the age play prominent roles here.

Challenges to Christianity increase in the wake of the Enlight-enment.[1] Though some thinkers, such as Hegel, continued to develop a rational theology, the idea of Christianity as the world's ordering principle began to dissolve. The natural sciences challenged the reli-gious worldview and emancipated themselves from holistic princi-ples. Already in the late eighteenth century, philologists pointed out inconsistencies in the Bible. Religious thinkers, who struggled to ex-plain difficult puzzles, including the origin of evil and the nature of God, turned at times to mystification and often defended the existing social hierarchy. The development of new disciplines, such as history and anthropology, challenged religious ideas of eternal truth. A se-quence of thinkers, most prominently Feuerbach, Marx, Nietzsche, and Freud, offered diverse critiques of religion. Scholarship became increasingly specialized and veered from even the ideal of the unity of knowledge. The concept of the absolute was discarded. This disso-lution of Christianity as the world's ordering principle accelerated after Hegel's death and became a marker of modernity. Not all of this was a negative development, because religion deserved much of the criticism leveled against it, and modernity opened up abundant new paths, including in art.

But with the dissolution of the idealist and Christian universe, we see a widespread rejection of transcendence or the idea that there is an ideal world we seek to understand and imitate in moral activity as well as in art, and we are left with a concept of reality as simply what is. This radical change in ontology receives its classical expression in Wittgenstein's "the world is all that is the case" (*Tractatus* 11). Witt-genstein's reality differs greatly from Plato's concept of reality as a higher order, this world being but the semblance of those higher forms, that true reality. Modernity's reality is no longer a realm of being that has implicit in it a normative claim, but sheer facticity, the merely sen-sible world. Whatever occurs is reality—there is nothing else. But mod-ernity does not stop there. The view emerges, and becomes dominant, that our existing world is repugnant, fragmentary, and without over-arching meaning. "Ugliness was the one reality," suggests Oscar Wilde's most famous aesthete (*The Picture of Dorian Gray* 3:325). The two de-fining moments of this new realism are immanence and repugnance. Kathryn Simpson has shown how Oskar Kokoschka, whose work com-mences shortly after Wilde's death, portrays himself as ugly in his non-artistic self-presentations and in works such as *Self-Portrait as Warrior*

(1909). Rendering himself displeasing became a way of underscoring Kokoschka's truthfulness to reality.

"Real" for Plato and also for Hegel is what is good, true, and beautiful. And therefore they would say that certain visible objects with which we engage ourselves, mundane aspects of everyday reality, are not really real. The visible includes ephemeral appearances, which do not form the core of reality. Art, which is able to capture essential structures beyond the ephemerality of everyday life, is closer to this higher reality. Once this concept of a higher reality collapses and insofar as one remains faithful to the idea of mimesis, the focus shifts. There is much to uncover that is ugly, much that invites description and analysis. Artists and writers devote more and more attention to ordinary reality in its unappealing aspects and in its ordinariness. What we see in realism becomes even more pronounced in modernism—the ordinary, the mundane, the everyday (Freed-Thall). Art can be everywhere, and everything can be art.

As part of this revolution in ontology we see a shift in the social sciences. The turn to a previously overlooked reality and the depiction of this new reality give rise in the later nineteenth century to scientific disciplines that have no equivalent in earlier concepts of science, for the concept of science in earlier cultures, which derived from their idea of reality, did not allow for such sciences. Science had always explored reality in its higher sense. In the modern world, where reality is whatever exists, we recognize, for example, among the new sciences, criminology, a discipline that analyzes evil, specializing in crime and its causes. Another discipline inaugurated only in modernity is sexual pathology. Richard von Krafft-Ebing's *Psychopathia Sexualis* could be conceived only in the wake of a revolution in ontology and thereby in science. One wants to analyze all existing sexual behaviors and perversions and write an erudite book about them—and this is scientific because it describes what happens to be the case. Such a work would not have been compatible with the concept of science in the Platonic and even Aristotelian models because the object was not dignified enough to be regarded as worthy of science. That changes in modernity.

This historical shift also explains why the sublime, in which dissonance likewise plays a major role, could be accepted long before the ugly but then become increasingly supplanted by it. In challenging

our senses and imagination, evoking terror through the display of vastness or power, the sublime nonetheless reaffirmed, in some cases even heightened, our sense of transcendence and nobility; think of Kant's moving comments at the end of his second critique. The early Hegelians, for example, Arnold Ruge, recognized in the sublime the reverse of the ugly, with the former evoking the infinite and the latter holding on to the finite (98). The transcendent moment explains the link between the sublime and the tragic, and it underscores how significant the sublime was in the eighteenth and early nineteenth centuries. The ugly, on the other hand, was traditionally more difficult, challenging us, via its repugnant subject matter or its seemingly nonorganic form, and leaving at least the initial sense that it is an affront to transcendence and nobility. In modernity, however, with widespread abandonment of the transcendent and a far more negative view of reality, the sublime is supplanted, and the ugly becomes dominant. One thinks of Zola's portrayals of the French proletariat, Upton Sinclair's exposé of the Chicago meat-packing industry, or Hauptmann's integration of extreme poverty and disease.

Using Schiller's categories, we can say that the art world moves from the elegiac, with its focus on past or future ideals, to the satiric, with its stress on the inadequacies of reality. The turn to the ugliness of reality both overlaps with, and reverses, what we saw in Catholic thinkers such as Bernard of Cluny and Protestant writers such as Andreas Gryphius, who likewise emphasized the world's ugliness but only to undermine it and so appeal to transcendence.

Not only does modernity reject the concept of an ideal world, it increasingly sees this world as distinctly ugly. Otto Dix's etching *Skull* confronts us with the inhumanity and devastation of World War I: an abundance of grotesque worms crawl over a human skull (illustration 35). The worms, which emerge out of the eye sockets, nose, and mouth, dominate, such that the human gives way to the animal realm. In an interview with Hans Kinkel, Dix makes clear that art cannot neglect ugliness: "War is something so brutish: hunger, lice, mud, these insane sounds. Everything is just completely different. You know, looking at the earlier paintings I had the feeling that one side of reality still hadn't been portrayed at all: the ugly" (Kinkel 13). Ugliness in modernity partly derives from a new focus on, and awareness of, reality's ugliness.

The turn to reality and focus on ugliness were reinforced by singular historical developments, among them the devastating effects of technological warfare; industrialization and its effects, which displaced the pastoral; and urbanization along with the crowdedness, busyness, and disorder of daily life. In Georg Heym's "The God of the City" (1910), the city is a raging demon that cannot be satisfied and destroys humans, who nonetheless pray to it: the smoke of factory chimneys rises like incense:

The red belly of Baal glows in the sunset,
About his feet great cities kneel and cower.
Unnumbered peals of bells from every church
Surge up to him out of a sea of black steeples.

Like a Corybantian dance the music of the millions
Drones loudly through the streets.
The chimney smoke, the clouds of the factories
Waft up to him, like a bluish incense haze.

<div align="center">(107, translation modified)</div>

At the turn of the twentieth century, Ouida, the pseudonym for English novelist Maria Louise Ramé, lamented "the ugliness of modern life" and bemoaned the ascension of factories and loss of the picturesque (196–223). Even home life was disrupted. Ouida writes that "in the houses of poor people, the things of daily usage have lost their old-world charm; the ugly sewing-machine has replaced the spinning-wheel, the cooking-range the spacious open hearth, the veneered machine-made furniture the solid home-made oaken chests and presses, a halfpenny newspaper the old family Bible" (201–2). A few decades later, Ainslie Darby and C. C. Hamilton wrote about ugliness and noise, bemoaning the extent to which arterial roads, motor vehicles, speed boats, and airplanes as well as power stations and pollution besmirched rural England's beauty.

This view of reality was also colored by rising social values. Secular consciousness turned toward issues to which a more enlightened consciousness should object: war, brutality, poor working conditions, racial biases, restrictive social conventions, asymmetrical gender relations. As part of a renewed emphasis on this world, Christianity developed greater awareness of social justice. Attending to ugliness is in some ways a continuation of the Judeo-Christian tradition that seeks to address the poor and the outcast, yet in other ways it represents a clear turn to this-worldliness. We see rising sensitivity to the objective causes of suffering and the effects of suffering and despair on the disenfranchised along with an attempt to describe and understand them with increasing exactitude. Not by chance sociology emerges as a new academic discipline. The scientific impulse enters literature too; Zola writes in 1867 that he approaches his characters with "scientific knowledge" (*The Experimental Novel* 9). In the process, loveliness and

harmony give way to truth and attentiveness to reality. Unveiling deficiencies becomes a higher value than creating beautiful constructs.

This new concept of reality came in tandem with, and helped to exacerbate, an abandonment of the theodicy. One answer to the theodicy had been that evil does not exist. This idea, the privation theory, which viewed evil as a privation of the good, *privatio boni*, begins already with Plotinus (1.8.3) and is prominent beyond him. For Pseudo-Dionysius, Augustine, and Aquinas, evil and ugliness do not ultimately exist; evil is a deprivation and ugliness a defect, a lesser beauty. All that is has a place in the larger order and harmony of God's creation, and so evil is not a positive force: it is simply a turning away from the good (Pseudo-Dionysius, *Divine Names* nos. 23–30; Augustine, *Confessions* 7.19, *On the Free Choice of the Will* 1.1.2.6 and 2.19.53.200; Aquinas, *De divinis nominibus* 4.5.345, 4.14.479, and 4.22.587). Even if the privation theory still has its contemporary admirers, among them, former archbishop of Canterbury Rowan Williams (79–105), the theory is not easily compatible with Christianity's emphasis on sin.[2] Conceiving of evil as a lack does not do justice to the active way in which evil manifests itself, especially in the wake of Christianity's understanding of the human will, Protestantism's emphasis on wickedness, and modernity's turn toward negativity. The privation theory had been attractive because it rendered the theodicy more manageable. Christianity did not want to allow for an agency of evil independently of God, nor did it want to view God as having created evil. Unfortunately, the privation theory seemed too facile a solution whenever it was confronted with extraordinary levels of evil, such as unjust wars or individual maliciousness. Evil is not an absence, but is present, real, and often combined with a strong and active will.

The greatest challenge to the privation theory came from the German idealist Friedrich Schelling, specifically his *Philosophical Investigations into the Essence of Human Freedom* (1809), which draws on Jakob Böhme. Schelling offers a perversion, not a privation, theory of evil. He insists on rendering justice to the phenomenological reality of deliberate, willful ugliness, and he wants to avoid both the privation theory (whereby evil does not exist) and the nonmonotheistic idea of two competing forces, which would limit God and indicate, moreover, the "self-rupture and despair of reason" (Ger. 66; Eng. 24, translation modified).

For Schelling, evil could have been avoided only if God had not created the world. Good and evil were originally united in the "absolute indifference" of the "non-ground" (Ungrund) (Ger. 127; Eng. 68). God is not simply positive, but a complex unity of positive and negative categories. Differentiation of the "non-ground" makes possible the "ground" (Grund) which unites the ideal and the real, good and evil, in absolute identity, that is, they are distinct but perfectly unified (Ger. 130; Eng. 69). In creating the world, God separated the real from the ideal. The real, as manifest, is dualistic. Evil is an inherent possibility in this world. Human freedom involves the "capacity for good and evil" (Ger. 64; Eng. 23). Humanity has the full power of darkness and the full power of light, but only in God are the dark and light unified. Without this separation of dark and light, and thus the possibility of evil, humanity would not be (Ger. 77; Eng. 32–33). In its freedom, the human being is called to resist evil, but the human being is finite and does not always succeed. Even though evil should not be, it is always possible, and when manifest, full of force and power. Insofar as ugliness is etymologically linked with what evokes fear (the Old Norse *uggligr* means "fearful" or "dreadful") and was only later softened to what is displeasing in appearance, Schelling has captured something that is even built into language.

We would be mistaken if we said that the ugly art of modernity can be understood as simply lacking beauty. The phrase is misleading. More often than not, modern ugliness is intentional. So in modernity we have three coinciding movements. Evil is seen to be not a lack of goodness but willful perversion. Related, ugliness involves not simply missing the mark on beauty: it is a willful artistic act. Some artists are actively engaged in creating ugliness. It would be wrong to say that they lack the capacity to create beautiful works—beauty is not in their sights. We see in aesthetics, too, the shift from privation to perversion. Finally, we begin to recognize in ways that break fully with medieval metaphysics that the ugly is not simply a lack but has a dialectical relation to the beautiful.

In literature, the focus on dissonance and loss of a speculative horizon means, for example, that tragic suffering does not fit within a larger frame that includes gestures to reconciliation. Comedies less frequently end in marriage or harmony, and when they do, they do so ironically. In painting, which tends to capture only a moment, those isolated moments are increasingly associated with suffering and the

causes of suffering. Voltaire's account of one almost unspeakable hardship after another in *Candide* (1759) is a paradigmatic example of this new concept of reality and its farewell to the theodicy. A turn from the transcendent involves a turn to reality and to reality as deficient.

Larger metanarratives, be they religious (and providential) or rational (and progressive), lose much of their persuasive power and give way to a focus on isolated moments of dissonance abstracted from any overarching speculative frame. Instead of asking, given a certain concept of God, how are we to understand the seeming dissonance of reality, we ask what possible concept of God could follow from the unambiguous dissonance of reality (Hösle, *God as Reason* 51). This latter question animated the Jewish philosopher Hans Jonas, who, affected by the unspeakably horrific Nazi death camps, including Auschwitz, where Jonas had lost his mother to the gas chambers, was driven to reflect on the theodicy.

Also emerging in tandem with the elevation of ugliness and contributing to it is a discovery of the complex inner psyche, which becomes an entirely new reality. Peter-André Alt has argued that when the Enlightenment banished the devil as the personification of evil, evil did not disappear; it became subtler, psychologically intertwined with our inner lives, whose darker moments were put on greater display (13). Goethe's Mephisto announces the emergence of a new kind of evil: "It's dated, called a fable; men are clever, / But they are just as badly off as ever; / The Evil One is gone, the evil ones remain" (Den Bösen sind sie los, die Bösen sind geblieben) (*Goethe's Faust* 2507–9). An interest in inner deviance and perversion increases, as we see with Schiller, Heinrich von Kleist, and E. T. A. Hoffmann, among others. The new discipline of psychology uncovers an array of human categories that had previously not been as visible to the eye or at least not been brought to the level of consciousness, including urges toward aggression.

The widespread abandonment of Christianity and idealism leaves modernity, then, with a new concept of reality, which is not to say that there are not still Christian artists, that authors such as Brecht simply accept reality as it is and do not move toward its reform, or that utopian writing disappears from the landscape. Still, the dominant mode is a new form of realism. Authors whose Christianity remains central to their identity wrestle, perhaps even more so than in the past, with uncertainty; satirists tend to focus only on the negativity of reality

without articulating an alternative; those who seek to transfigure reality may see reality not as subject to a transcendent standard but all the more malleable in and of itself; and the prominence of the utopia in the early modern era, as with Thomas More and Tommaso Campanella, is matched in the twentieth century by a dystopian turn in authors such as Aldous Huxley and George Orwell. Truth in modernity is no longer correspondence to an ideal norm; instead, it is what we make of this world, what we invent and create. The *verum-factum* principle, or the idea, first fully developed in the seventeenth century, that reality is not what we discover but what we construct, is at the core of this new realism.

Transformations in Aesthetic Values

Beyond the new concept of reality, and in some ways working in tandem with it, has been a series of aesthetic revolutions. These have involved above all a break with tradition, including a sense that beautiful forms are incompatible with increasingly ugly content, and a series of shifts in what is understood by autonomous art. Modern art more and more serves the purpose of undermining what is, which privileges aesthetic rupture and disruption, resulting in art that is abrasive, not harmonic. There is a need, first, for unusual forms to deal with what is truly unappealing. If the world is repugnant, then form, it is argued, should mirror this ugliness. The composer and musician Frank Zappa declared; "You can't write a chord ugly enough to say what you want to say sometimes." Given that beauty includes an appropriateness of form to content, in an aesthetic interpretation of the ugliness of life, great asymmetries and perversions of what is traditionally called beautiful may be appropriate.

We see a conscious rejection of past aesthetic norms associated with harmony along with a privileging of the disjunctive and asymmetrical. In rejecting tradition, many artists consciously eschew those elements that constitute traditional definitions of beauty. Ironically, modernity itself constitutes a new tradition defined by its hostility to tradition. Whereas unity and harmony were markers of Winckelmann's classical ideal, modernity is distinguished by the fragmentary and dissonant. Turning away from unity means an ascendance of parts,

which gain autonomy and need not be viewed from the perspective of the whole (Bürger 72). Likewise, ugliness need no longer be subsumed under beauty, and the art world abandons the concept of wholeness. Instead, artists seek to construct works out of a montage of independent parts.

In an era that does not view Christianity as the animating principle for all realms of life, art no longer portrays a divine ideal, and the artist ceases being the medium through which this ideal becomes visible (Hauser 349). The modern and contemporary artist wants to be innovative and different, which means pushing the limits of form (being creative and experimental at the cost of the organic) and pushing the limits of reception (creating works whose primary purpose is to surprise or shock or confuse). The modern artist is challenged by the burden of the great art of earlier ages and the increasing speed with which new art movements arise. To be original in such a climate is not easy, yet innovation becomes ever-more important.

Also in terms of content, the rejection of the past leads to artworks that respond to earlier works and earlier forms of consciousness, but in such a way that the responses become ever-more complex. A series of metalevels results. Heroic art shows greatness in the face of mutilation, but antiheroism unveils the hypocrisy behind heroism. And of course the self-righteousness of antiheroism is up for criticism too. In this spiral of critique, the harmonic moment, which seemed easier in a less complex era, becomes more difficult to achieve.

Art's autonomy includes the idea that art is not bound by reality. Already Aristotle recognized this claim, even if across time theories of strict mimesis occasionally gained ascendancy. In modernity the artistic flight into imagination took artists further and further away from recognizable categories, as became evident, for example, in surrealism, which felt itself unbound by reality, reason, and traditional aesthetics. In the short film *Un Chien Andalou* (*An Andalusian Dog*) (1929), surrealists Luis Buñuel and Salvador Dalí create a work that is untethered from reality. We see a kind of dream logic at play that defies nomological laws. Moreover, the images were consciously constructed to defy rational explanation. The scenes are disjointed, such that there is no coherent story line. Perhaps the one identifiable meaning arises early when Buñuel appears to slice open the eyeball of a young woman, thus underscoring that the film is designed to be an assault to the eye, unreal, irrational, and shocking—a revolution in art.

Also relevant is the autonomy of the individual arts. Through the Baroque era, churches were designed and built in such a way that the various arts together formed a holistic unity. This sense of unity begins to disappear in the late eighteenth century. Each art form becomes pure unto itself. Architecture tends to bracket color and ornamentation. Indeed, ornamentation, which cannot be autonomous, essentially dies out (Sedlmayr 90). Furniture is no longer fashioned in order to fit into a certain environment; pieces of furniture become ends in themselves.[3] Already with J. M. W. Turner we see the diminishing importance of lines, which are left to the province of sculpture. In Paul Cézanne we recognize the elevation of color, which partly disappears from sculpture and architecture. That the art museum emerged in the eighteenth century is not by chance; in such a museum, individual works are autonomous, not organically related to one another.

The extreme version of this autonomy is related to the first concept, freedom from reality: for example, as painting sought to define its unique capacities after the advent of photography, with its capacity to capture reality, painting became more and more autonomous; it no longer sought to capture reality (imagination became more prominent, reality less significant). Painting accentuated more and more what made it distinctive, including color, shape, stroke, and texture, which made it autonomous in relation to the other arts. Broch writes: "The logic of the painter demands that the principles of painting shall be followed to their conclusion with the utmost rigor and thoroughness, at the peril of producing pictures that are completely esoteric and comprehensible only to those who produce them" (*The Sleepwalker* 446; chap. 44 of *Huguenau*). The lack of external restrictions associated with autonomy means not only a severing of the arts but also new and unprecedented combinations, such as photomontage.

Also modern is the idea that art does not serve an exterior purpose, for example, the once dominant religious purpose, which makes possible the autonomy of music that Carl Dahlhaus calls "absolute music." Art is not beholden to other spheres. This idea reaches its pinnacle when art is severed from its connection to any other sphere, including the ethical. In the preface to *Dorian Gray*, we see the abandonment of any link between goodness and beauty. In addition, Wilde's character Gilbert asserts in *The Critic as Artist*: "The sphere of Art and the sphere of Ethics are absolutely distinct and separate" (4:189). With this separation of art and morality, the immoral need no longer be

considered ugly. This can lead to works that celebrate moral ugliness or that portray moral beauty as ugly or repugnant. Sade's *Justine; or, The Misfortunes of Virtue* and *Juliette; or, Vice Amply Rewarded* suggest that moral virtue not only goes unrewarded but is nothing but a hoax, and that sexual licentiousness, along with cruelty, torture, violence, and murder, leads to unrestrained pleasure and prosperity. The development of autonomy in art is part of a wider phenomenon that involves modernity's loss of an organic worldview.

In contrast to the Platonic and Christian paradigms, modernity separates out the different spheres of life, including art and ethics. We are taken by highly intelligent persons who commit evil acts, fascinated with the idea that reason and morality have separated. Although Christianity could recognize the devil's strategic intelligence, a more radical break comes with Hume, who makes the bold claim that reason does not affect our moral worldview. Our ends are determined by passions. Reason, which is "the slave to the passions," simply determines the means (*A Treatise of Human Nature* 2.3.3). This worldview has had its detractors: Kant objected to it, and in our age it has been rejected by the transcendental pragmatics of Karl-Otto Apel and the objective idealism of Vittorio Hösle, each of whom links morality and reason. But it was accepted by Arthur Schopenhauer and Friedrich Nietzsche, and it drives the rational choice theory of our day, with its focus on means rather than ends. The severing of reason and morality is today's dominant paradigm. A fascination with the intelligent wrongdoer is part of this worldview. We see it in early cinema, as in Fritz Lang's Dr. Mabuse films, and abundantly in our era, as with Hannibal Lecter in *The Silence of the Lambs* or Gordon Gekko in *Wall Street*. A still greater consequence is the value-free or even positive depiction of intelligent but evil figures, as in David Mamet's *House of Games*.

The ugly and grotesque had previously been understood as part of a larger whole; as a result they were present but subordinate. In modernity, the ugly holds sway independently of its relation to a larger whole. The very idea of a Hegelian synthesis is rejected. Unleashed and independent, ugliness is no longer a complement to beauty; it has autonomous value. Moreover, because the ugly is not subordinate to beauty, ugliness is no longer associated with low art, as was the case with Homer's Thersites or with the long historical connection between comedy and ugliness; instead, ugliness enters high art, becomes

prominent there, and replaces beauty. Adorno is the exemplary theoretical advocate for both these transformations: on the one hand, the independence of ugliness and its no longer being subordinate to beauty and, on the other hand, the release of ugliness from its association with low culture.

The final moment of aesthetic autonomy is the idea that art cannot be evaluated by anyone other than the artist. All others come at art from an external perspective. This view, though not dominant, is nonetheless aligned with today's widespread difficulty in making normative aesthetic judgments. If the artist alone speaks authoritatively, we can only receive works, we cannot evaluate them.

These two broader contextual dimensions—changes in reality and our perception of reality, and a set of interrelated revolutions in aesthetics—are in some ways intertwined and in fact occasionally surface together. Certainly one movement in which the new concept of reality and new aesthetic models were deeply interwoven was Dada. Grosz, one of the members of the Berlin Dada group, describes "the visual Dada-'art'" as "the art (or also the philosophy) of the garbage can" (*Ein kleines Ja* 130; *George Grosz* 134, translation modified). Kurt Schwitters collected trash from the streets: "rusty nails, old rags, toothbrushes without bristles, cigar butts, old bicycle spokes, half an umbrella" (Grosz, *Ein kleines Ja* 130; *George Grosz* 134). Grosz relates that whatever people no longer wanted Schwitters collected, glued onto boards, and sold as art, as "Art of the Rejected" (*Merzkunst*) (*Ein kleines Ja* 131; *George Grosz* 134). Artists, collectors, buyers, and others who wanted to profit from the enterprise took it in full seriousness, but Grosz sides with the more skeptical public: "Only ordinary people, who know nothing about art, reacted normally and called the Dada artworks junk and rubbish—which is after all what they were made of" (*Ein kleines Ja* 131; *George Grosz* 134, translation modified). A paradigm that rejects transcendence and emphasizes reality in its basest mode, including garbage, becomes combined with a revolution in what counts as art. Some resist, but modernity advances this fascinating combination, of which junk art becomes simply one example among many. A still richer example of art's immersion in ugliness is Wilde's *The Picture of Dorian Gray* (1890).

The Ambiguity of Wilde's *The Picture of Dorian Gray*

The Picture of Dorian Gray is a novel of inexhaustible attraction—in its story line, characters, and ideas. It is representative, even in its magical moments, of modernity's turn to a very dark reality and an apparent breakdown of the traditional link between beauty and goodness. The novel, deeply controversial in the late nineteenth century, was harshly criticized for its apparently positive depiction of homosexuality and its seeming endorsement of a morally depraved character.[4] Wilde presents us with a superficially beautiful character who immerses himself in moral ugliness. At a young age, the hero of the novel, Dorian Gray, admires a painting of himself and, under the influence of the cynic Lord Henry, who laments the loss of beauty to a "dreadful" state in which one is "old and wrinkled and ugly" (3:186), wishes that he, Dorian, could forever remain in appearance as young as in the painting. In a fantastic, almost Faustian transformation, Dorian's wish becomes reality, and as Dorian lets go of his soul, acting cruelly and eventually committing murder, the painting, which he stows away in his spacious attic, reveals his inner self and becomes hideous. In the end, Dorian, unable to live with the ugly painting and its reminder of his sins, stabs the work. However, destroying his soul in the painting results in his death. The painting is suddenly restored to its original beauty, and the physical Dorian dies an old and ugly man.

Much evidence suggests that the work is an aesthetic construct that has no relation to morality or religion. It would thus be an example of aesthetically appealing art that is indifferent to morality. This amoral reading finds support in Wilde's preface. Wilde argues that art has nothing whatsoever to do with morality: "There is no such thing as a moral or an immoral book. Books are well written, or badly written. That is all" (3:167). This view is also espoused by the witty and cynical Lord Henry, who shares much in common with Wilde. It also appears to match Wilde's own view, for Wilde elsewhere embraces the antagonism between the aesthetic and the ethical. In his dialogue "The Decay of Lying," which appeared one year after the novel, Wilde suggests not only that art has intrinsic value and need not be viewed as subordinate to external ends, but he also—or more precisely his character Vivian—goes further in suggesting that art cannot serve external ends; if it does, it is no longer art (4:82). In interpreting the death of Sibyl Vane as art, Lord Henry offers the reader a model of how to

interpret reality with an aesthetic as opposed to a moral compass. Lord Henry espouses Dorian's life as art, indirectly emphasizing that we are to interpret his life aesthetically, not morally. Moralism is tiresome and unaesthetic (3:352). Although Lord Henry fails to recognize the truth of Dorian's actions (3:214, 3:349), truth and goodness are not categories for Lord Henry; he cares not about whether his aphorisms are true, including whether they are internally consistent, but only whether they are clever. He is unreliable on the scale of veracity, but no evidence calls into question his reliability when it comes to aesthetic form, and only the latter matters. Tellingly, the amoral Lord Henry survives at the end, whereas the two figures who represent morality and immorality, Basil and Dorian Gray, die. Only the purely aesthetic mode, like the painting itself, survives.

The novel mocks any mixing of the aesthetic and the moral, including the concept of poetic justice: "In the common world of fact the wicked were not punished, nor the good rewarded" (3:339). Poetics is beyond the moral realm. The question of the theodicy is for a literary work irrelevant. Basil thinks that only God can disclose the soul (3:295), but in this work art, not religion, reveals the soul, and the only relevant question for our evaluation of Dorian is whether the development of his soul makes for a fascinating story, a beautiful plot. In the preface, Wilde points out that "vice and virtue are to the artist materials for an art" (3:167). Moral themes surface but only as the means for a good story. In a self-reflective passage, Dorian intuits this: "There were moments when he looked on evil simply as a mode through which he could realize his conception of the beautiful" (3:290). Lord Henry notes that Dorian's life is art, which is of course also literally true: "Life has been your art. You have set yourself to music. Your days are your sonnets" (3:352). For the bulk of the narrative, Dorian magically evades aging, thus seemingly linking him to Faust, but Wilde's novel does not incorporate the devil—and for good reason. If Lord Henry has vague similarities to Mephisto, just as Sibyl Vane loosely mirrors Gretchen and James Vane echoes Valentin, Lord Henry's counterpart is Basil, who as a creator may modestly echo God. But in any such analogy, with the death of Basil, God is dead too. The novel is an aesthetic, not an ethical or religious, work.

Any moral interpretation—seeing "ugly meanings in beautiful things"—comes from the spectator, not from the story itself, and any such evaluation is "corrupt without being charming"; that is, it is bad

form (3:167). Contrary to the ideas in the preface, Dorian himself allows the yellow book to influence him, and this is an error, a confusion of art and morality that proves part of his undoing. The fault lies with the reader, Dorian, not with the book itself, which hardly influenced Lord Henry in the same way. Any critique of Dorian would thus be restricted to his letting himself be influenced by what he reads, which brings him into the realm of ugliness and vulgarity: "Dorian Gray had been poisoned by a book" (3:290). That is what can happen when literature becomes a guide to life. The placement of this passage in chapter 11, the very center of the book, underscores its aesthetic importance.

Basil likewise brings art and morality too close together. Therefore, he is for the most part blind to Dorian's actions. Basil believes in the symmetry of physical and moral ugliness: "Sin is a thing that writes itself across a man's face. It cannot be concealed" (3:293). Basil's perception of reality is both simple and wrong. He is an unreliable guide. As his name implies, Basil simply adds flavor to the story but can be left behind as peripheral when the plot transcends him. His dead body is simply removed. Dorian repeatedly calls it a "thing" (3:300, 3:312, 3:313, 3:356). Sibyl's body, too, is a "thing" (3:244), as is the horrific painting (3:269). The final scene supports the amoral interpretation: when Dorian tries to destroy the painting, to erase his conscience, he kills himself, thus restoring art (the painting) that is unaffected by morality. The hideous man kills himself, whereas the picture, "in all the wonder of his exquisite youth and beauty," lives forever (3:357). In the previous part of the tale, there was too close a connection (in the form of the painting) between morality and art, but in the end the divide returns. Any echo of Dorian's life as an example to be avoided is simply a literary quotation, empty of meaning. Indeed, by destroying the painting, Dorian eradicates the enemy of new hedonism, the moral and religious conscience, and so sacrifices himself to restore beauty. His death is beautiful in the way that Sibyl's death was: fascinating, compelling, artful. It is an aesthetic spectacle, not a moral lesson. The painting survives, and Dorian Gray is immortalized in art.

When Basil confesses to Lord Henry that he adores Dorian, Lord Henry's interest is aroused, leading to Dorian's eventual corruption. Sibyl's confessing her love to Dorian results in her loss of artistry, her being rejected, and her death. Later, Dorian confesses to Basil, less to reveal his soul and more to gauge the painter's reaction, intrigued by the

idea of passing his suffering on to someone else: "He felt a terrible joy at the thought that some one else was to share his secret, and that the man who had painted the portrait that was the origin of all his shame was to be burdened for the rest of his life with the hideous memory of what he had done" (3:295). Dorian's confession leads to murder. Confession is not a privileged religious institution, but a splendid plot device, with dark consequences. The work's other references to religion are aesthetic gestures designed to mislead the moral reader. In truth, Dorian's interest in religion is more aesthetic than religious. Even the seemingly otherworldly transformation at the novel's end is nothing more than an aesthetic stratagem, well within the bounds of Gothic, to resolve the plot in such a way as to restore the beautiful painting.

However, one can read the novel contrary to authorial intention or at least the intention expressed in the preface and argue that the work portrays moral ugliness as ultimately repellent. In other words, we can defend the radically opposite position, a moral interpretation of the novel. Being in love with oneself and eschewing any connection to higher moral values lead to self-destruction and suicide. Dorian is "much too concentrated" on himself and laments: "I wish I could love" (3:342). The link between the painting's increasing ugliness and the soul of Dorian suggests that art and morality are indeed connected. The ugliness of the painting, which first enchants and then disgusts Dorian, exhibits art's capacity to render visible what is invisible in reality, in this case Dorian's soul: "This portrait would be to him the most magical of mirrors. As it had revealed to him his own body, so it would reveal to him his own soul" (3:258). Contrary to Lord Henry's espousal that art "has no influence" (3:352), the painting affects Dorian deeply. Further, he is misled by the poisonous book. Dorian's immoral reading recalls other sinners in the tradition, such as Dante's Francesca (*Inferno* 5.88–142).

The Basil–Dorian relationship can be read to support a moral reading. Dorian seeks to eradicate the apparent source of his misery, Basil. The "uncontrollable feeling of hatred" Dorian feels for Basil (3:299), who loves Dorian and knows of his ugly soul, is partly projection, which is underscored by Dorian's blaming Basil and the portrait for his own misdeeds (3:260, 3:301, 3:308, 3:355). Dorian "loathed the man who was seated at the table, more than in his whole life he had

loathed anything" (3:300). Dorian wants to destroy the person who knows of his faults. What Dorian cannot escape is his conscience. He wrestles with it despite his outward denials. He yearns to escape from himself, to be someone else (3:292, 3:325, 3:341). He longs for a symmetry of inner and outer self. This is the second reason for Dorian's hatred of Basil. Basil has the answer to Dorian's needs: the truth about his soul. We love that which can make us better, but we also hate it because we are embarrassed by others knowing our weaknesses and because change would be excruciatingly difficult, and we would prefer to obliterate the source of that call for change. Change would mean punishment of our current self, as that alone can make us better. Dorian senses, in an almost Platonic way, that "purification" exists "in punishment" (3:354), but Dorian refuses this path as atrociously unappealing. Instead he kills Basil and flees from the truth of his soul. Some years later, Wilde writes in *The Ballad of Reading Gaol* (1898), "Each man kills the thing he loves" (1:196; cf. 1:216).

Dorian experiences an intuitive desire, indeed a longing, for the symmetry of inner and outer self. This desire for unity explains Dorian confessing not only to Basil (3:297–99) but also, in a less direct sense, to Lord Henry (3:348). This is an additional and more subtle way, beyond the magical split of Dorian's physical body and painted soul, in which the protagonist suffers from an internally torn or "double life" (3:314). What Dorian expresses to the external world and what others acknowledge is not what he is in essence. What they see instead is a living version of Basil's original painting.[5] Shortly before Dorian's pseudo-confession to Lord Henry, Dorian identifies with the hare, "a hunted animal," as he himself is (3:300). That moment of presumably intuitive empathy motivates his wish that it should not be shot. However, for Dorian empathy is a passing fancy, which he suppresses in his conscious life, as when he castigates and blames Sibyl (3:243, 3:246). Because of this split and his lack of will, Dorian cannot in any substantial or enduring way realize the longed-for symmetry. He merely flirts with it. His late hint at remorse is likewise quickly submerged.

Lord Henry turns out to be unaware, as he completely overlooks Dorian's attempt at confession and misreads his character, stating in response to his indirect confession that Dorian is incapable of murder. Lord Henry and Dorian have reversed positions: now Lord Henry's insistence that Dorian is incapable of murder shows that Lord Henry

is hopelessly naive about the human soul. Where Lord Henry misreads Dorian, Dorian misinterprets confession. For Dorian confession is a burden: "Was he always to be burdened by his past? Was he really to confess?" (3:356). Confession is normally understood to mean an unburdening of the soul, a return to the collective, an overcoming of what Dorian at one point calls the "pride of individualism that is half the fascination of sin" (3:286). Dorian is drawn to Catholicism partly for aesthetic reasons (3:280, 3:285–86) and partly out of a prurient fascination with confession (3:280), but for the Catholic Church confession with contrite heart and religious disposition is said to be followed by "peace and serenity of conscience with strong spiritual consolation" (*Catechism of the Catholic Church* sec. 1468). Dorian can never reach true contrition. Lord Henry says more than he intends when he innocently searches for the right words to conclude Mark 8:36: "What does it profit a man if he gain the world and lose—how does the quotation run?—his own soul" (3:350). Dorian makes a half-hearted attempt at being good. He wants to redeem himself, but in the end he fails to confess publicly, to stake his life for his sins. He recognizes that his modest attempts are inadequate, simply the result of vanity.

Basil dies trying to help Dorian find salvation. Basil evokes allusions more to Christ than to God. His exhortation, "Pray, Dorian, pray" (3:299), is reminiscent of Christ calling on his apostles to pray with him in the garden of Gethsemane just before his death. The vermillion with which Basil signed his name on the portrait foreshadows the blood he spills as he seeks Dorian's salvation. The fact that the same knife kills both Basil and Dorian suggests, in retrospect, that in killing Basil, Dorian is already destroying his own (higher) self (3:357). Dorian tries to wreck the painting not because he wishes to be redeemed, but in order to try to escape the painting and thus his own soul. The painting is the one restriction and burden on his living a freely immoral life. To destroy the painting, however, is to annul his life, which suggests that the moral universe is inescapable, ineradicable, not simply a human construct. Dorian's consciousness is connected to his image in the painting. When he looks at the painting, he realizes that he is not as he should be. Because the painting is integral to who he is, he stabs himself, effectively committing suicide. The act is not external but part of his identity. Moral considerations can be temporarily hidden, but to seek to eliminate them completely is to destroy life itself. The art turns

out to be cleverer than Dorian. The painting whose ugliness Dorian cannot stand retains its power; it becomes beautiful, but he becomes ugly. Order is restored, as the original beauty of the painting returns to the canvas itself. Dorian cannot destroy art, which in fact all along unveiled his wretchedness. The name "Dorian" alludes to, and ultimately fulfills, the Dorian mode as explicated by Plato in his early dialogue *Laches*: a harmony of word and deed (188d). In unexpected ways *Dorian Gray* underscores Hegel's idealist comment that a portrait can be "more like the individual than the actual individual himself" (*Werke* 15:104; A 867). Dorian's lack of internal unity is of course partly aesthetic, a flaw in his character, but it is a lack of unity in the moral realm also: Dorian is not internally consistent, his body and soul are split, he wants to be someone else. Unity is a moral *and* an aesthetic category. And it is clearly religious, for the unity of body and soul is achieved as a result of both Dorian's actions and a higher power beyond our comprehension.

Although the lack of poetic justice in the course of the novel may seem to support an amoral reading, two arguments contest this claim. First, in the end we do experience poetic justice. Second, in many cases, especially in modernity, a delay or lack of poetic justice shocks the reader into recognizing reality's inadequacies. A gesture to poetic justice can all too easily render invisible reality's deficiencies. Here the horror of Dorian's misdeeds together with external beauty forces us to see reality—and the ugliness of reality—more clearly: "How ugly it all was! And how horribly real ugliness made things!" (3:274). The novel becomes moral insofar as the negative behavior of Dorian is negated. No positive position is presented, but we see a dialectic at work. The negation of the negation results in the restoration of the normative painting. Art and life intersect insofar as Dorian's sordid life wrecks the painting. The portrait interweaves the moral and the aesthetic, for in his pursuit of a beautiful but immoral life, Dorian's soul becomes ugly, soiled by his thoughts and deeds. The ugliness of reality hinders any simple creation of ideal art. Nonetheless, the ideal can be restored via a negation of a negation, with Dorian's death. The magical transformation is not simply an aesthetic stratagem but a gesture toward higher meaning, perhaps a numinous realm, or simply the objectivity and power of the moral law.

Moreover, to embrace the amoral, as we saw in the first reading, would itself be a moral position, one that negates the validity of moral

judgment, even though Wilde seeks to protect himself by calling the application of moral judgment to art not technically wrong, but instead "corrupt" and "not charming." This critique of the moral position as not charming loses its credibility, however, for utterly pejorative associations of the word "charming" arise via the epithet "Prince Charming," the name that for James Vane links Dorian with the person responsible for his sister's death. In addition, it is given ugly connotations by one of the women in the opium den (3:329). Moreover, when Dorian welcomes Basil the night he kills him, he does so with the phrase "I shall be charmed" (3:291).

One could argue that Dorian's vanity, emptiness, and immorality cause his demise, isolating him from love and leading to his self-destruction. Plato's *Gorgias* contends not only that punishment educates and restores but that pleasure can't sustain itself and must self-destruct. Dorian cannot escape his past, as much as he expresses the desire "to be somebody else" (3:292) and "escape from himself" (3:327). He even goes so far as to state, "There is no one with whom I would not change places" (3:341). Dorian directly or indirectly effects the deaths of others: Sibyl, Basil, James Vane, and Alan Campbell. Whereas Lord Henry does not realize his ideas, Dorian is more consistent. The bond between Lord Henry and Dorian recalls the relationship between Gorgias and Callicles. Dorian enacts a philosophy of hedonism and power positivism more consistently than his teacher. Sin is ugly, as already Aquinas noted (*ST* I-II.73.7), and such ugliness is also an aesthetic blemish. Even the aesthete must be concerned about vice insofar as vice affects the beauty and ugliness of the soul (McGinn, *Ethics, Evil, and Fiction* 139).

The preface has three possible interpretations. In the amoral reading, the novel has nothing to do with morality; it is a purely aesthetic artifact, to be judged as "well-written, or badly written" (3:167). In the moral reading, in contrast, Wilde's preface is ironic, and the narrative demands a moral interpretation. Both of these can be supported from the perspectives of production and reception aesthetics. The amoral reading finds support in Wilde's desire to avoid a moral challenge, which could have led to censorship and disgrace. But the moral reading finds support in Wilde's penchant for wit. Perhaps the preface's amoral statements are playful and ironic. Insofar as Wilde

sees the spectator determining the work's meaning—"It is the spectator, and not life, that art really mirrors" (3:168)—both readings could be said to emerge from the reader's presuppositions, be they amoral or moral. And both readings seem to be supported by textual evidence. A third reading can be supported, namely, that the preface is not meant to be ironic, but that the work itself is more complex than the artist's intentions, such that the preface turns out to be ironic after all. The meaning of an artwork is not reducible to the artist's intentions. The third reading—with its idea that the novel might say more than the preface intends—has an analogue in the painting: Basil creates more than he has in mind when he develops, unbeknownst to himself, a work that captures Dorian's soul.

And yet, sufficient support exists for each interpretation. What Wilde has created is a work that is deeply ambiguous. It is not black or white, but gray: the symbolism of the title arises not only from "Dorian," but also from "Gray." In this work, "the way of paradoxes is the way of truth" (3:202). To do the novel justice, we must recognize that competing readings can be supported. "Diversity of opinion about a work of art shows that the work is new, complex, vital" (3:168). Of course that makes the work amoral, but the work's ambiguity also allows for a moral reading, such that the work is hardly simply amoral. We can as readers bring forward evidence to support the kind of cynical perspective we find in Lord Henry and the moral worldview embodied by Basil, and we recognize further that both are artist figures, and each has elements of Wilde. Wilde's novel is a great artwork that embodies at its core indirection and ambiguity, two eminent literary values. Despite the dangers of *quatsch*, much of controversial art—and much of seemingly ugly art—is indeed great art.

FORMS OF BEAUTIFUL UGLINESS

In this third part of the book, I explore the ways in which distorted forms, ugly content, or both can be integrated into an artwork, even dominate it, and still the work is ultimately beautiful. I discuss six forms of beautiful ugliness: three *styles of beautiful ugliness* and three *structures of beautiful ugliness*. The first set of forms, *styles*, involves possible relations between form and content, and the three styles are the following: (1) *repugnant beauty*, which is widespread across cultures, is a combination of ugly content and beautiful form, as in Dante's *Inferno* or David's *Death of Marat*; (2) *fractured beauty* is the confluence of innocuous content and distorted form. We see early examples in Arcimboldo, but the style is most prominent in modernity. Think of cubist works; (3) *aischric beauty*, drawing on *aischros*, the ancient Greek word for both "repugnant content" and "distorted form," sublates repugnant and fractured beauty. Distorted form expresses ugly content, and so a metasymmetry surfaces, as with Grünewald's *Crucifixion* or the paintings of Grosz, who distorts the ugly figures he depicts, thus interweaving form and content.

The second set of forms, what I call the *structures of beautiful ugliness*, centers on the question of negation and the relation of part and whole. Those three structures are the following: (1) *beauty dwelling in ugliness*, where the artwork lingers in ugliness and eschews any negation or critique of that ugliness, as in Baudelaire's and Benn's poetry. Although the form is primarily modern, early examples arise, for example, with Franz Xaver Messerschmidt's character heads: his ugly creations are presented without evaluation. Beauty dwelling in ugliness tends to be the most difficult form to receive, since the ugliness is prominent but not in any way negated or overcome; (2) *dialectical beauty*, which is very close to what the Hegelians elevated. Here ugliness is not only presented, it is also negated. Think of the satires of Juvenal or the photomontages of Heartfield. Dialectical beauty is one of the most widespread forms of beautiful ugliness; (3) *speculative beauty* is less common, especially in our age. It not only portrays ugliness in detail and not only negates that ugliness, but it also includes or points toward a position that transcends ugliness, as in Aeschylus's *Oresteia*. Insofar as speculative beauty lingers in ugliness but also goes beyond it, taking us to another realm, we recognize a synthesis of the two earlier structures: ugliness is both preserved and negated, such that we move to a higher, more complex level. Although one might expect only the temporal arts to embody speculative beauty, examples in painting do in fact arise. Hegel's elevation of the third moment in the dialectic, the speculative, gives us a language to grasp this form of beautiful ugliness. Because the two sets of forms, styles and structures, apply to different aspects of a given artwork, we find intriguing combinations of styles and structures.

The forms of beautiful ugliness emerged from a combination of strategies. First, having elevated in part I content and form and part and whole as art's central categories, I asked what combinations were in principle possible. For example, could form and content both give evidence of ugliness but in such a way as to be ultimately in harmony with one another? And what differences exist between works where ugliness infuses the whole of a work and works where ugliness is dominant in one part but overcome in others? Second, I attended to the ways in which various theorists approached the presence of ugliness in beautiful artworks. The Hegelians, for example, place great emphasis on the structure of a double negation, recognition of the ugly as ugly, which manifests itself as a negation of negativity. This structure

does not capture all of ugly art, but it does conceptualize a certain kind of beautiful ugliness. Third, I analyzed many artworks by asking how they related to the forms as they were evolving in my mind. Over time, as I recognized that some artworks did not easily fit my developing terms, I further refined the forms. In short, the forms draw on a combination of conceptual analysis, history of theory, and the artworks themselves.

That explains the origin of the terms. Their validity can be assessed in at least two ways. Conceptually, we can ask whether the diverse forms follow rationally from coherent principles. Heuristically, we can ask whether the forms and questions they engender can help us better understand and interpret artworks. The conceptual and heuristic modes need not overlap. For example, we may find that a specific form of beautiful ugliness corresponds to only a small number of works or does not at all match reality, to which theorists, if they have justified confidence in their principles, may wish to respond, so much the worse for reality. In other words, from a conceptual perspective, we shouldn't simply probe the theory by focusing on the works, we should also interpret and evaluate the works with the help of the theory. As it turns out, the forms are all present in the art world, but different eras bring forth more examples of one or another style or structure, and here one can partly measure reality by the concept. A reduction of aesthetic possibilities is not always advantageous. Many modern and contemporary works are difficult to describe and evaluate because they consciously oppose traditional expectations and concepts. The forms I develop below can help us understand and analyze such works.[1] Instead of being overwhelmed or reducing our reception to the vapid descriptor "interesting," we can, with the help of meaningful categories, ask heuristic questions that allow a work's diverse features to come to light.

The trajectory of each chapter, which varies by the forms' idiosyncrasies, reviews diverse arts, from architecture to film; historical periods in which various styles and structures arise, with a particular focus on Christianity and modernity; the variety of themes that surface in diverse kinds of ugliness—physical, emotional, intellectual, and moral; and the philosophers whose ideas offer the closest proximity to various forms. The forms can be partly aligned with diverse thinkers from Aristotle to Adorno, but Hegel and the Hegelians play prominent roles, as they were most attentive to the paradoxical and dialectical structures intrinsic to beautiful ugliness.

STYLES OF
BEAUTIFUL
UGLINESS

R E P U G N A N T
B E A U T Y

In my analysis of styles of beautiful ugliness, I ask how the two mo-
ments of content and form are interwoven. Is ugliness only in the ob-
ject depicted, exclusively in the form of the work, or in both content
and form? In short, what combinations of form and content are pos-
sible? I begin with *repugnant beauty*, which is a beautiful depiction
of some aspect of ugliness. Grotesque animals and death; despair and
loneliness; arrogance and contradictions; vices of various kinds, vi-
olence, war, and hell as well as the consequences of moral ugliness—
are all examples of the kinds of topics we see in repugnant beauty. Im-
ages of physical, intellectual, emotional, and moral ugliness can all be
portrayed with technical virtuosity.

Think, for example, of Baudelaire, whose works layered ugly
and macabre images with traditional poetic forms, technical artistry,
and beautiful language in ways that reach beyond virtually all previous
work: "From ugliness . . . is born a new genre of enchantment" (*Œuvres
complètes* 2:167). *Flowers of Evil* (1857), which was published just four
years after Rosenkranz's account of ugliness had appeared, appalled au-
diences, eliciting devastating contemporary reviews and even a fine for
offending public morality. Instead of turning from sorrow, death, and
decay, Baudelaire insisted we linger with them. He does not hesitate to

describe "a choir of wormlets pressing towards a corpse" (53). His poem "A Carcass" (Une charogne), which was completed before the end of 1843, engages the ugly in a sustained, shocking, and beautiful way. The poem, which opens with a recollection of a beautiful June morning, unveils in vivid detail the ugly female carcass the poet and lover encounter: "Her legs were spread out like a lecherous whore, / Sweating out poisonous fumes, / Who opened in slick invitational style / Her stinking and festering womb" (Les jambes en l'air, comme une femme lubrique, / Brûlante et suant les poisons, / Ouvrait d'une façon nonchalante et cynique / Son ventre plein d'exhalaisons) (Œuvres complètes 1:31; Flowers of Evil 59). The poem describes the cadaver rotting, its wretched stench, the swarming flies and maggots. It concludes with an allusion to the putrefying flesh and the worms' horrible, filthy food. Baudelaire links these with a reminder that even the most beautiful lover dies. The a-rhyme of the first stanza already links "my love" (mon âme) and "vile carcass" (une charogne infâme), thus hinting at the deeper connection to come. Still, the poet returns to a traditional motif, the poet's capacity to preserve for eternity the "divine essence" of their love, thereby underscoring an ironic contrast between poetry and the cycle of life and death, between language and object, the beautiful and the base.

In his revolutionary works, Baudelaire consciously inverts or parodies the past. Pierre de Ronsard, the great sixteenth-century French poet known as "the prince of poets," published a sonnet titled *Quand vous serez bien vieille* (*When You Are Very Old*) (1578) that touches on an analogous theme, but remains entirely within the tropes of beauty. Baudelaire inverts and mocks this tradition. Similar in both is the *memento mori*. Also analogous is the idea that the poem renders the lover's beauty eternal, but for Ronsard the woman is still alive, and the poet is deceased. Ronsard's poem ends with a *carpe diem* and the evocation of roses. Also evoking the *carpe diem* and the rose motif is Ronsard's earlier "Ode à Cassandre" (1545), which likens the beloved to a fragrant rose that will lose its beauty, a far cry from Baudelaire's comparing the lover to a maggot-infested and putrid carcass. Baudelaire's inverted value system, his reconception of the beautiful and the ugly, becomes almost metaphysical when later in the *Flowers of Evil* he calls Satan "the most beautiful of angels" (no. 110). In 1846, Baudelaire had spoken of "pleasure in the face of ugliness" (la jouissance devant la laideur), a kind of joy in ugliness that comes from "a myste-

rious feeling" driven by "thirst for the unknown and taste for the horrible" (quoted in Krestovsky, *Le Problème* 133).

The Range of Repugnant Beauty

A recurring claim in the theory of ugliness has been that even when the object depicted is ugly, the properties of the work can still be beautiful. Already Aristotle recognized the beautiful depiction of ugly objects. Thus, despite modernity's emphasis on ugliness, repugnant beauty—ugliness in the object portrayed, but beauty in the work's properties—is not only modern. Indeed, repugnant beauty is the most prevalent style of beautiful ugliness across ages and cultures. Weiße implicitly comments on repugnant beauty when he offers an early critique of Lessing—when an ugly object is presented beautifully, even painting has little difficulty absorbing ugliness: "One sees easily, that, if one talks of artistically depicted ugly figures, their ugliness takes on the meaning of a *sublated* ugliness simply by virtue of its objective representation" (Weiße 2:217). The immediacy of the ugly in the real world is dissolved via the artistic mediation.

Almost all ugliness I have noted in ancient Greece involves repugnant beauty: Hesiod's poetic renderings of monstrous figures, Homer's tale of threats to Odysseus, Aeschylus's portrayals of the raging Furies, Sophocles's harrowing depictions of Antigone, Ajax, and Oedipus, Euripides's account of Dionysus outwitting Pentheus, and Aristophanes's integration of comically inept characters. Also, the writings of Roman authors such as Lucretius, Ovid, Seneca, Lucan, and Juvenal all embody repugnant beauty. We recall, for example, the gory description Lucretius offers of the brutal pestilence that ravaged Athens, composed in dactylic hexameters with vividly poetic language, rich in assonance and alliteration.

Examples of repugnant beauty abound also in the medieval universe. Written by an anonymous hand around 1200, the *Nibelungenlied* (*Song of the Nibelungs*) is full of violent emotions and gory details: it recounts tales of conquest and vengeance, culminating in a brutal slaughter, with Kriemhild chopping off Hagen's head and Hildebrand slaying Kriemhild. The beautiful metrical and rhymed verse epic was originally sung (like Homer's epics, it emerged out of an oral tradition). The content, however, is ugly, replete with all kinds of *nôt*—distress,

hardship, trials, and downfall. Medieval Christian art gives us further examples of repugnant beauty. Dante's *Inferno* is, if taken by itself, a paradigmatic example, indeed an intriguing one, for Dante consciously reflects on the difficulty of composing a beautiful poem about the ugliness of hell. The problem is not only stylistic but also metaphysical. Dante wrestles with the puzzle of portraying absolute ugliness. In the *Inferno*, as Dante the pilgrim approaches the devil in hell's innermost circle, Dante the poet recognizes that he cannot fully capture pure ugliness:

> Who, even in words not bound by meter,
> and having told the tale many times over,
> could tell the blood and wounds that I saw now?
>
> Surely every tongue would fail,
> for neither thought nor speech
> has the capacity to hold so much.
>
> (*Inferno* 28.1–6)

And in the final canto of the *Inferno*, we hear:

> Then how faint and frozen I became,
> reader, do not ask, for I do not write it,
> since any words would fail to be enough.
>
> (*Inferno* 34.22–24)

The ineffability of extreme moral ugliness in the *Inferno* is analogous to the difficulty that arises at the end of the *Paradiso*, for when Dante approaches the empyrean, the highest realm of heaven, he recognizes that a human being cannot fully capture God but can only hint at God's brilliance (*Paradiso* 33.55–57; cf. *Paradiso* 23.28–33; 30.16–27; 30.46–51). Pure ugliness and pure beauty are both beyond the limits of language.[1]

Late medieval and early modern examples of repugnant beauty include the depictions we explored in chapters 5 and 6 in Bosch, Baldung, Holbein, and Bruegel, among others. Also belonging to this mode are the poems of Andreas Gryphius, which express hatred toward the world's emptiness and vanity but do so in impeccably crafted sonnets. Gryphius is almost a stylistic forerunner of Baudelaire and Benn, and in writing beautiful poems about war and death, he im-

plicitly raises questions that will become pressing only after World War II, as we see later in this chapter with Paul Celan.

Examples of repugnant beauty surface even in the Renaissance. In *The Flaying of Marsyas* (1570–76), his last finished work, Titian captures the cruel story, told by Ovid, that the satyr Marsyas challenged the god Apollo to a musical contest. Having won, Apollo was free to select the punishment: Apollo flays Marsyas alive, stripping his flesh away, inch by inch, while a dog licks his blood. His body is almost the reverse of Christ's, which seems to underscore Apollo's lack of empathy. Placing the animal side up and the human side down also calls into question how we distinguish them. The beautiful work, with blotches of red evoking blood, conveys intense agitation and agony. Ugliness is beautifully represented.

When the Enlightenment brought forward examples of ugliness, it, like the Renaissance, tended toward repugnant beauty. In French neoclassical style, Jacques-Louis David's *Death of Marat* depicts a corpse (illustration 36). In contrast to the repugnant subject matter and trenchant political message, the form is exquisite; indeed, the antithesis could hardly be greater. This tension between content and form is a fascinating complexity we find to some extent in all examples of repugnant beauty. David's painting also shows how form can lift away some of the brutality. Consider the soft light on Marat as well as the almost peaceful expression and lifeless arm that breaks the horizontal frame and echoes, along with the shroud, the dying Christ—all of which convey a sense of martyrdom. Whereas David's classicism tempers the corpse, realism gives us ever-more grotesque, but still beautiful, images of death, as we see in Théodore Géricault's huge *Raft of the Medusa* (1818–19), which depicts dead bodies in morbid detail, partly the result of Géricault's having studied dying bodies and corpses. Despite the sea of sorrowful corpses, among whom we as viewers are submerged, a glimmer of hope lies in the sighting of a distant ship.

The modern counterpart to Dante's *Commedia* is Goethe's *Faust*, which likewise explores evil in a cosmic frame and seeks to combine eternal and historical truths. With its artistic depiction of Mephistopheles and Faust's errors and their disastrous consequences, including multiple deaths already in *Faust I*, Goethe's drama offers a rich example of repugnant beauty, but here it may be worthwhile to note that in some cases repugnant beauty captures an entire work, whereas in others—and *Faust* is certainly among them—repugnant beauty is only

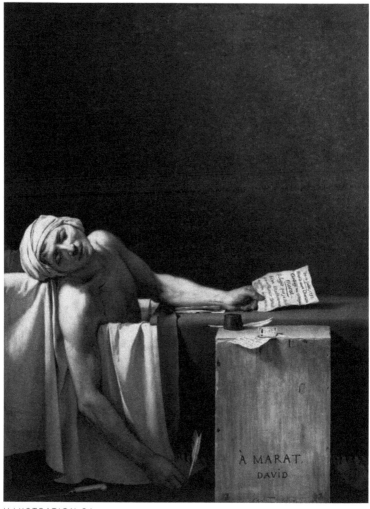

ILLUSTRATION 36
Jacques-Louis David, *The Death of Marat*, 1793, Oil on canvas, Musées Royaux des Beaux-Arts de Belgique, Brussels/Bridgeman Images.

a moment within the work. The scenes when Faust hears the church bells that call him away from his suicide and later takes his Easter walk are far removed from what we understand by repugnant beauty. Moreover, if formal distortion is not part of repugnant beauty, the image with which we opened the book, Dix's *The Match Seller*, contains such a moment of formal distortion in the overly long legs, and in one case almost horizontal position, of those fleeing the beggar. The work is dominated by, but not exhausted by, repugnant beauty.

The range of repugnant beauty is evident not only across periods; it even transcends Western culture. Geert Jan van Gelder has drawn our attention to a tradition in Arabic literature that delights in the perversity of describing ugly things as good and rendering good things ugly. The tradition is light, witty, ironic. Its elevation of rhetoric and eloquence has parallels with the carnivalesque, which likewise playfully upends normal categories. The ninth-century writer Sahl Ibn Hārūn wrote a treatise that praises miserliness and condemns generosity (Van Gelder 323–24). The mark of a great poet in such a context is the ability to turn whatever is base into something great. Al-Tha'ālibi's eleventh-century anthology *The Beautification of the Ugly and the Uglification of the Beautiful* exemplifies this tradition, with its clever and counterintuitive literary representations of immorality, including praise of evil and critique of goodness. Non-Western examples of repugnant beauty exist also in modernity. The short tale *Jelly* by the Urdu writer Saadat Hassan Manto tells the story of the stabbing of a man who sells ice from a push cart, his being taken away by the police, and the melted ice around the cart congealing with drops of blood, such that a child passing by with her mother exclaims, "'Look, mummy, jelly'" (192). The effect on the reader is horrific, underscoring the gruesome nature of murder.

Physical, Emotional, Intellectual, and Moral Ugliness

One of the most prominent themes of repugnant beauty is war, which includes physical ugliness, at times also emotional and moral ugliness. Consider *The Battle of Marignano, 1515* (1521), a drawing by the former Swiss mercenary Urs Graf. The corpses and inevitable future corpses, which will result from the positions of the warring forces, overwhelm the viewer. A century later Jacques Callot created *The Miseries and Misfortunes of War* (1633), the first antiwar series in European culture. Callot's etchings do not shy away from the ruinous effects of war also on civilians—pillaged homes, burned villages, looted monasteries, brutal hangings, and starving beggars.

Goya, who was influenced by Callot, is arguably unsurpassed in capturing war's ugliness. *The Third of May, 1808* (1814), a large work (approx. 9 x 11.5 ft.), depicts French troops shooting Spanish civilians during the Peninsular War (1808–14). In the wake of an uprising the

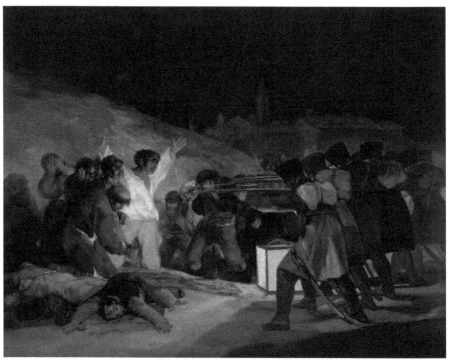

day before, the French had arrested and executed Spanish civilians on a hill outside Madrid. The dark night and almost ghostlike buildings convey a nightmarish atmosphere (illustration 37). The lantern casts long shadows, dividing executioners and victims. The white shirt and diagonally extended limbs draw our attention to the Christlike sacrifice. The other victims are also individualized, pleading, expressing fear, defying their executioners, or bowed in prayer, whereas the soldiers are faceless and anonymous, almost extensions of the guns they hold and the powers that command them. Unlike the painting's viewers, they do not look at the victims. The blood on the already dead victims is extensive. After they were shot, they were presumably stabbed in order to ensure death. Unlike most earlier war paintings, which tended to glorify rulers or soldiers, Goya elevates here ordinary citizens. We see again the legacy of Christianity. The energetic and at times vague renderings give the work greater power than would a refined, realistic portrayal.

For twentieth-century examples of repugnant beauty that focus on the ugliness of war, Otto Dix, George Grosz's fellow student in Dresden in the years before World War I, comes readily to mind. Dix, who experienced more than three years of horrendous trench warfare, was the commander of a machine-gun unit. From his fifty-print portfolio *War* (1924), consider the etching and aquatint *Corpse in Barbed Wire*: we see death via the white bones and decaying flesh. Similar in its ghastliness, but even more bracing as a close-up, is the etching *Corpses before the Position Near Tahure*. Despite the skull-like heads and decaying flesh, the two dead men look almost alive with their bold expressions and open mouths, making the work even more horrific. Like Grosz, Dix countered the idealism and heroism associated with war by focusing on realism and ugliness. The effects of war, including mutilation, also belong to repugnant beauty. Dix's *Match Seller* fits here, as does his *Skin Graft* (1924), which challenges us by forcing us to confront the damage done to the veteran's face and identity.

The repugnance of war and its aftereffects are prominent in German World War I novels, such as Ludwig Renn's *War* (1928), Ernst Glaeser's *Born in 1902* (1928), and Remarque's *All Quiet on the Western Front*. Accounts of the postwar environment are equally horrific. Consider Renn's *After War* (1930), Remarque's *The Road Back* (1931), and Hans Fallada's *Little Man, What Now?* (1932). World War I was particularly ugly for at least two reasons: the senselessness of the conflict and the introduction of advanced technology. The physical casualties were unprecedented: 9.5 million soldiers died, 20 million were severely wounded, and 8 million veterans returned home disabled (Deborah Cohen 1). Germany, moreover, suffered the psychological effect of a war unexpectedly lost; the national humiliation of being forced, by way of article 231 of the Treaty of Versailles, to accept responsibility for the war; and the economic reparations, which exceeded the country's capacity and led to runaway inflation. That the aftereffects in Germany were so destabilizing and abysmal made many German narratives of the Great War even darker. The style of all of these novels is *sachlich*, "direct and sober," neither poetic nor emotional; the novels process the horrific content with the kind of everyday language that allows readers to identify with, and imagine, the events.

A more complex work, not least because of the striking juxtaposition of form and content, is Paul Celan's poetic lament "Death Fugue" (1948), which uses lyrical language, full of beautiful rhythms and

patterns, with phrases repeated and recombined, to capture the most horrific aspect of World War II, the Holocaust (30–33). Celan, an Austrian Jew, lost both parents in the death camps. A sense of uncanny order is present in the poem's recurring chant, which hints at the camps' machine-like effectiveness. The mechanized nature of the camps presents us with a uniquely modern horror. The dominance of dactyls and trochees reinforces the tone of lament. The poem's lack of punctuation accentuates the poetic rhythms flowing one into the other. The rhythms so stand out against the horrific theme that many critics have questioned whether the poem is too beautiful for such a horrific topic. The unease underscores for us the radical change our concept of the beautiful has undergone. Repugnant beauty has surfaced in the wake of many horrific wars, including the Thirty Years' War, as with Gryphius's beautiful sonnets. But in modernity unease surfaces not with ugly content, which increases, but with beautiful form, which for the most part recedes. In public discourse, Celan's poem was brought together with Adorno's famous claim: "To write poetry after Auschwitz is barbaric" (Adorno, "Kulturkritik und Gesellschaft" 30, "Cultural Criticism" 34; cf. Emmerich). Can one write poetry at all about such historical ugliness, and if so, can the poetry itself be beautiful? Celan's answer is yes. Repugnant beauty is nothing other than this paradox and tension of depraved content and beautiful form, which Celan takes to the extreme by interweaving exceedingly horrific content with beautifully lyrical form. In Celan's poem, the disjunction is multivalent. On the one hand, the beautiful form seems too lyrical for such a horrendous event. On the other hand, the very juxtaposition of beautiful form and horrendous content seems fittingly disjunctive for such a dissonant theme. Although Celan's language is poetic, Ruth Klüger, who notes the tension between the horror of the camps and the beauty of the poetic language and rhythms, nonetheless observes that the language is also fragmentary, unsettling, uncanny ("Abstrakte Zeitgeschichte"). Oxymorons and paradoxes underscore dissonance. The almost incomprehensible irrationality of the Holocaust is evident in the very first words, the trochaic phrase "Schwarze Milch der Frühe," whose rhythm is, alas, lost in English translation, "Black milk of daybreak." The phrase is odd and startlingly oxymoronic. Milk is life-giving, nurturing, a life blood from the child's mother, whereas "black" suggests smoke and death. The reference to "Frühe" is not, as is often the case in poetry, a loose suggestion of a new begin-

ning, but an allusion to the state between life and death, as the process of dying begins. An implicit link between "Frühe" and "Führer" rings in the ear, not unlike the closer and more explicit link later in the poem between "Rüden" (attack dogs) and "Juden" (Jews). The incomprehensible irrationality of the camps is further underscored in the paradoxical statement, "We shovel a grave in the air." A grave in the air could have meaning only if bodies were not buried, but burned, and yet even then the idea would be, and is, realistically absurd. The line alludes to the *vanitas* tradition, which speaks of life as fleeting and passing in the air like the wind, for example, in Gryphius's poem "Human Misery." Here the metaphor becomes strikingly literal. In Gryphus, the vanity of this life is contrasted with the divine order of an afterlife, but in Celan, God seems as absent as the human lives that disappear. Their lives are, however, immortalized in poetry, which is both memory and lament.

Celan's poem has two recurring focal points: the "we" associated with the Jews who die and the "he" associated with the "master from Germany" who commands them. The poem echoes not only the *vanitas* tradition but also the Christian-European dance of death: "He commands us play up for the dance." A further connection exists to a Hasidic tradition of dance as longing for dialogue with God and in certain conditions preparing oneself for death (Kiesel and Stepp 125). The line "death is a master [Meister] from Germany," which likewise links the poem and death, is also a musical allusion. "Meister" is associated not only with superiority, as in the master race (*Meisterrasse* or *Herrenvolk*), but also the maestro—as with Bach, the master of fugues. The master who plays with death is both horrific and a kind of bizarre would-be artist. He plays with snakes and is morally repellent. Celan wants us to reflect on this bizarre heterogeneity (Müller-Seidel 178–80). The master plays with death, and the poem plays with the master, but the poem does so consciously, on a metalevel, which is different. The poem has only one rhyme: "death is a master from Germany his eyes are blue / he strikes you with leaden bullets his aim is true." The translation is effective: it preserves the content of the German rhyme: "blau" (blue) and "genau" (precisely or true). One hears in this rhyme a mirror of the recurring refrain, which increases toward the poem's conclusion: death is a master (the bullet is true) from Germany (his eyes are blue, which marks him as Aryan, much as the golden hair of Gretchen marks her as German). The recurring "your golden hair

Margarete" integrates German myth. The phrase alludes to Margarete (Gretchen) in Goethe's *Faust*, not only the most famous work of German literature but one that was traditionally received as a window onto the German character. The poem wants us to recognize in similar words and sounds heterogeneity. The poem contrasts the tragic German Gretchen, even as the meter remains the same, with the joyous Shulamith of the Song of Songs: "your golden hair Margarete / your ashen hair Shulamith." Here the biblical meaning of Shulamith is reversed: the reference to crematorium ashes ("your ashen hair Shulamith") associates the Jewish Shulamith with death. These lyrical sounds evoke Germany and the death camps. The two phrases also represent the final words of the poem, after which comes silence.

What Wilde's Dorian Gray most feared, aging and physical decline, is another topic for repugnant beauty. Examples abound in the northern Renaissance, for example, Hans Baldung Grien's *Three Ages of Woman and Death* (1540–43) (illustration 38). Four figures confront us: an infant, whose veil indicates that she does not yet know life and death; a beautiful young woman, who embodies both Renaissance beauty and the Baroque *vanitas* motif; an older woman who tries to hold off death and whose skin is closer to the color of death than that of the young woman; and death itself. The three living figures are crowded into about half the space, while death alone occupies the other half; death's hand, with its hour glass, reaches into the realm of life. The sense of melancholy that comes with the waning of life is not restricted to humans. Andreas Paul Weber's *The Old White Horse* (ca. 1956–57) beautifully captures an old and emaciated, seemingly forlorn horse. Paintings with skulls are usually layered with brooding over death and mortality, which can lead to emotional crises, as in Domenico Fetti's *Melancholy* (ca. 1620). Still, not every work depicting aging can be called repugnant. Often enough a well-crafted work captures a person whose face intimates rich experience. Aging by itself need not be repugnant. Consider Rembrandt's early etching *The Artist's Mother* (1628) or Félicien Rops's oil portrait *Head of Old Woman from Antwerp* (1873). In Rembrandt's late self-portraits, a furrowed brow with wrinkles, sagging cheeks, a bulbous nose, and a double chin are combined with gravitas and dignity.

The Crucifixion embodies extreme and in some ways unexpected suffering, bodily injury, and death, but many renderings of this ugliness are nonetheless beautiful. We noted examples from Raphael,

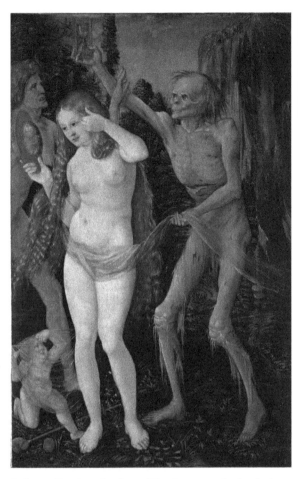

ILLUSTRATION 38
Hans Baldung Grien,
*Three Ages of Woman
and Death*, 1510,
Oil on limewood,
Kunsthistorisches
Museum, Vienna/Erich
Lessing/Art Resource, NY.

Rubens, Reni, and others. The focus on the body in contemporary art is not unconnected to this tradition.[2] Many contemporary artists who focus on the body or on sensuousness had Catholic backgrounds, which makes them well versed in incarnational imagination, among them Andy Warhol, Terrence McNalley, Elizabeth Murray, Robert Mapplethorpe, Andres Serrano, Petah Coyne, Robert Gober, Kiki Smith, Karen Finley, Renee Cox, Lisa Yuskavage, Janine Antoni, and Chris Ofili (Heartney). These artists are at least partly influenced by Catholic traditions and rituals, and in some cases also by Catholic art. Many of them portray seemingly ugly bodies, including the physically abject, as beautiful. For example, in his photograph series from 1992, *Morgue*, Serrano shows dead bodies as not only sad, disturbing, and in some instances horrific, but also in many ways beautiful and mysterious; they embody human dignity.

Kiki Smith speaks directly of her "Catholic influence" (Frankel and Posner 39) and, in responding to a question about artistic influences on her work, she names only one artist and one work, Grünewald's *Isenheim Altarpiece* (Frankel and Posner 36). She comments on "the millions of drops of blood coming out of Christ's pores, using the physicality of the body for expressive purposes" (Frankel and Posner 36). Rarely in the contemporary focus on the body do we recognize the sacramental idea that the absolute reveals itself in sensuousness, a structure that for centuries elevated the arts. More common is the abject as an end in itself, without transcendence. In her interview with David Frankel, Smith makes this distinction. Commenting on a work we explore in chapter 12, *Untitled* (1990), she contrasts Christ with her own depicted figures, who are without a belief system, "suckers . . . hanging out, going nowhere" (Frankel and Posner 39). When we have reacted against everything traditionally beautiful, when the suffering body is completely decoupled from the divine, a certain exhaustion results.

As Smith's work indicates, depictions of ugliness can also be cerebral, related to a sense of unease, be it psychological, historical, or metaphysical. In *The Death of Ivan Ilyich* (1886), Tolstoy captures a life devoid of meaning. The hero becomes conscious of his mundane, unremarkable, hollow life; yet that consciousness makes him remarkable. Kafka's tales of searching and not finding meaning, of falling short beautifully capture a kind of intellectual and emotional ugliness. And in his more socially specific, if nonetheless expressionist and bizarre tales, such as *The Bucket Rider* (1921), he tells of social ugliness and its physical consequences, including death. In masterful ways T. S. Eliot's *The Waste Land* evokes a void of desolation, a culture of decay, "stony rubbish" (line 20) and "broken images" (line 22). Beckett's *Waiting for Godot* (1953) captures an analogous sense of affect. All these are beautiful literary works about emotional ugliness, at times layered with physical ugliness.

Emotional ugliness can also be mocked. Consider the widespread despair of the aristocracy in Büchner's *Leonce und Lena*. Perhaps the greatest comic film about emotional ugliness is Ramis's *Groundhog Day* (1993). The film has many funny aspects, despite its radical despair. Part of the comedy derives from its embodiment of the Aristotelean principle of innocuous ugliness: the ugly misdeeds that follow from the hero's despair, including crime and suicide, have no conse-

quences, which reinforces another comic structure: iteration. The formal cleverness of comic structure lightens the hero's ugly actions and lingering despair.

Drawing and painting are likewise adept at capturing moments of loneliness, sadness, or unfulfilled nostalgia. Edward Hopper paints moments of elegiac sadness and unfulfilled longing and does so with great beauty, subtlety, and ambiguity. Hopper is a realist of the soul. His works captivate us in ways that often leave us uncertain about what precisely is at play, but we are clearly aware of an emotional longing and sense of unease. In *Sunday* (1926), a small figure sits among faded wooden buildings, with seemingly little to do and his gaze directed downward. In *Automat* (1927), likewise an image of an isolated figure in a quiet setting, the woman's eyes are cast down, her look contemplative, perhaps also tired or sad.

Negative emotions in music are often expressed via formal dissonance or discord and so do not fit repugnant beauty but instead align with aischric beauty, with its metasymmetry of ugly content and formal dissonance. However, the use of the minor key, in contrast to the brightness of mood that characterizes the consonance of a major key, does give us an experience that resembles repugnant beauty. When we hear a minor key, we are also implicitly hearing its variance vis-à-vis the major key, a form of acoustic interference. The sound is troubled, dark, unsatisfying, sad. Such works resonate well with what we understand by emotional ugliness, even if they are achingly beautiful.

Comedy, which can be as cerebral as it is physical, often engages intellectual ugliness. Consider King Peter, the would-be philosopher-king in Büchner's *Leonce und Lena*. The king has tied a knot to remember something, yet can't recall what it is. His valet clues him in: he wants to be reminded of his people! The king, whose territory ranges only as far as the eye can see, uses pseudo-philosophical language to mouth utter nonsense. He understands certain formal aspects of logic, but is indifferent to content and applies it absurdly: "The substance is the 'thing-in-itself,' that is I. (*He runs around the room almost naked.*) Understood? In-itself is in-itself, you understand? Where is my shirt, my pants?—Stop! Ugh! Free will is wide open here in front. Where is morality, where are my cuffs? The categories are in the most scandalous disorder, two buttons too many are buttoned, the snuff box is in the right-hand pocket. My whole system is ruined" (1.2). Büchner's mocking portrayal of the king, which spoofs idealist philosophy but

no less the uninformed reception of philosophy, is part of a general satire directed toward the idle and unjust court. The peasants are given a mere whiff of roast and are told precisely how to act. Büchner interweaves intellectual and moral ugliness.

Many comedies exemplify the modern overlay of moral turpitude and instrumental reason. Lelio, the comic hero of Carlo Goldoni's *The Liar* (1772), seeks evil but does so with irrepressible imagination, self-confidence, and inventiveness. He is charming, full of life, and quick of wit. Every chance event is brilliantly transformed into an act of his own intentions. He makes the most of every opportunity—until eventually his lies and deceit come back to haunt him, partly in the form of the persons he has disavowed in word but cannot objectively deny. His statements and the situation in which he makes them are utterly incongruous, culminating in his many assertions—always in the midst of a web of lies—that he has never uttered an untruth. Molière's Tartuffe also embodies this combination: he is brazen and an evil imposter, but also clever, quick, and nimble—and so can be contrasted with the intellectual ugliness or stupidity of his foil and victim, Orgon. Both comedies are formally brilliant and poetic, but ripe with ugliness.

In some comedies, intellectual ugliness is partly overcome but otherwise still present. In his early comedy *The Jews*, Lessing mocks prejudice and even more subtly the merely partial overcoming of biases that fails to recognize its own limits. Restrictive vision is also mocked on behalf of Tellheim in *Minna von Barnhelm* and the Templar in *Nathan der Weise*; each must develop beyond emotionally driven self-deception. In these two works intellectual ugliness is modest and overcome. Repugnant beauty allows for a lingering in ugliness and its eventual overcoming.

In Hofmannsthal's *The Difficult Man*, one of Austria's greatest comedies, intellectual ugliness is amusingly abundant. We see overpowering self-assurance and unwarranted confidence in Stani and Edine. Stani is the most delightful, for his intellectual ugliness is not paired with moral ugliness: he is instead ridiculous. He has absolutely no doubts as to his own greatness and constantly uses ridiculous phrases: "That's of course why women are so enormously impressed with me" (1.16, my translation). Hans Karl asks him: "Ah, you're always absolutely satisfied with the way you act?" Stani responds unhesitantingly: "Yes, if I weren't, then I would of course have acted differently" (1.8, my translation). In his misplaced arrogance, Stani is both

intellectually ugly and funny, harmless and delightful. He trivializes everything that should have higher meaning. His decision to marry Helen, for example, occurs on the stairwell: "I am resolved to marry Helen . . . I thought it all through. On the way up the stairs between here and the third floor" (1.16, my translation). Another intellectually ugly character, Edine, a would-be intellectual, trivializes intellectual discourse. Edine is further ironized by her unabashed question about Nirvana. She seeks to be transported "away from banality" and is herself banal (2.1). Yet another intellectually ugly figure is the famous man, a comic reduction of the philosopher's ideal influence on society; all he cares about is prestige and form. In a sense the two characters mirror one another. Edine seeks to transcend the social for the intellectual realm; as an intellectual the famous man wants to be recognized in the social world. Both of them are ugly, and both fail comically.

Tragedy, with its mix of horror, sacrifice, death, and injustice, and its consistent integration of pain and suffering, also often falls under repugnant beauty. In Sophocles's *Antigone*, the deaths of Eteocles and Polynices lead to Antigone's civil disobedience, imprisonment, and death. Her hanging herself in turn triggers Haemon's death, which itself becomes the catalyst for Eurydice's suicide. In tragedy, greatness leads to suffering. An organic connection animates the genre, in this case Antigone's steadfastness and loyalty to family values. Mirroring structures also often can add to the formal beauty. These can arise with two forces in conflict with one another, but they can also involve parallel plots, which can increase the ugly consequences. The one fully developed double plot in a Shakespearean tragedy arises in *King Lear*. The mirroring fates of Gloucester and Lear, their blindness and insanity in the wake of agony, add to the intensity of the suffering and the beauty of the work.

In what I have elsewhere called the "tragedy of suffering," the link between greatness and suffering is reversed: greatness does not lead to suffering; instead, suffering engenders greatness, such that an organic structure remains (Roche, *Tragedy and Comedy* 103–8). *King Lear* is the greatest example, an ugly work with a complex organic structure. Lear's suffering derives from his bad judgment and the machinations of others. Nonetheless his suffering engenders layered insights and a new sense of self, one focused not on himself but on the fate of the less fortunate, evident, for example, in his care for poor Tom. Expelled from his shell of power, Lear opens up to a reality previously unknown to him:

Poor naked wretches, wheresoe'er you are,
That bide the pelting of this pitiless storm,
How shall your houseless heads and unfed sides,
Your looped and windowed raggedness, defend you
From seasons such as these? Oh, I have ta'en
Too little care of this! Take physic, pomp;
Expose thyself to feel what wretches feel,
That thou mayst shake the superflux to them
And show the heavens more just.

(3.4.28–36)

Longing for knowledge, Lear moves on from the jokes of the fool and transitions to the philosophy of poor Tom.

Much as Oedipus attained wisdom after being blinded, Lear gains understanding as his physical suffering and emotional ugliness increase. Edgar notes: "O, matter and impertinency mixed, / Reason in madness!" (*King Lear* 4.6.174–75). Lear's disorientation mirrors the chaos that surrounds him and so embodies, in a paradoxical way, a connection to reality. Previously imperious and impatient, Lear understands suffering and endorses patience: "Thou must be patient. We came crying hither. / Thou know'st the first time that we smell the air / We wawl and cry" (4.6.178–80). Symbolic of his transformation is his shift to simple language when he has his recognition scene with Cordelia and later when he is deluded and tries to see her once again alive. At the beginning Lear is obsessed with recognition, but in the end he's completely absorbed in another, Cordelia. King Lear's kneeling before Cordelia reverses all hierarchies: the king kneels, the father kneels, and the man kneels. There is something great in this previously self-obsessed and arrogant king humbling himself before the daughter he wronged. Although the nineteenth century, an era of doubt and intellectual crisis, viewed *Hamlet* as the greatest Shakespearean play, one could argue that *King Lear*, a work about disaster and war and the ugliness of life, is the Shakespearean tragedy that best fits our age.

Moral ugliness is widespread in repugnant beauty, also beyond tragedy and comedy. Charles Csuri's *Gossip* (1990) has the welcome ambiguity of showing how attractive and seductive, even mesmerizing, gossip can be, a kind of play, where words leap through the air and seem to find their destination (illustration 39). Csuri underscores the idea, present to us already in Plato, that our lower selves are at-

ILLUSTRATION 39
Charles Csuri, *Gossip*, 1990, Unix environment, Image courtesy of @ CsuriVision Ltd.

tracted to ugliness, both physical and moral. The myth of Narcissus is a beautiful depiction of self-obsession, which renders manifest how alluring and tempting self-infatuation is. The myth conveys the temptation and seduction, danger and self-destruction of this ugly emotion.

Lolita (1955), Vladimir Nabokov's controversial novel about a middle-aged French literature professor's solipsistic, obsessional love for a nymphet, is a fascinating example of repugnant beauty. The narrator, Humbert Humbert, is an unrepentant pedophile, such that the novel is morally ugly, yet the form is exquisite, one of the most beautiful works of modern English literature. This disjunction has as a consequence that in the form itself we are implicated in a seduction loosely analogous to what the narrator himself experiences, the morally depraved represented as in some sense beautiful. But the novel does not become simply well-written pornography or an affirmatively beautiful account of moral ugliness: the horrendous consequences for Lolita become vivid, the narrator's self-delusion and unreliability accumulate, and his monstrous crimes mount. We become increasingly repulsed

and distant while the language remains beautiful and attractive. We are implicated in our own enjoyment of the language even as the stakes for Dolores, the nymphet whom Humbert calls "Lolita," are made abundantly clear. The story has something of a Dorian Gray structure, with its combination of a morally ugly hero and beautiful art. The work enacts the simultaneity of fascination and repulsion.

Under repugnant beauty we find in addition films that depict physical, emotional, intellectual, or moral ugliness. The master of suspense, Alfred Hitchcock, employed beautiful cinematic strategies to portray the complexity and nuances of moral ugliness. Hitchcock was fascinated with evil, the way it tempts and attracts us as well as endangers us, the power it has over us, the way it plays with us, behind our backs, and in the end is still not always revealed for what it is. In most of Hitchcock's films, moral ugliness wears a mask and needs to be unveiled. In *Shadow of a Doubt*, Uncle Charlie, who charms almost everyone, dissembles constantly. He is a Dorian Gray figure: handsome, alluring, charming, and absolutely evil. Hitchcock was intrigued by unexpected threats to well-being. A topic that fascinated Dostoevsky also engages Hitchcock: What drives people out of the realm of the ordinary and into evil acts? The theme is prominent throughout Hitchcock's films; examples, among others, would be *Strangers on a Train* and *Rope*. Very few Hitchcock films do not fit repugnant beauty.

Empathy and Varieties of Subversive Beauty

In some instances of repugnant beauty we are attracted and not at all repulsed, except by the conditions that have led to such suffering. Käthe Kollwitz, arguably Germany's greatest female artist, had a stronger interest in truth than in superficial beauty. Nonetheless, her sketches of hunger and misery, the poor and disenfranchised, and the effects of war have a certain beauty that widens our sense of empathy: her works draw attention to the abject circumstances of fellow human beings who are otherwise simply viewed as outcasts. Kollwitz attempts to show that what we take to be ugly, for example, destitute persons in poverty, is really beautiful. The circumstances are ugly, but the persons beautiful. Kollwitz cultivates our empathy for those who suffer the consequences of moral ugliness and awakens our moral outrage at the conditions under which they suffer.

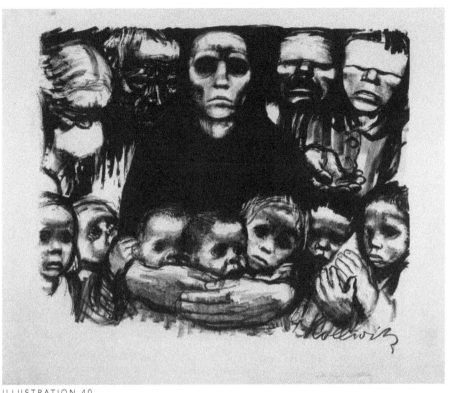

ILLUSTRATION 40
Käthe Kollwitz, *Die Überlebenden (The Survivors)*, 1923, Lithograph on beige wove paper, image: 22 x 27 in.; sheet: 27 3/8 x 32 1/2 in., The Vivian and Gordon Gilkey Graphic Arts Collection. Portland Art Museum, Portland, Oregon, 91.84.371 © 2022 Artists Rights Society (ARS), New York.

Consider such lithographs and etchings as *Misery* (1893–97), *Hunger* (1922), and *Unemployed* (1924), which engage poverty and death. Also prominent in Kollwitz's works are the effects of war, partly on the combatants but most especially on the survivors. One thinks of *The Fallen* (1920), *The Survivors* (1923), and the woodcut *The Parents* (1923). The harshness of the woodcut seems to emphasize the effects of grief. Unlike many of her contemporaries, Kollwitz depicts war primarily via its effect on survivors. The psychological effect, especially for mothers and children, is powerful. In 1914, Kollwitz lost her son Peter, who died in combat only months after volunteering. She focuses on the consequences of moral turpitude, as they shape the lives of others. An ambiguity arises with the central figure in *The Survivors*, who may be either a mother caring for those who are suffering or a symbolic representation of death (illustration 40). The blindfolds in

The Survivors convey the physical effects of war, but they also draw on the tradition of greater internal insight (the blind see more). They further suggest that justice is blind, not owing to a lack of bias, but because of ignorance, neglect, and indifference. From the effects of ugliness we may be tempted to avert our gaze. Yet the images evoke sympathy and a sense of human dignity violated, or human dignity in the face of difficult, even insurmountable conditions.

Contemporaneous with Kollwitz, we see in Weimar cinema and literature works that focus on victims of social problems and so awaken our empathy. Germany's greatest silent film, F. W. Murnau's *Der letzte Mann* (*The Last Laugh*) (1925), uses, among other strategies, an innovative moving camera to show the loss of stability, above all the developing plight of a demoted doorman, whose standing and sense of inner worth vanish with the loss of his uniform and his privileged role in society.[3] Earlier when the hero commits a blunder, the uniform is veiled by a poncho. Toward the end, the uniform is replaced by the clothes of a toilet attendant, the position to which he has been relegated. Like Kollwitz, Murnau thematizes postwar challenges. After the failed war, the soldiers lost their uniforms and prestige along with any meaningful identity or social role, a connection to a higher purpose, which could give their lives meaning. The film is complex insofar as the hero had earlier affirmed the very system that eventually spits him out. Carl Zuckmayer's dark comedy *The Captain of Köpenick* (1931) likewise plays with the power of a uniform and shows the extent to which it can replace human worth. The audience empathizes with the hero, who is faced with the absurd circumstance of being forced to break the law in order to obey the law.

Though Remarque's *All Quiet on the Western Front*, which did not appear until 1929, directly addresses the plight of the ordinary soldier during World War I, the novel indirectly alludes to the experiences of returning soldiers. Remarque awakens empathy with the war's victims and survivors. The returnees have experiences that are not unlike those of the combatants: hunger, instability, confusion about the causes of their suffering, distrust of authority, a loss of control, susceptibility to chance, a longing for comradeship, a simple wish for survival, and yet at the same time discouragement about the future. Although the Nazis hated Remarque, they drew on the situation he depicted: a man without hope was the perfect target for National Socialism, an ugly response to an ugly situation.

Von Sternberg's *The Blue Angel* (1930) tells a degrading story of the dismantling of human dignity. Professor Rath, a proper German high school teacher, falls in love with the nightclub singer Lola Lola. This leads to a conflict of two divergent worlds, and for the hero an unresolvable identity crisis. Rath loses his secure position and becomes economically dependent on people he views as below him. Von Sternberg contrasts the clean and sterile classroom atmosphere with the smoky, dingy, cluttered, disorderly nightclub. The use of a spotlight humiliates Rath, whereas Lola revels in it, indeed controls it. The film cynically portrays callous insensitivity to human suffering. Rath has lost his world and has no home in Lola's. The audience develops empathy for this previously strict and austere schoolmaster. Siegfried Krakauer writes: "Like a mortally wounded animal seeking shelter in its lair, he [Rath] sneaks back to the old school, enters his classroom, and there passes away" (216). The traditional chimes, representing this earlier world, are drowned out by Lola's music—brassy, sexy, provocative, and decadent. She is indifferent to Rath's fate. The film offers little in terms of moral evaluation; it simply presents the hero's loss of status and stages of degradation.

We can recognize in all of these works, beginning with Kollwitz's drawings, deep moments of empathy. At times the motivation for immersion in ugliness has a Christian impulse. Kollwitz's maternal grandfather was a Lutheran pastor and her father a radical Social Democrat. In *Hunger*, the Christian echo surfaces in the pietà allusion. Here, as one expects with repugnant beauty, we see a combination of the beautiful and the abject. Kollwitz notes that although the common, the obscene, and the repulsive have not traditionally had a place in art, she finds them beautiful: "The motifs I selected from this milieu [the life of workers] offered me, in a simple and unrestricted way, what I found to be beautiful . . . compassion and commiseration were at first of very little importance in attracting me to the representation of proletarian life; what mattered was simply that I found it beautiful. As Zola, or somebody, once said: 'Le beau c'est le laid' [The beautiful is the ugly]" (274–75).

With art critic Dave Hickey, one might speak of "subversive beauty," a portrayal of what society views as negative in a beautiful light. In *The Invisible Dragon* (1993), Hickey argued that beauty had in a sense been expelled from contemporary high art. Hickey recounts the neo-Marxist argument that because beauty is marketable, it must

in some way be spurious; as a result, for many years museum curators and other purveyors of the educative role of art excluded works of formal beauty and masterful technique, focusing instead on ideas, those of innovation and of protest, as markers of aesthetic quality. This meant, given the bracketing of beauty, a default elevation of conceptual art and of the ugly or what in terms of image and appeal was at least neutral. The concern was not with how art looks but with what it means.

At least two potential problems arise with this elevation of conceptual art. First, conceptual art tends to sever the link between form and content. In much of conceptual art, the sensuous dimension disappears altogether. How is the artwork then different from a philosophical statement? If there is no difference, then the *aesthetic* value disappears. In Ad Reinhardt's "black" paintings, we see something new, but neither something attractive nor something engaging, simply a single-tone dark canvass. Second, and related, conceptual art leads to one short-lived gimmick after another. What has not yet been done? As in other areas, pure innovation can over time become boring. The obsession with innovation is related not only to reception. If conceptual art lacks either sensuousness or complex thought, the artist's path to creating a meaningful aesthetic object is not easy. The work hardly invites continuing engagement, as is the case with a layered and complex artwork. Hickey suggests that the art world fails to recognize the value of beauty. We can think here not only of traditional beauty but also of creative combinations of beauty and ugliness.

Likewise problematic in the reigning ideology Hickey analyzes is the claim that beautiful art does not have the capacity to challenge value systems. Hickey overturns this cliché by focusing on the subversive beauty of Mapplethorpe's photographs, which are scandalous, Hickey argues, precisely because they show homoerotic images and the transgressive homoerotic act as alluring, as beautiful. This subversive beauty portrays what society views as negative in a beautiful light. Hickey's concept of subversive beauty is suggestive, but, in contrast to Hickey, I would argue that subversive beauty need not transgress norms; it can be subversive in a variety of ways, including by simply alerting us to overlooked or unsolved problems. Kollwitz, too, offers us a kind of seductive, subversive beauty—instead of treating the abject as abject, she draws us close to images we might otherwise repress. Kollwitz upends categories by using tremendous technical skill to evoke empathy and portray as beautiful what otherwise might ap-

pear to be repugnant. We also see the reverse, that is, beautiful depictions of what is morally ugly even though it seems to be alluring and attractive, as with Csuri's *Gossip*.

In Kehinde Wiley's 2016 show "Lamentation" at the Petit Palais in Paris, his large works in stained glass and oil on canvas seek to meld together traditionally beautiful religious art and bodies that have otherwise been excluded from that tradition and viewed by society as inferior, as ugly, Black bodies. Wiley comments: "If Black Lives Matter, they deserve to be in paintings" (Troop). Here beauty becomes a challenge to social biases, another mode of subversive beauty. Wiley's works are examples not of repugnant beauty but of radiant beauty: the works transform what to prejudiced persons seems like repugnant beauty, thereby opening their eyes to what is simply beautiful. Wiley's work, like other examples of subversive beauty, shows the limits of thinking that only ugliness can bring forward social and political critique.

R epugnant beauty illuminates a wide array of subject matter, including topics that might otherwise be beyond our gaze. In this sense, the philosopher we might associate with repugnant beauty is Aristotle, who was the first to suggest that we can render the ugly object beautiful and even transform ugly action, specifically the suffering of tragedy, into great drama. Repugnant beauty is capable not only of portraying ugly deeds, but it can also reveal the consequences that follow from diverse kinds of moral ugliness. We recognize the harshness of reality and the dignity of those who suffer the effects of moral ugliness. Of all styles, repugnant beauty is the most widespread, such that the examples I have given, partly by historical period, partly by theme, partly by art form, partly by culture, could be extended. Repugnant beauty is not only the most pervasive form of beautiful ugliness, it is also the most readily accepted. But it is not the most distinctively modern or the most complex. An analysis of beautiful ugliness that stops with repugnant beauty does not capture the full range of beautiful ugliness.

The willingness to break taboos in portraying the ugliness of what would otherwise be beyond our gaze, what it would be impolitic to show, reveals a connection to shameless figures in the philosophical tradition, such as Socrates and Diogenes, who also broke taboos in searching for truth. For Plato, the search for truth, which begins with

uncovering contradictions, presupposes a willingness to break taboos. Repugnant beauty, especially subversive beauty, does something analogous in the realm of art, bringing to light positions that otherwise would not be welcome in polite society.

In repugnant beauty we occasionally see an ambiguity. The beautiful form softens the harshness of the ugly content and allows us to linger in it, to experience it fully—physically, emotionally, and intellectually. Helped by the aesthetic form, we are less inclined to turn away but are instead able to spend the time that makes a full experience and possible grasp of ugly truths more likely. Although Dix's *Match Seller* laments the figures who flee, the painting draws us in, asks us to linger. Still, the very beauty of the form can also blind us to how devastating the content is. We may be tempted to minimize the depicted ugliness insofar as the aesthetic form lifts us beyond it. This ambiguity is one reason why repugnant beauty is attractive to artists across the ideological spectrum and particularly intriguing in its reception. But the concern that arises really only in modernity—that one should not portray ugly content with beautiful form—also explains why many modern artists turn away from repugnant beauty, and many critics, as we saw with the reception of Celan's poem on the death camps, reject the combination. Modernity asks, Can we capture ugly content with beautiful forms, or must we try other modes, other ways of imaginatively portraying ugliness?

F R A C T U R E D

B E A U T Y

In the second style of beautiful ugliness, what I call *fractured beauty*, artworks portray content that is not by its nature ugly but is interwoven with a form that is superficially askew, be it disjointed, fragmented, or ill-proportioned. Whereas repugnant beauty is widespread throughout the ages, fractured beauty arises for the most part in modernity. Although early instances exist, including in the sixteenth century, with Giuseppe Arcimboldo's composite heads and El Greco's elongated figures, only in modernity does fractured beauty become frequent. It becomes a highly conscious act in cubism, where facial features become disassociated, where the mimetic element diminishes, and where wholeness recedes as an aesthetic value, with the partial and fragmentary gaining ascendance. Paradoxically, whereas realism traditionally brought forward more and more of ugliness, abstraction from realism, as in cubism, rendered formal ugliness more present. A central paradox at play here is that repugnant and fractured beauty achieve the same ends, an integration of beauty and ugliness, through opposite means.

For early examples of fractured beauty, consider the distortion and mixing of forms we see with the clever and manneristic Arcimboldo, who layers images of objects, mainly from nature, such as fruits, vegetables, flowers, tree roots, and sea creatures, but also other objects, such as books, onto the canvas so as to create the bizarre semblance of a portrait or the creative rendition of a theme. With distortion and clever similitude, Arcimboldo fashions likenesses to the mostly innocuous subjects of his paintings. In the combination of slight distortion and abstraction from reality he becomes a forerunner of cubism and of puzzle-like paintings, such as those by M. C. Escher. Instead of breaking down what is whole, as in modernity, Arcimboldo creates the semblance of a whole out of parts that otherwise seem not to belong together. In many of his works, including most of his composite heads, there is no critique of the object or person, simply a play with imagination, which inevitably evokes a combination of distortion and illumination.

Anamorphosis, which represents deliberate distortion from one perspective, yet perfect perspective from another, was used from the late fifteenth century through the seventeenth century to distort reality and disfigure representation (Žukauskiene). Anamorphosis results in early examples of fractured beauty. As with Arcimboldo's paintings, we see in such works a kind of playful ugliness. Leonardo's drawing *Eye* (ca. 1485) is the oldest known instance. Other well-known examples include woodcuts by Dürer's pupil Erhard Schön, such as his *Vexierbilder* (*Picture Puzzles* or *Secret Images*) (ca. 1531–34), which on the surface looks like a bunch of ugly, nonsensical lines, but when viewed from the lower right-hand corner turn out to contain portraits of four contemporary European rulers, King Ferdinand I, Emperor Charles V, Pope Clement VII, and King Francis I of France.

If repugnant beauty makes an ugly object beautiful and if fractured beauty renders a beautiful or normal object distorted, then an art form that emerges before the modern revolution in painting also fits fractured beauty. I have in mind caricature. Caricature takes a normal person with slightly abnormal characteristics and exaggerates them to the point of distortion. Consider from the end of the fifteenth century works by Leonardo, such as his *Grotesque Heads*. In such a deformation, the part assumes a greater proportion than otherwise

would be the case. Here, then, as with all of fractured beauty, form becomes the content, such that the distorted form renders the otherwise indifferent content ugly, but with an artistic capacity that allows us to speak of beauty. As with most forms, we find precursors even in Greece, as with the enlarged and permanently erect penis of Priapus.

Early examples of fractured beauty seem primarily limited to smaller sculptures, paintings, and drawings, with the examples coming from the imaginative playfulness of elongated penises, composite heads, anamorphosis, and caricature. In modernity too, one of the most prominent areas for fractured beauty involves the visual arts. Picasso's many renditions of *Head of a Woman*, in sculpture and in painting, with their obvious asymmetries and disharmonies, can be considered paradigmatic for fractured beauty.

Modernity

Fractured beauty differs from repugnant beauty in being more distinctly modern. The scope of fractured beauty in modernity is evident if we think of the differences between abstract art and caricature; still, each has in common the capacity to distort forms. The range is also evident in reception: whereas the standard Marxist view, as with Michail Lifschitz, was highly critical of cubism for moving away from realism, caricature remained a valid element of the satiric worldview and so complemented socialist realism, as is evident in the East German elevation of the satirists Heinrich Heine and Heinrich Mann. The cause of the divergent evaluation is clear: in cubism and related movements, distortion tends to be an end in itself, whereas in satire, including New Objectivity, the distortion may be an artistic end in itself, but it is equally a means to an end, uncovering the inadequacies of reality.[1] Two structures of beautiful ugliness I introduce in chapters 12 and 13 further capture this distinction: one, beauty dwelling in ugliness, involves an immersion and even lingering in ugliness as an end in itself, and the other, dialectical beauty, portrays the ugly as ugly in order to effect a critique.

Modernity's turn to fractured beauty has multiple causes. One is the idea that in our world we cannot have the whole but only perspectives and thus distortion, even when the content is beautiful. Many modernist works arise from historical experiences of nonreconciliation

that call objectification into question and challenge ideal norms of shared meaning. Such works are removed from any kind of "harmony of intellectual and sensible faculties" (Pippin 48). This historical awareness shapes the content of modern art, including the focus on self-reflection, negative reality, and nonverisimilitude. Modernist formal structures move beyond "the beautiful as an artistic ideal" (Pippin 132). For Robert Pippin, who gives a modified Hegelian account of this interwoven historical and aesthetic development, such artworks contain the contradiction that they question the possibility of shared meaning even as they offer themselves as the promise of that possibility. A not surprising result of this historical and intellectual wrestling with historically relevant aesthetic possibilities is a turn to the nonharmonic, nonmimetic forms of fractured beauty. What we take to be stable and coherent and attractive is at its core in disarray, and the artist's task is to unravel seeming stability. The innovation may also be more formal: the playful desire to create by focusing on form alone. Seldmayer makes a slightly different and no less compelling formal claim on behalf of modern painting, where color is freed from any relation to shape or object; as a result a certain level of chaos and formlessness results (109). Within fractured beauty we see an assortment of motives and effects.

Fractured beauty, like most modern art, eschews imitative accuracy. As Henri Matisse suggested during what in retrospect can be seen as arguably the most revolutionary period in modern painting, "*Exactitude is not the truth*" (Read 44). Already Hegel had recognized that art's telos is not imitation or exactitude but the revelation of a higher truth (*Werke* 13:22). In modernity we often see a fragmentary glimpse of some kind of truth. What we find in Picasso are highly telling and alluring "fragments of visual experience" (Read 102). Consider *Violin and Grapes* (1912), which asks the recipient to complete the image or discern on the canvas a partial experience of objects. Formal capacities, combined with disjointedness and distortion, give fractured beauty its distinctive allure. Via unusual forms it seeks to capture a veiled conception or impression. French painter Georges Rouault's *The Clown* (1907) does not pretend to portray a clown's face in any realistic sense, but the work's various distortions, colors, and energy radiate a clownish spirit. Even the combination of media—oil, ink, and watercolor—adds energy. This ambiguous sketch evokes the complexity of the clown, who has a dual position as outcast and sad itinerant but also as a dream-filled and free spirit.

Fractured beauty is widespread among the Expressionists, who distorted and exaggerated reality, elevating the nonmimetic. In 1913, Emil Nolde created several versions of a *Young Danish Woman*: in each, including especially the lithograph at the Nolde Stiftung Seebüll, the facial features are distorted, and the colors, which are hardly mimetic, reinforce the dissonance. Consider also Karl Schmidt-Rottluff's *Nude* (1914), Erich Heckel's *Reading Aloud* (1914), Chaim Soutine's *Landscape at Cagnes* (ca. 1918), and Max Pechstein's *Head of a Fisherman* (1921). Not only in Europe but also in the United States we find examples, as with John Marin's *St. Paul's, Manhattan* (1914). Later expressionists succeed in crafting fractured beauty. German-American painter Frank Auerbach was sent on from Germany to England in 1939 at the age of seven, after which his Jewish parents died in concentration camps, and he was orphaned. His works are dark and expressionistic. Consider the portraits of his favorite model, Juliet Yardley Mills, almost all of which give us only the semblance of a face or figure, usually in some way distorted, such as *Head of J. Y. M. No. 1* (1981) or *J. Y. M. Seated* (1986–87). The heavy, dense layers of paint almost extend to a kind of textured sculpture, and the figures are not only awry and misshapen, with unexpected colors, but seem to want to pull themselves out of the works.

The sense of fractured form evident in Picasso and others takes us in the direction of abstract art, which can be jarring and fractured, even if some abstract art is clear and harmonious, as in Dutch painter Piet Mondrian's minimalist abstractions. The works of other abstract artists, such as Mark Rothko and Richard Diebenkorn, are more mysteriously and elusively beautiful. But many abstract artworks embody fractured beauty, as we see in Jackson Pollack's drip paintings, with their jarring eccentricities. Similar tendencies, though arguably even more pronounced, arise in American Franz Kline's abstract expressionism. Examples of fractured beauty can also involve abstract, meditative examples of beautiful ugliness, as we see in some of the ink drawings of K. R. H. Sonderborg.

The transition period toward abstraction, with paintings that contain partial shapes or gestures toward coherent forms, gives us ample examples of fractured beauty. These include paintings by Franz Marc, which in their color and complexity are beautiful and fragmented. Images by Marc that are gorgeous but not fully mimetic and which border on abstract art include *In the Rain* (1912), *Foxes* (1913), *The*

Mandrill (1913), and *Stables* (1913). We can also include works where superficially beautiful would be a less likely label: Stuart Davis's *Report from Rockport* (1940), Max Weber's *Three Literary Gentlemen* (1945), or Willem de Kooning's pastel and charcoal on paper *Two Women with Still Life* (1952). De Kooning, who is particularly adept at conveying the tension between abstraction and figuration, is a paradigmatic painter of fractured beauty. Two other examples from De Kooning are *Attic* (1949), an oil, enamel, and newspaper transfer on canvas, and the very large (nearly 7 x 9 ft.) *Excavation* (1950), an oil on canvas. Both works, which could almost be mistaken for pure abstraction, nonetheless allow us to recognize diverse shapes. In *Attic* we see vague and distorted outlines of human figures. The tension in the work is compounded by the combination of organic, curved and sharp, angular lines. In *Excavation* we vaguely discern animal forms, such as birds and fish, and disjointed human parts: teeth, eyes, noses, jaws, elbows, legs. In the center is a blurred red, white, and blue image loosely reminiscent of the U.S. flag. The work has something of the chaos and wonder of an excavation site, and as we move up the canvas, the shapes become even more difficult to discern but increase thereby our concentration and contemplation. Another example of fractured beauty that works at the intersection of figuration and abstraction is Danish painter Asger Jorn's *Letter to My Son* (1956–57). The partially abstract work is fractured and distorted but intentionally so in order to evoke the spontaneity and energy manifest in childhood and especially in childhood drawings.

Our perception of fractured beauty can shift over time. In early stages of reception, Impressionism was taken by some to be ugly because it lacked the clarity of realist endeavors. The shift from a linear to a radically painterly model was perceived to be disturbing and distorting. Still, it did not take long for the works to be recognized as superficially beautiful and in counterintuitive ways closer to reality. The movement away from realism and the apparent distortion and fracturing of reality ironically became simply another window onto aspects of reality that might otherwise be overlooked. Our reception caught up with recognition of the truths such works were able to convey. Viewers further grasped how the innovative form, at first disorienting, was the perfect medium for those truths.

In the contemporary era, examples of fractured beauty arise in the photo-paintings of Gerhard Richter. Richter's capacity for realism

is so great that his works could not easily be distinguished from photographs, but as he approaches the completion of his photo-paintings, he drags the still wet paint with a dry bush, effectively scraping back the paint and leaving us with a ghostly image, which looks like a blurred photograph, slightly out of focus. Richter's photo-paintings are excellent examples of seeming ugliness and fractured beauty: consider *Inge* (1965), *Woman Descending the Staircase* (1965), *Barn* (1983), and *Reader* (1994). His subjects are for the most part not at all negative and often include friends and family members, but Richter signals our inability to know such persons fully. This distancing strategy also motivates his practice, which increased over time, of painting figures with their gaze averted or even hidden, as in Richter's portrait of his daughter, *Betty* (1988). In their brilliant imprecision, these works offer a metacritique of painterly imitation of photography and a mystery-filled view of the world.

Richter's capacity to paint precisely and his decision to erase some of his skill to achieve a more meaningful end raises an interesting question: How do we differentiate between fractured beauty that results from a skillful, if unorthodox, but still beautiful way of conveying meaning and less successful works in which an obvious lack of skill is evident? The question relates to a tendency in contemporary art, "deskilling," a term used to refer to the conscious attempt to avoid cultivating or applying skill in creating and completing artworks. Certainly, many would turn to production aesthetics and say that a Picasso or a Richter who paints against the grain of simple mimesis can do so without impunity, but not someone who can barely hold a paint brush. But I would not want to fall back on a production-aesthetic argument. Instead, the significant question becomes whether the distortion is in the service of deeper meaning, whether there is in fact a rich idea, and whether idea and form are meaningfully interwoven. But to convey or embody a deeper idea in form is difficult if the artist's skill is deficient. I am not certain that the drawings of French artist Jean Dubuffet, who sought to imitate graffiti, the art of psychiatric patients, and the unburdened style of children's art and who coined the term *art brut* (literally, "raw art," but more conventionally "outsider art"), reach a level of beautiful ugliness and deeper meaning. If, however, absence is favored over presence, it is not easy to draw the line.

In architecture, fractured beauty arises late. Above all we think of postmodern architecture, which eclectically mixes surface materials,

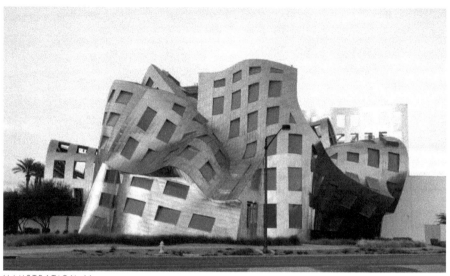

ILLUSTRATION 41
Frank Gehry, *Lou Ruvo Center for Brain Health*, Las Vegas, 2010/Monster4711. https://commons
.wikimedia.org/wiki/File:Gehry_Las_Vegas.jpg.

colors, styles, and decorative details and, even more dramatically, es-
chews symmetry and distorts lines. The fractured beauty of postmod-
ern architecture seeks to dissolve what it considers the monotony of
modernism; dissonance and even disorder are manifest. Consider the
Friedensreich Hundertwasser House (1986) in Vienna or many of the
creations of Frank Gehry, such as the Guggenheim Museum Bilbao
(1997), the Ray and Maria Stata Center, MIT (2004), or the seasick-
inducing lines of 8 Spruce Street in New York. The Guggenheim Mu-
seum Bilbao, with its seemingly random shapes and its celebration of
asymmetry, is a joyous embodiment of fractured beauty, whereas the
fractured beauty of the Lou Ruvo Center for Brain Health, Las Vegas
(2010) gives one a much stronger sense of deflation and concern
(illustration 41).

In the case of the MIT building, the university ended up suing
Gehry for the cracks, leaks, mold, drainage problems, and other struc-
tural issues that cost the university additional money for repairs. The
ultimate question with such a building is whether there is an underly-
ing logic, say, that an academic building matches the daring, complex,
and often unexpected nature of scientific discovery, or whether inno-
vation comes at the expense of other worthy aesthetic principles, such

Styles of Beautiful Ugliness

that the building is simply random and thrown together without any higher, even complex unity. Consider also the Wexner Center for the Visual Arts (1989) on the campus of Ohio State University, designed by Peter Eisenman: this structure has no front entrance because the building was intended to challenge or even erase hierarchy; it is fractured, unfunctional, and disorderly, suggesting a critique of both utility and linearity; it has steps that go nowhere, underscoring the idea that discord is to be elevated above connections.

An older kind of fractured beauty in architecture involves ruins. Though asymmetrical and fractured, they are nonetheless beautiful. Given our sense of being dwarfed by their temporal duration, one might even call them sublime (Schopenhauer, *The World as Will and Representation*, 1:264, 1:275). They evoke a past that far exceeds our capacity to see. In this way they remind us of our restricted vision and modest place in the universe. The meaning of ruins, given the lack of intentionality, except in rare Romantic cases of artificial ruins, suggests that the reception context, often a liking for nostalgia, plays a much greater role than is the case when we seek to understand the ideas embedded within works created by intentional fracturing.

As modernity began to seek ways to express a deeper reality beyond simply imitation, which became the province of photography, sculpture too increasingly moved from realistic mimesis to fractured beauty. Picasso was the first to apply cubism not simply to painting but also to sculpture. His bronze *Woman's Head* (1909), though deeply beautiful and evocative, is far from entirely mimetic. It is on its way to cubism and fractured beauty. Housed at the Guggenheim Collection in Venice, Henri Laurens's limestone *Head of a Young Girl* (1920) is wildly distorted, yet it nonetheless conveys beauty (illustration 42). The face is angular and the eyes asymmetrical, the hair is soft, and the shoulder curves gently. The figure as a whole is attractively shaped. The work has elements of classicism and cubism. It creates an impression that is deeper than a simple representation.

A contemporary sculptor engaged in fractured beauty is Georg Baselitz, who grew up in Nazi Germany and lived in East Germany before he came to the West while still a young man. His sculptures are intentionally unrefined and crude. Crafted with chainsaws, axes, knives, and paint, most of his objects are innocuous but distorted human figures and heads. For Baselitz harmony can be achieved only "via disharmony" (Baselitz 32). Not until the 1980s did Baselitz engage in

sculpture, and many of his earlier paintings also fit fractured beauty. He asserts that he "put a lot of effort into making provocative, ugly pictures" (Danchev 356). He adds, "I proceed from a state of dishar-mony, from ugly things" (Danchev 357). In his *Frakturbilder* (*Fractured Pictures*), Baselitz paints an image, such as a figure, on three separate horizontal segments, which he then puts together: they never quite match. The works seem to be a combination of painting and sculpture. In his upside-down paintings, the human figures are inverted, such that our reception of the work is disrupted. To some degree our atten-tion shifts from the content to the form, paint, surface. Such shifts are a signature element of fractured beauty.

Impressive within the realm of fractured beauty are sculptures that move away from simple mimesis and instead seek the deeper re-ality or essence of an object or a topic. They have analogies with Franz Marc's loose evocations of actual subjects as his paintings move to-ward abstraction. Consider Ukrainian-American artist Alexander Ar-chipenko's wood sculpture *Boxing Match* (1913), which via minimal-ist shapes conveys the vitality, energy, and brutal dynamics of such a

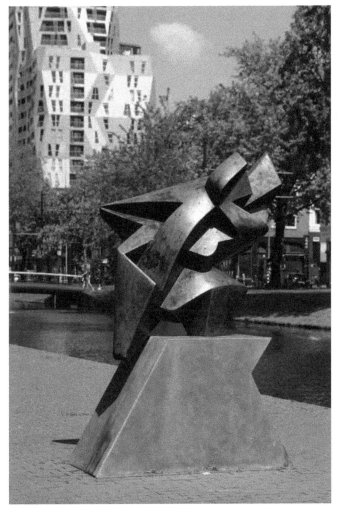

ILLUSTRATION 43
Umberto Mastroianni,
The Farewell, 1955,
Bronze, Rotterdam,
Image courtesy of
photographer
Jannes Linders,
CBK Rotterdam, and
Visual Art and Public
Space Rotterdam.

contest. In Italian sculptor Umberto Mastroianni's magnificent bronze *The Farewell* (1955) we recognize at first only a fusion of various masses above a plinth (illustration 43). However, the title (the original was *The Lovers*) makes clear that the forms are abstracted from the human body: we see a last enveloping of two lovers, and though we cannot fully differentiate the two figures, this itself is symbolic of their embracing as one before they depart. The diagonal orientation combined with the alternation of planes, angles, and shapes and darker and lighter accents give the work extraordinary dynamism, vitality, and tension, indeed almost a sense of chaos or eruption. The embrace is simultaneously departure. The roughness of the emotions is accentuated

by the fact that the bronze was not polished with a patina but left as it was coming out of the furnace. *Dancing* (1963), another Mastroianni bronze, has a stunning level of energy and tension. Limbs seem to fly in various directions. The vague and partial representation of a small string instrument makes the work seem almost musical, even if the very part of the sculpture that suggests an instrument could likewise be read as hinting at a face. The action is quick and dynamic, which renders precise perception difficult. Some of these images are, in their fractured nature and distance from reality, seemingly ugly. Abstractions from mimesis in order to capture an essence can be not only superficially but also complexly beautiful, as in Rumanian sculptor Constantin Brancusi's *Bird in Space* (1940), which via bronze evokes the soaring nature of a bird in flight.

This principle—that an abstraction can more deeply capture an essence—still animates many works today. Japanese sculptor Hiroshi Kamo's 1985 wood sculpture *Serenade (Theme and Variations)* is overgrown with leaves and other debris, suggesting either that the sounds have become transformed into solid objects that are spilling forward into the world or that the piano itself resembles an animate object (Koplos 153–54). Lin Emery's kinetic sculpture *Sunflower* (2009) evokes the ways in which a sunflower tilts to catch the sun and indeed reflects the sun. Such works allow us to see not simply the surface already present to us, but the essence behind externality. Paul Klee writes in this spirit: "Art does not reproduce the visible, but rather renders visible" (Kunst gibt nicht das Sichtbare wieder, sondern macht sichtbar) (118).

Other sculptors seek less to capture an object via abstract or fractured shapes as to create intriguing configurations and constellations that might seem ugly insofar as they do not resemble any recognizable objects, even if they might or might not gesture toward reality. They can be appreciated simply as creative and evocative compositions. American David Smith's works, including his last series of abstract structures, his burnished stainless-steel sculptures, which are welded together in some cases seemingly precariously, are made of geometric cubes, cylinders, and cones. Smith's *Cubis* can be said to embody fractured beauty. To incorporate an understandable idea or concept is easier when one is seeking to represent an object, especially a figure. Smith's sculptures, for example, *Cubi VI* (1963) and *Cubi XIII* (1963), often vaguely allude to figures; at times they seem to evoke architecture, as in *Cubi XXVII* (1965) and *Cubi XXVIII* (1965); and in some

cases they are simply intriguing shapes without clear real-world references. The occasional movement away from any kind of mimesis is one way in which fractured beauty tests the recipient's imagination. We can include under fractured beauty also junk sculptures, which Smith was involved in creating in the early 1950s, that is, assemblages welded from discarded metal. Among the most distinctive at the time were John Chamberlain's creations out of automobile body parts. We return here to the fluid boundaries between art and life as well as the suspension of traditional aesthetic categories we recognized in Dada's engagement with junk objects.

In music, as with architecture, few examples of fractured beauty emerge before modernity. In earlier eras, musical dissonance tends to arise as a means of conveying thematic elements that are disturbing or dissonant: unfulfilled longing, sadness and despair, evil and brutality. Atonal music shifts the paradigm. Here dissonant music need not be associated with thematic ugliness, for the form, not the content, drives the dissonance. Here, as so often elsewhere, fractured beauty is interwoven with modernity. Since instrumental music does not directly express content (when we speak of content, we tend to invoke associations and metaphors), to identify the difference between fractured beauty and a symmetry of discordant form and discordant content is not easy, but atonal works are commonly indifferent to content—and thus fractured.

When it comes to fractured beauty, literature is a puzzle. It is true, as in most other arts, that disjointedness and fragmentation become more visible in modernity. But since literary form and content are so closely interwoven, disjointed and fragmentary literary forms almost always arise together with some element of negativity: psychological turmoil and despair, chaos in the external world, lack of harmonic resolution. Even authors who are especially known for disjointedness, such as the Expressionists or more contemporary writers such as Arno Schmidt, tend to express rupture not only in form but also in content. The combination of innocuous content and dissonant form is even rarer in literature than it is in music.

Film is analogous. As with literature, disjointedness in cinematic form tends on the level of content to evoke dissonance or uncertainty. Thus it is difficult to speak of film as embodying fractured beauty. Consider as a twenty-first-century example *Mulholland Drive*, for which David Lynch received the Best Director award at the 2001

Cannes Film Festival. The film contains plot lines that seem to go no-where. We might think that the narrative is random and incoherent. Oscillating between violent and uncanny and funny and light, Lynch plays cat and mouse with us throughout; two prominent and literal keys mock our attempts to understand the fractious film. If we adopt an opposed reading, we might think that the film centers on Diane, a struggling and rejected actress, with the bulk of the film consisting of wish-fulfillment: idealism, adventure, and love over career. References to dream worlds as well as to sleep and beds abound. The end would then present Diane's real life, a failed existence. She arranges for her ex-lover to be killed and, stricken with guilt, takes her own life. But it is not clear that the film is this coherent, that the loose ends can be tied up. It seems to have more questions than answers.

Either way, the film is dominated not by story, but by image, at-mosphere, and technique. Aided by cinematography and score, Lynch is a master of mood. Diverse camera positions and out-of-focus shots render us unsure of perspective, which elicits unease and rapture. Partly by working against conventions, Lynch develops the distinctive ca-pacities of film and leaves us with a sense of fracturedness, something less than a conventional whole. The film is very much about identity and the search for identity, including the playing of roles; this applies not only to the characters but to the film as film. *Mulholland Drive* seems to mock film's pretension to any coherent reality. The disrup-tion, the fracturing of a coherent story, the play with the distortion of the camera, is partly innocuous, but since the film erodes meaning and higher meaning, ending with suicide, it seems not to fit fractured beauty, with its combination of fractured form and innocuous con-tent. It must belong to another type of ugliness. If not only the form but also the content is distorted, then "fractured beauty" is not the appro-priate term. Films such as these must be grasped with the next style, *aischric beauty*.

The advantages of fractured beauty include its insistence on origi-nality and innovation, which push form to the nth degree; its in-herent playfulness, which develops in part from its elevation of form over content; its demands on the viewer, which derive from its push-ing formal boundaries, which elevate the recipient's responsibility; its capacity to see incompleteness in what we might otherwise take to be

complete; and its attention via formal strategies to gaps between what is and what should be. In some ways fractured beauty is the most revolutionary form, for it combines content that need not be considered ugly and layers it with a brush that renders it deformed. With a small number of exceptions we can recognize that disjunction as distinctly modern, whereas the portrayal of ugly content reaches back to the ancient world, even if it, too, increases with modernity's turn toward realism and conscious emphasis on ugliness.

Despite being more distinctly modern, fractured beauty is not the most widespread of modern forms, for modernity turns again and again to the portrayal of ugly content. In other words, even if fractured beauty is more distinctly modern, repugnant beauty seems to be more widespread even in modernity. Still, repugnant beauty is challenged for supremacy by the next style I introduce, an aesthetically fascinating form that combines in the same work repugnant content and fractured form—only to end in an organically beautiful work.

CHAPTER 11

A I S C H R I C
B E A U T Y

The third style of beautiful ugliness, *aischric beauty*, encompasses works that are not only thematically ugly but also formally distorted. Consider a painting by Max Beckmann. In a repulsive collection of images, Beckmann's oil on canvas *The Night* (1918–19) evokes a postwar vision of chaos and torture (illustration 44). In the wake of World War I, Germany's social and political order had fallen apart: the kaiser had abdicated; the Germans, having thought that they were winning the war, were demoralized; and for a stretch governmental authority was unclear. Beckman's nightmare vision seeks to capture something of this social and metaphysical disorder. Hanging, bodily torture, rape, and abduction are all part of the claustrophobic scene, which is difficult to stomach. The agony takes place in an attic room, at home, so to speak, and in secret. The criminal in the upper right pulls down the shade. The person being strangulated in the upper left seems to scream, but the art form ensures that no sound is released. The tones of brown and red contribute to the sense of discomfort, as does the intended lack of depth (the image is much flatter than one would expect, which adds to the claustrophobic intensity). The image seems almost Gothic in its distortion. Beckmann was fascinated with German Gothic paintings (Selz, *Max Beckmann* 26–30). Despite the chaos, one

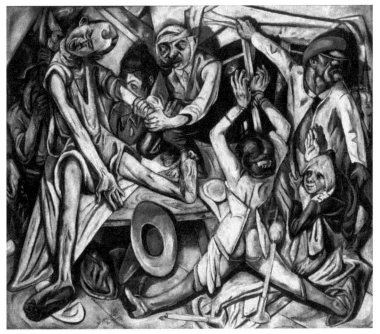

ILLUSTRATION 44
Max Beckmann, *The Night*, 1918–19, Oil on canvas, Kunstsammlung Nordrhein-Westfalen, Düsseldorf © 2022 Artists Rights Society (ARS), New York/Bridgeman Images.

recognizes, via the limbs and the furniture, patterns of shapes, angles, and lines (diagonal, perpendicular, and horizontal). Even the few vivid colors have correspondences, such as the blue shirt and lips in the upper left that match the blue corset in the lower right. Cold colors dominate. The few blotches of red, perhaps symbolic of blood, form almost an unconnected circle. The work combines asymmetries and symmetries. The regularities seem to imply that the chaos represents not simply an aberration but a new and chilling order (Lackner 56). The upturned palm of one of the tortured males alludes to Christ's stigmata, but *The Night* is not part of the fuller Christian narrative. We are caught instead in unredeemed suffering. Form and content work together to communicate the end of harmony.

I invoke the neologism "aischric beauty" to capture this fascinating style wherein ugly content and formal distortion reinforce one another. Most modern European languages, drawing on their Latin roots, use two words for the concept of ugliness. On the one hand is the aesthetic ugliness of form (*deformis* in Latin, *deformed* in English,

difforme in French, *deforme* in Italian). On the other hand is the moral ugliness of content (*turpis* in Latin, *ugly* in English, *laid* in French, *brutto* in Italian). The concept of aischric beauty draws on the Greek αἰσχρός (*aischrós*), a single word that encompasses both dimensions, formal and moral ugliness. The word is used to capture the outward appearance of Thersites, his physical ugliness and his status as ill-favored. In a moral sense, αἰσχρός means "shameful, disgraceful, base." Plato's *Gorgias*, for example, notes that it would be shameful (αἰσχρός) not to continue the public dialogue that Socrates and Gorgias began and from which Gorgias, who had run into difficulties, would have preferred to withdraw (458d). I use the term "aischric beauty" to refer to artworks, such as Beckmann's *The Night*, that are repugnant in content and dissonant in form. As such, form and content are on a meta-level in harmony with one another. Thematic dissonance finds its analogue in a distorted, fragmented, superficially ugly form. Aischric beauty differs from fractured beauty insofar as we see in this third style not a disjunction of form and content but a harmony of form and content, even if both are distorted or negative. In combing repugnant content and fractured form, aischric beauty is in some ways a synthesis of repugnant beauty and fractured beauty. Here in distinctive ways we see realized Hegel's idea that form should follow organically from the content (*Werke* 13:156; A 115).

From Architecture to Film

Architecture, especially modern architecture, gives us innovative examples of the interweaving of moral and formal ugliness. The Jewish Museum in Berlin, designed by Daniel Libeskind, is a twisted zigzag, with the entrance from the Old Building to the Libeskind Building accessible not via a traditional door or bridge but only by way of an underground passageway, which has lopsided corridors invisible to outside viewers. The windows of the Libeskind Building are irregular and disjointed, with the number of floors completely indiscernible to the external viewer. Several cavernous voids run vertically through the building; these permanently empty spaces seek to represent unrealized history and lost contributions, the absence of Jews in modern society. The entire floor of one of the voids further signals this loss: designed by Israeli artist Menashe Kadishman, it consists of 10,000 faces

or masks punched out of steel and tossed seemingly randomly across the floor. The title of the installation, "Shalekhet" (Fallen Leaves), alludes to the famous passage in book 6 of the *Iliad*, where Glaucus compares the dead to fallen leaves, but this exhibit lacks the hope of the Homeric passage: "As is the generation of leaves, so is that of humanity. / The wind scatters the leaves on the ground, but the live timber / burgeons with leaves again in the season of spring returning" (6.146–48).

The building consists of three axes. The Axis of the Holocaust alludes to lost lives; its architecture, which functions as sculpture, leads to a dead end, a tower with asymmetric walls and virtually no light except from a narrow slit high up the tower. The Axis of Exile seeks to convey the challenges and difficulties of those who left Germany. It leads outward to the Garden of Exile, which, through its lopsided floors, both slanting and uneven, evokes a sense of displacement, disorientation, and insecurity; these trigger a kind of nausea. The maze-like structure restricts the visitor's vision. The Axis of Continuity extends to the gallery exhibit, which illuminates Jewish history. Steps within this area that lead to dead ends underscore the loss of potential. Layer upon layer of fractured forms are designed to mark the difficult Jewish history in Europe and the lost potential of European Jews.

Some works that include anamorphosis fit fractured beauty, but some, including arguably the most famous one, Holbein's *The Ambassadors* (1533), fit aischric beauty (illustration 2). Why? Because here the form (distortion of perspective) has as its subject not something innocuous, but the mortality and vanity of life, which are evoked by a skull that escapes our normal gaze and presents itself at first blush simply as an ugly, indecipherable smear. To see death requires effort. Equally obscured to us, presumably because of our absorption in this world, is the countersymbol to death: in the very upper left-hand corner we can, with effort, recognize a partially veiled crucifix, the symbol of resurrection. We are reminded of the Christian idea that a focus on negativity and death is rendered easier by hope of their overcoming.

Although many of Arcimboldo's creations represent fractured beauty, in some we see an early symmetry of unappealing content and bizarre form. When in his four seasons series Arcimboldo wants to evoke the desolation of *Winter* (1563), we see not the distortion of a neutral object, but a harmony of distorted form and barren season (illustration 45). His more common tendency toward fractured beauty becomes in this case aischric beauty. In *Winter*, the figure may still be

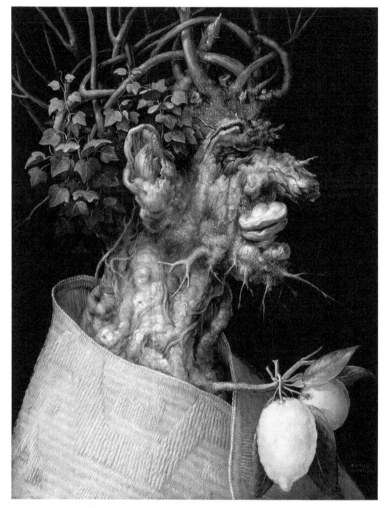

ILLUSTRATION 45
Giuseppe Arcimboldo, *Winter*, 1563, Oil on limewood, Kunsthistorisches Museum, Vienna/Bridgeman Images.

one with nature, as in Arcimboldo's other works, but here we see a tormented and desolate soul, both physical and emotional ugliness. The relative dead of the season is employed to craft an old man. The wrinkled skin of the neck consists of rough and cracked bark, while deeper abrasions in the wood represent his warts, and gnarled branches convey his hair. Broken stubs of branches become his peeling nose and ear, a black knot the eye. He has a thin beard of branches and roots. Swollen mushrooms portray the frowning lips of a toothless mouth.

Styles of Beautiful Ugliness

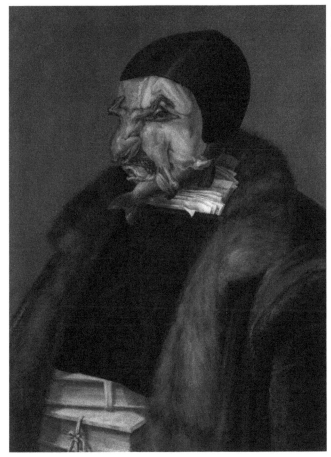

ILLUSTRATION 46
Giuseppe Arcimboldo,
The Lawyer, 1566,
Oil on canvas,
National Museum, Stock-
holm/Bridgeman Images.

In Arcimboldo's *The Lawyer* (1566), we are confronted by a sneering jurist, whose nose is formed by a decapitated frog and the cheeks and forehead by a plucked carcass of poultry (illustration 46). The mustache is created with what appears to be the bones of a bird's leg. A fish mouth and tail depict the lawyer's mouth and chin. A close look reveals that the eye is that of a bird. The body consists of various legal documents. Ugliness is also manifest in Arcimboldo's rendition of *The Cook* (ca. 1570), with the nose and eye consisting of a skinned and roasted chicken. This work belongs to Arcimboldo's genre of inverted heads: upside down, it is not a portrait of a cook, but a still life, a dish of roasted meats. The Viennese court painter dissolves boundaries between portraiture, still life, and landscape as well as between nature and humanity. When technical virtuosity is available, the temptation arises to use it as a formal device to the point where the artist breaks

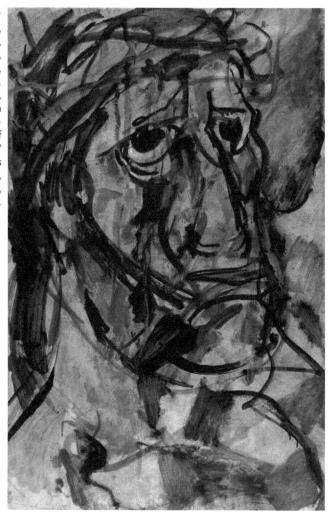

expectations, transgresses boundaries, plays with distortion, and creates something both technically remarkable and ugly, curious and fascinating as well as deformed and bizarre. Analogies exist in modernity, including among the surrealists, who admired Arcimboldo.

Not unlike Grünewald, modern artists who seek to evoke Christ's radical suffering often employ deformity to accentuate the torment. Georges Rouault works in this tradition. Consider his oil painting *Head of Christ* (1905): the misshapen human face expresses Christ's anguish (illustration 47). The crown of thorns seems to cover not simply Christ's head but his entire face. Blue and orange, not the most accurate colors for human skin, stand out as opposites in the color wheel, bringing

energy and tension. The eyes, which are likewise less than realistic, express how distraught Christ is. They look to the heavens—but seemingly in vain. Distortion is possible, perhaps necessary, if the artist's goal is not to replicate the reality before us but to evoke the meaning we might not otherwise see. Rouault understood that conveying such a deeper truth, removed from superficial exactitude, might come across as ugly, but he wanted viewers to affirm such distortion as a form of beauty. Rouault admired those who, while looking at his work, might say, "This is beautiful because it is ugly" (14), that is, it is beautiful because it captures something beyond the superficially accurate.

Distorted forms seem well positioned to represent ugliness. Eugène Delacroix's *The Massacre of Chios* (1824) shows what was viewed at the time as inappropriate subject matter, the terror and suffering of war, with neither hope nor heroism. Victims, not heroes, populate the canvas. We see the suffering and slaughtering up close, and the large canvas (more than 16 feet wide) reinforces the sense of unbridled misery. The loose brush strokes unnerved contemporary critics, who viewed them as ugly. The form, which lacks the symmetry and fine technique of classicism, conveys a sense of chaos and roughness, which, however, effectively matches the desolate content. Fractured in style, distorted in shape, and exaggerated in parts, Ludwig Meidner's chaotic images of crisis, for example, *I and the City (Self-Portrait)* (1913), formally mirror the disorientation of self and world. Literary parallels are visible, for example, the fragmentation and formlessness of Alfred Döblin's novel *Berlin Alexanderplatz* (1929), its disarray and disharmony, which match the protagonist's ugly and unfortunate situation. The lonely hero's thoughts come to us seemingly unfiltered in *erlebte Rede* ("free indirect discourse"), a mode in which the narrator's perspective merges with the hero's. We are given no further orientation. Ten years after the publication of Döblin's novel, Paul Klee painted his *Outbreak of Fear III (Angstausbruch III)* (1939), which deforms and fragments the dissolving self (illustration 48). The figure is broken into parts and tightly locked into a narrow space. We are reminded of the etymological proximity of *Angst* and *Enge* (narrowness) and also the physical effects of fear. The image formalizes the loss of a coherent and stable self.

When we see how works by Beckmann and Meidner embody aischric beauty, we realize to what extent the Germans differed from the formally fascinating, but overwhelmingly innocuous, cubists, who

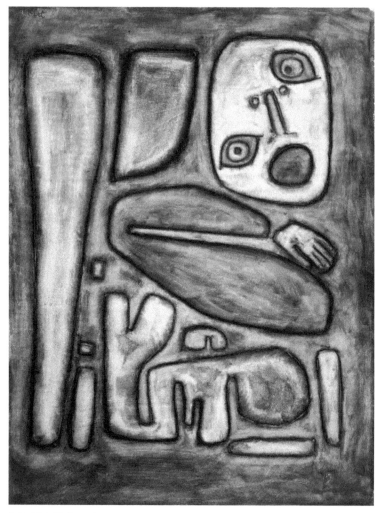

were their contemporaries. Along with Beckmann and Meidner, Dix
and Grosz are prominent and outstanding representatives of aischric
beauty. Even though I covered Dix under repugnant beauty, many of
his works include so much distortion that they must be categorized
under aischric beauty. In Dix's *Wounded Man (Bapaume, Autumn,
1916)* from the 1924 collection *War*, the eyes, mouth, and hands ex-
press simultaneously grief or horror and exasperation; the figure is in
a sense already in his grave (illustration 49). The work is also formally

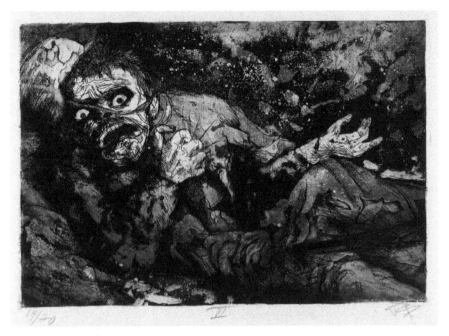

ILLUSTRATION 49
Otto Dix, *Wounded Man (Bapaume, Autumn, 1916)*, Plate 6 from *The War*, 1924,
© Minneapolis Institute of Art/The John R. Van Derlip Fund and Gift of Funds from
Alfred and Ingrid Lenz Harrison and the Regis Foundation © 2022 Artists Rights Society
(ARS), New York/VG Bild-Kunst/Bridgeman Images.

in disarray: the lack of clear horizontal or vertical lines underscores chaos. Normally, one would think of war as dark, but here a light is placed on the scene, the light of accusation and the light from the fires and bombs. We are reminded that in German, *Klage* ("lament") and *Anklage* ("accusation") are linked. To capture the ugliness of war, Dix's style moves toward distortion, beyond repugnant beauty to aischric beauty, and this fractiousness underscores his critique. Modern, antiheroic depictions of war tend toward ugliness and distortion.

Much of Dix's work, like Kollwitz's, focuses on the effects of war. His *Prague Street* (1920) shows limbless veterans reduced to begging in the streets. A woman in a tight pink dress has no time for these veterans. Nationalist rhetoric appeals to the most vulnerable persons: the paper held by the man moving via a skateboard has as its headline: "Jews Out." Also fascinating is the tension between the amputated body and the store window display, with its mannequins, whose purpose is to idealize in the service of commerce. The confusion and oddly

concentrated set of images create a kind of vertigo. The ugliness of the content combined with the formal distortion almost makes the viewer physically ill. Amidst the disarray and unrest, the viewer nonetheless empathizes with the figures' plight.

Consider also Dix's *Skat Players* (1920). The iron cross and the mutilated bodies, with prostheses, an iron jaw, and an extended hearing aid, reveal the figures to be veterans; the painting was later retitled *Card Playing War Invalids* (illustration 50). The prosthetic legs are virtually indistinguishable from the legs of the table and chairs, creating an image of equivalent clutter, a proximity of mechanical and organic (these men have been reduced to objects). Here confusion in the form reinforces the lack of distinction. The montage technique—the cards are pasted onto the oil painting—reinforces the mix of types. The painting is grotesque and revolting even as it evokes sympathy for the veterans.

Like Dix, Grosz is a master of aischric beauty, distorting figures whom he views negatively. His *Germany: A Winter's Tale* (1918) paints a chaotic image of post–World War I Germany, a disjointed world crashing and falling apart, even if the tumult revolves around an ignored representative of the German bourgeoisie sitting at the table with his local paper, smugly enjoying his beer and sausage and oblivious as the world around him reels. The form is intentionally disordered to mirror a society that lacks positive direction. Hans Hess has called Grosz's style "deliberately inartistic" (92). At the lower front is a diabolical trinity of the German hierarchy: church, military, and school, with the schoolmaster carrying a red, white, and black cane, the colors of German nationalism. Symbols of the past, for example, the spiked helmet, overlap with those of the present, such as the sailor and the prostitute. In this collage, Grosz himself appears as an angry figure at the bottom left. The form of Grosz's mocking *Beauty, I Shall Praise* (1919) is intentionally distorted (note the table, for example) in order to mirror a world of disgust and decadence. Not unlike the verbal satirist Juvenal, Grosz paints intemperance, gluttony, lust, and unbridled power as the driving forces of society. Grosz deforms diverse parts of persons in order to emphasize their moral ugliness. Another superb example—and one could include almost all of Grosz's works from World War I to the end of the Weimar Republic—is *The Funeral (Dedicated to Oskar Panizza)* (1917–18), which draws on the late medieval tradition of the *danse macabre* (illustration 51). We see

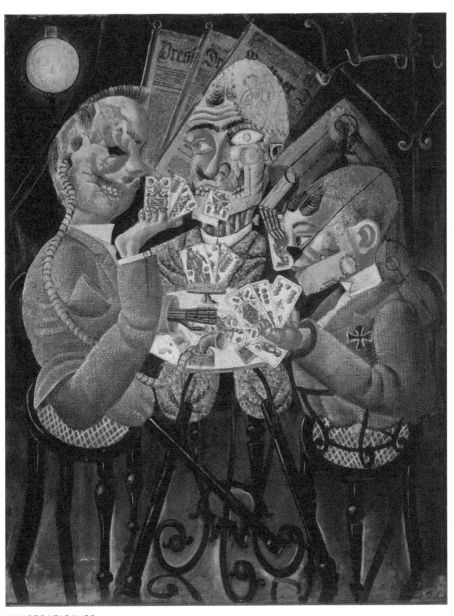

ILLUSTRATION 50
Otto Dix, *Skat Players/Card Playing War Invalids*, 1920, Oil and collage on canvas, Alte Nationalgalerie, Berlin © 2022 Artists Rights Society (ARS), New York/VG Bild-Kunst, Bonn/Erich Lessing/Art Resource, NY.

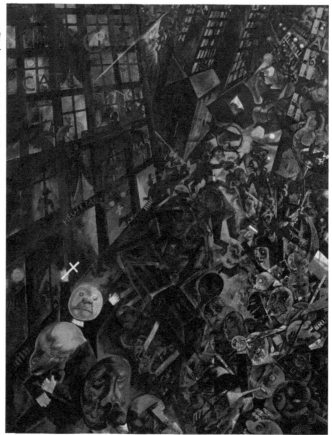

skeleton-like images, the words "Dance Today," and evocations of hell, with its reddish glow. In the oil painting is complete chaos, with distorted bodies, disconnected limbs, and buildings virtually collapsing on crowds of people. The diagonal lines and the red render the work unusually dynamic. The minister poses as if he is prepared to surrender. The death Grosz depicts is of an entire society. To portray with beautiful brush strokes a society one hates is difficult. It might even be misleading. With his distortion and caricature, Grosz disfigures society, shreds it apart.

Although I discussed Picasso as a leading creator of fractured beauty, he is also a master of aischric beauty. His *Guernica*, a huge painting measuring 12 x 20 feet, depicts the suffering of soldiers and civilians, including women and children, as well as animals during the Spanish Civil War, the result of an attack by German bombers, which

was designed to annihilate an entire city and destroy citizen morale (illustration 52). The Germans and Spanish chose their site carefully to maximize civilian casualties; the timing, too, was carefully orchestrated as a slightly delayed birthday present to Hitler (Irujo 40–68). The Germans attacked a completely undefended Basque town, close enough to the front that it could be occupied in advance of the Red Cross or any other international agencies that might report on the massacre. Guernica was also sufficiently small that it could be demolished with available planes. The Germans struck on a day of excellent visibility, flying low at the time of Guernica's weekly public market. Hermann Göring, who wanted to please Hitler, demoralize the resistance, and demonstrate the capacities of the German air force, personally directed the bombing, which included also hospitals. In 1941, after the Germans had occupied Paris, the Gestapo visited Picasso in his studio. A Gestapo officer held up a postcard of *Guernica* and asked, "Did you do that?" Picasso boldly responded: "No, you. . . . Take it, souvenir souvenir!" (Ashton 149). The French *souvenir* means not only "memory" or "remembrance." The verb, *se souvenir*, means literally "to remember," so Picasso is in effect mockingly saying to the German officer, "(You) remember (what you did)."

Guernica bears witness to horror. Only after decades of art for art's sake did Picasso overcome a focus on formal innovation alone. The Spanish painter's reception of his compatriot Francisco Goya and his interest in the Spanish conflict motivated his expanding range. In fact, in the upper right we see an echo of Goya's *The Third of May, 1808* (1814), which likewise depicts the slaughtering of civilians. In Picasso we see a deep relationship between ugliness and truth. To depict truth, the artist must sometimes portray ugliness. Picasso consciously chooses ugliness as a mode of truth-telling: formal distortion and fragmentation accentuate the visualized destruction. One could call the style ugly. Yet the fractured style and body parts effectively match the horrific content, such that on a higher level we can speak of a harmony of content and form—despite, or because of, the ugliness of both.

Picasso alludes to the suffering Christ: note at the bottom left the stigmata of the crucified Christ, which are manifest in the hand of the victim with outstretched arms. Also the wailing mother echoes Mary, and the light of the lantern symbolizes both Christianity and the Enlightenment. As with most figures, the wailing mother's body is distorted: her elongated neck and gaping mouth accentuate her despairing

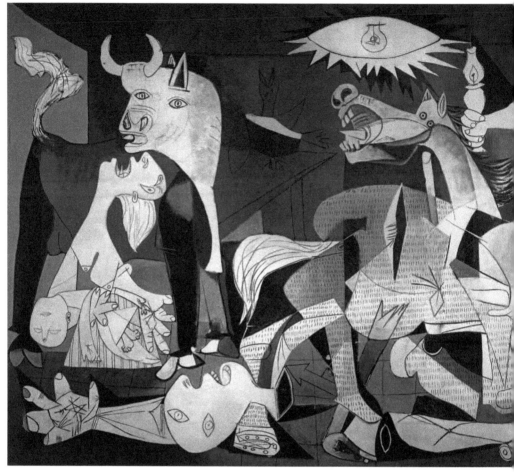

cries, while her splayed fingers, which express her anguish, echo grotesque images of the Crucifixion. The desolation is underscored by the lack of color—only black, white, and gray. The rich transhistorical elements are interwoven with contemporary traces, including the grainy newspaper print that marks the horse's body. Common to many critical works in modernity, empathy is primary and critique indirect: the perpetrators are not shown, but the effects of their actions are vivid: "In the victims themselves the perpetrators are present," writes Max Imdahl (47). The focus on those who suffer, includ-

ing civilians, heightens the accusation. Aesthetic ugliness frequently focuses on those who suffer physical ugliness, wounds, and even death, as well as emotional ugliness, horror, and emotional pain, at the hands of those who are morally ugly.

Picasso's series of paintings, drawings, and prints of the *Weeping Woman*, which offer a kind of postscript to *Guernica*, as in his rendition of *Weeping Woman* from 1937, housed in the Tate Modern in London, likewise capture in distorted form a grief that is difficult to endure (illustration 53). The white and blue mouth expresses horror, as do the disfigured eyes and forehead. Here, too, ugliness provides a witness to truth. The image, which emerged at the end of Picasso's efforts to render justice to the victims of Guernica, combines both cubist and realist tendencies and echoes the *mater dolorosa*, which is prominent in

ILLUSTRATION 53
Pablo Picasso, *Weeping Woman*, 1937, Oil on canvas, © 2022 Estate of Pablo Picasso/Artists Rights Society (ARS), New York, © Tate, London/Art Resource, NY.

the Spanish tradition. The distortion and facial fragments enhance the sense of agony. Picasso combines in this work the specificity of Guernica, the broader Spanish tradition, and universal suffering. It is difficult for us not to identify with the woman's tear-filled agony.

Similar symmetry of ugly content and fractured form is evident less than a decade later in American Ivan Albright's oil painting *The Picture of Dorian Gray* (1943–44). Painted for Albert Lewin's Oscar-winning film adaptation of Wilde's novel, the work portrays Dorian in his full monstrous ugliness. In the novel, the combination of base content and ugly form renders the painting hidden away in the attic

an example of aischric beauty, whereas the novel and its lead character embody repugnant beauty, ugly content, and beautiful form. With layers of dark paint, Albright captures the symmetry of moral and aesthetic ugliness. The macabre, almost unbearable portrayal of Dorian's corroding body seems to evoke a monster more than a human being. In a creative move that emphasizes both the distortion and the symmetry of soul and painting, the film shifts from black-and-white to color whenever the ugly painting is shown.

Sculpture, too, participates in aischric beauty. Antoine Bourdelle's bronze *Tragic Mask of Beethoven* (1901) exhibits the skill one would associate with a pupil of Rodin, yet the work is layered with anatomical deformations, scars, and rough surfaces, all of which hint at Beethoven's depth and suffering. The rough form fittingly captures a difficult life. Mastroianni's *Hiroshima* (1961), a bronze sculpture with gold patina and plaster remnants on a stone base, seems disjointed and chaotic. Toward the top, one recognizes abstract shapes that vaguely resemble dead faces or skulls. The fractured form addresses an ugly theme and so fits aischric beauty. A mimetic portrayal might not be so effective. Earlier we looked at some beautiful representations of aging. Dissonant images, in contrast, magnify the desolation of old age. In 1979–80, Edward Kienholz and Nancy Reddin Kienholz created *Sollie 17*, a filthy, dingy installation that offers a meditation on aging and loneliness. An old man, forgotten and alone, is presented in three separate poses, which convey the dismal dreariness of his daily routine.

When it comes to truly horrific topics, modern artists often choose aischric beauty. The primary catalyst seems to be the search for a mode of expression that matches ugly content. In some cases an additional motivation is humility. To capture horrific events via beautiful forms and realistic portrayals is difficult if the horror transcends our normal capacities for understanding. Already with Dante we saw that some instances of ugliness are so horrific that they transcend our capacity to grasp, let alone express, them. Whereas Dante created a work of repugnant beauty, modern artists tend toward formal distortion. Christian Boltanski's disfigured photographic installations allude to the Holocaust, in particular to unrecorded and forgotten lives. His *Altar to the Chases High School* (1986–87) seeks to evoke lost potential. Electric lights illuminate the faces on six photographs of children even as the lights also obscure them. Boltanski thematizes the difficulties of rendering justice to Holocaust victims. The nameless photographs taken

of Jewish students from Vienna of the 1930s are placed over a platform consisting of twenty-two stacked and rusted tin boxes. The photographs and the boxes gesture to unrealized possibilities and lost memories, "presence through absence" (Boltanski and Grenier 151). Just as the faces are not known, so can we not decipher what the tin boxes contain. We know only that they are often associated with the small keepsakes and memories children collect. We do not and cannot comprehend the persons or their lost memories, and the artwork thematizes our inadequacy. The artist notes in his book-length interview with Catherine Grenier the similarities between his work and the "blurriness" of Richter's photo paintings, which likewise stress epistemic longing and frustration (82). By portraying young persons, Boltanski evokes what humans, across time and culture, have most in common, "childhood" and "school" (79). Although the artist addresses a horrific event, he wants to preserve aesthetic ambiguity. Boltanski states in another interview: "A good work of art can never be read in one way. My work is full of contradictions. An artwork is open—it is the spectators looking at the work who make the piece, using their own background. A lamp in my work might make you think of a police interrogation, but it's also religious, like a candle. At the same time it alludes to a precious painting, with a single light shining on it. There are many way of looking at the work" (Boltanski and Garb 24).

Aischric beauty is not unique to Western modernity. Many African cultures see a close connection between physical and moral ugliness, and in some cases this connection is built into their languages. The linguistic overlap of moral and formal ugliness surfaces in almost fifty Bantu languages (Van Damme 53). The Anang in Nigeria create formally ugly masks and costumes to impersonate deceased persons whose lives were filled with evil (57). War masks with their lack of harmony and balance, their exaggeration and distortion, are designed to inspire terror and remind the enemy of war's horrid consequences (61). Ugly masks also convey illness, disability, and sudden misfortune. The Mbangu mask, which comes from the Central Pende people of the Democratic Republic of the Congo, represents a wounded figure who has suddenly experienced illness or misfortune, seeks the sorcerer who caused the problem, and tries to ward it off (Strother 139–53). In contrast to a view of African art as static, Z. S. Strother emphasizes localized masking. He notes variations in the Mbangu masks: for ex-

ample, widened eye-slits and a peanut-shaped face that portray the victim as sorcerer, such that the illness appears self-inflicted; a twisted, distorted, asymmetrical face that in its exaggeration has a comic, almost cartoonish effect, allowing viewers to distance themselves from, and mock, the buffoon's misfortune; and sharp features indicating the envy and aggression that can befall victims of illness or disability. And of course some masks awaken compassion for the victim. A constituent element of all is the conflation of external and internal distortion.

Aischric beauty is not uncommon in music, for when we encounter emotional or moral ugliness, we tend to receive dissonant musical signals. In earlier eras aischric beauty was restricted to isolated moments of negativity, from emotional despair to appearances of the devil, but in modernity it at times overtakes an entire work. Claudio Monteverdi, whose works straddled the eras of Renaissance and Baroque, offers us an early illustration when he breaks with traditional melodic expectations. In "Cruda Amarilli" (Cruel Amaryllis), a madrigal published in his *Fifth Book of Madrigals* (1605), the dissonance arrives unprepared and remains unresolved. The purpose is clear: to express emotions. In this madrigal, which portrays the love relationship between Amaryllis and Mirtillo, the extreme emotions of the dramatic text drive the music, such that Monteverdi breaks conventional rules for the treatment of dissonance. "Cruda Amarilli" is in the mode of G Mixolydian. In measure 13, the canto ascends to an A (the highest pitch of the piece), which clashes with the sustained G of the bass. The long G of the canto in the previous measures has already developed the tension and prepared this emotional highpoint on A. Its powerful effect is further reinforced by the immediately preceding quarter note rest (a breath that emphasizes the upcoming A), the harmonic dissonance of G and A, and the textual content: the sigh "ahi, lasso" (alas) is a reaction to *amar* as the root of both love and bitterness, love (*d'amar*) being evoked just previously and bitterness (*amaramente*, "bitterly") immediately after the sigh. Such grating innovations elicited harsh criticism from the distinguished theorist Giovanni Artusi, in whose fictional dialogue interlocutors describe such innovations as "contrary to what is good and beautiful in the harmonic institutions," "harsh to the ear," and even "barbaric" (394–95). For Artusi, the use of dissonance beyond established rules leads to "a tumult of sounds, a confusion of absurdities, an assemblage of imperfections"

(403). Yet Monteverdi broke with convention, as Austrian conductor Nikolaus Harnoncourt suggests, in order to elevate "musical truth" or the "optimal interpretation of the text" over "tonal beauty" (24).

We see again and again, and not only in music, the tension of truth and beauty. One solution to this antagonism is the idea that since beauty and truth are ideally one, we must reassess beauty by no longer recognizing superficial or conventional beauty (in this instance melodious sonority) as the principle of aesthetic excellence. Instead we should elevate the higher unity of form and content, which may in fact mean discordant, even ugly music that accords with truth. On a metalevel, then, we can speak of yet another kind of harmony, the harmony of truth and beauty or aesthetic excellence. A discordant form may paradoxically contribute to such harmony, for emotional and other forms of ugliness correlate well with discordant form.

In modernity an ambiguity in harmony can be part of the tonal plan. In Mahler's Fifth Symphony we encounter an ambiguity in the adagietto, the lyrical fourth movement. In this section, scored for strings and solo harp, we don't know whether F major or A minor is being played. The music opens Luchino Visconti's 1971 film version of Thomas Mann's *Death in Venice* and then appears for a sixth and final time as the hero dies. Leonard Bernstein conducted the movement at the 1968 funeral Mass for Senator Robert F. Kennedy. Mahler conceived the fourth movement as a statement of love for his new wife, Alma. In Visconti's film it is associated with love and death. Because of the tonal plan we are left in a state of longing, ambiguity, uncertainty (Bernstein 197–99). The use of nonharmonic tones evokes melancholy and unfulfilled yearning, which is a beautiful correlate to the film's dominant theme. We see here both emotional ugliness and a beauty or metaharmony of dissonant form and ugly content.

Dissonance that is unanticipated introduces a further level of discord or ugliness. Consider the climax of the adagio of Mahler's final and unfinished Tenth Symphony in F-sharp minor, where we hear in measures 204–8 the anguished and haunting dissonance of a nine-note chord for the full orchestra, which is foreign to the key area and which overrides the long high A of the trumpet. This chord has been described as "the most wrenchingly dissonant moment in all of Mahler" (Hefling 209) and "analogous in its agony to Edvard Munch's painting *The Scream*" (Lebrecht 179). We recognize ugliness insofar as the music deviates from the listener's expectations and even hurts the ears, yet

beauty arises through the profound way in which such music expresses moments that otherwise would be neglected and which, despite their dissonance, contribute to the whole. The effect is one of emotional ugliness.

The tritone, known as the "devil" in music, is the most dramatic way in which dissonant musical form expresses ugly content. The tritone is an interval of two notes played in sequence or together that are three whole tones apart, either an augmented fourth (as in C and F sharp) or a diminished fifth (as in C and G flat). The tritone is considered a restless interval because we sense the lack of harmony; it leaves the recipient with an unresolved ambiguity. It sounds ugly because it has an unusual ratio between the two frequencies: 1 to the square root of 2. The square root of 2 is an irrational number, and we hear the combination as unnerving and discordant. The tritone contrasts with more harmonic combinations, which consist of simple ratios of whole numbers: for instance, any two notes an octave apart (say, C to C) have a frequency ratio of 2:1, a perfect fifth (C to G) has a ratio of 3:2, and a major third (C to E) involves a ratio of 5:4. The tritone is the most jarring cacophony, the ugliest sound that two tones can make.

When Bach alludes to Satan, death, and sin, he employs the tritone. He uses it for his references to the devil in, for example, cantatas 18 ("The Devil's Deception"), 41 ("To Trample Satan beneath Our Feet"), and 80 ("Satan"). Beethoven adopts it in the dungeon scene in act 2 of *Fidelio* (1805). In Berlioz's *Damnation of Faust* (1846) we recognize the partial influence of Mephisto on Gretchen insofar as the tritone—from F to B, a rising augmented fourth—appears in her ballad "The King of Thule," thus echoing Mephisto's first appearance (when he suddenly materializes before Faust) and his final exit in hell, both of which are characterized by a diminished fifth, from B to F. Franz Liszt uses the tritone to suggest hell in his *Dante* Sonata (completed 1849), and Wagner employs it when Hagen contemplates revenge in *Götterdämmerung* (1876).

The tritone can also arise when a yearning for resolution is unsettled or resolved in a disturbing way, as in Wagner's *Tristan and Isolde*. The so-called Tristan chord, the work's first chord, which also occurs at the end of the final act, is introduced in measures two and three and does not fit into any conventional harmonic progression. The Tristan chord can be interpreted as a half-diminished seventh chord, consisting of the notes F, G-sharp, B, and D-sharp, where the F and B in the

bassoons and clarinets constitute the tritone. Its ambiguous sound, its uncertainty, signals unfulfilled potential, longing without resolution. The tritone can, however, also be interpreted as part of an augmented sixth, disguised by a G-sharp appoggiatura to A, in measure two, and consisting of F, A, B, and D-sharp. The augmented sixth is not unresolved, but instead resolves in an unusual way, thus making the resolution less fulfilling than most augmented sixth resolutions. The D-sharp, instead of resolving to the E pitch (which lies a semitone above), as it usually does, resolves downward a semitone to a D pitch (resolution 1). At the same time, the A pitch of the top voice rises to A-sharp and B (resolution 2). All other voices in this augmented sixth resolve to the usual target chord of E major, while the abovementioned resolutions form an upward and a downward motion, respectively. The rising top voice grabs our attention, but the dominant color of the chord is depressed owing to resolution 1, which permeates the entire chord. In this reading, where the chord is interpreted to include not G-sharp, here a nonchord tone, but instead A, the chord is resolved, but in such a distinctive way that it hints at a dialectic of romantic love that often, as in *Tristan*, combines unfulfillment (resolution 1) and longing (resolution 2).

In his minor-key, slow-tempo lament *Adagio for Strings* (1936), Samuel Barber employs the tritone in the form of diminished fifths to convey longing and unresolved struggle. Barber composed the work during the Great Depression. The piece, which has been called "the pietà of music" (Larson), is a paradigm of sorrow, which was played for the funeral of Franklin Delano Roosevelt, used effectively in the final scene of *The Elephant Man*, and employed by Oliver Stone in *Platoon* (1986) to grieve over the war dead in Vietnam; the sorrow is conveyed by the slow resolutions and delayed harmonies, a work in B-flat minor that seems to fade off into nothingness.

The diminished seventh offers another strategy for evoking dissonance or ugliness. A stack of four notes in intervals of minor thirds, it is produced by two superimposed tritones three half steps apart from each other, for example, G-sharp and D along with B and F. The only interval to consist of two tritones, the diminished seventh is extremely harsh and dissonant, a dark and ambiguous sound, an unstable harmonic tension that must be resolved. It marks discord and hints at fear, unease, anger, pain, and other elements of emotional ugliness and, like the tritone, it is effectively used to evoke the devil. In Bach's *St. Mat-*

thew Passion (1737) we hear a diminished seventh when the oratorio reaches Matthew 27:20–21. The chief priests and elders persuade the multitude to ask for Barabbas and not Jesus. In his bass voice, Pilate asks the crowd whether he is to release Jesus or the thief and murderer Barabbas, and both choirs cry out on a sudden diminished seventh chord: "Barrabam!" With this ugly, discordant chord, they ensure Christ's crucifixion. In Mozart's *Don Giovanni* (1787) the animated stone statue of the Commendatore enters on a diminished seventh, which is then resolved. In *Der Freischütz* (1821), Carl Maria von Weber uses the diminished seventh chord A C E-flat F-sharp in the Wolf's Glen to mark the appearance of the diabolical Black Huntsman Samiel, who offers the hero Max magic bullets that would allow him to succeed in any shooting contest but which could also lead to his ruin. Like the tritone, the diminished seventh is a privileged technique for conveying moral and emotional ugliness. Those who have experienced silent movies with live organ accompaniment will have heard the diminished seventh during scenes of suspense and danger.

Strange Fruit, a 1937 ballad written by Abel Meeropol and performed most prominently by Billie Holiday, whose father died of pneumonia in 1937 after being rejected for treatment at segregated southern hospitals, protests the lynching of African Americans: "Southern trees bear strange fruit, / Blood on the leaves and blood at the root, / Black body swinging in a southern breeze, / Strange fruit hanging from the poplar trees" (Holiday). Meeropol juxtaposes the pastoral, "gallant South" with the victim's "bulging eyes" and "twisted mouth," so too, the "scent of magnolia sweet and fresh" with "the sudden smell of burning flesh" (Holiday). A traditional symbol of life, here the tree signals death. Blood at the roots and blood in the leaves, evokes, on the one hand, bloodlines, the generations of Blacks who have suffered. On the other hand, blood on the roots alludes to a cause-and-effect relation, a critique of the root causes of this hatred and its effects. Not only the lyrics, but the distinctively somber and haunting delivery add to the mood, as does the choice of a dark key for the song, namely, B-flat minor. Moreover, instead of resolving with B-flat, as would be traditional, the song ends unresolved, with an F. The music is effective, aesthetically excellent, if you will. *Time* called it the best song of the twentieth century ("The Best"), but its subject is abhorrent, and the lyric, delivery, and music together underscore that ugliness. The song had a difficult reception (Margolick), but negativity was essential to

the song and to the moral outrage necessary to help engender the civil rights era. Here blues moves beyond solidarity in suffering to harsh critique of oppression.

Dissonant music is naturally poised to express negativity. Dmitri Shostakovitch's String Quartet no. 8 in C Minor evokes the victims of totalitarianism and is appropriately full of dissonance; the discord serves thereby a pattern and a purpose. Similarly effective is the dissonant twelve-tone music in Schoenberg's *A Survivor from Warsaw* (1947). We have already noted how the hidden harmony of perverse form and abhorrent content animates Penderecki's *Threnody for the Victims of Hiroshima*. Via a combination of music and sound effects, American composer John Zorn's *Elegy* (1992), a tribute to Jean Genet, conveys unease and discord to the point where the listener must at times wince.

Modern, arrhythmic dance often embodies fractured beauty. Consider the Merce Cunningham Dance Company's performances, where individual body parts are often not in sync with other body parts, and the dancers are intentionally out of sync with one another and with the accompanying music: as such, dissonance is a signature element of form. At times, however, the arrhythmic form is not simply formal; it is linked to ugly content. Cunningham's *Place* (1966) ends with the dancer getting into a large plastic garbage bag, pulling it up to the chest, and then thrashing about violently across the stage. The audience does not know whether the dancer is trying futilely to get wholly into the bag or to wrestle out of it, but the impression of physical and emotional ugliness is unambiguous. Political dance gives us even earlier examples, as in the arrhythmic movements and gestures in German choreographer Kurt Jooss's *The Green Table* (1932). The dislocations convey the futility of peace negotiations and the inevitability of war, with all its horrific consequences. Jooss's political ballet opens and closes with the inefficacy of peace negotiations and embeds into the long middle of the work the dignity, beauty, and deaths of soldiers and their loved ones. No matter what turns and twists take place, no matter how variously the scenes develop, war and death result. The diplomats are indifferent to the consequences. The grotesque masks reveal inner values, the partially arrhythmic dance moves create unease and evoke mistrust, and the occasional tension between serious negotiations and tango-like music reveals a Brechtian alienation strategy. As with many modern accounts of war, *The Green Table* integrates older

images, in particular the medieval dance of death, even as it seeks to address the specificity of the present.

Aischric beauty is widespread in modern literature, but earlier examples do surface, for example, in comedy. Shakespeare is a master at comically exposing stupidity and misplaced arrogance, in other words, intellectual ugliness. Nonsensical language is a fitting complement to the utter drivel of ideas. The dull-witted rustics Dull and Costard in *Love's Labor's Lost* (1597) fall into malapropisms as they try unsuccessfully to fit in with the learned. Similar is Dogberry, the constable in *Much Ado about Nothing* (written 1598–99). We first see Dogberry as he instructs his men on their duties: amidst the gibberish and abuse of language, we learn that it is fine to sleep on duty, and if the guards see a thief, they should not grab him, but let him go, so as not to become associated with a criminal, which would be bad for their reputations. Throughout, language is misused: "O villain! Thou wilt be condemned into everlasting redemption for this" (4.2.56–57). Full of malapropisms and pseudo-legal language, Dogberry speaks absurdly to Leonato, the governor. Dogberry offers a sequence of observations fully out of order: "Marry, sir, they have committed false report; moreover, they have spoken untruths; secondarily, they are slanders; sixth and lastly, they have belied a lady; thirdly, they have verified unjust things; and, to conclude, they are lying knaves" (5.1.211–15).

Dogberry is fascinating partly because, despite his ineptitude and comic stupidity, he manages to uncover the plot that makes the play's resolution possible. He insists that the official report include all that Conrade said about him: "do not forget to specify, when time and place shall serve, that I am an ass" (5.1.249–50). His final words give one a sense of his use of language: "I leave an arrant knave with your worship, which I beseech your worship to correct yourself, for the example of others. God keep your worship! I wish your worship well. God restore you to health! I humbly give you leave to depart; and if a merry meeting may be wished, God prohibit it!" (5.1.315–21). We see the coupling of intellectual ugliness (stupidity pretending to be knowledge) and physical ugliness (language misappropriated). The play is rich in beautiful ugliness, for we also have moral ugliness (Don John) and a more subtle form of intellectual ugliness that borders on moral ugliness: the Prince and Claudio are deceived, and deception is a form of intellectual ugliness, an intended untruth, but that deceit is coupled with an unappealing level of moral arrogance. The dissembling

experienced by the Prince and Claudio, which forms the impetus for their moral outrage, is met with counterdeception (the intrigue that Hero is dead), which, however, is designed to encourage contrition and bring forward a resolution, such that the deception, when unveiled, leads to joy, and so a mix of ugliness and beauty. Further, both Benedick and Beatrice are conned (into thinking that despite their verbal barbs against each other, Benedick loves Beatrice, and Beatrice loves Benedick), but this artifice, too, has a hidden logic and reveals a higher truth, such that we are again in the realm of beautiful ugliness, as befits a complex comedy. Finally, the stupidity and mistakes of Dogberry contrast wonderfully with the sharp wit of Beatrice and Benedick; still, the witty have trouble expressing their emotions, and Dogberry, for all his malapropisms, is able to communicate the essence of his discoveries. Despite its abundant ugliness, the play ends harmoniously as a comedy of forgiveness (Hunter).

An early German example of aischric beauty is Hans Jacob Christoph von Grimmelshausen's Baroque novel *The Adventures of Simplicius Simplicissimus* (1669). The picaresque form, with its disjointed, episodic flow, effectively mirrors the almost unimaginable horrors of the Thirty Years' War and the disoriented and rogue hero's confused mind. The roller-coaster narrative takes us through a life of cruelty and kindness, deception and revelation, a web of contraries and contradictions. Until the very end, the hero himself varies his modes of being and action—including the diverse roles he plays, from thief and gigolo to soldier (on both sides of the conflict) and pilgrim—without any clear trajectory or development. The changes in location and style are likewise bizarrely chosen and without any obvious internal logic. The hero recognizes "that there is nothing in the world more constant than inconstancy itself" (3.8). The work's heterogeneous chaos is manifest in the hero and the age but also in the form, thus giving readers a latent symmetry beyond the manifest disorder.

The drama of suffering can embody not only repugnant beauty but also aischric beauty. In its fragmentary and nonteleological form, Büchner's *Woyzeck* unveils a world of disarray and disharmony. The drama is fascinating not only because the disjointed formal structure matches the ugly content, but also because the language is in stretches beautiful, which gives the work elements of repugnant beauty too. Brecht is the greatest heir to Büchner. The goal of Brecht's epic theater is to break our emotional absorption and disrupt the story, elic-

iting reflection, for example, by offering summaries in advance of the action, having stagehands visible during the performance, or encouraging actors to distance themselves from the roles they are playing. The disjunction evident in Brecht's estrangement represents an element of form that serves what one might call its metacontent. That is, the disjunctive form, the technique of breaking the illusion of verisimilitude and alienating the audience, accentuates and even contributes to the content, which stresses not narrative continuity but intellectual puzzles.

Modernity's loss of overarching connections is expressed stylistically in the poetry of twentieth-century Germany, for example, in the parataxis and serial style of the early Expressionists. Note the seeming randomness of Jakob van Hoddis's "The End of the World" (1911), which describes a world moving toward the abyss:

> The bourgeois' hat flies off his pointed head,
> in the air all round echoes a screaming sound.
> Tilers plunge from roofs and split on the ground
> And the seas are rising round the coast—you read.
>
> The storm is here, crushed dams no longer hold,
> the savage seas come inland with a hop.
> The greater part of people have a cold.
> Off bridges everywhere the railroads drop.
> <div align="right">(Ger. 9; Eng. 49, translation modified)</div>

Virtually every line introduces a new subject. Any lyrical self, any figure of continuity, is absent. The citizen appears narrow-minded, and others simply read of the disaster or concern themselves with colds. Meanwhile, Munch's *The Scream* has come to life, and all the world's protective and connecting support structures are endangered or collapsing—roofs, dams, and bridges. The bizarre collage combines the comic and horrific: one doesn't know whether to laugh or scream.

Similar discontinuity, both formal and thematic, arises in Alfred Lichtenstein's "Twilight" (1911). Images seem jumbled together and out of place, but the formal technique stylistically underscores the thematic sense of disarray (*Dichtungen* 43). Lichtenstein's "Morning" (1913) is similarly disjointed. In each of the first two stanzas, one parataxis follows another, with no relation between them:

And all the streets lie smug there, clean and regular.
Only at times some brawny fellow hurries by.
A very smart young girl fights fiercely with Papa.
A baker, for a change, looks at the lovely sky.

The dead sun hangs on houses, broad as it is thick.
Four bulging women shrilly squeak outside a bar.
The driver of a cab falls down and breaks his neck.
And all is boringly bright, salubrious and clear.

<div align="right">(Ger. 49; Eng. 171)</div>

People are highlighted at random, then drop out of sight in the next line, as we move on to other figures, who are equally interchangeable. Everything is related only in its unrelatedness—the impersonal essence of modern life. Only with the last three lines of the third and final stanza do we come to a thought that reaches beyond one line, and its theme is a god who has forgotten or ignored the world. The title—"Morning"—is ironic, for instead of suggesting something positive, the rise of a new day, the poem evokes "the dead sun" and an indifferent god, ailing, laughing, dying.

Film, too, interweaves formal disarray and negativity, as we saw in Wiene's *The Cabinet of Dr. Caligari*. The ominous stylized surroundings convey disorientation and underline the mad, sinister *Angst*, suggesting a nightmarish scenario, a world out of joint, both in the film and beyond. Form not only reinforces content, as in the tradition; here both are manifestly ugly and match the confusion and chaos of early Weimar. The styles of beautiful ugliness can sometimes help us understand an entire work, as with the aischric beauty of *Caligari*, but they can no less involve moments within a work, be they anomalous or widespread moments of distortion. Murnau's *The Last Laugh* is primarily a work of repugnant beauty, but at least one scene, which underscores the protagonist's loss of coherent identity, moves radically into the realm of distortion. By associating with the doorman, the tenement's female residents enhance their sense of collective identity: they giggle shyly and fawn over the doorman and his uniform. But when the doorman loses his position, they feel betrayed. Their link to the upper world of the hotel now broken, they laugh sadistically. In a magnificent sequence, the moving camera, newly introduced for this film, simulates the effects of the doorman's drunkenness. He imagines

himself in his old glory only to be met later, as viewers are, by a montage of jeering faces, gaping mouths, and horrific laughter. The women express *Schadenfreude* and resentment. The humiliated doorman staggers about, as though each laugh were a blow to his back.

I n works of aischric beauty, the dissonance of content matches a dissonance of form, thus reaching on a metalevel a congruence of form and content. It is fascinating to see that in conveying ugliness, works often integrate formal moments of dissonance, which then serve the work's higher meaning and are thus on a metalevel not dissonant, but organic. The concept of the organic implies an act of fitting together and joining diverse parts in order to create a coherent whole. This connection between art and the organic, which was so important to objective idealists, such as Plato and Hegel, is directly countered, in modernity, which tends to elevate instead the fragmentary, the dissonant, the arbitrary. But in aischric beauty we see a complex synthesis in which the dissonant serves an organic purpose, linking form and content, part and whole: dissonant and fractured forms effectively express physical, emotional, intellectual, and moral ugliness. The concept of aischric beauty gives us a language to capture the often elusive organic structure of many modern works, where form and content do in the end constitute a higher, if complex unity. The identification of this style also makes it easier for us to comprehend why such works are on so many levels fascinating and worthy of our esteem: they take a traditional form, the organic, but turn it upside down. The iconoclastic aesthetics I am defending, built on an idealist concept of the organic, is not only compatible with ugliness; it may in fact offer the most creative and fascinating way of understanding, evaluating, and appreciating ugliness.

The most authoritative study of the avant-garde is by Peter Bürger. Translated into English in 1984, *Theory of the Avant-Garde* received its fifteenth English printing in 2016. Bürger argues that avant-garde art is defined by its negation of the organic. The concept of an "organic work of art," which Bürger describes as "a limited concept," is "destroyed by the avant-garde" (55–56). The modern avant-garde breaks with this tradition by elevating unintegrated parts and presenting only fragments: "The development of a concept of the nonorganic work of art is a central task of the theory of the avant-garde" (68). But Bürger

employs binary thinking: organic versus avant-garde (or nonorganic). Aischric beauty, however, offers a synthesis of organic and nonorganic. Its formal dissonance and seemingly nonorganic elements appropriately mirror disturbing and ugly content. On a metalevel, the form of aischric beauty, with its dissonance and fragmentation, is in harmony with its ugly content—and so paradoxically organic. Aischric beauty realizes Hegel's view of the ideal artwork as one in which "content and form show themselves to be completely identical" (*Werke* 8:266; *Encyclopedia Logic* 203).

STRUCTURES OF
BEAUTIFUL
UGLINESS

Whereas the three styles of beautiful ugliness draw on the relation of content and form, the three structures of beautiful ugliness—*beauty dwelling in ugliness, dialectical beauty,* and *speculative beauty*—weigh the relation of part and whole. Is the entire work ugly or only a part? If the whole of the work is ugly, is that ugliness simply presented or is it negated? Or does ugliness represent a mere part, such that however significant the ugliness may be, it nonetheless plays a subordinate role within the whole? The focus on parts and whole and their relation to negation leads to three overarching structures of beautiful ugliness. In beauty dwelling in ugliness, the entire work is immersed in ugliness, and no negation of this ugliness is evident. In dialectical beauty, the whole is ugly, but negation is evident. Works of dialectical beauty offer a negation of ugliness or a negation of the negation, since the ugly is already characterized by negation, by not being what it should be. In speculative beauty, ugliness represents only a part of the work, which is absorbed into a larger, more harmonic whole.

Whereas negation is a central category for Hegel and the Hegelians, the first structure, *beauty dwelling in ugliness,* presents ugliness but does not negate it. In some cases we are within the Aristotelean

mode of wanting above all simply to understand ugliness. In other cases, especially in modernity, we see not a disinterested presentation of ugliness, but instead its bold affirmation. This, too, is a mode of beauty dwelling in ugliness. Hegel and the Hegelians prefer rendering ugliness as a transitory moment, either in a dialectical structure where ugliness is negated, even if no positive alternative is shown, or as part of a fuller process in which ugliness is submerged into a larger whole. Hegel and the Hegelians argue that we are called to think through and discover contradictions, to dwell in them only insofar as we can eventually overcome them by recognizing their insufficiencies. By the power of immanent critique or determinate negation, we recognize that what seemed stable or solid contains within itself a contradiction, which must be dissolved, such that the position passes over into another and pushes on toward the whole. The Hegelian dynamic of negation emerges from the idea that all categories, all identities contain within themselves contradictions. Hegel famously criticized Kant by arguing that, though Kant had recognized in the antinomies of pure reason the value of contradiction, he recognized only four antinomies. For Hegel such antinomies or contradictions are visible in "*all* objects of all kinds, in *all* representations, objects, and concepts" (*Werke* 8:127–28; *Encyclopaedia Logic* 92; cf. *Werke* 20:356).

The first structure, then, with its lack of negation, seems to be very un-Hegelian, whereas the second two structures, *dialectical beauty* and *speculative beauty*, embody Hegelian thinking. However, Hegel invites us to dwell in, or linger with, the negative. Already in *The Phenomenology of Spirit* he argues that we achieve truth only when we find ourselves fully engaged with negativity: spirit or mind reaches its goal "only by looking the negative in the face and tarrying with it" (*Werke* 3:36; Eng. 19). Beauty dwelling in ugliness lingers with the negative, offering us an unsublated moment that is still a part of truth. It forces us to tarry. If we recognize that art can express less than the whole truth by focusing instead on a moment of truth, then such works have distinctive value. Hegel, at times too quick to move toward synthesis, was rebuffed by many of his nineteenth-century critics for not sufficiently lingering in ugliness, not fully working through reality's contradictions. Artists who tarry with the negative remind us that a seeming synthesis can be unveiled as too simplistic and false and that a genuine synthesis is not easy—indeed not always attainable or even appropriate.

B E A U T Y
D W E L L I N G I N
U G L I N E S S

Beauty dwelling in ugliness involves a lingering in ugliness without any signals of negation, without ugliness being rendered a moment in a larger, unfolding process. We see an effort to contemplate and capture aesthetically some aspect of ugliness without seeking to move beyond it. The motivations cover a wide range: deep empathy with those in ugly situations and conditions; a desire to dwell in negativity and so fully understand and absorb it without cutting it short in any way; a wish to extend the range of the aesthetically possible; fascination with the bizarre and grotesque; sober indifference coupled with a focus on what stands outside the norm; a countercultural celebration of ugliness; an ambiguity that borders on, but stops short of, critique; and a metaphysical desire to linger in negativity. Beauty dwelling in ugliness arises whenever a work lingers in ugliness without any distancing signals, any negation, any movement toward a greater whole in which ugliness might be submerged. Such works recognize the ineradicable ugliness of reality without going beyond it. Like repugnant beauty, this form of beautiful ugliness has tremendous historical range, reaching

as far back as Euripides, but like fractured and aischric beauty, it tends to be most concentrated in modernity.

The Various Arts

Sculpture, installations, and painting offer the most illustrative examples and so provide the best introduction to beauty dwelling in ugliness. Since these arts, unlike architecture, need not also fulfill a function, they can focus on the portrayal of ugliness, and because they are static, they tend to dwell in ugliness more than the temporal arts, such as literature and film, which frequently include ugliness but also often gesture or move beyond it.

In sculpture, we find examples in the late eighteenth century. Consider the character heads of Messerschmidt, who created more than fifty such works. The contorted faces, grimaces, and extreme expressions are ugly, but Messerschmidt presents the sculptures without evaluation. Though the style is neoclassical, the content is not: the distorted faces appear to have been inspired by the sculptor's own extreme pain, possibly his hallucinations, which he captured by studying himself in the mirror. The range of emotions, including ugly faces, arises from a combination of realism (capturing what is) and comprehensiveness (capturing as many expressions as possible). Messerschmidt expresses ambivalent emotions, for example, the grin as an expression of pain in *A Grievously Wounded Man* (no. 19) and the mix of anger and amusement in *An Arch Rascal* (no. 33) (Bückling 124 and 144).

Prominent in beauty dwelling in ugliness is empathy and lament. Kollwitz's *The Grieving Parents* (1932) is a World War I memorial for her son Peter, located at Vladslo German war cemetery in Belgium. With despair and resignation, the father, arms crossed and stiff, looks ahead to their son's grave, and the mother bows down in lament. The kneeling figures are in a state of emotional grief, perhaps also guilt, but the work itself is beautiful and simply dwells on their suffering over the fallen son, encouraging empathy with their lament.

A very different mode of expressing and lingering in emotional ugliness arises in Kiki Smith's *Untitled* (1990), which addresses isolation and frustration, including distance and disenchantment between two figures. In an installation of two beeswax and microcrystalline wax

Structures of Beautiful Ugliness

figures on metal stands, Smith displays one male and one female figure, separated from one another, both heads drooping, both leaking body fluids from their orifices. Out of the woman's breasts comes milk, and down the man's leg, below his penis, we see semen. Smith comments to David Frankel: "Her milk nurtures nothing, his seed seeds nothing. So it was about being thwarted—having life inside you, but the life isn't going anywhere, it's just falling down" (Frankel and Posner 38–39). The work soberly portrays emotional ugliness, rendering the weary figures neither heroic nor objects of the artist's critique.

Another contemporary we can consider here is Heide Fasnacht. Her artworks, simultaneously alluring and dreadful, portray demolitions, disasters, and explosions. Consider her *Exploding Plane* (2000), a large sculpture of graphite acrylic over neoprene, which evokes the moment a plane begins to explode, or her colored pencil on paper rendition of imploding buildings, *Three Buildings* (2000–2001). For Fasnacht, instability is a defining characteristic of the age. Instead of criticizing it, she invites us to contemplate it. Out of instability, disorder, and catastrophe the artist meets the challenge of creating beautiful constructs. One need not create representational works in order to evoke dissonance. Chamberlain's seemingly ugly sculptures, such as *Nutcracker* (1958) or *Balzanian* (1988), derive very much from the materials, which consist of car parts compressed and shaped into more or less abstract sculptures. The forms are fascinating, dynamic, colorful, evocative—yet almost all have echoes of car crashes.

Already with centaurs and satyrs, odd mixtures were seen to evoke ugliness, as Horace (*Ars poetica*, lines 1–5) and later Baumgarten (vol. 1, §445–77) argued. Early modern examples of hybrid creatures were designed for critique, for example, Lorch's *The Pope as Wild Man*. When we get to modernity, bizarre combinations need no longer be viewed negatively. Consider German artist Thomas Grünfeld, who fashions cross-species creatures, for example, his taxidermal *Misfit (St. Bernard)* of 1994: we see a St. Bernard, lying comfortably, with a raised front, but its head is that of a sheep. Other seamlessly joined collages include a bird's body with a pig's head and a fawn with bat wings. Whether his series of misfits, which he began in 1989, is designed to criticize technological advances and their bizarre consequences or simply show us seemingly ugly and disturbing creations is left open. With some of the collages consisting of animals that would otherwise be enemies, such

as a fish and a cat or a deer and a dog, one wonders whether the works awaken not simply horror but a hidden ideal of harmony, which would take us beyond beauty dwelling in ugliness.

Grünfeld's images seem wondrous and at times even incongruously funny, whereas the works of Piccinini are more provocative. Her disturbing silicone-based hyperrealistic creations involve imaginative creatures, partly human and partly animal. *The Young Family* (2002) consists of a sow-like creature lying on her side while three smaller creatures suck at her teats and another lies nearby (illustration 54). The work consists of silicone, fiberglass, leather, plywood, and human hair. The vulnerable-looking creatures have both animal and human traits: on the one hand, snouts, floppy ears, and tails, on the other hand, human-like flesh combined with eyes and an expression that radiates self-awareness. These creatures are monsters in the physical sense of radically abnormal, but they nonetheless awaken deep empathy. Piccinini herself comments that her works are "attractive and alluring," on the one hand, and "grotesque and disconcerting," on the other (Heyman). The exhibit raises questions about biotechnology and cloning as well as the essence of a human being. The work invites us to reflect on grotesque-looking animals with human-like traits, who could in principle be bred for our benefit (one thinks of stem cells or organ transfers), but the work itself does not move us toward answers or criticism. It simply invites reflection. Her artist's statement opens with the following sentences: "I take it for granted that technology will continue to advance. There are people trying to resist technological advancement as a whole, but I am not one of them. On the other hand, I'm not unquestioning of technology. I do not think technology is good or bad, it is just technology. And as technology progresses, we will need to figure out how we are going to use it" (Piccinini).

Among other contemporary artists we can place into beauty dwelling in ugliness are the Chapman brothers insofar as their works, which break taboos by depicting violence in unusual ways, do not criticize what they portray. In a 2008 interview with the White Cube gallery, Jake Chapman discussed *Fucking Hell* (2008), by his brother Dinos and himself, which was an update of *Hell*, a work created in 1999–2000 but lost in a 2004 storage factory fire (Chapman). Via toy soldiers, both works seek to portray scenes of hell, including Nazi genocide, and do so by consciously avoiding moral condemnation. Chapman stresses that "violence" and "atrocity" and "murder" and "wars"

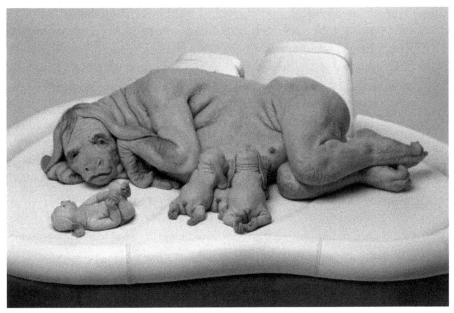

ILLUSTRATION 54
Patricia Piccinini, *The Young Family*, 2002, Silicone, fibreglass, leather, human hair, plywood, approx. 85 x 150 x 120 cm. Collection of Bendigo Art Gallery/Courtesy the artist, Tolarno Galleries and Roslyn Oxley9 Gallery..

are "absolutely necessary conditions of our lives." He wants viewers to engage these themes up close, rejecting any Enlightenment ideals for art, which might help move society beyond such horror. He calls their collaborative works "violently pessimistic."

Max Ernst painted many bizarre images that violate our expectations of physical reality. The odd juxtapositions and distortion are executed with extraordinary imagination and skill. They create disorientation more through the odd, at times unbelievable, content than through any formal strategies of distortion. Ernst's first large picture, *The Elephant Celebes* (1921), integrates Dada's seemingly accidental collage technique with the dream-like atmosphere of surrealism. The work includes in its center an odd, arguably monstrous, combination of elephant, machine, and bull's head. In the lower left we see a female nude, a mannequin-like figure, with no head. She seems to have no physical contact with her environment. In contrast to the flighty headless nude, the massive and centrally placed machine has an eye at its top. Two fish swim above the machine. With beautiful strokes Ernst gives us both physical and intellectual (in this case nomological)

ugliness, which in turn evoke a sense of emotional unease or laughter or both. A fascinating spinning anthropomorphic top dominates Ernst's *Ubu Imperator* (1923). On the one hand, we see the figure's instability and isolation, which is in tension with the work's title, "Commander"; on the other hand, there seems to be pure joy in the artistic image, independent of any possible critique. In *Obscure Exotic Portrait* (1934), the figures bizarrely combine dismembered human shapes and roosters, yet the work evokes a certain joy, emphasized by the colors and odd juxtapositions.

Most of Ernst's images are presented as fascinating objects without evaluation, but exceptions exist, such as *The Angel of the Home or the Triumph of Surrealism* (1937), which moves beyond beauty dwelling in ugliness. Painted shortly after the defeat of the Republicans in the Spanish Civil War, this political work portrays the havoc that fascism was engendering in Europe. The menacing angel, which covers the entire canvas, is the angel of death, and the kind of chaos we see in surrealism is here realized in politics. Understood ironically, the title suggests that surrealism, dwelling in ugliness instead of negating it, could do nothing to stop fascism.

In Rene Magritte's *The Lovers II* (1928), two lovers embrace and seem to kiss, but their heads are completely veiled, covered by fabric. Frustration and alienation are the result. The blue background adds to the paradox, for blue is normally a positive color associated with calm, the water of life, and the heavens. The woman's red may symbolize passion, whereas the man's black garb seems to suggest death. We experience options but not answers. Through a new and striking visual image, the work invites us to understand the phenomenon of isolation, a kind of emotional ugliness, which is here given physical shape.

Lucian Freud paints subjects without evaluating them. Consider his realistic and candid masterpiece *Benefits Supervisor Sleeping* (1995), with a heavy woman sleeping on a shabby couch, her uneven flesh contrasting with the smooth upholstery. Freud paints his figures in an uncompromising light, with attention to detail, including less appealing aspects, but always with a sense of dignity. This matches Hermann Cohen's concept that even ugly portrayals of the human figure must also reveal the human being as "worthy of love" (1:304). Freud seeks "an intensification of reality. Whether this can be achieved depends on how intensely the painter understands and feels for the person or

object of his choice" (Stiles and Selz 219). Not surprisingly, Freud's nonidealizing tendencies led him always to avoid professional models and instead to choose friends and family.

For examples of contemporary painters whose works embody beauty dwelling in ugliness, consider two Germans, Johannes Grützke and Anselm Kiefer. Grützke gives us distorted faces and bodies, formally a kind of realism with irony, yet without any implicit critique of his subjects and more as a formal exercise in distortion and amusement. Frequent in Kiefer's works is the combination of fracturedness and darkness, a deeply artistic portrayal of negativity, which invites lingering more than critique. Although Kiefer belongs to the modern tradition of upending traditional understandings of beauty, beauty remains his standard, even as his works embody despair, unease, negativity (Celant 446). When Kiefer was young and became conscious of his having begun painting flowers, he stopped himself, for such landscapes were, in his words, "too popular" and "too *affirmative*" (Parker). Instead Kiefer has been drawn to what he calls "something unspeakable . . . a black hole . . . a crater whose center cannot be attained" (Celant 157). Some of Kiefer's works hint at a critique of, or an ironic engagement with, German history and culture. In *Margarethe* (1981) and *Sulamith* (1983), works inspired by Celan's "Death Fugue," Kiefer mixes paint with ash, earth, and straw. Much of Kiefer's corpus seems almost to border on a kind of negative theology, seeking, but not quite finding, the mystical in negativity. Even if artistic beauty can be realized by way of horrific subjects, a process and a result that Kiefer, with his penchant for negativity and paradox, calls "a curse," he makes clear that art is not redemptive (Cocker). His works linger in negativity.

In architecture, beauty dwelling in ugliness is a recent phenomenon. Postmodern buildings take joy in their flouting of conventional concepts of beauty and order. Virtually all of the architectural examples I noted previously under fractured beauty, for example, the Friedensreich Hundertwasser House, Eisenman's Wexner Center for the Visual Arts, and Gehry's Lou Ruvo Center for Brain Health, fit here too. Although one could say that the content, driven by disarray and disorder, is negative, the negativity is embraced. For Eisenman, such architecture reflects the age. Architecture that "expresses the separation and fragility that man feels today in relationship to the technological scale of life" should, according to Eisenman, be privileged (Alexander

and Eisenman 65). In a world in which being comfortable and experiencing harmony are contrary to the spirit of the age, which is instead dominated by "anxiety," Eisenman feels "the need for incongruity, disharmony, etc." (67, 68). Eisenman wants to express "the nonwhole, the fragment" (65). Buildings in which people feel comfortable could easily lull them into misunderstanding the world. In contrast, Eisenman wants buildings to mirror the unease and anxiety that dominate our era.

Music can also immerse itself in ugliness without searching for, or longing for, either critique or redemption. Atonal music is hardly oriented toward resolution. It lingers in dissonance and is content not to move beyond it. Schoenberg's atonal harmonies "reject the very thirst for resolution" (Harrison 217). A popular-culture analogue to atonal music is punk rock, which uses highly dissonant, often jarring and at times incoherent sounds. Lyrics are as much shouted as sung. In the Ramones, for example, one of the earliest and most influential punk bands, listeners encounter highly distorted power chords, rapid guitar downstrokes, loud percussive sounds, swallowed words, and energetic, fast songs. One critic described the thrash of the Ramones as "the sound of 10,000 toilets flushing" (Gilmore). Like much of ugly painting and literature, punk rock thematizes darker issues, for example, unemployment and urban despair; like Dada, it tends toward the chaotic; and like much of performance art, punk rock seeks, with its breaking of sexual and other taboos, to provoke, unnerve, and shock. Offering a metaharmony of dissonant form and ugly content, its jarring music expresses feelings of dispossession and precarity, of not fitting in, that resonate with audiences, for example, the Ramones' "Nothin' to do, nowhere to go" from "I Wanna Be Sedated." In such works we find both discordant sounds and dissonant lyrics, a rare example of the overlap between aischric beauty and beauty dwelling in ugliness.

The blues, which address the reality of African American suffering, are another prominent example. They dwell on oppression and imprisonment, disillusionment and helplessness. Loss, failed relations, and broken dreams are prominent. The blues capture an existential situation, the experience and struggle of African Americans. They give voice to African American suffering and endurance, indirectly affirming African American humanity in an unjust or absurd world. Although some blues songs, such as "Strange Fruit," invoke protest

and critique, for the most part the focus is solidarity in suffering, not calls for change. Contrast the blues with African American spirituals, which likewise reflect suffering but, unlike the blues, invoke a Christian narrative of overcoming and hope, an account of eventual progress toward historical self-determination and ultimate justice (Cone, *The Spirituals*). African American spirituals thematize but go beyond the ugliness of reality, whereas the blues linger with this ugliness. The blues do not deny God, but they tend to ignore God, as their focus is elsewhere, the unmitigated historical experience of suffering and solidarity in suffering (Cone, *The Spirituals* 110).

For an example of blues suffering, consider "Stormy Weather" (1933), written by Harold Arlen and Ted Koehler, first sung by Ethel Waters at the Cotton Club in Harlem, and made still more famous by Lena Horne in the 1943 film *Stormy Weather*. Horne recorded the song not in G but in A-flat. The lyrics evoke a deep sense of melancholy, with extensive use of the blue note, a slight lowering of the pitch. The blue note reinforces the melancholic mood already in the song's first sound and then again four times in the first three lines (Friedwald 288). The song was created and received at a time of hardship and economic depression. The ellipses, evident already at the start, are signature elements of the blues.

> Life is bare
> Gloom and misery everywhere
> Stormy weather
> Just can't get my poor self together
> I'm weary all the time, the time
> So weary all the time
> (Lena Horne, "Stormy Weather")

The song's one reference to God ("the Lord above") is overshadowed by the focus on suffering. The song expresses disorientation, desolation, exhaustion, and loss. The horror to which it alludes does not diminish, but persists to the end.

The Psalms, which are full of ugliness, influenced the blues and African American spirituals. The psalms of lament criticize diverse catalysts of suffering, including God, even if trust in God remains a dominant motif. The psalms of lament, both communal and individual,

linger with negativity; they do not fully resolve ugliness. Contrary to overly optimistic renderings of faith, the psalms forcefully acknowledge reality's ugliness. With the psalms of individual lament constituting the largest group, the existential disorientation is front and center. The Psalms' immersion in darkness is not unrelated to what we have said about the connections between reality and ugliness: these songs recognize reality without a false lens. They shatter all pretensions. Reality comes before spirituality; the deepest moments of abandonment and ugliness are turned into words and reflection.

The laments tend to follow a basic pattern, which has been explored by scholars from Hermann Gunkel and Claus Westermann to Hans-Joachim Kraus and Walter Brueggemann. The speaker's plea begins with an intimate address to God, moves on to an urgent complaint about the desperate situation (for example, sickness or poverty, isolation or loss, mistreatment or destruction, and prominently the absence of God) for which God is deemed ultimately responsible. The speaker tries to arouse compassion, boldly petitioning for divine intervention, even via repeated imperatives. No one can help. Attempts are made to motivate God: the speaker is innocent, the speaker is guilty but repents, the speaker references God's goodness toward earlier generations, the speaker calls God's reputation into question, accusing God of dereliction and pleading with God to act "for your name's sake" (Ps. 109:21). The enemies, often rich and powerful and always evil, are prominently denounced. Without inhibitions, the speaker expresses distress and calls out for vengeance and restitution. The complaint usually shifts to praise, along with an assurance (or hope) of being heard and of the speaker in turn keeping his word. The shift is often sudden and brief (e.g., Ps. 13:4–5 and Ps. 22:21–22). But not all psalms resolve with assurance or hope. In Psalm 88, the speaker, who cries out and whose soul "is full of troubles" (2–3) and who compares himself to "those who have no help, / like those forsaken among the dead, / like the slain that lie in the grave, like those you [God] remember no more" (4–5), receives from God no response. The silence leads not simply to doubt but to desperation and continual, unanswered pleas: " O Lord, why do you cast me off? / Why do you hide your face from me?" (14). The psalm ends with despair.

"My God, my God, why have you forsaken me?" At the time of his ugly death, Christ speaks the opening line of Psalm 22 not in He-

brew but in Aramaic: *Eloi, Eloi, lama sabachthani?* (Mark 15:34). In prayer, Christ's words become also the active words of believers. Although Christ's moment of forsakenness is overcome in the redemptive arc of Christianity, this moment, taken by itself, remains pure ugliness. Readers of the psalm participate in a tradition that includes also the "Why?" of Job. In these moments, the human and divine are not resolved but simultaneously held together: God is addressed, but suffering still burdens the speaker. Participation in ugliness takes the form of prayer, and lamentation itself becomes a kind of prayer (Fuchs). The Psalms move between an agonistic relationship of abandonment and critique, on the one hand, and solidarity and gratitude, on the other. In lingering in negativity and ugliness and in offering a mediation, a reflection, a solidarity with suffering, and a way to cope with it, the Psalms can be understood as unusual forms of beauty dwelling in ugliness. The focus is negativity and suffering even if there is a hint of more. Respites are temporary, as we move on to the next lament. There is no guarantee that ugliness will be overcome. The speaker lingers between lament and praise, yet, as André LaCocque suggests, there is no clear division: "Praise remains plea until the end" (LaCocque and Ricoeur 209). Paul Ricoeur also stresses this unity: "The lament is sustained, without being suppressed . . . the transmutation to praise remains within the limits of lament" (219). Thus, there is a deeper rationale why complaint is not transformed into praise; at some level they are two sides of the same prayer.

Examples of beauty dwelling in ugliness abound in modern poetry. The topic of Rimbaud's sonnet "Venus Anadyomène" (1870) is the birth of Aphrodite (Venus) out of ocean foam. Venus emerges "slowly and stupidly" from a bathtub as "from a green zinc coffin" (25). She has "bald patches" and a "fat grey neck," heavy hips and folds of fat (25). She reeks and has an "ulcer on the anus" (25). Venus is "hideously beautiful" (belle hideusement) (25). The artful poem mocks traditional veneration of beauty. In "The Seated Men" (1871), Rimbaud paints a horrid portrait of old men sitting in chairs with "pockmarks," green circles around their eyes, and vague cankers on their skulls (127). They sit all day in their chairs, "knees to their teeth," almost like carcasses (127). In another assault on beauty and grace, Rimbaud's "What Is Said to the Poet Concerning Flowers" (1871–72) criticizes the poetic veneration of flowers, which has no more value than the "excrement of a sea-bird" (113). Instead, the poet would sing of

"tobacco" and "hydras" and "the potato blight" (118). Poetic examples of beauty dwelling in ugliness need not be negative or mocking. They can also be rapturous and affirmative. The greatest Bengali poet after Tagore, Jibanananda Das, evokes a range of images in "A Certain Sense" (1929) and does so in a way that embraces all of life, including its ugliness (6–8).

We can include under beauty dwelling in ugliness also the early poetry of Benn, with its formal mastery combined with its integration of ugly images, including dead body parts and human beings described as inanimate objects. Often the catalyst for elevating such images is a rejection of the idea of the human as having been made in the image of god, of having a special dignity. Similar, but from a Marxist perspective, is Brecht's "The Drowned Girl," which depicts the human body as being absorbed into nature, such that any meaningful connection to the transcendent is abandoned: "As her pale flesh rotted in the water, / It happened (in stages) that God gradually forgot her— / First her face, then her hands, and only at the very last, her hair. / Then she was rubbish [Aas] in the rivers with much rubbish" (*Ausgewählte Werke* 1:252; "The Drowned Girl" 9).

Not only poetry but also drama, in particular the drama of suffering, which we considered under both repugnant beauty and aischric beauty, maps on to beauty dwelling in ugliness. Among the ancients we think above all of Euripides, who focused on suffering at the expense of any organic connection to greatness, as, for example, in his *Trojan Women*. The Euripidean orientation has become dominant in modern art and literature. Realistic narratives tend to portray what is without idealizing reality and without assessing what is portrayed, as we see in Zola. A paradigmatic example of beauty dwelling in ugliness is Büchner's fragmentary novella *Lenz*, which not only portrays, through early use of focalization and figural narration, the troubled mind of a writer who has lost all meaning and orientation, but also on behalf of the hero programmatically elevates realism and with it the potential for ugliness: "In all, I demand—life, the possibility of existence, and then all is well; we must not ask whether it is beautiful or ugly, the feeling that the work of art has life stands above these two qualities and is the sole criterion of art. . . . One must love humanity in order to penetrate into the unique essence of each individual, no one can be too low or too ugly, only then can one understand them" (Ger. 1:234–35; Eng. 146–47).

Both realism and distortion can enhance ugliness. In its fascination with ugliness, a macabre and well-told horror tale such as Edgar Allan Poe's *The Fall of the House of Usher* (1839) exemplifies the structure of beauty dwelling in ugliness. In works that hover between realism and expressionism we sometimes see suffering, even the causes of suffering, but no moral stance is taken on the cause, no blame cast. Kafka always portrays crises and sometimes identifies causes of suffering, for example, in *The Bucket Rider*, but still more often we see simply frustration without moral evaluation, as in *An Imperial Message*, where an important communication to be delivered to "you" will, despite all heroic efforts on the part of the messenger, never arrive. Uncertainty and hopelessness result. Suffering and decline may be portrayed without evaluation. In Josef von Sternberg's *The Blue Angel*, neither Lola Lola nor Professor Rath seems responsible for the hero's dismal fate; a collision of incompatible worlds leads to his demise.

As we move into the contemporary era, and as artists seek to portray the ugly while eschewing evaluation—an increasingly postmodern phenomenon—we see ever-more instances of beauty dwelling in ugliness. Many of Haneke's films fit this model. Already his first feature film, *The Seventh Continent* (1989), embodies beauty dwelling in ugliness. The disintegration of a family and eventual suicide confront us, but because of the almost mechanical existence of the figures (the camera tends to focus on their bodies, anticipating their dehumanization) and the infrequent and innocuous dialogue, we cannot fully grasp their motivation. Haneke remains reticent. We are presented with a puzzle and are invited not to evaluate the characters, but instead to try to grasp their movement from their joyless and empty daily existence to horrific self-annihilation. The film is sober, almost clinical, removed from empathy and critique. Nothing transcends the negativity. Consider also Haneke's *The Piano Teacher* (2001), a disturbing and in some ways revolting film, a cinematic drama of suffering with a lead character who is deranged and malicious but also repressed, lonely, and suffering. The film asks us to dwell in this unsettling, even grotesque world of pain and disturbance without giving us internal signals toward evaluation. Far from anything remotely redemptive, it is at the opposite end of the spectrum.

Not only moral but also physical ugliness arises in film. British artist Sam Taylor-Johnson's (née Taylor-Wood) short film *Still Life*

(2001) focuses on physical ugliness. Drawing on the *vanitas* tradition, with its depiction of flowers past full bloom and fruit starting to turn, her film shows apples, peaches, and pears that decay in minutes, turning dark, with mold and bacteria consuming the fruit, which rots and collapses in on itself. Similar in style, though more dramatic and violent, is *A Little Death* (2002). In minutes the film shows the decomposition of a hare on a table, its leg propped against a wall. The hare loses its form, turns dark, and completely dissolves, as insects devour the body. The film is about death and decay, but also life (the hare is typically symbolic of life and reproduction). The passage from life is visible along with the idea of death as part of life. Beauty and ugliness combine in both sequences, which are as diverse as they are similar. Whereas the living fruit quietly and almost gracefully if repulsively decays, the already dead hare seems almost to come to life in the energetic dynamism of its decomposition. Lessing's insight that the temporal arts have advantages over the spatial arts in softening the effect of ugliness is here reversed; via technology, an accelerated temporality enhances and magnifies ugliness.

The Carnivalesque

The common link between ugliness and comedy is not unique to Western culture. In Ghana, ugliness is integrated as a counterpoint to more serious drama: "Ghanian concert events begin with music and dancing followed by an interlude of broad and robustly farcical comedy full of male chauvinist derisive attacks on women, pornographic gestures and scenes of mimed copulation" (Gilbert 347). Although this vulgarity would be repugnant and offensive in any nonperformative setting, here it "evokes boisterous laughter from the audience. These midnight cathartic thrills form another 'gateway': they are structurally oppositional to the morality play that follows and continues until dawn, the goal of which is for the audience to be uplifted emotionally and instructed in proper behavior and social responsibility" (347). Beyond the link between ugliness and comedy is the idea that ugliness can be portrayed without evaluation. We can dwell in it as a comic countermoment to serious, moral drama.

In the Western tradition, this kind of joyous and affirmative embrace of what might otherwise seem repugnant is visible in what

Structures of Beautiful Ugliness

Mikhail Bakhtin calls "grotesque realism," which he explores in the medieval and Renaissance carnival spirit in general and in François Rabelais in particular. The grotesque as it has developed in modernity tends to be a negative category. Bakhtin, however, views the concept differently. The emphasis on the body, in particular the exaggerated body, on flesh, on bodily parts, particularly the lower stratum, which we find in the grotesque, becomes for Bakhtin a site of laughter and hilarity, fearlessness and gaiety. The degradation of the intellectual to the material world is embraced. Bakhtin celebrates the joy of the clown and jester against cold rationalism and utilitarianism, against serious and self-important authoritarianism. He lauds an inverted world in which what usually has standing is knocked down and what normally appears base is affirmed. Freedom from restraint, prohibition, and stilted ceremony make possible a reveling in the body and the material world—even if that freedom is only temporary.

Being on the receiving end of slung excrement or being drenched in urine is in the carnivalesque spirit, but such debasing gestures, which lead us to the lower stratum of the body, are ambivalent, as this debased area is also "the area of the genital organs, the fertilizing and generating stratum" (Bakhtin 148). Bakhtin continues: "Therefore, in the images of urine and excrement is preserved the essential link with birth, fertility, renewal, welfare" (148). Carnivalesque revelry is able to withstand ugliness because its spirit is oriented toward the whole, toward death and birth, destruction and regeneration. It does not isolate poles within the realm of becoming, does not insist on propriety. Indeed, in the bowels and the phallus, even the boundaries between body and world or between body and body are overcome (317). One can linger in excrement and urine, in profanities and curses because they degrade even the most exalted, and so contribute to the inverted world of the carnivalesque, to a whole beyond distinction.

Bakhtin focuses on turning an ossified Christian hierarchy upside down. Paradoxically, the very idea that what has traditionally been degraded is now celebrated, that we need a disorientation from, and a reorientation away from, the status quo, from the traditional hierarchy of society is, formally, not radically different from the revolution of Christianity itself. This is one reason why Bulgakov turns to the carnivalesque in his Christian novel *The Master and Margarita* (1928–40), which interweaves the medieval mystery play with the carnivalesque. As a result, we see an unusual combination of grotesque

realism and spiritual victory (Milne). Immersed in negativity, the work, like Goethe's *Faust*, nonetheless pushes toward a transcendence of tragedy, which it finds in its embrace of striving and its evocation of love (Barratt 289–97). Even as the novel outstrips beauty dwelling in ugliness, its integration of the grotesque and the carnivalesque ensures that the work does not move beyond ugliness too quickly.

In his analysis of the carnivalesque, Bakhtin does not cite Nietzsche, but to see in the carnivalesque overcoming of boundaries a process akin to the Dionysian dissolution of Apollonian distinctions would not be unwarranted. Although the early Nietzsche opens a window onto ugliness via a tragic, as opposed to comic, mode, his philosophy of tragedy is as intoxicating as Bakhtin's concept of the carnivalesque. The ugly in the form of the vulgar and obscene also surfaces in the ancient Greek satyr play, which was performed after a series of three tragedies. The satyr play is not to be negated or organically overcome; instead, it is present as its own end.

The theoretician of ugliness we might associate most fully with beauty dwelling in ugliness is paradoxically Adorno. I say "paradoxically" because this is the one form that does not negate ugliness, and Adorno insists on negation, but since he does not introduce the self-reflexive structure of a negation of negation, Adorno is bound to repeat negativity. Adorno does not want us to shy away from ugliness, and he does not want us to pretend that we can overcome it. The ugly for him is a condition of our world that we cannot conquer. In elevating the moral dimensions of ugliness, Adorno challenges us with his suggestion that Auschwitz reveals an evil inherent in human nature that exceeds our capacity for goodness. Adorno wants us to dwell in nonreconciliation because anything else would be a violation of truth: "All post-Auschwitz culture, including its urgent critique, is garbage" (Alle Kultur nach Auschwitz, samt der dringlichen Kritik, ist Müll) (*Negative Dialektik* 359; Eng. 367). Adorno recognizes—to use Hegel's terms—neither the dialectical (the negation of a negation) nor the speculative (the presence of ugliness and its eventual overcoming). Adorno is right that if the ugly is not addressed, art is impoverished. But art is likewise arbitrarily restricted if all we see is the ugly, if beauty dwelling in ugliness becomes not one form of art among others but all of art, then art as a whole is impoverished. Still, without beauty dwell-

Structures of Beautiful Ugliness

ing in ugliness, we might fall too quickly into a nonhumble tendency to see ourselves as somehow beyond our fallenness in ugliness. Lessing and the Hegelians would presumably resist the structure. Lessing posited the importance of time and thus action (as opposed to the moment in space that characterizes the plastic arts) as a meaningful way of integrating and softening ugliness. For Lessing, the ugly cannot be an end in itself; it must be presented as part of a larger aesthetic whole. The Hegelians followed this pattern. If one wants, however, not to overcome, but instead to linger in, ugliness, Lessing's insight can be reversed: sculpture and painting, which capture only a moment in time, very much lend themselves to lingering in ugliness.

In terms of overlap, beauty dwelling in ugliness can involve any of the three styles—repugnant, fractured, or aischric beauty. Beauty dwelling in ugliness can readily overlap with repugnant beauty, for example, when artists want simply to linger on what they are able to capture in beautiful form, often enjoying the tension between abhorrent content and artistic majesty. Drawings and paintings we have already introduced that unite repugnant beauty and beauty dwelling in ugliness include, for example, Dürer's *Melencolia I*, Titian's *The Flaying of Marsyas*, David's *Death of Marat*, and Eakins's *The Gross Clinic*.

We have already discussed one of Albright's paintings. As another example of overlap between repugnant beauty and beauty dwelling in ugliness, consider *Into the World There Came a Soul Called Ida* (1929–30), which links aging with vanity (illustration 55). The dark void in the painting suggests approaching death, as do the burnt match and the decaying carpet; the allusion to entering the world implies also its exit; Ida's body, with its sagging, puckered flesh and varicose veins, shows clear signs of aging; and the angle of the painting almost draws us downward, as if falling to the right, again a mark of decay. The mirror, which may reflect Ida or the nothingness behind her, and the dresser, with its comb and cosmetic case, give evidence of vanity, and the slight and tawdry clothing suggests a desire to continue to appear young. Fascinating is the way a static image integrates the concept of time. Despite the desire to hold back her aging, Ida's pallid and ashen face resembles a corpse, as if she were already in the early stages of decomposition. Still, the inclusion of the word "soul" in the title makes clear that Albright renders her and her longing with empathy. In that sense the work echoes, or at least parallels, Baudelaire's "Little Old Women" (Les Petites Vieilles) (*Flowers* 180–87). Here, though

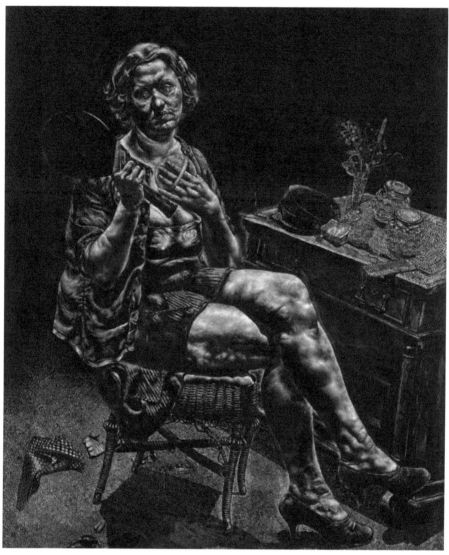

the old women are described as "disjointed monsters," "marionettes," "wounded animals," and "clothed in tattered petticoats and flimsy dresses," they still have souls. The poet, enraptured by them, looks at them tenderly, but they have lost their charm and glory, their days vanishing: "Monsters, hunch-backed, broken / Or distorted, let us love them! they still have souls."

One could name many more works, as repugnant beauty is by itself a frequent form, and the overlap of beauty dwelling in ugliness and repugnant beauty occurs across arts and ages, from the sculptures of Messerschmidt to the poetry of Benn. Each example beautifully captures an aspect of ugliness and invites us to linger in it. There are thematic limits, however. Artworks that address moral topics, such as war, are less likely to fit: neither Goya's nor Dix's renderings of war fit beauty dwelling in ugliness. In Vladimir Nabokov's *Lolita*, a work of repugnant beauty, moral criticism is subtle enough and emerges slowly enough that the novel seems to linger in beauty dwelling in ugliness but is not exhausted by this structure.

The overlap between repugnant beauty and beauty dwelling in ugliness transcends cultures. Bengali writer Manik Bandyopadhyay's *Prehistoric* (1937) tells a tale of beggars, one of whom is a killer. The male beggar neglects to treat the woman's leg wound because the open wound triggers alms. The story is beautifully told and not without empathy. In terms of content, it lingers in wretched suffering, disgusting images, petty squabbles, and horrific acts; it offers no signals as to how readers should evaluate the characters.

When fractured beauty is presented as an end in itself, it overlaps with beauty dwelling in ugliness. Think of Picasso's less political creations and works on the cusp of abstraction. Postmodern architecture, which belongs to fractured beauty and which revels in disunity, rarely offers critique. We have grown so accustomed to fractured artworks that when an artist creates fractured forms but gives them beautiful colors, we may at first be unsure whether ugliness is even an apt descriptor. Virtually all the works of American Elizabeth Murray involve fractured shapes, but the bright colors, especially evident in her later years, seem at tension with the fractious forms. The works are at times humorous. Certainly no critique is involved. We see a kind of formal ugliness, shattered and fractured shapes, that are nonetheless appealing. They belong to beauty dwelling in ugliness. Murray paints her constructions, for example, *The Sun and the Moon* (2005), such that the canvas is stretched on wooden supports that are connected like sculptures. These fractured and often colorful canvases are unusual in bridging modernism's formalist concerns with pop art's playfulness. Her works also have occasionally darker, angst-ridden, if not Sisyphean dimensions, such as *Careless Love* (1995–96), an oil on canvas over shaped wooden support, which is housed at the National Gallery of Art

in Washington, DC. Because careless love implies critique, it moves us beyond beauty dwelling in ugliness.

The least common style to overlap with beauty dwelling in ugliness is aischric beauty, for the combination of ugly content and fractured form usually implies critique, as we see with Dix and Grosz. Still, it is possible. When Van Gogh allows disturbing content to emerge in a style that is beautifully matched by his rough brushwork, he evokes radical emotions but without evaluation. His late *Wheatfield with Crows* (1890) seeks to uncover or understand unease rather than evaluate or criticize it. Also, a work such as Meidei's *Self and the City*, which evokes via formal disarray some of the vibrancy and confusion of the city, seems not primarily evaluative; instead it seeks to depict what exists beneath the surface of everyday reality. For early examples we can reach back to Arcimboldo. In terms of a contemporary artist, Anselm Kiefer's works sometimes combine aischric beauty and beauty dwelling in ugliness. Two prominent catalysts for ugly art are the desire to know and the desire to play with form, neither of which is directly evaluative. Under repugnant beauty we considered the extent to which grotesque mythological figures can be rendered faithfully and beautifully. In aischric beauty such figures are portrayed via distorted form, as in Kiefer's striking portrayal of *The Women of Antiquity—The Erinyes* (1995–98), which presents three female figures whose heads have become loose threads of wire, almost a kind of barbed wire, which is not restricted to their faces but moves also along the bottom of the painting. The work distorts any sense of a normal face, capturing instead the hate, rage, and fury, the wild thirst for vengeance, of the ancient Erinyes. The dynamism that emanates from these lines is combined with a sense of imprisonment, both their own and that of those caught in their web. Here aischric beauty is united with beauty dwelling in ugliness.

Beauty dwelling in ugliness is the least complex of the three structures I introduce, for it lacks a moment of negation, but the form is arguably the most difficult to receive, for such works signal no distance from the often harsh and horrific ugliness with which we are confronted. Its range is also remarkable, from horrendous cries of despair, as in Psalm 88, to quiet contemplation on lack of intimacy, as in Smith's *Untitled*. And, as we have seen, there are many other motivations in between: a desire for knowledge, playfulness, experimentation, and

shock as well as empathy and metaphysical impulses. Only moral revolt that results in negation, as opposed to empathy, does not surface as a catalyst for this structure, as that is reserved for the next structure we explore, dialectical beauty. We sometimes think of art for art's sake as being only about pure beauty, pure aestheticism, but in beauty dwelling in ugliness we have an intriguing combination of art for art's sake and ugliness, a confrontation with the horrific for its own sake. Wilde's preface to *Dorian Gray* is a signature modernist statement of this position: art is not about morality, but instead about form and reception.

D I A L E C T I C A L
B E A U T Y

The next structure of beautiful ugliness likewise grants ugliness a prominent role, yet works of *dialectical beauty* contain an implicit critique. Ugliness dominates the work, but instead of presenting the ugly without evaluating it or even while reveling in it, works of dialectical beauty point toward the ugliness of the ugly, or the negation of negativity. Immersing themselves in the ugly, dissonant, and negative, such works make evident by the way they portray ugliness that the ugly is abhorrent. Such works signal that ugliness should be overcome, but they do not spell out alternatives; they show the ugliness of the ugly without going beyond this double negation.

The Hegelian Structure and the Satiric Tradition

The Hegelians consistently stressed that the ugly cannot take over an artwork but must be simply a moment. They would have resisted anything resembling beauty dwelling in ugliness. For them the artwork should signal in some way that ugliness is a part and not the whole. For Rosenkranz, caricature was a privileged mode of revealing the ugliness of the ugly. More broadly, the Hegelians recognized the value of

the comic, with its implicit, at times even direct, negation of negativity and particularity.

One genre within a broad concept of the comic that leaves no doubt about the negation of ugliness is satire. Heinrich Mann's satiric novel *Der Untertan*, which has been translated as *The Subject* and as *Man of Straw*, exemplifies dialectical beauty. Not by chance the protagonist, a morally corrupt and selfish coward, who nonetheless finds a privileged place in society's hierarchy of power, has the name Diederich Heßling, which plays on *hässlich*, that is, the underlying ugliness of his character. The novel satirizes Diederich: we see an array of contradictions involving intellectual and moral ugliness, as when Diederich refuses to marry the woman he seduced since she is no longer pure. Expressing different political views depending on his audience, Diederich combines hypocrisy and cowardice. He lies constantly and even deceives himself: he condemns the empire of Napoleon III with a description that matches what the novel portrays of Wilhelminian Germany and of Diederich himself, including a preoccupation with materialism, theatricality, and power. Most of Diederich's contradictions have a comic effect, such as his dream to become the head of a great postcard or toilet paper factory: "The products of your life's work were in the hands of thousands" (Ger. 24; Eng. 23). In this literary universe, no attractive alternatives exist. The otherwise admirable Old Buck is a figure of the past, who consistently misreads and underestimates Diederich; the novel ends with Old Buck's death, leaving readers with only a negation of what is.

As a negation of a negation, satire often has a complex relationship to its object, yet it need not be only hateful. Heine frequently alludes to his tortured love of Germany, most famously in his preface to *Germany: A Winter's Tale* (*Sämtliche Schriften* 4:574) and his poem "Night Thoughts" (4:432–33). There is a dialectic at play not only in the negation of a negation but also in the combination of hatred and love, alienation toward the present and longing for more that motivates the desire to see a closer approximation to the ideal. To criticize an object is often to recognize that it is not yet what it should be, which for Plato was perfectly compatible with love. Fascinating are the analogous reflections on love and hate as elements of satire in Heine and Tucholsky, who, along with Brecht and Heinrich Mann, are Germany's greatest satirists. Tucholsky likewise stresses his tortured love of Germany, writing in the final essay of *Deutschland, Deutschland über*

alles (*Germany, Germany Above All Else*): "We have the right to hate Germany—because we love it" (Ger. 231; Eng. 226, translation modified). In an age when the idealist synthesis proved inadequate to the complexity of reality, the age that also sparked the early Hegelians, it is not the least surprising that with their political acumen figures such as Büchner and Heine would be drawn toward the ugly and the deficient, what in their eyes had been inappropriately overlooked. Deficiency and ugliness are their focus. In that spirit, they are the models for Germany's later satiric tradition, not only writers such as Tucholsky and Brecht but also visual artists, such as Dix and Grosz, who were deeply enmeshed in visual satire and ugliness.

Satire in Schiller's sense—recognizing a gap between the real and the ideal and emphasizing reality's deficiencies—is visible, then, not only in literature, as we saw with Juvenal, Heine, and Mann, but also in the visual arts. Goya presents cruel atrocities, such as torture, rape, and poverty, not to celebrate dissonance but to paint the problems as problems. He reverses the more traditional focus on successful warriors or self-sacrificing martyrs and portrays instead the oppressed. His *Disasters of War* (1810–20), including plate 39, deviates from the traditional assumption that in war only heroism should be portrayed (illustration 56). The muscular nude figures, appropriate subjects for academic figure drawing, are out of place in this horrific, dehumanizing scene. Goya accentuates the contradiction. The world is not as it should be and not as we normally see it. As such, his works are brutal and satiric. Goya proceeds similarly with his portraits. He avoids the idealizing tendencies advocated by Leon Battista Alberti, who in the first treatise on the theory and practice of painting recommended a practice implicit already in Aristotle (*Poetics* 1454b), whereby if the subject of a painting has a physical defect, the painter should slightly modify or embellish the trait so as to improve on reality while still preserving the likeness, portraying thereby what is "most beautiful and worthy" (Alberti, *On Painting* 56; cf. 18, 25, 40).[1] Instead, Goya unveils his subjects' vanity and superficiality, their arrogance and stupidity, as in his *Group on a Balcony* (ca. 1810–15) and *King Ferdinand VII of Spain* (1814). Realism and truth draw him to ugliness.

A century later, Dix likewise depicts the inhumanity and ugliness of war. His cycle of prints titled *War* (1924) follows in the tradition of Goya. Dix's friend Grosz also works in the tradition of Goya, having repeatedly cited Goya as a model (Flavell 130–31). Grosz paints Ger-

Structures of Beautiful Ugliness

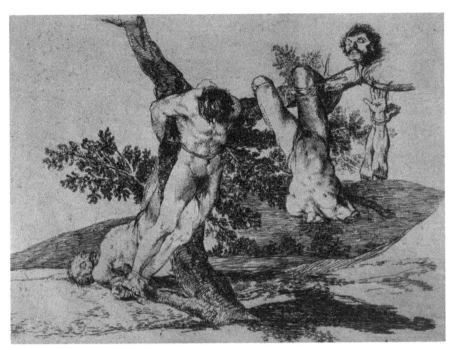

ILLUSTRATION 56
Francisco Goya, *Disasters of War*, 1810–20, Plate 39, Etching, Courtesy Metropolitan Museum of Art.

many's corruption and abuse of power and does so in ugly ways. His moral outrage is evident, and his portrayals are invariably designed to uncover the ugliness of the ugly. Though we see a negation of negativity, optimism for the future is not visible. A telling anecdote captures Grosz's pessimistic realism. Over a lunch that took place in New York City in summer 1934, Thomas Mann predicted that Hitler would not last much longer. Grosz, who was nearly twenty years younger but whose worldview was darker, countered that Hitler had too much support and was in fact the person that the stupid Germans who had voted for him deserved. Hitler would last years, perhaps six to ten (Flavell 117–20). Mann and especially his wife, Katja, were taken aback and unnerved by Grosz's declaration, but Grosz was right. He hated moral ugliness partly because he recognized its power. His modus operandi was to attack ugliness, but with little hope of a promising resolution.

A striking example of Grosz's negation of negativity is *Pillars of Society* (1926) (illustration 57). A scarred and brainless Nazi with a beer mug, sword, pince-nez, dueling scar, and mandarin collar stands

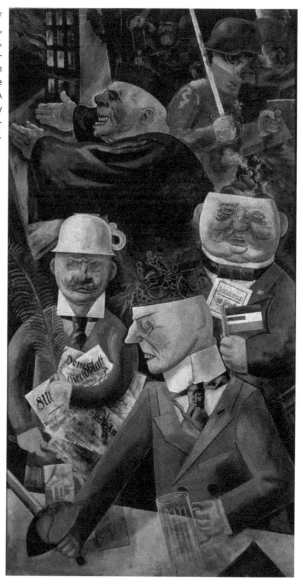

at the front. His brain reveals his thoughts: a soldier on horseback, a remnant of the past, is mowing down the German constitution and the rule of law. Nazism will destroy it with brutal force. Behind him is a man holding a small red, white, and black flag, the colors of German nationalism. His head is filled with a steaming pile of excrement. The figure with the walrus mustache and palm leaf, symbolizing piety or peace, has on his head an upside-down chamber pot. The hard edges

in each figure's headgear underscore that no ambiguity exists in these men's worldview. In the back, one sees a rather unappealing priest grinning and blessing all. The soldier has a bloodstained sword. Also in the back, other soldiers move in the opposite direction, signifying the conflict of the right and the left. The inferno gives the work a metaphysical frame.

We may recognize Grosz as the paradigmatic artist of dialectical beauty. His *5:00 A.M.* (1921) presents a contrast, the early hour for workers and the late hour for the fat and ugly, who vomit, grope, and revel. That the workers are on the top indirectly reveals their moral superiority. Grosz's *Eclipse of the Sun* (1926) is another mocking image. Four headless but wealthy bankers are working with President Hindenburg, dominant and dressed in his military uniform. In front of him on the table are a bloody sword and a black, white, and red crucifix, which underscores the Protestant church's nationalist tendencies. The industrialist whispering in Hindenberg's ear symbolizes the armaments industry. The donkey on the table has blinkers, with the imperial eagle on them. Turned the other way and blind to what is taking place, it seems to represent the German people. The image, which is out of perspective, is set such that the donkey will surely fall into the pit. Below we see a skull and a caged person; death and imprisonment await the Germans. The sun is shielded by a dollar sign, a symbol of reparations payments under the new Dawes Plan. The economy was stabilized by the renegotiations, but the reparations remained overwhelming. The background depicts a city in flames.

Before World War I, Grosz had intended to write a three-volume work titled *The Ugliness of the Germans* (*Die Häßlichkeit der Deutschen*) (Grosz and Herzfelde 18). In Grosz's trial for *Ecco Homo*, the judge stated that even the artist should abide by society's moral norms. Grosz responded that his ugly works were moral: "In my view precisely by portraying the ugliest things in my work, which, one could assume, alienate a number of people, an important educational service is achieved. For if I portray an old man with the ugliness of age and the ugliness of a body that has not been kept well, I induce people to look after their bodies, to exercise them from their early youth, for example, through sports and other activities. These are all clearly moral leanings even when it means portraying the grossest and ugliest things" ("Unterhaltungen zwischen Ohnesorge und George Grosz" 248). Grosz underscored that his portrayals of ugliness serve a moral purpose:

they unveil what is as something that should not be. Grosz saw Hogarth, Goya, and Daumier as models and wrote: "I drew and painted as a form of dissent and tried in my works to portray the world in all its ugliness, sickness, and hypocrisy" (Grosz and Herzfelde 21). In the eyes of the satirist Tucholsky, Grosz does not simply laugh at the world; he hates it: "And I don't know anyone who has captured the modern face of the powerful down to the last red wine veins the way this man has. His secret: he doesn't just laugh—he hates" (Tucholsky, "Fratzen von Grosz," *Gesammelte Werke* 3:42). One hates what one finds ugly because it is not as it should be.

Earlier we discussed one of Heartfield's anti-Nazi photomontages. Heartfield, a friend and collaborator of Grosz, created works that likewise exemplify dialectical beauty. A number of Heartfield's images play on the visual similarities (and radically different meanings) of the cross and the swastika. In *For the Establishment of the State Church . . . the Cross Wasn't Heavy Enough* (1933), an SA man screws extra wood onto the four ends of Christ's cross to transform it into a swastika. The work alludes to pro-Nazi clerics being installed at various levels in Germany's Protestant church. In *The Reichsbishop Drills Christendom . . . "Hey, the man there, the Crucifix a bit further to the right"* (1934), Heartfield shows the nationalist Protestant clergy lining up not with rifles on their shoulders but instead crucifixes converted into swastikas. In *The Old Motto of the New Reich: Blood and Iron* (1934), the ends of the cross become ax blades dripping with blood. *Normalization* (1936) likewise plays on the movement from cross to swastika: it anticipates changes in German–Austrian relations, including the Nazi transformation of Austria, part of the normal course of events. Brutal is one of the six images from Heartfield's *Program of the Olympic Games Berlin 1936* (1935), namely, *Javelin Throwing* (*Speerwerfen*, whereby *Speer* means not only "javelin" but also "lance"), in which an SA man hurls a lance directly at Christ on the cross.[2]

In other images, such as *The Real Meaning of the Hitler Salute: Millions Stand Behind Me!* (1932), we see unambiguous critique. Hitler's salute is met with dollars coming into his hand from a figure who represents big business; Hitler is backed not by millions of people but by millions of dollars. Heartfield depicts violence and destruction in *Goering, the Hangman of the Third Reich* (1933) and in his various photomontages of war corpses, which were created in advance of World War II. Heartfield's works have justly been described as ugly, but they

are nonetheless also spoken of as beautiful, for the concept of beauty captures aesthetic excellence: art as it should be, that is, aesthetically excellent art independently of whether it is pleasing. In response to a 1935 exhibition in France, the surrealist Louis Aragon wrote an essay for the *Commune* entitled "John Heartfield and Revolutionary Beauty." Aragon praises Heartfield with the recurring refrain: "John Heartfield *today knows how to salute beauty*" (John Heartfield *sait aujourd'hui saluer la beauté*) (Herzfelde 312–13; Aragon 65). Aragon elaborates: "He knows how to create those images which are the very beauty of our age, for they represent the cry of the masses. . . . John Heartfield *today knows how to salute beauty*. Because he speaks for the countless oppressed people throughout the world without lowering for a moment the magnificent tone of his voice, without debasing the majestic poetry of his tremendous imagination. *Without diminishing the quality of his work*" (Herzfelde 312–13; Aragon 65). Heartfield's "revolutionary beauty" winds together fracturedness and repulsion with an implicit telos: his photomontage is "a way of disassembling and reassembling the world order" (Kriebel 7).

A contemporary assemblage sculptor and installation artist who was a harsh critic of our modern world is Edward Keinholz. In *State Hospital* (1966), one of his most aversive works, two emaciated inmates lie on bunk beds in a minimalist cell, each tethered to their beds, a bed pan in the foreground. The image, which we see through a barred window, suggests that they are treated not as human beings but as objects or things, for not only are they locked in a cell, but each has instead of a face a kind of fish-bowl mask, and their bodies look partly human, partly extraterrestrial. By way of a neon caption, the figure on the bottom bunk dreams of an existence on the top bunk, basically the same sorry fate. The figures, degraded and trapped, have no meaningful prospects. The work fosters awareness of the alienation that takes place at such facilities, which the artist had experienced firsthand as an orderly. We turn away but do not forget the concept. Perhaps it is not surprising, given diverse cultures' receptivity to ugliness and, by extension, satire, that Keinholz had a stronger reception in Germany than in the United States (Hughes, *American Visions* 608).

A contemporary artist working within the concept of dialectical beauty—and very much engaged in the tradition of Bosch, Goya, Daumier, and the German Expressionists, but with his own unique stamp—is Maxim Kantor. The connection to the art-historical tradition

is evident, for example, if one thinks of the ways in which Kantor combines, like Bosch, the animal and the human, or if one compares Kantor's many versions of *Lonely Crowd* with Goya's *Pilgrimage to St. Isidor's Hermitage*. Not surprisingly, in 2018 and 2019 the Paintings Gallery of the Academy of Fine Arts Vienna devoted a special exhibit to Kantor and one of his predecessors, *Correspondences: Bosch and Kantor*. Kantor portrays the wretchedness and distortions of Russian and Western life in a style that exhibits formal inventiveness and elicits distance from what is portrayed, as in his *Wasteland* and *Metropolis* prints.

Kantor's *Dragon* (2016) effectively interweaves aesthetic quality and political aggression. The dragon figure, which alludes to Putin, is marked by death: the head is almost a skull, the spiritless eyes resemble sockets, the fingers are skeleton-like, and the skin color evokes putrefaction (as well as camouflage, which hints at both deception and war). The allusions to death imply that the figure should already be gone from our landscape. Since he is all too present, the death motif evokes the victims of his domestic totalitarianism and invasion of eastern Ukraine. What seems most alive are the large ears, an allusion to Putin's KGB past and the surveillance state. The crown evokes his complete power, but, accentuated by the small size, it is also mocking, undeserved. The painting, like the character, is at once fearsome and grotesque. The pigs at the bottom allude both to Putin's allies, who are animals, and to his victims, who are treated like animals. Across time, the two groups are not mutually exclusive. The colors, green and pink, are putrid. Kantor shows how an artist can effectively move along the border of the horrific and the comic in order to paint a compelling negation of negativity.

Kantor's works overall exhibit the ugliness of various vices, including corruption and injustice, and also their consequences, such as suffering and disenchantment. The Russian painter exposes not only terrorism but also the excesses of the war against terror. In this way his works indirectly affirm values. In Kantor, and in many other satiric artists, we see the overlap of aischric and dialectical beauty. Such combinations, which are possible insofar as the two modes cover different aspects of works, can be fascinating. Kantor stands with those figures who see a connection between ugly art and moral revolt.

Film satire belongs here too, for example, Sérgio Bianchi's disturbing fictionalized documentary *Chronically Unfeasible* (2000). The film denounces the immorality of contemporary Brazil. Bianchi por-

trays an ugly society, destitute and decadent, indifferent toward, or hostile to, those who are poor or racially outcast. In a metaphysical story that seems almost Heine-esque, one of the figures suggests that God ignores Brazil, with the exception of sleeping there and shitting there. The film's haphazard episodic form, with its abrupt cuts, occasional retakes, and unsteady camera, provides a formal analogue to social chaos and contradictions. The film uses contrast, absurdity, and other mocking devices to create critical distance. Even the union organizers are inept, as they discover that they are protesting at the wrong farm, but since it is convenient, they nonetheless stay. In some ways the film is styled on Juvenal's ninth satire. Much of the film takes place partly in a luxury restaurant, where the cynical and cowardly owner fires the male waiter with whom he has had sex. The two manage to humiliate one another. No less central is the contrasting image of the garbage cans that stand outside the luxury restaurant, which attract the starving poor and the fired waiter, who expresses there his wrath. Those in power, including those who directly cause deaths, lament that they are falsely blamed for the country's problems. A rich woman who wants to feel charitable bestows toys and clothing on two children and then smiles contentedly as she watches them get beaten up by the other street kids who fight over the presents. The film's narrator and moral commentator offers no viable orientation; his cynical voice becomes almost unbearable, and we can't help but distance ourselves from him. The film opens with an image of a torch burning a hornet's nest, suggesting that the film brings light even as it destroys what it touches.

Unexpected Juxtapositions

Another contemporary whose works fit dialectical beauty is African American installation artist Kara Walker, who works less with formal distortion and more with repulsive content to garner a negation of negativity, but elements of caricature remain: she identifies figures via racial stereotypes and occasionally exaggerates, as when a huge erection allows a boy to fly. Further, she creates distance by inverting a traditional art form: she transforms the genteel commemorative silhouette into a medium that exhibits racism, pornography, and the brutality of master–slave relations. This formal inversion is enhanced by two others: whereas panoramas have traditionally reinforced regional or

nationalist ideologies, she undermines that thrust; moreover, whereas panoramas have enveloped audiences with comforting narratives, she elicits discomfort, indeed a kind of surrounding negativity. Arguably Walker's most famous works, for example, *Gone: An Historical Romance of a Civil War as It Occurred between the Dusky Thighs of One Young Negress and Her Heart* (1994), are life-size wall silhouettes, black on white, of brutal scenes from the time of slavery. *The End of Uncle Tom and the Grand Allegorical Tableau of Eva in Heaven* (1995) continues the theme, but here the images are displayed in a circular space, which alludes to the nineteenth-century cyclorama, which adds to the brutal visual experience a sense of entrapment.

At first blush, the form, the clothing (such as hoop skirts and frock coats), and the settings evoke an idyllic era, but one quickly recognizes the brutality. The ironic signals begin with the form. Silhouettes commemorated family members. They were delicate, calm, and nostalgic, poetic and romantic. With her moon images Walker hints at this tradition but changes the context. The silhouettes are unsettling, indeed often brutal and horrific. The works include nonidealistic images of defecation and exaggerated but also semirealistic images of degradation and bodily violence from swords and axes. Rape and sodomy are present, as are allusions to lynching. In addition to white slaveowners objectifying Black bodies, we see parodies of the white person's view of Blacks as molesters and monkeys (as when a Black woman who is giving fellatio is depicted with a tail that is also in a sense an extension of the white male's penis). The images are graphic, and we experience at both a visceral and intellectual level the bodily transgressions and violations of taboos. The plainness of the form matches the simplicity of stereotypes, so the form is both surprising (the sentimental has become perverse) and fitting (the stereotypes surface in earlier silhouettes and in Walker's extensions and inversions of the form). Walker states: "The silhouette says a lot with very little information, but that's also what the stereotype does. So I saw the silhouette and the stereotype as linked" (Walker 1). Seemingly Black figures have thick lips and wide noses, white characters chiseled faces, yet with silhouettes, we sometimes don't have enough information to determine body parts, or even gender or race. This gives the works ambiguity, triggering uncertainty, rendering unsettled reactions likely, and underscoring the importance of interpretation. Several African American artists, including Betye Saar and Howardena Pindell, criticized Walker

for reinforcing and perpetuating derogatory and racist stereotypes, which shamelessly reinforce white bigotry (*Kara Walker-No, Kara Walker-Yes, Kara Walker-?*). In the meantime, a broader public has been unsettled by Walker's perceived pornography (Carter). Here, as elsewhere, the dialectical artist must walk a fine line between being seemingly immoral and being so directly moral as to reduce art to propaganda. Ambiguous works will sometimes be accused of being insufficiently moral, and less ambiguous works can fall into propaganda.

For another contemporary example, consider Wiley's *Prince Tomasso Francesco of Savoy-Carignano* (2006). The work is beautifully painted and captures an aristocratic pose from an earlier century. It modifies in fact Anthony van Dyck's seventeenth-century work of the same name. What makes Wiley's work seemingly ugly is the odd juxtaposition: such old master works, with a confident rider atop a horse, were designed to honor white male aristocratic privilege. Here we see an African American, not a white, wearing not a period costume, but baggy jeans and sneakers. It is jarring and not fitting, but that is the point. What Horace warned against, a mixing of realms, is here consciously embraced. The overly decorative style of the background underscores the artificiality of what we traditionally see and otherwise take for granted. The work is alienating in a Brechtian sense. We are invited to reflect on the constructed ways in which power and identity were forged in earlier eras and the extent to which such poses and structures still have command over us today.

Much as the Berlin Dadaist Kurt Schwitters used garbage to create artistic collages shortly after World War I, so have many contemporaries followed this tradition, often with a political purpose. Swiss artist Thomas Hirschhorn's huge installation *Too Too-Much Much* (2010) criticizes modern consumption and contemporary waste as well as the modern elevation of quantity. It consists of an overwhelmingly large number of empty beverage cans, millions of them, in fact, and includes also old furniture, computer parts, store mannequins, and porn magazines. The exhibit is so large that it overfills its own space and becomes for the viewer a surreal experience. In order to view the exhibit, recipients must participate in it, that is, walk into the space, including its various rooms. Sculpture becomes thereby performance. In unprecedented ways visitors are confronted with the overproduction of non-biodegradable waste. A political artist, Hirschhorn states in an interview with Alison Gingeras that quality is not his goal: "Quality, no!

Energy, yes!" (Gingeras and Hirschhorn 15). The dominant impression is of too much consumption and too much waste, but the title alludes to the overwhelming array of diverse problems in our age as well as, self-reflectively, the artist's desire to pack too much into a work.

Another contemporary who works with trash as a form of critique is Romuald Hazoumè, a sculptor from the Republic of Benin, who uses only recycled materials, trash, if you will, in order to create masks and sculptures. He has fashioned a series of masks out of trash, basically taking refuse from Europe, such as plastic milk jugs, gasoline canisters, wires, paint brushes, scraps of metal, doll parts, old shoes, and broken headphones, working with it artistically, and then selling it back. Many of his highly imaginative masks are intentionally ridiculous. Some are harsher. His *Liberté* (2009) parodies the Statue of Liberty (illustration 58). It includes a deformed or abstract face made out of a jug, which is both bright and dirty. The crown alludes as much to Christ as to Lady Liberty. The greenish color evokes not only the weathered copper of Lady Liberty but also early images of the crucified Christ. Having been raised in a Catholic family, Hazoumè is deeply familiar with this tradition. Africans are victims insofar as the old beautiful African masks are now housed "in the British museum or shops in Paris or London" (Aaron Rosen 128), and today's Africans are left creating new masks out of European refuse: "I send back to the West that which belongs to them, that is to say, the refuse of consumer society that invades us every day" (Pigozzi).

Dialectical beauty is evident not only in satire but also in tragedy and comedy. For Hegel, tragedy portrays two substantive positions, each of which is justified, yet each of which is wrong to the extent that it fails either to recognize the validity of the other position or to grant it its moment of truth, such that the conflict can be resolved only with the fall of the hero. This negation of negativity, realized through the work's action, fits dialectical beauty. Comedy, too, plays with incongruities and juxtapositions in such a way that it fits dialectical beauty. Already with Aristophanes we see a critique of untenable positions, as in the *Clouds*. Some forms of comedy are jubilant and harmonic, but others undermine negativity. Elsewhere I have described such comedies, which range from works with well-intentioned but weak-willed characters to works with formally clever but evil persons (Roche, *Tragedy and Comedy* 150–75). Molière's *Tartuffe* encompasses both categories. We see comic protagonists who pursue false and aberrant,

often grandiose, goals in Jonson's *Volpone* (1606), Molière's *The Miser* (1668), Goldoni's *The Liar*, and Kleist's *The Broken Jug* (1808). In all these comedies the morally ugly character ultimately fails. We recognize thereby the negation of negativity. As is the case with satire, we can understand the comic as more than just a literary genre. Andreas Paul Weber's lithograph *The Rumor* (1943) portrays rumor, and in its

exaggeration, mocks it (illustration 59). Consider along with the snake-like shape (a symbol of evil and deception), the large ears, the long nose, and of course the inclusion of the crowded and ugly tenement. German writer Arno Schmidt called the work "the best allegory since Leonardo" (*Nobodaddy's Kinder* 210).

The Puzzle of Architecture and Music

The reader may have noticed that until now I have offered no examples of dialectical beauty from architecture or music. The omission is not accidental, for the two arts are distinguished more by form than by content. With content not primary, to show two levels of content in contrast to one another is even more complex and challenging. Some seemingly ugly architecture certainly embodies thematic elements, such as buildings that suggest dynamism or elevate dissonance, but it is difficult to find a building that offers a metalevel of meaning, such that what is portrayed is also criticized. The closest examples may be

Structures of Beautiful Ugliness

deconstructionist buildings, such as the Wexner Center for the Visual Arts, but there the critique is of traditional architecture. There is no metacritique, such that what is ugly is portrayed as ugly. On the contrary, such structures seem joyfully to embrace disarray and disharmony. They are examples of beauty dwelling in ugliness. Libeskind's Jewish Museum in Berlin, with its complex and distorted structure does offer an indirect critique of those who forced the Jews into such a harrowing, pain-ridden history. I return to this complex case in the conclusion to this book.

Purely instrumental music also has a difficult time offering a metacritique of ugliness. In fact, I am not aware of a purely instrumental work that both embodies and criticizes ugliness. Purely instrumental music functions beyond moral categories. Music, however, is often paired with words. Consider the dialectical beauty of Brecht and Weill's *The Threepenny Opera* (1928). The contradiction between words and music is brilliantly executed and signals a metacritique of the positions voiced. "The Ballad of Mackie Messer" (popularly rendered as "Mack the Knife") a catchy tune in C major about a criminal and murderer, mocks our everyday fascination with moral ugliness as long as it is dressed up nicely, as long as it is part of a world we otherwise admire. "The Cannon Song" is analogous, another appealing tune, influenced by ragtime, about slaughtering the enemy. Brecht wants to draw our attention to the absurdity of each position by presenting a conflict or dissonance between word and music, which fosters alienation and encourages reflection. Too often, Brecht would contend, we hear music and lyrics and hum along without giving the matter any thought whatsoever.

"Love Song" is an overly schmaltzy duet that ends with a gesture, hardly reinforced by the music, and so on a metalevel even more discordant, to the vagaries of love, exactly what one does not expect to hear in a love duet: "For love will endure or not endure / Regardless of where we are" (*Ausgewählte Werke* 1:216; *The Threepenny Opera* 26). One cannot help but laugh at this mockery of the overly sentimental love song. The greatest discord between lyrics and music arises in the "First Threepenny Finale: Concerning the Insecurity of Human Circumstances" (*Ausgewählte Werke* 1:223; *The Threepenny Opera* 32, translation modified). Here Peachum, a businessman who oversees the union of beggars and exploits his employees, begins with an affirmation of humanity and human rights, the right to a basic subsistence:

Man has a right, in this our brief existence
To call some fleeting happiness his own
Partake of worldly pleasures and subsistence
And have bread on his table rather than a stone.
Such are the basic rights of man's existence.
(*Ausgewählte Werke* 1:223; *The Threepenny Opera* 32–33)

This optimistic and affirmative worldview is accompanied by a slow dirge, funeral music in a minor key, whose form contradicts the content; the music signals, therefore, critique of unappealing social circumstances and a disingenuous mind. Peachum mouths the words but does not mean them. He continues with a grotesque rebuttal of his earlier lines:

But do we know of anything suggesting
That man enjoys his basic rights, or no?
To have one's rights would be most interesting,
But in our present state this can't be so.
(*Ausgewählte Werke* 1:223; *The Threepenny
Opera* 33, translation modified)

These words—cynical and very much in the spirit of unfettered capitalism, with an accompanying view that the conditions of the poor simply cannot be addressed or changed—are sung to fast, vibrant, uplifting music, again underscoring the inner contradictions and absurdity of Peachum's worldview.

Dialectical Beauty and the Aesthetic Moment

Dialectical beauty is in many ways appropriate to our time insofar as much in our age invites negation and critique. Moreover, pointing to anything positive beyond the negation of negativity tends to be met with suspicion. Yet dialectical beauty runs into an aesthetic challenge: it tends to resist the ambiguity that is generally seen as essential to art. One could counter that when art is in the service of a particular cause, as with Heartfield, ambiguity (beyond, say, puns, such as the double meaning in the phrase "Millions stand behind me!") may be seen as

less than welcome. And yet, because of the tendency toward an almost schematic negation of a negation, dialectical beauty may minimize the multiplicity and ambiguity often associated with great art insofar as great art must, to some degree, be indirect. We may all too easily recognize the social and cultural purpose of dialectical artworks and reduce them to this external purpose. In this context, Adorno recognized a weakness in Brecht, at least in his theory (his dramas are at times more complex than his theory). Whereas Brecht with his strategies of alienation sought to cultivate thought, Brecht's didacticism was for Adorno "intolerant of the ambiguity in which thought originates" (Adorno, *Ästhetische Theorie* 360; *Aesthetic Theory* 242). Advantageous aesthetically is a double negation that is only implicit or that is complex and multifaceted, such that the viewer must be fully engaged in sorting through interpretations. In commenting on political poetry in his essay "Dialectic," Brecht is well aware of the need for complexity and nuance: "Poems become insipid, vacuous, and dull when they strip their subject matter of its contradictions, when the things they deal with are not presented vividly, that is, in a well-rounded way, when they are not taken to their end, and the form is not taken to its end. If the focus is politics, then *bad* tendentiousness arises. You get 'tendentious portrayals,' that is, portrayals that leave out all sorts of things, that mutilate reality, and that seek to create illusions. You get mechanical slogans, hackneyed phrases, and impracticable instructions" ("Die Dialektik" 19:394).

From a production-aesthetic angle, the puzzle of whether to make clear one's moral critique at the risk of being inartistic or to linger in ambiguity, which can dilute one's critique, is genuine. We see this in the history of satire. I highlighted Juvenal's ninth satire for its superb combination of subtlety and critique. The most prominent English reception of Juvenal arose in the seventeenth and eighteenth centuries with John Dryden and Samuel Johnson. When thereafter criteria for aesthetic and ethical evaluation diverged, the value of satire as a genre waned. It was considered moral but insufficiently literary. Not only English-language satire but also the reception of Latin verse was affected by this evaluative shift (Martindale 294–95). What allowed Jonathan Swift to endure was his combination of ethical ideas and aesthetic strategies. In German letters, Heine reigns supreme as the greatest satirist, partly because his satire often falls back on itself and

thus radiates ambiguity. Heine famously opens his mock epic *Germany: A Winter's Tale* with two warring songs. His critique of the first song, which encourages humanity to endure suffering and embrace a vision of heaven, is cleverly scathing. He writes that the little harp girl sang "mit wahrem Gefühle / Und falscher Stimme" (4:577), "Her voice / Was strong, though out of key" (*Poetry* 231). She sings of "Aufopfrung und Wiederfinden / Dort oben, in jener besseren Welt, / Wo alle Leiden schwinden" (4:577). In inadequate English: She sings of "sacrifice on earth, / And reunion in that better world / Where sorrows disappear" (*Poetry* 231, translation modified). Heine continues:

> She sang a heavenly lullaby,
> The song of abnegation,
> By which the folk, that giant cad,
> Is lulled to sleep when it groans
> (*Poetry* 232, translation modified)

———

> (Sie sang das alte Entsagungslied,
> Das Eiapopeia vom Himmel,
> Womit man einlullt, wenn es greint,
> Das Volk, den großen Lümmel.)
> (4:577)

But the alternative song, an implicit call for radical change and universal abundance, is so overdone as to be self-undermining:

> Wheat enough for all mankind
> Is planted here below;
> Roses and myrtle, beauty and joy,
> And green peas, row upon row.
>
> Yes, green peas enough for every man,
> As soon as they break their pods.
> (*Poetry* 182)

———

> (Es wächst hienieden Brot genug
> Für alle Menschenkinder,

Auch Rosen und Myrten, Schönheit und Lust,
Und Zuckererbsen nicht minder.

Ja, Zuckererbsen für jedermann,
Sobald die Schoten platzen!)
(4:577–78)

Even the position Heine favors is mocked via hyperbole. He brilliantly combines political ideas with aesthetic ambiguity. Twentieth-century German satirists Heinrich Mann and Kurt Tucholsky are considered high second-tier artists, sometimes witty and clever but pulling no punches. The only twentieth-century German satirist who is considered absolutely first tier is Brecht, who, like Heine, sometimes undermines his own positions, slipping from the moral impulses of epic theater to genuine tragedy.

Whenever an artist moves closer to the spectrum of beauty dwelling in ugliness, the tendency toward heavy-handedness is avoided. An initially bewildering but outstanding contemporary example is Eisenman's somber and disquieting *Memorial to the Murdered Jews of Europe* (2005), known as the *Holocaust Memorial*. This work, whose facets include elements of both repugnant and aischric beauty, consists of 2,711 concrete pillars or stelae placed at various heights (from zero to four meters) and extending over a span of rolling fields. Located in the center of Berlin, the graveyard-like monument evokes the fate of the victims, invites contemplative reflection, and alludes to the partly confusing semblance of order that made mass murder possible. Outside one enjoys almost a park-like atmosphere, but as one wanders inside, one experiences a narrowing of horizons to the point of claustrophobia. The anonymous tombs tower over us. Further, some of the stelae tilt disturbingly. The work is less devoted to pillorying the Nazis and more concerned with remembering the victims. The work has something of a psalmic lament. The memorial, which stretches across almost five acres of Berlin, invites us to dwell in the suffering of victims and seek, however impossible this is, some fragmentary sense of their suffering. Empathy may be in principle more aesthetic, because more indirect, than condemnation.

The best works of dialectical beauty contain rich formal elements that are interwoven with social-critical dimensions. Whenever the negation of negativity is only implicit or leads to as many questions as

answers, the viewer must actively sort through the positions. The Socratic principle that recipients best arrive at knowledge by exerting effort is readily present. For this reason the form, despite Adorno's critique, also appealed to Brecht, as in *The Good Person of Sichuan* (1943), where because of social conditions the hero is unable to resolve the conflict. The play ends with a call for reflection and change. The epilogue leaves "all questions open":

> What could the answer be?
> We couldn't find any, not even for payment.
> Should humanity be different? Or should the world be different?
> Perhaps just the gods? Or ought there be none?
>
> <div align="right">(Ausgewählte Werke 2:294)</div>

The final lines call on the audience to consider what changes, what measures would be necessary to make a happy ending possible (2:295). Dialectical beauty has in such cases a didactic function. Hegel writes concerning one of the functions of art: "For then the person *contemplates* his impulses and inclinations, and while formerly they carried him away without his reflecting, he now sees them outside himself and already begins to approach them in freedom, for they face him in their objectivity" (*Werke* 13:74; A 48–49, translation modified).

Works that integrate critique and ambiguity have aesthetic advantages. Consider *Where to . . .?* (1953), by one of the most famous Palestinian artists, Ismail Shammout. His work recalls that of a European artist, such as Käthe Kollwitz. Shammout evokes the plight and horror of the tens of thousands of Palestinian refugees who in 1948 were displaced. At age nineteen, Shammout was among those who were evicted from their homes and suffered the catastrophic march eastward, during which many perished. In this oil on canvas, an aged man, weary and destitute, but dignified, walks with three children: he holds the wrist of a crying child, a toddler sleeps on his shoulder, and a third child, also crying, walks alone behind. A minaret is in the distant background, the tree nearby is withered, and the lack of a mother figure signifies loss of homeland (Ankori 50). The life-size work visualizes a horrific event, which is part of Palestine's collective identity. Despite the work's overarching clarity, it does retain a modest ambiguity: the work hovers between empathetic immersion in the fate of the

sufferers and castigation of the implicit causes of their horror, which are not shown, but understood and implied. The fact that the man's feet are cropped creates a more intimate image and almost freezes the motion, asking us to linger in solidarity with his and his family's suffering (Ankori 49).

In some cases a work's interpretation may revolve around the distinction between two structures, beauty dwelling in ugliness and dialectical beauty. In *Thérèse Raquin* (1867), Zola's intention was to show, via a kind of literary experiment and "with the pure curiosity of a scientist," the consequences of certain temperaments (6). Characters with distinguishing traits and given backgrounds will under specific conditions act in a certain way. Thérèse is an ugly woman, whose husband, Camille, is weak. Thérèse falls for Camille's friend Laurent, who is lazy, but strong. Thérèse and Laurent agree to murder Camille. The work explores not only their adultery but also the torturous consequences of their murder: the couple's inability to live with its horror. The narrator suggests that when Thérèse expresses remorse to Camille's mother, Madame Raquin, contrition arises from her egotistical desire to free herself of her burdensome past, from "fear and cowardice" (166). By showing the self-destructive consequences of a murderous act, the claustrophobic, torturous, agonizing, hateful life the murderers endure in its wake as well as their betrayal and brutal intellectual "torture" of the paralyzed Madame Raquin, until they seek release via a double suicide, Zola's work offers not only an observation and analysis of what the narrator repeatedly calls "animals," but implicitly also censures their actions (167). On the level of production aesthetics, it is beauty dwelling in ugliness; on the level of artwork aesthetics, the narrative seems closer to dialectical beauty.

A work may also have two strands, such that beauty dwelling in ugliness and dialectical beauty are both evident. The bulk of Stanley Kubrick's film *A Clockwork Orange* (1971) satirizes the state's attempt to cure a vicious criminal. Alex, the film's antihero, is conditioned: violence and sex make him ill, and he will no longer commit crimes. The horrendous removal of the figure's humanity is portrayed satirically. We laugh at the state's bizarre project and recognize its dehumanizing effects. However, unresolved in the film is how to deal with Alex's loathsome instincts and sadistic actions, including beatings and rape. We linger with them and see brutality from the perspective of the hero,

who revels in them. As a result, the film has affinities not simply with works that diagnose violence and show its consequences but also with works that seem to celebrate violence.[3]

Dialectical beauty can in principle overlap with each style of ugliness, but overlap is least common with fractured beauty, for, unlike in dialectical beauty, the object depicted in fractured beauty is itself not viewed negatively. Repugnant beauty overlaps with dialectical beauty whenever the negation of the ugly content is achieved without formal distortion. One needs merely a hint in the direction of critique. In Marinus van Reymerswaele's *The Lawyer's Office* (1545), for example, the expression and ugly face combine to suggest critique. Distortion is not necessary. Aischric beauty overlaps especially frequently with dialectical beauty, for a distorted form may indirectly signal a critique of the portrayed content, which is itself ugly. We saw prominent examples among the artists of New Objectivity, such as Dix and Grosz. Critique via formal distortion occurs in other traditions too. *Echo of a Scream* (1937), by the Mexican surrealist David Alfaro Sequeiros, depicts the devastation of war and resulting loss, grief, and disorientation. Two babies amidst the chaotic landscape of shrapnel evoke war's horrific, unending effects.

Still, the situation is complex, for one of the greatest writers of dialectical beauty, Brecht, implicitly recognizes a connection between repugnant beauty and dialectical beauty. In a fragment on ugliness in realist art, Brecht endorses the presence of ugliness, but then adds that art does not simply exhibit ugliness and leave it at that ("Die Künste" 19:538). Instead, art overcomes ugliness, first, by enveloping it in beautiful form and, second, by portraying ugliness not as a necessary part of the world but instead as a societal form that could in principle be changed ("Die Künste" 19:538). If we understand Brecht's use of the phrase "beautiful form" to encompass not only the superficially beautiful forms of repugnant beauty but also the hidden beauty in distortion, then his observation does not exclude the harmony of aischric and dialectical beauty. One can understand Brecht's epic theater as a dissolution of theatrical form, but it is paradoxically also a new kind of beautiful form, with its own inner coherence. Such slipperiness is a case not of messy categories but of art's complexity and ambiguity, which cannot be reduced to a black-and-white formula, much

as tragedies and comedies often integrate aspects of the other or hover at each other's border.

Insofar as dialectical beauty ranges from lightly mocking comedy to indignant satire and even the self-destruction of the morally repugnant tragic hero, as with Shakespeare's Macbeth or Camus's Caligula, the term "dialectical beauty" is appropriately broad. In terms of a philosophical school that supports the ugly as a negation of a negation, the early Hegelians anticipate the concept of dialectical beauty by returning again and again to the idea of a double negation. Still, I take the term "dialectical" from Hegel, who recognizes the dialectical as the negative moment within the dialectic; the dialectical recognizes the self-destruction of the negative but does not itself represent resolution, which arrives only with what Hegel calls the "speculative" (*Werke* 8:168–79; *Enyclopaedia Logic* §79–83).

SPECULATIVE BEAUTY

In *speculative beauty*, the third structure of beautiful ugliness, the ugly, repulsive, or hateful, however pronounced, nonetheless recedes within a larger, more complex, and organic unity. Speculative beauty arises in works that include ugliness, as we see in the two previous structures—*beauty dwelling in ugliness* and *dialectical beauty*, but in speculative beauty, ugliness, even when prominent and pervasive, nonetheless represents only a moment of the work, not the whole. Moreover, in speculative beauty we reach a position beyond the self-cancellation of ugliness, that is, the work goes beyond the simple negation of negativity and includes also moments of harmony. The Christian narrative offers us a paradigmatic example of speculative beauty. Dante's comedy does not end with the *Inferno*, nor is Grüne-wald's *Crucifixion* the final work in his series. Despite their deep negativity, both artists move forward to speculative beauty.

Hegel and the Moments of the Dialectic

I draw on Hegel in my use of the term "speculative." To explicate the concept, we can turn to the *Encyclopaedia Logic*, where in paragraphs

79–82, Hegel offers his most compelling introduction to the dialectic, including the speculative. For Hegel, every step of the *Logic* has three moments. First is *Verstand* ("understanding"), in which concepts stand in rigid opposition to one another. Here is the realm of either-or thinking, one-sidedness, fixity. The categories of understanding are necessary for determinate thinking and everyday action. They are also essential in analyzing art. Hegel notes that we can explore genres and arts in their distinction from one another. Even within individual works we appreciate characters who act consistently and are not vague or indeterminate.

But Hegel insists that understanding does not have the final word. Categories are more complex, and when pushed to their extremes turn into their opposites. *Summum ius summa iniuria*: if abstract justice is driven too far, it turns into injustice. Hegel's examples continue—in politics the extremes of anarchy and despotism easily turn into each other. Too much wit outwits itself. The heart filled with joy relieves itself in tears. Life carries the seeds of death within itself. This more complex way of thinking, which all of us know from experience and from literature, Hegel calls the *dialectical*. In this second moment of the dialectic, one-sidedness is transcended, rendered more complex. The finite, if it is truly finite, cannot remain finite, but must give way. It must apply finitude to itself by being itself finite and so pass over into something else. Hegel reminds us that finitude is not the whole truth. Socrates was a master at showing how the positions his interlocutors held are not as clear and distinct as they thought they were and often pass over into their opposites.

Beyond the Socratic dialogues, Hegel does not give further examples from art, but tragedy likewise fits the transition from understanding to the dialectical. According to Hegel, tragedy is the collision of two goods, each of which has a moment of truth, yet each of which is wrong to the extent that it violates the opposing good: "The original essence of tragedy consists then in the fact that within such a conflict each of the opposed sides, if taken by itself, has *justification*, while on the other hand each can establish the true and positive content of its own aim and character only by negating and *damaging* the equally justified power of the other" (*Werke* 15:523; A 1196, translation modified). This unrelenting opposition turns out to be more complex than even the heroes themselves recognize.

In Sophocles's *Antigone*, not only does the tragic hero refuse to acknowledge the validity of the other position, the other position—or

at least the sphere it represents—is also an aspect within the hero even as he or she denies it. Creon decrees that because of treason, the body of Polynices may not be buried. Antigone, Polynices's sister, recognizes, in contrast, a higher, divine law and so tries to cover the body. As king, Creon sentences Antigone to death, even though Antigone was to have wed Creon's son, Haemon. Before the sentence is carried out, Antigone and Haemon commit suicide, as does Creon's wife, leaving Creon devastated and alone, his family in ruins. According to Hegel, not only is Creon stubborn and steadfast, Antigone, too, fails to recognize a legitimate conflict of goods and is in this sense as single-minded as her nemesis, if nonetheless more valid in her stance. Antigone is not only a sister but a privileged member of the polis, the daughter and niece of a king as well as the fiancée of Creon's son, so that "she ought to pay obedience to the royal command." Creon is not only a ruler but a father and husband, who "should have respected the sacred tie of blood and not ordered anything against its pious observance." The two tragic heroes transgress "what, if they were true to their own nature, they should be honouring." According to Hegel, the action of each hero is destructive of the other and also self-destructive: "So there is immanent in both Antigone and Creon something that in their own way they attack, so that they are gripped and shattered by something intrinsic to their own actual being" (*Werke* 15:549; A 1217–18).

According to Hegel, the tragic hero adheres to a one-sided position, denies the validity of its complementary and contrasting other, and eventually succumbs to the greater process in which it is submerged. Tragedy thus embodies the movement from understanding (the first moment in the dialectic) to the dialectical (the second moment in the dialectic). Hegel notes that in our complex world everything can be seen from another perspective. Everything finite is alterable or perishable. Skepticism and doubt ascend, but this moment of negativity, the dialectical, is itself merely another side of the dialectic. It, too, does not have the final word. In the introduction to his *Aesthetics*, Hegel raises the issue of *Verstand* with implicit reference to Kant: "Yet understanding [Verstand] cannot cut itself free from the rigidity of these oppositions; therefore, the solution remains for mere consciousness an *ought*, and the present and reality move only in the unrest of a hither and thither that seeks a reconciliation without finding one" (*Werke* 13:81; A 54, translation modified). The task of philosophy, Hegel argues, is to dissolve these contradictions and recog-

nize that truth lies not in one-sidedness or abstractions, but in mediation. Hegel continues: "This mediation is no mere demand, but what is absolutely accomplished and is ever self-accomplishing" (*Werke* 13:81–82; A 55). The truth of philosophy and of art does not lie beyond itself but in its own setting forth and unveiling of "reconciled opposition" (13:82; A 55). This internal unity brings us to Hegel's third moment of the dialectic.

Hegel calls this third moment, to which he turns in his analysis of the dialectic, the *speculative*: it represents a movement from mere negativity to a positive that includes the negative within itself. The speculative is the result of a process that includes moments of tension and negation. Hegel counsels against associating the speculative with any kind of fantasy. For Hegel the speculative is the antithesis of the subjective. Instead, the speculative works out, or thinks through, on a determinate level the contradictions of earlier positions, the ways in which understanding, in its abstraction, falls short, and the dialectical turns on itself. The speculative is a whole which recognizes that the moments within it are both distinct and connected. In other words, it transcends any either-or mentality, including ugly or beautiful. Not abstracting from one moment or another, the speculative is, in Hegelian language, "concrete."

The Drama of Reconciliation

In these paragraphs, Hegel does not offer a literary example of the speculative, but he does say elsewhere in his lectures that the either-or mentality of *Verstand* cannot grasp the unity of art (*Werke* 13:152) and that poetic, as opposed to prosaic, consciousness represents the literary equivalent of the speculative (15:240–45). Moreover, in his analysis of drama he introduces a deeply speculative structure, the drama of reconciliation. In discussing tragedy and comedy, Hegel briefly alludes to a third form of drama ("the deeper mediation of tragic and comic conception") in which resolution is achieved on stage: "Instead of acting with comical perversity, subjectivity is filled with the seriousness of solid relations and strong characters, while the tragic consistency of will and the depth of the collisions are so far mollified and smoothed out, that there can emerge a reconciliation of interests and a harmonious unification of individuals and their aims" (*Werke* 15:532; A 1203,

translation modified). Hegel mentions in this context Aeschylus's *Eumenides*, Sophocles's *Philoctetes*, and Goethe's *Iphigenia auf Tauris*. The supremacy of the drama of reconciliation corresponds to Hegel's argument that we should not remain at the merely negative result of the dialectic. For Hegel, tragedy, with the eclipse of one-sided, if substantive, positions, and comedy, with its negation of untenable positions, both point toward the positive. The speculative shows that the (partial) truth of each is only in recognition of the (partial) truth of the other.

It is not by chance that paradigmatic examples for speculative beauty would come from literature. We know from Lessing that in integrating ugliness, literature is privileged, for in the temporal art of literature ugliness can be vividly presented, but then eventually overcome and submerged into a larger whole. Such an integration of the ugly as a moment is evident in the drama of reconciliation. Like tragedy, the drama of reconciliation portrays, in a serious manner, substantial conflicts. The two genres differ in their endings: where tragedy culminates in catastrophe, usually death, the drama of reconciliation presents on stage a reconciliation of opposing forces. Whereas the tragic hero is one-sided and preoccupied with a position's exclusive validity, the reconciliatory hero sees the limits in his or her position and recognizes what is valid in the other. In Kleist's *Prince Friedrich of Homburg* (1810), for example, each of the opposing figures acknowledges the other to be in the right. The state, in the figure of the elector, becomes milder with its subject and acknowledges the right of the individual to act freely, which in effect leads the prince to acknowledge the legitimacy of forces beyond his subjectivity. The drama of reconciliation can be conceptualized either as an initially tragic conflict that culminates in reconciliation or as a comedy whose conflict is substantial, rather than superficial, and also resolved.[1]

The drama of reconciliation flourished in ancient Greece, in Aeschylus's *Oresteia* and in Sophocles's *Philoctetes* and *Oedipus at Colonus*. We also see it in the late romances of Shakespeare, *Cymbeline*, *The Winter's Tale*, and *The Tempest*. Those Shakespeare comedies that have an abundance of ugliness and also serious and potentially tragic moments, such as *Much Ado about Nothing*, could be said to belong here too. The final scene in this play echoes the aborted wedding from earlier, reminding us how difficult resolution is. Robert Ornstein writes: "Nothing that is painful is forgotten" (136). Lessing's comedy *Minna von Barnhelm* likewise could have progressed to tragedy if one of the

Structures of Beautiful Ugliness

subplots had not been comically resolved. The drama of reconciliation is prominent throughout the period of German idealism, not only in *Minna*, Goethe's *Iphigenia*, and Kleist's *Prince Friedrich*, but also in Lessing's *Nathan the Wise*, Schiller's *Wilhelm Tell*, and Goethe's *Faust II*. Although the drama of reconciliation is abundant during these three periods, it surfaces off and on throughout history, as, for example, in Calderón's Spanish Golden Age drama *Life Is a Dream*.

Aeschylus's influential *Oresteia*, which earned the tragedian first prize for the eighteenth and last time (he died two years later), is the earliest example of a drama of reconciliation. In 1968, when Robert F. Kennedy announced the assassination of Dr. Martin Luther King Jr., he movingly paraphrased Aeschylus's famous lines that wisdom comes through suffering: "Even in our sleep, pain which cannot forget falls drop by drop upon the heart until, in our own despair, against our will, comes wisdom through the awful grace of God." In the trilogy, we see a series of deaths, never a single one alone. Hate and murder abound in the work, as does despair. The *Oresteia* is a Hegelian tragedy insofar as both sides have some justification, and each side excludes the validity of the other, but the trilogy ends by moving beyond tragedy and inaugurating a new genre. Although the trilogy's theme is the transition from violence to law, passion to reason, and vengeance to statehood, the final play, the *Eumenides*, does not simply end with the triumph of law and rationality over the horrific forces of blood and vengeance. It culminates with the Eumenides being integrated into the political and religious life of Athens. Ugliness is not simply overcome, it is integrated into the social fabric.

As Hegel has suggested of tragedy (and of the movement from understanding to the dialectical), we see both opposition and identity. Aeschylus's trilogy begins with Clytemnestra's victory: she avenges Agamemnon for killing their daughter Iphigenia, thereby sacrificing the family (*oikos*) for the sake of the state (*polis*). In return, Orestes kills his mother, Clytemnestra, for having murdered his father. We see mirroring acts of vengeance. In *Agamemnon*, a woman kills a man (Agamemnon) in order to avenge a woman (Iphigenia). As a partner in crime stands a man (Aegisthus). In the act of vengeance, the victim's partner (Cassandra) also dies. The chorus, complementing the primarily female emphasis, consists of men. In *The Libation Bearers*, a man (Orestes) takes vengeance against a woman (Clytemnestra). He does this because of her injustice to a man (Agamemnon). In his

preparations, he is supported by a woman (Electra). As part of the vengeance, Orestes kills also his mother's beloved (Aegisthus). The chorus of *The Libation Bearers* is female to complement the dominance of its male hero. We see pairs throughout: Clytemnestra and Aegisthus; Agamemnon and Cassandra; Orestes and Electra. No gender acts alone. Apollo, a male god, supports Orestes. The Furies, female gods, support Clytemnestra. A mixed god, Athena, solves the riddle. Because Athena had no mother (she is born from Zeus's forehead), she has male dimensions. Identity and difference become a metatheme of the *Oresteia* (Hösle, *Die Vollendung* 46–55). The plot of each of the first two plays is, therefore, the inverse of the other. A dialectic is clearly at play.

As the vengeance unfolds, we fear that the cycle will not and cannot end. Justice is realized by an individual, the grieved party, acting against another individual, which continues the cycle and renews the tragedy. The principle of vengeance is repetition. However, differences exist between Clytemnestra and Orestes. Clytemnestra's revenge is not only retribution; it is also driven by passion and her adulterous relationship with Aegisthus. Orestes acts according to divine obligation: Apollo has called him to action. He has no personal interest in killing his mother. On the contrary, he suffers from it, both before (when he hesitates) and afterward (when he is haunted). Orestes asks, What am I to do? In Homer it was clear what Orestes must do. No conflict existed. Aeschylus rewrites Homer's narrative, using tragedy to pose questions about justice, much as Plato later does via the Socratic dialogues. Aeschylus, like Socrates later, lays bare a mode of suffering that is not simply physical. Moreover, when Orestes finally acts, he does so with his victims' knowledge, whereas Clytemnestra acts in stealth, such that Agamemnon is granted no recognition.

In the *Philosophy of Right*, Hegel analyzes revenge as a form of infinite regress (*Werke* 7:196–97; §102). The cycle of vengeance can only be halted when the judge and executioner are not themselves personally vested in the action. The quandary in Aeschylus is passed to a disinterested party, a jury of Athenian citizens. The split jury underscores the (partial) rightness of each side. The puzzle then passes to Athena, a goddess who had already appeared at the end of the *Odyssey*, putting a stop to continuing vengeance. Athena solves the seemingly unresolvable quandary by freeing Orestes and recognizing the Furies' claims. The new court is male, but the society that embraces the court expresses deep emotional respect for the female Furies. The

solution is driven not by *Verstand* and continuous opposition, but by dissolving the conflict and advancing to a unity of unity and difference. The resolution is in Hegel's vocabulary "speculative." It represents movement from the *oikos* to the *polis* while still honoring in the Furies the legitimacy of the *oikos*.

The new order is not something abstractly different but integrates into it the old, that is, the desire to do justice to the wounded parties. Not only Orestes, but the Furies, too, who represent the wrath of Clytemnestra, are assimilated and thereby freed of their hatred. Whereas for Homer the answer to conflict was located in the order of the household and the magnificence of the singular hero, for Aeschylus the answer lies in the collective, the institution. Aeschylus places family into a subordinate role while still recognizing its legitimacy. In the end, the Furies, led by Athena's encouragement, transcend the strict alternative of victory or defeat. The *polis* takes its strength from the emotional powers, which are not excluded but recognized as a necessary element within culture, society, and the state.

Sophocles's last play, *Oedipus at Colonus*, is likewise a drama of reconciliation.[2] At first blush it is difficult to imagine Oedipus, arguably the paradigmatic tragic hero, as a figure of reconciliation. Oedipus unknowingly kills his father and sleeps with his mother, thereby triggering the Athenian plague. When he discovers these truths, he tears two long brooches from his mother's clothes (she had hanged herself in despair) and digs them deep into his eye sockets, blinding himself, as a black hail of pulsing blood gushes down his face. Physical and emotional ugliness confront us, as does the ugliness of an arbitrary fate.

But in *Oedipus at Colonus*, a work that Hegel calls "eternally marvelous" (*Werke* 15:551; A 1219), Sophocles takes us beyond tragedy. Oedipus directly challenges the gods, arguing that he suffered against his will, a refrain he repeats many times: "I am innocent! Pure in the eyes of the law, / blind, unknowing, I, I came to this!" (line 548). Oedipus argues that his punishment was unjust and that the gods are arbitrary. The claim and the accusation are intriguing because they raise central questions from *Oedipus the King*. Wherein lies the tragedy? In Oedipus's succumbing to a preordained and horrendous fate or in his seeking out the truth against the counsel and warnings of others, even though this means his own destruction? If we understand tragedy as more than mere suffering, as heroic greatness that inevitably brings forth suffering, then the answer is clear. Only a banal reading of

Sophocles's play would argue that Oedipus is a passive victim of fate or that he has committed a crime and therefore receives his just punishment. Oedipus is a hero of great moral integrity who seeks the murderer and does not waver even when the search comes back to himself. Not the justice of the gods, but the strength of the individual, keeps the moral order intact. The final choral ode in *Oedipus the King* (864–910) raises the central questions: Is there a moral universe? Do the gods punish the unjust, the impious, the thieves? The answer is that the gods have withdrawn: "Nowhere Apollo's golden glory now— / the gods, the gods go down" (909–10). Justice is left not to fate or divine will but to Oedipus's determination to do the good even when he knows that he will suffer for it.

A second element of the theodicy in *Oedipus at Colonus*, beyond Oedipus challenging the justice of the gods, involves Oedipus moving beyond isolation and tragedy. Oedipus's self-inflicted blindness severed his connection to his environment. However, his blindness doesn't simply reinforce his isolation and symbolize a turn to inner knowledge, it also strengthens his ties to the external world, for he becomes dependent on others. Indeed, unlike Sophocles's *Antigone*, here *hērōs* and *polis* are not in opposition but instead come together; they need each other. Moreover, in *Oedipus at Colonus* the gods make amends. Oedipus is welcomed into Athens; finds a friend in Theseus; expresses deep love toward Antigone, his daughter and guide; and is reconciled even with the gods, for he receives divine stature, becoming a local deity.

Even the intensity of Oedipus's curse against the scheming Polynices is a sign of Oedipus's growing heroic powers. As earlier in his life, Oedipus speaks the truth even when it isolates him. The anger of Oedipus is part of his heroic essence; he has the highest expectations not only of himself but also of his surroundings. Sophocles alters the tradition and has Oedipus voice his brutal curse just before his divine-like death; the Greek word *ara* means both curse and prayer, a curse being a prayer for someone to come to harm. In his prophecies and during his last hours, Oedipus is in a position of almost divine power (*Oedipus at Colonus* 1425, 1428). He blesses Theseus and Athens and, despite his blindness, leads Theseus (1520–21).

We are reminded in *Oedipus at Colonus* that the chorus does not speak for Sophocles. Their most famous and abhorrent passage accentuates the ugliness of the human condition: "Not to be born is best

/ When all is reckoned in, but once a man has seen the light / the next best thing, by far, is to go back / back where he came from, quickly as he can" (*Oedipus at Colonus* 1225–38). The hero's development undermines this negativity. The chorus has already demonstrated its mediocrity, superficiality, and unreliability on more than one occasion. The play begins with Oedipus enjoying peace and tranquility. Soon thereafter the chorus lures him out of the sacred grove, the "holy ground" of the Eumenides, by promising him safety (176–77), but the chorus then breaks that promise: Oedipus should be sent into exile (226). Later, the chorus reopens his wounds with a malevolent curiosity (510–48). After Oedipus curses Polynices, the chorus awaits, in fear and despair, still more terror and suffering (1447–56, 1463–71), yet Oedipus is justly confident of his reconciliation (1472–76). The hero ends, as he began, in peace. He dies composed (1663–66). The thunder that brings panic and disarray to the chorus is for Oedipus the summons he had been awaiting (94–95). The same speech that laments human birth bemoans the isolation and wretchedness of old age: "Envy and enemies, rage and battles, bloodshed / stripped of power, companions, stripped of love— / the worst this life of pain can offer, / old age our mate at last" (1235–38). A complex artist such as Sophocles is able to introduce the cliché of wretched old age and simultaneously refute it. The chorus's depiction of despised old age is not authoritative, for everything the chorus says—stripped of power, devoid of companions, without love—is taken back in the course of the drama. Oedipus is powerful, and he moves within a deeply conciliatory horizon, beginning (even before these lines are spoken) with Antigone's and Ismene's love for their father and moving on to Theseus's friendship and Oedipus's own status as a local deity. Theseus, who calls Oedipus "kind" (631), a word, *eumeneia*, normally reserved for the gods, befriends Oedipus, and the play culminates in the hero's union with the gods.

The ugly lines about what is best and second best for humanity are for Sophocles a quotation: the passage is frequent in Greek literature and can be found in Theognis, Herodotus, and Euripides.[3] It is a moment that Sophocles includes but also overcomes. Sophocles takes viewers through ugliness, pessimism, and negativity before letting them recognize that such moments are ultimately superseded by a greater whole, including even the unity of divine and human. After the death of Oedipus, Theseus salutes the gods of Olympus and the powers of the earth, binding both together: "And, then, quickly, / we

see him bow and kiss the ground and stretch / his arms to the skies, salute the gods of Olympus / and the powers of the Earth in one great prayer" (*Oedipus at Colonus* 1651–56). Sophocles gestures thereby to Greece's other great drama of reconciliation, Aeschylus's *Oresteia*, which unites the Olympian gods and the netherworld.

This grand synthesis avoids falling into sentimentality, for it follows Odysseus's horrendous life and unjust suffering and comes very late (Oedipus himself notes, "It costs them [the gods] little to raise an old man! / Someone crushed in younger days" (*Oedipus at Colonus* 395). The curse of Polynices and the chorus's wayward song balance out the harmony, so, too, Oedipus's melancholic departure from Antigone and Ismene, which echoes the end of *Oedipus the King*. Even the moment of harmony with Theseus is dampened by Oedipus recognizing that he should not touch him. Such moments of unresolved negativity make the harmony more meaningful.

The drama of reconciliation is not restricted to the West. Consider Kālidāsa's ancient Hindu drama *The Recognition of Śakuntalā*, the first Sanskrit drama to be translated into a Western language. Goethe's poem "Sakontala" (1791) evokes the figure's wholeness:

> Wouldst thou the blossoms of spring, as well as the fruits
> of the autumn,
> Wouldst thou what charms and delights, wouldst thou
> what plenteously feeds,
> Would thou include both heaven and earth in one designation,
> All that is needed is done, when I Sakontala name.
>
> (*Poems* 291, translation modified)

Śakuntalā is not only beautiful, but also pious, humble, and at one with nature. The king, who during his journeys had fallen in love with Śakuntalā, fails to recognize her when she comes to court, so she is sent into exile. When after many years the curse of forgetfulness is erased, and the king is united with Śakuntalā and their son, tragedy is overcome, and we enter the realm of speculative beauty.

In Bengali Nobel laureate Rabindranath Tagore's *The King of the Dark Chamber* (1910), we find a more recent example of speculative beauty. The king is unseen by his people, including even his queen, Sudarshana, whom he receives only in his dark chamber. When the queen finally and momentarily glimpses the king, his ugliness shocks

her. She finds him "dark and terrible" (57): "The very possibility of a union with you has become unthinkable to me" (57–58). In this symbolic tale, the king, whose existence is doubted by many of his subjects and whose identity is at times confused with a pretender, represents God, Sudarshana the human soul. Sudarshana does not have the categories to process a figure whose essence transcends physical appearance; in exceeding ordinary human categories, the king is perceived as ugly. With a newfound sense of freedom, Sudarshana turns instead to the world, but she struggles, suffering temptations and disorientation. Eventually she achieves a kind of self-realization, which leads her back to the king. One can bear the king's sight only when one is prepared for a beauty that exceeds our everyday categories. In the final scene, Sudarshana says to the king: "You are not beautiful, my Lord—you are beyond compare" (103).

That such a work of speculative beauty would arise within a religious frame is not surprising. Christianity is hardly alone among world religions in providing a welcoming frame for speculative beauty. Not all dramas of reconciliation are religious, of course, but a religious framework can encourage reconciliation. The deeper harmony of world religions animates Cusa's *On the Peace of Faith* and Lessing's *Nathan the Wise*. Origen's concept of "the restitution of all" is in some ways a still bolder model of reconciliation. Origen advanced the position that even Satan would freely acknowledge God's excellence and so be saved, an idea that influenced a variety of European poets, including Goethe and Hölderlin.[4] At times speculative beauty draws on the Christian idea of grace: reconciliation can arise even when it is undeserved.

Occasionally and primarily in the context of Shakespeare's final plays, we hear as an equivalent term for the drama of reconciliation, "romance." As a general term within drama, "drama of reconciliation" seems more apt. "Romance" often implies overly idealized characters and "static conditions" (Scholes and Klaus 43). Because the drama of reconciliation integrates ugliness and negativity, it tends, in contrast, to have mixed characters and dynamic development. In addition, romance generally includes magical, fairy-tale moments that run counter to what I stress in the drama of reconciliation, not an external *deus ex machina*, as, for example, in Euripides's *Alcestis*, where Heracles brings Admetus's wife back from death, but internal and organic development. To take the issue of terminology one step further, I prefer as a still higher-level concept "speculative beauty," for what we understand

by the drama of reconciliation is not unique to drama. Speculative beauty occurs in other literary forms and even the other arts.

Speculative Beauty beyond Drama

Because narratives allow and indeed demand moments of negativity, which might be transformed in the course of the whole, we can find elements of speculative beauty also in novels that introduce ugliness and negativity but end with an element of reconciliation, even when it is incomplete. Hölderlin's *Hyperion* (1797–99), the most lyrical of all German novels and in terms of narrative structure one of the most complex, portrays tremendous suffering and death but integrates, through the distinction between the experiencing and narrating narrator, a culminating development toward composure and tranquility. Hölderlin comments in a letter to his mother from July 8, 1799: "The poet must . . . often say something untrue and contradictory, which, however, must of course be resolved in truth and in harmony within the totality in which it is presented as something transient" (*Sämtliche Werke* 3:372–73). Hölderlin's novel explicitly avoids a danger that sometimes surfaces in attempts to integrate ugliness into a positive resolution; the work ends with the narrator reemerging from his idyllic tranquility and adopting the satiric tone of a prophet, expressing a devastating critique of present inadequacies, yet voicing these without relinquishing his cerebral composure. We see how removed speculative beauty is from the concept of romance. Hölderlin's novel cites the ugly lines—"Not to be born is best / When all is reckoned in, but once a man has seen the light / the next best thing, by far, is to go back / back where he came from, quickly as he can"—from the chorus of *Oedipus at Colonus*, but the novel's conclusion takes these lines back and displays structural analogues to Sophocles's final play (Roche, "Die unverwechselbare Auffassung"). Harmony can be rich enough to include dissonance and ugliness, not only in the distant past but also in the immediate present. In Dickens's *Great Expectations* (1861), to cite another example, the early Pip is shocked by the grotesque figure of Magwitch, and when Magwitch is reintroduced at the end of the second part, he is even more repellent to Pip than he was at the beginning of the first part, yet Pip is slowly able to reconcile himself to Magwitch, whose greatness eventually becomes evident to him (Hösle,

Structures of Beautiful Ugliness

"The Lost Prodigal Son's"). We can likewise include one of the most grotesque of modern novels with its satiric intensity, magical absurdity and humor, and deep immersion in negativity, including the machinations of the devil himself. I'm thinking of Bulgakov's unfinished *The Master and Margarita*. In all three novels—by Hölderlin, Dickens, and Bulgakov—we see more of a gesture to reconciliation than anything resembling a fully developed happy end.

Speculative beauty can also arise in poetry. In his late hymns "Celebration of Peace," "The Only One," and "Patmos," Hölderlin elucidates for modernity a pneumatic concept: insight and reconciliation are the culmination of a long historical process that is not without moments of darkness (Jochen Schmidt). "Patmos" struggles with the dissolution of Christianity, engendered by Enlightenment and modern biblical criticism, but does not call for a return to naive belief or orthodox Christianity; instead, it embraces the Enlightenment as a necessary part of a more complex spirituality. Hölderlin's magnificent lines from "The Rhine" are fitting here: "For heavy [schwer] is the bearing of / Misfortune, but fortune weighs yet more" (*Sämtliche Werke* 1:333–34). Hölderlin speaks of happiness as heavier (and more difficult) because in order to be genuine, happiness must include not only itself but also its opposite, unhappiness. Ugliness must be affirmed as part of beauty. The poet reflects philosophically on this puzzle: "Only that is the most veritable truth wherein even error—because it is posited in the whole of its system, in its time and space—becomes truth. It [truth] is the light that illuminates itself and the night as well. This, too, is the highest poesy in which even the unpoetic—because it is said at the right time and at the right place within the whole of the work of art—becomes poetic" (*Sämtliche Werke* 2:521; *Essays and Letters on Theory* 46–47).

Still today we find complex poetic works of speculative beauty. Steinherr's "Reading Dante on the Train" consists of two stanzas: the first recalls some of the most gruesome aspects of Dante's *Inferno*, but the poem culminates in Origen's heretical teaching that perhaps even hell and all its demons will be brought into the light (182). Steinherr, like Hölderlin, is aware of the complexity of Christianity and so lingers in negativity before offering a glimpse of more, as in "Note in Damascus," his vivid and horrific, though also beautiful, poem on Holbein's *The Body of the Dead Christ in the Tomb*, which imagines Christ like a carcass cut to the bone, but vertical, on a meat hook, crying out (166).

Empathy is a common theme in Steinherr's works, as we saw in chapter 6 with his poem "Beauty."

Music, too, participates in speculative beauty. Beethoven's Ninth Symphony is layered with uncertainties, struggles, conflict, and darkness. The first movement ends with a funeral march in D minor. Even the fourth movement begins with considerable dissonance, uncertainty, and echoes of earlier struggles, but the symphony's dominant movement from D minor to D major culminates in a joyous vision of unity and fraternity.[5] Music is temporal: with a succession of sounds that form a whole, music can render both present and subordinate dissonance. Mahler's *Resurrection* Symphony, with its celebration of divine love, likewise moves toward speculative beauty. One could view also the classical sonata in the context of speculative beauty. Its exposition generally introduces two themes with conflicting character. A middle section follows, with elaboration and development of the opposition and various moments of dissonance. Then the recapitulation and coda bring forth a harmonic resolution, for example, with the return of the second theme not in the dominant but in the tonic key (Charles Rosen). In its opposition, dramatic development, and resolution, the sonata embodies what we understand by speculative beauty, even if we recognize that many variations of this musical form exist, not all of which match the conciliatory structure.

Creating speculative beauty is arguably most difficult in the spatial arts of architecture, sculpture, and painting. Nonetheless, it is possible to recognize here, too, modest elements of the speculative. Recall the role that gargoyles play in Gothic cathedrals. Architecture is stable in time, but our experience of such a vast space is temporal, thus eliding the difference between the visual and temporal arts. Ugly parts can be seen as subordinate within the greater architectural whole. The crucifix, which occupies a prominent position within any cathedral, offers us a further moment of ugliness within a larger, more speculative work. Lessing's argument can be modified slightly: the brief appearance of ugliness not only within a temporal frame but also within a larger spatial frame modifies its severity. If one accepts the idea that ugliness should not consume a work, the temporal arts do have an advantage, even if the claim modestly underplays the ways in which a static work, such as Holbein's *The Ambassadors*, can effectively present ugliness as a part. After all, the ugliness of the skull can be resolved,

and the work contains an almost veiled crucifix, which recalls not only coming death, but also what lies beyond.[6]

Speculative beauty is present in Ghirlandaio's *An Old Man and His Grandson*, which we analyzed in chapter 2 (illustration 7), and also in Caravaggio's oil on canvas *Crucifixion of St. Peter* (1600–1601), which captures and transforms an ugly moment. Peter is on his way to his crucifixion (with his head down by his own request because he did not feel worthy to die as Christ did, head up). In an ugly but aesthetically grand scene, the four figures form crossed diagonals. Whereas the faces of the executioners are in the dark (two completely and one slightly), Peter's face is graced by light, symbolic of the higher truth that Peter recognizes and that glorifies him. The light points toward that which transcends the material world, including pain and death.

We noted at the beginning of this chapter that the Crucifixion, when combined with the Resurrection, evokes speculative beauty. It is fascinating to see how works often insist on the negative moment, even when it is not part of the immediate subject matter. Even in seemingly idyllic portrayals of Christ's birth or youth, works sometimes hint at the coming negativity, integrating allusions to the Crucifixion. By integrating negativity, such artists avoid religious kitsch, art without suffering. For example, a cross is visible in the background of Giotto's fresco of the first crèche, *The Crèche at Greccio* (1297–1300), which he painted for the Upper Church of San Francesco at Assisi. In Leonardo da Vinci's *Benois Madonna* (1478), the Christ child holds a flower in the shape of a cross. In the beams of the stall, Tintoretto's *The Birth of Christ* (1576) alludes to the three crosses of Golgotha, even as the observer's perspective moves through these dark beams to the golden heavens of the risen Christ (illustration 60). Such images explain why the ugliness of the cross, which we emphasized in chapters 5 and 6, can be for the discerning believer not only "ugly and horrid" but also "beautiful" (Viladesau, *Beauty of the Cross* 12). Modern examples also exist, such as Caspar David Friedrich's dark *Easter Morning* (ca. 1828–35), which, with its dead trees and brown tones, nonetheless gestures toward what is to come.

Many religious works that focus on negativity also gesture toward its eventual overcoming. Although Michelangelo's *Pietà* (1498–99) portrays the deceased Christ, the seemingly repugnant content is softened by the sculpture's overarching classical grace, the love of Mary,

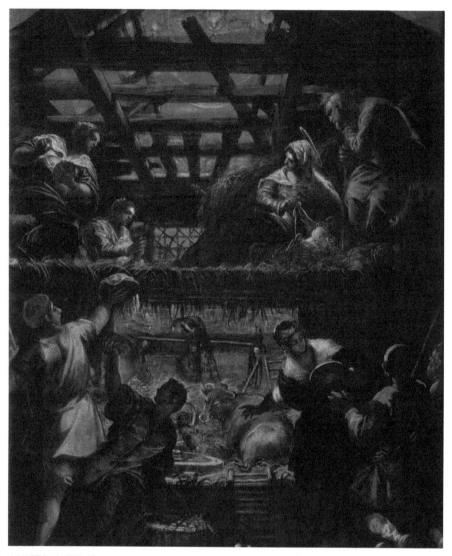

and the audience's knowledge of the purpose and full trajectory of
Christ's sacrifice. Religious works beyond the Crucifixion narrative
also capture aspects of speculative beauty. One thinks, for example, of
Raphael's final painting, *The Transfiguration* (1520), which depicts the
ugliness of a boy possessed by a demon, who, however, through Christ's
intervention expels the demon. Goethe noted the work's dynamism:

"How, then, are those upper and lower parts to be separated? The two are one: below, the suffering part, in need of help; above, the effective, helpful part, both of them linked together" (*Italienische Reise* 11:453; *Italian Journey* 364). Rubens's *The Martyrdom of St. Livinus* (1633) shows the martyr's tongue having been ripped out with tongs and being fed to the dogs, yet it also points, via the martyr's eyes and arms, upward to the heavenly angels. Much as scenes of the manger integrate negativity to ensure at least a gesture toward a fuller narrative, examples exist of the Crucifixion that point beyond its ugliness. A modern American example is cubist Herman Trunk's *Crucifix* (ca. 1930). The painting is brown, an allusion to Christ's earthly existence. Christ and the cross seem to converge via interlocking shapes, such that his identity is his death on the cross, but the effect is one of "stillness and composure," a gesture to what lies beyond suffering and death, both for Christ and the meditative believer (Fowler).

T hough Christianity is a dominant force behind speculative beauty in the visual arts, secular examples exist besides Ghirlandaio's *An Old Man and His Grandson*. The focus of Diego Velázquez's oil on canvas *The Surrender of Breda* (1634–35) is not the lengthy battle between the Netherlands and Spain, in which the Spanish conquered Breda despite its unusually strong fortress, but the ensuing reconciliation (illustration 61). Striking is the respect the victorious Spanish general Spinola extends to the Dutch army, with his humane kindness and recognition of their dignity. A tempering of ugliness is also visible in Antoine-Jean Gros's *Napoleon at the Pesthouse at Jaffa* (1804), where we see the effects of sickness on the soldiers' faces and skin, even as the soldiers are lifted up by Napoleon's visit, by his not shying away from touching them, by his sharing with them, much as before they had endured bullets together (Carrière, *Aesthetik* 1:163–64). In these examples we see elements of magnanimity and empathy, a solidarity with those who are suffering and recognition of their dignity.

Speculative beauty as a structure could in principle overlap with any of the three styles of beautiful ugliness, but repugnant beauty is the most common. This may arise above all from the fact that repugnant beauty is a universal form of beautiful ugliness, whereas fractured beauty and aischric beauty are more prominent in modernity, precisely when speculative beauty wanes. Almost all of the examples

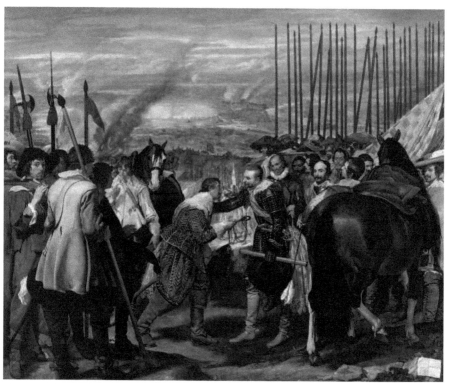

ILLUSTRATION 61
Diego Velázquez, *The Surrender of Breda*, 1634–35, Oil on canvas, Prado, Madrid/Bridgeman Images.

in this chapter include the integration of repugnant and speculative beauty. The least common overlap is with fractured beauty, for in such works the object is itself not viewed negatively, so there is no immediately negative content to be overcome. The deep connection between aischric and dialectical beauty renders the integration of aischric and speculative beauty also uncommon.

The Challenge of Speculative Beauty

Why is speculative beauty rare? To portray a speculative position is difficult. The fear of closure, the desire to avoid sentimentality, the hesitancy to obscure the negative, all play roles. It is, moreover, easy to fail when attempting such a work. One can, for example, paint over dissonances with an unearned harmony that only exacerbates suspicion.

Not only is there the danger of obscuring the negative, but, as Dante suggests, portraying ethereal beauty is not an easy task. Another argument from production aesthetics is the challenge of presenting speculative beauty in the static arts, in which it is more difficult to integrate the movement essential to the speculative movement. The fear of overlooking real problems and falling into kitsch, the idea that it is easier to portray crisis than resolution, also the spiral of criticism and complexity noted in chapter 8, in which the harmonic moment, which seemed easier in an earlier, less complex era, becomes elusive—all play roles. Finally, any movement beyond negativity tends to be met today with a certain level of skepticism.

Because we have so few instances of speculative beauty in modernity and because modernity, as Adorno well knew, tends to prefer not only dissonance but also innovation, speculative beauty looks less appealing, too traditional, not in keeping with the times. Decades after publishing his *Story of Art*, Gombrich noted an interesting irony in the movement toward artistic experimentation: "When I first conceived and wrote the Introduction and the chapter on Experimental Art I took it for granted that it was the duty of the critic and of the historian to explain and to justify all artistic experiments in the face of hostile criticism. Today the problem is rather that the shock has worn off and that almost anything experimental seems acceptable to the press and the public. If anybody needs a champion today it is the artist who shuns rebellious gestures" (610). Gombrich goes so far as to call "this dramatic transformation" the most important art-historical event he has witnessed since the *Story of Art*'s initial publication in 1950. Once antiart becomes canonical, then the only way to become truly contrarian is to challenge the ideology of negativity, to render negativity not the whole but a moment. A paradox is at the core of the argument that art should not be idealizing. Adorno and others who advocate this position scale art back to portraying what is. This evokes the question, In what way is art then countercultural? A truly nonmimetic art would need to portray an alternative to the dissonance of modernity, such as an idealizing art that avoids kitsch by integrating negativity. That is the essence of speculative beauty.

One can make the case, as Steven Pinker and Hans Rosling do, that, given reductions in global poverty and violent conflicts as well as increases in life expectancy and literacy, our age is not as deficient, not as ugly as many contemporary critics would like us to believe, yet

modernity and modern art are deeply attuned to present failings. We are sensitive to the ugliness all around us, and artists are strongly inclined to engage ugliness. Another reason why today's intellectuals are enamored of ugliness is the fear that they might otherwise be accused of flattery, endorsing what is or should be, as opposed to showing how competent they are in critical thinking, in uncovering untenability. This is related to the contemporary preoccupation with, and elevation of, negativity and critique. Think of Adorno and his heirs as well as deconstruction. Depicting any kind of positive resolution would be a form of flattery. Of course, the need to flatter and be flattered is nonetheless insatiable, so persons will sometimes flatter themselves and others as being immune to flattery. We know this structure from Shakespeare: "But when I tell him he hates flatterers, / He says he does, being then most flattered" (*Julius Caesar* 2.1.208–9). Still, the desire for more than mere negativity may be irresistible. After more than a century of deep immersion in ugliness, some critics have called for a return, in the words of Wendy Steiner, to "a time when beauty, pleasure, and freedom again become the domain of aesthetic experience and art offers a worthy ideal for life" (241). Nonetheless, the desire to move beyond an exclusive focus on suspicion and critique remains a minority position (Felski). The legacy of Adorno is visible among both critics and practitioners. German artist Heinz Mack laments that beauty remains "taboo in contemporary art" (Ackermann).

Works of unearned harmony fall into melodrama or kitsch. Artworks that only pretend to integrate negativity can be mistaken for great art. This is an argument from the realm of reception aesthetics. Another reception-aesthetic argument is the fear that aesthetic affirmation will be mistaken for real affirmation; this is Adorno's claim in his *Aesthetics* (Ger. 203; Eng. 134). Bürger also invokes the idea, arguing that though art may represent a better alternative than current reality, the fictional realization relieves existing society of any pressure for change (50). This is a version of Marx's argument on religion as a kind of opium, in this case with art as the opium. Adorno argues that to counter such intoxication, art must eschew positive meaning (Ger. 229; Eng. 153) and show happiness that is broken (Ger. 205; Eng. 136). An argument such as this, from reception aesthetics instead of artwork aesthetics, recognizes the genuine value in works that portray unresolved conflict and suffering. The effort to create speculative art carries with it the danger of reducing tension to the point of falling

into a realm of art that no longer addresses unresolved problems or no longer eludes us or evokes mystery.

In modernity, with its skepticism toward any kind of resolution, speculative beauty is rare. Still, it is desirable, not least of all because alternatives to the present can be appealing. A culture that makes no attempts at reconciliatory art is impoverished. At the same time, certain material simply does not lend itself to a positive resolution, whereas other stories are enriched by such a speculative end. Everything depends on the organic development of the material. Although the departure of Nora in the original version of Ibsen's *A Doll's House* (1879) went against all social and moral convention and triggered intense discussion, the work was a sensational success. It seemed clear that Nora must leave the marriage in order to find a more meaningful life. Torvald fails to act out a tragic self-sacrifice (recognizing Nora's love and spiting the world to stand with her—the miracle for which Nora had hoped). When the illusion of this possibility is broken, Nora's hopes for a meaningful marriage disappear. She must act. Still, Ibsen's German agent, Wilhelm Lange, and also the actress slated to play Nora on the German stage, Hedwig Niemann-Raabe, argued that the original ending would not be well received in Germany and that an adaptation with a more conciliatory ending, over which Ibsen would have no rights, would likely be favored. In order to retain authorship and meet these concerns about audience expectations, Ibsen wrote for the play's German debut an alternative ending, in which Nora does not leave the house ("The Alternative 'German' Ending," 5:287–88). Ibsen preferred to alter it himself rather than allow it to be adapted by others, even though he did so under pressure and never endorsed the change, calling the whole matter a "barbaric outrage" ("Some Pronouncements of the Author," 5:454). The revised work was performed in 1880. Eventually, audiences recognized the distortion and clamored for the original.

Another famous revision arose with Shakespeare's *King Lear* (1606). After the Restoration, *King Lear* was transformed for the stage with sentimental streaks and a happy end so that audiences would not be repulsed by its dark ugliness, an adjustment that fractured the organic nature of the work and moved it toward melodrama. However, in the seventeenth century, the original *Lear* failed to capture audiences, so Nahum Tate rewrote the ending for a performance in 1681, which for 150 years displaced Shakespeare's play. In the original,

Cordelia is executed, Lear dies of grief, and Gloucester, too, cannot survive the reunion with Edgar, which happens behind the scenes. In the Tate version, Cordelia, Lear, and Gloucester all survive. The revision ends with Edgar affirming that "truth and virtue shall at last succeed" (95). Tate's play lacks the subtlety, coherence, and gravitas of the original.

A contrasting example to the revisions of Shakespeare and Ibsen is Dickens's *Great Expectations*. Dickens first drafted a negative ending to *Great Expectations* but was rightly cautioned to revise it; in the end the novel does not unfold a reconciliation, but it does hint at one. In the original ending, Pip, who remains single, briefly sees Estella in London, who has remarried after having become Bentley Drummle's widow. Dickens liked that it was unconventional. But persuaded by his friend Edward Bulwer-Lytton, Dickens rewrote the ending: Dickens stated that Bulwer-Lytton "so strongly urged it upon me, after reading the proofs, and supported his view with such good reasons, that I resolved to make the change" (Forster 6:59). We do not know the precise rationale; presumably the ending seemed too dark after Pip's growth in character. Dickens rewrote the ending so that in the ruins of Satis House, Pip now meets Estella, whose suffering has led to remorse, and the last line of the 1862 edition reads: "I saw no shadow of another parting from her" (507). However, since Estella had said that she wished to remain alone ("And will continue friends apart") and since Pip had mentioned only a bit earlier his intention to remain a bachelor, whether Pip and Estella will marry or whether Pip will remain single remains open (484). The ambiguous ending hints at a possible reconciliation, but it does not show it and so represents a subtle form of speculative beauty.

Speculative beauty is more readily manifest in film than in the other arts. Not only in the Hollywood expectation of happy endings, which often border on kitsch, but also in films by truly artistic directors, speculative beauty is present. A new and popular art has more room for the speculative, for it is less burdened by the past and elite critics' expectations. Alfred Hitchcock's works are deeply immersed in negativity but frequently end with hints at reconciliation (Roche, *Alfred Hitchcock* 106–17). Other speculative films include, for example, Jean Renoir's *Grand Illusion* (1937), John Ford's *Young Mr. Lincoln* (1939), Charlie Chaplin's *Limelight* (1952), Akira Kurosawa's *Ikiru* (1952), and Sidney Lumet's *Twelve Angry Men* (1957).

More common in modernity is an approximation or intimation of the speculative, what I call *beckoning beauty*, moments of meaning and harmony toward the end of works otherwise dominated by dissonance and ugliness. We see merely a hint or glimpse of resolution, attractive and appealing, but not fully realized, an intimation of speculative beauty. Florian Henckel von Donnersmarck's *The Lives of Others* (2006) hardly embodies speculative beauty, given the film's dismal physical and moral ugliness, the problem of suicide, and the devastating death of one of the lead characters, but it constantly gestures toward the values of art and ends with an indirect moment of recognition and reconciliation—when Gerd Wiesler discovers the book dedicated to him. By the film's ending, an interesting symmetry arises: each main character, Georg Dreyman and Wiesler, looks at the other with the other not knowing. Christa-Maria Sieland's death in Dreyman's arms, one of the crucial late scenes, alludes to the pietà. If we understand the name "Sieland" to be a partial echo of "Heiland" (savior), Christa-Maria's name contains a threefold allusion to the Christ story (in German the pietà is called the *Marienklage*). Much as Christ fell three times on the road to Calvary (the stations of the cross have Christ falling three times, at stations three, seven, and nine), so too Christa-Maria falls three times: to prostitution, drugs, and betrayal. In the film's rich ambiguity, she is also the Judas figure: the drugs she receives are like Judas's silver coins, and her death can be read as suicide. The true savior is Wiesler, whose actions were inspired by the lives of Dreyman and Christa-Maria. Still, because Christa-Maria has sacrificed herself, the investigation will not continue; thus her death was not in vain.

Fatih Akin's Turkish-German film *The Edge of Heaven* gestures toward, without fully presenting, forgiveness and reconciliation. Although we encounter a series of disasters, including prison time for two individuals and the deaths of two others, we see in one strand of the story eventual reconciliation (Susanne and Ayten) and a hint of possible reconciliation in the other (Nejat and his father). The first gesture comes only after great suffering, and the second is not visible but merely anticipated—as a possibility. This is far from the dramas of reconciliation in the tradition, and its hovering between genres matches the complexity of two cultures in partial tension with one another (Volk 155–56). Clint Eastwood's *Gran Torino* (2008), which is deeply immersed in ugliness, including gang violence and the hero's misanthropy, also comes to mind as a tragedy that includes moments of

reconciliation (Roche and Hösle). After having interwoven a variety of difficult and substantive themes—a nuanced portrayal of multicultural America, a fascination with moral questions, including critique of violence, and a sophisticated wrestling with the institution of confession—Eastwood's film achieves a hint of redemption. The example I gave above of Dickens's *Great Expectations* also fits here. These works do justice to incompleteness.

We might think of a spectrum in which beckoning beauty occupies a minimalist position on the edge of speculative beauty. Much further along are works that are deeply harmonic but gesture to incompleteness. For example, despite their comic resolutions, Lessing's *Minna von Barnhelm* and *Nathan the Wise* both allude to continuing battles. Because comic works generally end happily and because modernity is skeptical of such solutions, aesthetically rich modern comedies tend toward beckoning beauty. For example, in Hofmannsthal's *The Difficult Man*, the play's final embrace—directed by Stani, the master of proper form—excludes the two main characters, Helen and Hans Karl: their relationship is too substantive to be reduced to generic and formal considerations and too substantial to be included in the play's final parody of form. Yet their exclusion also suggests the limits of harmony. They are an island within a sea of self-interest, arrogance, and negativity. Though the drama ends on a note of intersubjectivity, it is restricted.

Even tragedy as Hegel understands the genre borders on beckoning beauty, offering a hint or gesture toward the speculative. With the fall of the tragic hero, ethical equilibrium is restored: "In tragedy the substantive is expressed and comes into conflict but is ultimately victorious; ethical life is the absolute power, hence the denouement is structured such that reconciliation is present" (*Philosophie der Kunst* 250). For Hegel the catharsis of tragedy takes place in the consciousness of the audience, as it recognizes the supremacy of the whole of ethical life and sees it purged of one-sidedness. The tragic adherence to a partial position is stripped away and yields to the larger rational process of historical development. Tragedy thus contains within itself a hidden moment of resolution and reconciliation (*Werke* 15:524, A 1197; 15:526, A 1198; 15:547, A 1215).[7] In the complex dissonance of tragedy, beauty is violated and preserved. For Hegel, poetic dissonance must represent the moment and not the whole: "In poetry these disso-

Structures of Beautiful Ugliness

nances can proceed to the point of ugliness," but they cannot endure; they need to be resolved (*Philosophie der Kunst* 90–91).

All great art is inexhaustible; here beauty and ugliness have in common that they cannot be fully comprehended (Roche, *Why Literature Matters* 228–34). Drawing on Plato's link between love and beauty, Alexander Nehamas notes: "So long as we find anything beautiful, we feel that we have not yet exhausted what it has to offer" (9). We love what we lack, what we do not yet grasp; we love works that remain inexhaustible. Adorno argues that artworks are "enigmas," which "say something and in the same breath conceal it" (*Aesthetics*, Ger. 182; Eng. 120). In this elevation of art's nonrevealedness he is very close to his nemesis Heidegger, who likewise stressed the simultaneous revelation and concealment of great art, its lingering resistance to all attempts at interpretation (Heidegger 46–53). We love art that reveals and conceals, that continues to elude us, whose meaning is never exhausted by interpretation. Speculative art is certainly capable of this complexity, such that Adorno is wrong when he suggests that harmony obliterates dissonance (Ger. 78; Eng. 48). No matter how close we may come to analyzing and exhausting the meaning of a great work, even a work of speculative beauty, there are moments that affix us, transform us, captivate us—and simultaneously elude us. Adorno argues that artworks conceived as successful wholes or integrated parts necessarily render those parts dead (Ger. 84; Eng. 52), but this view suggests that a part cannot be interesting and vital in and of itself and also contribute to the whole. In contrast, Hegel argues that parts have continuing and independent interest for us even as their full meaning evolves only from their position within the whole of the artwork (*Werke* 13:156–57).

We might reformulate a phrase of Hegel's and propose that *art is its age captured in sensuous presentation*. This would explain the strong tendency toward negativity and ugliness in contemporary art. We can understand the turn to ugliness, in the form of the oppressed, marginal, and fractured, as a complete rejection of any attempt at wholeness, or we can conceptualize it as a recognition that what was taken for complete was only partial, that the longing for greater harmony is not to be abandoned. Attention paid to what was left out of the alleged classical synthesis can involve conscious affirmation of the fragmentary, as in Romanticism and in Adorno's quip, "The whole is the

untrue" (*Minima Moralia* 57), or it can, alternatively, involve recognition that what was taken to be whole was not itself complete and needs to be extended further. It can be viewed as an argument for greater integration instead of an argument against integration. One of Adorno's followers, Thomas Huhn, claims that the "preponderance of the ugly in modern art, the fragmented character of modernist works, is evidence of the impossibility of any return to harmony" (144). As with Adorno himself, a clever and provocative statement disguised as fact can be unveiled as an overstatement that is not at all logically compelling. If Huhn's thesis were correct, then harmonic works would have been impossible after any historical period when ugliness was prominent, but that has not been the case.

Often an artist is driven to focus on precisely those elements that need to be addressed before a greater whole can be viewed as truly harmonic.[8] The satiric moment requires, whether or not artists are conscious of it, an implicit ideal against which the deficiencies of reality are recognized as deficient. Thus a turn to the ideal need not be viewed as suspect as long as it does justice to the inadequacies of reality, to ugliness. No would-be resolution is complete, because the human condition is always deficient, even as a valid human goal is to seek to bridge the gap between the world as it is and the world as it ought to be. The contemporary artist's drive to focus on ugliness may well be a moment within a larger, more deeply integrative process or whole. The turn to ugliness in modern art may thus be indicative of a higher logic and part of a longer story, in which the ugly has a prominent, indeed irreplaceable, but hardly exclusive, role to play within the realm of aesthetic excellence.

CONCLUSION

There is a human desire, whether it arises from sensuous allure or cognitive fascination, to engage ugliness. As I show in this book, the ugly itself is not simply what is opposite the beautiful (since the ugly can be combined with the beautiful) or what we find repellent (since our reception may shift over time). A conceptual definition of ugliness as an appearance that contradicts what belongs to the normative concept of an object leads to an elaboration of the spheres in which we encounter ugliness—physical, emotional, intellectual, and moral. In each case we see an appearance that veers from what should be. The analysis of part I interweaves contemporary philosophical insights with neglected observations from medieval Christian thinkers, Hegel, and the Hegelians. Artists justly integrate ugliness for various reasons, including awakening empathy with suffering individuals, expressing moral revolt against the causes of such suffering, seeking to grasp complexity, playfully experimenting, and recognizing the role of ugliness within a metaphysical frame.

Part II focuses on the history of ugliness. The Greeks certainly knew the ugly, and in Hellenism ugliness takes on even greater prominence. But only with a metaphysics that recognizes an unbridgeable gulf between the world as it is and the world as it ought to be does the ugly become a dominant category. Imperial Rome's engagement with ugliness is motivated by its addressing reality's problems. Not only realism but hatred of the world's injustice, as we see in Lucan, brings

forth a deeper integration of ugliness. Satire, which takes realism and revulsion to another level, emerges in Rome as an entirely new literary genre. Christianity may seem too optimistic for ugliness, and in fact the Christian art that surrounds us today often borders on kitsch, but the great tradition of Christian art is deeply immersed in ugliness: both the horrendously brutal Crucifixion and the human propensity for evil. Empathy with suffering individuals and portrayals of willful evil abound into the present and offer two distinct paths for the portrayal of ugliness. But there is good reason why virtually all previous histories of ugliness begin with modernity. In the nineteenth century, ugliness takes center stage and eventually becomes a defining characteristic of modern art. In modernity, a new concept of reality emerges that is divorced from any normative sphere, and a series of aesthetic revolutions reject traditional norms and expectations.

Part III is an original account of forms of beautiful ugliness. The relation of content and form leads to three styles of beautiful ugliness: only the content is ugly (repugnant beauty), the content is innocuous and the form distorted (fractured beauty), and both form and content are ugly (aischric beauty), such that at a higher level a symmetry of form and content is discernible. In the first style, repugnant beauty, Aristotle's insight is realized: a beautiful depiction of an ugly object can be aesthetically excellent. This mode is widespread from antiquity to the present. In the second style, fractured beauty, the content is otherwise innocuous, but the form is distorted, almost always in revolutionary ways, which gives rise to seeming ugliness. Fractured beauty occurs in earlier eras but becomes central only in modernity. In the synthetic style, which I have named aischric beauty and which captures both moral and formal ugliness, we see a metaharmony of ugly content and fractured form. Aischric beauty, arguably the most intriguing and fascinating style of ugliness, gives us an innovative perspective, an entirely new window to understand modern art as complexly, perhaps in some cases even unintentionally, organic.

Three structures of beautiful ugliness are differentiated from one another by the ways in which the work as a whole relates to, or evaluates, its moments of ugliness: simply presenting ugliness and lingering in it without any overarching evaluation (beauty dwelling in ugliness), exhibiting the ugliness of the ugly and thus enacting a negation of negativity (dialectical beauty), or integrating the ugly into a larger process in which it plays an important but nonetheless subordinate

role (speculative beauty). In the first structure, beauty dwelling in ugliness, no evaluative perspective is present; the work simply lingers in, and in some cases expresses fascination with, ugliness. In dialectical beauty, which matches the dominant early Hegelian concept, we see a critique, a revelation of the ugliness of the ugly, as, for example, in the satires of Juvenal or the harsh paintings of Grosz. In speculative beauty, the ugly is present but absorbed into a larger process in which it becomes a moment, as in Christ's crucifixion and resurrection. Because the synthetic structure of speculative beauty represents a formal and ideological challenge, the latter especially so today, some artworks merely hint at reconciliation. Beckoning beauty is a variation on speculative beauty that seems especially prevalent in modernity even if it is not exclusive to our age.

As I noted in the introduction, the three *styles* of beautiful ugliness form a dialectical pattern (illustration 62). Repugnant beauty is the initial position, whose mirror and antithesis is fractured beauty, whereas aischric beauty returns us to a more organic structure by sublating repugnant and fractured beauty into a metaharmony of content and form. Ugliness constitutes both moments, but in such a way that the seemingly nonorganic art that defines modernity turns out to be organic in a more complex and unexpected way. The *structures* of beautiful ugliness follow a more complex sequence (illustration 63). Radiant beauty, in which ugliness plays little or no role, is the initial position. Beauty dwelling in ugliness and dialectical beauty together occupy the antithesis, whose nature it is to divide into two, and speculative beauty sublates the earlier moments: speculative beauty includes ugliness but is not dominated by it; moreover, it moves beyond ugliness in a positive and not merely negative way. What renders the structures even more complex is that speculative beauty seems modestly foreign to our age, such that I have introduced the term *beckoning beauty* for works that offer simply a gesture in the direction of speculative beauty. When an artwork merely hints at positive moments beyond the dominant ugliness, we can speak of beckoning beauty.

The categories I employ and issues I address should make it easier for readers to analyze seemingly ugly works from the tradition and wrestle with difficult contemporary works. Ugly artworks often have a vibrant reception context insofar as they challenge their audiences. Although beauty may encourage agreement, as Kant suggests, ugliness invites at least initially a more discordant reception. The categories

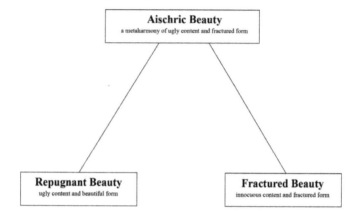

ILLUSTRATION 62
Styles of Beautiful Ugliness, graphics by John Ferletic.

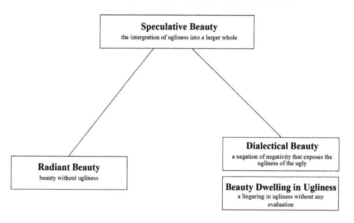

ILLUSTRATION 63
Structures of Beautiful Ugliness, graphics by John Ferletic.

and perspectives I offer, including *quatsch* and *prima facie quatsch*, as well as the diverse styles and structures of beautiful ugliness, can contribute to making such discussions richer and more nuanced.

Porous Boundaries in Forms of Beautiful Ugliness

Andrei Pop has raised the interesting puzzle of whether "the very same feature of a thing can count as both beautiful and ugly" (171). In aischric beauty as well as in beauty dwelling in ugliness, and dialectical beauty, we see such a confluence. In each case the same moments are both beautiful and ugly. If one sees the whole of a work as deriving from the integration of parts, such an integration could be said to apply to all six forms of beautiful ugliness. We can isolate the ugly and beautiful moments in repugnant and fractured beauty, but if we hold to Edmund Husserl's meaningful distinction between *Moment* (part as a moment or aspect) and *Stück* (part as an element, a piece or slice of a whole), then even in repugnant and fractured beauty, the two aspects of form and content are inseparable. Below we see the extent to which fractured form can have ripple effects on content, such that distorted form ultimately changes even seemingly innocuous content. In speculative beauty, where ugly moments unfold in a narrative that ends beautifully, the ugly parts belong to one organic whole. Still, the ugly moments can be isolated and subordinated and do not overwhelm the work. With modernity elevating the ugly, we can understand the attraction of combining ugliness and the static arts, for here ugliness tends not to be sublated. The increasing tendency toward negative resolutions in dramas and narratives further underscores the modern ascendance of ugliness.

Fascinating are works that hover between aspects of ugliness. Some works seem thematically innocuous, but the formal strategies are so unnerving that they transform the content. Van Gogh's paintings may not be perceived as superficially beautiful, but his unmistakably rough brush strokes and unusual patterns evoke an unease, a sense of anguish or dread that offers on a higher level an appropriate symmetry of form and content. Van Gogh is difficult to place for this reason: his content is as such benign, but the form so renders the content unnerving that it transforms it to the point where we must speak of a harmony of fractured form and haunting content. Goodman's concept of

exemplification is relevant here. The properties more than the object convey the work's meaning. Exemplification also arises in Expressionism, such that form transforms the content. Kirchner's street scenes offer sharp angles, jarring colors, and distorted perspectives that capture the vitality of city life, for example, *Five Women in the Street* (1913) and *Street, Dresden* (1919). The latter, with its mask-like faces, reminds us of the loss of individual personality in the large city. The distortions of *Berlin Street Scene* (1914) underscore the confused frenzy of urban life. The scene seems in principle innocuous, but the way it is captured renders it unsettling, agitated, anxiety-inducing, and so we recognize through the way that form transforms content a deeper symmetry of form and content.

Among more recent artists, such thematic unease continues. Seemingly innocuous subjects can be so distorted and fractured that anxiety ensues, as in Francis Bacon's various self-portraits from 1969 (illustration 64) and 1973 or his *Three Studies for a Portrait of George Dyer* (1963). The Irish-born painter creates unease and disquiet, even terror and hopelessness, partly because he takes the human form and mutilates it. Unlike cubist works, which play innocently with shapes, Bacon distorts his figures, including in his self-portraits, to give them a sense of bleak desperation and wrenching pain. And unlike the surrealists, his subjects are recognizable as truly human forms, even if they are fractured and dislocated. Already in the 1940s and 1950s, his variations on Velázquez's *Portrait of Pope Innocent X*, such as *Head VI*, were haunting. As the pope cries in anguish, his upper face is a distorted blur. Because of the expression of distress, we are not surprised by the erasure of superficially mimetic form. But Bacon takes even innocent subjects and distorts them. He paints heads that are so agitated in their own skin that they express a movement out of themselves. Representation becomes deformation. Brutal distortion and anguish render his subjects vulnerable and his works unsettling. A 2010 London exhibit was titled "Francis Bacon: A Terrible Beauty" (Barbara Dawson). Bacon's self-portraits "almost appear to be *about* self-loss and to deal with the *theme* of loss of self" (Alphen 10). The faces are not simply altered; they are wounded, even traumatized. Bacon's works transcend fractured beauty: the form is so warped that the seemingly innocent content becomes reconfigured, changing the subject and thereby altering the viewer's reception. Bacon comes close to what Hegel calls "the absolute relationship of content and form," such that there is "a

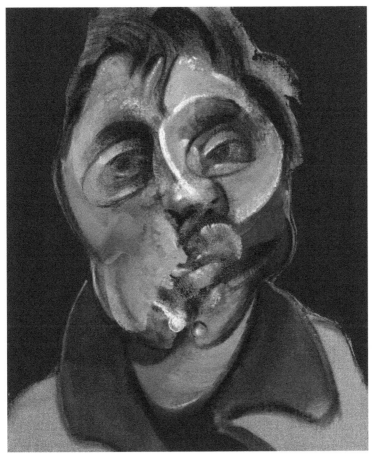

reciprocal overturning [Umschlagen] of one into the other." We experience "the *overturning of form* into content" and "the *overturning of content* into form" (*Werke* 8:265; *Encyclopaedia Logic* 202). Through such a transformation, we recognize the ambiguity and dynamism of works that move beyond one form and become another.

By changing the content of poetry, Benn reversed traditional topoi of human dignity. Bacon does something analogous with painting, but by way of form. Bacon's distorted works create such turbulence that the paintings are not simply a play with form. The deformation affects the work's meaning. Kent Brintnall writes, "These bodies are disturbing

because they are recognizably human despite their distortion" (164). We see the defenselessness of the human body, the inevitable decline from which the human figure cannot escape. Brintnall continues, "We are repulsed, nauseated, terrified, undone precisely because we identify with the bodies Bacon paints; we cannot *not* see our mortality, fragility, and instability in his distorted figures" (164). In terms of structure, Bacon's works represent neither dialectical nor speculative beauty. His crucifixes draw us in and ask us to linger in human fragility and inevitable decline. His works are paradigms of beauty dwelling in ugliness and so represent a modest anomaly in the tradition, for the combination of beauty dwelling in ugliness and aischric beauty is uncommon.

In the cover image of this book, *Just Warped* (2018), American Barbara Roche likewise combines forms (illustration 65). A self-portrait in distorted form might seem to be an example of fractured beauty, but the multiple, fragmented heads suggest an identity crisis, which brings the painting into the realm of aischric beauty. As with Bacon's works, there is no obvious critique, so *Just Warped* seems to embody beauty dwelling in ugliness, but a critique may nonetheless be implicit. Like Richter and her teacher Maria Tomasula, Roche is capable of exact representation, but here she modulates her craft. Ribbons, which are typical female ornamentation, become in this instance muffling, constraining, a restrictive garment, perhaps an allusion to others controlling women, wrapping them into something they are not, coercing them against their will. The term "warped" appears to allude to the warp and woof that defines the female craft of weaving (one thinks of Penelope in the *Odyssey*). The closed lips evoke silence. The prominent vertical ribbon under the most visible eye evokes tears. Painted in 2018, the work seems to embody the crisis, including identity crisis, many women felt during the presidency of Donald Trump. Indeed, "just" can be a temporal reference to what just recently happened.

But the female image is not simply passive. The multiple heads recall the Hydra, a threatening image, presumably an allusion to the indefatigable spirit of defiance that animated women during these years. "Just" warped can also mean "only" warped: twisted and distorted, but not defeated. Since Heinrich Heine's threefold cantation in his poem "The Weavers," weaving has been a symbol of political resistance. And the brightness of the work is not without a gesture of hope. Roche's artist statement underscores the sense of light: "My paintings attempt to provide an alluring visual experience while rejecting immediate

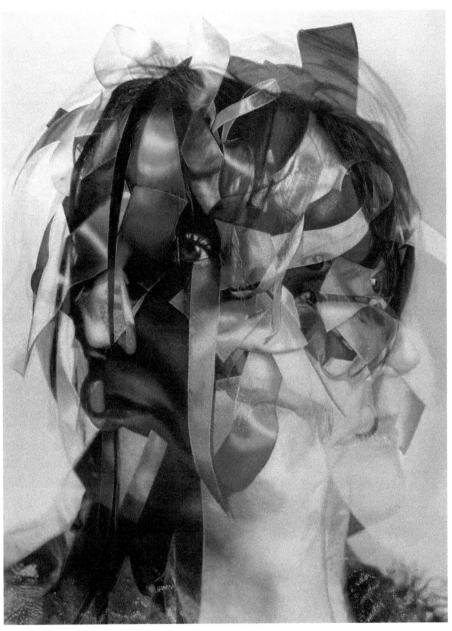

ILLUSTRATION 65
Barbara Roche, *Just Warped*, 2018, Oil on panel, 36 x 48 in., Private Collection
© Barbara Roche, Courtesy of the Artist.

understanding and creating estrangement. They can be dark, yet offer moments of radiance through luminous, glistening and saturated objects. The reflective quality of light fascinates me for its technical challenges and metaphorical implications." Not only the reference to light has Christian resonance, with its hint of transcendence, so, too, the triad of faces. Moreover, the dynamism of the work, with the tension between red and green, the flowing of the looser ribbons, and the semblance of a facial turn, suggest a temporal crisis in yet another sense: the three faces can be read as looking to the past, present, and future and seeking to forge a coherent identity among them. Not only the faces convey temporality: the innocent child-like bow at the top contrasts with the knowledge evoked by the most prominent eye, an eye of the present, which suggests deep awareness, penetrating diagnosis. The traditional link between knowledge and weaving, above all manifest in Athena, reinforces this interpretation. The future visage is likewise in internal tension: the eyes seem layered with angst, while the lips suggest a quiet, determined confidence.

Although one can stress the distinctively female elements of the work, these hardly exhaust what is at play. Throughout the *Statesman*, Plato uses the metaphor of weaving to articulate the ideal unity of opposites. For Plato, the statesman weaves together a beautiful cloth that moderates opposing outlooks, a fabric that encompasses and protects "all" (311c). Only a knowledgeable ruler can weave together out of diversity a just state of civic unity. For Plato, the warp is the stronger thread, associated at its extreme with recklessness and madness, whereas the absent woof is the softer, more moderate thread. The allusion underscores the work's implicit reference to abnormality, injustice, just(ice) warped. The phrase "just warped" implies that the work of the state is deficient, not at all a harmonic coincidence of opposites, but instead its opposite—antagonizing, constraining, exclusionary, warped—perhaps even mad. Such deficiency merits formal distortion. The hope of an ideal future, however, is implicitly evoked, and the concept, bright colors, and future gaze point beyond what is shown. The intertwinement motif is also a self-reflexive nod to the artwork itself, which likewise integrates competing strands. Some works are too multifaceted and ambiguous to be easily placed. Is there an implicit critique of the social and political world that warps the woman and against which the artist protests? Is there a hint of something more, perhaps in the value of the artwork itself?

The examples of Van Gogh, Kirchner, Bacon, and Roche make clear that form can so distort seemingly innocuous content that what seems to be fractured beauty turns out instead to embody a more complex form, aischric beauty. Although I analyzed Frank Auerbach under the concept of fractured beauty, it is difficult not to conclude that some of his figures are so distorted that the meaning of the works shifts, and aischric beauty results. Among the most fascinating works of beautiful ugliness are those whose ugly form does not simply match ugly content but instead transforms seemingly innocuous or even benign subject matter—an evening sky, a city street, a human face—into the realm of the ugly. Van Gogh, Kirchner, Bacon, and Roche are not alone but representative of artists who create fractured works that render meaning troubled. Blurring the images in his photo paintings, Gerhard Richter conveys a worldview of fragmentation. We do not know reality as fully as would be ideal, and this sense of unease, which the formal distortion evokes, arguably moves his works from fractured to aischric beauty. For another example, consider American Susan Rothenberg's *Half and Half* (1987). The painting portrays a human figure. Toward the front of the canvas we see the upper body, barely discernible. The frontal view, darkness, and wavy lines almost evoke Munch's *The Scream*. Fascinating is that the bottom half of the body is entirely separate and slightly behind. Not only are the two parts of the body fractured in our ability to discern them, but the body is literally split. The body's front is painted such that its interior seems to meld with the landscape behind it. The work creates a sense of discomfort, via style and composition, that affects the object depicted. As with Bacon, we see fractured beauty in its transition to aischric beauty and beauty dwelling in ugliness.

Likewise complex is Otto Dix. His subjects are rarely innocuous. Instead, he almost always paints repugnant content. But in some cases his style hovers between accurate and distorted, and this ambiguity moves many of his works from repugnant beauty to aischric beauty. For this reason we have included his works under both categories. Some works, such as *Match Seller*, fit repugnant beauty, some, such as *Skat Players*, fall under aischric beauty, and some, such as *Wounded*, are more ambiguous, only slightly exaggerated. Virtually all of Dix's works belong to dialectical beauty, even if they focus more on the victims than the perpetrators of injustice and invite us to dwell on their horrific plight. *Match Seller* asks us to contemplate society's

indifference. We do not move on immediately, but are instead called to linger and reflect. Still, the critique is unambiguous.

In a different way, some works exist on the border between beauty dwelling in ugliness and dialectical beauty. Juvenal, whose satires fit dialectical beauty, can be contrasted with Petronius: the latter's critique of vulgarity seems to be coupled with fascination. We encountered this combination again and again: the artist motivated by critique who is simultaneously fascinated with ugliness and so allows its portrayal to become an end in itself, at times in tension with what would otherwise represent critique. We noted the ambiguous playfulness in Bosch's portrayals of paradise and hell, but the structure reaches back to ancient Greece. In Aristophanes's the *Clouds*, the just discourse, which Aristophanes presents as the superior argument, seems to enjoy speaking in lurid detail of the vices against which it warns listeners (145–46). The weakening of moral certitude that manifests itself in such ambiguity has the effect of elevating the work's capacity for indirection. Heine, who in his preface to *Germany: A Winter's Tale* cites Aristophanes as a forerunner (4:573), provides further examples of a vacillation between moral certitude and irony, as with the warring songs with which his mock epic opens.

Architecture also presents us with classificatory puzzles. I analyzed postmodern architecture under fractured beauty, but the content of such buildings is paradoxical: the content is not viewed negatively, as is the case with most of aischric beauty, but the terms we associate with postmodern buildings, such as "disarray" and "disorder," are in principle negative. Further, the form and content tend to be in harmony with one another, which brings the works toward aischric beauty, but with a different evaluation than, say, Bacon or Dix: negativity is here embraced and so the examples of postmodern architecture we have considered belong under beauty dwelling in ugliness. Whether they represent fractured or aischric beauty is a more difficult question.

A poem we discussed in chapter 9 that hovers between repugnant beauty and aischric beauty is Celan's "Death Fugue." I included it under repugnant beauty because it is a beautiful poem about a horrific event, the Holocaust. But the work is a fascinating example of repugnant beauty that borders aischric beauty, depending on which aspect of form is emphasized: the form itself, which is beautiful, or the relation between (beautiful) form and (horrific) content, which is disjunctive. If we understand form as the relation of form and content,

then the two moments clash with one another, and this discord matches the already jarring content, which would make it a candidate for aischric beauty, not in a simple sense, but on a metalevel. The work is particularly chilling and successful partly because it is not easily assigned to one form or another. Often great works transcend genres and forms. Much as Celan's poem can move from repugnant beauty to aischric beauty when we conceptualize the rupture of ugly content and beautiful form as itself a formal moment, so can Bacon's fractured style turn seemingly innocuous subjects into horrific ones. Both forms can lead to aischric beauty. Something loosely analogous to Celan's poem is evident in Kafka: the content of his stories invariably tends toward the unimaginable, but the ways in which they are told is often direct and matter-of-fact. Is this repugnant beauty, or is the disjunction between bizarre, seemingly impossible content and sober everyday language itself a formal disjunction, such as to render Kafka's works closer to aischric beauty? Is it perhaps possible that both moments are simultaneously present, thus accentuating Kafka's ambiguity?

Dante uses beautiful language to portray sinners and their punishments. The *Inferno* is a work of repugnant beauty, but in hell we also experience moments of aischric beauty. Horrendously loud sounds and frozen silence characterize the satanic realm. We see two diabolical extremes. On the one hand, we encounter screaming sinners (1.113–15), earthquakes (3.130–32), thunder (4.1), crashing winds (9.64–72), Cerberus's barking (6.13–15), the roar of falling water (16.1), and loud voices (24.65–66). As soon as Dante enters hell, he experiences cacophony:

> Now sighs, loud wailing, lamentation
> resounded through the starless air,
> so that I too began to weep.
>
> Unfamiliar tongues, horrendous accents,
> words of suffering, cries of rage, voices
> loud and faint, the sound of slapping hands—
>
> all these made a tumult, always whirling
> in that black and timeless air,
> as sand is swirled in a whirlwind
>
> (3.22–30)

On the other hand, Dante encounters sinners who can only gurgle under water, unable to articulate their words (7.124–26). Those who committed suicide cannot speak unless they suffer a further wound (13.22–93). The soothsayers have their heads reversed on their bodies and so cannot talk (20.7–15). In the lowest pits of hell we find frozen shades who are unable even to weep (33.94–114). Lucifer himself utters not a single word. Both cacophony and silence contrast with the angels' divine music and melodious speech (2.55–57; *Paradiso* 32.97–99), but dissonance and silence fit hell perfectly.[1] The beautiful language of Dante the poet expresses evil, such that the work embodies repugnant beauty, but the cacophony and silence suggest that Dante the pilgrim experiences in hell something analogous to aischric beauty.

The Inexhaustibility of Ugliness

As we see with these examples, a focus on ugliness opens up new perspectives. A deep exploration of ugliness allows us to recognize unfamiliar depth in a seemingly familiar term. Most people think they know what ugliness means, but it is far more complex than we at first imagine. A focus on ugliness challenges us to see what Christian humility is or should be. It allows us to grasp the nature of satire. And it opens a window onto the diversity of art. Exploring ugliness gives us a fresh understanding of the relation of form and content and of part and whole. It encourages us to ask innovative questions and to formulate traditional questions in new ways. Do form and content reinforce one another, or are they at tension? Do the parts express the whole or does the whole give the parts greater meaning? Is the work's ugliness left for us to ponder as it is, or is it in some indirect way negated or overcome?

What do we make, for example, of Shakespeare's *King Lear*? In terms of the relation of content and form, it is a great work about moral misdeeds and deep suffering, so it fits repugnant beauty. It offers at the end only a gesture beyond suffering, so one can hardly call it speculative or even beckoning beauty. Yet it is not like a work of satire that clearly negates moral misdeeds even if it engenders disgust with the actions of Goneril, Regan, and Edmund. It is far more a work that immerses us in, and has us linger within, suffering. In this sense the drama anticipates works such as Büchner's narrative *Lenz* or the sketches and sculptures of Kollwitz: these works arouse empathy with suffering individuals.

Drawing on their distinctive art forms, Shakespeare, Büchner, and Kollwitz expand our horizons by asking us to dwell in ugliness.

Libeskind's postmodern Jewish Museum in Berlin is, in terms of overall composition, another interesting puzzle. The building's dissonant structure matches the horrendous history portrayed, the plight of the Jews, especially in twentieth-century Germany. Aischric beauty is at play, and though the work's dissonance might be said to hint at a critique of the Jews' victimization (and so embody dialectical beauty), the building itself is much more given over to contemplation, to empathetic lingering in ugliness. The jarring nature of the structure forces visitors to confront the past, but with a focus more on victims than perpetrators. The work, then, is ambiguous and fits beautifully the purposes for which it was designed.

By lingering with ugliness, we also recognize some of the strategies artists use to present moments of harmony without falling into kitsch: ensuring ample presence of ugliness, integrating comic elements, drawing on a tradition with substantive moral ideas, introducing ambiguities, and avoiding any resolution that is not subtle or hard-earned. Some works contain all four moments, for example, Lessing's cerebral comedy *Nathan the Wise*; Florian Henckel von Donnersmarck's film *The Lives of Others* with its portrayal of East German oppression and resistance; and Eastwood's film about multicultural America, violence, and religion, *Gran Torino*. Why do so many works immerse their recipients in ugliness? Not only to ensure that any eventual harmony avoids kitsch, but also because ugliness is so richly diverse. Tolstoy's *Anna Karenina* opens with the line: "Happy families are all alike; every unhappy family is unhappy in its own way" (3).

There is little doubt of modernity's pervasive ugliness. Ugliness is one of three signature elements of modern art, the others being self-reflexivity and technology. Self-reflexive art, art about art, is increasingly visible in modernity. Think of Friedrich Schlegel and E. T. A. Hoffmann and also Luigi Pirandello, Thomas Mann, and Bertolt Brecht, to name just a few. Self-reflection has formal analogues. The painter who turns away from content and focuses solely on color, shape, stroke, and texture independently of content concentrates on the possibilities of painting as painting, and is so engaged in a kind of self-reflection: painting turns inward. Arnold Gehlen has argued that "art today is contemplative art" (212). The centrality of ugliness can further be compared to the significance of technology, including the invention of new

art forms, such as photography and film, technology's influence on reception, including the mechanical reproduction of art, and the integration of technology-related themes, dimensions of modern art on which I focused in Roche, *Why Literature Matters in the 21st Century*. In my view these are the three signature elements of modern art: ugliness, self-reflexivity, and technology.

To explore more fully the overlap of ugliness, technology, and self-reflection would be promising. Two works from different cultures yet written almost simultaneously, E. T. A. Hoffmann's novella *The Sandman* (1816) and Mary Shelley's novel *Frankenstein* (1818), integrate all three distinctive dimensions of modernity. The protagonist of *The Sandman*, the writer Nathanael, is led to ugly actions, including suicide, after having been deceived by the apparent allure of the automaton Olympia. As with most of Hoffmann's artist narratives, *The Sandman* reflects on the limits of an unbridled poetic imagination that is fully removed from morality and a more normal social world, which, however, tends to be deflating toward the poetic imagination. The work is thus deeply ambiguous. The overlap of technology and ugliness is likewise manifest in *Frankenstein*, which reflects on physical and moral ugliness often in unexpected ways. The work examines the relation of creativity and morality. Closer to our era, we recognize self-reflexive gestures in Eakins's *The Gross Clinic* and Dix's *Match Seller* (viewers turn away from or flee images of ugliness). Contemporary Belgian artist Wim Delvoye has used technology to create a digestive and defecation machine, *Cloaca*, versions of which he began making in 2000: *Cloaca*, which refers to Rome's ancient sewer, is a machine of glass, metal, and tubes that absorbs food, processes it, and then defecates it. It is one of the smelliest artworks one will ever encounter. Is it a satire on the art world that nonetheless presents itself as art? Is it a work that exceeds the bounds of art and falls into *quatsch*, only pretending to be art? The answers are not simple, but without addressing these and related questions, we are left with the vague and uninteresting claim, that the work is simply "interesting."

The historical relations of ugliness and beauty are open to continuing puzzles. One is the extent to which in the past two centuries and in which arts, aesthetically defensible countermoments to ugliness have arisen, that is, art that is valued but in which ugliness plays either no role or only a subordinate role. Filmmakers, even as they portray extreme ugliness, suffer fewer historical inhibitions about including

moments of reconciliation. A related question for the present and more central for some arts than others is whether the intensity of ugliness has already begun to subside, or at least the diversity of art has increased, such that ugliness is no longer a ruling category of contemporary art, but one of several such categories. I have suggested that the extreme unleashing of ugliness in modernity is related to the partial abandonment of Christianity, yet connections between Christianity and ugliness run deep, and modern artists who turn to ugliness out of reasons of social conscience often integrate Christian iconography. The complex relations between ugliness, Christianity, and modernity, including the role of atheism and other challenges to Christianity, invite continuing aesthetic, historical, and theological reflection.

From a purely religious frame, the question arises: Has God created ugly things? If we live in a religious, but not a Manichaean, world, then the answer cannot be anything other than "Yes." An important religious obligation is to try to understand the world's ugliness. Why is it part of God's creation? Why must Christ undergo suffering? The ugly must be part of God's plan, even if much of it is created by humans as secondary agents of God's work. Therefore, believers should not look away from it but seek to understand it. Thus even a religious perspective must seek out ugliness. There is a reason why Dante must first travel to the inferno before reaching paradiso. The Dadaist and Catholic Hugo Ball suggested, "Victory over the ugly presupposes experience of it" (*Flucht* 60; *Flight* 42). Though true in a religious context, Ball's insight transcends the specifically religious realm. Only in countering ugliness can certain virtues, such as sacrifice, arise. If we were to live in a society without any need for struggle or sacrifice, we would in some ways be impoverished. There's a hidden logic to ugliness in the world and in artworks, to which religious thinkers should be drawn.

The continuing richness of the Christian tradition can be linked to modernity's ugliness. Ball writes:

> If our abstract pictures were hanging in a church, they would not need to be veiled on Good Friday. Abandonment [Verlassenheit] itself has become an image. No God, no people are to be seen anymore. And we can still laugh instead of sinking into the ground in dismay? What does it all mean? Perhaps just one thing: that the world is in the midst of a general hiatus and has reached zero; that a universal Good Friday has dawned, which is felt more strongly outside

the church in this particular case than in it; that the church calendar has burst and that God remains dead on the cross even at Easter. The well-known philosophic phrase "God is dead" is beginning to take shape everywhere. But where God is dead, the demon will be all-powerful. It would be conceivable that much as there is a liturgical year, so is there a liturgical century, and that Good Friday and more precisely the moment of death on the cross should fall in ours. (*Flucht* 162; *Flight* 115, translation modified).

For Ball there is no question that as central as Christianity has been to every facet of ugliness, the material is ripe for still more reflection.

Just as religious thinkers should be drawn to ugliness, so should philosophers. Wisdom, understanding diverse parts from the perspective of the whole, has traditionally been the philosopher's highest calling. Informally, we say that someone is wise when they recognize life's difficulties as necessary parts of the person they are today or when they have a sovereign understanding of how the diverse parts of contemporary society illuminate one another. Studies of truth often develop their arguments by delineating diverse kinds of fallacies. Recognizing error as error is a mode, underscored already by Socrates, of arriving at truth. Similarly, analyses of goodness are deeply attuned to modes of evil. One can successfully combat evil only when one understands it from within. Yet scholarship on beauty has often ignored ugliness. However, an analysis of ugliness has much to tell us about elements of the world we might otherwise miss, it gives us direct and indirect insight into the nature of beauty, and it illuminates why and in what ways beautiful ugliness is so alluring and so resonant with meaning.

N O T E S

Introduction

1. Few publications on ugliness existed as recently as fifteen years ago, but since then at least eight books have appeared. Nuttall's anthology (*Beautiful Ugly*) explores cross-cultural views of ugliness. Umberto Eco (*On Ugliness*) and Stephen Bayley (*Ugly*) offer images with brief commentary. Sianne Ngai (*Ugly Feelings*) focuses on emotional ugliness. Andrei Pop and Mechtild Widrich's anthology (*Ugliness*) explores diverse cultural and theoretical issues, Gretchen Henderson (*Ugliness*) offers a cultural history of ugliness, and Timothy Hyde (*Ugliness and Judgment*) analyzes episodes of aesthetic judgment where architecture is viewed as ugly. Finally, Wouter van Acker and Thomas Mical's anthology (*Architecture & Ugliness*) explores postmodern architecture.

2. In "Foundational Issues," Hösle offers an appealing set of arguments against the contemporary hesitancy to adopt objective idealism, and in "Einstieg" he argues why objective idealism is superior to the two dominant paradigms of our age, naturalism, which believes that the only valid truths are those of the natural sciences, and social constructivism, which reduces truth claims to the conditions of their genesis.

3. For an account of the value of religious kitsch from a reception-aesthetic vantage point, see Morgan (*Visual Piety*). Another defense of religious kitsch comes from Griffiths (321–25), who stresses the clarity of the Christian message, for which kitsch is not inappropriate, and the class differences between recipients of high art and kitsch. Against Griffiths one can note that differences in education (that is, reception) do not eliminate differences in quality, and some artworks, including deeply Christian works, such as Dickens's *Great Expectations*, satisfy criteria for both high and popular art. Art can be accessible without becoming kitsch.

4. For commentary on the tetradic in Hegel, see Hösle, *Hegels System* 130–54, 344–46, 424–62, 590–611.

5. My suggestion that we appreciate beautiful ugliness from an idealist perspective can be contrasted with the contemporary Italian Hegelian Giacomo Rinaldi, who restricts the value of ugliness to the comic and the sublime and so criticizes modern art and modern art theory for its elevation of ugliness.

ONE. Unveiling Ugliness

1. *Greater Hippias* entertains but refutes a definition of beauty as pleasing to the eyes and ears. Still, the work is not without partial answers: the idea is clearly endorsed that beauty must cover more than just one instance, one sense, one form of art; the definition must encompass "that which is beautiful always and for everyone" (292e). The most promising definition, though left behind in this inconclusive work, a typical strategy in the early dialogues, involves the suggestion that the beautiful is what is appropriate.

2. Socrates alludes multiple times to hidden knowledge (*Euthyphro* 3d, 11b, 15e). At 14c he suggests that Euthyphro was close to a correct definition but then turned away.

3. Nietzsche, in contrast, argues in *Twilight of the Idols* that "every *healthy* morality is dominated by an instinct of life" (*Werke* 2:967; *Complete Works* 9:67). Nietzsche does not recognize self-sacrifice on behalf of a higher good as a legitimate moral category, for he bases all valuation on the instinct of life, which, if weak, loses its right to life: "*Morality for doctors.*—The invalid is a parasite on society. In a certain state, it is bad form to continue to live. To vegetate away in cowardly dependence on doctors and procedures, after the meaning of life, the *right* to life has disappeared, ought to incur society's deep contempt" (*Twilight of the Idols*, in *Werke* 2:1010; *Complete Works* 9:107–8). We see here in Nietzsche's focus on physical ugliness over moral dignity a blindness to his own moral ugliness.

4. The most significant study of the grotesque is Kayser's book from 1957, *Das Groteske*. Of other studies, I would highlight the recent overview by Edwards and Graulund, *The Grotesque*, which contains a bibliography of earlier literature; the wide-ranging anthology edited by Frances Connelly, *Modern Art and the Grotesque*; Connelly's monograph, *The Grotesque in Western Art and Culture*, which emphasizes rupturing boundaries and contradicting what we take to be normal or proper; and the somewhat earlier study by Harpham, *On the Grotesque*, which likewise explores the grotesque as a form of contradiction, for example, of attraction and repulsion or of normal form and abnormal content. The focus on contradiction and on the violation

of norms in Connelly and Harpham accentuates the category's implicit connection to ugliness.

5. Kollwitz began working in the 1890s and continued to produce superb work for decades. Lipps's various contributions on empathy (*Einfühlung*) date from 1903 to 1913. Scheler, who introduces a series of additional terms, including *Miteinanderfühlung* ("communal feeling"), *Einsfühlung* ("empathetic identification"), *Nachfühlung* ("vicarious feeling"), *Mitgefühl* ("compassion"), *Menschenliebe* ("benevolence"), and *akosmitische Personenliebe* ("noncosmic personal love"), completed the first edition of his monograph on sympathy in 1912. He published it the following year under the title *Zur Phänomenologie und Theorie der Sympathiegefühle und von Liebe und Hass*. The 1923 edition, with the more recognizable title *Wesen und Formen der Sympathie*, is more than twice the length of the original. The English translation reads simply *The Nature of Sympathy*. During the same stretch, in 1917, Edith Stein completed and published her dissertation on empathy, "Zum Problem der Einfühlung."

6. Many of Tarantino's films—*Pulp Fiction* (1994), *Kill Bill*, Volumes 1 and 2 (2003, 2004), *Inglourious Basterds* (2009), and *The Hateful Eight* (2015)— play with an artistic celebration of killing and death. Tarantino's works depict the victims of violence with artistic fascination but an indifference to brutality. One might counter that his films indirectly criticize violence, but the claim that violence is treated ironically is less convincing when it is recurring and consistent. It is difficult to have it both ways: a film filled with brutality and then the assertion that the film is criticizing what it in fact embodies.

7. Bayley adds that in the National Gallery's gift shop, postcards of *The Ugly Duchess* sell at least as well as Claude Monet's beautiful *Water-Lily Pond* ("The Ugly Truth" 22).

TWO. Aesthetic Categories

1. I have articulated some related aesthetic principles in the first two chapters of Roche, *Why Literature Matters*, and I draw occasionally on that study here. I also expand it in several ways.

2. For an example of an experimental philosophy of art along these lines, see Kamber, "Experimental Philosophy of Art." My objection is not to surveys as such (it is always useful to understand the lay of the land), but to a view of art that prioritizes the *is* at the expense of the *ought*, that hopes to understand art simply by describing what people think about art instead of what they *should* think if their criteria and application are *rationally defensible*.

3. A capacious understanding of reception is essential if we want to understand the relative value of reception aesthetics. The first major work of

aesthetics written in the analytic tradition, Monroe Beardsley's *Aesthetics*, rightly elevates the artwork, but Beardsley has a truncated concept of reception as affect, "the psychological effects of the aesthetic object upon the recipient" (460), which leads him to underestimate its relative value.

4. The French philosopher Michel Ribon, who does not appear to be familiar with Goodman, nonetheless makes an analogous distinction: "The question of ugliness in its relation to art is twofold: that of the ugliness *in* the work and that of the ugliness *of* the work" (10). Although I cite Goodman as the best modern representative, the distinction is a recurring insight in the history of the idea of ugliness.

5. The weight of 175 pounds at installation can further be interpreted as a generalized or approximate weight of a healthy individual. In fact, the same weight was used in Gonzalez-Torres's *"Untitled" (Portrait of Dad)*, which he created the same year and which consisted of white mint candies in clear wrappers. Each work has both a specific and a general significance. New meanings and interpretations develop with each installation and with variations in how viewers engage with Gonzalez-Torres's works.

6. For contextual information on the exhibit of degenerate art, see Peters's edited volume, *Degenerate Art*. For a reconstruction of the exhibit, see Barron, *Degenerate Art*. On the fate of Gies's work, see Engelhardt, "Ans Kreuz geschlagen."

7. The original German is taken from Barron (51), but her version contains two typographic errors, which I have corrected above. "Under Centrist rule" refers to the Deutsche Zentrumspartei, the German Centrist or Catholic party, which was at the time Nolde created his painting the Reichstag's largest party.

THREE. Intellectual Resources

1. My account in this chapter draws on the Hegelians for a set of heuristic categories. It does not seek to be an exhaustive account of the history of Hegelian contributions to ugliness. For that reason I overlook several thinkers and comment only briefly on Rosenkranz. I hope in a future publication to analyze the theory of ugliness from Plato to Adorno and beyond, with significant attention to the Hegelians.

2. On Weiße's complex relationship to Hegel and the Hegelians, see Briese 65–77.

3. The *Historische Vorlesungsverzeichnisse der Universität Leipzig* list Weiße teaching aesthetics seven times between 1825 and 1830. In addition, he offers courses on Hegel's system, Hegel's *Encyclopaedia*, and post-Kantian systematic philosophy already in 1825 and 1826.

4. Rosenkranz's study has appeared with publishers Frommann (1968), the Wissenschaftliche Buchgesellschaft (1973, 1979, and 1989), Reclam (1990, 1996, 2007, and 2015), and Inktank (2018).

PART II. The History of Beautiful Ugliness

1. In offering chapters on ancient Greek, medieval, and Renaissance art and literature before moving on to his primary focus on modernity, Ribon, *Archipel de la Laideur*, represents an exception, as does another, earlier French writer Krestovsky, *La Laideur dans l'Art*. Krestovsky, who likewise focuses on modernity, especially French artists, nonetheless includes brief chapters on primitive peoples, the Middle Ages, and the Renaissance. Eco, *On Ugliness*, and Gretchen Henderson, *Ugliness*, provide the richest collections of materials on ugliness across time. Interestingly, Krestovsky, Ribon, and Eco all leave out imperial Rome, presumably because a tendency exists to associate the ugly primarily with nonhuman monsters, which were more pronounced in ancient Greece and medieval Christianity.

2. Trentin, *Hunchback in Hellenistic and Roman Art*, offers a catalogue of fifty-five hunchback representations in Hellenistic and Roman art, mostly miniature statuettes, predominantly male and hyperphallic, and overwhelmingly with caricatured facial features and grotesque expressions.

3. The link between deformity and negative omens was not universal in the ancient world. In Egypt, deformity was viewed favorably, even in some cases "as a mark of divine beneficence" (Sullivan 262).

4. Not only Hölderlin and Nietzsche had this view; so, too, Schiller, who wrote to Goethe on July 7, 1797, that critics torture themselves trying to rhyme "the coarse, often base and ugly nature" of Homer and the tragedians with the concept of "Greek beauty." Schiller pleads, therefore, for elevating "truth in its fullest sense" over "beauty" (*Der Briefwechsel zwischen Schiller und Goethe* 1.359–60), an implicit argument for the value of portraying ugliness.

FOUR. Imperial Rome

1. Fuhrmann's study of gruesome and disgusting motifs in Latin literature ("Die Funktion grausiger und ekelhafter Motive in der lateinschen Dichtung") is compelling and engaging even if he brackets from his study Roman satire.

2. The Old Comedy of Aristophanes, with its critique of Socrates and Euripides as well as political figures and senseless war, has similarities with satire and engages in a satiric spirit; not by chance both Horace (*Satires* 1.4.1)

and Persius (*Satires* 1.123–25) see Aristophanes as a predecessor, and Horace notes that the first satirist, Lucilius, also viewed Old Comedy as a partial model (*Satires* 2.3.12), but Old Comedy is not yet satire as an independent literary genre. In addition, the word "satire" does not originate from the Greek mythological figure of the satyr (even if the two were brought together in a mistaken reception much later). Nor does it arise from the satyr plays that complemented tragedy and were rich in ugliness. Instead, the word "satire" (*satura*) comes from everyday Latin, as in *lanx satura*, literarily, "a full dish" or "heaped plate," as in a platter full of various fruits (Knoche 7–16). Satire is peculiar to Rome, not derivative of Greece, and the only genre of Latin poetry that had a Latin name.

3. The conscious portrayal of ugliness presupposes a split between is and ought. With the exception of Socrates/Plato, such dualism was not pervasive in Greek culture, nor does it surface with a philosopher such as Marcus Aurelius, who was influenced by ancient Greece and by Stoic acceptance. The two new genres in the Roman world are satire, written in Latin, and the meditations of Marcus, written in Greek, the latter involving an emphasis on the self that was mostly foreign to the Greeks. However, whereas the satirist is immersed in the abstract tension between is and ought, Marcus is completely at home with the idea that the world is as it ought to be (Marcus Aurelius, *Meditations* 10.4). The animating idea of satire—that there is a higher measure for this world—only increases with Christianity. So, too, does sensibility for ugliness.

4. In an exhaustive account of imperial Rome's chroniclers of ugliness, Tacitus too could be examined, for in *Agricola* and his two major works, the *Histories* and the *Annals*, all written between 98 and 105 AD, Tacitus exposes the empire's moral decrepitude. Consider, for example, the masterful speech that the Caledonian chieftain Calgacus gives to his troops. He condemns Roman imperialism as brutal and unjust: "The plunderers of the world they have laid waste the land till there is no more left, and now they scour the sea. If a people are rich they are worth robbing, if poor they are worth enslaving; and not the East and not the West can content their greedy maw. They are the only men in all the world whose lust of conquest makes them find in wealth and in poverty equally tempting baits. Robbery, murder, and rape they falsely call empire; they create desolation and call it peace" (*Agricola* 30, translation modified). What makes Tacitus distinctive is not simply his bleak vision and critical account of Roman corruption, but his unnerving psychological acumen, for example, his account of Domitian, who has no inner sense of self-worth, fears being outshone by Agricola, and hates the former British general, for "it belongs to human nature to hate those you have injured" (42, translation modified).

5. The original reads: "cum lassata graui ceciderunt bracchia massa, / callidus et cristae digitos inpressit aliptes / ac summum dominae femur exclamare coegit." *Exclamare* means "to shout or cry out," but what is crying out

here is the top of her thigh. Reinforcing the sexual import, both John Ferguson in his Bristol edition of the Latin text (204) and J. N. Adams in *The Latin Sexual Vocabulary* (98) view *crista* here as an ad hoc metaphor for clitoris. The translation is bold but also accurate.

6. For my analysis of Juvenal's ninth satire, I owe much to the splendid interpretation of S. H. Braund.

7. With reference to grammar and intensity, Juvenal has rightly been called "the satirist of comparatives and superlatives" (Rimell 81).

8. In ancient Rome, an impotent husband could be legitimately divorced, at which time he would also lose his wife's dowry or fortune (Jane Gardner 81, 102). Line 75 alludes to the wife having broken the tablets (*tabulas quoque ruperat*), that is, effectively having torn up the marriage contract (which would have been written on thin tablets of wood) and being ready to leave (until Naevolus stepped in for the rescue).

FIVE. Late Medieval Christianity

1. Christianity shares with Buddhism and Gnosticism an extraordinary elevation of the significance of suffering, but whereas Buddhism and Gnosticism emphasize cessation of suffering, Christianity finds salvation directly in suffering and thus in ugliness. This is a remarkable difference and part of Christianity's distinction within Western history and in relation to other world religions.

2. The slow emergence of the crucifix (and the presentation of a truly suffering Christ) is evident in Church history. Beginning mainly in the thirteenth century, the cross becomes part of the altar, yet only with the Roman Missal of Pius V in 1570 does an altar crucifix become obligatory.

3. Other prominent examples of Gothic fork crosses that express brutal agony can be found in the Basilica of St. Severin and the Basilica of St. Georg in Cologne and in the Cologne Cathedral, which contains the famous Gero Crucifix, possibly the first crucifix to portray Christ with his eyes closed. For the wider context and further analysis of the fork cross, see Hoffmann, *Das Gabelkreuz in St. Maria im Kapitol.*

4. Devotional images of Christ did not always accentuate Christ's extreme suffering. In his *Christ Crowned with Thorns* (1495–1500), for example, Hieronymus Bosch portrays Christ calmly looking at the viewer, modeling composure in the face of adversity. The primary purpose of this comparatively undramatic *imitatio Christi* is not to show Christ identifying with our suffering but instead to encourage viewers to strive toward Christ's model composure (Gibson 92). Thus, in this painting we recognize the double meaning of the thorns: even as Christ's abusers seek to inflict suffering and

humiliation, the thorns form a crown and a halo (Koerner, *Bosch and Bruegel* 148). In the twentieth century, Paul Klee works with an analogous structure, cleverly showing in *Attempt at Mocking* (1940) a direct image of Christ, composed and dignified under adversity, as the figures who mock him are given disordered profiles. They, not Christ, deserve and receive our scorn. Like Bosch, Klee exhibits range, creating also in his final year a pain-filled and tearful Christ in *ecce*.... (1940).

5. If there is a model for Altdorfer's crucifixion, the most likely source, because of greater geographical proximity and the common element of blood running down the entire body, would be Jörg Breu's *Crucifixion* of 1501 from the Aggsbacher Altar (Winzinger 87).

6. Consider the robbers' extended, pain-ridden fingers in Gabriel Angler's *The Crucifixion of Christ. Tabula Magna Altarpiece* (1444–45); Lucas Cranach the Elder's *The Lamentation of Christ* (*The Schleißheim Crucifixion*) (1503); and Hans Baldung Grien's *Crucifixion of Christ* (1512). In Grünewald's other crucifixions—in Karlsruhe; Washington, DC; and Basel—we again see the extended fingers. The head of Christ in Grünewald's *Christ Bearing the Cross* (1523–25), which is housed in Karlsruhe, with Christ collapsing in despair and anguish, has been described by Heinrich Alfred Schmid as "surely one of the ugliest in all Christian art" (2.235).

7. The flatterers' punishment is superbly captured in Sandro Botticelli's ink and tempera illustration for *Inferno* 18, a reproduction of which is available in Clark, *The Drawings by Sandro Botticelli* 49.

8. The human preference for order derives presumably already from evolutionary biology and has been effectively explored by Gombrich, *The Sense of Order*. In *Heaven and Hell in Western Art*, Hughes offers rich images of heaven and hell, which underscore the contrast between order and chaos.

SIX. The Theological Rationale for Christianity's Immersion in Ugliness

1. Although the idea of one God being reflected in, and embracing, all of humanity led Christianity over time to conceptualize and defend universal dignity and human rights, the Catholic Church has of course not always acted in accordance with those ideals. In the fifteenth century, for example, Popes Nicholas V and Alexander VI authorized slavery in the Portuguese and Spanish territories (Noonan 62–67); in advance of the U.S. Civil War, most American Catholics resisted the case for the abolition of slavery (McGreevy 43–67); and even today women are unjustly subordinate within the Church.

2. Reprehensible uses of the cross further underscore that the idea and history of Christianity are not one and the same. During the Crusades, "tak-

ing up the cross" was associated with hatred (and violence) toward Jews and Muslims (Jensen, *The Cross* 170–76). More recently, one thinks of the fiery crosses of the Ku Klux Klan and the contemporary white supremacist version of the Celtic cross.

3. The passage survives in Latin, not in Greek.

4. On the Old Testament prefiguration of Passion iconography, especially in Germany, see Marrow, *Passion Iconography in Northern European Art of the Late Middle Ages and Early Renaissance*.

5. In Mark, only the demons (1:24) and the centurion (15:39) fully grasp the meaning of Christ.

6. A nonexhaustive list of the disciples' failure to understand would include the following passages from the Gospel of Mark: 4:13, 6:52, 7:18, 8:17, 8:21, 9:32. In contrast, the Evangelist hopes that the reader will understand (13:14).

7. Other catalysts for infant exposure, beyond deformity, were illegitimacy, poverty, evil omens, and despair (Harris).

8. My explication of Christ as female and as mother, including the examples, derives from Bynum, *Fragmentation* chaps. 3–6, and *Jesus as Mother* chap. 4.

9. I agree with Hegel's general point that the conceptual importance of evil ascends in Christianity, but exceptions exist in ancient Greece, for example, Creon in *Oedipus at Colonus* or Callicles in Plato's *Gorgias*. A further anomaly within the dominant Greek harmony of knowledge and virtue, intelligence and goodness is Plato's comment in the *Republic* that there exist smart but evil men whose intelligence only increases their mischievousness (519a). As with most generalizations, complexity lies below the surface even if the general trend is clear.

10. Rigby analyzes original sin in the *Confessions*. Toews, *Story of Original Sin*, offers a broader account of original sin, including a brief history and critical comments from the perspective of a theologian. For a philosophical analysis of sin, including original sin, see Mellema, *Sin*.

11. Though knowledge and action are almost universally linked in Socrates/Plato, we see the hint of something like a concept of will or weak will arise in the *Republic* when Leontius's eyes pull his body, seemingly against his own thoughts, toward the vision of a corpse (439e–440a).

12. Cf. the analogous comments in 1 Corinthians 15:21–22: "For since death came through a human being, the resurrection of the dead has also come through a human being; for as all die in Adam, so all will be made alive in Christ."

13. See 2.783, 2.931, 3.321, 3.561, and 3.595. Also Juvenalian is the explicit attack on Rome and the extended misogyny.

Historical Interlude

1. Alexander Lee's *The Ugly Renaissance* tries to reveal the underside of the Renaissance by addressing sex, greed, violence, and depravity, but his focus is not artwork aesthetics. Works from the Italian Renaissance that integrate ugliness, such as Leonardo's grotesque heads or Masaccio's fresco *Saint Peter Healing the Sick with His Shadow* (1425), are relatively rare.

2. Although Goethe associates Hugo with a kind of blasphemy, Hugo himself thought his integration of ugliness deeply Christian. With some of his predecessors, Hugo shares the idea that Christianity fosters an aesthetic revolution: Christianity recognizes connections between the beautiful and the ugly and brings forward a form of art in which "the ugly" and "the grotesque" play prominent roles (*Préface* 21–22; "Preface" 362–63). For Hugo, in contrast to Alberti, the task of art is not to select, correct, or ennoble nature but to show it in a kind of "concentrating mirror" (un miroir de concentration) (*Préface* 60; "Preface" 386). Thus art integrates "the deformed, the ugly, the grotesque" (*Préface* 40; "Preface" 374).

3. Goethe writes: "It is a literature of despair, from which by degrees everything true, everything aesthetic, is banished. Victor Hugo's *Notre Dame de Paris* captivates the reader by the good use he makes of his diligent study of old localities, customs, and events; but in the figures who act there is no trace of natural life. These inanimate male and female figures are constructed according to very correct proportions, but except for their wooden and iron skeletons, they are nothing but stuffed limbs and puppets, which the author treats in the most merciless manner, turning and twisting them into the strangest positions, torturing and lashing them, mangling them physically and mentally—though indeed they have no real body, mercilessly tearing them to shreds, and ripping them into rags; yet all of this occurs with decided historical-rhetorical talent, and it cannot be denied, that the author possesses a vivid imagination, for without it he never could produce such abominations" (*Briefwechsel* 3.436; Eng. 457–58, translation modified).

4. Simon Richter's *Laocoön's Body and the Aesthetics of Pain* underscores the extent to which pain, a form of physical and emotional ugliness, should not be underplayed in classical aesthetics. Goethe and Schiller are too complex for an either/or reading of beauty or ugliness even if both were cautious about giving ugliness the final word.

SEVEN. Modernity

1. The story of the ugly emerging and becoming prominent in modernity is not uncharted territory, nor is modernity's abandonment of classical

aesthetics or its rejection of Christianity as an all-encompassing worldview. A vast literature exists on modernity's "celebration of ugliness" (Higgins 2), including Krestovsky, *Le problème*; Gagnebin; Kleine; Engelmann; and Bayley. The story of modern ugliness surfaces also in books in which ugliness is not primary—from older general books by Mario Praz and Hans Sedlmayer to newer general works by Wendy Steiner, Anthony Julius, Lesley Higgens, and Peter-André Alt. In addition, accounts of ugliness surface indirectly in detailed studies of specific art forms (such as Hugo Friedrich on modern lyric), diverse cultures (such as Linda Worley on nineteenth-century German literature and Charlotte Wright on contemporary American literature), and individual authors and artists (such as Christoph Eykman on Heym, Trakl, and Benn). Whatever one thinks of the overarching evaluations and individual analyses, these diverse studies offer ample evidence of the move toward ugliness, including the rise of disjointed forms, portrayals of pathologies, and emphasis on moral ugliness. The modern and contemporary elevation of dissonance is recognizable whether one speaks of naturalism, expressionism, Dada, or later movements.

2. On the development of caricature, see McPhee and Orenstein, *Infinite Jest*, and Hofmann.

3. In analogous fashion, Kara Walker exhibits indirect resistance to the instrumental structure of slavery; in *The End of Uncle Tom and the Grand Allegorical Tableau of Eva in Heaven* (1995) she depicts female slaves in erotic relations with one another.

4. For details on the Grosz trials, see Schuster 167–74.

5. The dearth of evaluation is striking. Maxwell Anderson, a former museum director who anomalously argues for evaluation, laments that many art historians "run from judgment" (37). The tendency to discuss production and reception context instead of evaluating works is widespread (Lewis 12). Intellectual historians, such as Eco, catalogue ugly images and provide context, but do not evaluate them (*On Ugliness*). Representative of many literary critics, Alt is consciously nonevaluative, simply chronicling cases of moral ugliness (29). Some analytic philosophers who approach ugliness circumvent the puzzle by avoiding examples altogether. Sibley, for example, focuses exclusively on semantic theory. The issue is not restricted to the academy. In a 2002 survey of art critics at general-interest news publications, the two items ranked lowest in terms of emphasis were theorizing about the meaning of the works and rendering judgments. The highest-ranked activity was description (Szántó 27). However, when it comes to classic works, by thinkers such as Hegel, Rosenkranz, Sedlmayr, Gehlen, and Adorno, each of whom is radically different, we find not only description and analysis but also evaluation.

6. Scholarly interest in kitsch, both historical and theoretical, has increased in recent decades. Broch is justifiably the starting point for most studies. A reasonable attempt at a conceptual analysis of kitsch, even if I

would not agree with all of his claims, is Kulka, *Kitsch and Art*. Among other studies, I would name works by Giesz and by Beylin for helpful orientation and by Dorfles and by Killy for examples.

EIGHT. Modernity's Ontological and Aesthetic Shift

1. Arguably the best brief analysis of the dissolution of Christianity is in Hösle, *Die Krise* 48–58, on which I partly draw in this paragraph.

2. One strategy to rescue the view of evil as privation would be to distinguish between a wider metaphysical frame which suggests that in the long run even evil will be unveiled as part of a larger pattern in which it justifiably and ultimately benefits the whole and a narrower view according to which (1) evil is characterized empirically by its activity, not its privation (cruelty, for example, is not simply an absence of kindness) and (2) its ultimate logic or justification is not one that we can empirically grasp. Yet this tension and the inability of the privation theory to offer any kind of satisfactory empirical account of evil is so great that one understands why the view has so few contemporary adherents.

3. In emphasizing the autonomy of the arts, I am articulating a general trend. There are of course exceptions, such as the Bauhaus elevation of unity and integration and Frank Lloyd Wright's concept of organic architecture.

4. Much of the novel's early criticism attacked Wilde's novel using the moral criteria of the age, a mode of criticism Wilde sought to counter in his preface. More recent criticism has for the most part moved away from the relation of the ethical and the aesthetic and the puzzle of the ending. Instead, it has focused on historical and cultural context as well as identity studies, including Irish studies and gay studies. A partial overview of trends and a sampling of recent essays are available in Philip Smith, *Approaches to Teaching the Works of Oscar Wilde*, but any approach is almost forced to comment to some degree on the ending, even if only in passing, for example, in Smith 58–59 and 71. The novel's ambiguity is addressed in broad strokes by Gillespie, *The Picture of Dorian Gray*, who devotes, however, little attention to two central puzzles, the conclusion and the relation of preface and story. For a recent and engaging ethical reading of the novel, which integrates moral psychology, see Profit, *The Devil Next Door*. Alas, Profit does not address the tension of the ethical and aesthetic, which is core to any comprehensive reading. The one work that is most focused on the ending and its relation to the preface is, interestingly, not by a literary critic, but by a philosopher, McGinn, *Ethics, Evil, and Fiction*, who argues for a moral (and nonambiguous) reading of the novel.

5. McGinn argues that Dorian becomes the painting, which is certainly symbolically true, as Dorian does not exhibit any aging, but it is difficult

to see how it could be literally true, and it hardly solves the complexity of the conclusion, which requires a magical or numinous moment to resolve the transformation either way (*Ethics, Evil, and Fiction* 128–43). According to McGinn, when Dorian stabs "the picture" (212), he stabs himself, not the painting, but in either case, the two are one, and the picture and the body need magically to exchange places.

PART III. Forms of Beautiful Ugliness

1. Few Western theorists have endeavored to conceptualize types of ugliness. The list is exhausted by the sixteenth-century Italian Vincenzo Maggi and two Hegelians, Bohtz and Rosenkranz, none of whom offer a consistent logical or structural rationale for their categories. The Indian philosopher Arindam Chakrabarti also seeks to understand types of beautiful ugliness and is in some ways the closest to my study. Chakrabarti introduces "six different modes of absorbing disgust and ugliness within a positive art-experience" (159). His modes include (1) justified disgust, (2) disgust as a shocking contrast to beauty, (3) reduction to the ridiculous, (4) ugliness overcome by heroism or love, (5) a serene sense of the vanity of earthly pleasures and earthly life, and (6) absorption of the hideous as part of a desire to understand and experience every fold of embodied existence. The strengths of Chakrabarti's analysis include his desire to understand the diverse ways in which the ugly is absorbed into the beautiful and his inclusion of a range of examples from Indian culture. The types, however, seem to be selected by way of heterogeneous categories. A systematic structure is not evident. Modes (1) and (6) address the realm of production; (2) would seem to apply in some degree to all instances of beautiful ugliness; (3), (4), and (5) suggest diverse ways in which one can deal with, but also overcome, ugliness.

NINE. Repugnant Beauty

1. We do not know whether Dante knew Bernard of Cluny, but Bernard not only anticipates many of the torments in Dante's *Inferno*, he also raises the issue of human silence before "the joys of the blessed" and "the woes of the wicked" (1.498–99).

2. The emphasis on the body that is visible especially, but not only, among Catholic or formerly Catholic artists has as one of its origins the suffering Christ. The fascination is further linked to the Virgin Mary, who is venerated for her roles as mother and virgin, an otherwise impossible bodily combination.

3. Austrian novelist Joseph Roth thought *The Last Laugh* "one of the best films not just of Germany but of the world" (2:327). In the United States, "the almost universal decision of Hollywood" was that this was "the greatest picture ever made" (Eisner 167). Hitchcock, who was on the set, called *The Last Laugh* "almost the perfect film" (Spoto 68).

TEN. Fractured Beauty

1. As with most generalizations, exceptions exist. In *Guernica*, Picasso draws on cubist shapes to effect his political message.

THIRTEEN. Dialectical Beauty

1. Alberti's avoidance of, or idealization of, ugliness fits very well with the classical and idealizing tendencies of the Italian high Renaissance (Wölf-flin, *Die klassische Kunst*), but they are for the most part left behind, as we move toward modernity, even if a small number of anomalies exist, such as Franz Marc's turn to abstraction as a mode of circumventing ugliness (141).

2. *In Memory of the Catholic Victims of Fascism!* . . . (1937) is another photomontage that draws on the cross. It is unusual in being not mocking, but religious and even moving—and for that no less persuasive as a warning. At the bottom is a statue of the tormented, suffering Christ; above is text in the form of a cross that details the Nazi destruction of Catholic churches and other Catholic buildings, such as convents and hospitals, and the numbers of Catholic victims at various locations during the Spanish Civil War. Since the image is otherwise rarely reproduced and not readily available on the internet, I note that it can be found in Pachnicke and Honnef (177).

3. The Anthony Burgess novel on which Kubrick's film is based has two different endings, an original ending and an American version, which left off the final chapter, chapter 21, in which the hero seeks to reform himself. Kubrick's film follows the darker American version.

FOURTEEN. Speculative Beauty

1. In Roche, *Tragedy and Comedy*, I give a lengthy analysis of the drama of reconciliation, with literary and cinematic examples and a discussion of the remarkably modest literature on the topic (247–89).

2. In my eyes, the most compelling interpretations of *Oedipus at Colonus* are Whitman and Hösle (*Die Vollendung*), on whose readings I partly draw.

3 Theognis 425–28; Herodotus 1.31 and 5.4; and Euripides, fragments 285, 449, 452, 908 in *Tragicorum Graecorum Fragmenta*.

4. See Origen, *On First Principles* 1.6.1–4 and 3.6.1–9. In 553, the Second Council of Constantinople condemned Origen's concept of universal restoration or the restitution of all (*apokatastasis panton*) as heretical. Origen's speculative idea partly animated Hölderlin (in his late hymns) and Goethe (at the end of *Faust II*).

5 Schiller's first version of "Ode to Joy," the second version of which is integrated into the Beethoven's Ninth Symphony as a symbol of universal embrace, includes lines that go perhaps as far as any in the direction of the speculative, as they echo the *apokatastasis panton*: "Allen Sündern soll vergeben / Und die Hölle nicht mehr sein" (All sinners shall be forgiven, / And hell shall be no more) (Schiller, *Werke und Briefe* 1:413).

6. Another counterexample to Lessing is the intriguing idea that in the temporal arts a reverse movement is possible and in modernity present: instead of a moment of ugliness embedded within the arc of a positive whole, any of the temporal arts can portray moments of beauty that are swallowed up within a narrative whole defined by ugliness. In Jooss's *Green Table*, the beauty and sacrifice of the soldiers and their loved ones are framed on both sides by ugly and futile peace negotiations.

7. Not surprisingly, given the infrequency of speculative beauty in modernity, the idea that tragedy might gesture toward harmony recedes after Hegel. Rare is the modern theory of tragedy that sees in the genre even a glimmer of reconciliation or rational order.

8. The significance of discovering neglected moments in earlier attempts at synthesis is a central dimension of Roche, *Dynamic Stillness*; see esp. 121–23.

Conclusion

1. For a study of music and sounds in Dante's *Commedia*, see Hammerstein, "Die Musik."

Abelard, Peter. *Epitome theologiae christianae.* Edited by F. H. Rheinwald. Berlin: Herbig, 1835.

Abrams, M. H. *Natural Supernaturalism: Tradition and Revolution in Romantic Literature.* New York: Norton, 1973.

Ackermann, Tim. "'Wir hatten einfach keine Vorbilder mehr!'" *Die Zeit,* March 31, 2015. https://www.zeit.de/kultur/kunst/2015-03/zero-kunst-avantgarde-heinz-mack.

Adams, J. N. *The Latin Sexual Vocabulary.* Baltimore: Johns Hopkins University Press, 1993.

Adorno, Theodor W. *Ästhetische Theorie.* Frankfurt: Suhrkamp, 2003.

———. *Aesthetic Theory.* Translated by Robert Hullot-Kentor. Minneapolis: University of Minnesota Press, 1997.

———. "Cultural Criticism and Society." In *Prisms,* translated by Samuel Weber and Shierry Weber, 17–34. Cambridge, MA: MIT Press, 1981.

———. "Kulturkritik und Gesellschaft." In *Kulturkritik und Gesellschaft I,* 11–30. Frankfurt: Suhrkamp, 2003.

———. *Minima Moralia: Reflexionen aus dem beschädigten Leben.* Frankfurt: Suhrkamp, 1969.

———. *Negative Dialectics.* Translated by E. B. Ashton. New York: Continuum, 1973.

———. *Negative Dialektik.* Frankfurt: Suhrkamp, 1982.

———. *Noten zur Literatur.* Frankfurt: Suhrkamp, 2003.

———. *Notes to Literature.* 2 vols. Translated by Shierry Weber Nicholsen. New York: Columbia University Press, 1991–92.

———. *Philosophy of Modern Music.* Translated by Anne G. Mitchell and Wesley V. Blomster. New York: Seabury, 1973.

Akin, Fatih. "The Making of The Edge of Heaven." In *The Edge of Heaven,* 2007. Culver City, CA: Strand Releasing, 2008.

Alberti, Leon Battista. *On Painting*. Translated by Cecil Grayson. New York: Penguin, 1991.

Alexander, Christopher, and Peter Eisenman. "Contrasting Concepts of Harmony in Architecture: Debate between Christopher Alexander and Peter Eisenman." *Lotus International* 40, no. 21 (1983): 60–68.

Alphen, Ernst van. *Francis Bacon and the Loss of Self*. Cambridge, MA: Harvard University Press, 1993.

Alt, Peter-André. *Ästhetik des Bösen*. Munich: Beck, 2010.

Anderson, Maxwell L. *The Quality Instinct: Seeing Art through a Museum Director's Eye*. Washington, DC: American Alliance of Museums, 2012.

Anderson, William. "The Programs of Juvenal's Later Books." *Classical Philology* 57 (1962): 145–60.

Ankori, Gannit. *Palestinian Art*. London: Reaktion, 2006.

Anselm. *The Prayers and Meditations of St. Anselm with the "Proslogion."* New York: Penguin, 1973.

Aragon, Louis. "John Heartfield and Revolutionary Beauty." In *Photography in the Modern Era: European Documents and Critical Writings, 1913–1940*, edited by Christopher Phillips, 60–67. New York: Metropolitan Museum of Art, 1989.

Aristophanes. *The Clouds*. In *The Trials of Socrates*, edited by C. D. C. Reeve, 88–176. Indianapolis: Hackett, 2002.

Aristotle. *The Basic Works of Aristotle*. Edited by Richard McKeon. New York: Random House, 1941.

Arnheim, Rudolf. "The Rationale of Deformation." *Art Journal* 43 (1983): 319–24.

Artusi, G. M. "From L'Artusi, ovvero, Delle imperfezioni della moderna musica [1600]." In *Source Readings in Music History: From Classical Antiquity through the Romantic Era*, edited by Oliver Strunk, 393–404. New York: Norton, 1950.

Ashton, Dore. *Picasso on Art: A Selection of Views*. New York: Viking, 1972.

Athanassoglou-Kallmyer, Nina. "Ugliness." In *Critical Terms for Art History*, 2nd ed., edited by Robert S. Nelson and Richard Schiff, 281–95. Chicago: University of Chicago Press, 2003.

Auerbach, Erich. *Mimesis: The Representation of Reality in Western Literature*. Translated by Willard R. Trask. Princeton, NJ: Princeton University Press, 1968.

———. "*Sermo humilis*." *Romanische Forschungen* 64 (1952): 304–64.

Augustine, Saint. *Opera Omnia. Corpus Augustinianum Gissense*. Edited by Dr. Cornelius Mayer. Basel: Schwabe, 1995.

———. *The Works of Saint Augustine: A Translation for the 21st Century*. Edited by Boniface Ramsey. New York: New City Press, 1990–.

Babbitt, Milton. "Who Cares If You Listen?" *High Fidelity* 8, no. 2 (1958): 38–40, 126–27.

Bachmetjevas, Victoras. "The Ugly in Art." *Man and the Word* 9 (2007): 29–34.

Baker, Naomi. *Plain Ugly: The Unattractive Body in Early Modern Literature.* Manchester: Manchester University Press, 2010.

Bakewell, Liza. "Frida Kahlo: A Contemporary Feminist Reading." *Frontiers: A Journal of Women Studies* 13, no. 3 (1993): 165–89.

Bakhtin, Mikhail. *Rabelais and His World.* Translated by Hélène Iswolsky. Bloomington: Indiana University Press, 1984.

Ball, Hugo. *Flight out of Time: A Dada Diary.* Edited by John Elderfield. Translated by Ann Raimes. New York: Viking, 1974.

———. *Die Flucht aus der Zeit.* Lucerne: Stocker, 1946.

———. *Gedichte.* Edited by Eckhard Faul. Göttingen: Wallstein, 2007.

Balthasar, Hans Urs von. *The Glory of the Lord: A Theological Aesthetics.* 7 vols. Translated by Erasmo Leiva-Merikakis et al. San Francisco: Ignatius, 1983–1991.

———. *Herrlichkeit: Eine theologische Ästhetik.* 3 vols. Einsiedeln: Johannes Verlag, 1961–69.

Barratt, Andrew. *Between Two Worlds: A Critical Introduction to "The Master and Margarita."* Oxford: Clarendon, 1987.

Barron, Stephanie. *Degenerate Art: The Fate of the Avant-Garde in Nazi Germany.* New York: Abrams, 1991.

Barth, Karl. *Briefe:1961–1968.* Edited by Jürgen Fangmeier and Hinrich Stoevesandt. Zürich: Theologischer Verlag, 1979.

———. *Church Dogmatics.* Vol. 2/1, *The Doctrine of God.* Edinburgh: Clark, 1957.

———. *Die kirchliche Dogmatik.* Vol. 2/1, *Die Lehre von Gott.* Zurich: Theologischer Verlag, 1980.

———. *Letters: 1961–1968.* Edited by Jürgen Fangmeier and Hinrich Soevesant. Grand Rapids, MI: Eerdmans, 1981.

Baselitz, Georg. *Georg Baselitz.* Cologne: Benedikt, 1990.

Baudelaire, Charles. *Flowers of Evil.* Translated by James McGowan. New York: Oxford, 1993.

———. *Œuvres complètes.* 2 vols. Paris: Gallimard, 1975–1976.

Baudez, Claude-François. "Beauty and Ugliness in Olmec Monumental Sculpture." *Journal de la Société des Américanistes* 98 (2012): 7–31.

Baumgarten, Alexander Gottlieb. *Aesthetica.* 2 vols. Hamburg: Meiner, 2007.

Bayley, Stephen. *Ugly: The Aesthetics of Everything.* New York: Overlook, 2012.

———. "The Ugly Truth." *The Architectural Review* 233, no. 1392 (2013): 22–23.

Beardsley, Monroe C. *Aesthetics: Problems in the Philosophy of Criticism.* 1958. Indianapolis: Hackett, 1981.

Bellandi, Franco. "Naevolus cliens." In *Persius and Juvenal*, edited by Maria Plaza, 469–505. Oxford: Oxford University Press, 2009.

Belting, Hans. *Hieronymous Bosch: Garden of Earthly Delights*. New York: Prestel, 2002.

Benedict XVI. "Meeting with Artists" (November 21, 2009). Vatican City: Libreria Editrice Vaticana. https://www.vatican.va/content/benedict-xvi/en /speeches/2009/november/documents/hf_ben-xvi_spe_20091121 _artisti.html.

Benjamin, Walter. *The Work of Art in the Age of Its Technological Reproducibility, and Other Writings on Media*. Edited by Michael W. Jennings, Brigid Doherty, and Thomas Y. Levin. Cambridge, MA: Harvard University Press, 2008.

Benn, Gottfried. *Prose, Essays, Poems*. Edited by Volkmar Sander. New York: Continuum, 1987.

———. *Sämtliche Werke: Stuttgarter Ausgabe*. 7 vols. Edited by Gerhard Schuster. Stuttgart: Cotta, 1986–2003.

Bernard of Clairvaux. *The Steps of Humility and Pride*. Kalamazoo, MI: Cistercian, 1989.

Bernard of Cluny. *Scorn for the World: Bernard of Cluny's "De contemptu mundi": The Latin Text with English Translation and an Introduction*. Edited by Ronald E. Pepin. East Lansing, MI: Colleagues Press, 1991.

Bernstein, Leonard. *The Unanswered Question: Six Talks at Harvard*. Cambridge, MA: Harvard University Press, 1976.

"The Best of the Century." *Time*, December 31, 1999, 73–77. http://content .time.com/time/magazine/article/0,9171,36533,00.html.

Bettella, Patrizia. *The Ugly Woman: Transgressive Aesthetic Models in Italian Poetry from the Middle Ages to the Baroque*. Toronto: University of Toronto Press, 2005.

Beylin, Pawel. "Der Kitsch als ästhetische und außerästhetische Erscheinung." In *Die nicht mehr schönen Künste: Grenzphänomene des Ästhetischen*, edited by Hans Robert Jauß, 393–406. Munich: Fink, 1968.

Boethius. *The Consolation of Philosophy*. Translated by Victor Watts. New York: Penguin, 1999.

Bohtz, August Wilhelm. *Ueber das Komische und die Komödie: Ein Beitrag zur Philosophie des Schönen*. Göttingen: Vandenhoeck, 1844.

Boltanski, Christian, and Tamar Garb. "Interview." In *Christian Boltanski*, 8–37. London: Phaidon, 1997.

Boltanski, Christian, and Catherine Grenier. *The Possible Life of Christian Boltanski*. Translated by Marc Lowenthal. Boston: Museum of Fine Arts, 2009.

Bonaventure. *The Tree of Life*. In *Bonaventure: "The Soul's Journey into God," "The Tree of Life," "The Life of St. Francis,"* translation and introduction by Ewert Cousins, 117–75. New York: Paulist, 1978.

Bosanquet, Bernard. *A History of Aesthetic.* New York: Macmillan, 1892.

———. *Three Lectures on Aesthetic.* London: Macmillan, 1915.

Boulboullé, Guido. "Groteske Angst: Die Höllenphantasien des Hieronymus Bosch." In *Glaubensstreit und Gelächter: Reformation und Lachkultur im Mittelalter und in der Frühen Neuzeit,* edited by Christoph Auffarth and Sonja Kerth, 55–78. Berlin: LIT, 2008.

Boylan, Alexis L., ed. *Thomas Kinkade: The Artist in the Mall.* Durham, NC: Duke University Press, 2011.

Braund, S. H. *Beyond Anger: A Study of Juvenal's Third Book of Satires.* Cambridge: Cambridge University Press, 1988.

Brecht, Bertolt. *Ausgewählte Werke in sechs Bänden.* Frankfurt: Suhrkamp, 2005.

———. "Die Dialektik." In *Gesammelte Werke in 20 Bänden,* edited by Suhrkamp Verlag in collaboration with Elisabeth Hauptmann, 19:394–95. Frankfurt: Suhrkamp, 1967.

———. "The Drowned Girl." Translated by Richard Moore. *American Poetry Review* 20, no. 2 1991: 9. http://www.jstor.org/stable/27780326.

———. "Die Künste in der Umwälzung." In *Gesammelte Werke in 20 Bänden,* 19:483–555. Frankfurt: Suhrkamp, 1967.

———. *The Threepenny Opera.* Translated by Ralph Manheim and John Willett. New York: Methuen, 1979.

Der Briefwechsel zwischen Schiller und Goethe in drei Bänden. 3 vols. Edited by Hans Gerhard Gräf and Albert Leitzmann. Leipzig: Insel, 1912.

Briese, Olaf. *Konkurrenzen. Philosophische Kultur in Deutschland 1830–1850: Porträts und Profile.* Würzburg: Königshausen, 1998.

Brintnall, Kent. *Ecce Homo: The Male-Body-in-Pain as Redemptive Figure.* Chicago: University of Chicago Press, 2011.

Broch, Hermann. "Das Böse im Wertsystem der Kunst." In *Schriften zur Literatur,* Vol. 2, *Theorie,* 119–57. Frankfurt: Suhrkamp, 1975.

———. *The Sleepwalkers.* Translated by Willa and Edwin Muir. San Francisco: North Point, 1985.

Brod, Max. *Über die Schönheit häßlicher Bilder: Essays zu Kunst und Ästhetik.* 1913. Göttingen: Wallstein, 2014.

Bronfen, Elisabeth, and Beate Neumeier, eds. *Gothic Renaissance: A Reassessment.* Manchester: Manchester University Press, 2014.

Brown, Frederick. *For the Soul of France: Culture Wars in the Age of Dreyfus.* New York: Knopf, 2010.

Brown, Raymond E. *The Death of the Messiah: From Gethsemane to the Grave.* 2 vols. New York: Doubleday, 1994.

Brueggemann, Walter. *The Message of the Psalms: A Theological Commentary.* Minneapolis: Augsburg, 1984.

Brus Muehl Nitsch Schwarzkogler: Writings of the Vienna Actionists. Edited and translated by Malcom Green. London: Atlas, 1999.

Büchner, Georg. *Complete Works and Letters.* Translated by Henry J. Schmidt. New York: Continuum, 1986.

———. *Sämtliche Werke.* 2 vols. Edited by Henri Poschmann. Frankfurt: Deutscher Klassiker Verlag, 1992.

Bückling, Maraike. "Character Heads: Catalogue nos. 4–23." In *The Fantastic Heads of Franz Xaver Messerschmidt,* edited by Maraike Bückling, 105–212. Frankfurt: Liebieghaus, 2006.

Bulgakov, Mikhail. *The Master and Margarita.* Translated by Richard Pevear and Larissa Volokhonsky. New York: Penguin, 1997.

Bultot, Robert. *Christianisme et valeurs humaines.* 2 vols. Louvain: Éditions Nauwelaerts, 1963–64.

Bürger, Peter. *Theory of the Avant-Garde.* Translated by Michael Shaw. Minneapolis: University of Minnesota Press, 1984.

Burke, Edmund. *A Philosophical Enquiry into the Origin of Our Ideas of the Sublime and Beautiful.* Edited by Adam Phillips. New York: Oxford University Press, 1990.

Bynum, Caroline Walker. *Fragmentation and Redemption: Essays on Gender and the Human Body in Medieval Religion.* New York: Zone, 1991.

———. *Jesus as Mother: Studies in the Spirituality of the High Middle Ages.* Berkeley: University of California Press, 1982.

Calvin, John. *Institutio Christianae religionis.* Edited by A. Tholuck. Berolini: Eichler, 1834–1835.

———. *The Institution of Christian Religion.* Translated by Thomas Norton. London: Hatfield, 1599.

Carmichael, Peter A. "The Sense of Ugliness." *Journal of Aesthetics and Art Criticism* 30, no. 4 (1972): 495–98.

Carrière, Moriz. *Aesthetik: Die Idee des Schönen und ihre Verwirklichung im Leben und in der Kunst.* 2 vols. 3rd ed. Leipzig: Brockhaus, 1885.

———. *Das Wesen und die Formen der Poesie: Ein Beitrag zur Philosophie des Schönen und der Kunst. Mit literarhistorischen Erläuterungen.* Leipzig: Brockhaus, 1854.

Carter, Barry. "Controversial Painting in Newark Library Is Bared Once Again." *Newark Star-Ledger,* January 20, 2013.

Catechism of the Catholic Church. Rev. ed. London: Chapman, 1999.

Celan, Paul. *Poems of Paul Celan.* Translated by Michael Hamburger. New York: Persea, 2002.

Celant, Germano. *Anselm Kiefer.* Milan: Skira, 2007.

Chakrabarti, Arindam. "Refining the Repulsive: Toward an Indian Aesthetic of the Ugly and the Disgusting." In *Indian Aesthetics and the Philosophy of Art,* edited by Arindam Chakrabarti, 149–65. New York: Bloomsbury, 2016.

Chapman, Jake. "Interview (with White Cube) on Themes Behind 'Hell' and Its Successor." Video. *Guardian*, June 16, 2015. https://www.theguardian.com/artanddesign/video/2015/jun/16/jake-dinos-chapman-fucking-hell-video.

Charlton, W. "Moral Beauty and Overniceness." *British Journal of Aesthetics* 20 (1980): 291–304.

Cinotti, Mia, ed. *The Complete Paintings of Bosch*. New York: Abrams, 1966.

Clark, Kenneth. *Civilisation: A Personal View*. New York: Harper, 1969.

———. *The Drawings by Sandro Botticelli for Dante's "Divine Comedy."* London: Thames, 1976.

Claudius, Matthias. *Werke in einem Band*. Edited by Uwe Lassen. Hamburg: Hoffmann, n.d.

Cobb, Stephanie L. *Divine Deliverance: Pain and Painlessness in Early Christian Martyr Texts*. Berkeley: University of California Press, 2016.

Cocker, Jack. *Anselm Kiefer: Remembering the Future*. BBC Documentary, November 18, 2014. https://player.vimeo.com/video/112053965?h=2aa0c5e6f2.

Cohen, Deborah. *The War Come Home: Disabled Veterans in Britain and Germany, 1914–1939*. Berkeley: University of California Press, 2001.

Cohen, Hermann. *Ästhetik des reinen Gefühls*. 2 vols. Berlin: Cassirer, 1912.

Comaroff, Joshua, and Ong Ker-Shing. *Horror in Architecture*. New York: ORO, 2013.

Cone, James H. *The Cross and the Lynching Tree*. Maryknoll, New York: Orbis, 2011.

———. *The Spirituals and the Blues: An Interpretation*. New York: Seabury, 1972.

Connelly, Frances S. *The Grotesque in Western Art and Culture: The Image at Play*. Cambridge: Cambridge University Press, 2012.

———, ed. *Modern Art and the Grotesque*. Cambridge: Cambridge University Press, 2003.

Cook, John W. "Ugly Beauty in Christian Art." In *The Grotesque in Art & Literature: Theological Reflections*, edited by James Luther Adams and Wilson Yates, 125–41. Grand Rapids, MI: Eerdmans, 1997.

Cotton, Nicola. "Norms and Violations: Ugliness and Abnormality in Caricatures of Monsieur Mayeux." In *Histories of the Normal and the Abnormal: Social and cultural histories of norms and normativity*, edited by Waltraud Ernst, 122–41. New York: Routledge, 2006.

Cotton, Nicola, and Mark Hutchinson, ed. *Nausea: Encounters with Ugliness*. Nottingham: Djanogly Art Gallery, 2002.

Courtney, Edward. *A Commentary on the Satires of Juvenal*. London: Athlone, 1980.

Csuri, Charles. *Charles A. Csuri Project*. Columbus: Ohio State University. https://csuriproject.osu.edu/.

Dahlhaus, Carl. *The Idea of Absolute Music*. Translated by Roger Lustig. Chicago: University of Chicago Press, 1989.

Danchev, Alex. *100 Artists' Manifestos: From the Futurists to the Stuckists*. New York: Penguin, 2011.

Dante. *The Inferno*. Translated by Robert Hollander and Jean Hollander. New York: Anchor, 2002.

Danto, Arthur C. *The Abuse of Beauty: Aesthetics and the Concept of Art*. Chicago: Open Court, 2003.

———. *What Art Is*. New Haven, CT: Yale University Press, 2013.

Darby, Ainslie, and C. C. Hamilton. *England, Ugliness and Noise*. London: King, 1930.

Das, Jibanananda. *A Certain Sense*. Edited by Sukanta Chaudhuri. Calcutta: Sahitya Akademi, 1998.

Daston, Lorraine, and Katharine Park. *Wonders and the Order of Nature. 1150–1750*. New York: Zone, 2001.

Davis, Murray S. "That's Interesting! Towards a Phenomenology of Sociology and a Sociology of Phenomenology." *Philosophy of the Social Sciences* 1 (1971): 309–44.

Dawson, Barbara, ed. *Francis Bacon: A Terrible Beauty*. Göttingen: Steidl, 2009.

Dawson, David. *Flesh Becomes Word: A Lexicography of the Scapegoat or, the History of an Idea*. East Lansing: Michigan State University Press, 2013.

Derbes, Anne. *Picturing the Passion in Late Medieval Italy*. New York: Cambridge University Press, 1996.

Dewey, John. *Art as Experience*. New York: Penguin, 1934.

Dickens, Charles. *Great Expectations*. New York: Penguin, 1996.

Dorfles, Gillo, ed. *Kitsch: The World of Bad Taste*. New York: Universe, 1969.

Dostoevsky, Fyodor. *Crime and Punishment*. Translated by Richard Pevear and Larissa Volokhonsky. New York: Vintage, 1993.

———. *The Idiot*. Translated by David Magarshack. New York: Penguin, 1955.

Douglas, Mary. *Purity and Danger*. New York: Routledge, 1966.

Dryden, John. "Discourse concerning the Original and Progress of Satire." In *The Works of John Dryden*, edited by A. B. Chambers and William Frost, 4:3–90. Berkeley: University of California Press, 1974.

Dürrenmatt, Friedrich. *Werkausgabe in dreißig Bänden*. Zürich: Diogenes, 1980.

Dutt, Carsten. "Bruitistisches Krippenspiel, lautpoetische Totenklage. Hugo Balls Dadaismus als Reflexion christlicher Religion." *Hugo-Ball-Almanach*, Neue Folge 7 (2016): 78–99.

———. "Das leere Grab—mit fremdem Leben erfüllt: Allusion und Reflexion in Jeff Walls Fotoarbeit The Flooded Grave." *Zeitschrift für Ästhetik und Allgemeine Kunstwissenschaft* 66, no. 1 (2021): 13–38.

Eco, Umberto, ed. *On Ugliness*. New York: Rizzoli, 2007.

Edwards, Justin D., and Rune Graulund. *The Grotesque*. New York: Routledge, 2013.

Egenter, Richard. *The Desecration of Christ*. Edited by Nicolete Gray. Translated by Edward Quinn. Chicago: Franciscan Herald, 1967.

———. *Kitsch und Christenleben*. 2nd ed. Munich: Arena, 1962.

Eisenman, Peter. "The Blue Line Text." *Architectural Design* 58, no. 7 (1988): 5–10.

Eisner, Lotte H. *Murnau*. Berkeley: University of California Press, 1973.

Elizondo, Virgilio. *Galilean Journey: The Mexican-American Promise*. 2nd ed. Maryknoll, NY: Orbis, 2000.

Elkins, James. *On the Strange Place of Religion in Contemporary Art*. New York: Routledge, 2004.

———. *What Happened to Art Criticism?* Chicago: Prickly Paradigm, 2003.

Emmerich, Wolfgang. "Paul Celans Weg vom 'schönen Gedicht' zur 'graueren Sprache': Die windschiefe Rezeption der 'Todesfuge' und ihre Folgen." In *Jüdische Autoren Ostmitteleuropas im 20. Jahrhundert*, edited by Hans Henning Hahn and Jens Stüben, 359–83. New York: Peter Lang, 2002.

Engberg, Siri, ed. *Kiki Smith: A Gathering, 1980–2005*. Minneapolis: Walker Art Center, 2005.

Engelhardt, Katrin. "'Ans Kreuz geschlagen': Die Verhöhnung des 'Krucifixus' von Ludwig Gies in der Weimarer Republik und im Nationalsozialismus." In *Das verfemte Meisterwerk: Schicksalswege moderner Kunst im "Dritten Reich,"* edited by Uwe Fleckner, 29–48. Berlin: Akademie Verlag, 2009.

Engelmann, Ines Janet. *Hässlich?! Eine Diskussion über bildende Kunst und Literatur vom Anfang des 19. bis zum Beginn des 20. Jahrhunderts*. Weimar: VDG, 2003.

Eusebius. *Ecclesiastical History*. 2 vols. Translated by Kirsopp Lake and J. E. L. Oulton. Cambridge, MA: Harvard University Press, 1926.

Eykman, Christoph. *Die Funktion des Häßlichen in der Lyrik Georg Heyms, Georg Trakls und Gottfried Benns: Zur Krise der Wirklichkeitserfahrung im deutschen Expressionismus*. Bonn: Bouvier, 1969.

Feldkeller, Paul. "Das Häßliche des Krieges als Gegenstand künstlerischer Darstellung." *Das literarische Echo* 17 (1915): 915–18.

Felski, Rita. *The Limits of Critique*. Chicago: University of Chicago Press, 2015.

Ferguson, John, ed. *Juvenal: The Satires*. London: Bristol Classical Press, 1999.

Fiedler, Leslie A. *Pity and Fear: Myths and Images of the Disabled in Literature Old and New*. New York: International Center for the Disabled, 1981.

Fine, Gary Alan. *Talking Art: The Culture of Practice and the Practice of Culture in MFA Education*. Chicago: University of Chicago Press, 2018.

Fischer, Kuno. *Diotima: Die Idee des Schönen*. Pforzheim: Flammer, 1849.

Fitzgerald, F. Scott. *Before Gatsby: The First Twenty-Six Stories*. Edited by Matthew Bruccoli. Columbia: University of South Carolina Press, 2001.

Flavell, M. Kay. *George Grosz: A Biography.* New Haven, CT: Yale University Press, 1988.

Forster, John. *The Life of Charles Dickens.* 6 vols. Leipzig: Tauchnitz, 1872–74.

Fowler, Barbara Hughes. *The Hellenistic Aesthetic.* Madison: University of Wisconsin Press, 1989.

Fraenger, Wilhelm. *Matthias Grünewald.* Munich: Beck, 1983.

Frank, Joseph. *Dostoevsky: The Miraculous Years, 1865–1871.* Princeton, NJ: Princeton University Press, 1995.

Frankel, David, and Helaine Posner. *Kiki Smith.* Boston: Bulfinch, 1998.

Freed-Thall, Hannah. *Spoiled Distinctions: Aesthetics and the Ordinary in French Modernism.* New York: Oxford University Press, 2015.

Friedrich, Hugo. *Die Struktur der modernen Lyrik: Von Baudelaire bis zur Gegenwart.* Hamburg: Rowohlt, 1956.

Friedwald, Will. *Stardust Melodies: The Biography of Twelve of America's Most Popular Songs.* New York: Pantheon, 2002.

Fuchs, Ottmar. *Die Klage als Gebet: Eine theologische Besinnung am Beispiel des Psalms 22.* Munich: Kösel, 1982.

Fuhrmann, Manfred. "Die Funktion grausiger und ekelhafter Motive in der lateinschen Dichtung." *Die nicht mehr schönen Künste: Grenzphänomene des Ästhetischen. Poetik und Hermeneutik 3,* edited by Hans Robert Jauß, 23–66. Munich: Fink, 1968.

Gagnebin, Murielle. *Fascination de la Laideur: L'en-deçà psychanalytique du laid.* 2nd ed. Seyssel: Champ Vallon, 1994.

Gardner, Jane F. *Women in Roman Law and Society.* Bloomington: Indiana University Press, 1986.

Gardner, John. *On Moral Fiction.* New York: Basic Books, 1978.

Garland, Robert. *The Eye of the Beholder: Deformity and Disability in the Graeco-Roman World.* 2nd ed. London: Bristol, 2010.

Garvin, Lucius. "The Problem of Ugliness in Art." *Philosophical Review* 57 (1948): 404–9.

Gauguin, Paul. *The Writings of a Savage.* Edited by Daniel Guérin. New York: Viking, 1978.

Gegen Klimt: Historisches, Philosophie, Medizin, Goldfische, Fries. Vienna: Eisenstein, 1903.

Gehlen, Arnold. *Zeit-Bilder: Zur Soziologie und Ästhetik der modernen Malerei.* Frankfurt: Athenäum, 1960.

"Gerhard Richter: Viel heutige Auktionskunst ist 'Müll.'" *Süddeutsche Zeitung,* May 16, 2014. https://www.sueddeutsche.de/kultur/kunst-gerhard -richter-viel-heutige-auktionskunst-ist-muell-dpa.urn-newsml-dpa-com -20090101-140516-99-05930.

Gethmann-Siefert, Annemarie. *Einführung in Hegels Ästhetik.* Munich: Fink, 2005.

———. "Hegel über das Häßliche in der Kunst." *Hegel-Jahrbuch* (2000): 21–41.

Gibson, Walter S. "'Imitatio Christi': The Passion Scenes of Hieronymus Bosch." *Simiolus: Netherlands Quarterly for the History of Art* 6, no. 2 (1972–73): 83–93.

Giesz, Ludwig. *Phänomenologie des Kitsches: Ein Beitrag zur anthropologischen Ästhetik*. Heidelberg: Rothe, 1960.

Gigante, Denise. "Facing the Ugly: The Case of Frankenstein." *English Literary History* 67 (2000): 565–87.

Gilbert, Michelle. "Things Ugly: Ghanaian Popular Painting." In *Beautiful/Ugly: African and Diaspora Aesthetics*, edited by Sarah Nuttall, 340–71. Durham, NC: Duke University Press, 2006.

Gillespie, Michael Patrick. *The Picture of Dorian Gray: "What the World Thinks Me."* New York: Twayne, 1995.

Gilmore, Mikal. "The Curse of the Ramones." *Rolling Stone*, May 19, 2016.

Gingeras, Alison M., and Thomas Hirschhorn. "Interview." In *Thomas Hirschhorn*, 8–39. New York: Phaidon, 2004.

Glockner, Hermann. "Kuno Fischer und Karl Rosenkranz." *Archiv für Geschichte der Philosophie* 40 (1931): 106–16.

Goethe, Johann Wolfgang von. *Der Briefwechsel zwischen Goethe und Zelter*. 3 vols. Leipzig: Insel, 1913–18.

———. *Goethe's "Faust."* Translated by Walter Kaufmann. New York: Doubleday, 1961.

———. *Goethe's Letters to Zelter: With Extracts from Those of Zelter to Goethe*. Translated by A. D. Coleridge. London: Bell, 1887.

———. *Italian Journey*. Translated by Robert R. Heiter. Edited by Thomas P. Sain and Jeffrey L. Sammons. New York: Suhrkamp, 1989.

———. *Italienische Reise*. In *Werke: Hamburger Ausgabe*, edited by Erich Trunz, 11:7–349. Munich: Beck, 1981.

———. *The Poems of Goethe*. Translated by Edgar Alfred Bowring. New York: Hurst, 1881.

———. "Review of J. G. Sulzer, *Die schönen Künste in ihrem Ursprung, ihrer wahren Natur und besten Anwendung. Leipzig 1772.*" In *Goethes Werke*, edited by Karl Heinemann, 21:17–23. Leipzig: Bibliographisches Institut, 1901–1908.

———. "Sakontala." In *Goethes sämmtliche Werke in fünfundvierzig Bänden*, 1:126. Stuttgart: Reclam, 1850.

———. "Der Tänzerin Grab." In *Goethes Werke*, edited by K. Goedeke, 27:303–7. Stuttgart: Cotta, 1867.

———. *Tag- und Jahreshefte als Ergänzung meiner sonstigen Bekenntnisse*. Volume 36 of *Goethes Werke*, edited im Auftrage der Großherzogin Sophie von Sachsen Weimar: Böhlau, 1887–1919.

———. "Von deutscher Baukunst." In *Werke. Hamburger Ausgabe*, edited by Erich Trunz, 12:7–15. Munich: Beck, 1981.

Gombrich, E. H. *Art and Illusion: A Study in the Psychology of Pictorial Representation.* 1960. Princeton, NJ: Princeton University Press, 2000.

———. *Norm and Form: Studies in the Art of the Renaissance.* London: Phaidon, 1966.

———. *The Sense of Order: A Study in the Psychology of Decorative Art.* Ithaca, NY: Cornell University Press, 1979.

———. *The Story of Art.* 1950. 16th ed., rev., exp., and redesigned. London: Phaidon, 1995.

———. *Tributes: Interpreters of Our Cultural Tradition.* London: Phaidon, 1994.

Goodley, Dan. *Disability Studies: An Interdisciplinary Introduction.* Los Angeles: Sage, 2001.

Goodman, Nelson. *Languages of Art: An Approach to a Theory of Symbols.* 2nd ed. Indianapolis: Hackett, 1976.

———. *Ways of Worldmaking.* Indianapolis: Hackett, 1978.

Götze, Alfred. "Häßlich." *Zeitschrift für Wortforschung* 7 (1905): 202–20.

Greenberg, Clement. "Avant-Garde and Kitsch." *Partisan Review* 6, no. 5 (1939): 34–49.

———. "Review of Exhibitions of Mondrian, Kandinsky, and Pollock; of the Annual Exhibition of the American Abstract Artists; and of the Exhibition *European Artists in America*." 1945. In *The Collected Essays and Criticism*, Vol. 2, *Arrogant Purpose*, 14–18. Chicago: University of Chicago Press, 1986.

Griffiths, Paul J. *Decreation: The Last Things of All Creatures.* Waco, TX: Baylor University Press, 2014.

Grimmelshausen, [Hans Jakob Christoph von]. *Der abenteuerliche Simplicissimus.* Darmstadt: Wissenschaftliche Buchgesellschaft, 1978.

Grosz, George. *Ein kleines Ja und ein großes Nein: Sein Leben von ihm selbst erzählt.* Hamburg: Rowohlt, 1974.

———. *George Grosz: An Autobiography.* Translated by Nora Hodges. Berkeley: University of California Press, 1983.

Grosz, George, and Wieland Herzfelde. *Die Kunst ist in Gefahr: Drei Aufsätze.* Berlin: Malik, 1925.

Grubbs, Judith Evans. "Church, State, and Children: Christian and Imperial Attitudes toward Infant Exposure in Late Antiquity." In *The Power of Religion in Late Antiquity*, edited by Andrew Cain and Noel Lenski, 119–31. Burlington, VT: Ashgate, 2009.

Gryphius, Andreas. "A Sonnet of Andreas Gryphius: Tears of the Fatherland, Anno 1636." Translated by George Schoolfield. *German Quarterly* 25, no. 2 (1952): 110.

———. "Two Poems by Andreas Gryphius." Translated by Scott Horton. *Harper's Magazine*, August 11, 2007. https://harpers.org/2007/08/two -poems-by-andreas-gryphius/.

Gunkel, Hermann. *Introduction to Psalms: The Genres of the Religious Lyric of Israel*. Translated by James D. Nogalski. Macon, GA: Mercer University Press, 1998.

Gutiérrez, Gustavo. *A Theology of Liberation: History, Politics and Salvation*. Translated by Sister Caridad Inda and John Eagleson. Maryknoll, NY: Orbis, 1973.

Hamburger, Jeffrey F. "'To make women weep': Ugly Art as Feminine and the Origins of Modern Aesthetics." *Res* 31 (Spring 1997): 9–33.

Hammermeister, Kai. *The German Aesthetic Tradition*. Cambridge: Cambridge University Press, 2002.

Hammerstein, Reinhold. "Die Musik in Dantes *Divina Commedia*." *Deutsches Dante-Jahrbuch* 41/42 (1964): 59–125.

Handke, Peter. *Die Theaterstücke*. Frankfurt: Suhrkamp, 1992.

Harnoncourt, Nikolaus. *The Musical Dialogue: Thoughts on Monteverdi, Bach, and Mozart*. Translated by Mary O'Neill. Portland, OR: Amadeus, 1989.

Harpham, Geoffrey Galt. *On the Grotesque: Strategies of Contradiction in Art and Literature*. Princeton, NJ: Princeton University Press, 1982.

Harris, W. V. "Child-Exposure in the Roman Empire." *Journal of Roman Studies* 84 (1994): 1–22.

Harrison, Thomas. *1910: The Emancipation of Dissonance*. Berkeley: University of California Press, 1996.

Harvey, R. A. *A Commentary on Persius*. Leiden: Brill, 1981.

Haug, Walter. *Literaturtheorie im deutschen Mittelalter von den Anfängen bis zum Ende des 13. Jahrhunderts. Eine Einführung*. Darmstadt: Wissenschaftliche Buchgesellschaft 1985.

———. *Vernacular Literary Theory in the Middle Ages: The German Tradition, 800–1300, in its European Context*. New York: Cambridge University Press, 1997.

Hauser, Arnold. *Sozialgeschichte der Kunst und Literatur*. 1953. Munich: Beck, 1973.

Hay, William. *Deformity: An Essay*. Edited by Kathleen James-Cavan. University of Victoria: English Literary Studies, 2004.

Hayum, Andrée. *The Isenheim Altarpiece: God's Medicine and the Painter's Vision*. Princeton, NJ: Princeton University Press, 1990.

Heartney, Eleanor. *Postmodern Heretics: The Catholic Imagination in Contemporary Art*. New York: Midmarch, 2004.

Hefling, Stephen E. "Aspects of Mahler's Late Style." In *Mahler and His World*, edited by Karen Painter, 199–223. Princeton, NJ: Princeton University Press, 2002.

Hegel, G. W. F. *Aesthetics: Lectures on Fine Arts*. Translated by T. M. Knox. Oxford: Clarendon, 1975.

———. *The Encyclopaedia Logic: Part I of the Encyclopaedia of the Philosophical Sciences with the Zusätze.* Translated by T. F. Geraets, W. A. Suchting, and H. S. Harris. Indianapolis: Hackett, 1991.

———. *Hegel Texts and Commentary.* Translated by Walter Kaufmann. Notre Dame, IN: University of Notre Dame Press, 1977.

———. *Lectures on the Philosophy of Art: The Hotho Transcript of the 1823 Berlin Lectures.* Translated by Robert F. Brown. Oxford: Oxford University Press, 2014.

———. *Phenomenology of Spirit.* Translated by A. V. Miller. Oxford: Clarendon, 1977.

———. *Philosophie der Kunst: Vorlesung von 1826.* Edited by Annemarie Gethmann-Siefert, Jeong-Im Kwon, and Karsten Berr. Frankfurt: Suhrkamp, 2005.

———. *Vorlesungen über die "Philosophie der Kunst": Berlin 1823.* Nachgeschrieben von Heinrich Gustav Hotho. Edited by Annemarie Gethmann-Siefert. Hamburg: Meiner, 1998.

———. *Vorlesungen zur Ästhetik. Vorlesungsmitschrift Adolf Heimann (1828/1829).* Edited by Alain Patrick Olivier and Annemarie Gethmann-Siefert. Munich: Fink, 2017.

———. *Werke in zwanzig Bänden.* Edited by Eva Moldenhauer and Karl Markus Michel. Frankfurt: Suhrkamp, 1978.

Heidegger, Martin. *Der Ursprung des Kunstwerkes.* Stuttgart: Reclam, 1995.

Heine, Heinrich. *Poetry and Prose.* Edited by Robert C. Holub. New York: Continuum, 1982.

———. *Sämtliche Schriften.* 6 vols. Edited by Klaus Briegleb et al. Munich: Hanser, 1968–1976.

Heller, Eric. *The Disinherited Mind: Essays in Modern German Literature and Thought.* London: Bowes, 1975.

Henderson, Gretchen E. *Ugliness: A Cultural History.* London: Reaktion, 2015.

Hengel, Martin. *Crucifixion in the Ancient World and the Folly of the Message of the Cross.* Translated by John Bowden. Philadelphia: Fortress, 1977.

Herodotus. *Herodotus.* 4 vols. Cambridge, MA: Harvard University Press, 1975.

Herrera, Hayden. *Frida: A Biography of Frida Kahlo.* New York: Harper, 1983.

Herzfelde, Wieland. *John Heartfield: Leben und Werk dargestellt von seinem Bruder Wieland Herzfelde.* Dresden: Verlag der Kunst, 1962.

Hesiod. *"Theogony" and "Works and Days."* Translated by Catherine M. Schlegel and Henry Weinfield. Ann Arbor: University of Michigan Press, 2006.

Hess, Hans. *George Grosz.* New Haven, CT: Yale University Press, 1974.

Heym, Georg. *Poems: A Bilingual Edition.* Translated by Antony Hasler. Evanston, IL: Northwestern University Press, 2006.

Heyman, Stephen. "The Bizarre Silicone World of Patricia Piccinini." *New York Times*, March 31, 2016. https://www.nytimes.com/2016/03/31/arts /international/the-bizarre-silicone-world-of-patricia-piccinini.html.

Hickey, Dave. *The Invisible Dragon: Four Essays on Beauty*. 1993. Chicago: University of Chicago Press, 2009.

Higgins, Lesley. *The Modernist Cult of Ugliness: Aesthetic and Gender Politics*. New York: Palgrave, 2002.

Highet, Gilbert. *Juvenal the Satirist: A Study*. Oxford: Clarendon, 1954.

Historische Vorlesungsverzeichnisse der Universität Leipzig. Leipzig: Universitätsbibliothek, 2008–20. https://histvv.uni-leipzig.de/vv/.

Hoffmann, Godehard. *Das Gabelkreuz in St. Maria im Kapitol zu Köln und das Phänomen der Crucifixi dolorosi in Europa*. Worms: Wernersche Verlagsgesellschaft, 2006.

Hofmann, Werner. *Die Karikatur: Von Leonardo bis Picasso*. Vienna: Rosenbaum, 1956.

Hofmannsthal, Hugo von. *The Difficult Man*. Translated by Willa Muir. In *Selected Plays and Libretti*, edited by Michael Hamburger, 633–823. New York: Bollingen Foundation, 1963.

Hoge, Warren. "Art Imitates Life, Perhaps Too Closely." *New York Times*, October 20, 2001. https://www.nytimes.com/2001/10/20/arts/art-imitates-life-perhaps-too-closely.html.

Hohendahl, Peter Uwe, ed. *Benn—Wirkung wider Willen: Dokumente zur Wirkungsgeschichte Benns*. Frankfurt: Athenäum, 1971.

Hölderlin, Friedrich. *Essays and Letters on Theory*. Edited by Thomas Pfau. Albany: State University of New York Press, 1988.

———. *Sämtliche Werke und Briefe in drei Bänden*. Edited by Jochen Schmidt. Frankfurt: Deutscher Klassiker Verlag, 1992–94.

Holiday, Billie. "Strange Fruit." *Strange Fruit Live 1959 [Reelin' In The Years Archives]*. https://www.youtube.com/watch?v=-DGY9HvChXk.

Homer. *The Iliad of Homer*. Translated by Richmond Lattimore. Chicago: University of Chicago Press, 1951.

Horace. *Satires. Epistles. The Art of Poetry*. Translated by H. Rushton Fairclough. Cambridge, MA: Harvard University Press, 1926.

Horne, Lena. "Stormy Weather." Written by Ted Koehler and Harold Arlen. Conducted by Lennie Hayton. RCA Victor, 1957. https://genius.com /Lena-horne-stormy-weather-lyrics.

Hösle, Vittorio. *Dantes "Commedia" und Goethes "Faust": Ein Vergleich der beiden wichtigsten philosophischen Dichtungen Europas*. Basel: Schwabe, 2014.

———. "Einstieg in den objectiven Idealismus." In *Idealismus heute: Aktuelle Perspektiven und neue Impulse*, edited by Vittorio Hösle and Fernando Suárez Müller, 30–49. Darmstadt: Wissenschaftliche Buchgesellschaft, 2015.

———. "Foundational Issues of Objective Idealism." In *Objective Idealism, Ethics and Politics*, 1–40. Notre Dame, IN: University of Notre Dame Press, 1998.

———. *God as Reason: Essays in Philosophical Theology*. Notre Dame, IN: University of Notre Dame Press, 2013.

———. *Hegels System: Der Idealismus der Subjektivität und das Problem der Intersubjektivität*. 2 vols. Hamburg: Meiner, 1987.

———. *Die Krise der Gegenwart und die Verantwortung der Philosophie: Transzendentalpragmatik, Letztbegründung, Ethik*. Munich: Beck, 1990.

———. "The Lost Prodigal Son's Corporal Works of Mercy and the Bridegroom's Wedding: The Religious Subtext of Charles Dickens' *Great Expectations*." *Anglia* 126 (2008): 477–502.

———. *Morals and Politics*. Notre Dame, IN: University of Notre Dame Press, 2004.

———. *Die Vollendung der Tragödie im Spätwerk des Sophokles: Ästhetisch-historische Bemerkungen zur Struktur der attischen Tragödie*. Stuttgart-Bad Cannstatt: Frommann-Holzboog, 1984.

Hughes, Robert. *American Visions: The Epic History of Art in America*. New York: Knopf, 1997.

———. *Heaven and Hell in Western Art*. New York: Stein and Day, 1968.

Hugo, Victor. *Notre-Dame de Paris*. Translated by John Sturrock. New York: Penguin, 2004.

———. *Préface de Cromwell*. Paris: Larousse, 2004.

———. "Preface to Cromwell." In *Prefaces and Prologues to Famous Books*, 354–408. New York: Collier, 1910.

Huhn, Thomas. "Diligence and Industry: Adorno and the Ugly." *Canadian Journal of Political and Social Theory* 12, no. 3 (1988): 138–46.

Huizinga, Johan. *The Waning of the Middle Ages: A Study of the Forms of Life, Thought and Art in France and the Netherlands in the Fourteenth and Fifteenth Centuries*. London: Arnold, 1924.

Hume, David. "Of the Standard of Taste." In *Selected Essays*, edited by Stephen Copley and Andrew Edgar, 133–54. New York: Oxford, 1993.

———. *A Treatise of Human Nature*. Edited by David Fate Norton and Mary J. Norton. New York: Oxford University Press, 2000.

Hunter, Robert Grams. *Shakespeare and the Comedy of Forgiveness*. New York: Columbia University Press, 1965.

Husserl, Edmund. *Logische Untersuchungen*. Hamburg: Meiner, 2009.

Hyde, Timothy. *Ugliness and Judgment: On Architecture in the Public Eye*. Princeton, NJ: Princeton University Press, 2019.

Iannelli, Francesca. "Hegel und die Hegelianer über das Häßliche: Eine kontroverse Rezeption." In *Kulturpolitik und Kunstgeschichte: Perspektiven*

der Hegelschen Ästhetik, edited by Ursula Franke and Annemarie Gethmann-Siefert, 195–214. Hamburg: Meiner, 2005.

———. *Das Siegel der Moderne: Hegels Bestimmung des Hässlichen in den Vorlesungen zur Ästhetik und die Rezeption bei den Hegelianern*. Munich: Fink, 2007.

Ibsen, Henrik. *The Oxford Ibsen*. 8 vols. Edited by James Walter McFarlane. New York: Oxford University Press, 1960–1977.

Imdahl, Max. *Picassos Guernica*. Frankfurt: Insel, 1985.

Innocent III, Pope [Lotario dei Segni]. *De miseria humane conditionis*. Edited by Michele Maccarrone. Lugano: Thesaurus Mundi, 1955.

———. *On the Misery of the Human Condition (De miseria humane conditionis)*. Edited by Donald Roy Howard. Indianapolis: Bobbs-Merrill, 1969.

Irenaeus. *Against Heresies*. In *The Ante-Nicene Fathers: The Writings of the Fathers down to 325 A.D.*, edited by A. Cleveland Coxe, 1:309–567. New York: Scribner's, 1926.

———. *Libros Quinque Adversus Haereses*. Edited by W. Wigan Harvey. Cambridge: Typis Academicis, 1857.

Irujo, Xabier. *Gernika, 1937: The Market Day Massacre*. Reno: University of Nevada Press, 2015.

Jacobs, Lynn F. "The Triptychs of Hieronymus Bosch." *Sixteenth Century Journal* 31 (2000): 1009–41.

Jensen, Robin Margaret. *The Cross: History, Art, and Controversy*. Cambridge, MA: Harvard University Press, 2017.

———. *Understanding Early Christian Art*. New York: Routledge, 2000.

Johnson, Samuel. *A dictionary of the English language: in which the words are deduced from their originals, and illustrated in their different significations by examples from the best writers*. 2 vols. London: Strahan, 1755.

Jonas, Hans. "The Concept of God after Auschwitz: A Jewish Voice." *Journal of Religion* 67, no. 1 (1987): 1–13.

Jones, B. C., A. C. Little, I. S. Penton-Voak, B. Press Tiddeman, D. M. Burt, and D. I. Perrett. "Facial Symmetry and Judgements of Apparent Health: Support for a 'Good Genes' Explanation of the Attractiveness–Symmetry Relationship." *Evolution and Human Behavior* 22, no. 6 (2001): 417–29.

Julian of Norwich. *The Writings of Julian of Norwich*. Edited by Nicholas Watson and Jacqueline Jenkins. University Park: Pennsylvania State University Press, 2006.

Julius, Anthony. *Transgressions: The Offenses of Art*. Chicago: University of Chicago Press, 2002.

Jung, Werner. *Schöner Schein der Häßlichkeit oder Häßlichkeit des schönen Scheins: Ästhetik und Geschichtsphilosophie im 19. Jahrhundert*. Frankfurt: Athenäum, 1987.

Juniper, Andrew. *Wabi Sabi: The Japanese Art of Impermanence*. Boston: Tuttle, 2003.

Juvenal. *The Satires*. Edited by John Ferguson. London: Bristol Classical Press, 1999.

———. *The Sixteen Satires*. Translated by Peter Green. New York: Penguin, 1998.

Kamber, Richard. "Experimental Philosophy of Art." *Journal of Aesthetics and Art Criticism* 69 (2011): 197–208.

Kammen, Michael. *Visual Shock: A History of Art Controversies in American Culture*. New York: Vintage, 2006.

Kandel, Eric. *The Age of Insight: The Quest to Understand the Unconscious in Art, Mind, and Brain, from Vienna 1900 to the Present*. New York: Random House, 2012.

Kant, Immanuel. *Critique of Judgement*. Edited by Nicholas Walker. Translated by James Creed Meredith. Oxford: Oxford University Press, 2007.

———. *Werkausgabe*. 12 vols. Edited by Wilhelm Weischedel. Frankfurt: Suhrkamp, 1968.

Kara Walker-No, Kara Walker-Yes, Kara Walker-? Introduction by Howardena Pindell. Essays by 28 Artists, Educators, Writers and Poets. New York: Midmarch, 2009.

Kayser, Wolfgang. *Das Groteske: Seine Gestaltung in Malerei und Dichtung*. Oldenburg: Stalling, 1957.

Kelleher, Katy. "Ugliness Is Underrated: In Defense of Ugly Paintings." *Paris Review*, July 31, 2018. https://www.theparisreview.org/blog/2018/07/31/ugliness-is-underrated-in-defense-of-ugly-paintings/.

Kelly, Daniel. *Yuck! The Nature and Moral Significance of Disgust*. Cambridge, MA: MIT Press, 2011.

Kennedy, Robert F. "Statement on Assassination of Martin Luther King, Jr., Indianapolis, Indiana, April 4, 1968." John F. Kennedy Presidential Library and Museum. https://www.jfklibrary.org/learn/about-jfk/the-kennedy-family/robert-f-kennedy/robert-f-kennedy-speeches/statement-on-assassination-of-martin-luther-king-jr-indianapolis-indiana-april-4-1968.

Kiesel, Helmuth, and Cordula Stepp. "Paul Celans Schreckensmusik." In *Getauft auf Musik: Festschrift für Dieter Borchmeyer*, edited by Udo Bermbach and Hans Rudolf Vaget, 115–31. Würzburg: Königshausen, 2006.

Killy, Walther. *Deutscher Kitsch: Ein Versuch mit Beispielen*. Göttingen: Vandenhoeck, 1962.

King, David, and Ernst Volland. *John Heartfield: Laughter Is a Devastating Weapon*. London: Tate, 2015.

King, Martin Luther, Jr. "Letter from a Birmingham Jail." In *A Testament of Hope: The Essential Writings of Martin Luther King, Jr.*, edited by James Melvin, 283–302. San Francisco: Harper, 1986.

King, Ross. *The Judgment of Paris: The Revolutionary Decade That Gave the World Impressionism*. New York: Walker, 2006.

Kinkel, Hans. "Begegnung mit Otto Dix." In *Otto Dix: Gemälde, Handzeichnungen, Aquarelle*, 11–14. Darmstadt: Hessisches Landesmuseum, 1962.

Kirchmann, Julius Hermann von. *Aesthetik auf realistischer Grundlage*. 2 vols. Berlin: Springer, 1868.

Kißel, Walter, ed. *Aules Persius Flaccus: Satiren*. Heidelberg: Winter, 1990.

Klee, Paul. *Schriften: Rezensionen und Aufsätze*. Edited by Christian Geelhaar. Cologne: DuMont, 1976.

Kleine, Sabine. *Zur Ästhetik des Häßlichen: Von Sade bis Pasolini*. Stuttgart: Metzler, 1998.

Kleiner, John. *Mismapping the Wunderworld: Daring and Error in Dante's "Comedy."* Stanford, CA: Stanford University Press, 1994.

Klüger, Ruth. "Abstrakte Zeitgeschichte." In *Gemalte Fensterscheiben*, 129–35. Göttingen: Wallstein, 2007.

———. *Von hoher und niedriger Literatur*. 2nd ed. Göttingen: Wallstein, 1996.

Knoche, Ulrich. *Roman Satire*. Translated by Edwin S. Ramage. Bloomington: Indiana University Press, 1975.

Koerner, Joseph Leo. *Bosch and Bruegel: From Enemy Painting to Everyday Life*. Princeton, NJ: Princeton University Press, 2016.

———. *The Moment of Self-portraiture in German Renaissance Art*. Chicago: University of Chicago Press, 1993.

Kollwitz, Käthe. *Ich sah die Welt mit liebevollen Blicken: Ein Leben mit liebevollen Blicken*. Edited by Hans Kollwitz. Hannover: Fackelträger-Verlag, 1968.

Kolnai, Aurel. *On Disgust*. Edited by Barry Smith and Carolyn Korsmeyer. Chicago: Open Court, 2004.

Koplos, Janet. *Contemporary Japanese Sculpture*. New York: Abbeville, 1991.

Koren, Leonard. *Wabi-Sabi for Artists, Designers, Poets and Philosophers*. Point Reyes, CA: Imperfect, 2008.

Korsmeyer, Carolyn. *Savoring Disgust: The Foul and the Fair in Aesthetics*. New York: Oxford University Press, 2011.

Krakauer, Siegfried. *From Caligari to Hitler: A Psychological History of the German Film*. Princeton, NJ: Princeton University Press, 1947.

Kraus, Hans-Joachim. *Psalmen*. 2 vols. 5th ed. Neukirchen-Vluyn: Neukirchener Verlag, 1978.

Krestovsky, Lydie. *La laideur dans l'art: A travers les ages*. Paris: Seuil, 1947.

———. *Le problème spirituel de la beauté et de la laideur*. Paris: Presses universitaires de France, 1948.

Kriebel, Sabine. *Revolutionary Beauty: The Radical Photomontages of John Heartfield*. Berkeley: University of California Press, 2014.

Kristeva, Julia. *Powers of Horror: An Essay on Abjection.* Translated by Leon S. Roudiez. New York: Columbia University Press, 1982.

Kulka, Thomas. *Kitsch and Art.* University Park: Pennsylvania State University Press, 1996.

Lackner, Stephan. *Max Beckmann.* New York: Abrams, 1991.

LaCocque, André, and Paul Ricoeur. *Thinking Biblically: Exegetical and Hermeneutical Studies.* Translated by David Pellauer. Chicago: University of Chicago Press, 1998.

Larson, Thomas. *The Saddest Music Ever Written: The Story of Samuel Barber's "Adagio for Strings."* New York: Pegasus, 2010.

Lavater, Johann Caspar. *Essays on Physiognomy. For the Promotion of the Knowledge and the Love of Mankind.* 3 vols. Translated by Thomas Holcraft. London: Robinson, 1789.

———. *Physiognomische Fragmente, zur Beförderung der Menschenkenntniß und Menschenliebe.* 4 vols. Leipzig: Weidmann, 1775–78.

Lebrecht, Norman. *Why Mahler? How One Man and Ten Symphonies Changed Our World.* New York: Pantheon, 2010.

Lee, Alexander. *The Ugly Renaissance: Sex, Greed, Violence and Depravity in an Age of Beauty.* New York: Random House, 2014.

Leibniz, Gottfried Wilhelm. *Philosophical Essays.* Translated by Roger Ariew and Daniel Garber. Indianapolis: Hackett, 1989.

Leroy, Louis. "L'Exposition des impressionnistes." *Le Charivari*, April 25, 1874, 79–80. Reprinted in *The New Painting. Impressionism 1874–1886: Documentation*, Vol. 1, *Reviews*, edited by Ruth Berson, 25–26. San Francisco: Fine Arts Museum, 1996.

Lessing, Gotthold Ephraim. *Laocoön.* Translated by Edward Allen McCormick. Baltimore: Johns Hopkins University Press, 1984.

———. *Laokoon.* Edited by Wilfried Barner. Frankfurt: Deutscher Klassiker Verlag, 2007.

Lewis, Michael. "How Art Became Irrelevant." *Commentary* 139, no. 7 (2015): 11–22.

Lichtenstein, Alfred. *Dichtungen.* Edited by Klaus Kanzog and Hartmut Vollmer. Zürich: Arche, 1989.

———. "Morning." In *Modern German Poetry, 1910–1960: An Anthology with Verse Translations*, edited by Michael Hamburger and Christopher Middleton, 171. London: MacGibbon, 1962.

Lifschitz, Michail. *Krise des Häßlichen: Vom Kubismus zur Pop Art.* Translated by Helmut Barth. Dresden: VEB, n.d.

Link, Luther. *The Devil: A Mask without a Face.* London: Reaktion, 1995.

Long, D. Stephen. *Saving Karl Barth: Hans Urs von Balthasar's Preoccupation.* Minneapolis: Fortress, 2014.

Lorand, Ruth. "Beauty and Its Opposites." *Journal of Aesthetics and Art Criticism* 52 (1994): 399–406.

Lovejoy, Arthur O. *The Great Chain of Being*. Cambridge, MA: Harvard University Press, 1976.

Lucretius. *On the Nature of Things*. Translated by Martin Ferguson Smith. Indianapolis: Hackett, 2001.

Lund, Roger D. "Laughing at Cripples: Ridicule, Deformity and the Argument from Design." *Eighteenth-Century Studies* 39, no. 1 (2005): 91–114.

Luther, Martin. *Tischreden, 1531–1546*. Edited by Joachim Karl Friedrich Knaake. Weimar: Böhlaus, 1912–21.

Luther, Martin, and Philipp Melanchthon. *Deuttung der czwo grewlichen Figuren, Bapstesels czu Rom und Munchkalbs zu Freijberg ijnn Meijsszen funden*. In *D. Martin Luthers Werke: Kritische Gesamtausgabe. Weimarer Ausgabe*, 11:370–85. Weimar: Böhlau, 1883–.

Lyall, Sarah. "Is It Art, or Just Dead Meat?" *New York Times*, November 12, 1995. https://www.nytimes.com/1995/11/12/magazine/is-it-art-or-just-dead-meat.html.

Machiavelli, Niccolò. *The Prince*. Translated by David Wootton. Indianapolis: Hackett, 1995.

Maggi, Vincenzo. *De Ridiculis*. 1550. In *Trattati di poetica e retorica del Cinquecento*, edited by Bernard Weinberg, 2:91–125. Bari: Laterza, 1970.

Maiorino, Giancarlo. *The Portrait of Eccentricity: Arcimboldo and the Mannerist Grotesque*. University Park: Pennsylvania State University Press, 1991.

Manetti, Giannozzo. *On Human Worth and Excellence*. Edited by Brian P. Copenhaver. Cambridge, MA: Harvard University Press, 2019.

Mann, Heinrich. *Man of Straw*. New York: Penguin, 1984.

———. *Der Untertan*. Munich: DTV, 1978.

Mann, Thomas. *Bekenntnisse des Hochstaplers Felix Krull*. Frankfurt: Fischer, 1976.

———. *Confessions of Felix Krull, Confidence Man*. Translated by Denver Lindley. New York: Vintage, 1992.

———. *Der Zauberberg*. Frankfurt: Fischer, 1924.

Manto, Saadat Hassan. *Mottled Down: Fifty Sketches and Stories of Partition*. Translated by Khalid Hasan. New York: Penguin, 1997.

Marc, Franz. *Briefe, Schriften und Aufzeichnungen*. Edited by Günter Meißner. Leipzig: Kiepenheuer, 1989.

Margolick, David. *Strange Fruit: Billie Holiday, Café Society, and an Early Cry for Civil Rights*. Philadelphia: Running, 2000.

Marinetti, F. T. *Critical Writings*. Edited by Günter Berghaus. New York: Farrar, Straus and Giroux 2006.

Marquard, Reiner. *Karl Barth und der Isenheimer Altar*. Stuttgart: Calwer, 1995.

Marrow, James H. *Passion Iconography in Northern European Art of the Late Middle Ages and Early Renaissance: A Study of the Transformation of Sacred Metaphor into Descriptive Narrative.* Kortrijk, Belgium: Van Ghemmert, 1979.

Martindale, Charles. "The Horatian and the Juvenalesque in English Letters." In *The Cambridge Companion to Roman Satire*, edited by Kirk Freudenburg, 284–98. New York: Cambridge, 2005.

Marx, Karl. "On Money." In *Selected Writings*, 2nd ed., edited by David McLellan, 118–20. New York: Oxford University Press, 2000.

McGinn, Colin. *Ethics, Evil, and Fiction.* Oxford: Clarendon, 1997.

———. *The Meaning of Disgust.* New York: Oxford University Press, 2011.

McGreevy, John T. *Catholicism and American Freedom: A History.* New York: Norton, 2003.

McPhee, Constance C., and Nadine M. Orenstein. *Infinite Jest: Caricature and Satire from Leonardo to Levine.* New York: Metropolitan Museum of Art, 2011.

Mele, Christopher. "Is It Art? Eyeglasses on Museum Floor Began as Teenagers' Prank." *New York Times*, May 30, 2016. https://www.nytimes.com/2016/05/31/arts/sfmoma-glasses-prank.html.

Mellema, Gregory. *Sin.* Notre Dame, IN: University of Notre Dame Press, 2021.

Mellinkoff, Ruth. *The Devil at Isenheim: Reflections of Popular Belief in Grünewald's Altarpiece.* Berkeley: University of California Press, 1988.

———. *Outcasts: Signs of Otherness in Northern European Art of the Late Middle Ages.* Berkeley: University of California Press, 1993.

Menninghaus, Winfried. *Disgust: The Theory and History of a Strong Sensation.* Translated by Howard Eiland and Joel Golb. Albany: State University of New York Press, 2003.

Merback, Mitchell B. *The Thief, the Cross, and the Wheel: Pain and the Spectacle of Punishment in Medieval and Renaissance Europe.* Chicago: University of Chicago Press, 1999.

Mersch, Dieter. "Representation and Distortion: On the Construction of Rationality and Irrationality in Early Modern Modes of Representation." In *Instruments in Art and Science: On the Architectonics of Cultural Boundaries in the Seventeenth Century*, edited by Helmar Schramm, Ludger Schwarte, and Jan Lazardzig, 20–37. Berlin: De Gruyter, 2008.

Mill, John Stuart. *Autobiography.* New York: Penguin, 1989.

Miller, William Ian. *The Anatomy of Disgust.* Cambridge, MA: Harvard University Press, 1997.

Milne, Lesley. *"The Master and Margarita": A Comedy of Victory.* Birmingham: University of Birmingham, 1977.

Moltmann, Jürgen. *The Crucified God: The Cross of Christ as the Foundation and Criticism of Christian Theology*. Translated by R. A. Wilson and John Bowden. New York: Harper, 1974.

———. *Der gekreuzigte Gott: Das Kreuz Christi als Grund und Kritik christlicher Theologie*. 1972. 9th ed. Gütersloh: Gütersloher Verlagshaus, 2007.

Morgan, David. *Visual Piety: A History and Theory of Popular Religious Images*. Berkeley: University of California Press, 1998.

———. "Warner Sallman and the Visual Culture of American Protestantism." In *Icons of American Protestantism: The Art of Warner Sallman*, edited by David Morgan, 25–60. New Haven, CT: Yale University Press, 1996.

Mühlberg, Fried. "Crucifixus Dolorosus: Über Bedeutung und Herkunft des gotischen Gabelkruzifixes." *Wallraf-Richartz-Jahrbuch* 22 (1960): 69–86.

Müller-Seidel, Walter. *Probleme der literarischen Wertung: Über die Wissenschaftlichkeit eines unwissenschafltiches Themas*. 2nd ed. Stuttgart: Metzler, 1969.

Nashe, Thomas. *The Works of Thomas Nashe*. 5 vols. Edited by Ronald B. McKerrow. Oxford: Blackwell, 1958.

Nehamas, Alexander. *Only a Promise of Happiness: The Place of Beauty in a World of Art*. Princeton, NJ: Princeton University Press, 2007.

Nenning, Guenther. "Ohne Schönheit stirbt der Mensch." *Die Zeit*, March 3, 1995.

The New Oxford Annotated Bible with Apocrypha: New Revised Standard Version. 4th ed. Edited by Michael D. Coogan. New York: Oxford University Press, 2010.

Ngai, Sianne. *Our Aesthetic Categories: Zany, Cute, Interesting*. Cambridge, MA: Harvard University Press, 2012.

———. *Ugly Feelings*. Cambridge, MA: Harvard University Press, 2005.

Nietzsche, Friedrich. *The Complete Works of Friedrich Nietzsche*. Stanford, CA: Stanford University Press, 1995–.

———. *Werke*. Ed. Karl Schlechta. 3 vols. 6th ed. Munich: Hanser, 1969.

Nikulin, Dmitri. *Critique of Bored Reason: On the Confinement of the Modern Condition*. New York: Columbia University Press, 2022.

Nin, Anaïs. *The Novel of the Future*. New York: Collier, 1970.

Noonan, John T., Jr. *A Church That Can and Cannot Change: The Development of Catholic Moral Teaching*. Notre Dame, IN: University of Notre Dame Press, 2005.

Nussbaum, Martha. *From Disgust to Humanity: Sexual Orientation and Constitutional Law*. New York: Oxford University Press, 2010.

———. *Upheavals of Thought: The Intelligence of Emotions*. Cambridge: Cambridge University Press, 2001.

Nuttall, Sarah. "Introduction: Rethinking Beauty." In *Beautiful/Ugly: African and Diaspora Aesthetics*, edited by Sarah Nuttall, 6–29. Durham, NC: Duke University Press, 2006.

Oliver, Michael, and Colin Barnes. *The New Politics of Disablement.* New York: Palgrave, 2012.

Olyan, Saul M. *Disability in the Hebrew Bible: Interpreting Mental and Physical Differences.* New York: Cambridge University Press, 2008.

Origen. *Against Celsus.* In *The Ante-Nicene Fathers: The Writings of the Fathers Down to 325 A.D.*, edited by A. Cleveland Coxe, 4:395–669. New York: Scribners, 1926.

———. *Matthäuserklärung II. Die lateinische Übersetzung der Commentariorum Series. Die Griechischen Christlichen Schriftsteller der ersten Jahrhunderte Origenes Elfter Band.* Edited by Erich Kolstermann. Berlin: Akademie, 1976.

———. *On First Principles.* Translated by G. W. Butterworth. New York: Harper, 1966.

Ornstein, Robert. *Shakespeare's Comedies: From Roman Farce to Romantic Mystery.* Newark: University of Delaware Press, 1986.

Ortega y Gasset, José. *"The Dehumanization of Art" and Other Essays on Art, Culture, and Literature.* Princeton, NJ: Princeton University Press, 1968.

Otto, Rudolf. *Das Heilige: Über das Irrationale in der Idee des Göttlichen und sein Verhältnis zum Rationalen.* 1917. Munich: Beck, 2004.

Ouida [Maria Louise Ramé]. *Critical Studies.* Leipzig: Tauchnitz, 1901.

Ovid. *Metamorphoses.* Translated by Charles Martin. New York: Norton, 2004.

Pachnicke, Peter, and Klaus Honnef. *John Heartfield.* New York: Abrams, 1993.

Panofsky, Erwin. *Studies in Iconology: Humanistic Themes in the Art of the Renaissance.* New York: Oxford University Press, 1939.

Parker, Ian. "Anselm Kiefer's Beautiful Ruins." *New Yorker*, July 3, 2017. https://www.newyorker.com/magazine/2017/07/03/anselm-kiefers-beautiful-ruins.

Parry, Hubert H. "The Meaning of Ugliness." *Musical Times* 52 (August 1, 1911): 507–11.

Pepys, Samuel. *Memoirs of Samuel Pepys.* New York: Warne, 1879.

Perl, Jed. *Magicians and Charlatans.* New York: Eakins, 2012.

Peters, Olaf, ed. *Degenerate Art: The Attack on Modern Art in Nazi Germany 1937.* New York: Prestel, 2014.

Phillips, Todd, dir. *Hated: GG Allin & the Murder Junkies.* DVD. Oaks, PA: MVD Visual, 2007.

Piccinini, Patricia. *The Young Family* (2002). https://www.patriciapiccinini.net/writing/51.

Pigozzi, Jean, ed. *Contemporary African Art Collection.* http://www.caacart.com/.

Pinker, Steven. *Enlightenment Now: The Case for Reason, Science, Humanism, and Progress.* New York: Viking, 2018.

Piper, Reinhard. *Mein Leben als Verleger: Vormittag. Nachmittag.* Munich: Piper, 1964.

Pippin, Robert B. *After the Beautiful: Hegel and the Philosophy of Pictorial Modernism.* Chicago: University of Chicago Press, 2014.

Plato. *The Collected Dialogues.* Edited by Edith Hamilton and Huntington Cairns. Princeton, NJ: Princeton University Press, 1961.

Plotinus. *The Enneads.* Translated by Stephen MacKenna. New York: Penguin, 1991.

Plutarch. *Moralia.* Translated by Frank Cole Babbitt. Cambridge, MA: Harvard University Press, 1927.

———. *Plutarch's Lives.* Translated by Bernadotte Perrin. Cambridge, MA: Harvard University Press, 2014.

Pokorny, Erwin. "Hieronymus Bosch und das Paradies der Wollust." *Frühneuzeit-Info* 21, no. 1–2 (2010): 22–34.

Pop, Andrei. "Can Beauty and Ugliness Coexist?" In *Ugliness: The Non-Beautiful in Art and Theory*, edited by Andrei Pop and Mechtild Widrich, 165–79. New York: Tauris, 2014.

Profit, Vera B. *The Devil Next Door: Toward a Literary and Psychological Definition of Human Evil.* Amsterdam: Rodopi, 2014.

Prudentius. *Prudentius.* Translated by H. J. Thomson. Cambridge, MA: Harvard University Press, 2014.

Quintilian. *The Orator's Education.* 5 vols. Edited by Donald A. Russell. Cambridge, MA: Harvard University Press, 2001.

Read, Herbert. *A Concise History of Modern Painting.* London: Thames & Hudson, 1959.

Reuter, Astrid. "Zur expressiven Bildsprache Grünewalds am Beispiel des Gekreuzigten." In *Grünewald und seine Zeit*, edited by Staatliche Kunsthalle Karlsruhe, 78–86. Munich: Deutscher Kunstverlag, 2007.

Ribon, Michel. *Archipel de la Laideur: Essai sur l'Art et la Laideur.* Paris: Éditions Kimé, 1995.

Richardson, John. "A Different Guernica." *New York Review of Books*, May 12, 2016, 4–6.

Richter, Gottfried. *The Isenheim Altar: Suffering and Salvation in the Art of Grünewald.* Translated by Donald Maclean. Edinburgh: Floris, 1998.

Richter, Simon. *Laocoon's Body and the Aesthetics of Pain: Winckelmann, Lessing, Herder, Moritz, Goethe.* Detroit: Wayne State University Press, 1992.

Rigby, Paul. *Original Sin in Augustine's "Confessions."* Ottawa: University of Ottawa Press 1987.

Rimbaud, Arthur. *Complete Works, Selected Letters: A Bilingual Edition.* Translated by Wallace Fowlie and Seth Whidden. Chicago: University of Chicago Press, 2005.

Rimell, Victoria. "The Poor Man's Feast: Juvenal." In *Cambridge Companion to Roman Satire*, edited by Kirk Freudenburg, 81–94. New York: Cambridge University Press, 2005.

Rimington, Greta. "The Cross and the Crucifixion in Christian Art." *Areopagus* 4 (1991): 41–46.

Rinaldi, Giaccomo. *The Philosophy of Art.* Vol. 1. Oxford: Pertinent Press, 2022.

Ringleben, Joachim. *Dornenkrone und Purpurmantel: Zu Bildern von Grünewald bis Paul Klee.* Frankfurt: Insel, 1996.

Robinson, Paul. "Response." In Leslie A. Fiedler, *Pity and Fear: Myths and Images of the Disabled in Literature Old and New*, 18–23. New York: International Center for the Disabled, 1981.

Roche, Barbara. "Artist Statement." Conference on Beauty, Notre Dame Institute for Advanced Study, January 2010.

Roche, Mark W. *Alfred Hitchcock: Filmmaker and Philosopher.* New York: Bloomsbury, 2022.

———. "Being at Home in the Other: Thoughts and Tales from a Typically Atypical Germanist." In *Transatlantic German Studies: Personal Experiences*, edited by Paul Michael Lützeler and Peter Höyng, 181–97. Columbia, SC: Camden House, 2018.

———. *Dynamic Stillness: Philosophical Conceptions of Ruhe in Schiller, Hölderlin, Büchner, and Heine.* Tübingen: Niemeyer, 1987.

———. "Idealistische Ästhetik als Option für die heutige Ästhetik und Literaturwissenschaft." In *Idealismus heute: Aktuelle Perspektiven und neue Impulse*, edited by Vittorio Hösle and Fernando Suárez Müller, 271–89. Darmstadt: Wissenschaftliche Buchgesellschaft, 2015.

———. *Tragedy and Comedy: A Systematic Study and a Critique of Hegel.* Albany: State University of New York Press, 1998.

———. "Die unverwechselbare Auffassung des Göttlichen in Hölderlins *Hyperion.*" *Hölderlin Jahrbuch* 39 (2014–2015): 66–78.

———. *Why Literature Matters in the 21st Century.* New Haven, CT: Yale University Press, 2004.

Roche, Mark W., and Vittorio Hösle. "Religious and Cultural Reversals in Clint Eastwood's *Gran Torino.*" *Religion and the Arts* 15 (2011): 648–79.

Rosen, Aaron. *Art + Religion in the 21st Century.* London: Thames, 2015.

Rosen, Charles. *Sonata Forms.* New York: Norton, 1988.

Rosenkranz, Karl. *Aesthetics of Ugliness: A Critical Edition.* Translated by Andrei Pop and Mechtild Widrich. New York: Bloomsbury, 2015.

———. *Ästhetik des Hässlichen.* 1853. Darmstadt: Wissenschaftliche Buchgesellschaft, 1979.

———. *System der Wissenschaft: Ein philosophisches Encheiridion*. Königsberg: Gebrüder Bornträger, 1850.

———. *Von Magdeburg bis Königsberg*. Berlin: Heimann, 1873.

Rosling, Hans, with Ola Rosling and Anna Rosling Rönnlund. *Factfulness: Ten Reasons We're Wrong about the World—and Why Things Are Better Than You Think*. New York: FlatIron, 2018.

Roth, Joseph. *Werke*. 6 vols. Edited by Klaus Westermann and Fritz Hackert. Cologne: Kiepenheuer, 1989–91.

Rötscher, Heinrich Theodor. *Aristophanes und sein Zeitalter: Eine philologisch-philosophische Abhandlung zur Alterthumsforschung*. Berlin: Voss, 1827.

Rouault, Georges, and André Suarès. *Correspondance*. Edited by Marcel Arland. Paris: Gallimard, 1960.

Ruge, Arnold. *Neue Vorschule der Ästhetik: Das Komische mit einem komischen Anhang*. 1837. Hildesheim: Olms, 1975.

Rugoff, Ralph, Kristine Stiles, and Giacinto Di Pietrantonio. *Paul McCarthy*. London: Phaidon, 1996.

Russell, Jeffrey Burton. *Lucifer: The Devil in the Middle Ages*. Ithaca, NY: Cornell University Press, 1984.

Santayana, George. *The Sense of Beauty: Being the Outline of Aesthetic Theory*. New York: Dover, 1955.

Schaeffer, Jean-Marie. *Art of the Modern Age: Philosophy of Art from Kant to Heidegger*. Princeton, NJ: Princeton University Press, 2009.

Schasler, Max. *Ästhetik: Grundzüge der Wissenschaft des Schönen und der Kunst*. 2 vols. Leipzig: Freytag, 1886.

———. *Kritische Geschichte der Aesthetik von Plato bis auf die Gegenwart: Grundlegung für die Aesthetik als Philosophie des Schönen und der Kunst*. 2 vols. Berlin: Nicolai, 1872.

Schelling, Friedrich Wilhelm. *Philosophical Investigations into the Essence of Human Freedom*. Translated by Jeff Love and Johannes Schmidt. Albany: State University of New York Press, 2006.

———. *Über das Wesen der menschlichen Freiheit*. Edited by Horst Fuhrmans. Stuttgart: Reclam, 1977.

Schiller, Friedrich. *Essays*. Edited by Walter Hinderer and Daniel O. Dahlstrom. New York: Continuum, 2005.

———. *Werke und Briefe in zwölf Bänden*. Edited by Otto Dann, Heinz Gerd Ingenkamp, Rolf-Peter Janz, Gerhard Kluge, Herbert Kraft, Georg Kurscheidt, Matthias Luserke, Norbert Oellers, Mirjam Springer, and Frithjof Stock. Frankfurt: Deutscher Klassiker Verlag, 1988–2004.

Schlegel, Friedrich. *On the Study of Greek Poetry*. Translated by Stuart Barnett. Albany: State University of New York Press, 2001.

———. *Über das Studium der griechischen Poesie: Kritische Friedrich-Schlegel Ausgabe*, edited by Ernst Behler, I.1.217–367. Paderborn: Schöningh, 1979.

Schmid, Heinrich Alfred. *Die Gemälde und Zeichnungen von Matthias Grüne-wald*. 2 vols. Strassburg: Heinrich, 1908–11.

Schmidt, Arno. *Nobodaddy's Kinder; Aus dem Leben eines Fauns; Brand's Haide; Schwarze Spiegel*. Zürich: Haffman, 1985.

Schmidt, Ernst A. "Problematische Gewalt in der Psychomachia des Pruden-tius?" In *Dulce Melos*, edited by Victoria Panagl, 31–51. Alessandria: Edizioni dell'Orso, 2007.

Schmidt, Jochen. *Hölderlins geschichtsphilosophische Hymnen: "Friedensfeier," "Der Einzige," "Patmos."* Darmstadt: Wissenschaftliche Buchgesellschaft, 1990.

Schoenberg, Arnold. *Style and Idea: Selected Writings of Arnold Schoenberg*. Edited by Leonard Stein. New York: St. Martin's, 1975.

Scholes, Robert, and Carl H. Klaus. *Elements of Drama*. New York: Oxford University Press, 1971.

Schopenhauer, Arthur. *Zürcher Ausgabe: Werke in zehn Bänden*. Zürich: Di-ogenes, 1977.

Schorske, Carl. *Fin-de-siècle Vienna: Politics and Culture*. New York: Knopf, 1980.

Schubert, Michael. *Der Isenheimer Altar: Geschichte—Deutung—Hintergründe*. Stuttgart: Urachhaus, 2007.

Schultze-Naumburg, Paul. *Kunst und Rasse*. Munich: Lehmann, 1928.

Schuster, Peter-Klaus, ed. *George Grosz: Berlin—New York*. Berlin: Nicolai, 1994.

Schwarz, K. Robert. "In Contemporary Music, a House Still Divided." *New York Times*, August 3, 1997. https://www.nytimes.com/1997/08/03/arts /in-contemporary-music-a-house-still-divided.html.

Scruton, Roger. *Beauty: A Very Short Introduction*. New York: Oxford, 2011.

Sedlmayr, Hans. *Verlust der Mitte: Die bildende Kunst des 19. und 20. Jahr-hunderts als Symptom und Symbol der Zeit*. 1948. Salzburg: Müller, 1998.

Selz, Peter. "John Heartfield's 'Photomontages.'" *Massachusetts Review* 4, no. 2 (1963): 309–36.

———. *Max Beckmann*. New York: Museum of Modern Art, 1964.

Shakespeare, William. *The Complete Works of William Shakespeare*. 6 vols. Edited by David Bevington. New York: Bantam, 1988.

Sibley, Frank. "Some Notes on Ugliness." In *Approach to Aesthetics: Collected Papers on Philosophical Aesthetics*, 190–206. Oxford: Clarendon, 2001.

Sidonius Apollinaris. *Poems and Letters*. Cambridge, MA: Harvard Univer-sity Press, 2014.

Siebers, Tobin. *Disability Aesthetics*. Ann Arbor: University of Michigan Press, 2010.

Simmel, Georg. *Das Individuum und die Freiheit: Essais*. 1957. Berlin: Wagen-bach, 1984.

Simpson, Kathryn. "I'm Ugly Because You Hate Me: Ugliness and Negative Empathy in Oskar Kokoschka's Early Self-Portraiture." In *Ugliness: The Non-Beautiful in Art and Theory*, edited by Andrei Pop and Mechtild Widrich, 122–40. New York: Tauris, 2014.

Slonimsky, Nicolas. *Lexicon of Musical Invective: Critical Assaults on Composers since Beethoven's Time*. New York: Coleman-Ross, 1953.

Smith, David Livingstone. *Less than Human: Why We Demean, Enslave, and Exterminate Others*. New York: St. Martin's, 2011.

Smith, Philip E., II, ed. *Approaches to Teaching the Works of Oscar Wilde*. New York: MLA, 2008.

Solomon, Maynard. *Mozart: A Life*. New York: HarperCollins, 1995.

Sophocles. *The Three Theban Plays*. Translated by Robert Fagles. New York: Penguin, 1984.

Southern, R. W. *Medieval Humanism and Other Studies*. Oxford: Blackwell, 1970.

———. *Scholastic Humanism and the Unification of Europe*. 2 vols. New York: Blackwell, 1995–2001.

Specht, Henrik. "The Beautiful, the Handsome, and the Ugly: Some Aspects of the Art of Character Portrayal in Medieval Literature." *Studia Neophilologica* 56 (1984): 129-46.

Spike, John T. *Caravaggio*. New York: Abbeville, 2001.

Spitzer, Leo. *Linguistics and Literary History: Essays in Stylistics*. Princeton, NJ: Princeton University Press, 1948.

Spoto, Donald. *The Dark Side of Genius: The Life of Alfred Hitchcock*. Boston: Little, Brown, 1983.

Stang, Ragna. *Edvard Munch: The Man and His Art*. Translated by Geoffrey Culverwell. New York: Abbeville, 1979.

Statius. *Thebaid. A Song of Thebes*. Translated by Jane Wilson Joyce. Ithaca, NY: Cornell University Press, 2008.

Steiner, Wendy. *Venus in Exile: The Rejection of Beauty in Twentieth-Century Art*. 2001. Chicago: University of Chicago Press, 2002.

Steinherr, Ludwig. *Das Mädchen. Der Maler. Ich*. Munich: Allitera, 2012.

Stiles, Kristine, and Peter Selz, eds. *Theories and Documents of Contemporary Art: A Sourcebook of Artist's Writings*. Berkeley: University of California Press, 1996.

Stolnitz, M. Jerome. "On Ugliness of Art." *Philosophy and Phenomenological Research* 11 (1950): 1–24.

Strother, Z. S. *Inventing Masks: Agency and History in the Art of the Central Pende*. Chicago: University of Chicago Press, 1998.

Sullivan, R. "Deformity—A Modern Western Prejudice with Ancient Origins." *Proceedings of the Royal College of Physicians of Edinburgh* 31 (2001): 262–66.

Suso, Henry. *"Little Book of Eternal Wisdom" and "Little Book of Truth."* Translated by James M. Clark. New York: Harper, 1953.

———. [Seuse, Heinrich]. *Deutsche Schriften*. Edited by Karl Bihlmeyer. Stuttgart: Kohlhammer, 1907.

Szántó, András. *The Visual Art Critic. A Survey of Art Critics at General-Interest News Publications in America*. New York: Columbia University National Arts Journalism Program, 2002.

Szondi, Peter. *Poetik und Geschichtsphilosophie II*. Edited by Wolfgang Fietkau. Frankfurt: Suhrkamp, 1974.

Tacitus. *The "Agricola" and "Germania" of Tacitus*. Translated by K. B. Townshend. London: Methuen, 1894.

Tagore, Rabindranath. *The King of the Dark Chamber*. New Delhi: Rupa, 2002.

Tatar, Maria. *Lustmord: Sexual Murder in Weimar Germany*. Princeton, NJ: Princeton University Press, 1995.

Tate, Nahum. *The History of King Lear*. Edited by James Black. Lincoln: University of Nebraska Press, 1975.

Taubes, Jacob. "Die Rechtfertigung des Häßlichen in urchristlicher Tradition." In *Die nicht mehr schönen Künste: Grenzphänomene des Ästhetischen*, edited by Hand Robert Jauß, 169–85. Munich: Fink, 1968.

Tertullian. *The Five Books against Marcion*. In *The Ante-Nicene Fathers: The Writings of the Fathers down to 325 A.D.*, edited by A. Cleveland Coxe, 3:269–455. New York: Christian, 1885.

———. *On the Flesh of Christ*. In *The Ante-Nicene Fathers: The Writings of the Fathers down to 325 A.D. Latin Christianity*, edited by A. Cleveland Coxe, 3:525–43. New York: Christian, 1885.

Theognis. *The Elegies of Theognis and Other Elegies included in the Theognidean Sylloge*. Edited by T. Hudson-Williams. London: Bell, 1910.

Thomas, Aquinas. *In librum beati Dionysii "De divinis nominibus expositio."* Edited by Ceslai Pera. Rome: Marietti, 1950.

———. *Summa Theologica*. 5 vols. 2nd ed. Translated by Fathers of the English Dominican Province. Westminster, MD: Christian Classics, 1981.

———. *The Three Greatest Prayers: Commentaries on the Our Father, the Hail Mary, and the Apostles' Creed*. Translated by Laurence Shapcote. Westminster, MD: Newman Press, 1956.

Tillich, Paul. *Writings in the Philosophy of Culture. Kulturphilosophische Schriften*. Edited by Michael Palmer. New York: De Gruyter, 1990.

Timmerman, John. "The Ugly in Art." *Christian Scholar's Review* 7 (1977): 138–45.

Toews, John E. *The Story of Original Sin*. Eugene, OR: Pickwick, 2013.

Tolstoy, Leo. *Anna Karenina*. Translated by Constance Garnett, Leonard J. Kent, and Nina Berberova. New York: Modern Library, 2000.

———. *War and Peace*. Translated by Richard Pevear and Larissa Volokhonsky. New York: Vintage, 2008.

Tragicorum Graecorum Fragmenta. 2nd ed. Edited by August Nauck. Leipzig: Teubner, 1889.

Trentin, Lisa. *The Hunchback in Hellenistic and Roman Art*. New York: Bloomsbury, 2015.

Trinkaus, Charles Edward. *In Our Image and Likeness: Humanity and Divinity in Italian Humanist Thought*. 2 vols. Notre Dame, IN: University of Notre Dame Press, 1995.

Troop, William. "Kehinde Wiley Reimagines Old Portraits Because 'if Black Lives Matter, they deserve to be in paintings.'" *World,* November 2, 2016. https://theworld.org/stories/2016-11-02/kehinde-wiley-reimagines-old -portraits-because-if-black-lives-matter-they-deserve.

Tucholsky, Kurt. *Deutschland, Deutschland über alles: Ein Bilderbuch von Kurt Tucholsky und vielen Fotografen montiert von John Heartfield*. 1929. Hamburg: Rowohlt, 2006.

———. *Deutschland, Deutschland über alles. A Picture-book by Kurt Tucholsky. Photographs Assembled by John Heartfield*. Translated by Anne Halley. Amherst: University of Massachusetts Press, 1972.

———. *Gesammelte Werke in 10 Bänden*. Edited by Mary Gerold-Tucholsky and Fritz J. Raddatz. Hamburg: Rowohlt, 1975.

Tumlir, Jan, and Jeff Wall. "The Hole Truth." *Artforum International* 39, no. 7 (2001): 112–17.

Tzara, Tristan. *Seven Dada Manifestos and Lampisteries*. Translated by Barbara Wright. New York: Riverrun, 1992.

"Unterhaltungen zwischen Ohnesorge und George Grosz." *Das Tage-Buch*, February 23, 1924. Heft 8. Jahrgang 5:240–48. Repr., Königstein/Ts.: Athenäum, 1981.

Van Acker, Wouter, and Thomas Mical. *Architecture & Ugliness: Anti-Aesthetics and the Ugly in Postmodern Architecture*. New York: Bloomsbury, 2020.

Van Damme, Wilfried. "A Comparative Analysis concerning Beauty and Ugliness in Sub-Saharan Africa." *Africana Gandensia* 4 (1987): 1–97.

Van Gelder, Geert Jan. "Beautifying the Ugly and Uglifying the Beautiful: The Paradox in Classical Arabic Literature." *Journal of Semitic Studies* 48, no. 2 (2003): 321–51.

Van Hoddis, Jakob. "End of the World." In *Modern German Poetry, 1910–1960: An Anthology with Verse Translations*, edited by Michael Hamburger and Christopher Middleton, 49. London: MacGibbon, 1962.

———. *Weltende: Die zu Lebzeiten veröffentlichten Gedichte*. Edited by Paul Raabe. Zürich: Arche, 2001.

Vasari, Giorgio. *The Lives of the Painters, Sculptors and Architects*. 8 vols. Translated by A. B. Hinds. London: Dent, 1900.

———. *Vasari on Technique. Being the Introduction to the Three Arts of Design, Architecture, Sculpture and Painting, Prefixed to the Lives of the Most Excellent Painters, Sculptors and Architects.* Translated by Louisa S. Maclehose. 1907. New York: Dover, 1960.

Viladesau, Richard. *The Beauty of the Cross: The Passion of Christ in Theology and the Arts, from the Catacombs to the Eve of the Renaissance.* New York: Oxford University Press, 2006.

———. *The Triumph of the Cross: The Passion of Christ in Theology and the Arts, from the Renaissance to the Counter-Reformation.* New York: Oxford University Press, 2008.

Vischer, Friederich Theodor. *Ästhetik oder Wissenschaft des Schönen.* 1846–1857. 6 vols. 2nd ed. Edited by Robert Vischer. Hildesheim: Olms, 1975.

———. *Kritische Gänge.* 6 vols. Stuttgart: Cotta, 1860–1873.

Volk, Stefan. "Von der Form zum Material: Fatih Akins doppeltes Spiel mit dem Genrekino in *Gegen die Wand* und *Auf der anderen Seite.*" In *Kultur als Ereignis: Fatih Akins Film "Auf der anderen Seite" als transkulturelle Narration,* edited by Özkan Ezli, 151–58. Bielefeld: Transcript, 2010.

Walker, Kara E. *Kara Walker: My Complement, My Enemy, My Oppressor, My Love.* Organized by Philippe Vergne. Minneapolis: Walker Art Center, 2007.

Wall, Jeff. *Selected Essays and Interviews.* New York: Museum of Modern Art, 2007.

Warr, Tracey, ed. *The Artist's Body.* New York: Phaidon, 2012.

Weiße, Christian Hermann. *System der Ästhetik als Wissenschaft von der Idee der Schönheit.* 2 vols. 1830. Hildesheim: Olms, 1966.

Westermann, Claus. *The Psalms: Structure, Content, and Message.* Translated by Ralph D. Gehrke. Minneapolis: Augsburg, 1980.

Weyl, Hermann. *Symmetry.* Princeton, NJ: Princeton University Press, 1952.

Wilde, Oscar. *The Complete Works of Oscar Wilde.* 8 vols. New York: Oxford University Press, 2001–2018.

Williams, Rowan. *On Augustine.* New York: Bloomsbury, 2016.

Wilson, Robert Rawdon. *The Hydra's Tale: Imagining Disgust.* Edmonton: University of Alberta Press, 2002.

Winckelmann, Johann Joachim. *Gedanken über die Nachahmung der griechischen Werke in der Malerei und Bildhauerkunst.* 1756. Stuttgart: Reclam, 1977.

Winkler, Christine. *Die Maske des Bösen: Groteske Physiognomie als Gegenbild des Heiligen und Vollkommenen in der Kunst des 15. und 16. Jahrhundert.* Munich: Scaneg, 1986.

Winkler, Martin M., ed. *Juvenal in English.* New York: Penguin, 2001.

Winzinger, Franz, ed. *Albrecht Altdorfer: Die Gemälde.* Munich: Piper, 1975.

Wismer, Beat, and Michael Scholz-Hänsel. *El Greco and Modernism*. Düsseldorf: Museum Kunstpalast, 2012.

Wittgenstein, Ludwig. *Tractatus logico-philosophicus*. 1959. Frankfurt: Suhrkamp, 1979.

———. *Vermischte Bemerkungen*. Frankfurt: Suhrkamp, 1977.

Whitman, Cedric. *Sophocles: A Study of Heroic Humanism*. Cambridge, MA: Harvard University Press, 1951.

Wölfflin, Heinrich. *Die klassische Kunst: Eine Einführung in die Italienische Renaissance*. Munich: Bruckmann, 1914.

———. *Kunstgeschichtliche Grundbegriffe: Das Problem der Stilentwicklung in der neueren Kunst*. 1915. 19th ed. Basel: Schwabe, 2004.

———. *Renaissance und Barock. Eine Untersuchung über Wesen und Entstehung des Barockstils in Italien*. 1888. 8th ed. Basel: Schwabe, 1986.

Wood, Amy Louise. *Lynching and Spectacle: Witnessing Racial Violence in America, 1890–1940*. Chapel Hill: University of North Carolina Press, 2009.

Worley, Linda Kraus. "The Body, Beauty, and Woman: The Ugly Heroine in Stories by Therese Huber and Gabriele Reuter." *German Quarterly* 64, no. 3 (1991): 368–78.

Wright, Charlotte M. *Plain and Ugly Janes: The Rise of the Ugly Woman in Contemporary American Fiction*. New York: Garland, 2000.

Wycherley, William. *Miscellany Poems*. London: Wale, 1706.

Zappa, Frank. "The Rolling Stone Interview: Frank Zappa." With Jerry Hopkins. *Rolling Stone*, July 20, 1968. https://www.rollingstone.com/music/music-news/the-rolling-stone-interview-frank-zappa-81967/.

Zervigón, Andrés Mario. *John Heartfield and the Agitated Image: Photography, Persuasion, and the Rise of Avant-garde Photomontage*. Chicago: University of Chicago Press, 2012.

Ziermann, Horst. *Matthias Grünewald*. Munich: Prestel, 2001.

Ziolkowski, Jan. "Avatars of Ugliness in Medieval Literature." *Modern Language Review* 79, no. 1 (1984): 1–20.

Zola, Èmile. *"The Experimental Novel" and Other Essays*. Translated by Belle Sherman. New York: Haskell, 1964.

———. *Thérèse Raquin*. Translated by Robin Buss. New York: Penguin, 2004.

Žukauskiene, Odeta. "Orderly Ugliness, Anamorphosis and Visionary Worlds: Jurgis Baltrušaitis' Contribution to Art History." In *Ugliness: The Non-Beautiful in Art and Theory*, edited by Andrei Pop and Mechtild Widrich, 190–215. New York: Tauris, 2014.

Page numbers in italics refer to illustrations.

Abelard, Peter, 92

abjection, 51, 141, 163

Adorno, Theodor: *Aesthetics*, 404; on artwork as enigma, 409; Brecht criticized by, 377, 380; on kitsch, 228; on modernity, 203, 403; on ugliness, 354

Aeschylus: *Agamemnon*, 389; *Eumenides*, 388, 389; *The Libation Bearers*, 389–90; *Oresteia*, 13, 107, 388–90, 394

aesthetics: artwork, 8, 29, 51, 62–66, 72, 75, 381; of beautiful ugliness, 3, 34, 65; dialectical beauty and, 376; distortion and, 77; Hegel and Hegelians on, 66, 94–108; hermeneutics and, 86; idealism and, 14–16; laissez-faire, 61; medieval, 8, 90–93; negative aesthetic value, 3, 66, 70, 107, 228, 230; positive aesthetic value, 3, 34, 62, 66–70, 72, 226; production, 62–65, 381, 403; reception, 29, 51–54, 62–65, 72, 404, 431n3; seeming ugliness and, 63, 66; transformations in, 245–49. *See also* beauty

African Americans: Black Lives Matter movement, 219; lynching and, 27, 169, 219, 370; racism and, 70, 81, 84, 369–71; spirituals of, 347

African cultures, aischric beauty in, 324–25

aischric beauty, 306–36; in African cultures, 324–25; beauty dwelling in ugliness and, 346, 358; comedy and, 331–32; dialectical beauty and, 13, 368, 382, 402; dissonance and, 308, 325–30, 336; distortion and, 306–9, 312–16, 318–22, 334–35; drama of suffering and, 332–33, 350; empathy and, 320; grotesqueness and, 316; in modernity, 324, 401; moral ugliness and, 308; physical ugliness and, 308; repugnant beauty and, 308, 323; symmetry/asymmetry and, 307, 309

Akin, Fatih: *The Edge of Heaven*, 84–85, 407; *In July*, 84

Alberti, Leon Battista, 362, 442n1 (chap. 13)

Albright, Ivan: *Into the World There Came a Soul Called Ida*, 355, 356; *The Picture of Dorian Gray*, 322–23

Alexander the Great, 111

alienation: beauty dwelling in ugliness and, 344; dialectical beauty and, 361; difficult beauty and, 77–78; dissonance and, 375; moral ugliness and, 365

Allen, Woody: *A Midsummer Night's Sex Comedy*, 41

Alt, Peter-André, 204, 244

Altdorfer, Albrecht: *Christ on the Cross between Mary and St. John*, 139, 436n5

anamorphosis, 3, 292, 293, 309

Anselm of Canterbury: *Prayer to Christ*, 135

apokatastasis panton (restitution of all), 395, 443nn4–5

Aragon, Louis: "John Heartfield and Revolutionary Beauty," 367

Archipenko, Alexander: *Boxing Match*, 300–301

Arcimboldo, Giuseppe: aischric beauty and, 309–12; beauty dwelling in ugliness and, 358; *The Cook*, 311; fractured beauty and, 291, 292; *The Lawyer*, 311, *311*; playful fascination and, 57; *Winter*, 309–10, *310*

Aristophanes: *The Clouds*, 41–42, 372, 422; comedy and, 41, 105, 433n2 (chap. 4); on happiness, 104

Aristotle: on artwork, 68, 362; on knowledge as virtue, 174; on *mirabilia* (marvels), 55; *Poetics*, 88; on ugliness, 7, 88, 100, 108, 267

Arlen, Harold: "Stormy Weather," 347

art brut (outsider art), 297

Artusi, Giovanni, 325–26

artwork aesthetics, 8, 29, 51, 62–66, 72, 75, 381

asymmetry: aischric beauty and, 307, 309; fractured beauty and, 299; ugliness and, 25, 35, 169

atonal music, 77, 222, 229, 303, 346

Auerbach, Eric, 141, 169–70

Auerbach, Frank, 295

Augustine (saint): on beauty, 29, 90–92; *City of God*, 54, 91; *Confessions*, 175–76, 179; on crucifixion of Christ, 93, 165–66; on narrative of Christ, 93; *On Order*, 92; on pride, 42; *True Religion*, 91; on ugliness, 90–92, 165–66, 242

avant-garde, 12, 86, 202, 229–30, 335–36

Babbitt, Milton, 223

Bach, Johann Sebastian: *St. Matthew Passion*, 328–29

Bacon, Francis, 2, 54, 416–18, *417*

Baker, Naomi, 194–95

Bakhtin, Mikhail, 353–54

Baldung, Hans: *Death and the Woman*, 155; *Death with an Inverted Banner*, 155–57; *Three Ages of Woman and Death*, 276, *277*

Ball, Hugo, 74–75, 203, 427–28

Balthasar, Hans Urs von: *The Glory of the Lord*, 183–85

Bandyopadhyay, Manik: *Prehistoric*, 357

Barber, Samuel: *Adagio for Strings*, 328

Barnes, Colin, 81

Baroque, 191, 193, 196–98, 202, 247, 276, 325, 332

Barth, Karl, 168

Baselitz, Georg: *The Big Night Down the Drain*, 57–58; fractured beauty and, 299–300; *Frakturbilder*, 300

Bassano, Jacopo: *Adoration of the Shepherds with Saints Vittore and Corona*, 170–71

Baudelaire, Charles: on beauty, 85; *Flowers of Evil*, 265–67; "Little Old Women," 355–56

Baumgarten, Alexander Gottlieb, 341

Bayley, Stephen, 58, 431n7

Beardsley, Monroe: *Aesthetics*, 431n3; on critical evaluation, 75

beautiful ugliness: aesthetics of, 3, 34, 65; conditions required for, 2; dialectical pattern of, 413, *414*; in modernity, 59; porous boundaries of, 415–18, 420–24; Rosenkranz on, 105. *See also* aischric beauty; dialectical beauty; fractured beauty; repugnant beauty; speculative beauty

beauty: beckoning, 407–8, 413, 424; cognitive dimension of, 33; crucifixion and, 96–97; definitions of, 31, 86, 430n1; difficult, 70–78, 82, 83, 229–30, 234; early modern Christians on, 90–92; female nude as traditional embodiment of, 44–45; in Greece (ancient), 112; Hegel and Hegelians on, 33, 96–108; inversions of idealized, 207–13; medieval, 90–93; moral, 43, 46, 47, 49, 248; as opposite of ugliness, 7, 25–26, 29, 33; perspective and, 3;

in transformation of ugliness, 5, 289; virtue and, 46. *See also* aesthetics; aischric beauty; dialectical beauty; fractured beauty; repugnant beauty; speculative beauty

beauty dwelling in ugliness, 339–59; aischric beauty and, 346, 358; carnivalesque spirit and, 352–54; dialectical beauty and, 381; distortion and, 345, 351, 375; drama of suffering and, 350; empathy and, 340, 342; features of, 13, 338, 339; fractured beauty and, 357; Hegelian resistance to, 360; literature review, 340–52; negation and, 337; postmodernism and, 345–46, 351, 357; repugnant beauty and, 355–57; spectrum of, 379

Beckett, Samuel: *Waiting for Godot*, 278

Beckmann, Max: *Descent from the Cross*, 82, *83*; *The Night*, 306–8, *307*

beckoning beauty, 407–8, 413, 424

Beethoven, Ludwig van: *Fidelio*, 327; *Ninth Symphony*, 398, 443n5

Benn, Gottfried: beauty dwelling in ugliness and, 13, 357; "Lost I," 40, 77; *Morgue*, 201–3; repugnant content in poetry of, 2; ugliness and, 68, 350

Berlioz, Hector: *Damnation of Faust*, 327

Bernard of Clairvaux, 135, 171, 173

Bernard of Cluny, 177–78, 239

Bernstein, Leonard, 77, 326

Bianchi, Sérgio: *Chronically Unfeasible*, 368–69

biases. *See* discrimination

Bidermann, Jacob: *Cenodoxus*, 145

Bisbee, John, 186

Black Lives Matter movement, 219

Blacks. *See* African Americans

blues music, 346–47

Boethius: *Consolatio philosophiae*, 40

Böhme, Jakob, 242

Bohtz, August Wilhelm, 98

Boltanski, Christian: admiration for Christianity, 179; *Altar to the Chases High School*, 323–24

Bonaventure: *Tree of Life*, 166–67

Borges, Jorge Luis, 38

Bosanquet, Bernard: *A History of Aesthetic*, 71, 72

Bosch, Hieronymus: *Christ Carrying the Cross*, 160, 160–61; *The Garden of Earthly Delights*, 151–54, *152*; portrayals of human depravity, 129

Boulboullé, Guido, 153–54

Bourdelle, Antoine: *Tragic Mask of Beethoven*, 323

Brancusi, Constantin: *Bird in Space*, 302

Brecht, Bertolt: "Dialectic," 377; "The Drowned Girl," 350; *The Good Person of Sichuan*, 380; in satiric tradition, 361, 362, 379; *The Threepenny Opera*, 375–76

Brintnall, Kent, 417–18

Broch, Hermann, 228–29

Bruegel, Pieter (the Elder): *Christ Carrying the Cross*, 182–83, *184–85*; *Triumph of Death*, 154, *156–7*

Brueggemann, Walter, 348

Büchner, Georg: *Lenz*, 350; *Leonce and Lena*, 204, 278, 279; *Woyzeck*, 205–6

Buddhism, 5–6, 435n1

Bulgakov, Mikhail: *The Master and Margarita*, 188–89, 353, 397

Bulwer-Lytton, Edward, 406

Buñuel, Luis, 246

Burden, Chris, 225

Bürger, Peter: reception-aesthetic argument by, 404; *Theory of the Avant-Garde*, 335–36

Burgess, Anthony, 442n3 (chap. 13)

Burke, Edmund, 33

Cage, John, 38, 85

Calderón, Pedro: *Life Is a Dream*, 389

Callas, Maria, 26

Callot, Jacques: *The Miseries and Misfortunes of War*, 271

Calvin, John: *Institution of the Christian Religion*, 157–58

Caravaggio: *Calling of Saint Matthew*, 17; *Conversion of Saint Paul*, 17; *Crucifixion of St. Peter*, 399; *The Incredulity of St. Thomas*, 171; *Madonna of the Pilgrims*, 171, *172*; *Madonna of the Rosary*, 171

caricature: dialectical beauty and, 369; as distortion, 206–7; fractured beauty and, 292; grotesqueness and, 50; Impressionism and, 76; satire and, 104, 293; ugliness and, 94, 102, 104, 107, 360

Carmichael, Peter, 42

carnivalesque spirit, 153–54, 271, 352–54

Carpeaux, Jean-Baptiste: *Ugolino and His Sons*, 43

Carracci, Annibale: *The Virgin Mourning Christ*, 144

Carrière, Moriz Philipp: *Aesthetik*, 107

Celan, Paul: "Death Fugue," 273–76, 422–23

Cézanne, Paul, 76, 247

Chamberlain, John: *Balzanian*, 341; fractured beauty and, 303; *Nutcracker*, 341

Chaplin, Charlie: *Limelight*, 406

Chapman, Jake and Dinos, 225, 342

Christianity: degenerate art and, 82; dialectical beauty in, 167; in early modern era, 93–94, 109, 145; empathy motif in, 56; Enlightenment and, 397; Eucharist in, 74, 173, 182; hierarchy within, 353; idealism and, 14–16; kitsch and, 16–17, 183; legacy of, 272; modernity and, 213–22; on moral depravity, 173–78; redemptive arc of, 349; resurrection of Christ, 180–82; *The Resurrection of Christ*, 181; secular reinterpretations of, 59; speculative beauty and, 395, 397; transitory ugliness and, 179. *See also* crucifixion of Christ; medieval Christianity

Claudius, Matthias, 182

Cohen, Hermann, 108, 344

comedy: aischric beauty and, 331–32; beckoning beauty and, 408; dialectical beauty and, 372–73, 383; in drama of reconciliation, 106–8, 387–88; negation and, 100, 102, 105, 361; tragicomedies, 51, 85; ugliness and, 41, 43, 100, 103, 107–11, 279, 352

Cook, John, 5

Cornelisz, Jacob: *The Man of Sorrows*, 173

Cotton, Nicola, 78–79

Courtney, Edward, 124

Cox, Renee: *It Shall Be Named*, 219

Cranach, Lucas (the Elder): *Christ as a Man of Sorrows*, 139; *The Lamentation of Christ*, 141

crucifixion of Christ: Augustine on, 93, 165–66; beauty and, 96–97; deformity and, 166; degenerate art and, 82; Hegelians on, 108; Hegel on, 144; lowliest of the low and, 162–71, 173; in medieval Christianity, 131–37, 139–43; scandal caused by, 164; speculative beauty and, 399–401

crucifixus dolorosus (plague cross), 134, *136, 137*

Csuri, Charles: *Gossip*, 282–83, *283*, 289

cubism, 291–93, 299

cynicism, 49, 110, 227

Dahlhaus, Carl, 247

Dali, Salvador: *An Andalusian Dog*, 246; *The Persistence of Memory*, 48; *Soft Construction with Boiled Beans (Premonition of Civil War)*, 48–49

danse macabre, 316, *318*

Dante: *Commedia*, 47, 59; *Inferno*, 43, 146–49, 268, 384, 397, 423–24; on speculative beauty, 403; ugliness and, 82, 107

Darby, Ainslie, 241

Darwin, Charles, 55

Das, Jibanananda: "A Certain Sense," 350

Daumier, Honoré-Victorin, 366

David, Jacques-Louis: *Christ on the Cross*, 183; *The Death of Marat*, 7, 269, *270*, 355

Davis, Stuart, 296

Dead Lovers, The (anonymous), 154, 155

Debussy, Claude: *L'Après-midi d'un faune*, 77–78; *Prelude to the Afternoon of a Faun*, 77

deconstructionism, 375, 404

deformities: crucifixion of Christ and, 166; disabilities and, 78; in Greece (ancient), 59, 111; grotesqueness and, 50; hunchbacks, 93, 111, 195–96, 204, 433n2 (part II); negative omens and, 111, 433n3; in Roman Empire, 111, 196; ugliness and, 25, 104; wickedness and, 46

degenerate art, 8, 46, 81–82

de Kooning, Willem: *Attic*, 296; *Excavation*, 296; *Two Women with Still Life*, 296

Delacroix, Eugène: as "Apostle of Ugliness," 76; *The Massacre of Chios*, 313

Delvoye, Wim: *Cloaca*, 426

Derbes, Anne, 134

Deutsch, Niklaus Manuel: *Death and the Girl*, 157

Dewey, John, 5, 229

dialectical beauty, 360–83; aesthetic moment and, 376–82; aischric beauty and, 13, 368, 382, 402; beauty dwelling in ugliness and, 381; challenges of, 374–75; in Christianity, 167; comedy and, 372–73, 383; distortion and, 368, 375, 382; fractured beauty and, 382; Hegelian structure of, 13, 360–68; juxtapositions and, 369–74; moral ugliness and, 363, 365; repugnant beauty and, 382; satire and, 13,

361–62, 366–69, 372–74, 377–83; tragedy and, 372

Dickens, Charles: *Great Expectations*, 47, 396, 406, 408

Diebenkorn, Richard, 295

difficult beauty, 70–78, 82, 83, 229–30, 234

Dinteville, Jean de, 3–4, *4*

Diogenes of Sinope, 110–11

disability studies, 8, 35, 78–81, 210

discrimination: disabilities and, 78–80; normative/descriptive, 89; racism, 70, 81, 84, 369–71

disgust, 51–53, 56

dissonance: aischric beauty and, 308, 325–30, 336; alienation and, 375; in atonal music, 346; emancipation of, 222; fractured beauty and, 292–93, 303; innovative, 27; microtonality and, 5; modernity and, 78, 85, 222–23, 403; in narratives, 396; poetic, 408–9; premodern, 292–93; speculative beauty and, 402; of tragedy, 408; unresolved, 2, 203

distortion: aesthetics and, 77; aischric beauty and, 306–9, 312–16, 318–22, 334–35; of architectural forms, 87; beauty dwelling in ugliness and, 345, 351, 375; caricature as, 206–7; as condition for beautiful ugliness, 2; dialectical beauty and, 368, 375, 382; emotional ugliness and, 36, 38, 69; modernity and, 323; objects in harmony with, 86; of perspective, 3, 292–93, 309, 416; of reality, 421

Dix, Otto: *The Match Seller*, 1–2, *2*, 270, 273, 421–22; moral

ugliness and, 49; negation in works by, 13; New Objectivity and, 382; *Prague Street*, 315–16; in satiric tradition, 362; *Sex Murder*, 207; *Skat Players/Card Playing War Invalids*, 316, *317*, 421; *Skin Graft*, 273; *Skull*, 239, *240*; *War*, 273, 314–15, 362; *Wounded Man*, 314–15, *315*

Döblin, Alfred: *Berlin Alexanderplatz*, 313

Dostoevsky, Fyodor: *Crime and Punishment*, 204–5; *The Idiot*, 188; *Notes from Underground*, 40

Douglas, Mary: *Purity and Danger*, 28

drama of reconciliation, 106–8, 200, 387–96

drama of suffering, 205–6, 332–33, 350–51

Dryden, John, 122, 377

Dubuffet, Jean, 297

Dukes, Mark: *Ferguson Mother of God: Our Lady against All Gun Violence*, 219

Dürer, Albrecht: *Adam and Eve*, 156–57; *Melencolia I*, 36, 355

Dürrenmatt, Friedrich: *The Physicists*, 51; on thought experiments, 57; *The Visit*, 51

Dursch, Johann G. M., 98

Dutt, Carsten, 75, 220

Eakins, Thomas: *Portrait of Dr. Samuel Gross (The Gross Clinic)*, 60, 355

Eastwood, Clint: *Gran Torino*, 407–8, 425

Eco, Umberto, 433n1 (part II)

Eisenman, Peter: *Memorial to the Murdered Jews of Europe*, 379; on postmodernism, 345–46; Wexner Center for the Visual Arts and, 299

El Greco, 194, 291

Eliot, T. S.: *The Waste Land*, 278

Elkins, James, 17

Emery, Lin: *Sunflower*, 302

emotional ugliness: aischric beauty and, 310; distortion and, 36, 38, 69; examples of, 36–40, *37*, *39*; forms of, 36, 47, 48; isolation and, 344; moral ugliness and, 49; physical ugliness and, 48; repugnant beauty and, 271; in self-portraits, 40

empathy: aischric beauty and, 320; beauty dwelling in ugliness and, 340, 342; repugnant beauty and, 284–89; speculative beauty and, 401; ugliness and, 56–59, 196

Enlightenment, 55, 196, 199, 203, 237, 244, 269, 319, 343, 397

Ensor, James: *Christ's Entry into Brussels in 1889*, 161; *The Intrigue*, 43

Erasmus, Desiderius: *Praise of Folly*, 56

Erdmann, J. E., 103

Ernst, Max: *The Angel of the Home or the Triumph of Surrealism*, 344; *The Elephant Celebes*, 343; *Murdering Airplane*, 48; *Ubu Imperator*, 344

Escher, M. C.: fractured beauty and, 292; playful fascination and, 57; *Relativity*, 49; *Up and Down*, 49

Euripides: *Alcestis*, 395; *Trojan Women*, 350

Eusebius, 174

evil. *See* moral ugliness

exemplification, 68, 416

Expressionism, 77, 86, 180, 207, 295, 333, 351, 367, 416

facial symmetry, 35

Facio, Bartolomeo: *Of the Excellence and Outstanding Character of Man*, 193

Fallada, Hans: *Little Man, What Now?*, 273

Fasnacht, Heide: *Exploding Plane*, 341; *Three Buildings*, 341

Feldkeller, Paul, 203

Fellini, Federico: *Fellini Satyricon*, 128

Ferguson, John, 124

Ferrer, Horacio: *Madrid 1937 (Black Aeroplanes)*, 27

Fetti, Domenico: *Melancholy*, 276

Feuerbach, Ludwig, 101

Fischer, Kuno: *Diotima: The Idea of the Beautiful*, 103

Fischer, Urs: *You*, 224–25

Fitzgerald, F. Scott: "The Popular Girl," 25

Fontane, Theodor: *Effi Briest*, 32

Ford, John: *Young Mr. Lincoln*, 406

fractured beauty, 291–305; advantages of, 304–5; anamorphosis and, 292, 309; asymmetry and, 299; beauty dwelling in ugliness and, 357; caricature and, 292; cubism and, 291–93, 299; dialectical beauty and, 382; dissonance and, 292–93, 303; lack of negativity in, 382, 402; in modernity, 291, 293–304, 401; postmodernism and, 297–99; realism and, 296–97

Frankel, David, 278, 341

Freud, Lucian: *Benefits Supervisor Sleeping*, 344

Friedensreich Hundertwasser House (Vienna), 298, 345

Friedrich, Caspar David: *Easter Morning*, 399

Fuhrmann, Manfred, 113–14

Gaius Lucilius, 120–21

Gardner, John, 57

gargoyles, 92–93, 192, 398

Gauguin, Paul, 203

Gehlen, Arnold, 227, 425

Gehry, Frank, 298, *298*

Genet, Jean, 330

Gethmann-Siefert, Annemarie, 95, 96

Ghirlandaio, Domenico: *An Old Man and His Grandson*, 79, *80*, 399, 401

Gies, Ludwig: *Crucified Christ*, 82

Gingeras, Alison, 371–72

Giotto: *The Crèche at Greccio*, 399; *Invidia* (envy), 149, *150*; *The Last Judgment*, 149–51; *Vices and Virtues*, 149

Glaeser, Ernst: *Born in 1902*, 273

Gnosticism, 435n1

Goethe, Johann Wolfgang von: *The Dancer's Grave*, 200; *Faust*, 40, 59, 175, 269–70, 354, 389; *Iphigenia in Tauris*, 96, 200, 388, 389; "On German Architecture," 71; Origen as influence on, 443n4; "Sakontala," 394; ugliness and, 199–200

Goldoni, Carlo: *The Liar*, 280, 373

Gombrich, E. H.: on Bosch, 151, 153; on caricature, 207; on Hegel, 15; *Story of Art*, 139–40, 403

Gonzalez-Torres, Felix: *"Untitled"* (*Portrait of Dad*), 432n5; *"Untitled" (Portrait of Ross in L.A.)*, 72–74, *73*

Goodman, Nelson, 3, 68–69, 415–16

Göring, Hermann, 319

Gothic, 71, 74, 137, 192, 195, 204, 306, 398

Goya, Francisco: *Disasters of War*, 217, 362, *363*; *Group on a Balcony*, 362; as influence on Grosz, 366; *King Ferdinand VII of Spain*, 362; *Los caprichos*, 56; negation in works by, 13; *Pilgrimage to St. Isidor's Hermitage*, 368; *Still Life of Sheep's Ribs and Head*, 217, *218*; *The Third of May, 1808*, 271–72, *272*, 319

Graf, Urs: *The Battle of Marignano*, 271

Greece (ancient): deformities in, 59, 111; drama of reconciliation in, 388; ugliness in, 109–12, 354

Greenberg, Clement, 77, 229

Greenfield, Lauren: *The Queen of Versailles*, 206

Grenier, Catherine, 324

Grimmelshausen, Hans Jacob Christoph von: *The Adventures of Simplicius Simplicissimus*, 332

Gros, Antoine-Jean: *Napoleon at the Pesthouse at Jaffa*, 401

Grosz, George: *Beauty, I Shall Praise*, 316; *Ecco Homo*, 365; *Eclipse of the Sun*, 365; *5:00 A.M.*, 365; *The Funeral (Dedicated to Oskar Panizza)*, 316, 318, *318*; *Germany: A Winter's Tale*, 316; on Hitler, 363; moral ugliness and, 56, 363, 365–66; New Objectivity and, 382; *The Pillars of Society*, 363–65, *364*; in satiric tradition, 13, 362; *Shut Up and Soldier On*, 213, *214*

grotesqueness: aischric beauty and, 316; caricature and, 50; in Greece (ancient), 110; hunchbacks and, 433n2 (part II); literature review, 430n4; in modernity, 50, 353; in narratives, 397; realism and, 353–54; repugnant beauty and, 265; ugliness in relation to, 50–51

Gründgens, Gustav, 175

Grünewald, Matthias: *Concert of Angels—Nativity*, 145; *Crucifixion*, 139–43, *140*, *142*, *143*, 168, 384; *The Resurrection of Christ*, 180–82, *181*

Grünfeld, Thomas: *Misfit (St. Bernard)*, 341–42

Grützke, Johannes, 345

Gryphius, Andreas, 177, 197–98, 268–69, 275

Guggenheim Museum Bilbao, 298

Gunkel, Hermann, 348

Gutiérrez, Gustavo: *A Theology of Liberation*, 168–69

Hamburger, Jeffrey, 137

Hamilton, C. C., 241

Handke, Peter: *Offending the Audience*, 225–26

Haneke, Michael: *The Piano Teacher*, 351; *The Seventh Continent*, 351; *The White Ribbon*, 44

Harnoncourt, Nikolaus, 326

Hasek, Jaroslav, 213

Hauptmann, Gerhard, 206

Hay, William, 196

Hazoumè, Romuald: *Liberté*, 372, *373*

Heartfield, John: anti-Nazi photomontages, 215–16, 366, 442n2 (chap. 13); *As in the Middle Ages*, 215, *215–16*; *For the Establishment of the State Church*, 366; *Goering, the Hangman of the Third Reich*, 366; *In Memory of the Catholic Victims of Fascism!*, 442n2 (chap. 13); *Normalization*, 366; *The Old Motto of the New Reich: Blood and Iron*, 366; *Program of the Olympic Games Berlin 1936*, 366; *The Real Meaning of the Hitler Salute: Millions Stand Behind Me*, 366; *The Reichsbishop Drills Christendom*, 366

Heckel, Erich: *Reading Aloud*, 295

Hegel, G. W. F.: on abstraction, 79–81; *Aesthetics*, 66, 94–95, 386; on artwork, 336, 380; on beauty, 33, 96–97, 228; on Christ's crucifixion, 144; on contingency in modern art, 85; on disagreeable parts, 27, 67; on drama of reconciliation, 106–8, 387–96; early Hegelians, 98–108; *Encyclopaedia Logic*, 30, 103, 384–85; on moments of the dialectic, 384–87; "On Wallenstein," 96; on organic art, 84; *The Phenomenology of Spirit*, 104, 338; *Philosophy of Right*, 390; on poetic dissonance, 408–9; on Romantic art, 145; on satire, 119–20; on self-motion of concepts, 28; on thinking contemplation of objects, 73; on tragedy, 372, 408; on ugliness, 94–98

Heidegger, Martin, 409

Heine, Heinrich: *Germany: A Winter's Tale*, 361, 378–79, 422; in satiric tradition, 293, 377–78; "The Weavers," 418

Heller, Eric, 200

Henckel von Donnersmarck, Florian: *The Lives of Others*, 407, 425

Henderson, Gretchen, 433n1 (part II)

hermeneutics, 11, 29, 65, 67, 69, 74, 86, 217

Hesiod, 110, 111, 267

Hess, Hans, 316

Heym, Georg: "The God of the City," 240–41

Hickey, Dave: *The Invisible Dragon*, 287–88

Highet, Gilbert, 121

Hindemith, Paul: *Matthias the Painter*, 158

Hinrichs, Hermann Friedrich Wilhelm, 103–4

Hirschhorn, Thomas: *Too Too-Much Much*, 371–72

Hirst, Damien, 61, 225

Hitchcock, Alfred, 284, 406

Hitler, Adolf, 81, 363. *See also* Nazis

Hoffmann, E. T. A.: *The Sandman*, 426

Hofmannsthal, Hugo von: *The Difficult Man*, 280–81, 408

Hogarth, William, 366

Holbein, Hans (the Younger): *The Ambassadors*, 3–5, *4*, 57, 86, 309, 398; *The Body of the Dead Christ in the Tomb*, 186–88, *188–89*, 397; *The Cardinal, the Abbott, or the Monk*, 155

Hölderlin, Friedrich: on beauty, 33; "Celebration of Peace," 397; on Greece (ancient), 112, 396; *Hyperion*, 396; as idealist, 15; "The Only One," 397; Origen as influence on, 443n4; "Patmos," 397; "The Rhine," 397

Holiday, Billie, 329

Homer: *Iliad*, 31, 309; *Odyssey*, 37, 41–42, 56, 390; ugliness and, 110, 111

Hopper, Edward, 279

Horace, 121, 341, 371, 433n2 (chap. 4)

Horne, Lena, 347

Hösle, Vittorio: *Morals and Politics*, 15; on objective idealism, 248, 429n2

Hotho, Heinrich Gustav, 94–97, 102

Huezo, Roberto: *Stations of the Cross*, 169

Hugo, Victor: *Notre-Dame de Paris*, 31–32, 93, 438n3

Huhn, Thomas, 410

Huizinga, Johan: *The Waning of the Middle Ages*, 154

Hume, David, 26, 43, 248

hunchbacks, 93, 111, 195–96, 204, 433n2 (part II)

Husserl, Edmund, 66–67, 415

hyperrealism, 59, 342

Iannelli, Francesca, 96, 97

Ibsen, Henrik: *A Doll's House*, 405

ignorance: description of, 88–89; intellectual ugliness and, 40–42, 59; of Nazis, 82; willful, 31, 32

Imdahl, Max, 320

Impressionism, 75–76, 296

Innocent III (pope): *On the Misery of the Human Condition*, 178, 192

intellectual ugliness: comedy and, 279; examples of, 41–42; forms of, 40–41, 47, 59; moral ugliness and, 42–43, 49–50, 92; physical ugliness and, 45, 48; as property of artwork, 70

Irenaeus, 165

Isaac, John: *Self Portrait as an Uninhabited City*, 40

Jewish Museum (Berlin), 308–9, 375, 425

Johns, Jasper, 38

Johnson, Samuel, 195, 377

jolie laide (pretty-ugly), 26

Jonas, Hans, 244

Jones, David: *Crucifixion*, 186

Jonson, Ben: comedy and, 105; *The Masque of Queenes*, 195; *Volpone*, 373

Jooss, Kurt: *The Green Table*, 330–31, 443n6

Jorn, Asger: *Letter to My Son*, 296

Julian of Norwich, 167

Jung, Werner, 106

Justin Martyr, 170

Juvenal, 35, 121–28, 369, 377, 422

Kadishman, Menashe: "Shalekhet," 308–9

Kafka, Franz: *The Bucket Rider*, 278, 351; emotional ugliness and, 38; *An Imperial Message*, 351; *The Metamorphosis*, 40

Kahlo, Frida: *The Broken Column*, 211, *212*; *A Few Small Nips*, 210; *Remembrance of an Open Wound*, 210–11

Kālidāsa: *The Recognition of Śakuntalā*, 394

Kamo, Hiroshi: *Serenade (Theme and Variations)*, 302

Kant, Immanuel: criticisms of, 338; *Critique of Judgment*, 36; on disgust, 52

Kantor, Maxim: Bosch and, 368; *Dragon*, 368; *Golgotha*, 186, 187; *Lonely Crowd*, 368; *Metropolis*, 368; *The Temptation of St. Anthony*, 158–59, *159*; *Wasteland*, 368

Karlsruhe Passion, 137

Kayser, Wolfgang, 50–51

Keinholz, Edward: *State Hospital*, 367

Kelleher, Katy, 6, 203

Kelly, Daniel, 52

Kennedy, Robert F., 326, 389

Kiefer, Anselm: *Margarethe*, 345; *Sulamith*, 345; *The Women of Antiquity—The Erinyes*, 358

Kienholz, Edward: *Sollie 17*, 323

Kienholz, Nancy Reddin: *Sollie 17*, 323

kimokawaii (ugly-cute), 26

King, Martin Luther, Jr., 42, 389

Kinkade, Thomas, 229–30

kitsch, 16–17, 183, 186, 206, 228–30, 234–35, 399, 403–4, 439n6

Klee, Paul: on art and visibility, 302; *Attempt at Mocking*, 435–36n4; *Outbreak of Fear III*, 313, *314*

Kleist, Heinrich von: *The Broken Jug*, 373; *Prince Friedrich of Homburg*, 388, 389

Klimt, Gustav, 76–77

Kline, Franz, 295

Klüger, Ruth, 274

Koehler, Ted: "Stormy Weather," 347

Koerner, Joseph Leo, 154, 156–57

Kokoschka, Oskar: *Self-Portrait as Warrior*, 37, 237–38; *Self-Portrait with Hand near Mouth*, 37–38

Kollwitz, Käthe: empathy in works of, 56, 284–85; *The Grieving Parents*, 340; *Hunger*, 285, 287; literature review, 431n5; moral ugliness and, 49; *The Survivors*, 285, 285–86

Kolnai, Aurel, 52

Koons, Jeff, 229

Korsmeyer, Carolyn, 52

Krafft-Ebing, Richard von, 238

Kraus, Hans-Joachim, 348

Krestovsky, Lydie, 433n1 (part II)

Kristeva, Julia, 51

Kubrick, Stanley: *A Clockwork Orange*, 381–82, 442n3 (chap. 13)

Kurosawa, Akira: *Ikiru*, 406

LaCocque, André, 349

Lactantius, 170

laissez-faire aesthetics, 61

Lang, Fritz, 248

Lars, Mario, 218

Laurens, Henri: *Head of a Young Girl*, 299, *300*

Lavater, Johann Caspar, 46

Laycock, Ross, 73–74

Lee, Alexander: *The Ugly Renaissance*, 438n1 (historical interlude)

Leibniz: *On the Ultimate Origination of Things*, 93–94; on plenitude and efficiency, 91

Leonardo da Vinci: beauty in works of, 48; *Benois Madonna*, 399; *Eye*, 292; *Grotesque Heads*, 50, 292–93

Leroy, Louis, 76

Lessing, Gotthold Ephraim: *The Jews*, 280; *Laocoön*, 52, 89; *Minna von Barnhelm*, 388–89, 408; *Nathan the Wise*, 389, 395, 408, 425; on temporal

arts, 108, 388, 398; on ugliness, 94, 267, 352, 355, 388

Lewin, Albert, 322

Lewis, Matthew: *The Monk*, 204

Libeskind, Daniel, 308, 375, 425

Lichtenstein, Alfred: "Morning," 333–34; "Twilight," 77, 333

Lifschitz, Michail, 293

Lipps, Theodor, 56, 431n5

Liszt, Franz F., 327

Lorand, Ruth, 6, 36

Lorch, Melchior: *The Pope as Wild Man*, 199, 341

Lou Ruvo Center for Brain Health (Las Vegas), 298, *298*, 345

Lucan: *Civil War*, 56, 115, 117–19

Lucas, Sarah: *Au Naturel*, 225

Lucretius, 60; *On the Nature of Things*, 115–16

Lumet, Sidney: *Twelve Angry Men*, 406

Lund, Roger, 195–96

Luther, Martin: *Interpretation of Two Gruesome Figures*, 54; *Table Talk*, 157

Lynch, David: *The Elephant Man*, 47, 79, 328; *Mulholland Drive*, 303–4

lynching, 27, 169, 219, 370

Mack, Heinz, 404

Magritte, Rene: *The Lovers II*, 344

Mahler, Gustav: *Fifth Symphony*, 326; *Resurrection Symphony*, 398; *Tenth Symphony*, 326–27

Mamet, David: *House of Games*, 248

Manet, Eduard: *Olympia*, 76, 207

Manetti, Giannozzo: *On Human Worth and Excellence*, 192–93

Mann, Heinrich: *Der Untertan*, 361; in satiric tradition, 293, 379

Mann, Katja, 363

Mann, Thomas: *The Confessions of Felix Krull, Confidence Man*, 50; *Death in Venice*, 326; *Doctor Faustus*, 36; on Hitler, 363; *The Magic Mountain*, 14

Mannerism, 191, 193–94

Manto, Saadat Hassan: *Jelly*, 271

Marc, Franz, 295–96, 300, 442n1 (chap. 13)

Marcus Aurelius, 121, 434n3

Marin, John: *St. Paul's, Manhattan*, 295

Marx, Karl, 29, 101, 404

Mastroianni, Umberto: *Dancing*, 302; *The Farewell*, *301*, 301–2; *Hiroshima*, 323

Matham, Jacob: *Avarice*, 145–46, *146*

Matisse, Henri, 294

Matsys, Quentin: *Christ Carrying the Cross*, 139; *The Ugly Duchess*, 58

Maturin, Charles: *Melmoth the Wanderer*, 204

McCarthy, Paul, 232

McGinn, Colin, 52–53

medieval Christianity: aesthetics of, 8, 90–93; crucifixion in, 131–37, 139–43; repugnant beauty and, 268; on sin and hell, 145–61

Meeropol, Abel: *Strange Fruit*, 329–30

Meidner, Ludwig: *I and the City (Self-Portrait)*, 313, 358

Melanchthon, Philip: *Interpretation of Two Gruesome Figures*, 54

Melville, Herman, 81

Menninghaus, Winfried, 52

Merce Cunningham Dance Company: *Place*, 330

Messerschmidt, Franz Xaver:
 An Arch Rascal, 340; beauty
 dwelling in ugliness and, 357;
 A Grievously Wounded Man,
 340; ugliness and, 36, 60
metaphysical frame, 59
Michelangelo: beauty in works of,
 48; *Pietà*, 399–400
Mill, John Stuart, 223, 224
Miller, William, 52
Mills, Juliet Yardley, 295
Milton, John: *Paradise Lost*, 174
mirabilia (marvels), 54–55
misogyny, 34, 44–45, 122, 195, 197,
 202, 207
MIT building, 298–99
modernity: aesthetic evaluation of,
 96; aischric beauty in, 324, 401;
 audience uncertainty and,
 222–27; Christianity and,
 213–22; contingency theme in,
 84–85; degenerate art as attack
 on, 82; despair in, 40; disso-
 nance and, 78, 85, 222–23, 403;
 distortion and, 323; fractured
 beauty in, 291, 293–304, 401;
 grotesqueness in, 50, 353;
 inversions of idealized beauty
 and, 207–13; kitsch and *quatsch*,
 228–35; loss of connection in,
 333–34; organic art and, 84;
 reality and, 236–45; skepticism
 and, 405, 408; speculative beauty
 in, 401, 407, 443n7; ugliness
 and, 59, 203–7, 404, 410
Molière: *The Miser*, 373; moral
 ugliness and, 43; *Tartuffe*, 372
Moltmann, Jürgen, 168
Mondrian, Piet, 295
Monet, Claude: *Impression, Sunrise*,
 76

Monteverdi, Claudio: "Cruel
 Amaryllis," 325–26
moral beauty, 43, 46, 47, 49, 248
moral depravity, 173–78
moral revolt, 9, 56–58, 117, 120,
 359, 368, 411
moral ugliness: aesthetics and, 94;
 aischric beauty and, 308;
 beauty dwelling in, 351–52;
 boredom and, 204; dialectical
 beauty and, 363, 365;
 educational view of, 365;
 emotional ugliness and, 49;
 ethical violations and, 31;
 examples of, 43–44; in Greece
 (ancient), 110; intellectual
 ugliness and, 42–43, 49–50, 92;
 misogyny and, 34, 44–45;
 motivations for inclusion of,
 57–58; physical ugliness and,
 45–47; power of, 363; as
 property of artwork, 70;
 repugnant beauty and, 271, 282
Mozart, Wolfgang Amadeus: *Don
 Giovanni*, 329; negative
 reception of, 75
Mukomberanwa, Nicholas:
 Desperate Man, 38
Munch, Edvard: *The Scream*, 38, 39,
 326, 333
Murano, Quirizio di Giovanni da,
 173
Murnau, F. W.: *The Last Laugh*,
 286, 334–35
Murray, Elizabeth: *Careless Love*,
 357–58; *The Sun and the
 Moon*, 357

Nabokov, Vladimir: *Lolita*, 283–84,
 357
Nashe, Thomas, 194

naturalism, 193, 206, 429n2

Nazis: anti-Nazi photomontages, 215–16, 366, 442n2 (chap. 13); on degenerate art, 8, 46, 81–82; Grosz's portrayal of, 363–65, *364*; illicit categories imposed by, 70; occupation of Poland, 5; racial ideology of, 46, 81. *See also* Hitler, Adolf

negation of a negation, 13, 85, 99–101, 256, 361, 377, 383

negative aesthetic value, 3, 66, 70, 107, 228, 230

Nehamas, Alexander, 33, 409

New Objectivity, 293, 382

Ngai, Sianne, 38

Nicolaus of Cusa: *On the Peace of Faith*, 395

Nietzsche, Friedrich: on Greece (ancient), 112; philosophy of tragedy, 354; *Twilight of the Idols*, 430n3; vocabulary of ugliness, 35

Nin, Anaïs, 224

Nolde, Emil: *The Life of Christ*, 82; *Young Danish Woman*, 295

nomological ugliness, 48–49, 343–44

norms: moral, 79, 365; social, 78–79; traditional, 42, 75

Nussbaum, Martha, 52, 53

objective idealism, 14–16, 88, 248, 335, 429n2

Oliver, Michael, 81

Origen, 163, 395, 397, 443n4

Ornstein, Robert, 388

Ortega y Gasset, José, 223, 225

Otto, Rudolf, 141

Ouida (Maria Louise Ramé), 241

Ovid: *Metamorphoses*, 57, 113–14

Panofsky, Erwin, 64

Park Chan-wook: *Oldboy*, 233–34

Parmigianino: *Madonna with the Long Neck*, 193

Pechstein, Max: *Head of a Fisherman*, 295

Penderecki, Krzysztof: *Threnody for the Victims of Hiroshima*, 5, 86, 330; ugly depictions of ugly objects by, 68; unresolved dissonance in works of, 2

Pepys, Samuel, 55

Perl, Jed, 61

Persius, 121

perspective: beauty and, 3; conceptual, 261; cynical, 258; distortion of, 3, 292–93, 309, 416; Hegelian, 28; idealist, 15, 430n5; Marxist, 350; normative, 21, 63, 227; in portrayal of reality, 3; post-Christian, 59; religious, 427

Petronius, 128, 422

physical ugliness: ability to see beyond, 79; aischric beauty and, 308; beauty dwelling in, 351–52; cultural influences on, 35; emotional ugliness and, 48; examples of, 33–36, *34*; gargoyles and, 92; in Greece (ancient), 110; intellectual ugliness and, 45, 48; moral ugliness and, 45–47; repugnant beauty and, 271; in self-portraits, 40; universal features of, 35

picaresque form, 128, 194, 332

Picasso, Pablo: distortion in works of, 7; fractured beauty and, 357; *Guernica*, 27, 64, 318–21, *320–21*; *Head of a Woman*, 293;

Picasso, Pablo (*cont.*)
 Violin and Grapes, 294;
 Weeping Woman, 321–22,
 322; *Woman's Head*, 299
Piccinini, Patricia: hyperrealism
 and, 59, 342; *The Young Family*,
 342, *343*
Pico della Mirandola, Giovanni:
 Oration on the Dignity of Man,
 193
Pindell, Howardena, 370–71
Pinker, Steven, 403–4
Pippin, Robert, 294
Piscator, Erwin, 213
Pissarro, Camille, 76
Plato: on beauty, 33, 88, 93;
 Euthyphro dilemma of, 29;
 Gorgias, 308; *Greater Hippias*,
 31, 430n1; on ignorance,
 88–89; intellectual ugliness
 and, 42; on knowledge as
 virtue, 174; on love, 361, 409;
 on organic arguments, 84;
 Philebus, 89; *Sophist*, 30, 42,
 88–89; *Statesman*, 420;
 Symposium, 42; on ugliness,
 88–89, 93, 112
playful fascination, 57, 114
Plotinus, 16, 242
Poe, Edgar Allan: *The Fall of the
 House of Usher*, 351
poetic dissonance, 408–9
Pollack, Jackson, 77, 295
positive aesthetic value, 3, 34, 62,
 66–70, 72, 226
postmodernism: beauty dwelling
 in ugliness and, 345–46, 351,
 357; fractured beauty and,
 297–99
prejudice. *See* discrimination
production aesthetics, 62–65, 381,
 403

Prudentius: *Psychomachia*, 116–17
psalms of lament, 347–49
Pseudo-Dionysius, 90, 164, 242
Putin, Vladimir, 158, 368

quatsch, 228–35
Quintilian, 119

Rabelais, François, 353
racism, 70, 81, 84, 369–71
Raft of the Medusa (Géricault), 269
Ramé, Maria Louise (Ouida), 241
Ramis, Harold: *Groundhog Day*,
 278–79
Raphael: beauty in works of, 48;
 Crucifixion, 183; *Madonna of
 the Meadow*, 191–92; *The
 Transfiguration*, 400
realism: antirealism, 12; critical, 75;
 fractured beauty and, 296–97;
 Gothic, 137; in Greece
 (ancient), 111; grotesque,
 353–54; hyperrealism, 59, 342;
 socialist, 293; ugliness and, 60,
 351, 362–63. *See also*
 surrealism
reality: beauty dwelling in ugliness
 and, 341, 350; caricature and,
 104; concept in harmony
 with, 30, 32; deficiencies of,
 58, 362, 410; distortion of,
 421; fractured beauty and,
 299; idealized versions of,
 70, 78; intensification of, 344;
 modernity and, 236–45;
 perspective in portrayal of,
 3; ugliness and, 38, 40, 105;
 unwillingness to confront, 1
reception aesthetics, 29, 51–54,
 62–65, 72, 404, 431n3
reconciliatory art, 405–8. *See also*
 drama of reconciliation

Reinhardt, Ad, 288

Remarque, Erich Maria: *All Quiet on the Western Front*, 56, 273, 286

Rembrandt: *The Artist's Mother*, 276

Renaissance: artistic imagination in, 36; beauty during, 48; carnivalesque spirit during, 353; classical and idealizing tendencies of, 442n1 (chap. 13); humanism during, 191; perspective in, 3; repugnant beauty in, 269; underside of, 438n1 (historical interlude)

Reni, Guido: *Crucifixion*, 144

Renn, Ludwig, 273

Renoir, Jean: *Grand Illusion*, 406

repugnant beauty, 265–90; aischric beauty and, 308, 323; beauty dwelling in ugliness and, 355–57; dialectical beauty and, 382; drama of suffering and, 350; empathy and, 284–89; grotesqueness and, 265; range of, 267–71; speculative beauty integrated with, 402; tragedy and, 281; ugliness and, 271–84, 289–90; universal nature of, 401

resurrection of Christ, 180–82; *The Resurrection of Christ*, 181

Rhoades, Jason: *Garage Renovation New York*, 225

Ribera, Jusepe de, 50

Ribon, Michel, 432n4

Richter, Gerhard: *Barn*, 297; *Betty*, 297; fragmentation worldview of, 421; *Inge*, 297; *Reader*, 297; realism and, 296–97; *Woman Descending the Staircase*, 297

Richter, Simon, 438n4

Ricoeur, Paul, 349

Rimbaud, Arthur: *A Season in Hell*, 213; "The Seated Men," 349; "Venus Anadyomène," 349; "What Is Said to the Poet Concerning Flowers," 349

Ringleben, Joachim, 141

Roche, Barbara: *Just Warped*, 418–20, *419*

Rodin, Auguste: *Despair*, 36–37, *37*; *Ugolino and His Children*, 43

Roman Empire: deformities in, 111, 196; satire in, 119–30; ugliness and disgust in, 111, 113–18, 130

Romanticism, 145, 203, 204, 409

Ronsard, Pierre de: *When You Are Very Old*, 266

Roosevelt, Franklin Delano, 328

Rops, Félicien: *Head of Old Woman from Antwerp*, 276

Rosenberg, Alfred, 81

Rosenkranz, Karl: *Aesthetics of Ugliness*, 46, 99, 103–5; on beautiful ugliness, 105; on dialectical beauty, 360

Rosling, Hans, 403–4

Rothenberg, Susan: *Half and Half*, 421

Rothko, Mark, 295

Rötscher, Heinrich Theodor, 105–6

Röttgen Pietà, 136–37, *138*

Roualt, Georges: *The Clown*, 294; *Head of Christ*, *312*, 312–13

Rubens, Peter Paul: *Christ on the Cross*, 144; *Descent from the Cross*, 144; *Head of the Medusa*, 33–34, *34*, 44, 196; *The Martyrdom of St. Livinus*, 401

Ruge, Arnold, 101–2, 239

Russian invasion of Ukraine, 368

Saar, Betye, 370–71

Sade, Marquis de, 49, 203

Sallman, Warner, 17, 183

Santayana, George, 27

satire: caricature and, 104, 293; dialectical beauty and, 13, 361–62, 366–69, 372–74, 377–83; moral norms and, 79; moral revolt and, 56; in Roman Empire, 119–30; on ugliness of reality, 105

Saville, Jenny: *Suspension*, 68; *Torso II*, *209*, 209–10; *Trace*, 210

Schaeffer, Jean-Marie, 62

Schasler, Max: *Critical History of Aesthetics*, 106; on difficult beauty, 72; on ugliness, 31, 102, 106

Scheler, Max, 56, 431n5

Schelling, Friedrich Wilhelm: *Philosophical Investigations into the Essence of Human Freedom*, 242–43; theory of evil, 100–101, 242–43

Schiele, Egon: *Self-Portrait with Striped Armlets*, 48

Schiller, Friedrich: "The Artists," 16; *Don Carlos*, 96; *On Naive and Sentimental Poetry*, 129; *The Robbers*, 46, 56, 96; in satiric tradition, 120, 362; ugliness and, 95, 433n4 (part II); *Wallenstein*, 96; *Wilhelm Tell*, 96, 389

Schlegel, Friedrich: *On the Study of Greek Poetry*, 89

Schmidt, Arno, 303, 374

Schmidt-Rottluff, Karl: *Nude*, 295

Schoenberg, Arnold: atonal harmonies of, 346; on dissonance, 222–23; *A Survivor from Warsaw*, 330

Schön, Erhard: *Vexierbilder* (*Picture Puzzles* or *Secret Images*), 292

Schopenhauer, Arthur, 52

Schultze-Naumburg, Paul: *Art and Race*, 81–82

Schwitters, Kurt, 371

Scruton, Roger, 17

Sebastian (saint), 183

seeming ugliness: aesthetics and, 63, 66; assessment of, 32; difficult beauty and, 71, 72; disability studies, 8, 78–79; in holistic frame, 35; misjudgment of, 70, 81

Seneca: *Oedipus*, 114–15; *On Providence*, 92; *Thyestes*, 114

Sequeiros, David Alfaro: *Echo of a Scream*, 382

Serrano, Andres: *Piss Christ*, 217; *Shit*, 233, *233*

Shakespeare, William: *Cymbeline*, 388; drama of reconciliation and, 388, 395; *Hamlet*, 195, 282; *Julius Caesar*, 404; *King Lear*, 43, 196, 281–82, 405–6, 424–25; *Love's Labor's Lost*, 41, 331; *Macbeth*, 195, 205; *Much Ado about Nothing*, 41, 331–32, 388; *Richard III*, 194, 195; *The Tempest*, 195, 388; ugliness and, 107; *The Winter's Tale*, 195, 388

Shammout, Ismail: *Where to . . .?*, 380–81

Shelley, Mary: *Frankenstein*, 426

Sherman, Cindy: *Untitled #175*, *208*, 208–9

Shostakovitch, Dmitri, 330

Sibley, Frank, 6, 26, 32

Sidney, Philip: *The Countess of Pembroke's Arcadia*, 195

Sidonius Apollinaris, 45–46

Siebers, Tobin, 211, 213

Sigüenza, Jose de, 151
Simmel, Georg, 136
Simpson, Kathryn, 237
Sinclair, Upton, 239
skepticism, 224, 249, 386, 403, 405, 408
Smith, David: *Cubis*, 302–3
Smith, Kiki: *Tale*, 51, 207; *Untitled*, 278, 340–41, 358
social constructivism, 429n2
socialist realism, 293
Socrates: dialogues of, 385, 390; on hidden knowledge, 380, 430n2; on ignorance, 89; physical ugliness of, 8, 45; subjectivity and, 119
Sonderborg, K. R. H., 295
Sophocles: *Antigone*, 98, 205, 281, 385–86, 392; *Oedipus at Colonus*, 56, 107, 388, 391–94, 396; *Oedipus the King*, 391–92, 394; *Philoctetes*, 388
Southern, R. W., 133
Soutine, Chaim: *Landscape at Cagnes*, 295
speculative beauty, 384–410; beckoning beauty and, 407–8; challenges of, 402–10; Christianity and, 395, 397; crucifixion and, 399–401; dissonance and, 402; drama of reconciliation and, 387–96; empathy and, 401; kitsch and, 403, 404; in modernity, 401, 407, 443n7; moments of the dialectic and, 384–87; repugnant beauty integrated with, 402; spatial arts and, 398
Spencer, Stanley: *The Resurrection of the Soldiers*, 214
Spitzer, Leo, 84
Statius: *Thebaid*, 118

Stein, Edith, 56, 431n5
Steiner, Wendy, 404
Steinherr, Ludwig: "Beauty," 185–86, 398; "Note in Damascus," 189, 397; "Reading Dante on the Train," 397
Stockhausen, Karlheinz, 85
Stoicism, 92, 114–15, 120, 130, 196
Stolnitz, Jerome, 53
Stone, Oliver: *Platoon*, 328
Stravinsky, Igor: *The Rite of Spring*, 27
suffering, drama of, 205–6, 332–33, 350–51
surrealism, 246, 312, 343, 344
Suso, Henry: *Little Book of Eternal Wisdom*, 135–36
Sutherland, Graham: *Crucifixion*, 186
Swift, Jonathan, 377
symmetry: aischric beauty and, 307, 309; facial, 35
Szondi, Peter, 19

Tacitus, 121, 434n3
Tagore, Rabindranath: *The King of the Dark Chamber*, 394–95
Tarantino, Quentin, 57, 431n6
Tarr, Béla: *Damnation*, 48, 59
Tate, Nahum, 405–6
Taylor-Johnson, Sam: *A Little Death*, 352; *Still Life*, 351–52
Tertullian, 165, 170
Tha'ālibi, Al-: *The Beautification of the Ugly and the Uglification of the Beautiful*, 271
Thomas à Kempis: *Imitation of Christ*, 177
Thomas Aquinas: elevation of color by, 31; on *mirabilia* (marvels), 55; *Summa theologiae*, 90; on ugliness, 90, 242

Tillich, Paul, 75

Timmerman, John, 6

Tintoretto, Jacopo Robusti: *The Birth of Christ*, 399, *400*

Titian: *The Flaying of Marsyas*, 269, 355

Tolstoy, Leo: *Anna Karenina*, 425; *The Death of Ivan Ilyich*, 278; *War and Peace*, 43, 47

tragedy: beckoning beauty and, 408; comedy as negation of, 102; dialectical beauty and, 372; dissonance of, 408; in drama of reconciliation, 387–94; elements of, 95–96, 385; Nietzsche's philosophy of, 354; repugnant beauty and, 281; tragicomedies, 51, 85; ugliness and, 110, 111, 407–8

transitory ugliness, 179

tritones, 77, 327–29

Trunk, Herman: *Crucifix*, 41

Tucholsky, Kurt: *Germany, Germany Above All Else*, 361–62; on Grosz, 366; in satiric tradition, 129, 379

Turner, J. M. W., 247

ugliness: asymmetry and, 25, 35, 169; attraction to, 1, 56, 88; caricature and, 94, 102, 104, 107, 360; comedy and, 41, 43, 100, 103, 107–11, 279, 352; definitions of, 7–8, 25–33; early modern Christians on, 90–92; empathy and, 56–59, 196; in Greece (ancient), 109–12, 354; Hegel and Hegelians on, 94–108; inexhaustibility of, 424–28; intellectual, 40–43, 45, 47–50, 59, 70, 92; literature review, 6, 429n1; medieval, 44–46, 53, 57, 90–93; modernity and, 59, 203–7, 404, 410; motivations for inclusion in art, 8, 56–60; negative aesthetic value of, 3, 66; neighboring terms, 50–55; nomological, 48–49, 343–44; as opposite of beauty, 7, 25–26, 29, 33; as organic, 84–87; realism and, 60, 351, 362–63; as repellant, 1, 7, 26–29, 31, 33; repugnant beauty and, 271–84, 289–90; in Roman Empire, 111, 113–18, 130; tragedy and, 110, 111, 407–8; transformation of, 5, 289; transitory, 179. *See also* beautiful ugliness; emotional ugliness; moral ugliness; physical ugliness; seeming ugliness

Ukraine, Russian invasion of, 368

unintegrated parts, 2, 203, 325

unresolved dissonance, 2, 203

van Dyck, Anthony, 371

van Gelder, Geert Jan, 271

van Gogh, Vincent: *The Bedroom at Arles*, 69; *The Church at Auvers*, 69; *The Starry Night*, 69; ugliness and, 38, 415; *Wheatfield with Crows*, 358

van Hoddis, Jakob: "The End of the World," 77, 333

van Reymerswaele, Marinus: *The Lawyer's Office*, 382; *The Misers*, 43

Vasari, Giorgio: *The Lives of the Painters, Sculptors, and Architects*, 192

Velázquez, Diego, 401, *402*, 416

Verstand (understanding), 385–87, 391

Vico, Giambattista, 16

Virgil: *Aeneid*, 113

virtue: beauty and, 46; knowledge as, 174

Vischer, Friedrich Theodor: *Ästhetik oder Wissenschaft des Schönen*, 102–3

Visconti, Luchino, 326

Voltaire: *Candide*, 244

von Sternberg, Josef: *The Blue Angel*, 287, 351

wabi-sabi (imperfection), 5–6, 26

Wagner, Richard: *Götterdämmerung*, 327; *Tristan and Isolde*, 327–28

Walker, Kara: criticisms of, 370–71; dialectical beauty and, 369; *The End of Uncle Tom and the Grand Allegorical Tableau of Eva in Heaven*, 370; *Gone*, 370

Wall, Jeff: *The Flooded Grave*, 219–20, *220*

Warhol, Andy, 38

Waters, Ethel, 347

Watkins, Franklin: *The Crucifixion*, 219

Weber, Carl Maria von: *Der Freischütz*, 329

Weber, Max: *Three Literary Gentlemen*, 296

Weber, Paul: *The Old White Horse*, 276; *The Rumor*, 373–74, *374*

Weill, Kurt: *The Threepenny Opera*, 375–76

Weiße, Christian: on instrumental music, 85; *System of Aesthetics as the Science of the Beautiful*, 99–101

Westermann, Claus, 348

Wexner Center for the Visual Arts, 299, 345, 375

Weyl, Hermann, 35

Wiene, Robert: *The Cabinet of Dr. Caligari*, 7, 86–87, 334

Wilde, Oscar: *The Critic as Artist*, 247–48; moral ugliness and, 8, 43–44; *The Picture of Dorian Gray*, 204, 250–58, 276, 322, 359, 440nn4–5

Wiley, Kehinde: "Lamentation," 289; *Prince Tomasso Francesco of Savoy-Carignano*, 371

Williams, Rowan, 242

Wilson, Robert, 52

Winckelmann, Johann, 112, 119

Wittgenstein, Ludwig, 86, 237

Wölfflin, Heinrich, 64, 197

Wolgemut, Michael: *Dance of Death*, 155

Wycherley, William, 195

Zappa, Frank, 245

Zervigón, Andrés, 216

Ziolkowski, Jan, 45, 47

Zola, Émile: *The Experimental Novel*, 57; on scientific curiosity, 241; *Thérèse Raquin*, 381

Zorn, John: *Elegy*, 330

Zuckmayer, Carl: *The Captain of Köpenick*, 286

Zurbarán, Francisco de: *Christ Crucified*, 144

MARK WILLIAM ROCHE

is the Rev. Edmund P. Joyce, C.S.C., Professor of German Language
and Literature, concurrent professor of philosophy, and former dean
of the College of Arts and Letters at the University of Notre Dame.
He is the author of many books, including *Realizing the Distinctive
University* (University of Notre Dame Press, 2017) and *Why Choose
the Liberal Arts?* (University of Notre Dame Press, 2010),
which won the Frederic W. Ness Book Award.

Printed in the USA
CPSIA information can be obtained
at www.ICGtesting.com
LVHW061920271123
765060LV00011B/78